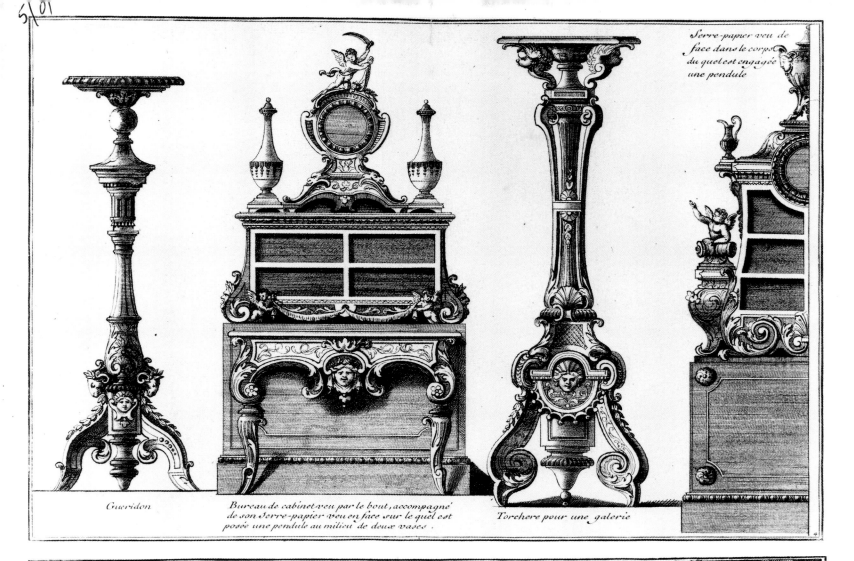

Gueridon

Bureau de cabinet veu par le bout, accompagné de son Serre-papier veu en face sur le quel est posée une pendule au milieu de deux vases.

Torchere pour une galerie

Serre-papier veu de face dans le corps du quel est engagée une pendule

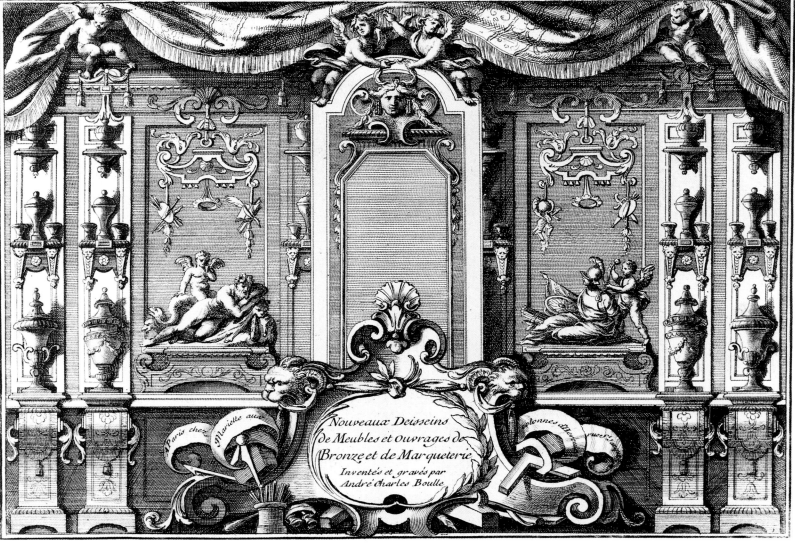

Nouveaux Deisseins de Meubles et Ouvrages de Bronze et de Marqueterie Inventés et gravés par André Charles Boulle

A Paris chez Mariette aux

FRENCH FURNITURE MAKERS

THE ART OF THE ÉBÉNISTE
FROM LOUIS XIV TO THE REVOLUTION

© 1989 Sté Nlle des Editions du Chêne

Published in the United States by the J. Paul Getty Museum,
17985 Pacific Coast Highway, Malibu, California 90265

First published in this English language edition for Sotheby's Publications
by Philip Wilson Publishers Ltd, 26 Litchfield Street, London WC2H 9NJ.

ISBN 0-89236-183-2

LC 89-060462

Typography by Peter Ling
Designed and conceived by Hachette Groupe Livre,
79 Bd Saint-Germain, 75288 Paris Cedex 06, France

Printed in France by Mame Imprimeur, Tours
Phototypeset by Tradespools, Frome, Somerset

PAGE 1
Above: *Plate IV of the portfolio of engravings by Boulle published by Jean Mariette
(1660–1742). The eight plates in this collection were included by Mariette in the
second edition of* L'Architecture à la mode, *which is to be dated after 1707 (date of
the death of Mariette's nephew, Nicolas II Langlois, who had printed the first
edition and held the rights). In the second edition Mariette added plates by Pineau
and Oppenordt with those by Boulle in order to illustrate the new style, which would
date Boulle's engravings c. 1710–20*

Below: *Plate I of Mariette's portfolio of engravings by Boulle*

PAGE 5
*Design for a porcelain jewel-cabinet made by Carlin for the dealer Daguerre; from
the Saxe-Teschen album (see page 39) (Metropolitan Museum of Art, New York)*

PAGE 440
Above: *Plate V of the Boulle portfolio*
Below: *Plate II of the Boulle portfolio*

Alexandre Pradère

FRENCH FURNITURE MAKERS

The Art of the Ébéniste
from Louis XIV to the Revolution

Translated by Perran Wood

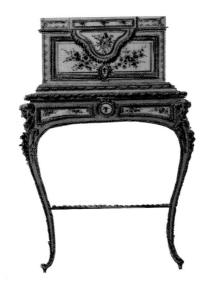

THE J. PAUL GETTY MUSEUM
MALIBU, CALIFORNIA

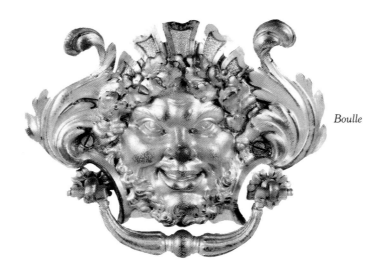

Boulle

CONTENTS

Boulle

Benneman

Riesener

Leleu

INTRODUCTION

THE CRAFT OF THE ÉBÉNISTE

The title of this work calls for preliminary comment. A good third of the French ébénistes of the seventeenth and eighteenth centuries were first or second generation immigrants. A glance at the contents list of this book will bear this out. Ébénistes of the century of Louis XIV came from the Flemish Netherlands or from Holland. Boulle's family originated from Guelderland, Gole was born in Holland, as was Oppenordt, while Laurent Lelibon was born in Antwerp and Michel Camp in the duchy of Julliers. The great names of the rococo style also came from these regions, such as the Criards from Brussels and the Vanrisamburghs from Holland, and some also from Germany like Latz and Joseph Baumhauer. In the next generation, almost all the great ébénistes came from Germany, particularly from the Rhineland, such as Oeben, Riesener, Carlin, Benneman, Weisweiler, Schneider and Molitor. On coming to Paris these foreigners grouped themselves together in certain quarters such as the Faubourg Saint-Antoine, where ancient privileges placed them outside the regulation of the Parisian Guild of Menuisiers, and so enabled them to work.

It was the aim of the guild system, as it operated in France in the seventeenth and eighteenth centuries, above all to protect the interests of a group of established craftsmen, and it did not welcome free competition or the establishment of newcomers. At a time when family or guild ties were fundamental to the organization of society, integration by strangers was difficult. In many cases integration took place only if the newcomer married into a family of Parisian ébénistes. From the outset, the network of family protection helped him to obtain his mastership and set up a workshop. In the majority of cases the newcomers were integrated into the heart of a Flemish or German community in the Faubourg Saint-Antoine closely bound together by family ties, and worked for the marchands-merciers or other ébénistes-marchands without having direct access to a private clientèle. The situation may be summarized as follows. The most lucrative side of the business, the retailing of furniture, was effectively reserved by the families of the Parisian ébénistes who were established in the commercial quarters in the centre of the city or in the Grand-Rue du Faubourg Saint-Antoine where they had access to private clients, whereas production was mostly carried on in the Faubourg Saint-Antoine by unknown foreign craftsmen. It is true that certain Germans such as Oeben or Riesener enjoyed a celebrity unique to the profession; but they were exceptional. Who in their life-time had heard of B.V.R.B., or of Latz, Joseph Baum-

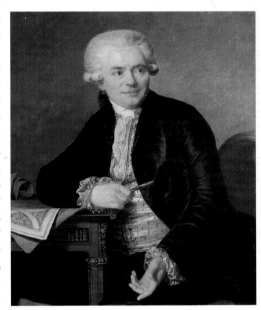

Detail of the armoire-chiffonnier stamped Bury and Tuart [296], showing decoration painted in oil on a ground of wavy sycamore, attributed to Jean-Louis Prevost. (Archives Galerie Gismondi, Paris)

Portrait of Riesener by Vestier; the ébéniste is here depicted holding the pen of a designer of furniture rather than a craftsman's plane: one senses the desire to affirm his status as an artist. (Musée de Versailles)

hauer, R. V. L. C., Carlin or Weisweiler? Their names are not mentioned in any contemporary sale catalogue and the poverty of their probate inventories bears witness to their modest circumstances. On the other hand, certain ébénistes whose names are barely known to us were then highly sought-after, such as Lefèbvre who worked in the rue Saint-Denis during the reign of Louis XIV or Noël Gérard during the Régence and, in the second half of the eighteenth century, Tuart, Séverin, Macret and Héricourt. Reading old almanacs can be revealing in giving the addresses most in demand in Paris. In 1772 the *Tablettes royales de renommée* lists the following ébénistes:

– Dubois, rue de Charenton, owner of a manufactory and famous furniture shop, delivers to the country and abroad.
– Fromageot, Grand-Rue du Faubourg Saint-Antoine, owner of a manufactory and shop for all kinds of high quality furniture and makes deliveries to the country and abroad.
– Garnier, rue Neuve-des-Petits-Champs, for ébénisterie.
– Hobenne [sic] owns a manufactory at the Gobelins and a large shop dealing in ébénisterie, delivers to the country and abroad.
– Widow Hobenne, at the Arsenal, owns a large furniture emporium.
– Joubert, butte Saint-Roch, 'Ébéniste ordinaire du roi', has just completed furniture of top quality for Mmes la Dauphine and la Comtesse de Provence.
– Leleu, Rue Royale, owner of a manufactory and shop dealing in ébénisterie, delivers to the country and abroad.
– Sevrin, rue Dauphine, ébéniste, holder of the secret of 'vernis d'Angleterre' to colour brass mounts.

The same almanac, however, says nothing about other important ébénistes who were active at the same time, such as Carlin, R. V. L. C., Dautriche, Kemp or Rübestuck. Material success and fame were enjoyed by the sellers, whilst the lot of the producers was precarious. Probate inventories reflect the prosperity of the former and the relative poverty of the latter, in whose scanty lodgings little if anything in the way of pictures or tapestries is usually to be found, a modest amount of plate and few pieces of furniture; cane chairs, walnut buffets and fruitwood commodes being the staple rudimentary furnishings. The marchands-ébénistes, on the other hand, owned large stocks of furniture; Pierre Roussel's inventory after his death in 1783 detailed no less than 244 pieces of furniture in the shop. Some of them had made large fortunes, such as Noël Gérard who during the Régence had become established in the former hôtel of Jabach the banker and now dealt in timber as well as furniture, objets d'art and pictures.

This hierarchy within the trade was observed by Roubo who wrote in 1769 in *L'Art du Menuisier*:

The menuisiers-ébénistes, for the most part, do not sell the finished work for the price that it would be worth if it were of good quality and well made. They cannot do otherwise, seeing as most of them work exclusively for the marchands who do not pay what the work is worth. The luxury in fashion today is also one of the causes of the lack of finish in ébénisterie, as everyone wishes to own it without having the means to pay for its true value.

Roubo adds, 'The menuisiers-ébénistes, for the most part, do not make the carcases themselves but have them made at rock-bottom prices by other menuisiers who do nothing else.'

Towards the end of the eighteenth century the division at the heart of the ébéniste's trade between producers and sellers became accentuated and led to extreme cases such as that of Nicolas Héricourt, who was both ébéniste and marchand-mercier and employed nearly a hundred workers. In 1790 his widow, Marie-Anne Kropper, was obliged to give a list of workers employed by her to the syndic of the marchands-merciers; amongst the fifty-four ébénistes in her employ, there were twenty-seven independent craftsmen, the same number as master ébénistes: [Louis-Claude] Pierre; [Jean-Baptiste] Vassou; [Joseph] Kochly; [Martin] Oehneberg; [Conrad] Mauter; [François-Claude] Menant; [Denis-Louis] Ancellet; [Pierre II] Roussel; Charière; [Denis] Jullienne; [Jean-Pierre] Dusautoy; [Jean-Frédéric] Birckel; Depaux; Guillard; Marchand; Lausanne; [Jean-Frédéric] Ratié; [Jacques] Lucien; [Charles] Topino; [Pascal] Coigniard; [Étienne] Avril l'Aîné; [Jean] Caumont; Kans; [Jean-Baptiste] Pignit; [Antoine-Simon] Mansion; Folemayere; Foulon. (Arch.Nat. F30/132.)

Besides these ébénistes, the widow Héricourt employed bronze workers (the caster Alain, the chaser Maurot), 'metal-guilders' (Bécard father and son; Martin), wood-gilders, chaser-mounters (Gendé), a locksmith, two clock-makers (Cronier and Le Guay), a 'caster-maker', a 'sconce-maker' and a wood-carver. It is clearly specified that all these craftsmen worked at home and no doubt had the right to work for other employers beside Héricourt. The craft infrastructure was thus perfectly secure, even if, with hindsight, it is clear that the foundations had already been laid for the industrialization of the nineteenth century.

The importance of foreign workmanship and the stratification of the trade into producers and sellers are two factors unique to Parisian ébénisterie, and intimately linked to its dynamism. This is evident if the ébénistes are compared to their fellow professionals the menuisiers. The latter, who were generally of French origin, were established in the centre of Paris. Their conservative nature and lack of innovatory urge mark the art of chair-making during the eighteenth century, in spite of individual successes. By contrast, in furnishing the enterprising and inventive merchants with able foreign workmanship, the system favoured the extraordinary rise of the Parisian ébéniste. A constant flow of innovations accompanied the progress of ébénisterie – in design and types of furniture, new combinations of materials, new techniques, etc. The guild system was active at the heart of all this. Aimed in theory at maintaining the trade in a craft framework, with the production and selling processes indivisible, it resulted in practice in the exclusion of a large section of foreign workers from the retailing of their products.

THE GUILD OF MENUISIERS

Design for a marquetry chair, to be compared to four armchairs made by Boulle for the Grand Dauphin in 1686. (Musée des Arts Décoratifs, Paris)

During the seventeenth century and even more so during the eighteenth, the trades involved in the making of articles of wood in France, the métiers du bois, were strictly regulated by the guilds. Originally craftsmen in wood were grouped together in one single guild, that of the menuisiers, which had broken away from the guild of carpenters during the Middle Ages. During the eighteenth century techniques of working with wood became more sophisticated, resulting in specialized groups of craftsmen. Two distinct trades existed under the umbrella of the same guild, as well as the menuisiers specializing in wall-panelling or in carriages, with their own methods of work and places of business. The menuisiers who made furniture in solid wood (beds, chairs and consoles) were mostly of French origin and lived in the area around the rue de Cléry. They were used to working with wood-carvers, painters and guilders who also grouped themselves together in neighbouring areas. The menuisiers en ébène, who were later to be called 'ébénistes', specialized in furniture in veneered wood or marquetry (cabinets, commodes and bureaux) and embellished their furniture with bronze mounts. It was no longer the custom in the eighteenth century to combine ébénisterie and the making of articles in carved gilt wood in France, as Gole and Cucci had done in the seventeenth century, and similarly, chairs in France were no longer embellished with marquetry or gilt-bronze, as had been some work by Boulle for the Grand Dauphin. It was a question of work practices rather than written rules. The delineation between the two specialities of ébéniste and menuisier was complicated by numerous exceptions. Many pieces of furniture in solid wood (walnut commodes, nighttables, dressing-tables) were made by ébénistes and not by menuisiers. The day-book of the Garde-Meuble Royal has many entries for commodes in walnut, bidets and dressing-tables delivered by Gaudreaus and later by Joubert and Riesener. Furthermore, a certain number of chairs are stamped by ébénistes such as Garnier, Cosson or L. Moreau. These were chairs dating from about 1778, made in mahogany in the latest fashion, and ébénistes had been commissioned to make them: mahogany, an ébéniste's wood, was used for veneering and called therefore for an ébéniste's technique. When, with Jacob, the use of mahogany for chairs became more widespread around 1785, the wheel could be said to have come full circle, with the menuisiers using the technique of veneering.

The guild of menuisiers gave itself new statutes in 1743, which were approved by the King; it was granted letters patent in 1744. These new statutes came into conflict with the interests of other guilds, such as the turners, upholsterers and marchands-merciers, from whom there was an immediate reaction. The various objections were countered by successive orders made in 1745, 1749 and 1751 and the definitive registration of the new statutes by the Parlement took place in 1751. A résumé follows.

Menuisiers and ébénistes formed a panel within the guild, annually electing a syndic or principal who sat for one year and three adjudicators who sat for two years. Thus at any one time there was one syndic and six adjudicators. The ébénistes who were new-comers to this ancient guild had a minority representation, one ébéniste being elected every two years. The panel was responsible for the collection of fees due when a master was admitted and for the re-distribution of these monies, in part to the 'poor masters' or 'widows of poor masters', and in part to the Royal School of Design. Above all, the panel was responsible for preserving the privileges of the guild. The most important of these was the monopoly of pro-duction, which involved the exclusion of anyone not a master from working as an ébéniste in Paris or the Faubourgs or even owning a shop or working at home. In fact, a monopoly of production of this nature could be applied only at the point of sale, to ensure that the only furniture on the market was that of the master ébénistes. This led to the idea of a stamp. The master ébénistes were therefore obliged to stamp their work, and they would receive a visit four times a year from the adjudicators, who were charged with ensuring that their work conformed to the rules and showed no 'defects' or 'poor workmanship'. At the time of their visit the adjudicators would place next to the maker's stamp the official hall-mark, com-posed of the letters 'J. M. E.' (Jurande des Menuisiers-Ébénistes), and levy a modest charge.

Mastership could be obtained after three years work as an apprentice, followed by a further three years work as a journeyman to a master ébéniste. It was necessary to produce a *chef-d'oeuvre* in the workshop of an adjudicator, proving competence as an ébéniste. Finally, at the time of receipt of the letters of mastership, the ébé-niste had to pay a fee to the panel of the guild. This varied con-siderably, depending on whether the new master was the son of a master or a stranger to the guild. So a son or a son-in-law of a master adjudicator or former adjudicator had to pay only about 120 livres, whereas the son or son-in-law of a plain master ébéniste had to pay 180 livres if he was born after the date of his father's mastership, and more than 280 livres if he was born before the date of his father's mastership. The fees for a simple apprentice who was neither son nor son-in-law of a master amounted to more than 380 livres, and for a worker who was a complete outsider to the guild, more than 530 livres. These fees must have seemed very high, particularly for a young foreign ébéniste (to give a point of comparison, the annual salary of a journeyman assistant would have been around 400 livres). In fact, many ébénistes, as we shall see, obtained their mas-tership fairly late in their career. Masterships were, further, reserved for Catholics and French or naturalized French craftsmen. Thus many young craftsmen originating from Germany or Holland had no other choice than to work either illegally or as journeyman to a master, or else to avoid the obligation of gaining the mastership by working in 'privileged areas'.

Certain areas in the neighbourhood of monasteries and convents had been placed under religious protection in the Middle Ages and had preserved their franchises. This was the case in the Enclos du Temple, Saint-Jean-de-Latran, Saint-Denis-de-la-Chartre and above all in the Faubourg Saint-Antoine, and ébénistes who worked there could not be harried by the guild. However, the guild of menuisiers hindered the sale of such craftsmen's work as much as possible, considering it to be illegal. Upholsterers were forbidden to sell the furniture of independent workers which was therefore not stamped. Master ébénistes were also forbidden to buy the production of independent workers or even to stamp it or to lend them their stamp, although there are many indications that some of them found it very convenient to do so. These prohibitions were rendered effective by the right of inspection and of confiscation by the guild adjudicators. The guild increased its inspections on the fringes of the privileged areas in order to seize the furniture which the independent craftsmen were trying to sell. The annual accounts of the guild for the year 1779 advised of

visits made with the bailliff and several strong men, by night and day, in the neighbourhood of Porte Saint-Antoine, Saint-Jean-de-Latran, Saint-Denis-de-la-Chartre, the Temple and other privileged areas, in order to seize the miscreants and stop the contravention of the guild privileges, the said visits by night and day having been made many times and occasioned many seizures [. . .] and having besides produced the sum of 23,850L in masters' qualifying fees [. . .] the said masters would not have been received had they not been watched by the syndics and strong men who confiscated their works as soon as they were dispatched. [Arch. Nat. H2 2118, 1779.]

The only outlets for these independent artisans amounted to selling directly to individuals, on condition that the latter themselves arranged the collection of articles purchased from workshops. The statutes were precise on this point:

When the citizens of Paris buy works from the said trade in the privileged areas, they are obliged to take and accompany them themselves, transporting them to their homes either themselves or having their children or servants do so, giving them a statement signed personally to the effect that they have ordered a certain piece from a certain worker or dealer living at [. . .] for their own use and not for that of others [. . .]

Another outlet for the independent makers was sale to the dealers, the marchands-merciers. This powerful guild had actually resisted the attempts of the guild of ébénistes and menuisiers to force them to sell only furniture made by masters. The statutes of 1751 maintained the marchands-merciers' right to 'do business in all works and pieces of furniture, stamped or unstamped, even to import it from outside the town or from abroad, in a finished or unfinished state'. The menuisiers and ébénistes had the right to stamp their furniture 'without the marchands-merciers being obliged to

sell only stamped work, neither may the said menuisiers inspect the marchands-merciers' premises nor make any seizure from them.'

It is easy to understand that without the facilities to market their products freely, the independent craftsmen depended almost entirely on the marchands-merciers or on their colleagues, the master ébénistes, even if in theory the latter could not touch their work. It should also be noted that the guild strove to constrain the trade of menuisier and ébéniste within the traditional craftsmen's confines; the statutes indicate that 'each master of the said profession may not have more than one single shop or workshop either in the town, or in the Faubourgs, or in the privileged areas, and is obliged to make his residence in the place and building of his shop.' They were permitted to have a yard or store of wood in a different place from their workshop on the condition that the door was kept locked and that it would not be used as a second workshop. The number of apprentices a master could employ was limited to two at any one time (engaging one every three years for a period of six years), but the master could employ as many journeymen as he wished, on condition that he made sure they were registered with the guild committee and declared them all at the annual inspection of the adjudicators.

Outside the privileged areas journeymen were forbidden to own tools or a workbench at home. 'Any journeyman in the said trade is expressly forbidden to carry out any work, business or function of a master for anyone in our aforesaid town [. . .] or to have at his place, in his room, house or inn or anywhere else, a workbench or strong table pierced with holes for a vice, on which he could work . . .' Those journeymen who were established as independent craftsmen in the privileged areas had to work alone ('Let us prevent all journeymen who may be in religious houses, colleges, communities or other areas, whether privileged or not, such as we have in our aforesaid town, faubourgs and suburbs of Paris, from keeping or having under them either journeyman or apprentice [. . .]').

The guild system, however rigid it seemed, could be manipulated in several ways. It never prevented foreign craftsmen from establishing themselves in Paris and sometimes even succeeding and founding veritable dynasties. As well as acting as a fund of support for the most needy, it had the advantage of keeping all the métiers du bois in a craft framework, ensuring quality and strength. The disappearance of the guild system at the beginning of the Revolution led to the end of the small ébénistes' workshops, which were now replaced by larger units, almost small factories. The workshop of Jacob employed 322 workers in 1808, and his successor Jeanselme also employed more than three hundred workers in 1850. The Revolution, from this point of view, marked the end of the golden age of French furniture. We can well believe Aimée de Coigny when she stated in her memoirs:

March 1791: The assembly dissolved the guilds which over the course of centuries have permitted the development of the best producers of all the

beautiful objects which the world used to buy from us at top prices. Furthermore, in grouping together people of the same trade, they were an intermediary body of the greatest use for the protection of the poor, henceforth delivered up as nonentities to the rapacity of the large entrepreneurs. [*Journal d'Aimée de Coigny,* p. 74.]

THE FRENCH CLIENTÈLE

The factors that made Paris the capital of commerce for luxury goods in the eighteenth century are well known. France was then the richest country in Europe, with the highest population, and its capital was a great city with a love of ostentation and novelty. The numerous contemporary descriptions of Paris bear witness to the sumptuousness of Parisian houses and the admiration which they evoked in foreign capitals. Shameless luxury was the order of the day. Voltaire's *L'Apologie du Luxe* (which was also entitled *La Défense du Mondain*), written in 1720, expressed a common sentiment rather than a new idea. The taste for luxury was a driving force in the economy, of which the authorities were well aware and which they sought to encourage. Thus in 1730 Louis XV gave an order for several large lengths of embroidered silk, even though he had no precise use for them, with the sole aim of encouraging the industry in Lyon. Not until 1785, with the advent of the 'moralists' and the obsession with the national debt, did luxury veil itself behind a feigned austerity and a ruinous simplicity. Later, Napoleon I, continuing the Bourbon tradition, made efforts to revive the furniture industry by giving orders to numerous Parisian ébénistes.

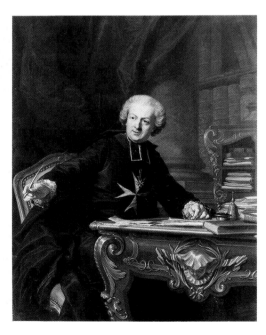

Furniture in the eighteenth century acquired an element of social prestige clearly reflected in contemporary portraits. Portrait of the Abbé de Breteuil by Louis-Michel Van Loo. (Private collection)

Royal orders play an essential rôle in the history of furniture-making during the period of our study. Whether for reasons of political expediency or personal taste, the royal family surrounded itself with sumptuous furnishings which were frequently replaced. Ébénistes in royal service were usually highly innovative; Pierre Verlet, in his four volumes on French royal furniture, has highlighted the originality of many of their creations. However, there were long breaks between royal orders, corresponding to the wars at the end of the reign of Louis XIV, which dried up Treasury funds from 1690, and the minority of Louis XV until 1735. For almost a half a century, Paris took over the lead from Versailles. The two great ébénistes of the period, Boulle and Cressent, completed few commissions for the Crown; they worked rather for Parisian financiers and noblemen. The royal family at Versailles by no means had a monopoly on ostentation; in Paris the princes of the blood, the ministers and financiers sought the same sumptuous furniture as did the king. Louvois ordered cabinets of pietra-dura [9] from Oppenordt comparable to those which Cucci was making at the same time for Louis XIV, while the Duc de Bourbon ordered furniture of a similar luxury from Boulle. In the same room in the Wal-

lace collection there are two commodes by Gaudreaus [117, 123], incontestably the finest examples of the Régence style; one belonged to Louis XV and the other to a financier, M. de Selle, who also owned sumptuous furniture by Cressent [88, 92].

The most interesting document on the clientèle and taste of the middle of the eighteenth century remains the *Livre Journal* of *Lazare Duvaux,* whose author supplied furniture to the King and the royal family, the Dauphin and especially the Dauphine. His principal client was Mme de Pompadour whose name occurs no less than 499 times in the ten years covered by the day-book. Ministers and members of the Parlement were also clients of Duvaux. He furnished the Château d'Asnières for the Marquis d'Argenson, the Hôtel de Roquelaure and the Château de Champlâtreux for President Molé. Amongst the ministers in the circle of Mme de Pompadour, the names of Choiseul and Bernis are mentioned. Some figures from the Court are among the important clients (the Comte du Luc, the Comtesse d'Egmont, the Duchesse de Lauraguais, the Marquis de Gontaut, the Duc de Bouillon, the Duchesse de Brancas and the Marquis de Brancas, the Duc d'Aumont and the Duc de la Vallière). Finally, the most numerous clients are certainly the financiers (M. de la Reynière, Pâris de Montmartel, Blondel d'Azincourt, Blondel de Gagny, MM. de Boulogne father and son, de Caze, Dangé, Fonspertuis, Fabus Roussel, Bouret de Villaumont and de Verdun). A well-known engraved portrait of Pâris de Montmartel before 1766 [270] helps to explain how the taste of the Fermiers Généraux could rival that of the royal family. The vanity of the Fermiers Généraux in this domain was unbridled: for example, the young Grimod d'Orsay had Riesener make a copy of the famous 'bureau du roi' even before Riesener had finished the piece for Louis XV.

At the end of the eighteenth century the houses of the financiers were amongst the finest in Paris and were described in accounts by foreign visitors. The Baronne d'Oberkirch who accompanied the Comtesse du Nord to Paris in 1782, returning in 1784, glowingly described the house of Grimod de la Reynière, and particularly that of Beaujon. ('The house is furnished magnificently, mostly old furniture and wonderful vernis Martin. They showed us a mahogany staircase and a dining-table in the same wood for thirty places. I will say nothing of the statues, the pictures, and amazing objects to be found at every step; one could do with a catalogue [. . .]'). At the end of the eighteenth century, besides the financiers and the noblemen, the ébéniste's clients included courtesans; they were noted at the time for the sumptuous décor of their surroundings, settling together in the new houses of the Chaussée d'Antin and the Faubourg du Roule and collecting the most precious furniture of Japanese lacquer and pietra-dura, with a predilection, it seems, for furniture with porcelain plaques. This taste was illustrated by the sale in 1782 of the furniture of Mlle Laguerre in which various pieces by Carlin were included, such as the small lacquer secrétaire [416] or the commode in pietra-dura now in the Brit-

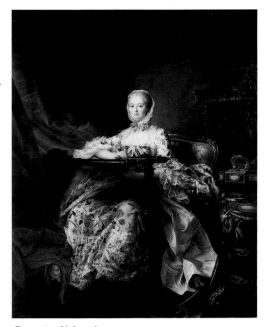

Portrait of Mme de Pompadour by Drouais in 1764; the work-table in the foreground is certainly by J.-F. Oeben who was one of the favourite ébénistes of the King's mistress; it highlights the interest taken by Mme de Pompadour in the early Neo-classical style. (National Gallery, London)

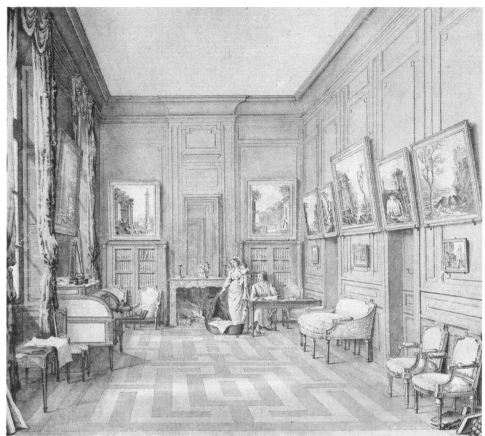

One of the very rare eighteenth-century illustrations showing contemporary furniture arrangement, this interior view can be dated c. 1795 on account of some of the paintings by Hubert Robert on the walls. (Private collection)

ish Royal Collection [415]. The Baronne d'Oberkirch once again recorded her impressions after a visit to another courtesan, Mlle Dervieux. 'On leaving the Palais-Royal, we went to see the little house and garden of Mlle Dervieux, the famous courtesan. It was a delicious confection! The furnishings are worth a king's ransom. The Court and the town have paid her tribute.' On the subject of Mlle Guimard she adds,

this famous lady, in spite of the enormous sums of money that she has cost so many people of the Court and the town, finds herself in financial embarrassment [...] and wants to offer her house in a lottery. It is valued at 500,000L and it's really quite another matter from Mlle Dervieux's house. They talked of a Chinese cabinet which was worth crazy amounts [...] it was, people said, unique in Europe, even in Holland there isn't another one like it; we gazed at it as something out of this world.

However, fine furniture was not reserved for the élite. If the ambience of the Court and high finance set the tone, they were closely followed by the provincial and Parisian bourgeoisie. The middle classes were also benefiting from the prosperity currently enjoyed by the country and were developing a taste for luxury, described by Roubo and denounced by moralists such as Louis-Sébastien Mercier: 'When the house is built you haven't even started! That's only a quarter of the expense. Along comes the menuisier, the decorator,

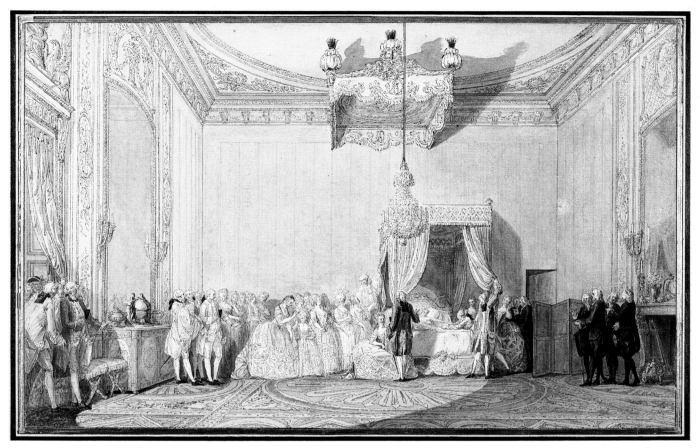

the ébéniste, etc., and the interior takes three times longer than the construction of the building [...] the emphasis on magnificent furnishings is out of all proportion.' It is difficult to form an idea of an eighteenth-century middle-class interior; the only known pictorial representations show sumptuous interiors. In paintings by Chardin and Greuze old-fashioned furniture in natural wood may be seen; it is clear that the middle classes could not renew their furniture with the same frequency as the élite.

A study by Annik Pardailhe-Galabrun, *La Naissance de l'intime*, based on probate inventories of 3,000 Parisian households during the seventeenth and eighteenth centuries, gives an accurate picture of bourgeois interiors of the period. Whereas in modest households the furniture mainly comprised beds, cane chairs and strictly utilitarian furniture, in the more affluent households there were pieces of furniture that were as much decorative as functional, and this survey indicates the large amount of storage furniture such as armoires and commodes that was to be found in all bourgeois houses. The taste for comfort and intimacy that had developed in well-to-do society during the eighteenth century was reflected in the furnishing of interiors by a progressive specialization in the use of space – the appearance of dining-rooms, drawing-rooms, bed-rooms, boudoirs etc. instead of the chambers or halls which made up seventeenth-

Watercolour signed by Belanger (and with the effaced signature of Dugourc) depicting the birth of the Duc d'Angoulême at Versailles in 1775. Court ceremonial as well as the shape of women's dresses dictated that the centre of reception rooms was largely free of furniture, banishing all small tables and relegating furniture to a wall-side position. (Private collection)

19

century houses. Parallel with this was a large increase in furniture made for a specific function: tables for writing or for dinner, dressing-tables, work-tables, tea-tables, games-tables, night-tables, etc. The quest for comfort by the middle classes was as much responsible for the development of Parisian ébénisterie of the period as the aristocratic taste for ostentation.

FOREIGN CLIENTÈLE

The supremacy of French furniture in our period was generally recognized throughout Europe, although perhaps to a lesser extent in Italy and England. The Faubourg Saint-Antoine exported some of its finest furniture, and advertisements by ébénistes are to be found in contemporary almanacs offering to make 'deliveries to the country and abroad'. Some furniture found today in Britain, Russia and Germany must have arrived there before the Revolution, sent from Paris by diplomats posted abroad, by travellers or commercial agents to foreign princes. It should be added that French ambassadors were accustomed to order a sumptuous suite of furniture from Paris for their new posting, and it would usually be sold locally, when the ambassador returned home.

The oldest examples of foreign purchases are Swedish, dating from the 1690s. Through Daniel Cronström, secretary to the Ambassador of Sweden in France, numerous pieces of furniture were ordered for the Swedish Court and for Swedish noblemen. The correspondence between Cronström and the architect of the King of Sweden, Nicodème Tessin le Jeune, the richest source of information on the decorative arts at the end of the reign of Louis XIV, is informative about some of these orders. Since 1693 Cronström had been recommending Berain and Cucci:

The tables and guéridons that you want to have for the King are difficult to find ready made. If you want to have them made, it is best to order in good time but I do not know whom to choose for this. Cucci is excellent. On the other hand, Berain has admirable designs and good workers. Please decide between the two. Berain would like to do it. [Letter dated 22 May 1693.]

In 1695 Cronström purchased bureaux for Count Piper and also ordered a set of chairs for him. The following year he recommended to Tessin the purchase of a cabinet in pietra-dura, 7 to 8 pieds in width, which was coming up for sale on the death of Mlle de Guise. In 1699 he suggested a long-case clock made under the direction of Berain, as well as an organ case in tortoiseshell and ebony belonging to Perrault (letter dated 5 October 1699):

Here is [...] a clock that Berain has made so perfectly, the most pleasing and rich workmanship that has ever been carried out in this style. It was intended for the Petite Galerie du Roi, but there has been some kind of misunderstanding which has meant that it is still with him [Berain]. It is, I suppose, 8 to 10 pieds in height with its base. It has cost him, I think,

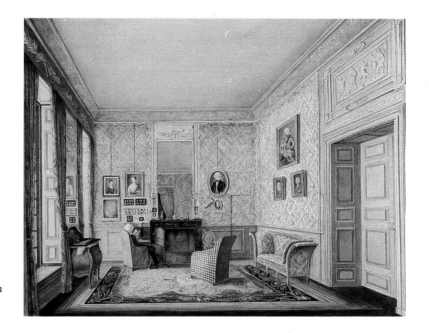

Anonymous watercolour depicting the Duchesse d'Arenberg in the bedchamber of her palace in Brussels, c. 1795. (Private collection)

5,000 livres. [There is] an organ case suitable for an apartment, which Mr Perrault wants to sell. It is of tortoiseshell, ebony and bronze, made at the time when he was at the Bâtiments. Judge for yourself that it's by good craftsmen [...]

In 1702 he sent a bureau to M. Walrave, then in 1707 a commode to Mme Hermelin, which he hailed as the very latest in furniture: 'I am very impatient to know how and if the bureau of Mme Hermelin has been received. [...] For the rest, you have told me nothing of this latest design, they are called commodes, I don't know if you like them' (letter of 16 October 1707).

Of all the European countries, Germany was the most attracted by French art. The collections of French furniture still to be seen in the Munich Residenz, Schloss Moritzburg near Dresden, in Cassel, Ansbach, Bamberg and Berlin, are the remains of collections made by German princes in the eighteenth century. The rhythm of their purchases was influenced by the unsettled diplomatic relations between the two countries and it is notable that the two finest collections of French furniture, in Munich and Dresden, belonged to Catholic princes who were allied to France on several occasions. During the seventeenth century the constant warring between Louis XIV and the Empire hindered trade relations. After the treaty of Baden in 1714, which brought the War of the Spanish Succession to an end, foreigners returned to Paris. We have the account in *Le Mercure de France* of the visit made by the princes of Bavaria to Boulle's workshop in 1723. This was certainly not an isolated occurrence. For their part, various French architects in the service of German princes ordered furnishings from Paris for new apartments. We know that Robert de Cotte ordered two commodes from Boulle for the Elector of Cologne in 1718. The Munich Residenz has a fine

From the eighteenth century onwards, German princes tended to acquire their furnishings from Paris; this commode attributed to Cressent was bought, according to Feulner, at some time between 1730 and 1737 by Charles-Albert, Elector of Bavaria. (Residenzmuseum, Munich)

collection of furniture by Cressent, Carel and other Parisian ébé-
nistes of the Régence, which it seems that the Elector Charles-
Albert had bought in Paris between 1730 and 1737 (according to
Feulner, 1926, p. 286). In Dresden the furnishings date rather from
the years 1740–50; apart from a pair of coffers by Boulle, the collec-
tion mainly comprises commodes by B. V. R. B. and clocks by Latz
of the rococo period. Most of the furniture was bought in Paris by
the agent of the Elector of Saxony, M. Leleux, whose name is men-
tioned in an inventory after Latz's death in 1754. In Berlin the taste
of the King of Prussia, in keeping with that of his neighbour the
Elector of Saxony, also led him to order furniture from Latz, mainly
long-case clocks through his agent M. Petit. The Seven Years War
interrupted these purchases and Frederick II was forced to have his
furniture made in Berlin by German cabinet-makers and bronze-
workers such as Spindler and Kambly. However, the influence of
Latz is still strongly noticeable in their work.

In Italy, where local traditions of furniture-making were strong,
fondness for French furniture was found only in a few princely
courts related to the French royal family. The chief collection of
such furniture, now at the Quirinal in Rome, consists of pieces
ordered in Paris in about 1748 by the daughter of Louis XV,
Madame Infante, for her palace at Parma. These are pieces in
rococo style by B. V. R. B., Latz and Dubois. In Naples, Queen
Maria-Carolina, perhaps following the example of her sister Marie-
Antoinette, ordered lavish lacquer furniture from Daguerre, today
in the Metropolitan Museum of Art [477], as well as a table with
porcelain plaques by Carlin which had formerly belonged to Mme
du Barry [401].

In Spain, the Bourbon kings adhered closely to the French taste.
In 1715 Philip V, through the offices of Robert de Cotte, ordered a
bureau and a commode from Boulle for the Alcazar Palace, Madrid
(see p. 70). Charles III later made the purchase, no doubt through
his French clock-maker Godon, of several pieces of furniture in
Paris. This explains the presence in the Oriente Palace, Madrid of
several important pieces by Carlin, Levasseur and Benneman. In
1799 the departure to Madrid of Dugourc, the former designer of
the Garde-Meuble Royal, increased the influence of the French
taste in Spain at the end of the century.

During the 1730s in Portugal, King Jão V ordered sumptuous
furniture from Paris for his palace in Lisbon. Everything dis-
appeared during the earthquake of 1755, and the only traces left of
these orders are in archival documents. It is known that Cressent re-
ceived an order for a cartel clock representing 'Love conquering
Time' in 1733. From an unpublished document (Arch. Nat. Y
12398) we learn that the following year a Parisian caster and chaser,
Pierre Lourdet, had a commode and two encoignures in his work-
shop, intended for the King of Portugal, valued at 7,000 livres.
Finally, it is known that B. V. R. B. was working in Lisbon before
1738 (see p. 184).

In England, where there was a prosperous furniture-making trade and where there was a greater desire for comfort than for ostentation, the taste for French furniture developed very slowly. French furniture sent to England during the eighteenth century was often acquired by ambassadors in Paris or by travellers making the Grand Tour. The bureau plat by B. V. R. B. at Temple Newsam, Leeds [173] was acquired by Richard Arundale before 1746. Towards the end of the century interest deepened. The fame of the great dealer Poirier, and then of his successor Daguerre, won them many orders. In 1765 Lord Coventry bought a 'bureau à la grec', probably by René Dubois, from Poirier, which inspired a series of English tables made in 1772 for Osterley Park. At the same time Horace Walpole bought various pieces from Poirier, including a clock, a secrétaire, a coffer and a table with porcelain plaques, no doubt by B. V. R. B. or R. V. L. C. [181, 312], which were listed in an inventory of the contents of Strawberry Hill in 1798. Two bonheurs-du-jour with porcelain plaques by Carlin, now in the Metropolitan Museum of Art, came from Lord Spencer who very probably bought them from Poirier during a visit to Paris in 1773 or 1777. Later Daguerre also supplied numerous lacquer pieces to Lord Spencer which are today at Althorp. A consignment in 1791 comprised two commodes and two encoignures in lacquer by Saunier, as well as two secrétaires en cabinet by Weisweiler. Other English clients bought furniture from Daguerre. Baroness d'Oberkirch mentioned in her memoirs in 1784 'a sumptuous buffet' ordered by the Duke of Northumberland, which everyone was admiring at Daguerre's. Daguerre played an important part in the furnishing of Carlton House for the Prince Regent. Daguerre's English clientèle became so important after the Revolution that he decided to send some of his stock to London in 1791, and he opened a shop in Sloane Street in 1793.

Russia was interested in French furniture from the beginning of the eighteenth century. Shortly after the death of Louis XIV on 30 December 1715, the Tsar was offered the furniture from the King's bedchamber, the bed and chairs, by the First Gentleman of the Bed-chamber who had been granted it according to prerogative. Rather than buy furniture from Paris, Peter the Great preferred to bring the decorator, Nicolas Pineau, to St Petersburg, together with a score of Parisian craftsmen. For their part, some Russian noblemen brought home sumptuous furniture from Paris. On return from his embassy to Paris in 1721, Baron de Scheulnitz brought back 'three commodes with marquetry in Japanese wood, one bureau in ebony, two large guéridons in gilt wood and two pairs of bellows with marquetry'. Royal gifts also fostered this taste. In 1745 Louis XV sent 'a bureau in kingwood with compartments decorated with bronze ornaments with serre-papiers and a clock in the middle' to the Empress Elizabeth. This piece was ordered from Hébert; it was in a 'new and dignified style'. Denis Roche described it thus:

1). A bureau de cabinet 6 pieds in length and 3 in width, of kingwood,

with compartments, cabriole legs, quart-de-rond, and other ornaments in gilt-bronze. 2). A small matching armoire, 3 pieds 4 pouces in width, to be placed at one end of the bureau. 3). A serre-papiers of about 3 pieds in height which is placed on the small armoire. 4). A clock treated in the same style to complete the serre-papiers. The ensemble belonging to the King and costing His Majesty the sum of 7,000 livres.

The registers of the *Présens du Roy* record this gift on 22 May 1745 and price it at 7,255 livres.

Other bureaux plats were ordered in Paris for Marshal Bestuzhev and Chancellor Vorontsov. The latter made a collection of fine furniture in his house at St Petersburg. In 1758 Louis XV presented him with several pieces, amongst which was 'a very fine commode of Japanese lacquer in relief decorated with its double cartel motif on the front and the sides with blue turquin marble, of 4½ pieds in length . . .1,230L' and 'two very fine encoignures in Japanese lacquer, decorated with gilt mounts of a new shape, and bleu turquin marble . . .1,250L'.

The French ambassadors' sale of fine furniture in St Petersburg at the end of their postings enriched Russian collections. Soon the Russian enthusiasm for French furniture became so great, and imports so numerous, that the French commercial agent wrote in 1772: '[The Russians have decided to] engage workers in bronze and marquetry to make furniture which they are already copying very well and all kinds of other work in bronze in order to prevent the large consignments of this nature which are being sent from France.' This protectionist practice was instigated by Catherine II who seems to have preferred the furniture of Roentgen to that of the French ébénistes. The Tsarevich Paul and his wife Maria Fyodorovna, however, were passionately keen on Parisian objets d'art, and during their visit to Paris in 1782 under the names of the Comte and Comtesse du Nord, they placed orders with the marchands-merciers Daguerre and Granchez. Thus top-quality furniture with porcelain plaques by Carlin and Weisweiler was sent to Pavlovsk where it embellished the boudoir of Maria Fyodorovna.

It is evident that the popularity of French furniture abroad dates from well before the Revolution. And this explains the massive export of furniture to England, Germany and Russia that followed the sales after the Revolution and the fall of the Empire.

THE PRICE OF FURNITURE

The received notion that furniture was very expensive in the eighteenth century needs to be seriously reconsidered. First, new and second-hand furniture (called 'de hazard' in the language of the time) should be distinguished. Second-hand furniture was considerably cheaper, except for collectors' items such as Boulle furniture. At a time when the cost of the workmanship was a

less important factor than the price of raw materials, the price of a piece of furniture depended on the richness of its gilt-bronze mounts or the application of precious materials such as panels of pietra-dura, oriental lacquer or porcelain. Only this type of furniture fetched high prices, especially when the mounts were made to a new design. In fact, very little furniture had bronze decoration, besides the escutcheons and sabots, and usually bronze was varnished not gilded, and known as 'en couleur d'or'. The fashion for rich gilt mounts began in the last quarter of the eighteenth century and led to a great increase in the price of furniture. Everyday furniture, with simple marquetry or veneering, always remained cheap.

There is no real standard by which to translate the livre of the Ancien Régime into modern francs. On the one hand, the monetary fluctuations (the livre contained 8.3 gm of silver during the seventeenth century and only 4.5 gm after 1726) and the constant increase in prices during the eighteenth century meant that on the eve of the Revolution the livre was worth only about half its pre-1690 value. On the other hand, average personal wealth during the period was much lower than it is today. Increase in personal wealth only got under way after 1830. This means that to translate old prices into modern francs at fixed rates would lead to absurd results. We could use, as the economists suggest, a worker's daily or annual salary as a comparison. During the seventeenth century the daily rate for a worker was about 15 sols (the livre had 20 sols), the annual salary about 300 livres. For example, that was the salary Boulle used to pay his sister and brother-in-law, Poitou, in 1674. During the eighteenth century daily wages varied between 1 and 3 livres, which amounted to an annual salary of about 500 livres. However, in a society such as that of the Ancien Régime, where there was an enormous differential between the resources of the rich and the poor, this is a yardstick of very limited use. At a time when labour was very poorly paid and when a large section of society did not have the means to acquire anything more than the basic necessities, this amounts to measuring luxury by poverty. It is better to diversify the means of comparison.

For the seventeenth century we have some interesting details in the *Livre commode des adresses de Paris*, published in 1692 by Abraham du Pradel, who gives, for example, the price of meals: 'You eat at an inn table [. . .], for 20, 30 or 40 sols [. . .] People who can afford only a very small sum can find small inns in any quarter of Paris where they can have soup, meat, bread and beer in plenty for five sols.' According to d'Argenson, it was possible to stay the night in these inns for one sou. At the same time, the salary of a captain in the King's army was 900 livres, while a grand lady such as the Princesse des Ursins lived on an allowance of 30,000 livres granted to her by Louis XIV. In 1700 the income and allowances of the Princesse Palatine amounted to 450,000 livres, which enabled her to pay the wages of 250 persons in her household. According to Annik Par-

dailhé-Galabrun (*La Naissance de l'intime*) the personal wealth revealed by probate inventories during the eighteenth century was less than 1,000 livres in 55 per cent of cases, between 1,000 and 3,000 livres in 24 per cent and above 3,000 livres in only 21 per cent of cases; and 35 per cent had less than 500 livres. Abraham du Pradel gives several prices for lodgings in Paris: 'A house [. . .] in the quarter of Saint-André-des-Arts, with three apartments, large poultry yard, coach-house, valued at about 40,000 livres, let at 1800 livres [. . .]' and 'a large house for sale with three apartments, two shops, 14 or 15 fireplaces, four stables for 30 horses, three cellars and a courtyard for 20,000 livres, rue Mouffetard'.

The current rate for furniture, as far as one can judge from Gole's inventory of 1684 (see pp. 50–51), ranged from 10 livres for tables in walnut or cedar and about 80 livres for walnut bureaux. Desks with marquetry of brass and pewter, which we now call 'bureaux Mazarin', fetched about 200 livres each and the most lavish furniture was priced at less than 1,000 livres. Boulle's prices were comparable, as recorded in the accounts of the Bâtiments du Roi. The coffer made for the Grand Dauphin in 1684 cost 700 livres. The seven tables supplied to the Ménagerie at Versailles in 1701 cost 6,400 livres in all. The famous commodes which he supplied for the King's Bedchamber at Trianon in 1708 cost 1,500 livres each and the other commodes which he supplied for the bedchamber of the King at Marly and Fontainebleau were valued at between 1,250 and 1,600 livres. By comparison with these prices the cost of furniture made by Cucci at the Gobelins was enormous: 30,500 livres for the cabinets of Apollo and Diana, 27,568 livres for lapis cabinets and 16,000 livres for the cabinets at Alnwick Castle [7]. These prices can be explained by the nature of the workmanship, but above all by the intrinsic value of the materials involved: lapis, jasper, agate, etc.

Towards the end of the eighteenth century prices rose considerably. Although the average annual salary was between 300 and 500 livres, it was also often lower. Amongst the domestic staff in the service of the Marquis de Marigny in Paris in 1778, the flunkeys and floor-polishers were paid 216 livres, whereas the 'chef d'offices' was paid the same as the concierge, 800 livres, and the chef 1,000 livres. The total annual wage bill for his Parisian household cost the Marquis de Marigny 4,800 livres. He also had to pay an annual allowance of 12,000 livres to his estranged wife. The annual income of a person of quality would have been in the region of 10,000 livres. Arthur Young puts the annual cost of living for a household with four servants, three horses and one carriage living in a country manor-house at 7,000 livres. In 1768 Marigny paid 700 livres for two paintings by Watteau, *L'Indifférent* and *La Finette* (Louvre), while two marine paintings by Vernet were bought by M. de la Borde for 5,000 livres at the La Live de Jully sale in 1770; Dutch paintings, then very fashionable, reached 20,000 livres in sales of the end of the century. The price of a bottle of Bordeaux was about $1^1/_2$ livres.

Accommodation at this time was not a major expense for Parisians. However, if the rental for modest accommodation was about 100 livres, it reached 1,000 livres for a desirable place to live. In 1757 Joubert rented a whole house in the rue Saint-Anne for 1,250 livres and Necker paid the same amount in 1765 for a huge apartment in the Hôtel d'Halwyll in rue Michel-le-Comte. The range of disposable income was as wide as ever. If the lowest salaries were about 200 livres, the highest were several hundreds of thousands of livres. In 1772 the assets of Necker, one of the principal bankers in Paris, were estimated at seven million livres. When he became Comptroller General of Finance in 1786, his annual emolument was 220,000 livres. The range of salaries at the time was therefore at least a thousandfold. That of incomes was even wider. The income of the Court banker the Marquis de Laborde was 1,600,000 livres and that of the Duc d'Orléans 2,400,000 livres, according to Gouverneur Morris's Diary (2 October 1789). Choiseul, before his fall, lived on an income of one million, and the richest man in the country, the Prince de Conti, had an income of 3,700,000 livres in 1789.

Compared to these figures, prices of furniture in the 1770s and '80s look low: some tens of livres for walnut furniture and about 100 to 200 livres for veneered or marquetry furniture. In 1788 Bircklé invoiced the Garde-Meuble Royal for his walnut secrétaires at 60 livres, the tulipwood commodes at 96 livres, those in walnut at 125 livres, and those in bois satiné at 216 livres. These were simple pieces without mounts. The presence of gilt mounts could drastically increase the price. This is shown by the rates submitted by Riesener to the Garde-Meuble Royal in 1786. The same commodes were worth between 300 and 600 livres according to whether the mouldings were in mahogany or gilt-bronze (see p. 379). The sumptuous pieces were worth several thousand livres at that time, particularly pieces in Japanese lacquer, in pietra-dura or with porcelain plaques. We know the prices paid by Mme du Barry to the dealer Poirier for a series of pieces of furniture with porcelain plaques made by Carlin: 1,440 livres for a bonheur-du-jour in 1768, 1,800 livres for a jewel-cabinet in 1770 [423], 1,500 livres for a tric-trac table in 1771; in the following year she paid 9,750 livres for a commode with porcelain plaques decorated with scenes after Watteau and Lancret, 5,500 livres for a small table decorated with a scene after Leprince [401], 2,400 livres for a small secrétaire and 2,640 livres in 1773 for another secrétaire, the plaques with a green ground of the same type [407]. Also in 1773 she bought a jardinière for 600 livres and a small table en chiffonnière of a popular type for 840 livres [428].

For certain finely detailed porcelain plaques the price could be very high: in 1780 the Comte d'Artois spent 6,000 livres on a guéridon which he gave to the Comtesse Grabowska in Warsaw. Lacquer furniture was sold for comparable prices: in 1766 Marigny bought a commode in a new style by Joseph Baumhauer from Poirier [240]. The price of 4,000 livres was high and Marigny took three years to

pay. The furniture that the Darnault brothers sold in 1785 to Madame Victoire for her Grand Cabinet at Bellevue was even more expensive: the commode made by Carlin [420] cost 6,500 livres and the pair of encoignures 5,400 livres. Marquetry furniture could, in certain instances, reach these price levels. Leleu's invoice for furniture made in 1772 and 1773 (see p. 338) includes some sumptuous commodes at between 2,500 and 10,000 livres. If we seek a comparison with modern prices, a commode by Leleu of a quality equal to those bought by the Prince de Condé sold in the late 1980s for 12,000,000 francs, which is the equivalent of at least ten times its price at the time when it was made. The difference between original prices and today's sale prices is not as extreme in the case of everyday furniture. In sum, the original range of prices was much narrower than today's range of antique furniture prices.

EIGHTEENTH-CENTURY AUCTION SALES

Until the middle of the eighteenth century, auction catalogues did not categorize furniture as such. Only paintings, drawings, works of sculpture and intaglios were deemed worthy of coverage in a printed catalogue. In dispersals by executors, second-hand furniture, which was judged to be of little value, was sold by auction without a catalogue, or by the upholsterers. There was no catalogue in 1741, 1751 or 1752 when Louis XV sold in the Louvre and Tuileries the finest cabinets made for his great-grandfather Louis XIV. The situation changed half-way through the century: old pieces, particularly Boulle's, became collectors' items, eagerly sought after by enthusiasts. From then on catalogues included a chapter usually entitled 'Meubles curieux' or 'Meubles de Boulle'. Most of the sales were ordered by executors and followed probate inventories. Sometimes the catalogue even followed an inventory word for word. 'Inventory' became synonymous with the public auction sale: 'I bought these candelabra from M. Boucher's inventory,' wrote Marigny's agent with regard to two pieces bought at the sale that followed the death of the painter Boucher in 1771. Sales could be freely organized and numerous dealers had recourse to this procedure in order to shift their stock. Cressent was the first important marchand-ébéniste to make use of auctions. Three times, in 1749, 1757 and 1765, he tried to sell his stock of furniture and gilt-bronze mounts. In 1777 Julliot, the well-known specialist in Boulle furniture, put his stock up for auction after the death of his wife. Here we find, amongst genuine pieces by Boulle, pastiches made by Levasseur and Montigny on Julliot's initiative. The race was on. During the years that followed, numerous dealers put their businesses up for sale: Paillet in 1777, Lebrun in 1778 and in 1791, Dulac in 1778, Poismenu, a 'second-hand dealer' in 1779, Mme Lenglier in 1778, Dubois, a 'marchand-joaillier' in 1785 and again in 1788 following his bankruptcy, and Donjeux in 1793.

At the same time, several famous sales launched fine collections

of Boulle furniture onto the market: Jullienne in 1767, Blondel de Gagny in 1776, Randon de Boisset in 1777, the Comte du Luc in 1777, Vaudreuil in 1787, Calonne in 1788 and Choiseul-Praslin in 1793. During this period the price of Boulle furniture rose as much as that of Flemish paintings. The attitude towards old furniture had changed and the antique-furniture collector had been born. Presentation of catalogues was improved and descriptions were made more accurate. We can see from the catalogues of the 1780s, such as that for the Duc d'Aumont's sale, that all the modern auction house techniques were already in use: publicity, detailed descriptions, provenances, historical details, attributions to particular important ébénistes or bronziers, and even engraved illustrations of certain details. At the end of the eighteenth century the auction houses played a rôle in the art market comparable to that which they do today, even to the extent that dealers like Lebrun started their own salerooms alongside their galleries.

THE TRADE IN CURIOSITÉS

In the seventeenth century the furniture trade was divided between the ébénistes, the tapissiers (upholsterers) and the marchands-merciers. The marchands-merciers included furniture under the same general heading of 'curiosités' as shells, Chinese porcelain and scientific instruments. The 'curiosity' trade was located on the Île de la Cité near the Palais, and in the rue Saint-Honoré, near the Louvre:

Here is a list of dealers who own shops, who buy, sell and trade in pictures, Chinese furniture, porcelain, crystal, shells and other decorative objects and jewellery: M. d'Hostel [Dotel], at the beginning of Quai de la Mégisserie; Malaferre and Varenne, quai de l'Horloge; La Fresnaye et Laisgu, rue Saint-Honoré [near the Fathers at the Oratory]; Quesnel, rue des Bourdonnais; Protais, rue des Assis; Fagnany, quai de l'Ecole [À la Descente de la Samaritaine']; Antheaume, behind the Hôtel de Bourgogne; Nancay at the Palais, etc.

These were noted by Abraham du Pradel in the *Livre commode des adresses de Paris* for 1692, where he also cites other addresses:

M. Dorigny, rue Quinquempoix, M. Laittier and Mlle Le Brun at the Port of Paris also have fine pieces of porcelain and Chinese ware [i.e. oriental lacquer] [...] M. de Cauroy, rue Briboucher, has a shop for jewellery and English boxes, with pieces of porcelain, pierced terracotta pagodas and Chinese furniture [...] The Sieurs Langlois, father and eldest son, who copy and brilliantly restore Chinese lacquer furniture, are on the Grande-Rue du Faubourg Saint-Antoine near the Hôtel de Bel Air [...] They make exceptionally fine cabinets and screens in the Chinese style [...] Sieur Taboureux, who is on the quai de la Mégisserie near the Fort l'Evêque, makes very good copies of English coffers and locks.

It may be seen that the curiosity trade specialized in goods from the Far-East and from England. To buy everyday furniture, it was

Trade label of the marchand-mercier Bertin found on a bureau plat stamped Dubois. (Sotheby's Monaco, 24 November 1979, lot 146)

necessary to turn directly to the producers. Abraham du Pradel also wrote at the time: 'Cabinets, bureaux, bookcases and other furniture veneered in walnut, marquetry, ebony and cedar are made and sold along the Faubourg Saint-Antoine, at the Porte Saint-Victor, rue Neuve-Saint-Médéric, rue Grenier-Saint-Lazare, rue du Mail, etc.' Some of the production of the ébénistes was also sold by the upholsterers, a guild that was then very powerful (it was one of the principal suppliers of furniture, as fabrics played such an important rôle in furnishing in the seventeenth century). 'The tapissiers-fripiers [upholsterers and second-hand clothes dealers] are mostly grouped under the pillars of les Halles, rue de la Truanderie, Montagne Sainte-Geneviève, Descente du Pont-Marie and the rue du Grenier-sur-l'Eau.'

The fashion for silver furniture must not be ignored. This was apparently not only commissioned for royal palaces: 'Furniture in silver is beautifully made by M. Delaunay, silversmith to the King, in front of the Galeries du Louvre.' Finally, the reputation of the great ébénistes at the end of the century was such that the most important clients went directly to them: 'M. Cussy [sic] at the Gobelins, Boulle at the Galeries du Louvre, Lefebvre in the rue Saint-Denis at the 'Chêne-Vert' excel in furniture and other objects with marquetry.'

THE MARCHANDS-MERCIERS

I n the eighteenth century ordinary furniture was sold directly by the ébénistes, whereas luxury furniture was sold increasingly through the dealers, then called the 'marchands-merciers'. The fashion begun by Boulle of decorating furniture with rich gilt-bronze mounts made its production very expensive. The ébénistes, who were always short of capital, gradually lost the initiative in the making of fine furniture, which eventually only marchands-merciers could afford to commission. The demands of a clientèle avid for luxury and novelty were such that the dealers scarcely knew what to dream up next. Some, like Hébert, dismantled Japanese chests in order to take out the lacquer panels and apply them to new pieces of furniture. Others, like Poirier, had porcelain plaques made at Sèvres to adorn certain small precious pieces. The rôle of the merciers was therefore essential as they were involved in the design of furniture as well as its sale, and they invented combinations of materials and techniques that would have been impossible for the ébénistes themselves to imagine, hampered as they were by the restrictions of their guild.

The definition of the marchand-mercier according to the *Encyclo-pédie*, 'dealers in everything – makers of nothing', is no mere sally. Their statutes allowed them to sell everything, including imported goods, but forbade them to make anything themselves. Thence comes the term 'marchand-mercier' – a deliberate use of tautology, since 'mercier' derives from the Latin 'mercator', which also means

'dealer'. This distinguished the marchands-merciers from the marchands-artisans (dealer-craftsmen). They handled a wide range of merchandise that included provisions, metalwork, fabrics and carpets, stationery, haberdashery (ribbons and braids), leather goods, jewellery and dressing-table accessories. Although not obliged under their statutes to do so, the merciers all specialized in certain goods. Three classes of merciers employed the ébénistes. The most important were the marchands d'objets d'art, who sold, according to Savary des Bruslons, 'paintings, prints, candelabras, brackets, girandoles of bronze and gilt-bronze, crystal chandeliers, figures in bronze, marble, wood and other materials, clocks, time-pieces and watches; cabinets, coffers, armoires, tables, shelves and guéridons with bois de raport veneers and gilt wood, marble tables, and other pieces suitable for furnishing apartments.' Most of the dealers mentioned hereafter belonged to this class. The marchands de miroirs specialized in toilet accessories and some, such as Delaroue, commissioned lavish pieces of furniture to match these articles (mirrors, chests and dressing-tables). The marchands-bijoutiers sold not only jewellery but porcelain and hard stones mounted in gilt-bronze, firedogs, candelabras and furniture. The word 'jewel' (bijou) was loosely used, and applied to anything precious whether furniture or object, so that the marchands-bijoutiers were generally synonymous with marchands d'objets d'art. Lazare Duvaux called himself 'bijoutier et joaillier'. Aubert, a former jeweller who had turned to dealing, sold furniture and porcelain as well as jewellery to the Comte d'Artois. Another marchand-bijoutier, Duchesne, who was established in 1791 in the rue de Richelieu at the sign 'A la Couronne d'Or', which he had taken over from Daguerre, sold bracelets as well as mahogany tables and clocks, as can be seen on a bill of purchase by the Duchesse d'Arenberg (see the illustration above right).

The marchands-merciers were established not far from Les Halles, in the section of the rue Saint-Honoré between the Palais-Royal and the streets leading to the Pont-Neuf (rue du Roule and rue de la Monnaie). Hébert, Dulac, de la Hoguette, Julliot, Lebrun, Bertin, Tuart and the most famous of them all, Poirier, as well as his successor Daguerre, were all in the rue Saint-Honoré. Towards the Pont-Neuf, Lazare Duvaux, Calley and Darnault were in the rue de la Monnaie; Bazin was in the rue du Roule and Boileau on the Quai de la Mégisserie. Finally, the dealer Granchez's shop, at the sign of the 'Petit-Dunkerque', was by the exit from the Pont-Neuf, on the left bank of the Seine. Ébénistes who also wished to deal in furniture settled in the same quarter, between the Pont-Neuf and the Louvre, in order to attract the elegant clientèle of the marchands-merciers: Boudin was in the rue Froidmanteau and later in the Cloître Saint-Germain-l'Auxerrois; Genty in the rue de l'Echelle; Joubert in the rue Sainte-Anne; Criard the Younger in the rue de Richelieu and later rue de Grenelle (now rue Jean-Jacques-Rousseau), and in 1781 Roentgen chose to establish his furniture business in the same street. Antoine Héricourt, famous in the mid-1780s, was established

Certain ébénistes who acted as dealers used trade labels in the same way as the marchands-merciers; this one for Séverin appears on a console made by Boulle. (Sotheby's Monaco, 22 May 1986, lot 554)

By the end of the eighteenth century, a marchand-bijoutier such as Duchesne, with a shop close to the Palais-Royal, could sell bracelets as well as furniture and gilt-bronze objects, as is confirmed by this invoice of 1791. (Arch. Nat. T/362)

The superb wrought-iron balcony of this house situated on the corner of rue Saint-Honoré and rue des Prouvaires would certainly have overhung the shop-front of a marchand-mercier

in the rue Saint-Honoré opposite the Hôtel Montbazon. Finally, Séverin was established in the rue de l'Arbre-Sec and rue des Prêtres-Saint-Germain-l'Auxerrois.

The principal marchands-merciers of the eighteenth century were the following:

GERSAINT (died 1750), marchand-joaillier, was established on the Notre-Dame bridge. His first sign, 'Au Grand Monarque', Watteau's famous painting now in Charlottenburg, reveals that he used to sell pictures as well as clocks with Boulle marquetry, consoles and mirrors. On the small trade label engraved by Boucher in 1740 there is a Chinese porcelain figure perched on a Chinese lacquer cabinet surrounded by shells, pictures and tea-sets. It reads: 'At the Pagoda, Gersaint, marchand-joaillier on the Notre-Dame bridge, sells all kinds of new and tasteful metal-work, jewellery, mirrors, cabinet paintings, pagodas, lacquer and Japanese porcelain, shells and other items of Natural History, stones, agates and generally all kinds of interesting merchandise from abroad.'

THOMAS-JOACHIM HÉBERT (died 1773), enjoyed the benefit of a special warrant as 'marchand suivant la cour' (dealer to the Court), known also as 'marchand privilégié du Palais' (approved dealer to the Palace). At Versailles these dealers were established in the lower Galeries and on the staircases of the Château. In Paris Hébert had his shop first on the quai de la Mégisserie at the sign 'A l'Écu de France' and then in the rue Saint Honoré. In 1745 he is mentioned as 'marchand bijoutier, rue Saint Honoré, vis à vis le Grand Conseil'. He married in 1714 Louise Dezgodetz who died in 1724, and then Marie-Jeanne Legras who died in 1763. He was renowned during the years 1737 to 1750, when he supplied the royal family with all kinds of furniture in Chinese lacquer or vernis Martin as well as with porcelain, clocks and chandeliers. The ébéniste to the King at the time was Gaudreaus, but the royal family preferred to use Hébert for any furniture out of the ordinary, and in particular for lacquer work, which seems to have been his speciality. It is probable that he was the first to have the idea of using panels of Japanese lacquer to decorate furniture; the oldest documented piece in Japanese lacquer is the commode stamped by B. V. R. B. which he supplied in 1737 for the private sitting-room of Marie Leszczyńska at Fontainebleau. For ten years he alone supplied furniture of this type to the Crown, which suggests that he must have had something in the nature of an exclusive right. He gave work to the ébénistes B. V. R. B. and Criard, entrusting the former with furniture in Japanese lacquer and the latter with furniture in vernis Martin such as the pieces supplied in 1742 to Mlle de Mailly at Choisy. In ten years, from 1737 to 1747, Hébert supplied more than forty sumptuous pieces of furniture to the royal family, including two commodes and a small bureau in Japanese lacquer, a dozen pieces in Chinese lacquer and the same

again in vernis Martin. In 1747 he supplied a suite of furniture in green vernis Martin to the daughters of Louis XV. The pieces with floral marquetry which he supplied in 1745 to the Dauphin and Dauphine were the first entries for floral marquetry, then a new fashion, in the day-book of the Garde-Meuble Royal. Hébert's success was prodigious. On the occasion of his daughter's marriage in 1751 to Dufour, the son of the first lady of the bedchamber to the Dauphine, the Duc de Luynes noted in his memoirs: '[…] daughter of the celebrated Hébert, marchand to the court, who will have a large inheritance […]' He seems to have retired at about this time, having in 1752 obtained the post of 'Conseiller secrétaire du Roi, Maison, Couronne de France et de ses Finances'.

CLAUDE DELAROUE was established between 1746 and 1785 in the rue de la Verrerie in a shop at the sign of 'La Toilette Royale', where he sold furniture, mirrors, fabrics and everything to do with toilette. His father and grandfather had been 'lustriers du roi', (makers of chandeliers to the King), a title kept by his brother Jérémie and then his nephew until the Revolution. He himself was a marchand ordinaire, an ordinary dealer to the Court, and supplied the Garde-Meuble with chandeliers and girandoles as well as ébénisterie and meubles de toilette. He was purveyor to the Comte de Provence. (He supplied a jewellery-box in gilt wood and crimson velvet intended for the Comtesse de Provence on the occasion of their marriage in 1771.) He also supplied the Comte d'Artois with various meubles de toilette intended for Bagatelle or the Palais du Temple, including two commodes fitted with toilet accessories made by Dester, decorated with Paris porcelain plaques [378]. For Bagatelle he supplied a 'table mobile' which was both bureau and dressing-table, with marquetry in mosaic of blue wood and richly decorated with gilt-bronze mounts on a martial theme. For the boudoir of the Comtesse d'Artois at the Palais du Temple he supplied a writing-table in bois satiné, decorated with tôlework medallions painted with dancing figures in the classical style.

LAZARE DUVAUX (1703–58), son of a marchand bourgeois, was related to Thomas-Joachim Hébert and also to the great collector Louis-Jean Gaignat, who acted as a witness for him at his marriage in 1741. He entered the guild of marchands-merciers around 1740 and then, like Hébert, became 'marchand suivant la cour', dealer to the Court. Established first of all in the rue de la Monnaie, he moved to the rue Saint-Honoré where he rented a house from Hébert and probably took over his business. (The high rental of 6,000 livres for the building would suggest that Duvaux had taken over the entire establishment; furthermore, the period of Duvaux's success covers the years 1748 to 1758, overlapping to a certain extent Hébert whose name is not mentioned after 1752.) In 1755 Duvaux was appointed 'orfèvre-joaillier du roi' (silversmith-jeweller to the King). On his death in 1758, he left a large stock, evidence of his pros-

perity. The inventory (Arch.Nat. Min.Cent. XCIV/290) gives the names of his principal suppliers, including the ébénistes Joseph Baumhauer (credit of 1,726 livres); Jean-François Dubut (credit of 62 livres); Pierre Macret (1,169 livres); the Martin brothers, lacquerers; the clock-makers Moisy, Etienne Lenoir, and various bronziers including Osmont, Paffe and Vassou. The day-book in which Lazare Duvaux registered all his commercial transactions between 1748 and 1758 (published by Courajod, new edition by de Nobele, 1965) gives the names of his clients and records the whole range of his business operations.

THE JULLIOT DYNASTY: CLAUDE-ANTOINE JULLIOT (died 1760); CLAUDE-FRANÇOIS JULLIOT (1727–94); PHILIPPE-FRANÇOIS JULLIOT (1755–1835). After 1739, the royal accounts mention 'Julliot, jeweller,' as supplier to the Crown. In that year Claude-Antoine Julliot supplied a rock-crystal chandelier for the Petite Galerie at Versailles. In 1740 and 1741 he supplied numerous objects in Chinese porcelain, as well as fire-dogs, girandoles and Chinese lacquer furniture, to Versailles. These included two commodes, one for Versailles in 1740 and the other for the bedchamber of Mlle de Mailly at Choisy in 1741, followed by two encoignures and two sets of corner shelves. In 1744 Julliot supplied 'a large bureau in amaranth decorated with six heads, of which two were of Bacchus, with escutcheons, handles, sabots and other gilt-bronze decoration.' This piece was intended for the King, for the Cabinet des Tableaux adjacent to the Petite Galerie at Versailles. It is possible, as Daniel Alcouffe has suggested, that this was a bureau by Cressent, since several pieces of furniture by Cressent were in Julliot's sale in 1777. In 1752 Julliot was the expert in charge of the sale, which took place at the Tuileries, of Louis XIV's cabinets in pietra-dura.

Son of Claude-Antoine Julliot, 'marchand bourgeois de Paris' and of a Mlle Février, Claude-François Julliot married Marguerite Martin in 1753. At the time he is noted as a 'marchand-bijoutier' on the quai de la Mégisserie. The following were present at the wedding: the agent of the King of Prussia, Mathieu Petit de Rougemont, the marchand-bijoutier Antoine Hazon, the marchand-mercier Rochinel de la Planche, and the casters Jean-François Prévost and Jean-Gabriel Dugué. The groom's assets were estimated at 6,000 livres.

While in the 1740s his father had specialized in chinoiserie, in the 1770s Claude-François Julliot made a speciality of the resale of Boulle furniture. Between 1769 and 1789 he was one of the main buyers of this type of furniture at public auctions. During this period he also commissioned pastiches by the ébénistes Levasseur, Joseph Baumhauer and Montigny. In 1777 he supplied a commode by Levasseur for the bedchamber of the Comte d'Artois at the Palais du Temple. The same year, following the death of his wife, there was a sale of Julliot's stock: besides some well-known pieces by Boulle, such as the coffers said to have belonged to the Grand

Dauphin [14], there were pieces by Joseph Baumhauer and Levasseur [244, 355]. The inventory taken after the death of Mme Julliot (Arch. Nat., Min. Cent. X/666, 5 November 1777) adds to the information given by the sale catalogue and confirms that the initiative in imitating Boulle furniture did indeed come from Julliot. There are descriptions of stocks of bronze models copied from Boulle (masks, corner mounts, eagle-head escutcheons, fringes, zephyr-heads and various unidentified figures in bas-relief which must have been copied from the furniture in Julliot's stock, decorated with the Seasons or the legend of Apollo). The bronze models were catalogued as 'models of ornaments in the style of Boulle suitable for bookcases', or 'models for commodes' or 'models for armoires basses', thus describing the three types of furniture which were a speciality of Julliot. The mention of 'eight ribbons in relief and nine unchased medallions' suggests that Julliot must have been making copies of famous armoires basses by Boulle with the figures of Aspasia and the Philosopher [32] decorated with medals. No doubt this was the origin of the pair of armoires from the Roudinesco Bequest (Versailles), which are stamped by Montigny and have medallions which are very obviously recast. In 1777 Julliot was established in the rue Saint-Honoré near the rue du Four (now rue Vauvilliers). He seems to have retired at this time. When he died in 1794 he was living in a house which he owned in the rue des Deux-Ecus. The inventory made after his death (Arch. Nat., Min. Cent. X/813) reveals that he no longer owned any stock of furniture or bronze mounts. His modest furnishing comprised a few pieces of furniture in mahogany or walnut. His assets amounted to 4,736 livres in cash and state bonds representing an annual income of 2,420 livres.

His son Philippe-François, known as Julliot the Younger

Sketch for a commode in pietra-dura inscribed 'This drawing was made for [?] on 7 September 1784 under the direction of P.-F. Julliot the Younger'. The piece was never made and the panels were ultimately used on various pieces of furniture by Weisweiler – see [491] and [492]. (Musée des Arts Décoratifs, Paris)

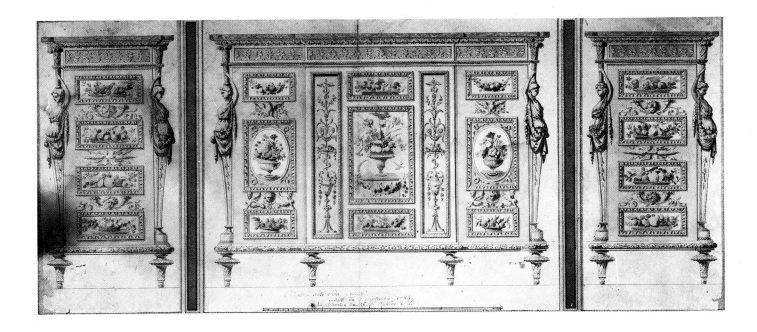

House of the dealer Pierre Le Brun, rue de l'Arbre-Sec, Paris

(1755–1835), became a dealer during the 1780s. The inheritance from his mother in 1779 as well as various loans and gifts from his father in 1782 and 1787 helped him to establish himself. He took over his father's shop at the sign of the 'Curieux-des-Indes' at the corner of the rue du Four and rue Saint-Honoré. He conceived the idea of decorating furniture with panels of pietra-dura from large, dismantled, seventeenth-century cabinets. A drawing (see p. 35) in the Musée des Arts Décoratifs, signed 'Julliot Fils' and dated 1784, is a sketch for a commode close to the one in Stockholm [491]. The few recorded pieces using this technique were stamped by Joseph, Carlin and Weisweiler, all ébénistes who worked for Julliot or for Daguerre, the other dealer who also specialized in furniture in pietra-dura. Julliot the Younger was also expert in charge at the most important auction sales of the period: at the sale of the Duc d'Aumont in 1782, then at the sale of Montribloud's cabinet of curiosities in 1784, and finally at the Duc de Richelieu's sale in 1788. In other catalogues his name also appears as purchaser: in the Billy sale in 1784 he bought lot 175, a small secrétaire, 'decorated with four inlaid panels, in Florentine work', which can be identified as the secrétaire by Carlin recently acquired by the Louvre.

When his father died in 1794, Julliot was described as a 'négociant, rue Jean-Jacques-Rousseau, no. 392'. In 1802 while he was in jail at Sainte-Pélagie, there was a sale of his stock, winding up the activities of the firm of Julliot. The catalogue describes several cabinets and one commode in pieta-dura, along with some 'old' pieces by Boulle and many 'in the genre of Boulle', among them 28 low armoires, several cabinets, and pedestals of various shapes, some of which are described as 'unfinished', which shows that the production of pastiche Boulle furniture was still very active around 1800. On his death in 1835 he was described as a 'person of independent means living in Paris in the impasse Longe-Pierre near Saint-Jacques.'

PIERRE LEBRUN (died 1771) was established in the rue Saint-Honoré between the rue des Poulies and the Oratory, at the sign 'Au Roi des Indes'. He was recorded as still being there in 1765. He later moved to a fine house in the rue de l'Arbre-Sec opposite the rue de Bailleul, where he lived until his death in 1771. The catalogue of the sale after his death, which took place on 18 November 1771, described the assets of his business: 'paintings, drawings, prints, mounts, terracottas, marbles, different kinds of porcelain, interesting pieces of furniture by Boulle and other objects of curiosity which make up the business of the late Pierre Lebrun, painter of the Académie Saint-Luc, whose sale will take place in his house in the rue de l'Arbre-Sec, opposite the rue Bailleul . . .' He was the father of Jean-Baptiste Lebrun, husband of the artist Mme Vigée-Lebrun. Like his father before him, Jean-Baptiste Lebrun was an expert as well as an important buyer in the auction sales between 1776 and 1788, specializing in paintings and Boulle furniture. He used the

considerable funds accumulated from his wife's portrait-painting for his own business and commissioned the architect Raymond to build a large house on the rue du Sentier in 1785. Part of the house gave onto the rue de Cléry and was used as a sale-room; its Boulle pastiche furnishings were supplied by Levasseur [354]. Bad management forced him to put his collections up for sale in April 1791.

DARNAULT AND HIS SONS. Established in the rue de la Monnaie at the sign 'Au roy d'Espagne', the business named 'Darnault et Compagnie' supplied the Garde-Meuble Royal from 1738 with various gilt-bronze wall-lights and lacquer étagères. During the 1750s Darnault often used the services of Joseph Baumhauer, as indicated by the presence of his business label on a lacquer commode in the J. Paul Getty Museum, a pair of commodes in the National Gallery of Washington and on a cartonnier in the Hermitage. He also used the services of Hansen, as confirmed by the label found on a commode en console in the Rosebery Collection (Mentmore sale, 18 May 1977, lot 141). In the 1780s the Darnault sons employed Carlin and Levasseur and became the main suppliers to Mesdames, Louis XVI's aunts, at their Château at Bellevue, supplying them with sumptuous furniture in Japanese lacquer (see pp. 344, 355).

Trade label of the marchand-mercier Darnault found on a commode stamped Hansen. (Sotheby's London, 24 November 1988, lot 10)

SIMON-PHILIPPE POIRIER (*c.* 1720–85), son of a marchand-mercier, in 1742 married the only daughter of mercier Michel Hécéguère who was also the niece of the well-known Hébert. At the same time he was received into the guild of the Parisian marchands-merciers. The large dowries (12,000 and 13,500 livres) from the two families enabled the Poirier couple to join the Hécéguère parents in the building occupied by them at 85 rue Saint-Honoré 'A la Couronne D'Or', opposite the Hôtel d'Aligre. This partnership lasted until the death of Hécéguère in 1753. The inventory of the business drawn up at that time gives the names of their clients, who included the Prince de Soubise (who owed 26,577 livres), the Prince de Condé, the Garde-Meuble Royal, the Duchesse du Maine, the Cardinal de Soubise, the Duc de Duras, etc. Many ébénistes were employed by Poirier-Hécéguère: B.V.R.B., Dubois the Younger, Dubut, Garnier, Joseph, R.V.L.C., Lhermite and Tuart the Elder.

The size of the business is reflected in the high figures in the accounts: 27,088 livres in stock and 75,082 livres in credit. Later Poirier became one of the most important clients of the Sèvres factory. Between 1758 and 1770 he bought almost 700,000 livres worth of porcelain. From 1760 he ordered porcelain plaques from Sèvres to decorate furniture which he commissioned, first from B.V.R.B. and later from Joseph Baumhauer, R.V.L.C. and Carlin. Poirier had virtually a monopoly of these types of porcelain plaques from Sèvres. Furthermore, almost all furniture with porcelain plaques made during this period passed through his hands. This rare and expensive furniture attracted a prestigious clientèle. Between 1768

Trade label of the marchand-mercier Poirier at the time of his association with Hécéguère, at 'A la Couronne d'Or'; found on a table by B.V.R.B. (Musée d'Art et d'Histoire, Geneva)

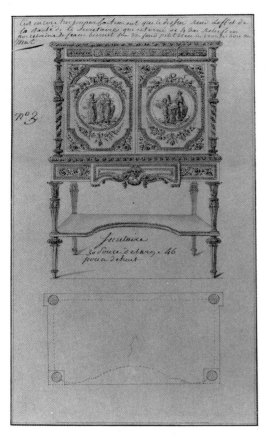

and 1774 he sold almost 100,000 livres worth of furniture to Mme du Barry. He also sold to the Duchesse de Mazarin, the Comtesse d'Artois, the Comte de Provence, the Marquis de Marigny, and foreigners such as the Earl of Coventry and Horace Walpole. In 1772 Poirier took Dominique Daguerre, a cousin by marriage, as a partner and made over his business to him in 1777.

DOMINIQUE DAGUERRE (c. 1740–96), cousin by marriage to Simon-Philippe Poirier, became almost an adopted son to the Poiriers. At the time of his marriage in 1772, he became involved in their business and was given a stock of gilt-bronze models as a gift. As we have seen, in 1777 Poirier made over to him the management of the whole business, which at the time was very successful, with credit amounting to 505,929 livres and liabilities of 286,497 livres. In the same year Poirier became an associate of Francotais, but this relationship lasted only until 1781. A comment in the *L'Almanach général des marchands-négociants* for 1779 recommends 'Daguerre and Francotais for fine furniture with French porcelain plaques.' Like Poirier, Daguerre had made a speciality of furniture with Sèvres porcelain plaques although the volume of his purchases of plaques from Sèvres declined considerably after 1778. Daguerre entrusted his ébénisterie to Carlin until 1785, briefly to Schneider, and also to Saunier and Weisweiler. He also commissioned furniture in Japanese lacquer from the same ébénistes. The presence of identical bronze mounts on pieces made by these various ébénistes confirms that the bronze models did indeed belong to Daguerre. Daguerre also imported furniture from England, such as the two mahogany tables sold to the Comte d'Artois in 1779, and he reinterpreted the English styles in pieces such as the tea-tables which he had made by Weisweiler. He also had the idea of importing Wedgwood plaques from England (he had the sole agency in France from 1787) which he had mounted on small pieces of furniture made by Weisweiler. From 1777 he sold furniture to Mme du Barry [479], such as 'a small table in burr-mahogany with cameos and glass top, the legs in cluster columns of bamboo in gilt-bronze . . . 720L'.

During the 1780s Daguerre was the most famous dealer in Paris. Naturally all important visitors from abroad came to him, such as the Comte and Comtesse du Nord on their visit to Paris in 1782. The list of his clients spans the aristocracy (the Duc de La Force, the Maréchale de Mirepoix, the Comte de Médavy, the Comtesse d'Ennery, the Baron de Breteuil, the Duc d'Aiguillon) as well as bankers (Perregaux), the royal family and princes of the blood (Artois, Provence, Condé and Orléans). After 1785, when the Garde-Meuble Royal stopped employing Riesener and used Benneman for its current needs, the finest furniture intended for the King or Queen at Versailles and Saint-Cloud was bought from Daguerre. When a present was required for one of her sisters, the Queen turned to him. Her correspondence with Mercy in 1786 mentions one of the royal

gifts: 'I have asked the King, Sir, for the money which he is prepared to provide for the gift to my sister [Marie-Christine]. He is no more knowledgeable on the subject than I, but I do believe that a piece of furniture, decorated with nice mounts and above all with *good lines*, would be the best thing, and you can go to between 75 to 100 louis. I think that will repay, even with interest, for the King's pleasure in the wretched boxes which my sister gave him [...] Daguerre came this morning and the oval table seems to me to be perfect. It is also the one which my sister preferred the day she went to the dealer.' The Queen's sisters, Maria-Carolina, Queen of Naples and Marie-Christine of Saxe-Teschen, Governor of the Austrian Netherlands, in their turn became Daguerre's clients. It is probable that the latter ordered an important suite of furniture with porcelain plaques from him for her palace at Laeken. The only trace of this today is in a book of sketches in the Metropolitan Museum of Art (see p. 5 and the illustrations at left and right).

In 1789 Daguerre became associated with Martin-Eloi Lignereux and began to forge business links with England. He supplied furniture to the Prince of Wales, to the Duke of York, Lady Holderness, Lord Spencer and the Duke of Bedford at Woburn. In 1791 he put his stock from France up for sale at Christie's. He died in 1794.

CHARLES-RAYMOND GRANCHEZ originally came from Dunkirk, where he had a shop at the sign of 'La Perle d'Orient'. He became a marchand-mercier in 1767, and in that year established a second shop called the 'Petit Dunkerque' on the quai de Conti, at the entrance to the Pont-Neuf. In Dunkirk as well as in Paris, Granchez's success came from the goods which he imported from England. Advertisements in *L'Avant-coureur* from 1767 to 1773, and then in the *Mercure de France*, reveal his growing success. In 1782 he had become one of the sights of Paris. Baroness d'Oberkirch who accompanied the Comtesse du Nord to Paris devoted a long passage to him in her memoirs: '28th May. We spent the whole morning running around the shops. We spent several hours at the Petit Dunkerque. It's the name of a jeweller on the approach to the Pont-Neuf. Nothing is so pretty or so gorgeous as this shop, filled with jewels and gold trinkets, which cost ten times the value of their materials. They sell at fixed prices and, even though the pieces are elegant and varied and the work exquisite, the dealer says that they are not expensive. And there are often so many people there that a guard is placed at the door. We chose the most fashionable piece, a little ornamental model of a windmill. Mme La Comtesse du Nord took a lot back to Russia with her.' It is not known what course Granchez's subsequent career took, but it is likely that the Revolution and the blockades that followed put an end to his trade with England.

In the creation of the fine furniture of the eighteenth century the rôle of the marchands-merciers was fundamental. At a time when most ébénistes had neither the means nor the artistic talent to

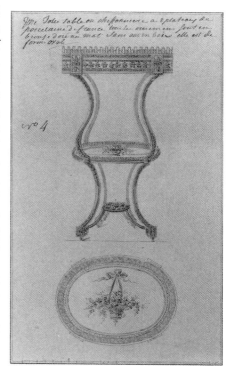

Designs for furniture mounted into porcelain that were made either by Carlin or by Weisweiler; the adulatory annotations would indicate that these sketches were originally part of a sale catalogue of Daguerre's stock. Other annotations in the same album would suggest that the majority of the pieces depicted did in fact belong to the Duchesse de Saxe-Teschen, Governor of the Austrian Netherlands, and were considerably damaged in a shipwreck off the Danish coast after the Duchesse de Saxe-Teschen had fled from Brussels before the advancing French Revolutionary forces. (Metropolitan Museum of Art, New York)

undertake the finest pieces of furniture, the merciers, who rubbed shoulders with architects, decorators, and most importantly, with a demanding clientèle, were constantly inventive. It was they who had the idea of marrying marquetry to precious materials; panels of Chinese or Japanese lacquer, porcelain plaques from Sèvres or Wedgwood, tôlework plaques imitating oriental lacquer, panels of pietra-dura or Boulle marquetry. They also invented many new types of furniture such as jewel-cabinets, the bonheur-du-jour or the secrétaire en cabinet, and numerous kinds of tables. They adopted new styles as fast as the most daring of the ébénistes.

With the exception of works by Cressent, Doirat, Latz, Oeben, Garnier, Leleu and Riesener, almost all the finest furniture of the eighteenth century was the result of the imagination and commercial enterprise of the marchands-merciers. Given this situation, the ébéniste appeared at the time to play a very secondary rôle, his talent being seen largely in craftsmanship of assemblage, the achievement of graceful curves and perfection of marquetry. It is therefore not surprising that ébénistes were described in contemporary records merely as 'workers'. In an invoice dated 1774 submitted to Mme du Barry relating to a table by Carlin, which is now in the Louvre, Poirier described Carlin's work as follows: 'invoice, order and delivery note for a tea-table with porcelain plaques, commissioned *from the workers* and the Sèvres factory.' A fine piece of furniture was often the work of a team with the ébéniste playing his part alongside the dealer who conceived the idea, the designer who created the form, the carver who supplied the bronze models, the bronzier who cast them, the craftsmen who chased and gilded them, and finally the lacquerer or the porcelain-painter who decorated the surface.

Nowadays, believing as we do in the idea of individual creativity, it is hard to understand the phenomenon of collective production. For this reason and partly also because of the existence of stamps, the history of furniture-making has recorded above all the names of the ébénistes. For practical reasons this study is organized along the same lines and covers sixty-three of the great ébénistes, who practised from the early years of the reign of Louis XIV, from around 1660 onwards, up to the Revolution. We shall need to be aware of the limitations of such an approach.

(right) *The bronze mounts on precious pieces of furniture at the end of the eighteenth century were of jewel-like quality, thus relegating the role of the ébéniste to a secondary one; it is not surprising, for instance, that we do not know the name of the ébéniste of this jewel cabinet. It was executed by the goldsmith Henry Auguste for William Beckford, the mounts being modelled by J.-G. Moitte in 1792. The cartouches are cameo-like, imitating Wedgwood. William Beckford mentions this piece in a letter of 27 February 1792 to William Hamilton: 'If the King of Naples is desirous of having good work in gold, silver or bronze, he should apply to Auguste ... I think you will be enraptured with the furniture I am having made under his direction in the true spirit of Corinth and Athens.' (Private collection)*

(right, below) *Detail of the mounts on the jewel-cabinet shown above right.*

Design for a frieze in arabesque style for the coffer by J.-G. Moitte shown on p.41. (Formerly in the Odiot Collection; Sotheby's Monaco, 26 November 1979, lot 620)

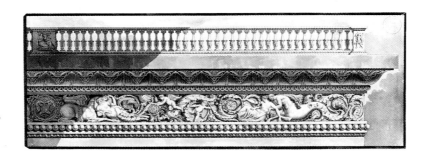

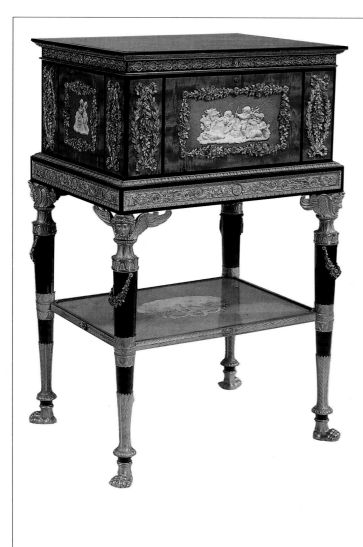

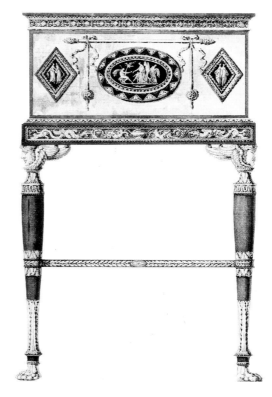

Design by J.-G. Moitte (1746–1810) for the jewel-cabinet made for William Beckford; inscribed 'diamantaire de Lord Beckford', it was made under the direction of Henry Auguste, for whom Moitte executed numerous other designs for silver or furniture. (Sotheby's Monaco, 22 February 1986, lot 181)

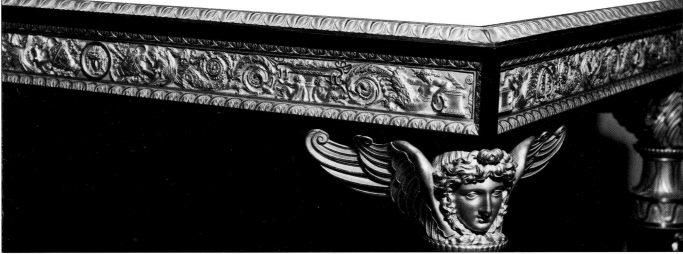

Cabinet in Japanese lacquer stamped Weisweiler, made c. 1792 under the direction of the goldsmith Henry Auguste for William Beckford who was an avid collector of Japanese lacquer, with mounts probably designed by J.-G. Moitte. The Hamilton Palace sale catalogue in which the piece featured in 1882 indicates that the medallions were painted by Benjamin West. (Private collection)

(right) Design for a cabinet by J.-G. Moitte for Henry Auguste, c. 1792, probably commissioned by William Beckford. (Sotheby's Monaco, 26 November 1979, lot 619)

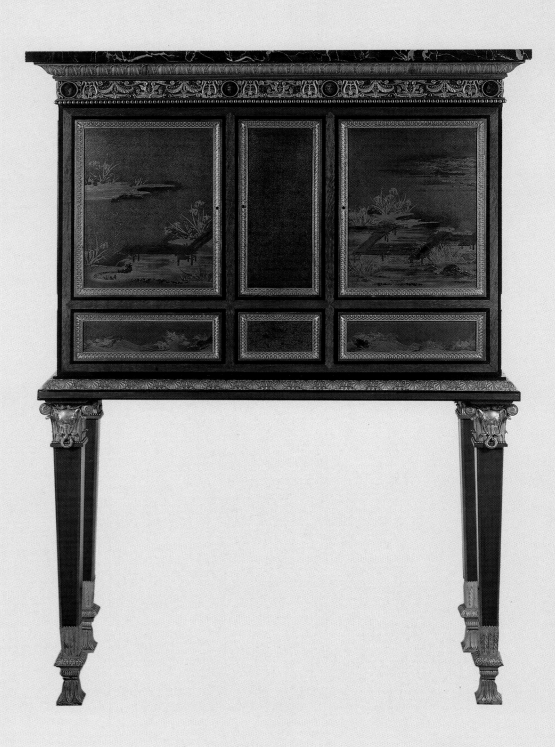

THE ÉBÉNISTES

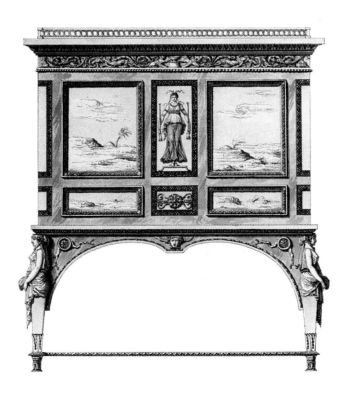

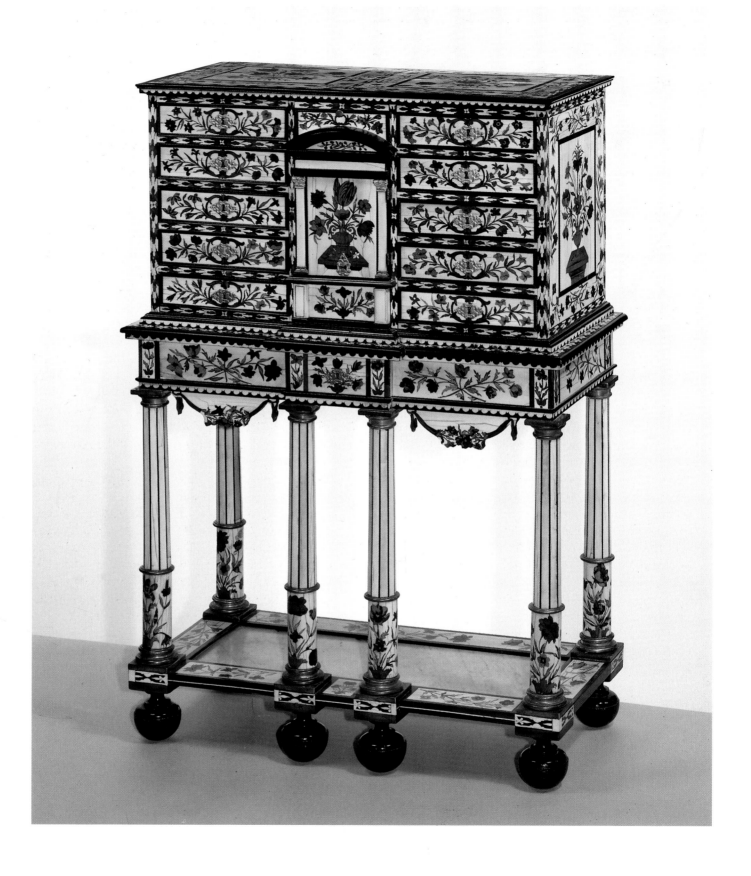

Pierre
GOLE

c. 1620–84; MASTER BEFORE 1656

Only recently, through the researches of Lunsingh Scheurleer, have we come to know of Pierre Gole, certainly the most important ébéniste during the first half of Louis XIV's reign. He was born in Bergen near Alkmaar in Holland in about 1620 and settled at a young age in Paris. In about 1643 he worked as apprentice to the 'menuisier en ébène' Adrien Garbrant, whose eldest daughter he was soon to marry. The marriage contract, drawn up on 22 January 1645, records that Anne Garbrant was provided with a dowry of 2,000 livres. Garbrant was partially paralysed and Gole had therefore to assume responsibility for the workshop and the Garbrant family. The connections were strengthened between the two families when one of Pierre's brothers, Adrien Gole, also a 'menuisier en ébène', married Marguerite, a sister to Anne Garbrant. Moreover, another sister, Charlotte Garbrant, married Jean Marot, architect to the Bâtiments du Roi, and this family connection may explain the origins of royal commissions received by Gole. From as early as 1656, from the time of Mazarin's first commissions, a document describes Gole as 'maître menuisier en ébène ordinaire du roi'. The first royal order is a vast piece of furniture designed to house Louis XIV's collection of drawings and medals in his Grand Cabinet du Louvre, delivered in 1661. This piece, which was later enlarged until it measured nearly three metres high and as much across, was decorated in floral marquetry and gilt bronze, at a cost of 6,600 livres.

Before he concentrated on floral marquetry, Gole produced a number of cabinets in ebony in the man-

ner of his father-in-law, for instance those made in 1646 for the Maître des Comptes M. Rossignol and for Macé Bertrand de la Bazinière. The latter type stood on spiral columns decorated with vine fronds and birds. In 1661 the first work Gole carried out for the Crown was for the new apartments for the King and Queen at the Château de Vincennes. Here he delivered a cabinet d'architecture in floral marquetry on an ebony ground as well as seven tables, each supplied with a pair of matching guéridons as was fashionable at the time. Two of these tables were decorated in 'vernis façon de la Chine' (japanned), two others with pewter marquetry on a tortoiseshell ground, one embellished with mother-of-pearl and the remaining two with floral marquetry.

At about this time Louis XIV was becoming increasingly interested in Versailles, and Gole was one of the ébénistes, together with Michel Campe, Daniel Manesse, Pierre Lallamant, Jacques Talon, Jean Thierry, Nicolas Hordebois and Sébastien Luce, commissioned to furnish the new residence. In 1662 Gole supplied three tables decorated with floral marquetry, in the following year a table with ivory and tortoiseshell marquetry, followed by two cabinets with designs of flowers and birds in ivory and tortoiseshell marquetry in 1664. These cabinets with innovatory glazed doors containing the King's collection of crystals were admired by Mlle de Scudéry.

FURNISHING OF THE GRANDS CABINETS FOR THE CROWN AND COLLABORATION AT THE GOBELINS

In 1663 Gole completed two sumptuous cabinets ordered by Mazarin in his will as a present worthy of the King, and which give the measure of Gole's

[1] Cabinet, c. 1662, with floral marquetry on an ivory ground, made for Monsieur, brother of Louis XIV, at the Palais-Royal. (Victoria and Albert Museum, London)

reputation. These cabinets, designed in ebony and gilt bronze, after drawings by Le Brun, incorporated five niches with allegorical figures separated by columns of polychrome marble, and surmounted by a balustrade. The base of each was composed of twelve caryatids in gilded wood symbolizing the months of the year. Identified by M. Scheurleer in the Cluny Museum, these caryatids are very similar to the stucco terms designed at the same period by Le Brun for the Oval Salon at Vaux-le-Vicomte and the Ambassadors' Staircase at Versailles.

Gole's most important royal commission remains that of two large 'cabinets de la Guerre et de la Paix' executed between 1665 and 1668 and for which payments continued at intervals up to 1678, amounting to 25,800 livres. These cabinets have disappeared, as have those of Mazarin and many others belonging to Louis XIV, probably broken up in the middle of the eighteenth century by dealers or ébénistes who would have bought them from the Crown (there were four sales of Louis XIV's cabinets in 1741, 1751 and 1752) in order to retrieve the precious materials with which they were embellished. However, the appearance of Gole's cabinets is preserved for us in an engraving in the Kunstbibliothek in Berlin. They resembled triumphal arches with central and incurving sides on a base formed by caryatids. Veneered in ebony, they were decorated with small panels of brass and pewter, and in particular miniature pictures on copper flanked by columns of lapis lazuli. This raises the question of Gole's collaboration with the workshops at the Gobelins where the King's cabinets were being assembled – mainly under Cucci, following designs by Le Brun. There is no mention in the records of any links between Gole and the Gobelins, while it is known that he had his workshop at the junction of the rue de l'Arbre-Sec, in that elegant quarter close to the Louvre. Nevertheless, it is very likely that Gole did work periodically on the important royal commissions at the Gobelins, maintaining another workshop in Paris for his private clientèle. The famous tapestry recording the King's visit to the Gobelins in 1667 [6] depicts at least two ébénistes, one of whom is clearly Cucci, while the other must be Gole, presenting a table with tortoise-shell marquetry (the type of furniture for which he was favoured with commissions by the Crown). In addition, the inventory drawn up after his death in 1684 mentions the sum of 659 livres 'owed to Sr Huzé,

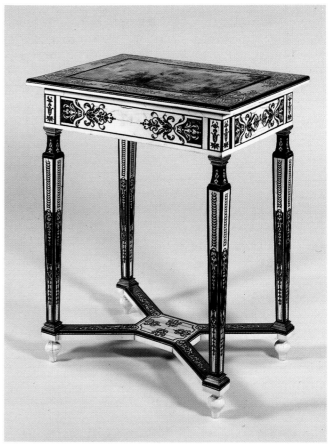

[2] Table c. 1674, in ivory and blue-stained horn, probably produced for the Trianon de Porcelaine. (J. Paul Getty Museum, Malibu, California)

brewer at the Gobelins... for beer supplied by him', which can only imply that Gole had a team of craftsmen working under his direction at the Gobelins.

MARQUETRY IN IVORY AND CHINOISERIE

In 1663 and 1664 Gole delivered a suite of furniture with floral marquetry on ivory ground for Versailles. It consisted of a large cabinet with its two guéridons and their attendant tables, one with matching guéridons. The legs of the cabinet as well as those of the tables were in the form of columns. It would seem that Gole had made a speciality of this type of marquetry in ivory in Paris. According to the records of the Bâtiments du Roi he is the only ébéniste recorded as producing it, which enables one to attribute a cabinet recently acquired by the Victoria and Albert Museum to him [1]. It was made between 1661 and 1670 for the

Duc d'Orléans, Louis XIV's brother, at the Palais Royal. Soon after 1670 Gole delivered four tables with their eight matching guéridons and four cushion-stands decorated in blue and white in imitation of porcelain for the Trianon de Porcelaine, where the matching decorative theme in blue-and-white was designed to imitate Chinese porcelain.

Besides his creations in trompe-l'oeil, Gole made at least two tables in blue-and-white marquetry on an ivory ground. The first is recorded in a delivery in 1664: 'An ivory table with compartments of flowers and foliage inlaid in blue to look like porcelain, 8 pieds in length and 3½ pieds in width, with a wooden stand painted to imitate porcelain.' The second, smaller table, which can be identified from an inventory at Versailles of 1718, is now in the J. Paul Getty Museum [2]. It is the sole recorded surviving baroque piece of the time of Louis XIV, when the most costly materials were used to create trompe-l'oeil effects; it is more-over a rare example of the development of the taste for chinoiserie in France. Gole also made other pieces in the Chinese manner. As well as the 'coffer in the form of a mausoleum lacquered in the Chinese manner' designed to hold the Treasure of Childéric, Gole delivered to the King in 1667 a pyramidal cabinet with a series of nine drawers 'decorated overall with the most delicate examples of work in the Chinese style'.

THE CREATION OF THE 'BUREAU MAZARIN'

The first mention of a 'bureau' delivered to the Court appears in 1669 in the accounts of the Menus Plaisirs. It was in cedar, made by Gole, who went on to make more than twenty-five bureaux of various kinds for the Court, of a type known since the nineteenth century as a 'bureau Mazarin' (although the prototype only appeared after the Cardinal's death). Gole would seem by all accounts to have invented the bureau Mazarin which generally consisted of six drawers placed on either side of a central recess, sometimes fitted with a cupboard, supported on six or eight columnar legs or carved wooden gilded or silvered terms. The only piece of furniture of this type identifiable today is a small desk in the Duke of Buccleuch's collection at Boughton House, Northamptonshire [3] which was certainly made for Versailles in 1672. The top of this bureau is 'brisé' (broken), folding in half while the fronts of the upper drawers form a fall-front, revealing

[3] 'Bureau brisé' with pewter marquetry on a brass ground. Originally part of the furnishings of Louis XIV at Versailles, it can be identified from a delivery by Gole in 1672 for the price of 1,800L. (Boughton House, Northamptonshire; Duke of Buccleuch's collection)

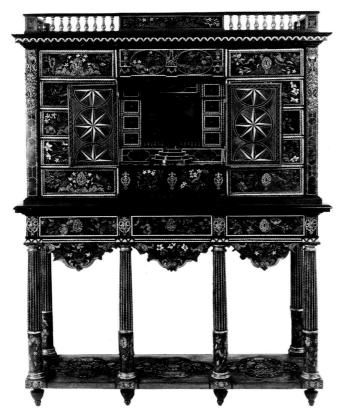

[4] Cabinet with floral marquetry in fruitwood inlaid with ivory. (Christie's London, 23 June 1988)

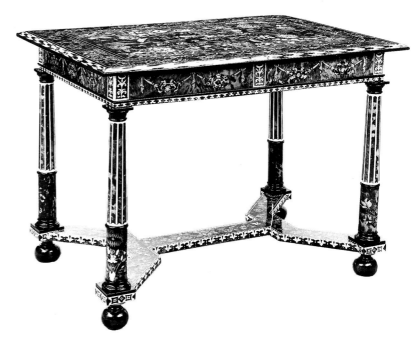

[5] Table with ivory and wood marquetry on a tortoiseshell ground. Almost identical to a table formerly at Mentmore, originally in Mazarin's collection, and therefore dating, like the latter, from c. 1655–60. (Archives Galerie Aveline, Paris)

a work surface which could be easily closed when required. This bureau 'à brisure', of a type frequently mentioned in Louis XIV's inventories, without doubt represents the first evolutionary stage in the development of the bureau Mazarin, the forerunner of the secrétaires.

COMMISSIONS FOR VERSAILLES

From 1670 to 1680 Gole was almost entirely concerned with works for Versailles, which was in the process of becoming the King's principal residence. They were mainly tables in walnut or floral marquetry. The six tables delivered in 1679, as well as the twenty-three others delivered in 1682 at the time of the King's move to Versailles, were decorated on the top with a central motif of a vase or bouquet of flowers on an ebony or cedar ground. The legs, generally columnar, were also square and tapered or with terms of carved and gilded wood.

At the same time Gole also produced parquetry floors, as did Macé and Sommer. In 1673, he constructed the platform for the Queen's State Bedchamber, and then a second one for the same apartment. In 1682 he was paid 7,550 livres 'for the parquet he made for the mezzanine of the cabinet of Monseigneur the Dauphin', the design for which is preserved in the Musée des Arts Décoratifs in Paris.

Gole's last commissions coincided with the first important works by Boulle for the Crown, particularly the work for the Dauphin, with its astonishing decoration. He died on 27 November 1684. His son Corneille was not able to succeed him. As a result of the revocation of the Edict of Nantes he was forced to leave France in the following year, settling first in the Hague, and then in 1689 in London.

INVENTORY TAKEN AFTER GOLE'S DEATH

The inventory of Gole's workshop in the rue l'Arbre-Sec lists an important stock: about two hundred pieces of furniture are described, valued at approximately 11,000 livres. Most were complete and ready for sale, while fifteen were still in the process of construction.

Of the various types of furniture itemized, the table was the most widely represented. Forty-four tables are listed, often together with a pair of matching guéridons (17 pairs), mostly in walnut (noyer de Grenoble). The most luxurious of them, valued at between 50 to 200 livres each, were embellished with floral marquetry. They were supported on console legs or by caryatids in carved and gilded wood, less frequently on fluted columnar or square tapered legs. A number of tables were veneered in burr olivewood, more rarely in cedar or ebonized wood. Desks, equally numerous in the inventory (23), were obviously at the height of fashion as almost all the pieces in the process of construction were actually desks. The brevity of the descriptions does not give a clear idea of these pieces, but at least two were of the type called 'brisés', and when the feet are described they are usually 'termes dorés', or 'gaines dorées' or 'columns'. They are valued at between 40 and 220 livres each. Of cabinets, a type of furniture which was later to pass out of fashion, there are still thirty examples mentioned in Gole's inventory, most of them 'en armoires', that is, the upper section forming a cabinet while the lower has two hinged doors. Most of these pieces were in walnut from Grenoble or 'bois d'Allemagne', i.e. in burr-walnut, or again in ebony. Two cabinets veneered in tortoiseshell are mentioned, one 'decorated with flowers' and the other 'with gilt figures' as well as a single cabinet in pietra-dura, deemed old-fashioned and given a low valuation. The numerous pieces of hardstone, columns and pilasters mentioned at the beginning of the inventory indicate that Gole had made cabinets in pietra-dura as had Cucci and Oppenordt, including cabinets decorated with flowers and fruit in relief. Judging from the 1684 inventory, Gole very seldom used marquetry in metal. Only six pieces using this technique are listed, and these are the most expensive pieces in the inventory, the marquetry composed only of brass and pewter, sometimes with ebony (and not combined with tortoiseshell in Boulle's style).

— One small cabinet with marquetry of engraved brass and pewter and enriched with a quantity of gilt-bronze ornaments, together with a base. *800L*
— A large table with marquetry of engraved brass and pewter with a carved gilded and silvered base: with 2 guéridons. *440L*
— A small bureau in marquetry of brass and pewter,

length 2 pieds 8 pouces, supported on consoles in the form of gilt terms and mouldings also gilded. *220L*
— An écritoire and a casket with brass and pewter marquetry on an ebony ground with one small shelf in kingwood. *50L*
— One serre-papiers in brass and pewter marquetry on an ebony ground. *40L*
— One cabinet 'en armoire' with ornamentation and ebony on a pewter ground.

The stocks of wood in Gole's workshop consisted predominantly of ebony, but also of palisander, of 'lie de vin' (amaranth?) and bois jaune. Papers detailed at the end of the inventory give a list of Gole's creditors, among whom was the gilder Chamin and the London cabinet-maker Jansen, who sold Gole 400 livres of 'glue and merchandise'. There is a list of Gole's assistants (Jean Houwar, François-Nicolas Nathey, Pierre Doyenne, Nicolas Delahaye, Pierre Masme, Jacquin, carver, Desessars, lacquerer and Jocob, apprentice), as well as a list of his clients, among whom were the Princess of Mecklenburg, the Princess of Baden, Louise de Savoie (who owed 1,200 livres in 1667) and, above all, Marie de Bourbon, Princesse de Carignan who owed him 7,265 livres in 1670.

It is difficult to define Gole's style, judging from the few pieces so far identified by Lunsingh Scheurleer to date. Nevertheless, certain characteristics can be observed. On the edges of tables or cabinets are two types of borders. One comprises laurel garlands with alternate leaves in ivory and palisander with small central rosettes in ivory; this is the more common [5]. The other is a black-and-white border imitating a galloon of rounded festoons, a motif certainly originating from upholstery. Columnar legs with capitals and astragals were frequently employed by Gole, but also found on furniture by other Flemish and Parisian ébénistes of the same period. Floral marquetry, as far as may be judged from one piece of furniture dating from around 1662 [1], does not display the same realistic effects of depth and precision as is to be found on Boulle's furniture between the years 1680 and 1700. It represents the first stages in the development of floral marquetry where efforts were made to reproduce the linear yet colourful effects of marquetry in pietra-dura, using grounds of ebony or ivory to imitate the white or black marble found on Florentine furniture.

BIBLIOGRAPHY

Arch. Nat. Min. Cent. Et/LIII/92

Lunsingh Scheurleer: 'Pierre Gole, ébéniste du roi Louis XIV', *Burlington Magazine*, June 1980; 'The Philippe d'Orléans ivory cabinet by Pierre Gole', *Burlington Magazine*, June 1984; 'A la recherche du mobilier de Louis XIV', *Les Mélanges Verlet, Antologia di belle arti*, 1985, nos. 27–28

Jean-Nerée Ronfort: 'Le Mobilier royal à l'époque de Louis XIV', *L'Estampille*, April 1985

Gillian Wilson: 'Two newly discovered pieces of royal French furniture', *Les Mélanges Verlet*, 1985, pp. 61–66

APPENDIX

EXCERPT FROM THE INVENTORY TAKEN AFTER THE DEATH OF PIERRE GOLE ON 10 JANUARY 1685 (ARCH. NAT. MIN. CENT., ET/LIII/92):

The following are the tools, wood, glues, works completed and those still incomplete, priced by the aforesaid Jean, assistant to Jean Thierry, master ébéniste, living in the rue du Temple and César Campe, also master ébéniste living in the same street.

— Firstly, in the courtyard, there is a quantity of 6,164 livres of ebony priced at 15L the hundred, altogether *924L*
— Item, a quantity of 306 livres of palisander wood priced at 10L the hundred, altogether *30L 12s*
— 29 livres of calambour priced at 6s the livre, altogether *8L 14s*
— 31 livres of bois d'anis, priced at 4s the livre, *6L 4s*
— 187 livres of bois jaune, priced at 7L the hundred. *134L 1s*
— 36 livres of bois de cane, priced at 5s the livre. *9L*
— 298 livres of lie de vin, priced at 50L the hundred. *149L*
— 13 livres of bois violet, priced at 10L the hundred, *5L 5s*
— 1,145 livres of violet ebony, priced at 10L the hundred. *114L*
— 66 livres of grenaille priced at 2s the livre. *6L 12s*
— 116 livres of orangewood, priced at 10L the hundred. *114L*
— 37 livres of cedarwood, priced at 2s the livre. *3L 14s*
— 672 livres of all kinds of off-cuts priced at 3L the hundred. *20L 3s*
— 5 livres of tortoiseshell,

estimated at 100s the livre. *25L*
— 23 livres of ivory cut into sheets, priced at 30s the livre. *34L 10s*

The following items were found in the closet next to the kitchen:

— Various types of sawn wood of different colours, priced altogether at *400L*
— 14 livres of glue. *54L*
— 11 livres of fish glue. *17L 5s*
— 7 dozen blades for jointing planes as well as planes. *24L*
— 12 dozen braces and bits large and small. *100s*
— 72 moulding blades and a work bench. *22L*
— 1 small stand with tools. *11L*
— 2 amethyst columns *66L*
— 8 columns of Spanish brocatelle [marble]. *24L*
— 2 further columns of Spanish brocatelle. *11L*
— 2 columns of white alabaster. *3L*
— 2 further grey alabaster columns. *9L*
— 4 small white alabaster columns. *11L*
— 2 columns of 'fleuri de Sicile' [marble]. *33L*
— 2 pilasters in 'fleuri de Sicile'. *12L*
— 12 classical columns in lapis lazuli. *6L*
— 19 pieces of stone for drawer fronts of fruits and flowers in inlaid pietra-dura, and the door of the central compartment of a cabinet. *400L*
— 7 pieces of Spanish brocatelle both small and large, such as are used in pilasters. *8L*
— Various pieces of amethyst gathered together and various pieces of jasper. *12L*

— Various pieces of lapis. *4L*

In the shop:

— Item, 10 vices and 6 marquetry saws, priced together *20L*
1] Tortoiseshell cabinet with flowers, priced *90L*
2] Item, one cabinet in grey yew wood. *60L*
3] One cabinet en armoire, with decorations and ebony on a pewter ground. *80L*
4] One cupboard for books in four-coloured marquetry. *66L*
5] One bureau in Grenoble walnut of 3 pieds 8 pouces. *60L*
6] 10 tables in Grenoble walnut, one gilt, altogether. *44L*
7] One bureau of Grenoble walnut 3½ pieds long with drawers down to the feet. *60L*
8] One small table desk. *22L*
9] One table and 2 guéridons in solid walnut, altogether *16L*
10] One gradin decorated with cedar and ebony marquetry with one small walnut estudiole with 4 drawers. *22L*
11] One small cedarwood table priced *9L*
12] One solid walnut bookcase. *11L*
13] One bois violet bureau with gilded terms. *50L*
14] Another bois violet bureau with its gradin on twisted columns. *70L*
15] A small bureau in cedarwood with drawers banded in olivewood. *33L*
16] One small table desk in cedarwood. *15L*
17] One bureau brisé with columns. *60L*
18] 3 games tables covered in green serge, altogether *12L*
19] One carved table pedestal. *33L*
20] Comprising one cabinet-shaped casket in [?] with 2 écritoires with marquetry and 2 others 'façon de la chine'. One small cabinet with marquetry with 4 drawers with one small square of bois violet, altogether *33L*
21] One small reliquary with four columns decorated with looking glass. *15L*
22] 5 walnut shelves with one in cedarwood and one old tabletop with marquetry on ivory ground. *25L*
23] 2 small walnut folding tables, together *36L*
24] 3 walnut reading-stands

and 2 small round tabletops, together *9L*
25] One table decorated with flowers on an ebony ground with its wooden frame on the top and also guéridons of the same type. *55L*
26] One revolving stand in oak and 4 turning shelves. *20L*
27] One small partition with glass frame and 2 further frames, also of glass. *20L*
28] One small lacquered mirror with an ebony frame. *3L*

In the room above the shop:

29] One small cabinet with marquetry of engraved brass and pewter and embellished with a quantity of ornaments of gilt bronze together with the base. *800L*
30] One large armoire in walnut with landscapes. *400L*
31] One walnut armoire with 2 doors and 2 small armoires and a stand, altogether. *75L*
32] One walnut armoire with 4 panelled doors. *75L*
33] One armoire in handsome Grenoble walnut with 4 doors. *80L*
34] One tortoiseshell cabinet with gilt figures. *150L*
35] One ebonized cabinet with allegories and ornaments in tortoiseshell and accompanied by a stand. *100L*
36] 3 tables and 2 pairs of guéridons in Grenoble walnut. *82L*
37] One table and 2 guéridons in solid walnut. *16L*
38] One large table with marquetry in engraved brass and pewter and with one carved pedestal, gilt and silvered, with 2 guéridons. *440L*
39] One bureau worked with flowers overall with gilt straight legs. *200L*
40] One small bureau with marquetry in brass and pewter, 2 pieds 8 pouces long, mounted on drawers, with gilt console-shaped legs with mouldings. *220L*
41] One table decorated with flowers amongst festoons, mounted on square terms also veneered with flowers with gilt Ionic capitals and a pair of guéridons in the same manner, together *200L*
42] Another table decorated with flowers, 3 pieds long, with fluted wooden columns and

matching guéridons, in all *110L*

43] One table in burr-olivewood with columns and similar guéridons. *45L*

44] One small table in burr-olivewood in the shape of a bureau decorated with bands of bois violet. *25L*

45] One prie-dieu in Grenoble walnut with bands of ebony. *30L*

46] One bureau without a top in pear-wood ebonized and decorated with silver ornaments. *55L*

47] One table with flowers with a rim of pewter and a foot carved and gilt à console, and matching guéridons. *150L*

48] One table with flowers mounted on a base of console-shaped gilt figures and 2 matching guéridons. *165L*

49] Another table with flowers and with garlands mounted on square legs veneered with flowers and two matching guéridons *135L*

50] 2 large gilt guéridons 5 pieds high supported by 2 putti. *100L*

51] 2 more smaller gilt guéridons supported by term-shaped figures. *45L*

52] 2 tables 'à la dauphine', ebonized. *20L*

53] One table with panels of flowers with wooden structure for upper and lower part, 2 similar guéridons, unmounted. *55L*

54] One écritoire and one box with marquetry in brass and pewter on ebony ground with one small shelf in kingwood. *50L*

In the room on the second floor next to the kitchen:

55] One small bureau in calambour with pewter fillets. *60L*

56] One large ebony cabinet en armoire priced *150L*

57] One large box in bois d'Allemagne. *15L*

58] One strong box in bois d'Allemagne embellished with iron bands mounted on a foot. *100L*

59] One coffre de nuit 2 pieds 15 pouces in length decorated in marquetry of brass and pewter on 6 small gilt putti and decorated with gilt bronze lambrequins. *220L*

60] One cabinet en armoire with four doors in Grenoble walnut. *150L*

61] One old cabinet with inlaid hardstones on an ebony ground. *30L*

62] One table in solid walnut without its guéridon. *16L*

63] One small table desk in burr-olivewood. *25L*

64] One old table in bois d'Allemagne with handles at each end, on an ebonized base. *15L*

65] One gradin with flowers and ornamented with bands of pewter. *22L*

66] One cabinet en armoire in Grenoble walnut with pilasters. *90L*

67] Two small cabinets en armoire with two estudioles in bois d'Allemagne, incomplete, altogether *50L*

68] One serre-papiers in brass and pewter marquetry on an ebony ground. *40L*

69] One bureau brisé veneered in bois violet, 3 pieds 5 pouces in length, on columns, priced *60L*

70] One old table base composed of carved blackamoors. *40L*

71] Various pieces of carving with a carved panel. *30L*

72] 3 candlesticks carved, altogether *15L*

73] One night chest in Grenoble walnut. *24L*

74] 2 tables and a pair of guéridons in Grenoble walnut. *50L*

75] One table in burr-olivewood with its guéridons. *44L*

76] One table with festoons of flowers on gilt consoles with its matching guéridons. *165L*

77] Another, different table on fluted columns, bases and gilt capitals with matching guéridons. *110L*

78] 2 écritoires with marquetry of ebony on a pewter ground. *20L*

79] One round table covered in green serge with one small table à la dauphine ebonized, together *12L*

In the little side chamber where the deceased died:

80] One bureau in bois d'Allemagne of 3¹⁄₂ pieds and with 5 drawers. *40L*

81] One estudiole with its table in Grenoble walnut. *25L*

82] Various pieces of marquetry of brass and pewter and ebony, altogether *66L*

83] One old table en armoire in walnut. *12L*

84] One bookcase with four-coloured marquetry on a white ground. *60L*

85] One old bookcase façon de la Chine. *12L*

In the upper shop where the employees worked:

— 12 work-benches together with their tools both good and mediocre, altogether *130L*

— 4 saws for sawing ebony and a ripping saw, other saws without handles, altogether *15L*

— 16 saws, both hand and marquetry. *16L*

— 4 saws. *15L*

— 4 pots of glue and 2 pots of ebonizing fluid, one grill and two whetstones. *18L*

— 22 screw presses, altogether *22L*

In a loft above the shop:

— A number of beams of timber. *110L*

— One large press. *3L*

86] One bureau with flowers 6 pieds long, incomplete. *230L*

87] Another bureau with flowers, 3 pieds 9 pouces in length. *150L*

88] One cabinet en armoire, 3 pieds 9 pouces in length. *50L*

89] 3 small bureaux with marquetry of 3 colours incomplete. *100L*

90] One bureau, 5 pieds in length, the veneering started, that is the ebony cut and the white wood cut out for 2 other bureaux similar, altogether *60L*

91] 4 tabletops in floral veneer, altogether *300L*
Tortoiseshell and pewter prepared. *63L*

92] 3 games of raffle begun in walnut, altogether *20L*

93] 15 table legs with their bases with 6 tops. *66L*

94] The carcase of a large armoire in oak with 6 guéridon tops altogether *30L*

95] 3 sides of bureaux with one small estudiole, 2 sides of a small table à la dauphine, one box with its lock, altogether *50L*

Here follow the bronze, metals and lead:

— 29 livres and a half of sheets of bronze, engraved, priced at 15s the livre, altogether *22L*

— 125 livres of all sorts of models in bronze priced at 25s the livre, altogether *156L*

— 231 livres of bronze priced at 12s the livre, altogether *127L*

— 17 pieds of large gilt lace priced at 30s the pied, altogether *251L*

— 296 pieds of bronze lace of various sorts, priced at 2s 6 deniers the pied, altogether *37L*

— 464 livres of old scrap iron. *28L*

— 130 livres of lead priced at 7L the hundred, altogether *9L*

96] One large ebony cabinet with carving and 2 large doors and a compartment, priced *90L*

97] One clock with counter weight, priced *20L*

[6] (overleaf) Detail of the tapestry depicting the visit of Louis XIV to the Gobelins in 1673; on the right Cucci points to a lapis cabinet, and on the left Gole carries a table in tortoiseshell, with one of his assistants carrying a square unit of floor parquet. (Musée de Versailles)

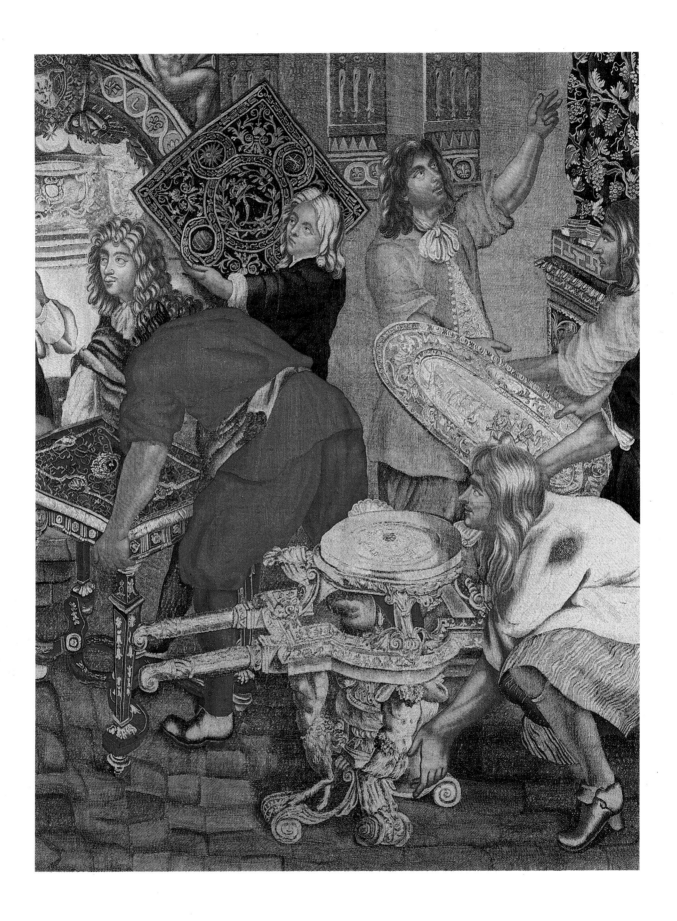

Dominique
CUCCI

BEFORE 1640–1705; ÉBÉNISTE AND CASTER IN THE SERVICE OF THE KING; ACTIVE 1660–98

The name was written in a number of ways: Cucci, Cuccy, de Cussy, Cussi or Cucy. Originally from Todi near Rome, Cucci is known to have received his training as an ébéniste in Italy before coming to Paris where he is first mentioned in 1664. In that year he married the daughter of the painter Gougeon, took French nationality and received his first royal commissions, the cabinets of Apollo and Diana. The importance of the commission as well as the terms of his letters of naturalization, which praise his 'large ebony cabinets with sculpture, miniatures, work in hard stones, silverware and other decorations' supplied to the royal residences, confirm that Cucci was already, well before 1664, an Italian ébéniste of marked talent. He must have been one of the artisans whom Louis XIV imported from Florence with the aim of encouraging the decorative arts and crafts in France, which until then had mainly flourished abroad. The Grand Duke of Tuscany had founded a workshop in Florence specializing in marquetry of pietra-dura, l'Opificio delle Pietre Dure, which produced not only tables and cabinets but also altars, tabernacles and mural decoration. Louis XIV therefore also wanted a workshop for pietra-dura and established it at the Gobelins in the Faubourg Saint-Marcel with Cucci as its director. In 1667 he established the Manufacture Royale des Meubles de la Couronne which for twenty years was responsible for furnishing the royal palaces. At the Gobelins a wide variety of crafts were assembled together: besides tapestry-weaving with two workshops for high warp and two for low, there was embroidery and painting on silk (directed by Bonnemer), the manufacture of silverware (by du Tel, de Villers and Loir) as well as woodcarving, gilding of wood and metal, work in bronze, mosaic-work in pietra-dura and ébénisterie. The variety of disciplines assembled in one place under royal protection, and therefore shielded from the rules of the guilds, must have enabled an ébéniste such as Cucci to experiment freely within his craft, combining widely diverse techniques in the construction of his furniture such as carved wood, marquetry, gilded metal and encrustations of pietra-dura. Although Cucci would become renowned chiefly as an ébéniste, his talents also included the art of gilt bronze. In the accounts of the Bâtiments du Roi he is sometimes mentioned as ébéniste and sometimes as 'fondeur en bronze', and he was in fact paid more for his work in bronze than for his ébénisterie. Between 1664 and 1697 he received more than 290,000 livres for his work in bronze as against about 166,000 livres for his ébénisterie. This would explain why the Swedish envoy Daniel Cronström, in his correspondence with Tessin, refers to Cucci only as a bronzier: 'Chandeliers are only made now in gilt bronze. The Sieur Cucci at the Gobelins who has made almost everything for Versailles is the best in this field,' he writes in 1693.

The accounts of the Bâtiments du Roi are vague as to the nature of these gilt bronzes. They consisted mainly of frames, ironwork fittings, bolts and catches for doors and windows of the royal residences, the Louvre, the Tuileries, Versailles and Saint-Germain, which Cucci had cast, chased and gilded in his workshops. Certain pieces are described more precisely: in 1669 Cucci supplied the door fittings for a glazed armoire to contain the King's collection of crystals at the Tuileries, an armoire that can be identified as no. 229 in the general inventory: 'A large armoire painted to imitate various types of marble and gilded, fitted with glazed panels with stands on which to place agates and crystals, about 13 pieds in height, $17^{1}/_{2}$ pieds in width and $3^{1}/_{2}$ pieds in depth.'

Between 1676 and 1679 he made the gilt-bronze balustrade for the Escalier des Ambassadeurs at Versailles for which he was paid 31,200 livres. At the same time he was working in the Appartement des Bains on the ground floor at Versailles: in 1677 he supplied the decoration for the over-doors of the octagonal room as well as for figures of the Months of the Year which were placed at regular intervals around the room. In the following year he supplied 'works in silver and gilt-bronze' for the large marble mirror-surround in the Chambre des Bains, as well as two marble cisterns for the same apartment. In 1681 he made the 'door fittings in gilt-bronze for the shutters protecting the King's best pictures' (at Versailles). It was the fashion then to rivet mirror plates to the wall and Cucci was called on to design the gilt-bronze mouldings that framed them. He made the ones for the Galerie des Glaces in 1682, those for the Grand Appartement in the following year, those in the Grand Dauphin's Grand Cabinet on the ground floor of the palace, those in the Cabinet of the Princesse de Conti and finally, those in the Cabinet des Miroirs at the Grand Trianon. During this period the workshop at the Gobelins was producing the grandest pieces of furniture for the King. The first commission in 1664 was for two cabinets with decoration based on the themes of Apollo and Diana for which Cucci was paid 6,000 livres in advance. This pair of cabinets was embellished with six gouaches by Werner depicting Louis XIV in all the guises of Apollo and Queen Marie-Thérèse as Diana. The *Inventaire général du mobilier de la couronne* has an incomplete description of them:

No. 219) A very large cabinet, called the Cabinet of Apollo, above which is represented the King as Apollo driving four horses, and lower down, seventeen figures in relief, all in gilt bronze; decorated at the front with two large aventurine columns with gilt-bronze bases and Corinthian capitals and various other fine stones, and in the central arcade, the tripod of Apollo, also in gilt bronze, all supported on male terms and pilasters, 12 pieds in height by 8 pieds in width and 2½ pieds in depth. No. 220) Another very large cabinet, called the Cabinet of Diana, of the same dimensions and design as the preceding piece, above which the Queen is represented as Diana leading four deer, the two central columns in jasper.

Shortly afterwards Cucci executed two highly important cabinets for the Galerie d'Apollon at the Louvre.

They represented the Temple of Glory and the Temple of Virtue, for which the payments, together with those for the cabinets of Apollo and Diana, came to 20,500 livres between 1664 and 1667. Later, the iconographical significance of these cabinets was altered and they can now be identified in the General Inventory under the numbers 10 and 11 as the Cabinets of Peace, with Louis XIV as Mars and the Queen as Pallas:

No. 10) A cabinet in ebony made by Dominico Cuccy [Cucci], called the Cabinet of Peace, applied overall with jasper, lapis and agate, in two sections; the lower section is constructed with a large archway, with a niche in perspective with looking glass, in which is the figure of the King dressed as Mars; above, the arms of France supported by angels, and to the sides, four figures of heroes in bas-relief; the upper section which is the frontispiece and which is also decorated with a small niche in which is a figure of Peace supported on a giltwood base, is supported at the front by two blue pilasters and four figures representing the four principal rivers of the world; placed on four reclining lions, also in giltwood, 8 pieds in height, 5 pieds 4 pouces in width and 1 pied 7 pouces in depth.

Between 1667 and 1673 Cucci made 'two large cabinets in ebony enriched with bronze and lapis' for the King, at a total cost of 27,568 livres, which can be identified in the General Inventory:

Nos. 223 and 224) Two very large cabinets in ebony outlined in pewter, enriched with various swags, festoons, ciphers and other ornamentation in gilt-bronze, four large twisted columns, ground of false lapis, overlaid with vine tendrils in gilt-bronze, and eight fluted pilasters of tortoiseshell, all with gilt bases and ionic capitals, supported on six lion-paw feet, 12 pieds in height, 6 pieds in width and 2 pieds 7 pouces in depth.

These highly baroque pieces of furniture, on which Cucci perfected the art of imitation lapis, can be recognized on the right-hand side of the tapestry commemorating the visit of Louis XIV to the Gobelins, woven in 1673 [6]. As soon as they were completed Cucci sent them, together with four other cabinets and four tables, to Versailles. Five years later Cucci started work on an organ case for the King's Ante-

[7] *Cabinet with pietra-dura panels, one of a pair made between 1679 and 1683 at the Gobelins under Cucci's direction for Louis XIV at Versailles. (Alnwick Castle; Duke of Northumberland's collection)*

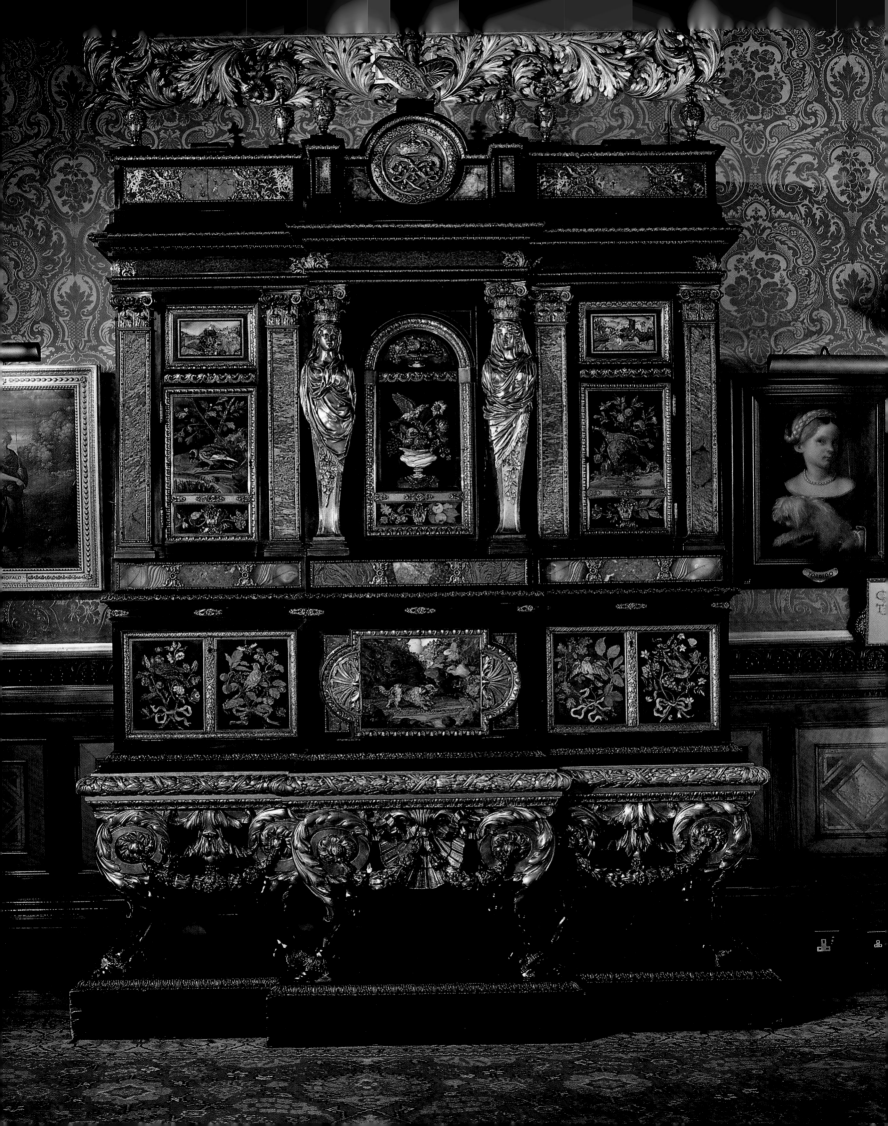

chamber at Versailles which he finished in May 1681, at a cost of 8,000 livres. The description in the General Inventory is short: 'No. 231) A large organ case with springs, gilt and ebonized, supported on gilt sphinxes, 12 pieds in height, 6 pieds in width and 2 pieds in depth.'

Between 1678 and 1681 Cucci undertook a large cabinet for the King, for which he was paid over 6,000 livres. In 1683 he supplied two large cabinets in pietra-dura, on which he had been working since 1679, for a sum of 16,000 livres. These pieces, described in the General Inventory under the numbers 372 and 373, are today in the Duke of Northumberland's collection at Alnwick Castle [7]. A short time later there were 'two cabinets in marquetry and gilt bronze to take the organ and the harpischord in the Great Chamber of the King' on which Cucci worked between 1684 and 1688. It was at this time that he received the most important commission of his career, the panelling in lapis and tortoiseshell for the King's Petite Galerie at Versailles. The first payments were made in the summer of 1685 and Cucci continued to work on them at the Gobelins until at least 1688. This decorative ensemble, without doubt the most ambitious decorative scheme initiated by Louis XIV, was never actually installed. The expenses of the War of the League of Augsburg forced Louis XIV to retrench drastically – work on the lapis panels had to stop. In 1692 he ordered them to be sent to the Tuileries 'as they are', together with the two organ cases, still incomplete.

Cucci made a speciality of these decorative schemes in lapis. In 1691 he commissioned his son-in-law René Chauveau to decorate a complete oratory as well as a prie-dieu in lapis for the Marquise de Seignelay at Sceaux. This was not genuine marquetry in lapis-lazuli but an imitation in horn, stained with an admixture of blues (probably powdered lapis or ultramarine with a binding agent and size). Cucci and his son-in-law would seem to have been the first to use this technique, and possibly even discovered this complex process which consisted of fusing the horn to the coloured base. The process still struck the Swedish envoy Cronström as a novelty in 1697 and is revealed in his correspondence with Tessin: 'For the secret of fusing onto lapis M. Chauveau has claimed that he knows the process as his father-in-law [Cucci] was the one who made it for the Galerie aux Bijoux' (20 January 1697), and: 'you do not have an ébéniste in Sweden capable of

sticking and even fusing horn and lapis as it is done here.' The Seignelay Archives (Arch. Nat. T1123 29B) contain the 'Mémoire des ouvrages de lapis et bronze doré d'or moulu faits à l'oratoire de la marquise de Seignelay à Sceaux par René Chauveau en 1691' which states clearly: 'lapis is made of English horn, thus melted, stuck and polished', and 'the back of the niche is in lapis made with powdered ultramarine.' Quite simply, this was a way of achieving, with the least expense, certain costly mural marquetry effects of the type being achieved in Florence during the same period. Boulle used this technique to a large extent in the years between 1700 and 1720 on his models of pedestals with aprons.

The decoration of the Petite Galerie at Versailles was Cucci's last royal commission. Owing to lack of funds caused by the War of the League of Augsburg, the workshop at the Gobelins was forced to close from 1694 to 1699. Until 1697 Cucci was still carrying out certain minor commissions in gilt-bronze for the Crown. At the same time, to compensate for the falling off in royal orders, he carried out commissions for private clients. Thus in 1690 he supplied chenets, chandeliers and gilt-bronze wall-lights for a total of 18,410 livres to the Marquis de Seignelay for his various residences at Sceaux, Paris and Versailles. The order comprised two pairs of magnificent large chandeliers of a new type (at 2,100 and 1,660 livres each pair) as well as forty pairs of wall-lights (for between 70 and 100 livres each) and nine fire-grates or pairs of chenets, of which some were new models, at 550 livres each. At Sceaux, Cucci made the gilt-bronze mouldings framing the mirrors in the Marquise's cabinet, while Chauveau was deputed to create the imitation lapis decoration in the Marquise's oratory.

In 1698 the consignments by Cucci to the Bâtiments du Roi ceased. He was by now too old to continue work and the King granted him an annual pension of 300 livres from 1699 until his death in 1705.

Virtually nothing remains of Cucci's work, apart from the bronze mouldings in the Galerie des Glaces and two cabinets in the Duke of Northumberland's collection. Almost all the important cabinets made for the Crown have been destroyed, many in the eighteenth century. In the reign of Louis XV four sales took place, from the Tuileries and the Louvre in 1741, 1751 and 1752, of Louis XIV's cabinets which must

have been considered old-fashioned and cumbersome. The dealers who bought these pieces would have dismantled some of them, in order to retrieve the precious panels of pietra-dura. Some, like Julliot, even made a speciality of this between the years 1770 and 1790, the latter re-using them on contemporary furniture which he had made by Carlin or Weisweiler. It seems that certain pieces escaped this fate, such as the Northumberland cabinets which were in the 1751 sale and the cabinets with twisted lapis columns, numbers 223 and 224 in the General Inventory, which later belonged to the Duc d'Aumont and were included in his sale in 1783, lot 312, when they were bought back by his son, the Duc de Villequier, for the considerable sum of 2,451 livres. In 1748 Louis XV presented twelve cabinets and a table in pietra-dura to Buffon for the Cabinet of Natural History. The cabinets of Peace and Apollo and Diana can be identified among them. It is more than likely that these pieces were broken up on Buffon's orders to recoup the jasper, lapis and agates with which they were covered, and the stones were then placed in display cabinets in the Museum.

CUCCI'S ASSISTANTS

In his guide to Paris of 1706, Germain Brice writes of the pietra-dura workshop at the Gobelins: 'In the great courtyard close to the silversmiths' workshops are to be found the workshops formerly run by Branchier and Ferdinand de Meliori who were brought from Italy to work on marquetry which demands much time and expense.' The accounts of the Bâtiments du Roi from 1668 give an accurate record of the names of the stone-cutters who worked there under Cucci's direction. These included the Florentines Orazio and Ferdinando (died 1683) Megliorini, Filipo Branchi (died 1699) and Gian Ambrogio Giachetti (whose name disappears from the accounts in 1675), as well as the Frenchman Letellier. They produced pictures in flat mosaics of flowers and birds (as can be seen on the tables in the Musée d'Histoire Naturelle, in the Galerie d'Apollon at the Louvre and in the Museum of Tours) as well as small panels of fruit and flowers in relief.

It would seem that Ferdinando Megliorini specialized in both these techniques. Mention is made in the inventory after his death in 1683 of 'one hundred and thirty-one pieces of cornelian cut in the shape of cherries and grapes', as well as a 'duck entering the water and a duck emerging from the water'. Giachetti, who was one of Autelli's assistants in 1663 in the production of the famous octagonal table in Florence, was expert in the manufacture of flat mosaics. The presence of his signature on the back of one of the small plaques in relief on a piece in the Royal Palace at Stockholm proves that he also worked in the second technique. Branchi obviously specialized in the technique of flat mosaic work, as a number of such tables were supplied by his workshop in 1691, 1693 and 1694, while he was the only surviving Italian stone-cutter still active.

For the carved wood stands of these tables and cabinets, Cucci turned to Philippe Caffieri (1633–1716), a fellow Italian and the principal wood-carver employed at the Gobelins. It is recorded in 1668 that they both worked with the menuisier Prou on 'a large cabinet of 9 pieds in height by between 11 and 12 pieds in width and 4 pieds in depth . . . to be used to arrange and store all His Majesty's works in filigree'. Another Italian sculpteur, Jean-Baptiste Tuby, was employed by the Bâtiments together with Caffieri. In 1672 he was paid, together with Cucci, Caffieri and Anguier, 'for the model they made of the Parterre d'Eau' at Versailles. Towards the end of his life it is probable that Cucci employed René Chauveau (1663–1722) and Sébastien Slodtz (1655–1726) who married his daughters Catherine and Madeleine (the first in 1690, the second in 1696). Finally, the gilding of the carved details was executed by Paul Goujon, called La Barronnière.

It is difficult to evaluate the rôle played by Cucci himself in the production of the large cabinets that made him famous. The conception of these cabinets came from Lebrun, director of the manufactory at the Gobelins and the driving force of French artistic life of the period. From his pupil Claude Nivelon, we know that Lebrun provided 'the drawings of these magnificent historic cabinets to be found in the palaces of the Tuilieries and Versailles' (*Vie de Charles Lebrun*). This supervision by Lebrun of the Royal Manufactory explains the unity of decorative elements to be found running through all their productions. There are striking similarities between furniture in silver and examples in carved and gilded wood, between silver and gilt-bronze models, between the statues embellishing the gardens, the stuccoes at Versailles and the caryatids decorating the bases of the cabinets, or again be-

tween the designs of Savonnerie carpets with a black ground and those of tables in pietra-dura designed at the same time at the Gobelins. Even if the character of these great cabinets, on which ebony or lapis predominated, seems at first glance to be very Italianate, the overriding influence of Lebrun is still clearly to be seen.

BIBLIOGRAPHY

Arch. Nat., Seignelay papers, T 1123/13/A and T 1123/29/B

Jules Guiffrey: *Comptes des Bâtiments du Roi*, vols I, II, III and IV, and *Inventaire général du mobilier de la couronne sous Louis XIV*, Paris, 1885, vol. II, pp. 131, 149 and 150

A. de Champeaux: *Le Meuble*, Paris, 1885, pp. 41–47 and pp. 101–05

E. Molinier: *Le Mobilier au XVIIe et au XVIIIe siècle*, pp.45–50

Pierre Verlet: *French Royal Furniture*, London, 1963, pp. 3–5, pp. 46–50

Lunsingh Scheurleer: 'A la recherche du mobilier de Louis XIV', in: *Antologia di belle arti*, Rome, nos 27–28, 1985, pp. 38–44

APPENDIX

EXCERPT FROM THE ACCOUNTS OF THE BÂTIMENTS DU ROI CONCERNING PAYMENTS MADE TO CUCCI

1 May 1664: to Sr Domenico de Cuccy, Italian ébéniste, in part payment for work carried out on the two large cabinets of Apollo and Diana. *6,000L*
10 July 1665: to Domenico Cuccy, ébéniste, in part payment for two large cabinets which represent the Temple of Glory and the Temple of Virtue for the Galerie d'Apollon at the Château du Louvre. *16,000L*
The year 1666: collect the sum of 5,000L for part payment to Domenico Cuccy, ébéniste, for the two large cabinets which represent the Temple of Glory and the Temple of Virtue to be placed in the Gallerie d'Apollon.
3 November 1666 – 9 May 1667: to Domenico Cuccy in part payment for bars, bolts and other works in bronze made by him for the doors and windows of the Tuileries. *1,200L*
24 August 1667: to Domenico Cucci, ébéniste, in part payment for the two cabinets which he is

making, one representing the Temple of Glory and the other that of Virtue. *5,000L*
9 January 1667: collect *5,000L* for part payment to Domenico Cuccy, ébéniste, for two large cabinets representing the Temple of Glory and that of Virtue. Receipt made for payment of *4,500L* in addition to *26,000L* which he received earlier, making *30,500L* for the complete payment for the two large cabinets representing the Temple of Glory and that of Virtue
December 1667: collect *5,000L* for part payment to D. Cuccy, ébéniste, on the two large cabinets made by him for the King.
1 May 1667 – 21 May 1668: to D. Cussi, part payment on the bronze fittings made by him for the doors and windows of the Tuileries. *17,300L*
18 June 1667: to D. Cucci in part payment for two large cabinets in ebony enriched with silverwork ornaments, representing the Temple of Glory and that of Virtue. *14,500L*
To Cussy *350L* for various works which he has executed for the King.

3 December 1668: to Domenico Cuccy in part payment for the works in bronze made by him for the fastenings of doors and windows of the Palais des Tuileries. *1,800L*
17 December: to him for the cleaning and fastening of all door and window locks of the Palais des Tuileries. *100L*
14 March – 19 September 1668: to Cuccy, ébéniste, in part payment on the bronze fittings made by him for the door and casement locks of the Grande Galerie of the Louvre and Palais des Tuileries. *5,500L*
28 February 1669: collect for part payment to Cuccy, ébéniste, on the large cabinets which he is making for the King. *5,000L*
8 October 1669: to D. Cuccy for the metal fittings made by him for machine in the form of a large armoire for storing part of the collection of agates and crystals and other curiosities at the Palais des Tuileries. *1,400L*
25 February 1669: to D. C., bronze caster, final payment on 36,271L for his bronze work for the fittings of the doors and casements of the Tuileries between the years 1667 and 1668. *2,471L*
19 March 1669 – 1 January 1670: to D. Cucci in part payment for parquetry and metalwork for the fittings of the doors and windows of the Petit Appartement of the King [at Saint-Germain]. *10,100L*
2 November 1669: to D. Cucci, caster, in part payment for the commissions which he is carrying out in His Majesty's service at the château [Saint-Germain]. *2,400L*
19 March 1669: to D. Cucci in part payment for two cabinets which he is making for the King. *5,000L*
Year 1670: collect *5,000L* for payment to Cucci, ébéniste, for two large cabinets which he is making for the King's use.
18 November 1670 – 15 January 1671: to Cucci in part payment for bronze fittings made by him for the casements of the Grande Galerie at the Louvre. *800L*
17 June 1670 – 4 January 1671: to Cuccy, ébéniste and caster, for bronze fittings which he is making for the doors and casements at Versailles. *3,200L*
1 March – 25 May 1670: to D. Cucci, caster, final payment on

18,071L for the bronze fittings made by him for the King's Appartements at the said place [Saint-Germain]. *5,571L*
5 April: to him for his fee for gilt-brass work in the King's Petit Appartement. *114L*
January 1671: to D. Cucci, caster and ébéniste, for a clock-face which he provided for the Gobelins and the journeys he made to Saint-Germain to repair sundry breakages in the King's Petit Appartement. *91L*
1 December: to him part payment for the two large cabinets made by him for the King. *5,000L*
March 1671 – 3 January 1672: to Cucci in part payment for the bronze handles and fastenings which he is making for the doors and casements of the Château de Versailles. *8,100L*
13 October 1672 – 11 April 1673: to Cucci for repairs to the bronzes in the King's cabinet. *106L*
14 April 1672: to Anguier, Tuby, Cuccy and Caffieri, for the model made by them for the Parterre d'Eau. *550L*
February 1672 – 9 March 1673: to Cucci in part payment for the bronze fittings for the doors and windows of the Grand Appartement [at Versailles]. *13,100L*
November 1673: collect for final instalment of 6,568L to D.C. on complete payment of 27,568L for two large cabinets in ebony which he has made for H. M., with sundry decorations in bronze and lapis.
1673: to Cuccy for the bronze fittings which he is making for the King's library [or bookcase?] at the Louvre. *600L*
18 November 1673: to Cuccy for bronze fittings made by him. *313L*
20 May – 18 November: to Cucci for bronze fittings supplied by him [Versailles]. *5,400L*
1 September 1673: to Cucci for the rocailles which he has supplied to Versailles. *225L*
29 November 1673: to Cucci for final payment of 27,568L for two large cabinets in ebony enriched with various mounts. *6,568L*
11 February – 5 October 1674: to D. Cucci, final payment on 5,271L for the bronze fittings for the doors and casements for the room designated for the King's pictures [Louvre]. *4,671L*

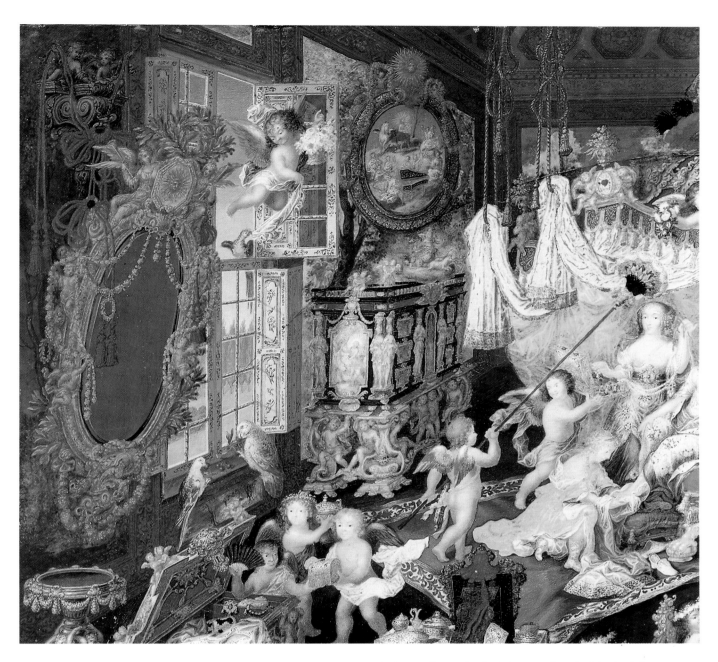

[8] Detail of a gouache depicting an imaginary scene with Mme de Montespan, c. 1670, combining aspects of the Appartement des Bains at Versailles as well as of the Trianon de Porcelaine. The cabinet, decorated with lapis and ebony inset with gouaches of the legend of Apollo and surmounted by the solar chariot, evokes the cabinets of Apollo and Diana supplied in 1664 by Cucci to Louis XIV, but with significant discrepancies from the description in the inventory. (Sotheby's London, 6 July 1987, lot 81)

Versailles:
to Cucci for gilt-bronze garnitures. *454L*
20 January 1674 – 23 February 1675: to Cucci in part payment for bronze fittings for the doors and windows of the Appartements. *7,100L*
7 February 1676: to Cucci, caster, for bronze fittings for the Galerie d'Apollon. *1,500L*
20 March – 30 September 1675: to Cucci, final payment on 42,556L for the bronze fittings he has made. *6,056L*
3 July 1675: to him for all the masks he has placed on all the casements in the first-floor Appartement. *686L*
To Cucci for mercury gilding work carried out by him. *329L*
April 1676: to Cucci, caster, final payment on *4,004L* for the bronze fittings which he furnished for the Galerie d'Apollon at the Louvre. *2,504L*
1676 (bâtiment du Val): to Cucci, caster. *512L*
26 February 1676, Versailles: to Cucci, caster, for the balustrade which he is making for the grand staircase. *500L*
2 June – 13 November 1676: to him for the bronze fittings which he has supplied. *3,755L*
3 February – 6 September 1677: to Cucci, complete payment for the gilt-bronze fittings he is making for door ornaments in the

octagonal room in the ground-floor Appartement, and the Twelve Months. *4,740L*
29 December 1677 – 16 January 1678: to him for the gilt-bronze balustrade of the grand staircase. *2,700L*
3 July 1678: to Cucci for a cabinet made by him. *1,000L*
12 June for le Val: to Cucci for fittings in bronze and brass. *358L*
5 February – 24 December 1678: to Cucci in part payment for the gilt-bronze balustrade for the grand staircase. *16,000L*
5 February – 29 March: to him, his final payment on 6,012L for bronze fittings made by him for the Appartement des Bains. *2,712L*
30 May, 1678: to him final payment on 2,324L for silver-gilt and gilt-bronze fittings for the great marble mirror in the Chambre des Bains. *1,1214L*
15 May – 24 November: to him in part payment for his work. *9,500L*
14 October: to him in part payment for gilt-bronze fittings for the casements in the Appartements. *600L*
8 January 1679: to him in part payment for gilding in the Appartement des Bains. *800L*
15 January 1679: to him in part payment for an organ-case which he is making for the Château de Versailles. *1,000L*
1679 (maison des Gobelins): to Blancheton, locksmith, for work carried out in the foundry of D. Cucci. *60L*
3 September 1679: to Cucci, caster, for a number of bronze mouldings to contain the mirrors in the Queen's Cabinet at the old château [Saint-Germain]. *119L*
29 January – 16 July 1679: to D. Cucci, final payment on 31,200L for the gilt-bronze balustrade for the grand staircase at Versailles. *7,400L*
13 August – 17 September: to him for the gilt-bronze decorations on the pedestals and brackets for the grand staircase. *1,500L*
14 January 1680: to him on the bronze frames which he is making around the iron doors on the grand staircase. *1,500L*
26 February – 10 December 1680: to him in part payment for gilt-bronze mounts made by him. *7,200L*
26 February – 31 March: to him in part payment for a cabinet which he is making. *2,200L*

23 April: to him final payment on 1,800L for the bronze ornaments which he has made for the four pedestals in the Chambre des Bains. *600L*
25 June – 19 November: to him for gilding door and casement fittings in the Appartement des Bains. *1,000L*
19 November: to him for the gilt-bronze ornaments which he is making for the two marble basins in the Appartement des Bains. *400L*
28 May – 22 October: to him for the gilt-bronze fittings for the doors and casements of the Petit Appartement du Roi at the Petit Château. *4,200L*
18 June: to him in part payment for an organ-case for the King. *1,200L*
1 April 1679: to D. Cucci, ébéniste, in part payment for two large cabinets. *1,000L*
28 January – 21 April 1680: to D. Cucci, caster, part payment for the gilt-bronze frames which he is making for the five doors for the grand staircase at Versailles. *5,200L*
19 May: to him for the works and gilt-bronze fittings which he is making for the doors and casements of the Appartements of the Château. *20,500L*
14 May: to him for the organ-case in the King's Antechamber. *1,000L*
4 August: to him in part payment for the bronze fittings of the doors of the Appartement of the King and Queen at the Château. *5,000L*
1 July 1681: to him in final payment on 55,902L for works in gilt-bronze made at the Château in 1677, 1678, 1679 and 1680. *6,911L*
30 November 1681 – 11 January 1682: to Cucci, caster, for works for the seventeen casements of the gallery [at Versailles]. *1,600L*
20 July – 10 August 1681 [Cabinet des Bains]: complete payment for the bronze ornaments made by him for the two basins in the said Cabinet. *1,810L*
22 June [Versailles]: to Cucci, caster, for work carried out to enhance the paintings in the Petits Appartements of the King. *763L*
To him for brass mounts on a large armoire at the Garde-Meuble *433L*
24 August – 2 November: to him for other works. *2,000L*

To him for gilt-bronze fittings which he has made for the shutters in front of the King's finest paintings. *366L*
20 July 1681: to Cucci for the cabinets which he is making for the King. *500L*
23 November 1681: to Cucci for refurbishing some bronzes [Saint-Germain]. *155L*
27 April 1681 – 18 May [various]: to Cucci, caster, in part payment for a large cabinet made by him for the King. *3,000L*
4 May: to him in final payment on 8,000L for an organ-case which he made for the King. *2,600L*
8 March – 22 November 1682: to Cucci for the gilt-brass rods which were made to hold the glass panes of the nine casements in the Grande Galerie [Versailles]. *1,010L*
8 March: to Cucci in payment for the bronze fittings supplied by him for the doors and casements of the Grands and Petits Appartements at the Château de Versailles in 1681. *3,035L*
1 September: to Cucci, payment for gilding the mouldings around the mirrors in the Cabinet of Madame la Princesse de Conti. *757L*
19 September: to Cucci, caster, final payment on 10,341L for works in brass made by him on doors and casements in the Appartements at the Château [Versailles]. *4,241L*
18 August: to Cucci, caster, for brass works for four picture frames at the château [Versailles]. *318L*
To him for refurbishing bronze items on the doors and windows at the château [Versailles]. *538L*
25 January – 31 May 1683: to Cucci for two cabinets which he is making for the King. *3,000L*
12 April – 20 June: to him for the gilt rods around the panes of the casements in the Grands Appartements of the château. *2,600L*
22 August: to him for his gilt-brass works in the cabinets and mezzanines of Mgr le Dauphin in the great wing. *800L*
13 February: collect 10,800L for payment to Dominique Cuccy, ébéniste, making, together with the 5,200L which he has already received, complete payment on 16,000L for two ebony cabinets enriched with numerous gilt-bronze mounts made by him for

the use of His Majesty. *10,800L*
22 August – 17 October: to Cucci for the refurbishment of the woodwork and metal fittings of the casements and doors at the Château de Versailles. *420L*
To Cucci, ébéniste, for the pedestals and ebony plinths to support the bronzes in the Cabinet des Curiosités [Versailles]. *279L*
11 July 1683: to Cucci, caster, final payment on 8,558L for gilt-brass works in the Appartements of the King and the Queen, and other places at Versailles. *4,958L*
11 January – 31 October: to Cucci for the mouldings, gilt rods and other bronze fittings which he is making for the Appartements of the King and Monseigneur (at Clagny). *3,400L*
1 January: to him for the two large cabinets he is making for the King (at Clagny). *600L*
19 December: to Cucci for fire-gilt works on the 14 casements of the Grand Appartement of the King. *322L*
21 February: to Cucci, ébéniste, final payment on 16,000L for two ebony cabinets decorated with numerous gilt-bronze ornaments for the King. *10,800L*
27 February 1684: to Domenico Cuccy, caster, for his works on the two cabinets to be placed in the Grands and Petits Appartements of the King [Versailles]. *518L*
22 April – 19 November: to him for gilt-brass works in the King's Appartements at the Petit Château. *4,607L*
16 July: to him, final payment on 11,764L, the total sum for his gilt-brass work for the Grande Galerie, Grands and Petits Appartements of the King and Queen, and the Cabinet des Curiosités, as well as the Cabinet des Curiosités of Monseigneur and in other parts of the château in 1684. *1,964L*
10 September 1684: to him for two cases in gilt-bronze with marquetry for the organ and harpsichord in the King's State Bedchamber, and other works [Versailles]. *1,000L*
17 September – 5 November 1684: to him for brass works for the painted doors and casements of the gallery. *1,400L*
Expenses 1687:
27 January 1686 – 2 February 1687: to Domenico Cucci, caster, in part payment for works he has

undertaken to do for His Majesty in the following year. *18,000L*
21 January 1685: to Domenico Cucci, caster, in part payment for gilt-brass works which he has supplied and the gilding of fittings in the Appartements of the King in the Château of Versailles. *600L*
11 February – 1 July: to him for the large spring bolts which he made for the casement in the Grande Galerie. *3,300L*
25 February: to him for gilding which he carried out in the château. *1,000L*
8 July – 9 December 1685: to him for work in lapis and tortoiseshell which he made for the King's Petite Galerie. *2,000L*
11 November – 9 December: to him for the gilt-brass rods which he made to hold the mirrors in the cabinets for Monseigneur. *2,000L*
21 April – 28 July 1686: to Cuccy, caster, for the six lanterns made by him for the barge and the galley. *5,200L*
25 August – 17 November: to him for the refurbishment and small repairs to the bronze fittings in all the Grands and Petits Appartements at the château. *1,100L*
25 August – 6 October: to him for the seven bronze rims which he made for the tables from Italy [Versailles]. *900L*
22 September – 22 October: to him for the gilt-bronze door fittings for the Antechamber of the King next to the Gallery [Versailles]. *600L*
24 March 1686 (Saint-Germain): to Domenico Cuccy, caster, for the gilt-bronze mouldings which he made around the mirrors in the Cabinet du Roi and that of Monseigneur. *300L*
Year 1687: collect the sum of 500L which should have been paid to D. Cucci, ébéniste, in part payment for the two large marquetry organ-cases which he is making for His Majesty, which he has not received
February – 7 December 1687: to Cucci, caster, in part payment for works in gilt bronze made by him for the Château [Versailles]. *6,300L*
April – 7 December: to him for sundry works in the Petite Galerie. *10,500L*
31 March – 21 December: to him for gilt-bronze works in the château in 1684 and 1685. *200L*

25 May – 6 July 1687: to him for the gilt-bronze fittings and mouldings holding the mirrors in the Cabinet of Mme la Princesse de Conti [Versailles]. *1,800L*
19 – 31 August, works in ebony: to Domenico Cucci, ébéniste, in part payment for two large organ-cases with marquetry which he is making for His Majesty. *1,300L*
Year 1688: works in gilt-bronze:
11 January – 26 December: to Domenico Cucci, caster, in part payment for gilt-bronze works which he has supplied for the Château de Versailles since 1685. *2,300L*
22 February – 28 November: to him, complete payment for the gilt-bronze work which he has made for the rims of the marble tables at the Trianon. *4,387L*
16 May – 28 November: to him, complete payment for the gilt-bronze mouldings holding the mirrors in the Cabinet des Miroirs at Trianon. *2,315L*
22 February – 15 June: to him in part payment for works in imitation lapis and of bronze which he has carried out for the King's Petite Galerie. *2,600L*
Year 1688: marquetry:
7 March: to the journeymen ébénistes of Cucci for time spent dismantling the marquetry of the ceiling and floors of the cabinets of Monseigneur. *75L*
12 December: to Cuccy for repairs which he had carried out to the bronze fittings in the Château de Versailles. *255L*
18 April [1689]: to Domenico Cucci, ébéniste, on account for the two large organ-cases in marquetry which he made for the King's use. *1600L*
1689:
24 July – 9 October: to D. Cucci, ébéniste, in part payment for the gilt-bronze rims which he is making for the marble and alabaster tables at the Trianon. *400L*
4 June 1690: to Domenico, ébéniste, final payment on 680L for eight polished bronze rims which he made for eight tables in Montahuto alabaster at Trianon. *280L*
Year 1691:
19 August – 9 December: to D. Cucci, caster, in part payment for works in bronze and other work which he carried out in the service of His Majesty in preceding years. *500L*

18 November 1691: to D. Cucci, caster, for the small gilt-bronze borders which he made for the chimneypieces in the Appartements of the Surintendance des Bâtiments at Versailles. *54L*
Year 1692: collect the sum of 21,332L to be delivered to Domenico Cucci, ébéniste, in complete payment, together with 92,818L, for work and repairs to his work which he carried out in the King's service from November 1683 until now, apart from the payments made to him above, including 57,553L on the one hand, for works in gilt tortoiseshell, lapis, joinery, bronze mounts, models and others which he made for the gallery of the Petit Appartement at the Château de Versailles, in the state in which they are described in an inventory ordered by His Majesty, and 14,899L on the other hand for those [works] in marquetry and bronze carried out on two organ-cases in the state in which they are described in the inventory also made of these, all delivered by Cucci and placed in the Palais des Tuileries.
11 January 1693: to D. Cucci for the chased and gilt-bronze mouldings for a chimneypiece at the Surintendance des Bâtiments at Versailles. *33L*
20 January 1693: to Cucci, ébéniste, for expenses incurred by him and days spent dismantling and removing from the Gobelins to the Galerie des Ambassadeurs at the Château des Tuileries the lapis and tortoiseshell panelling [made for] the Galerie des Bijoux in the King's Petit Appartement at Versailles. *197L*
9 October 1695: to Cucci, ébéniste and caster, for 23 pieds 9 pouces of gilt-brass moulding which he supplied and positioned around the mirrors above the chimneypiece in Monseigneur's Petite Chambre. *95L*
30 October 1695: to Cucci, ébéniste and caster, for 12 feet of gilt-brass mouldings which he supplied for the mirror of the chimneypiece in the Cabinet à la Capucine of Monseigneur. *36L*
22 January 1696: received from Domenico Cuccy, ébéniste caster, for the price of 850L weight of bronze which was

supplied to him by Sr Fossier from the store in Paris at 55L the hundred. *467L*
26 February: received from D. Cucci for the price of 200L weight of bronze from the King's stores at 55L the hundred. *110L*
6 December 1696: to Domenico Cuccy, ébéniste and caster, for the bronze moulding round the mirror which he has made for Meudon. *150L*
2 January: to Cucci, ébéniste caster, for the gilt-bronze work which he has carried out at the Château de Saint-Germain since 1686. *538L*
Year 1696: to Cucci who is making all the gilt-bronze fittings for the doors and casements of the Royal Residences, as his annual fee. *60L*
Year 1697 [Fontainebleau]
15 September – 6 October: to Domenico Cuccy, caster, for 25 pieds 2 pouces of gilt-bronze mouldings which he has supplied and fitted to serve as a border for two mirrors which are placed on the chimneypieces of the Appartement of Mme la Princesse de Conti at the said château. *125L*

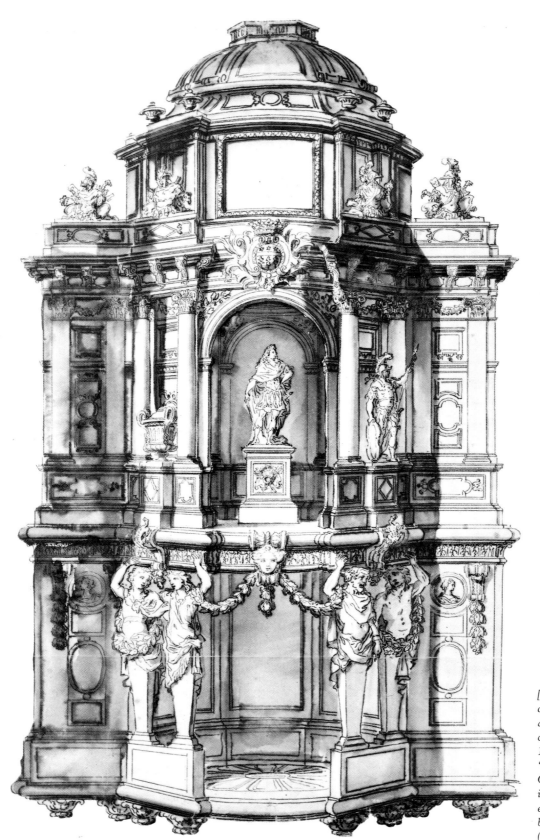

[9] Design by Jean Berain for a
cabinet in pietra-dura with the
arms of Louvois. In the inventory
drawn up after Louvois' death in
1693, mention is made of two
'large cabinets made by
Oppenordt with marquetry and
inlaid hardstones', each
estimated at 4,000L, which must
be related to this drawing.
(Private collection)

Alexandre-Jean
OPPENORDT

c. 1639–1715; ÉBÉNISTE ORDINAIRE DU ROI

Born in the Netherlands in 1639, Oppenordt was the son of Henri Oppen Oordt and Marie Tendart. He established himself in Paris at the beginning of Louis XIV's reign and worked in the privileged quarter of the Temple, the area where ébénistes not yet become master could practise their craft. In 1679 he was naturalized. His papers described him as 'compagnon menuisier en ébène ... native of the town of Guelder, professing the Catholic religion'. In 1684 Oppenordt obtained lodgings at the Louvre and began work in the service of the Bâtiments du Roi.

In early 1684 he was paid 3,600 livres for 'twelve marquetry cabinets which he made for His Majesty's medals, at 300 livres each'. These cabinets were installed at Versailles in niches in the Cabinet des Curiosités also called the Cabinet des Médailles and were complemented by a sumptuous bureau (for a sum of 6,500 livres) and four other cabinets in kingwood. Lunsingh Scheurleer has shown that the twelve marquetry cabinets, for a long time identified as the celebrated 'armoires à chutes de médailles' at Versailles [32], were completely different. This is confirmed by Félibien's description of 1685: 'Twelve armoires or individual cabinets only breast high ... placed in the niches and embrasures ... and gilt and enriched with ornamentation and here and there figures of children forming terms.' The great desk was designed by Berain, who, with Clairin, supervised the engraving of its marquetry. Félibien described it as 'a large table fitted with drawers and made in the form of a desk'. As yet not one of these pieces has been traced, but various engravings by Berain give an idea of its style, as well as the description in the inventory of 1718: '567: A large octagonal table in marquetry of brass and pewter on a tortoiseshell ground, 6 pieds 5

pouces in length and 4 pieds in width, the top covered with velvet with a gold and silver braid. All round the table are drawers fitted with locks. It is supported on eight square tapering legs enriched with gilt-bronze mounts. Between the stretchers is placed a small cupboard with drawers in the same marquetry and ornamentation as the rest.' (Arch. Nat. 0^13336.) The bronze mounts for the desk were modelled by Le Hongre and Charmenton and cast by Le Nègre.

In 1685 Oppenordt was paid 240 livres 'for compartments made for two bureaux for His Majesty's Petit Cabinet'. These were probably the marquetry panels made for a bureau recently identified as from Louis XIV's Cabinet de la Poudre at Versailles [12].

Between 1684 and 1686 Oppenordt made the parquet for Louis XIV's Petite Galerie at Versailles. During these years he was also working for Louvois, making two pietra-dura cabinets for him which are mentioned in the inventory drawn up after the latter's death in 1693. A drawing by Berain for a cabinet in pietra-dura with the arms of Louvois is probably the only surviving evidence we have of either of these pieces. It once again confirms the collaboration between Berain and Oppenordt [9].

The Swedish envoy Cronström mentions in a letter in 1693 that Berain habitually used his team of craftsmen for ébénisterie commissions he had received: 'I do not know whom to recommend to make tables and guéridons. Cucci is excellent. On the other hand Berain has admirable designs and skilled craftsmen ...' In the author's opinion this refers to Oppenordt, and therefore one may attribute to him two works that were designed by Berain: the sarcophagus-shaped commode in the Wallace Collection [10], after an engraving by Berain which can be dated, according to Jérôme de la Gorce, to *c.* 1690–95, and the flooring

in tortoiseshell marquetry of the royal coach in Stockholm, executed in Paris in 1696 [11]. In both cases the composition of the marquetry, made of small arabesques delineated by bandwork, is very different from Boulle's. Moreover, Cronström, when referring to the floor of the coach which was made in Paris, makes no mention of either Cucci or Boulle, both of great contemporary renown. He would surely have boasted of using their services if this had been the case: 'They are starting to make the body of the coach, it will cost 600 livres. It is admittedly an enormous price, but the quality and the renown of the 'menuisier du roi' accounts to a large extent for this price' (letter, 14 August 1696). This reference to the 'menuisier du roi' definitely applied to Oppenordt, who in the 1690s continued in the service of the Bâtiments du Roi but received no further commissions, all projects being brought to a halt by the lack of funds due to the War of the League of Augsburg. He could therefore concentrate on his private clientèle.

In 1694 Oppenordt made a pilgrimage to Italy. From 1691 to 1714 there is no further mention of him in the accounts of the Bâtiments Royaux except for his annual retainer of 30 livres. He died in 1715.

[10] *Sarcophagus-shaped commode, c. 1695. Following an engraving by Berain, it is here attributed to Oppenordt who collaborated on several occasions with Berain. It featured in the M. de Billy sale in 1784, lot 170, then in the sale of the dealer Dubois in 1785, lot 213. (Wallace Collection, London)*

BIBLIOGRAPHY

H. Vial, A. Marcel and A. Girodie: *Les Artistes décorateurs du bois*

Lunsingh Scheurleer: 'A la recherche du mobilier de Louis XIV', *Antologia di belle arti*, nos 27–28, 1985

Alfred Marie: *Mansart à Versailles*, Paris, 1972, vol. II, pp. 407–17

Jean-Nerée Ronfort: 'Versailles et le bureau du roi', *L'Estampille*, April 1986

Arch. Nat. Min. Cent. Et/LXXV, 533 and 534 [Distribution of furniture belonging to the Louvois estate]

Jérôme de la Gorce: *Berain*, Paris, 1987

APPENDIX

EXCERPT FROM THE ACCOUNTS OF THE BÂTIMENTS DU ROI CONCERNING PAYMENTS MADE TO OPPENORDT

2 January 1684: to Sr Openor, ébéniste, for the marquetry cabinets he has made for the medals. *400L*

16 January – 12 March: to Openor, ébéniste, full payment of 3,600L for 12 marquetry cabinets which he has made for His Majesty's medals, at 300L each. *3,200L*

12 March – 6 May: to him on full payment of 6,500L, which sum is for the bureau for the Cabinet of Curiosities. *3,000L*

1 July: to him in reimbursement of an equal sum which he advanced for 3,575 livres of bois gris de lin des Indes, bought at 12s the livre for use in the service of His Majesty. *2,145L*

18 March – 9 December: to him for the parquet which he has made for the Galerie du Petit Appartement of His Majesty. *9,000L*

14 April – 19 November: to him for the bureau which he has had made for the Cabinet of Curiosities. *3,500L*

21 October 1685: to Openor, another ébéniste, his payment for 2 models of door-frames which he has made for His Majesty's Petite Galerie at Versailles. *200L*

25 July: to Jean Oppenor, ébéniste, for compartments made for 2 bureaux in His Majesty's Petit Cabinet. *240L*

31 December 1684 – 11 March 1685: to Openor, ébéniste, full payment for marquetry works he has made for the repair of 12 medal cabinets for the King. *1,632L*

23 November 1686: . . . made over 632L to the said Oppenort, ébéniste, payment for 4 cabinets in bois violet and other works which he made for His Majesty's Cabinet des Medailles

December: to Oppenor, ébéniste, for marquetry pieces to store medals at the château 180L

15 December: to Oppenort, ébéniste, for 4 cabinets in bois violet and other works which he made for the Cabinet des Médailles. *632L*

3 February – 10 March: to Oppenor, ébéniste, for 11 pieces of red sandalwood weighing 2,171 livres which he delivered to the store, at 12s the livre. *1,302L*

10 March: to him for the parquet in compartments of different colours which he made for the Petite Galerie at Versailles. *2,000L*

8 February 1688: to Oppenor,

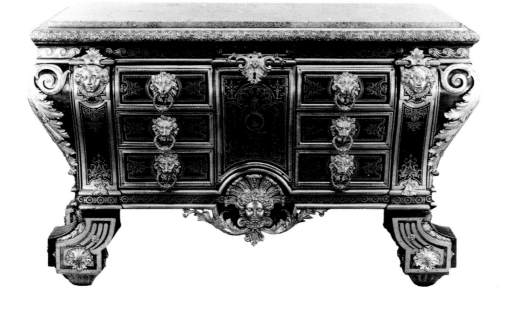

ébéniste, for work in marquetry and gilt-brass which he made for Monseigneur le Duc de Bourgogne. *360L*

28 March: to Sr Oppenort, ébéniste, for 10 drawers in oak made and fitted to take trays of agates in the Cabinet des Médailles. *30L.*

[*Comptes des Bâtiments du Roi*, published by Guiffrey, vols. II and III]

[11] *Parquet with tortoiseshell and brass marquetry from the Royal Swedish coach, made in Paris in 1696 by the 'menuisier du roi', certainly Oppenordt, after designs by Berain, at a cost of 600L. (Royal Palace, Stockholm; Livrustkammaren)*

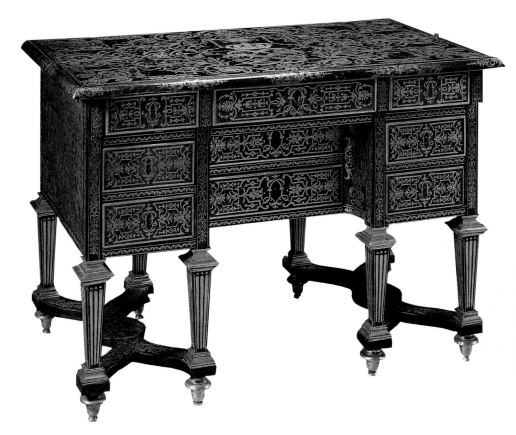

[12] *Bureau brisé, the marquetry work almost certainly made by Oppenordt in 1685. It is described in the inventory of Louis XIV's collections in 1718 as number 561, with its pendant, since altered. (Metropolitan Museum of Art, New York)*

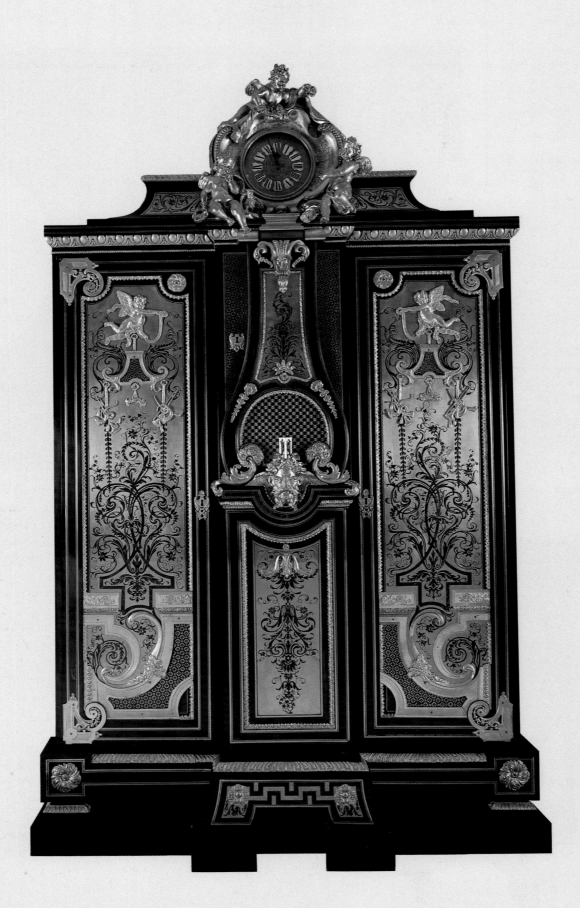

André-Charles
BOULLE

Born in Paris in 1642, André-Charles Boulle was a member of a family originally from Guelder-land in the Netherlands. His father, who for a long time signed his name 'Jean Bolt', was himself a 'menuisier en ébène' who settled in about 1653 on the hill of Saint-Geneviève. André-Charles became a master before 1666, in that year being referred to as 'maître menuisier en ébène' in a legal document. He lived and worked in the rue de Reims near Saint-Étienne-du-Mont, as did his parents. He would seem to have achieved success early in his career, to the extent that he was granted the royal privilege of lodgings in the Galeries du Louvre in 1672. On this occasion Colbert recommended him to the King as 'the most adept amongst his profession in Paris'. In the same year Boulle received the warrant, signed by the Queen, of 'ébéniste, ciseleur, doreur et sculpteur du roi'. Like Cucci, therefore, Boulle could pride himself on the title of 'bronzier' as well as 'ébéniste', and he maintained these two roles throughout his life. In doing this he was infringing the rules of the guilds in force at the beginning of the eighteenth century which forbade the simultaneous practice of two professions. However, his position as 'ébéniste du roi' at the Louvre shielded him from prosecution.

This first establishment at the Louvre, formerly occupied by Macé, comprised three mezzanine floors below the Grande Galerie, opening on the ground floor into the rue des Orties. On Colbert's authorization it was enlarged to include adjoining rooms in 1679. Boulle was obviously doing well. Sometime

before 1685 he was also given a second set of rooms on the present site of the Stairway of the Victory of Samothrace comprising three mezzanine floors beneath the Academy of Painting. He expanded still further in 1685, buying a wooden lean-to which abutted onto his second lodgings, giving onto the rue Froidmanteau. Around this outhouse, situated in the courtyards in front of the Louvre between the Place du Vieux-Louvre and the rue Froidmanteau, Boulle erected a number of temporary buildings which served as workshops, wood-stores, storage for furniture and even living quarters.

In 1677 Boulle married Anne-Marie Leroux who was provided with a dowry of 10,000 livres. They had seven children, among them the future ébénistes Philippe (1678–1744), Pierre-Benoît (1680–1741), André-Charles II (1685–1745), and Charles-Joseph (1688–1754). Boulle's reputation grew apace. Brice wrote in 1684: 'He produces works in marquetry, extraordinarily well made, which are treasured by connoisseurs.' The *Livre commode des adresses de Paris* for 1691 points out that 'Boulle produces works in marquetry of a singular beauty', and in the 1692 edition includes Boulle with Cucci and Lefèvre as the only three ébénistes worthy of mention in Paris. From 1672 Boulle had assumed the title of 'ébéniste' or 'marqueteur ordinaire du roi' to which he frequently added the title 'ciseleur' (bronze-chaser), even on one occasion in 1685 'marchand-ébéniste'. Despite this he actually supplied very little furniture to Louis XIV, who, one must assume, preferred the work of Cucci, Gole and particularly Gaudron. The only delivery of a piece by Boulle made to the Garde-Meuble Royal took place in 1681: 'no. 338 – a fine table with marquetry of interlaced gilt-bronze and pewter on a tortoiseshell and ebony ground having five compartments above,

[13] Armoire/long-case clock in contrepartie; mentioned in the deed of gift of Boulle to his sons in 1715, it was then owned by

Donjeux and appeared in his sale in 1793. (Wallace Collection, London)

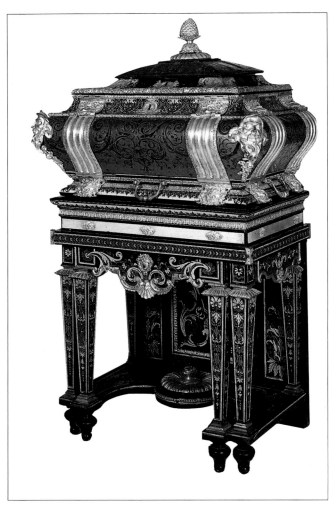

[14] *Sarcophagus-shaped coffer known as 'du Grand Dauphin'. There is a pair to this coffer with a different stand, and a third example at Blenheim. One of them is described in an inventory of the collections of the Grand Dauphin in 1689 and appears to* *correspond to a delivery by Boulle in 1684. Two coffers of this type appeared in the Lauraguais sale in 1772 and a third in the dealer Julliot's sale in 1777. (J. Paul Getty Museum, Malibu, California)*

before supplying his first piece to the King. In 1681 his first commission for the Crown was an organ-case for Versailles for the considerable sum of 8,000 livres.

At the same time he created what was to be his masterpiece and make him famous among his contemporaries, the marquetry floors and wainscoting in the Dauphin's apartments at Versailles. Finished in 1683 at a total cost of nearly 100,000 livres, this decorative ensemble had to be completely dismantled the following year, and moved and adapted for another apartment which the Dauphin took on the ground floor of the Palace. For this new apartment Boulle supplied in 1683 'two tables in marquetry as well as a crystal cabinet-stand' (1,650 livres) and the following year a marquetry coffer (700 livres), which, from the inventory of the Grand Dauphin in 1689, can probably be identified as one of the two coffers now in the J. Paul Getty Museum [14]. In 1686 he supplied four fauteuils and four stools in tortoiseshell and brass marquetry, unique chairs whose appearance may be imagined from a drawing in the Musée des Arts Décoratifs. In 1700, having worked for twenty-eight years for the Bâtiments Royaux, Boulle supplied a piece of furniture to the King for the first time. This was a large armoire in purplewood for the Garde-Robe du Roi at Marly (1,000 livres). The following year he supplied seven tables for the Ménagerie (6,400 livres), the residence the King was having refurbished for the young Duchesse de Bourgogne in the park at Versailles. Lunsingh Scheurleer has identified three entries which probably correspond to these tables:

No. 725) A small table in brass and tortoiseshell marquetry rounded at the front, in the form of a putto astride a dolphin leaning against an anchor, in one hand a trident, in the other a lance. The stand comprises three consoles decorated with the same marquetry and with a ram's head above in gilt-bronze, measuring at the back 22 pouces across and 30 deep in the middle.

No. 726) Another small square table with brass and tortoiseshell marquetry with central motifs of a putto on a swing flanked by two further putti and a shepherd playing the bagpipes, the remaining area filled with figural and animal grotesques and ornamental motifs in the same marquetry. 2 pieds 8 pouces in length and 15 pouces in depth.

No. 727) Two small tables also in tortoiseshell and gilt-bronze marquetry with square corners at the back and rounded at the front, designed to be placed in a corner, decorated with garlands and various musical instruments,

supported by six square tapering legs with gilt-bronze capitals. Length 5 pieds, depth 2 pieds 8 pouces, height 2 pieds 10 pouces, sent to Versailles.' In fact Boulle worked in the service of the Bâtiments du Roi, making mostly marquetry and parquet floors or decorative details in gilt-bronze (see the accounts of the Bâtiments cited below) and furniture only as a sideline. Over a period of forty-two years, between 1672 and 1714, he supplied less than twenty pieces of furniture. His first commissions were for the Queen and the Grand Dauphin and he had to wait until 1700

marquetry legs and triangular stretcher, 17 pouces wide and 20 deep.

While the table decorated with the swing motif brings to mind the celebrated consoles by Boulle with the same decoration [29], the two last entries correspond to a type [15] by Boulle of which a few rare examples exist (in the Victoria and Albert Museum, Longleat and in a private collection in Paris). In 1708 Boulle supplied two bureaux at a cost of 3,000 livres for the King's Bedchamber at the Grand Trianon. Pierre Verlet has identified them from the inventory description as two commodes now at Versailles [17]. At this time commodes, a new type of furniture, were still called 'bureaux', after the type of furniture from which they derived. Boulle supplied two further 'bureaux' at a cost of 2,500 livres in the same year for the King's Bedchamber at Marly. Again these were commodes. They remained in Louis XV's Bedchamber at Marly until 1765 when they were itemized in an inventory as:

No. 527) Two fine commodes in brass and tortoiseshell marquetry with griotte marble tops, each having three large drawers with locks, the escutcheons and handles in gilt-bronze; 1 pied 1 pouce long, 2 pieds deep and 2 pieds 9 pouces high (0¹3336).

In 1712 he supplied two desks for Versailles, one in marquetry for the Dauphine (1,025 livres), the second for the King in 'brass and tortoiseshell marquetry enriched with gilt-bronze mounts' at a cost of 1,250 livres. In 1714, for the first time, the term 'commode' appears: Boulle supplied a commode in amaranth at a cost of 1,600 livres for the King's Bedchamber at Fontainebleau, which is described in an inventory as:

No. 818) A commode in amaranth with mouldings and decoration in gilt-bronze, fitted with three drawers at each end, the front with three fixed panels, the central one with a sunflower; griotte marble top with canted corners, 4 pieds in length, 2 pieds in depth and 32 pouces in height.

In 1715, the year of Louis XIV's death, Boulle, aged seventy-three years, made over his business and all his assets to his four sons. The workshop continued to supply only a few pieces of furniture to the Crown. During the summer of 1720 a fire broke out one night in the workshops in the courtyard of the Louvre, destroying furniture and part of the collections amassed by Boulle. In 1725 Boulle, no doubt officially recognized to be in declining health, was granted an annual

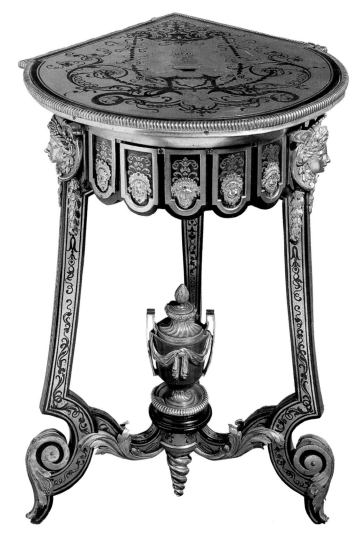

[15] Table (one of a pair) made for the Duchesse de Bourgogne in 1701 for the Ménagerie with five others, for a total cost of 6,400L; described in the royal inventories under the number 727. (Victoria and Albert Museum, London)

pension by the King of 500 livres which he drew until the end of 1731, dying in March 1732. The inventory taken after his death reveals that he retained the residue of his possessions which had survived the fire, including his collection of drawings and prints and particularly the bulk of his bronze models. On the other hand, no furniture on the stocks is mentioned in his workshop and the inventory lists only seven workbenches. His total assets were estimated at 13,053 livres while debts had risen to 20,160 livres (of which

1,000 livres was owed to the marchand-joaillier Thomas-Joachim Hébert, the residue of a bill in 1723 of 3,000 livres, and 5,000 livres to the widow of Francois Thomé). The sons were therefore forced to auction their father's assets. According to Mariette, the sale, conducted by the bailiff Sébastien Tesnière in May 1732, lasted a long time and realized 14,914 livres.

BOULLE'S CLIENTS

In the only two legal documents to have survived concerning Boulle's workshop (the deed of gift, or 'acte de délaissement' to his sons and the inventory taken after his death in 1732) the various items described are linked to the names of those who ordered them, thus enabling us to distinguish his principal clients. These were mainly financiers, ministers or important officials: Claude François de la Croix (died 1729); François-Christophe Lalive (1674–1753); Paulin Pondre (died 1723); Samuel Bernard (died 1739); Paul Poisson de Bourvalais (died 1719), owner of the Château de Champs; Pierre Crozat (1665–1740) and his brother Antoine (1655–1738); Nicolas Desmaretz (died 1721); Bernard de Cotteblanche; Jean de Sauvion (who went bankrupt in 1701); Jean Phelypeaux (1646–1711), brother of the minister Pontchartrain; Pierre Thomé (1649–1710) who was one of Boulle's

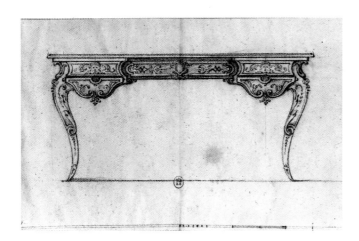

[16] Design for a bureau commissioned to Robert de Cotte for Philip V's palace in Madrid, the redecorating of which de Cotte directed c. 1712. Several pieces of furniture were ordered

from Boulle, who made a bureau and a commode in 1713 for the sum of 3,586L. (Bibliothèque Nationale, Paris; Cabinet des Estampes)

most important clients and creditors; Pierre Gruyn (died 1722); Étienne Moulle (died 1702) whose famous collection was already mentioned in the *Livre commode des adresses de Paris* in 1692; Pierre Langlois (died 1719); the minister Louvois (died 1693); Jacques-Louis de Beringhen (1651–1723); Claude Le Bas de Montargis (1659–1741), Jules Hardouin-Mansart's son-in-law; Pierre Delpech (1642–1712); Moyse-Augustin de Fontanieu (died 1725), superintendant of the Garde-Meuble Royal from 1711.

To this list of financiers and ministers must be added other important figures such as Cardinal de Rohan (1674–1749) and foreign princes such as Philip V of Spain, who in 1713 ordered from Boulle through Robert de Cotte 'a commode and bureau in bois des Indes with gilt-bronze mounts' for 3,586L [16]. In 1718–19 de Cotte again commissioned Boulle to make two commodes with gilt-bronze mounts at a cost of 1,675 livres for Joseph-Clementz of Bavaria, Elector of Cologne in Bonn. His clients among the members of the royal family included the Duc de Bourbon, who ordered several pieces of furniture for Chantilly in 1720, the Regent, the Duc d'Orléans and his daughter the Duchesse de Berry (died 1719). In his work on Boulle, Jean-Pierre Samoyault has carried out an indispensable study of the probate inventories of Boulle's clients. Eighteenth-century guides of Paris also describe numerous 'cabinets de curiosité' containing Boulle furniture still bought directly from the workshop. The most well-known cabinet of curiosities belonged to Blondel de Gagny, and it is well worth reading its description in the *Dictionnaire pittoresque et historique* by Hébert in 1766. Jean de Jullienne (1686–1766) also had an important collection of Boulle furniture which he would seem to have assembled in the 1720s.

BOULLE'S COLLECTIONS AND DEBTS

Boulle was an inveterate collector. In his *Abecedario* Mariette writes of him: 'No sale of drawings or prints took place which he did not attend, at which he did not make frequent purchases without having the means to pay; he was almost always forced to borrow at high rates of interest; another sale would take place, again he had to resort to expedients.' A large part of his extensive collections disappeared in the fire which destroyed his workshop during the night of 30

August 1720. The damage, estimated by Boulle at 212,220 livres, included, so he said, innumerable series of prints as well as a precious Rubens manuscript, a series of two hundred and seventy drawings by Stefano della Bella, a folio of one hundred Van Dyck portraits, two portfolios of drawings by the Carracci, two volumes of drawings of Philippe de Champaigne, two thousand studies of Corneille and Massé, a folio of forty-eight drawings by Raphael representing Ovid's *Metamorphoses*, a manuscript on the art of warfare illustrated with drawings by Callot and nearly one hundred and forty portfolios of drawings by French Masters (Brebiette, Berain, Puget, Leclerc, François Mansart and Jules Hardouin-Mansart, Lafage, Boitard, Lebrun, Verdier, Bourdon, Melan, Perrier, and so on). Boulle also collected medals: he owned six thousand as well as medals cast from the antique Greek medals in the Fouquet Collection. 'The fire did appalling damage,' writes Mariette; 'what was saved was as nothing compared to what was destroyed even though what was rescued was still extensive.' One appreciates this comment by Mariette when studying the probate inventory of 1732 published by M. Samoyault: Boulle still owned more than two hundred and fifty volumes or portfolios of prints and one hundred and forty-six volumes or portfolios of drawings, among which were entire series by Poussin, Van der Meulen, Le Sueur, Lebrun and Mignard.

In giving free rein to his passion for collecting, Boulle spent his entire life in financial difficulties. The first mention of his problems was his obligation in 1681 to reimburse Anne de Prélasque the sum of 2,000 livres which he had borrowed from her 'for the settling of urgent affairs'. The various lawsuits and proceedings against him show that his debts continued to increase, that he paid his assistants and suppliers irregularly and that he lived from hand to mouth. In 1684 he was sued by the innkeeper François Breguet for a bill for drink for his workforce. The following year it was the turn of fifteen of his workers who sued him for back pay. In June 1685 he was even imprisoned in the Châtelet for a day over a debt of more than 1,500 livres owed to Charles Leclerc, 'marchand maître batteur d'or'. In 1697 Pierre Crozat instigated proceedings against him for the non-delivery of four pedestals, two armoires and a base for which he had paid in advance. By 1701 his situation was so desperate that he had to seek the protection of the King

against his creditors who were planning to have him arrested at the Louvre. Despite various settlements, these debts were still not paid off in 1704. In 1715 they had risen to 36,000 livres which were still partly owing in 1732.

BOULLE'S ASSISTANTS AND THE EXTENSION OF HIS WORKSHOP

The names of Boulle's colleagues are known from the records of legal proceedings against him by his workforce, whom he paid very infrequently. Besides his four sons, he was assisted by one of his cousins, Pierre Boulle, who declared in 1710 that he had worked for him for thirty-five years and petitioned the Duc d'Antin to order his arrest for the payment of 1,700 livres owed to him, which sum would enable him to obtain his mastership. The proceedings against him by the innkeeper Breguet in 1684 include the names of three of his employees, Girard, Cieppe and Gaspard. In the following year he was forced to update the wages of fifteen of his workforce of which many were 'journeymen gilders, ébénistes and menuisiers': Jacques La Neuville, Jean Saint-Yves, Antoine Aztigues (or Oztigues), Maurice Degrea, Ulrich Cemelmer, Leo Rhindorffe, Simon Chotepot, Adam de Vaux, Michel Chastelier, Joseph Lutier, Leo Venneman, Zacharie Strague (or Strack), Dominique Poulain, Jean Mangin and Denis Desforges (who was apprenticed in 1660 to Gole). Another colleague between 1674 and 1676 was also his brother-in-law Philippe Poitou. A widower in 1677, the latter contracted a second marriage to the daughter of the ébéniste Sommer and left to work in his workshop. Finally, the recently discovered contract of apprenticeship of Jean-Pierre Mariette reveals that he worked as a caster in Boulle's workshop between 1725 and 1731. The workshop, which comprised a workforce of at least fifteen in 1685, continued to expand, rising by 1720 to nearly thirty workers. There were at that time twenty workbenches for ébénistes as well as equipment for six workers in bronze, a foundry and a printing press. It would seem that the workshop went into a period of noticeable decline after the fire in 1720. On Boulle's death in 1732 only seven work-benches are mentioned. The probate inventory was taken in the first workshop in the rue des Orties. This took up only the ground and first floors and there was no mention of

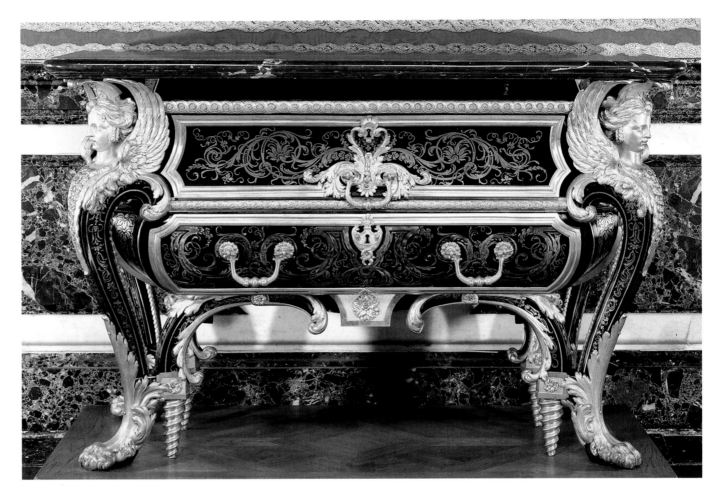

[17] Commode, one of a pair supplied by Boulle in 1708 for the bedchamber of Louis XIV at the Grand Trianon. This model was repeated by Boulle and is found in several important eighteenth-century collections (de Selle, Randon de Boisset, du Luc, Marigny, de Merle, Choiseul-Praslin, Comte d'Artois). Termed 'bureau' in 1708, this piece represents the earliest development of the commode, between the table and the sarcophagus-shaped coffer. (Musée de Versailles)

further amenities. The stocks of wood had also declined considerably. Probably the other work-benches and the rest of the tools had been divided between Boulle's sons before his death and were installed in other areas of the workshop.

BOULLE'S PRODUCTION: ASPECTS OF ATTRIBUTION

Boulle's workshop did not stamp its production. In the absence of a stamp the scholar must use archival sources to make attributions (such as the deed of gift and the inventory after Boulle's death, royal archives, the inventories of his clients, and the collection of his models engraved by Mariette after 1707, *Nouveaux Desseins de meubles et ouvrages de marqueterie*) and stylistic criteria. To a lesser extent the drawings in the Musée des Arts Décoratifs and the eighteenth-century sale catalogues are helpful, though the latter need to be consulted with care since they tend to attribute all furniture with tortoiseshell marquetry to him. From the royal records it is possible to attribute those commodes with mounts of winged female heads definitely to Boulle. It is recorded that he delivered a pair in 1708 for the King's Bedchamber at Trianon [17]. More-over, the deed of gift mentions three others in white wood in the workshop, proof that there were at least five constructed at that time. They can be followed through various sales during the eighteenth century: de Selle sale in 1761, lot 143; Randon de Boisset sale in 1777, lot 779; du Luc sale in 1770, lot 40; Marigny sale in 1781, lot 584; de Merle sale in 1784, lot 206;

[18] Additional plate to
Mariette's folio of engraved
designs by Boulle, 1707–30. The
folio contained eight plates;
however, the copy belonging to
Baron Pichon, according to
Guilmard, contained two
additional plates, of which this is
one (Bibliothèque Doucet, Paris)

[19] Low bookcase, decorated
with a figure of Bacchus. Similar
examples, heightened during the
reign of Louis-Philippe, are now
in the Louvre and were
confiscated at Chantilly during
the Revolution from the Prince de
Condé whose father was one of
Boulle's clients around 1720.
(Private collection)

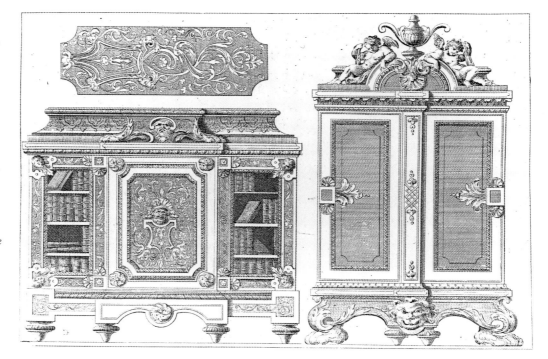

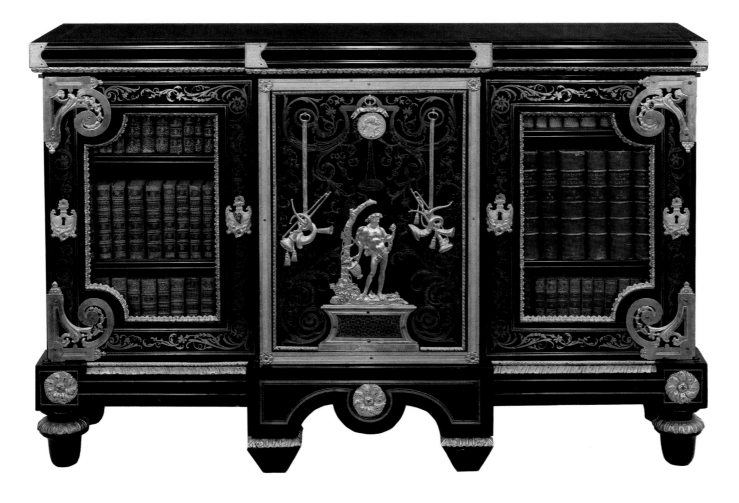

Choiseul-Praslin sale in 1793, lot 244. An identical commode was confiscated from the Comte d'Artois' apartment at Versailles in 1794. The coffers in the J. Paul Getty Museum [14] can also be attributed with certainty: the identical description of one of them – though with different measurements – appears in the inventory of the collections of the Grand Dauphin with the words 'made by Boulle'. It is possible that this was the coffer supplied in 1684 by Boulle to the Dauphin for 700 livres, according to the accounts of the Bâtiments (see below). A coffer of this type was part of the dealer Julliot's stock and was included in his sale in 1777 as lot 706. A pair of comparable coffers are described in the Lauraguais sale in 1772, lot 20.

The series of low bookcases [19] with two glazed doors flanking a solid door decorated with mythologi-

cal figures must also be attributed to Boulle. The examples in the Louvre were confiscated from Chantilly during the Revolution and belonged to the Duc de Bourbon who patronized Boulle in about 1720. This type was repeated for other private clients (de Merle sale in 1784, lot 208). The last royal commissions were the little tables supplied for the Ménagerie in 1701, of a type that was seldom repeated. Four other pairs at the most are recorded (see below).

The deed of gift of 1715 facilitates further definite attributions: the armoire with long-case clock in the Wallace Collection [13] which appears first on the list, with pair in contrepartie, were estimated respectively at 5,000 livres and 4,000 livres. They were included in the Donjeux sale in 1793 as lots 546 and 547. It is also possible to identify a type of commode termed 'en tambour par les deux bouts' (drum-shaped on both sides) or 'oval' [20]. The Wallace Collection has two examples of this type. In the inventory of Boulle's client, the financier La Croix, who owned four examples of this type of commode, they are described as being embellished with deep-rimmed tops in Chinese

[20] Oval commode with tortoiseshell and brass marquetry with amaranth borders. Two commodes of this type are termed 'drum-shaped at each end' and described in the deed of gift of 1715. They were commissioned by the financier La Croix who owned four at the time of his death in 1729, of which three had tops of cabaret trays in Chinese lacquer. (Archives Galerie Aveline, Paris)

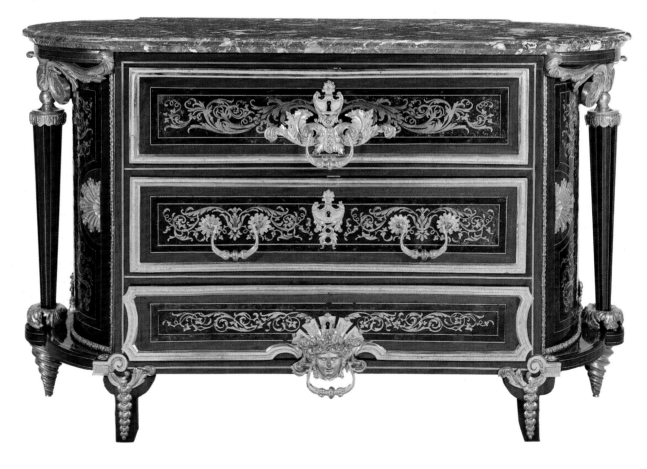

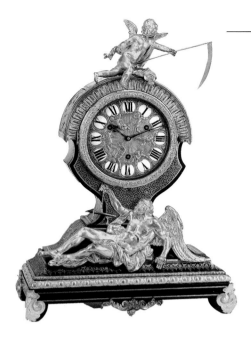

also retained until 1732 (no. 90). Apart from the example now in the Archives Nationales, formerly at Chantilly in the collection of the Duc de Bourbon, several of these clocks appeared in eighteenth-century sales: Jullienne sale in 1767, lot 1632; Lauraguais sale in 1772, lot 23; Randon de Boisset sale in 1777, lot 799.

To this list can be added furniture mentioned in the inventory of 1732: the low armoires [22] with figures of the Seasons, also reproduced in the folio of Mariette engravings, a pair of which is now at Versailles, confiscated from the Duchesse de Noailles during the Revolution. Two of these armoires appear in the Jullienne sale in 1767, lot 1628, and according to the contemporary catalogue they were of a rare type.

Mariette's folio *Nouveaux Desseins de meubles et ouv-*

[21] *Clock 'with recumbent Time'; mentioned in the inventory taken after Boulle's death in 1732 ('a box containing the models of the clock of M. Desmarais with recumbent Time by M. Girardon...') and in the 1715 deed of gift. This clock*

corresponds to a drawing in the Musée des Arts Décoratifs. There were several versions which can be recognized in the background of paintings by Jean-François De Troy. (Sotheby's Monaco, 9 December 1984, lot 1030)

[22] *'Bas d'armoire with Seasons', one of a pair confiscated from the Duchesse de Noailles during the Revolution. Two identical pieces were in the Jullienne sale in 1767 where they are described as rare models. The*

inventory drawn up after Boulle's death in 1732 mentions 'a box containing models of the mounts made for the cupboards for M. de La Croix and Langlois amongst which are figures of the Four Seasons'. (Musée de Versailles)

lacquer. Two examples with marble tops appeared in the Lambert sale in 1787 as lots 301 and 302. There is also a clock embellished with figures of Venus and Cupid corresponding to examples now at Waddesdon Manor and in the Wallace Collection. The models of the figures remained in Boulle's possession and are mentioned in the 1732 inventory (no. 79). The famous clock with the reclining figure of Time [21], of which there exist numerous examples, may be identified as the one made for the financier Desmaretz. The various models of Time were the work of Girardon and are found in the 1732 inventory (no. 88). The 'clock with the figures of the Fates' may also be identified as one in the Wallace Collection. The models designed by Coustou are also mentioned in the 1732 inventory (no. 76). A second example of this clock with Fates appears in the same inventory; this must correspond to the clock with the Fates in bas-relief surmounted by a figure of Time of which one example was in the San Donato sale, while another is in the Louvre (former Fabre Collection). Another type of clock is mentioned in 1715: one with figures of Night and Day after Michelangelo, whose models Boulle

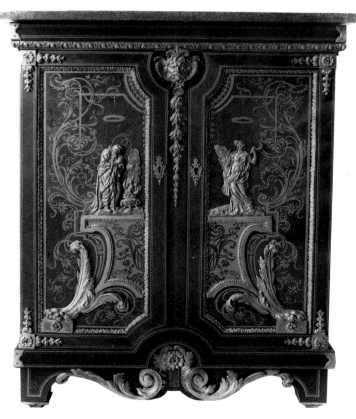

rages de bronze et marqueterie inventés et gravés par André-Charles Boulle (from which four plates are reproduced on the first and last pages of this book) facilitates the identification of other prototypes. The pedestals with aprons (plate I) were of a type often repeated. Numerous examples are to be found in eighteenth-century sales (two in the Randon de Bois-set sale in 1777 which reappeared in the Lebrun sale in 1778, lot 199; two in the Dubois sale in 1785, lot 216, and again in a Dubois sale in 1788, lot 153; two in the Choiseul-Praslin sale in 1793, lot 243, which came from the Julliot sale in 1777; and six examples in the Donjeux sale in 1793, lots 555–56 and 557). Many examples exist today (see under Appendix II below).

The sphinx clock illustrated in Mariette's Plate II (see p. 40) corresponds to another well-known type. An example in a private American collection was exhibited at the Frick Collection ('French Clocks') in 1982 and a second one supported on a stand was recently sold in Paris (Couturier-Nicolaÿ sale, 7 December 1979, lot 124). The bureau plat with six legs in Mariette's Plate III is comparable with a famous ex-

ample formerly in the Ashburnham Collection [26] which also has convex drawer fronts. In the same print the right-hand section of the desk is reminiscent of the one at Vaux-le-Vicomte [25] which belonged to Randon de Boisset and was included in his sale in 1777, lot 781. In Plate IV, the two guéridons are also of a known model. An example of the one on the left, of a rare type, belonged to Anna Gould (sale Sotheby's

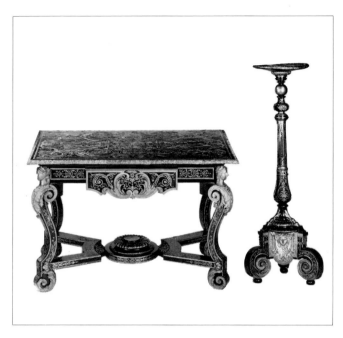

[23] (right) *Guéridon with scroll feet of a type often repeated, with a table which can be dated around 1690–1700. In the reign of Louis XIV, tables* *were generally sold with pairs of matching guéridons. (Formerly in the Dashwood Collection; Christie's London, 20 June 1985, lot 73)*

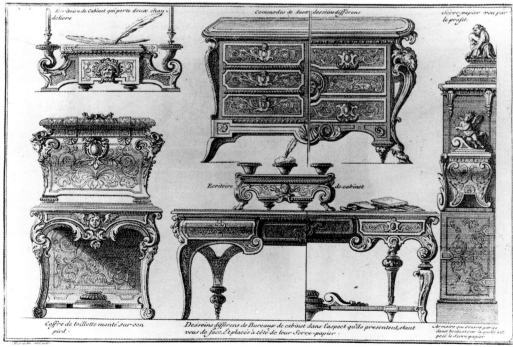

[24] (left) *Plate III of Mariette's folio of Boulle's engraved designs, 1707–30*

[25] (opposite above) *Bureau plat, to be compared to the right half of the desk in Plate III of the Boulle folio. This desk belonged to Randon de Boisset and appeared in his sale in 1777. (Château de Vaux-le-Vicomte)*

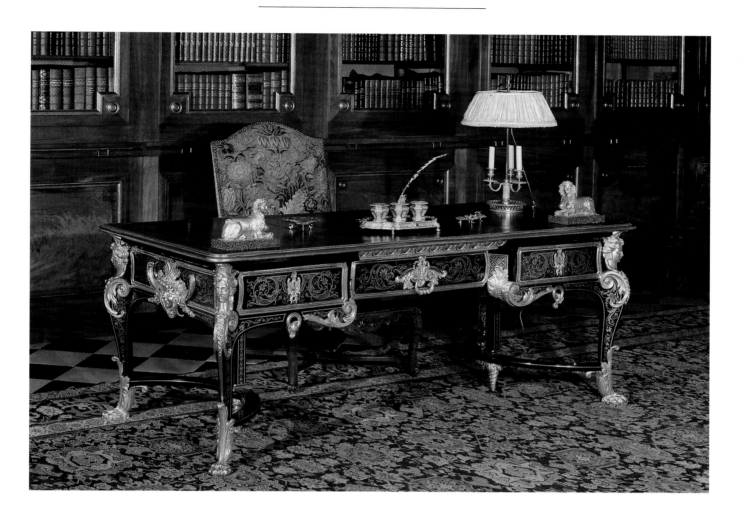

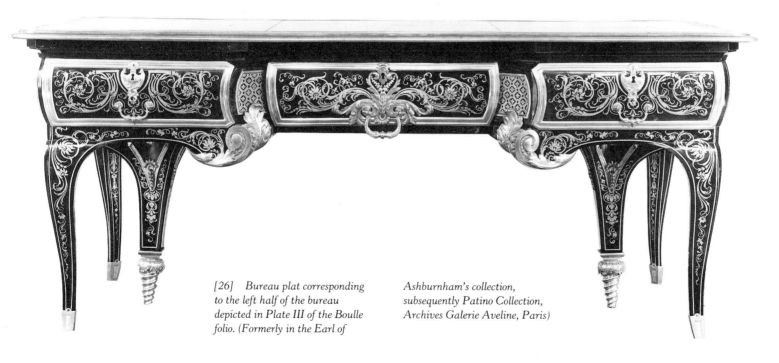

[26] Bureau plat corresponding
to the left half of the bureau
depicted in Plate III of the Boulle
folio. (Formerly in the Earl of

Ashburnham's collection,
subsequently Patino Collection,
Archives Galerie Aveline, Paris)

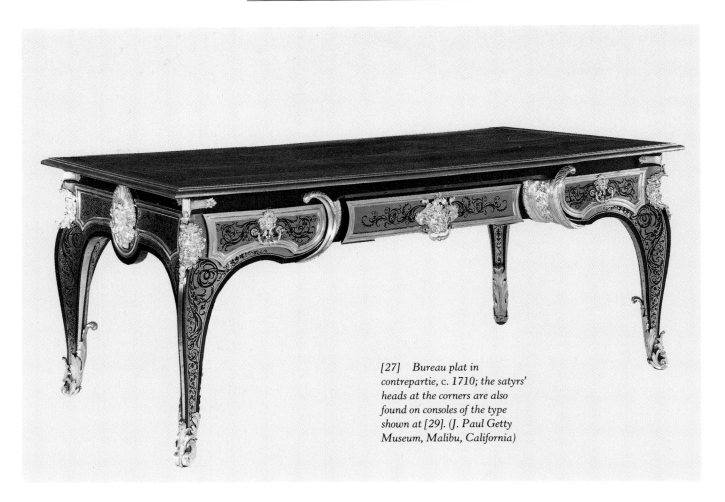

[27] *Bureau plat in contrepartie, c. 1710; the satyrs' heads at the corners are also found on consoles of the type shown at [29]. (J. Paul Getty Museum, Malibu, California)*

Monaco, 14 June 1982, lot 494). The second with 'C'-scroll legs [23] is of a type often repeated in the Boulle workshop (Julienne sale in 1767, lot 1629).

The console with ram's head in Plate V (see p. 440) is similar to the description of the one supplied by Boulle in 1701 to the Duchesse de Bourgogne at the Ménagerie (mentioned above), as well as another one mentioned in Boulle's 1732 inventory ('a box containing the models for the Trianon commodes and "tables with rams"'). Boulle designed a series of these tables with variations: some were decorated with rams' heads and hooves (Blondel de Gagny sale in 1776, lots 963–64, with three feet; Randon de Boisset sale in 1777, lot 784; Donjeux sale in 1793, lots 550–51 with two feet and faun's head mask). Others are decorated with lions' heads and paws and three legs (du Luc sale in 1777, lot 44, with Apollo mask and fringes; Le Boeuf sale in 1783, lot 213). The two tables now in the Wallace Collection and at Waddesdon Manor are embellished with lions' heads and resemble the du

Luc and Donjeux consoles, but with small discrepancies which render precise identification impossible.

On the same Plate V (see p. 440) is the base of a armoire with figures of the Seasons already mentioned, as well as a console with six legs of a well-known type, of which versions exist in the Wallace Collection and several private collections (see under Appendix II below; [29]). Such consoles frequently appear in eighteenth-century sales (Julienne sale in 1767, three examples, nos 1642, 1648 and 1649; Dubois sale in 1785, lot 215 in contrepartie; Chevalier Lambert sale in 1787, lot 310).

The drawings of furniture attributed to Boulle in the Musée des Arts Décoratifs are problematic. It would apparently seem unwise to rely on them for the purposes of attribution; yet the majority of these drawings in black or red chalk would seem to be by the same hand; moreover, they correspond to works definitely by Boulle and it is known that he made draw-

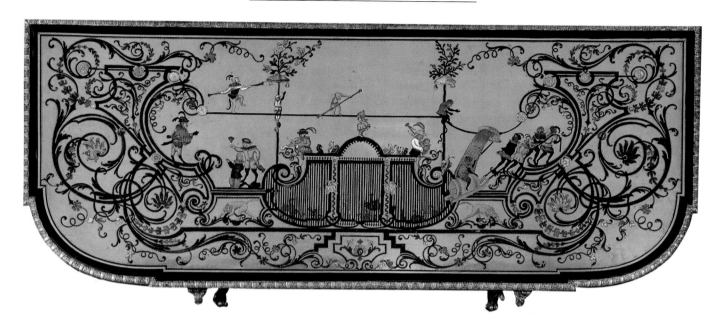

[28] *Top of a console on six legs with motif of an aviary drawn by monkeys. (Archives Galerie Gismondi, Paris)*

[29] *Console supported on six legs, of a model depicted in Plate V of Boulle's folio of engravings as well as in a drawing of the Musée des Arts Décoratifs. The*

mounts (satyrs' heads on the legs and fauns' masks) are also found on various bureaux plats. (Sotheby's Monaco, 14 June 1982, lot 492)

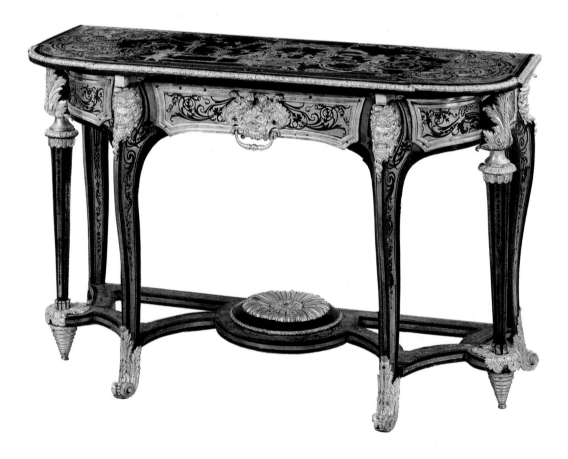

ings himself (as indicated by the title of the engraved folio). One of the drawings of an armoire [30] bears an inscription on the reverse concerning a delivery of sconces made by Boulle for the Dauphin at Meudon in 1701. From this drawing it is possible to attribute the two large armoires now in the Louvre to him [31] as well as the group of bas d'armoires with figures named 'Religion and Wisdom'. These figures are actually Aspasia and the Philosopher and were inspired, as Beatrix Saule has discovered, by motifs painted by Corneille in the Queen's Antechamber at Versailles. This group can therefore be dated after 1701, probably from 1710–25. They appear in various sales during the eighteenth century; a pair, Gaillard de Gagny sale in 1762, lot 54, described as being 'by Boulle the

Elder'; a single one, Blondel de Gagny sale in 1776, lot 955; a pair in the Poulain sale in 1780, lot 188; two pairs, first in the Sainte-Foix sale in 1782, lots 142 and 143, then in the Leboeuf sale of 1783, lots 209, 210, described with 6 medals on each door; a pair in contrepartie in the Choiseul-Praslin sale in 1793, lot 242; a pair in première partie in the Grimod de la Reynière sale in 1797, lot 107 and another pair in contrepartie in the same sale, lot 108; finally, three pairs in contrepartie in the Choiseul-Praslin sale of 1808, lots 55–57, which were purchased by Demidoff. Many pieces from this group are today at Versailles, confiscated during the Revolution from Lenoir du Breuil or the Duc de Noailles and stamped by the ébénistes who were required to restore them for resale during the

[30] *Drawing of an armoire attributed to Boulle, with an inscription on the reverse concerning two wall lights supplied by Boulle for the* *Antechamber of the Grand Dauphin at Meudon in 1701. (Musée des Arts Décoratifs, Paris)*

[31] *Armoire, one of a pair, with figures of Aspasia and the Philosopher. It is comparable to the drawing [30] and, like it, can* *be dated to around 1701. (Musée du Louvre, Paris)*

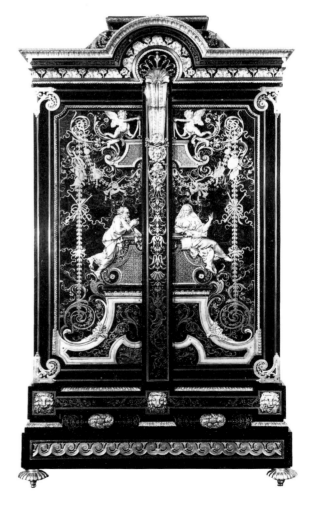

[32] Low armoire, c. 1725, one of a pair with figures of Aspasia and the Philosopher; the various recorded examples (eight pairs at least) display small differences, for example, in the ribbons tied to medals and the number of medals. It is therefore possible to identify this pair in the Sainte-Foix sale in 1782, then in the Le Boeuf sale in 1783, together with a second pair in contrepartie. (Private collection)

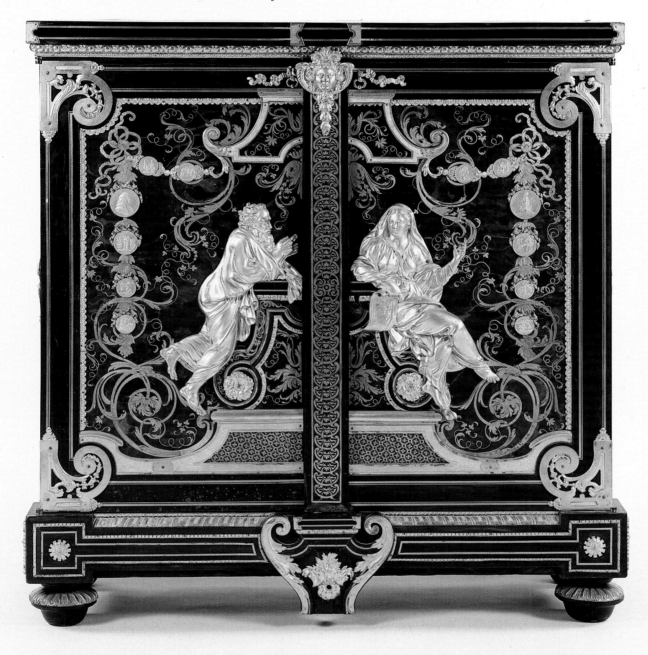

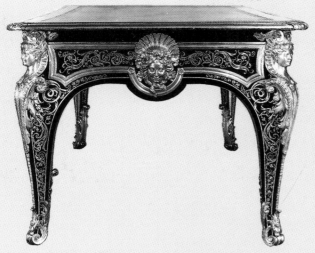

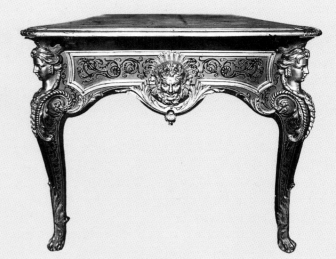

[33] Side of a bureau plat with Chinese heads, c. 1720 (Archives Galerie Aveline, Paris)

[34] Side of the bureau illustrated at [35]: the swelling curve of the top of the leg was imitated by Cressent around 1730, and this would lead us to date it among the latter productions of Boulle's workshop.

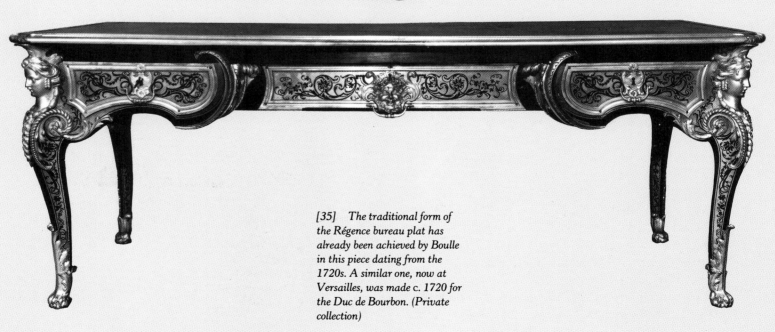

[35] The traditional form of the Régence bureau plat has already been achieved by Boulle in this piece dating from the 1720s. A similar one, now at Versailles, was made c. 1720 for the Duc de Bourbon. (Private collection)

second half of the eighteenth century: J.-F. Delorme and Montigny. Two others, of inferior quality, from the Roudinesco Bequest, are definitely pastiches made in the 1770s by Montigny for the dealer Julliot. Another drawing in the Musée des Arts Décoratifs can be linked to a famous armoire now in the Louvre [53] whose pair is now in the Hermitage; it corresponds to the description of an armoire in the Watteville sale in 1779, lot 117, which later belonged to M. de Goguelat.

Besides this group of furniture, whose attribution to Boulle is certain, it is possible to attribute to him numerous other pieces decorated with the same marquetry and bronze mounts:

– The large armoires of the type represented by the one in the Wallace Collection [59] decorated with the story of Apollo, his pursuit of Daphne and the flaying of Marsyas. Many of them are decorated with fleurs-de-lys on the hinges, suggesting a provenance within the royal family; one of them appeared in the Julliot sale in 1777.

– A group of low bookcases with glazed doors decorated with putti [60] are based on the bookcases from Chantilly, and can be linked to an entry in the 1732 inventory ('no. 46 – a box containing the chased and repaired models with decorative elements and putti from the cabinet of M. Bourvalais'). The pair at Versailles were confiscated during the Revolution from the Duc de Brissac. A second pair (private collection) were in the Blondel d'Azincourt sale in 1782, lot 414, where they were attributed to Boulle.

– The bureaux plats are of two different types. The first type, with concave apron and central everted drawer, is represented by various examples of which the finest is at Boughton House, Northamptonshire. This type with sabre legs typical of Boulle would seem earlier than the second, with cabriole legs and recessed central drawer, the design of which corresponds to that of Régence bureaux. It is not possible to make accurate identifications from the vague descriptions in eighteenth-century catalogues. Moreover, their appearance in portraits by Roslin in the 1770s and 1780s occurs too regularly to imply that they belonged to the subject of the painting in each case. It was obviously a status symbol for financiers and important people of the time.

– The most common type of cabinet was usually one with a high marquetry base, as can be seen in the

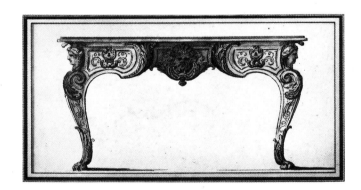

[36] *Drawings attributed to Boulle or to the designer Gilles-Marie Oppenord, for a console table on six legs and two bureaux. (Musée des Arts Décoratifs, Paris)*

drawing in the Musée des Arts Décoratifs and the two examples in the Louvre. In the inventories or sales of Boulle's clients such as Pierre Thomé in 1710 or Jean de Jullienne in 1767, lot 1653, these cabinets still have their marquetry bases supported on square tapering feet. They are also found described in the sales of Gaillard de Gagny in 1762, lot 55, Randon de Boisset in 1777 and then Lebrun in 1778. However, in the deed of gift of 1715, the bases are described separately from the cabinets ('twelve cabinet bases with square

tapering feet, the cabinets being in deal'), indicating that the cabinets could be sold separately. In this case they were probably placed on giltwood bases. An example was in the Duc de Tallard sale in 1756, lot 1033. In the sale catalogues of the last third of the eighteenth century, many of these cabinets appeared without their stands and it is in this state that the majority of them have survived to the present day: Julliot sale in 1777, lots 694–95; Dubois sale in 1788, lots 148–49; Mme Lenglier sale in 1788, lot 344; Tricot d'Espagnac sale in 1793, lot 208; Donjeux sale in 1793; Lambert sale in 1787, a pair, lot 306 and a third, lot 308; Marigny sale in 1782, lot 586. It is highly likely that they were transformed into low cabinets in the 1770s by removing the table-like stands and replacing them with plinths and short spiral feet, the wooden tops being replaced with marble [38]. The ébéniste responsible for these changes was definitely Levasseur who stamped many examples of this type, probably on commission from the dealer Julliot: it cannot be coincidental that this type of low cabinet first appeared among the sale of Julliot's stock and afterwards appeared in other dealers' sales (Dubois, Mme Lenglier, Donjeux).

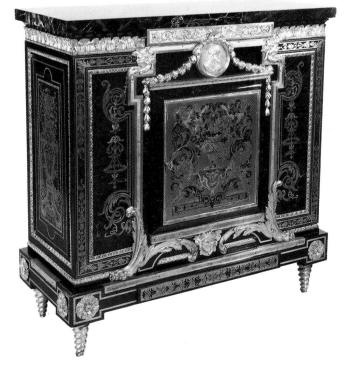

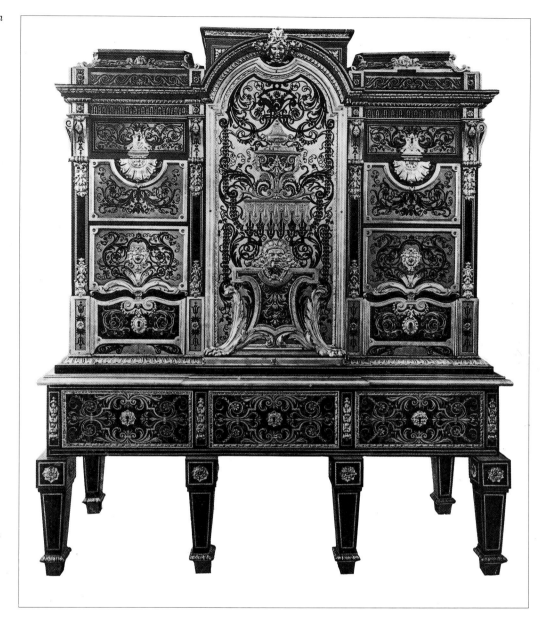

— There is also another, rarer type of cabinet designed with a central dome, which can also be attributed to Boulle. These cabinets, of larger dimensions than the first type, were also supported on high bases. The one in the Tallard sale of 1756, lot 1032, had a giltwood base. The example in the Jullienne sale in 1767, lot 1645, was described as having 'a base with six legs of square section, veneered in ebony with three drawers in marquetry', and this can be linked to a similar example in the Sheremetiev Collection now in the Hermitage [39]. Two other similar cabinets in contrepartie appear in the Grimod de la Reynière sale in 1797, lot 106, on a 'base serving as supports with three drawers', perhaps of the same type.

— Caskets, also called 'coffres de toilette' in Mariette's folio of engravings, could also serve as medal cabinets or jewel-cabinets. As in the case of the cabinets they were supported on bases, generally with square tapering feet in marquetry [41]. These are thus mentioned in the probate inventories of Boulle's clients. Among the effects of Pierre Gruyn in 1722 was found 'a small marquetry coffer, work by Boulle enriched with gilt-bronze mounts, on its base, 800 livres', and among the effects of Étienne Moulle in

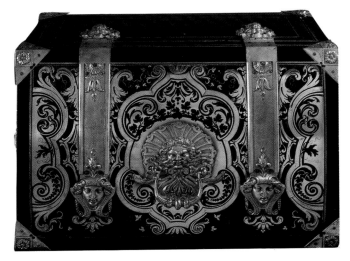

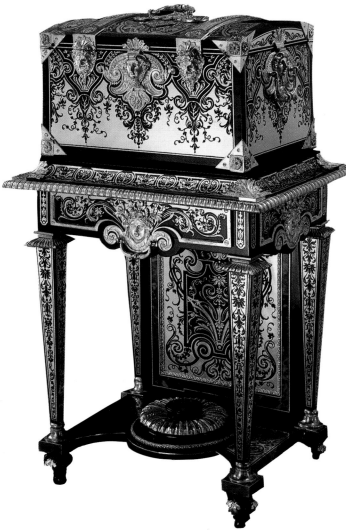

[41] Toilet coffer in
contrepartie, c. 1700. (Archives
Galerie Segoura, Paris)

1702 'two caskets with their Boulle marquetry stands embellished with gilt-bronze mounts, 500 livres'. They are to be found in many sales during the eighteenth century with this type of stand: one in the Angran de Fonspertuis sale of 1748, lot 370; a pair, Jullienne sale in 1767, lot 1635, described as having 'a base with five legs'; a pair, Lauraguais sale in 1772, lot 21; a single example, Lambert sale in 1787, lot 309; a pair, Dubois sale in 1788, lot 250; one only, Ségur-de Clesle sale in 1793, lot 219. Another type of base composed of cabriole legs with female heads is also mentioned in old sales (Gaillard de Gagny sale in 1762, lot 56; and a pair in contrepartie, Dubois sale in 1785, lot 219). They correspond to the coffers now at Blenheim Palace and Schloss Moritzburg, near Dresden.

The various types of commodes made by Boulle are of an astonishing inventiveness. Besides the two types already mentioned as identifiable from the records, it is possible to attribute several others to him:

– The type of commode in arched form decorated with faun's head [42] may be followed in several sales of the eighteenth century (Marigny sale in 1781, lot 583; Le Boeuf sale in 1783, lots 206 and 207; Vaudreuil sale in 1787, lots 359 and 369; Donjeux sale in 1799, lot 553).

– Another type decorated with lions' heads of which two examples were in the Wildenstein Collection [44] must also be attributed to Boulle's workshop. This type is found in various important sales (Vaudreuil sale in 1787, lot 394; Donjeux sale in 1793, lot 552; Julliot sale in 1777, lots 698 and 699).

– A rare type of commode with caduceus [65], in fact conceals a medal-cabinet. The only two examples recorded (J. Paul Getty Museum and Hermitage) were originally a pair which belonged to the daughter of the goldsmith Delaunay who was also the daughter-in-law of Robert de Cotte.

There are several types of pedestal attributed to Boulle in contemporary sale catalogues:

– The most sumptuous, the octagonal pedestal with a door, is described with its pair in the sale of Dubois' assets in 1788, lots 168 and 169. Another one in contrepartie was in the de Merle sale in 1784, lot 211.

– Pedestals with bowed fronts of the type at Chatsworth and in the Saint-Senoch Collection [62] are mentioned in the du Luc sale in 1777, lot 43 and the Le Boeuf sale in 1783, lot 211.

– Square tapering pedestals of rectangular section of

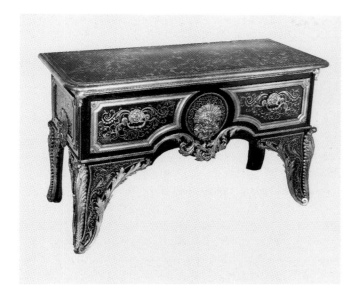

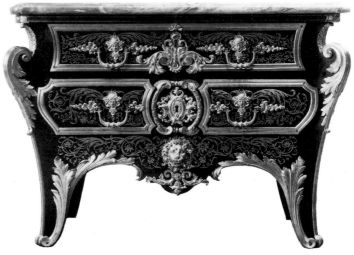

[42] Commode, c. 1700–10. Called 'tables en bureaux' at the time, these early commodes in fact derive from a type of bureau in the form of an arch. (Musée du Louvre, Paris)

[43] Commode, c. 1720, a variant of the Wildenstein commode; the corners are derived from certain bureau forms of Boulle. (Wallace Collection, London)

[44] (below) Commode, c. 1720. The final form of the commode is here achieved. The Bacchus mask is typical of Boulle. It is stamped Levasseur who restored it in about

1770–80. It appeared with its pair in the Jullienne sale in 1777, then alone in the Calonne sale in 1788. (Formerly in the Wildenstein Collection; Sotheby's Monaco, 25 June 1979)

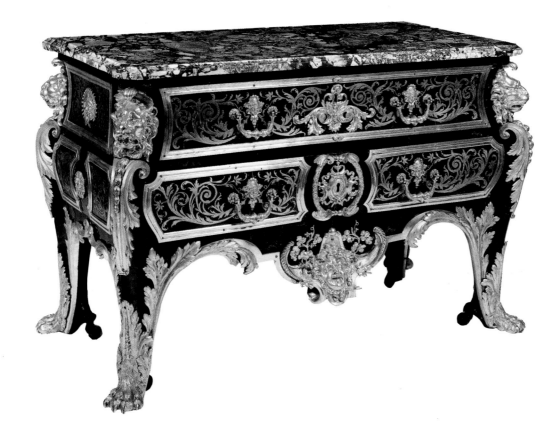

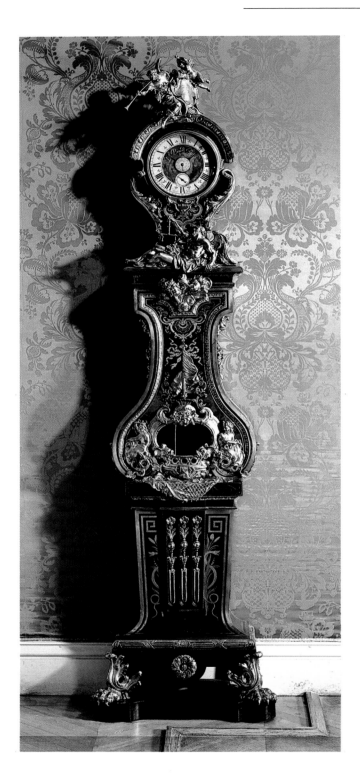

the type in the Victoria and Albert Museum are rarer. The three pairs in the Lambert sale in 1787 fetched high prices, nearly 1,300 livres each. There were also comparable examples in the de Billy sale in 1784, lot 174 and the Dubois sale in 1785, lot 214.

There is a reference in the deed of gift of 1715 to the model of a small medal cabinet ('eight small medal cabinets commenced for M. de Launay of which half are in amaranth and the remainder with marquetry, valued at 480 livres'). It is tempting to identify them with those containing the sixty-five medals of the Kings of France of which Marigny owned an example in amaranth (Sotheby's Monaco, 4 December 1983, lot 314) and the Duc de Bourbon's two examples with marquetry, today in the Bibliothèque Nationale.

Clocks represented about a third of the output of Boulle's workshop. The deed of gift itemizes 63 out of a total of 300 pieces and the inventory taken after the fire lists 75 out of a total of 220. (By comparison, there were 32 commodes in 1715 and 18 in 1720.) Among the principal clock-makers in Paris who commissioned cases from Boulle, mention must be made of Isaac Thuret (died 1706) and his son Jacques (died 1738), who also had workshops at the Louvre; Balthazar Martinot (1636–1716), 'horloger ordinaire du roi', from whom the Grand Dauphin ordered several clocks; his cousin Louis-Henry Martinot (1646–1725), 'valet de chambre horloger du roi', also with a workshop at the Louvre and Girardon's son-in-law; Antoine Gaudron (retired in 1711), who amalgamated with his son Pierre in 1698 (retired in 1728, died in 1745); Nicolas Gribelin (1637–1719), 'horloger to Monseigneur' in 1674; Louis Mynuel (died 1742), 'marchand-horloger privilégié du roi' in 1705; François Rabby (about 1655–1717), 'horloger de la Duchesse d'Orléans' in 1686. Their names occur regularly in the inventories of Boulle's clients. Several well-known long-case clocks with tortoiseshell marquetry can be attributed to Boulle: the one in the Louvre [45] was made for the Paris residence of the Comte de Toulouse, now the Bank of France, in about 1720, after a drawing by Antoine Vassé now in the Musée des Arts Décoratifs. Another long-case clock has similar

[45] Long-case clock, c. 1720 made for the Comte de Toulouse after a design by Vassé; veneered in brown tortoiseshell and blue-tinted horn imitating lapis-lazuli.

Movement by the clock-maker Le Bon; case stamped Roussel who either restored or resold the clock in the 1760s. (Musée du Louvre, Paris)

[46] Armoire in contrepartie decorated with scenes from the myth of Apollo – Apollo and Marsyas; Daphne and Apollo. (Private collection)

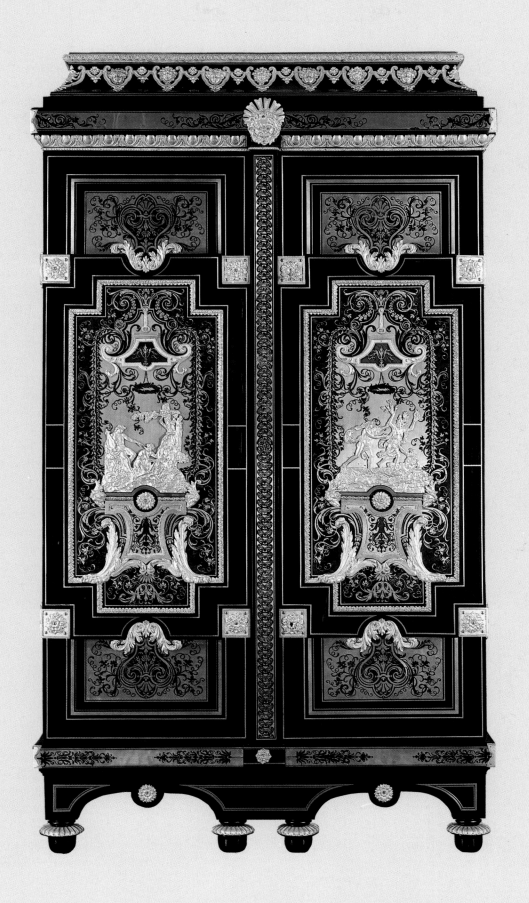

decoration to the central part of an armoire in the Wallace Collection [58]. The Saturn mask corresponds to one mentioned in the 1732 inventory ('no. 47 – a cast of the large head of Saturn with its decoration for the long-case clock of M. le Prince de Condé'). This probably refers to the one bought by the Prince de Condé from Boulle and the clock-maker Rabby in 1707–08 for the Yellow Salon in his Paris house. The dimensions cited in the inventory of 1723 of the Petit Luxembourg correspond ('9³/₄ pieds in height'). The works were originally by Rabby but were replaced during the reign of Louis XVI.

A clock with the figure of Atlas can be recognized in the inventory of the wife of one of Boulle's clients, Mme Le Bas de Montargis, done in 1748 at her house in the Place Vendôme. The example in the Conservatoire des Arts et Métiers, dated 1712, is signed by Thuret, precisely as was the one belonging to Mme de Montargis. There is a drawing by Gilles-Marie Oppenord in the Musée des Arts Décoratifs for the stand which supports it. Boulle repeated this model on two occasions (former Rothschild Collection, Château de Ferrière; sale Sotheby's Monaco, 15 June 1981, lot 142). The clock with the chariot of Apollo, of which two examples exist (Château de Fontainebleau and the Residenz, Munich [81] on a later pedestal), corresponds to an example attributed to Boulle in the Blondel de Gagny sale in 1776, lot 1022 and which was in the sale of his son Blondel d'Azincourt in 1783 with the annotation 'made for the Regent'. The Fontainebleau example was confiscated from the Prince de Condé at Chantilly during the Revolution. Finally there are several drawings of long-case clocks in the Musée des Arts Décoratifs corresponding to models by Boulle with cockerels' heads and other figures from Boulle's repertoire.

STYLE AND PROBLEMS OF CHRONOLOGY

A survey of Boulle's output reveals not only its creative force but also its homogeneity. Its principal characteristic is the importance of sculptural elements: gilt-bronze mounts play a completely new role in the history of furniture. On earlier pieces by Gole, Cucci and Oppenordt, the mounts remain subordinate to the architectural elements of the cabinets, which were really temples or triumphal arches in miniature, whereas Boulle gives the mounts a much

larger scale and uses them in profusion. They become central elements in the composition, the panels of marquetry organized around them. On earlier furniture, marquetry scrolls were delineated within compartments. In Boulle's case the marquetry swags and tendrils seem to extend the design of the gilt-bronze mounts. Conversely, an arabesque in marquetry can be extended by a small gilt-bronze trophy which seems to be suspended. The least important of his bronze mounts are still of very high quality. They were original creations, modelled by the greatest sculpteurs of the time who were often Boulle's neighbours in the Galeries du Louvre, or colleagues working with him on the same commissions from the Bâtiments du Roi. As well as Desjardins, with whom Boulle was employed in 1699 at Meudon on the bronzes for the Dauphin's chimneypiece ('with putti, mosaics and trophies'), or Girardon and Coustou whose names were found in the 1732 inventory, mention must be made of Jean Varin, Daniel Bouthemy, Van Opstal, Louis Lecomte and François Flamand, whose models in terracotta or wax were in Boulle's possession at the time of the fire in 1720. Finally, the third of Boulle's sons, André-Charles II, was a talented sculptor who was awarded the second prix de Rome in 1709.

The 1732 inventory, published by M. Samoyault, gives a list of Boulle's bronzes, which is indispensable to a study of Boulle's work. The repertoire of bronzes was largely inspired by classical mythology (Saturn, the Fates, Atlas, Mars, Ceres, Pomona, Bacchus) and in particular the *Metamorphoses* of Ovid (Apollo and Daphne, Apollo and Marsyas). Themes from contemporary sculpture were readily adopted (the Four Seasons, the Stoic and Epicurean Philosophy with the masks of Heraclitus [48] and Democritus). Certain bas-reliefs copied contemporary paintings such as Aspasia and the Philosopher. The treatment of animals was very naturalistic (lions' masks and paws of various types, rams' heads and hooves). Certain motifs on pedestals or guéridons were inspired by those from the upholstery style fashionable during Louis XIV's reign, such as the gilt-bronze fringes which imitate the 'campanes' or festooned tablecloths. The motifs of putti, a decorative element much favoured by the King in about 1700, appeared frequently: putti in flight holding up drapery [31], reclining putti [60], Eolus or Zephyrs with bulging cheeks

[38]. Motifs borrowed from antique statuary often reappear, such as escutcheons in the form of peltas found on numerous bureaux. A screaming mask, perhaps representing Hercules, also sometimes called 'Bellone', appears on the cornices of armoires, sometimes alternating with calm masks [53]. The most frequent ornamental motifs are male or female fauns' heads, their hair plaited or wreathed in fruiting vines. Boulle used a number of grimacing or smiling masks which must not be confused with the masks of Apollo and Daphne with braids tied beneath the chin. The motifs of female heads found on the corner mounts of furniture, which at first glance seem similar, are in fact of four types. The earliest type, as seen on the Wildenstein [55] and Dashwood tables, reappears in a more vigorous manner on the commodes at Trianon [17]. The same bust, but without wings, is found on the bureaux plats [35]. The last type, wearing a chinese hat [33], seems to anticipate the work of Cressent.

To appreciate fully Boulle's originality in his own time would require a precise chronology of his work. But the problem is that very little of his work can be dated before 1701, and most of the furniture which is illustrated in Mariette's folio of engraved plates must be dated after 1707. An exact date for these prints is in fact difficult to establish. Mariette included them in the second edition of *L'Architecture à la mode* which did not appear until after 1707 (the date of the death

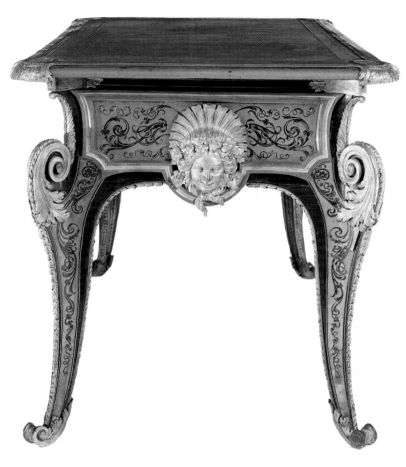

[47] *Small bureau, c. 1700–10, forming the pendant in contrepartie to a bureau in the Musée Condé, Chantilly. Both bureaux were confiscated during the Revolution from Lenoir du Breuil. (Sotheby's New York, 7 May 1983, lot 207)*

[48] *Bronze mask of Heraclitus on a bureau plat. (Sotheby's Monaco, 4 March 1989, lot 268)*

of Mariette's nephew, Nicolas II Langlois, who published the first edition in 1705). Mariette included in this second edition plates by Pineau (1684–1754) and Gilles-Marie Oppenord (1672–1742, son of the ébéniste Alexandre-Jean), which, together with those by Boulle, represented the new style which would come to be known as Régence. For these reasons the plates might be dated around 1715–20.

SUMMARY OF THE CHRONOLOGICAL GUIDELINES TO BOULLE'S WORKS

1688. Purchase by the Prince de Condé of 'two marquetry toilet coffers for the wedding of Mlle de Bourbon to the Prince de Conti, at the price of 1,260L'.

Before 1689. Coffer for the Grand Dauphin mentioned in his inventory of 1689; possibly supplied in 1684 [14].

1700. 'Déclaration somptuaire' of Boulle's workshop, mentioning four low armoires.

1701. Delivery of the tables for the Ménagerie at Versailles [15].

1701. Date of the drawing in the Musée des Arts Décoratifs made as a study for the armoires [31].

1702. Two chests by Boulle mentioned in an inventory of his client Étienne Moulle.

After 1707. Publication of the engraved folio by Boulle.

1707–08. Purchase of the long-case clock with Saturn's head by the Prince de Condé, probably the model shown at [58] for the price of 2,000L.

1708–09. Two commodes supplied to the Trianon [17], no. 566.

1710. Two cabinets with stands mentioned in the inventory of Pierre Thomé, one of Boulle's clients.

1711. 'A small casket on a base all in marquetry made by Boulle' cited in an inventory of Jean Phelipeaux.

1712. Date on the clock by Thuret in the Conservatoire des Arts et Métiers, the base for which was designed by Oppenord.

1715. Deed of gift where mention is made of the armoire [13], the oval commodes [20] and various clocks. Numerous bureaux and commodes are mentioned.

1720. Fire in the workshop. The report cites the commissions for the Duc de Bourbon among which were the low bookcases [19] and 'a desk six pieds

long . . ., a serre-papiers with a clock'.

1732. Inventory taken after Boulle's death where the casts of the gilt-bronze mounts still in use are mentioned; those no longer in fashion are classed as 'old', of which there were only a few.

Even allowing for the fact that the prototype of a piece of furniture would have been made before the engraved plate depicting it, it is doubtful whether Mariette would have published pieces which had been designed more than a decade previously under the title of 'nouveaux desseins'. Likewise, the great number of bureaux plats between five and six pieds long described in the 1715 inventory [41] and that of 1720 [21] reveal that it was at this period that Boulle's bureau plat in its final form was being made. The same conclusion applies to the large number of commodes listed in 1715 and 1720. On the other hand, cabinets were beginning to go out of fashion; twenty of them were listed after the fire, all described as 'old'. Glancing through these chronological notes, it is clear that most of the furniture identified today as being by Boulle does not coincide with the main period of Louis XIV's reign (covering only the last fifteen years of it) but rather with the period of the Régence.

FLORAL MARQUETRY AND PLAIN VENEERS

How, therefore, should we visualize Boulle's work prior to 1700? Various references in the records mentioned indicate that Boulle was making the wooden floral marquetry so much in favour in Paris in the 1680s. Thus in 1720 the fire destroyed 'five boxes filled with different flowers, birds, animals, leaves and decorative elements in wood in all sorts of natural colours, mostly made by Sr. Boulle the Elder in his youth'. In the 1715 inventory these woods are itemized as 'about twenty-five large cords of bois jaune, a number of roots of ash, six split logs of bois rouge or sandalwood and various pieces of stetin, ten cases of sawn wood in mixed sheets such as box, thorn, barberry, holly, Brazil and others'.

Boulle's work in this technique has great stylistic

[49] *Cabinet commemorating the victory of a French prince, probably an allusion to the Battle of Steinkerque in 1693, at which the Duc de Chartres, the Duc de Bourbon and the Prince de Conti* took part. *The victory of France over Spain and the Empire is symbolized here by the Cockerel victorious over the Lion and the Eagle. (J. Paul Getty Museum, Malibu, California)*

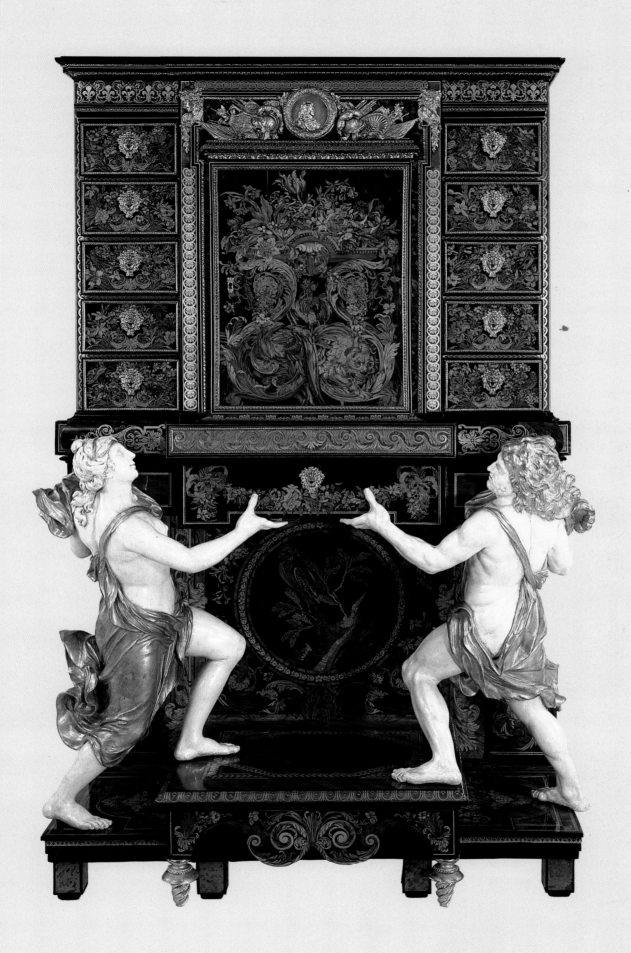

unity (armoire in the Louvre [53]; cabinets at Versailles or at the Cleveland Museum of Art, Drumlanrig Castle or the J. Paul Getty Museum [49] and Wallace Collection; bureaux at Longleat and formerly in the Helft Collection [50]), having recurring decorative motifs, such as vases of flowers or birds perched on a branch, throughout. These motifs are also found on furniture by contemporaries such as those, for example, supplied by Gole in about 1680, or those supplied by Gaudron for the Crown in about 1690. However, marquetry by Boulle is of a finer quality and more naturalistic and finely detailed. His masterpiece is a marquetry panel, remounted in the middle of the eighteenth century on an English cabinet, now in the Bowes Museum at Barnard Castle [51]. The style is close to that of Monnoyer, with very full-blown flowers, birds, butterflies, a cockerel and a dog. According to the deed of 1715, Boulle had in his possession one hundred and seventy sketches and studies of flowers taken from life and about fifty sketches of birds painted from life by Patel the Younger, which served him as models, as well as numerous flower paintings by Baudesson, mentioned in 1732. One

would like to know the origin of the two 'Hercules Cabinets' (J. Paul Getty Museum [49] and Drumlanrig Castle). The presence of fleur-de-lys on the frieze would indicate that they were made for a member of the royal family. The theme of Hercules would suggest a heroic occasion, a theme taken up in the marquetry of the central panel on which a cockerel triumphs over a lion and an eagle. The theme is clear: the allusion is to a French victory over Spain and the Holy Roman Empire. This could refer to the victory of Steinkerke in 1693, which was regarded at the time as a personal triumph for the young princes of the House of Bourbon, the Duc de Chartres, the Duc de Bourbon and the Prince de Conti. The bureau at

[50] *Bureau on eight legs, c. 1690, with floral marquetry. (Previously Alexander and Berendt Ltd, London; now private collection, United States)*

[51] *Large marquetry panel, c. 1690; reapplied to the front of an English cabinet in the eighteenth century. Probably the finest marquetry picture by Boulle, this panel was inspired by paintings by Jean-Baptiste Monnoyer. (Barnard Castle, County Durham; Bowes Museum)*

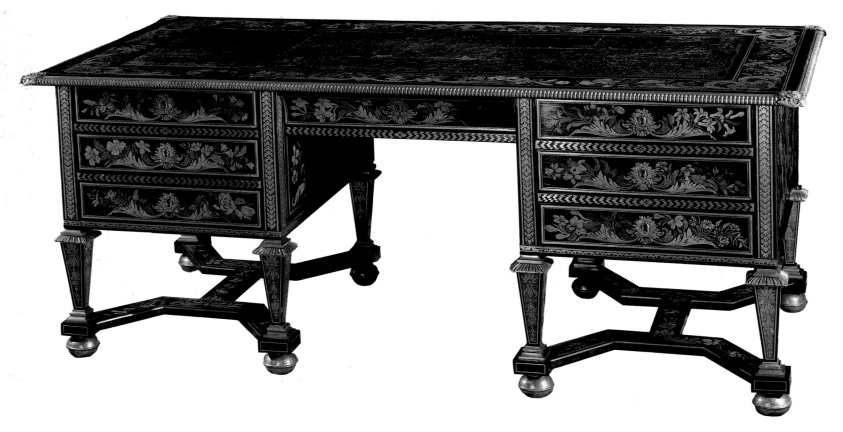

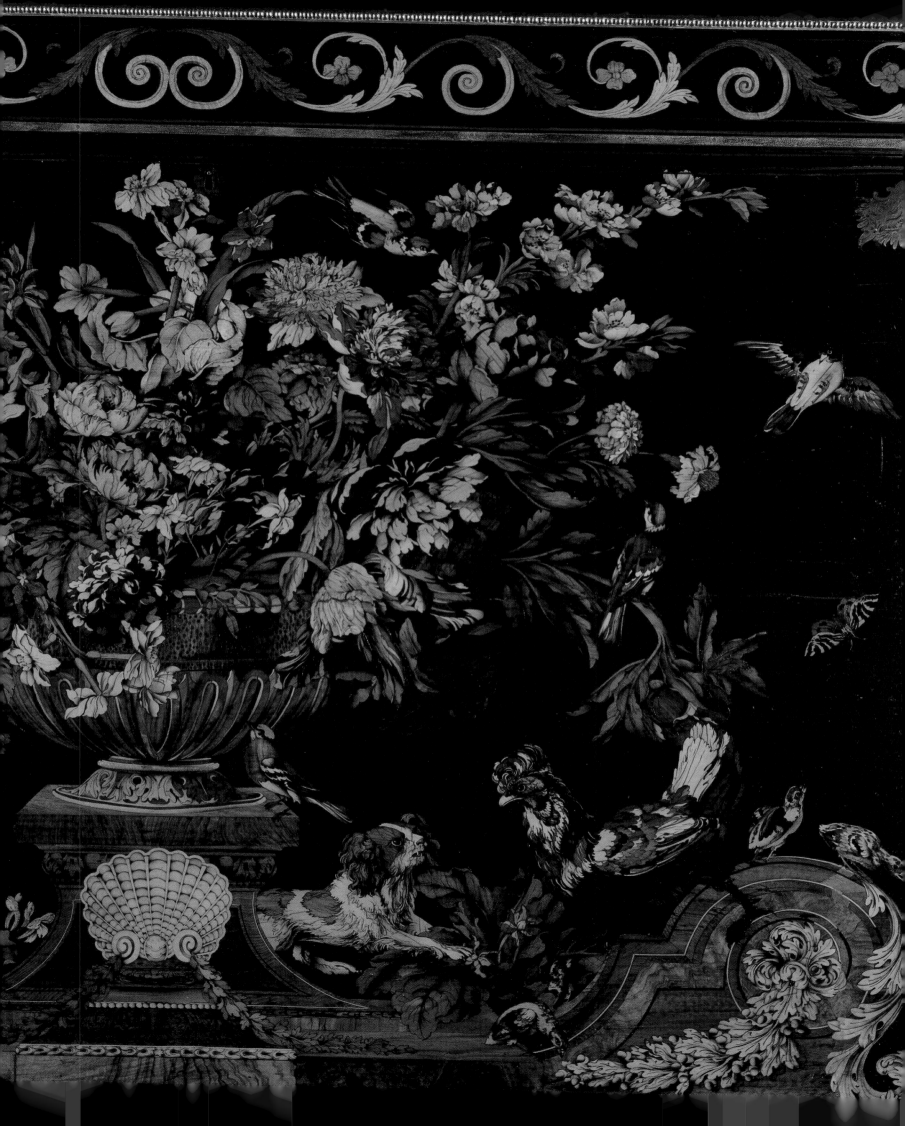

Longleat must also be dated to the 1690s. It is decorated in parts with horn stained to resemble lapis, a technique perfected by Cucci in about 1685–88, which still appeared as newsworthy to the Swedish envoy Cronström in 1696.

Furniture veneered in plain wood represents a large part of the workshop's production. The Deed of 1715 mentions many of them ('another commode in palisander . . . ordered by M. de la Croix', 'a bureau in amaranth ready for gilding, made for M. de Cotte', 'a serre-papiers in amaranth with three doors ordered by the Marquis de la Vieuville'). The accounts of the Bâtiments du Roi record an armoire in bois violet supplied by Boulle to Marly in 1700, as well as a commode in amaranth supplied in 1714 for Fontainebleau. Finally, there are numerous mentions in the inventories of Boulle's principal clients of pieces in palisander or in 'bois de violette', woods which were at that time frequently confused with amaranth. An example of this type of furniture is a commode in palisander [63], a drawing for which is in the Musée des Arts Décoratifs.

From the meagre chronological data at our disposal, it is difficult to gain an idea of the role played by Boulle in the development of three new types of furniture which appeared at the end of the seventeenth century: the commode, the bas d'armoire and the bureau plat. Commodes had already been in existence for about fifteen years when Boulle supplied his first examples to Trianon in 1708. In the daily entries of the Garde-Meuble Royal, two commodes called 'tables en bureaux' in walnut appeared in 1693, followed in 1695 by a commode in floral marquetry supplied by Gaudron for Marly. In the same way the bas d'armoire in walnut or marquetry appeared in the royal residences in about 1688 and was well distributed by about 1695, about ten years before any examples by Boulle, which are not recorded before 1700 (in an official document of 1700, the 'déclaration somptuaire' of Boulle's workshop, four low armoires are mentioned).

On the other hand, Boulle definitely played a role in the creation of a piece of furniture popular throughout the eighteenth century, the bureau plat with three drawers. This was the last transformation of the so-called 'bureau Mazarin', as well as the large bureaux on eight round or square tapering legs made by Gole or Gaudron, which are mentioned in the Royal Archives up to about 1710. Boulle would seem to have designed this type before 1710. In 1711, in the inven-

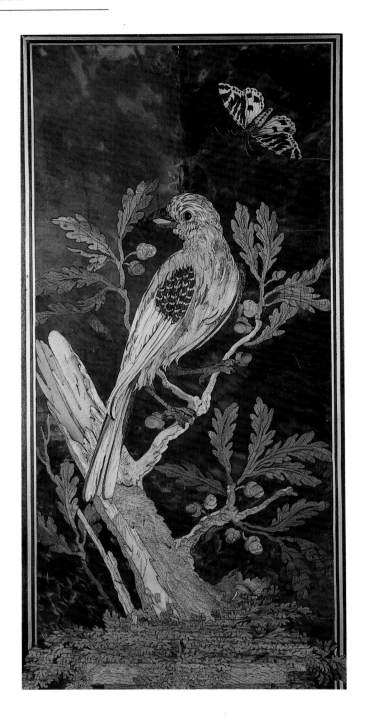

[52] Detail of the right side of the armoire shown at [53]; the marquetry is particularly realistic and detailed

[53] Armoire, c. 1700, decorated with a combination of floral marquetry in fruitwood and marquetry panels in brass and pewter on a tortoiseshell ground. The drawing for this piece is in the Musée des Arts Décoratifs. (Musée du Louvre, Paris)

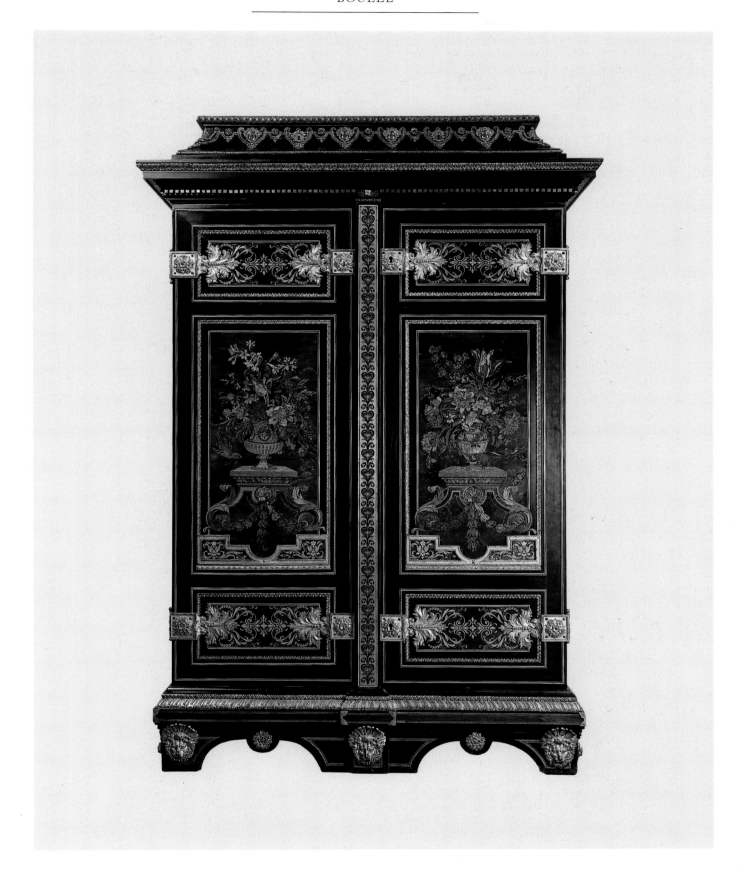

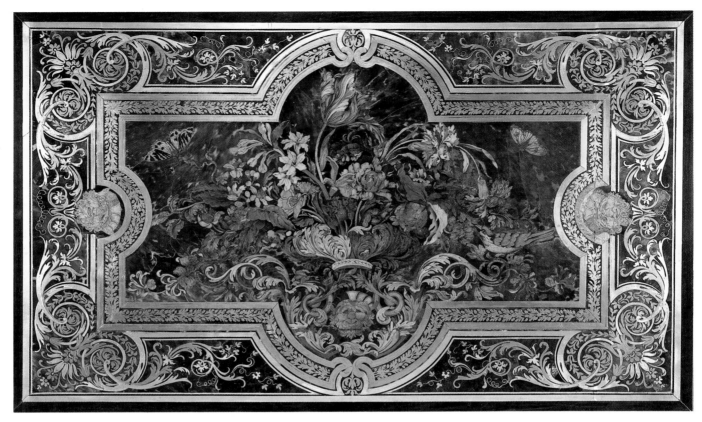

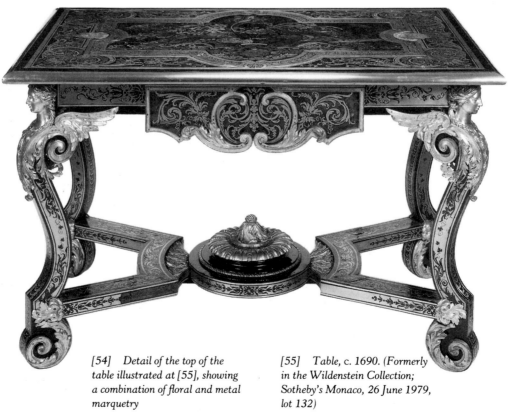

[54] Detail of the top of the
table illustrated at [55], showing
a combination of floral and metal
marquetry

[55] Table, c. 1690. (Formerly
in the Wildenstein Collection;
Sotheby's Monaco, 26 June 1979,
lot 132)

tory of Jean Phelipeaux, one of his clients, a bureau of this type is described as 'a large bureau in marquetry with gilt-bronze mounts, covered with black velvet, fitted with three drawers'. Daniel Alcouffe has discovered that in about 1713 the Verany de Varenne, dealers in the Place Dauphine, offered for sale 'a large bureau made by Boul [sic] decorated with gilt-bronze mounts, with a tortoiseshell ground'. However, it would seem improbable that this type of desk was designed before 1700. There is a drawing by Gilles-Marie Oppenord in the Cooper-Hewitt Museum which served as a preliminary study for these desks and it is known that he only returned from Italy in 1699.

If Boulle's role as the designer of new types of furniture is uncertain, his role in the evolution of furniture styles is clear. As opposed to the massive forms of French furniture dating from 1680 to 1700, he created dynamic forms, sometimes of a lightness that prefigures the rococo. The curved line not only affects the decoration on the surface of a piece of furniture but also animates its form. The cabriole legs, the concave aprons and the swelling forms that appear in his work of the years 1700–25 all herald the Régence style.

BIBLIOGRAPHY

Jean-Pierre Samoyault: *André-Charles Boulle et sa famille*, Geneva, 1979

Gillian Wilson: 'Boulle', *Furniture History Society Bulletin*, 1972

Jean-Nerée Ronfort: 'Le fondeur Jean-Pierre Mariette et la fin de l'atelier de Boulle', *L'Estampille*, September 1984, no. 173; 'André-Charles Boulle, die Bronzearbeiten und seine Werkstatt im Louvre', *Vergoldete Bronzen*, Munich, 1986, vol. II, pp. 459–520; 'La Déclaration somptuaire d'André-Charles Boulle et son atelier', *L'Estampille*, February 1985, pp. 60–61

Jules Guiffrey: *Comptes des Bâtiments du roi sous le règne de Louis XIV*, Paris, 1881–1901; *Inventaire général du mobilier de la couronne sous Louis XIV*, Paris, 1885–86

Nouvelles Archives de l'art français: 1873, p. 86: 'Logements d'artistes au Louvre' (J. Guiffrey); 1880, vol. II: 'Sentences et arrêtes rendus contre Boulle au profit de ses ouvriers' (J. Guiffrey), p. 316; 1882, vol. III, pp. 106–10: 'Déposition du sculpteur Girardon contre Boulle'

Pierre Verlet: 'A propos de Boulle et du dauphin', *Nederlands Kunsthist. Jaarboech*, p. 31

A. de Champeaux: *Le Meuble*, Paris, 1885, pp. 60–97

E. Molinier: *Le Mobilier français aux XVIIe et XVIIIe siècles*, pp. 53–80

Henry Havard: *Les Boulle*, Paris, 1893

Lunsingh Scheurleer: 'A la recherche du mobilier de Louis XIV', *Antologia di belle arte*, Rome, 1985, no. 27, pp. 48–49

Daniel Alcouffe: *Il Mobile francese dal Medievo al 1925*, Milan, 1981

Archives de l'art français, 1855–56, vol. IV, 'Pierre et Charles-André Boulle, ébénistes de Louis XIII et Louis XIV'

H. Hébert: *Dictionnaire pittoresque et historique de Paris*, 1766 [for the cabinet of Blondel de Gagny]

Gustave Macon, *Les Arts dans la Maison de Condé*, Paris 1903

APPENDIX I

EXCERPTS FROM THE ACCOUNTS OF THE BÂTIMENTS DU ROI RELATING TO BOULLE

20 June–9 November 1672: to Boulle in part payment for the Petite Chambre [of the Queen] at Versailles. *3,700L*

8 May–8 August 1673: to Boulle in part payment for another dais for the apartments of the Queen at Versailles. *1,200L*

17 August 1674: to Boulle in part payment for several daises in marquetry which he is making. *300L*

25 April 1675–8 May: to Boulle, ébéniste, final payment on 7,954L for the dais in marquetry for the Petite Chambre of the Queen. *2,754L*

30 April 1679: to Boulle, ébéniste, for repairing a parquetry floor. *70L*

19 January 1681: to Boulle,

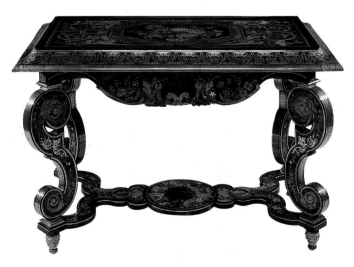

[56] Table with floral and pewter marquetry on a tortoiseshell ground, c. 1690.

(J. Paul Getty Museum, Malibu, California)

ébéniste, for a marquetry organ case decorated with bronze mounts to be placed in one of the apartments of the Château [Versailles]. *8,000L*

25 May 1681: to Boulle for his work on the organ for the Appartements of the Queen at Versailles. *210L*

9 August 1682: to Boulle, ébéniste, for his works. *21,900L*

11 January–18 July 1683: to Boulle, ébéniste, on the works in marquetry which he is making for the Cabinet of Monseigneur. *38,000L*

28 November 1683: to Boulle, ébéniste, for 2 marquetry tables and a stand for a rock crystal cabinet supplied for Monseigneur le Dauphin. *1,650L*

11 June 1684: to Boulle, ébéniste, on 17 gilt-bronze girandoles which he is making for the billiard room in the Petits Appartements of the King. *400L*

9 July–17 December: to him for gilt-brass works which he is making for the cabinets of Monseigneur. *15,100L*

9 January 1684: to Boulle for a marquetry coffer for Monseigneur. *700L*

2 January 1685: to Boulle, ébéniste, in part payment for works in marquetry and gilt-bronze which he is making for the cabinet of Monseigneur. *600L*

19 August–23 December 1685: in part payment for the parquet which he has laid in the cabinet of Monseigneur and other new works which he is carrying out. *10,300L*

11 November 1685: to Boulle, ébéniste, for his time and that of his assistants in repairing the marquetry dais in the Queen's bedchamber at Fontainebleau. *183L*

31 December 1684: to Boulle, ébéniste, for works in marquetry which he has carried out to the parquet in the alcove for Madame la Dauphine. *167L*

10 February–17 November 1686: to André-Charles Boulle, ébéniste, in part payment for the marquetry floor laid by him and the 8 chairs with marquetry, tortoiseshell and brass which he has made for the Cabinet des Bijoux of Monseigneur. *9,102L*

16 February 1687: to André-Charles Boulle for reinstating and polishing the marquetry floors in the Cabinets of

Monseigneur at the Château de Versailles. *129L*

21 December 1687: to him for days spent by journeymen ébénistes reinstating the said parquets of Monseigneur at Versailles. *117L*

15 January 1690: to Boulle, ébéniste, for 2 brackets and '8 culs-de-lampe' [pendants] in gilt-bronze supplied by him for the Cabinet of Monseigneur and for the restoration of 6 marquetry pedestals. *157L*

8 April 1691: to Boulle, ébéniste, for rods or mouldings of bronze, gilded and ungilded, which he has supplied and positioned on the chimneypiece in the Petit Appartement of Monsieur at the Palais Royal. *23L*

9 December 1692: to obtain 15,174L to be paid to André-Charles Boulle, ébéniste, which, together with 79,250L already received by him, makes complete payment of 94,424L to cover all the marquetry works which he has carried out in the Cabinet des Bijoux of Monseigneur le Dauphin during 1682, 1683 and 1684 and the four fauteuils and four folding stools which he has supplied for the said Cabinet in 1686, together with 126L for taxes. *15,300L*

25 December 1692: to Boulle final payment on 94,424L for the marquetry works which he installed in the Cabinet des Bijoux [same description as the preceding entry]. *15,174L*

15 March–21 June 1699: to the aforesaid Boulle, ébéniste and fondeur, for the bronzes made by him for the chimneypiece at Meudon: 4 bases, 2 capitals, 2 pilasters with 4 brackets. *2,492L*

6 April 1700: receipt of 700L for the price of 36 pinewood beams sold to Sr Boulle, ébéniste, on 21 March 1699 and supplied on 17 November [. . .] *700L*

7 February–7 March 1700: to Charles Boulle, ébéniste, for an armoire made by him and placed in the King's wardrobe at Marly. *1,000L*

27 February–30 October 1701: to André-Charles Boulle, ébéniste, in part payment for 7 tables made by him for the Ménagerie at Versailles. *6,400L*

14 August–18 September: to him in part payment for the double gilt-bronze wall lights which he has made for the chimneypiece in the antechamber of

Monseigneur at Meudon. *850L*

30 October–13 November: to him for the clock-stands which he made for the King's use. *600L*

11 December 1701: to André-Charles Boulle, ébéniste, for clock-stands made by him in 1701. *150L*

29 October 1702: to André-Charles Boulle, ébéniste, for the repair of the large armoire in bois violet in the King's wardrobe at the Château de Marly. *55L*

22 June 1704: to André-Charles Boulle, ébéniste, for marquetry work with which he repaired a dais in the apartments of the Château de Fontainebleau in 1703. *160L*

19 February–8 April 1708: to Boulle, ébéniste and caster, for 2 marquetry bureaux made for the King's Bedchamber at Marly. *2,500L*

3 September 1708–18 April 1709: to him for 2 bureaux which he has made for the Palais de Trianon. *3,000L*

11 February 1712: to the said Boulle, ébéniste, for the marquetry bureau made by him for the apartments of Madame la Dauphine at Versailles in 1711. *1,025L*

1 May 1712: to Boulle, ébéniste, for the works in marquetry made by him for the alterations to the bureaux in the Petit Appartement of the late Madame la Dauphine at Versailles in 1712. *120L*

25 November 1712: to him for a tortoiseshell marquetry bureau enriched with gilt-bronze mounts which he has made and supplied for the King's use at the Château de Versailles during 1712. *1,250L*

6 August 1714: to Boulle, ébéniste and caster, for a commode in amaranth with gilt-bronze mounts made by him for the King's Bedchamber at Fontainebleau during this year. *1.600L*

To him for a bureau with tortoiseshell marquetry and gilt-bronze mounts which he made for the King's use. *1,350L*

APPENDIX II

LIST OF BOULLE'S WORKS (WITH THE EXCEPTION OF CLOCKS)

Boulle's output is enormous. It represents more than sixty years of activity of a workshop which

employed 20 assistants in 1685 and up to 30 in about 1730. It would be foolhardy to attempt a comprehensive catalogue. The present list is restricted to the principal known works (with the exception of clocks and long-case clocks).

Armoires with long-case clocks
1) Wallace Collection (F429): the movement of the clock signed by Pierre Gaudron; the marquetry in contrepartie. Provenance: described in the Deed of Gift by Boulle in 1715; later appeared in the Donjeux sale in 1793, lot 546.
2) Formerly in the Jean Saïdman Collection: in première partie. Provenance: also described in the Deed of Gift by Boulle in 1715 and then in the catalogue of the Donjeux sale in 1793.

Armoires with the legend of Apollo (Apollo and Daphne, Apollo and Marsyas)
3) Wallace Collection (F61; stamped by Dubois): in première partie, the sides with allegorical figures of Autumn and Winter. Hinges decorated with fleur-de-lys.
4) Wallace Collection (F62): in première partie, the hinges marked with a crowned 'C'. Hinges with tooled fleur-de-lys.
5,6) Formerly in the Demidoff Collection, San Donato sale, 24 March 1870, lot 267; the pair in première partie reputedly from the Choiseul-Praslin Collection.
7) British Royal Collection, Windsor: in première partie, mounts marked with a crowned 'C'. See C. Laking: *The Furniture of Windsor Castle*, 112.
8) Private collection: see exh. cat. *Louis XIV*, Musée des Arts Décoratifs, May 1960, no. 50 [46].
9) Private collection, Paris: with a bow-fronted cornice. Appeared in exh. cat. *Louis XIV*, Musée des Arts Décoratifs, May 1960, no. 49.

Armoire with Apollo's chariot
10) Formerly in the Collection of the Duc de Gramont: sale, Paris, 22 May 1925, lot 51, subsequently Sert Collection; the marquetry mainly in contrepartie and without a cornice; sides decorated with figures of Bacchus and Ceres. Illustrated in

exh. cat. *Louis XIV* at the Musée des Arts Décoratifs, May 1960, no. 48, pl. XIV.

Armoires of different designs

11) Metropolitan Museum of Art: formerly in the Collection of the Duc de Gramont; almost identical to the previous item but without the gilt-bronze bas-reliefs on the doors.

12) British Royal Collection, reproduced in C. Laking: *The Furniture of Windsor Castle*, p. 111. In contrepartie, in design very close to the armoires, nos 3–8, but with hinges applied in a different manner, the doors decorated with Neo-classical bronze medallions which are found on several bookcases by Levasseur. The marquetry on the doors, very dense, is different from that of Boulle. The doors were perhaps altered by Levasseur.

13) Wallace collection (F63): in première partie with a bowed cornice; male and female heads in profile on the doors in gilt-bronze.

14) Musée du Louvre (OA441); marquetry mainly in contrepartie, cornice decorated with sunflowers. Provenance: from the Royal collection restored by Riesener in 1774.

Armoires with vases of flowers in wooden marquetry

15) Musée du Louvre (OA5515): corresponds to a drawing by Boulle in the Musée des Arts Décoratifs. A similar armoire appeared in the sale of the Comte de Watteville, 12 July 1779, lot 117. Confiscated from M. de Goguelat during the Revolution [53].

16) The Hermitage; illustrated in *Les Arts Décoratifs de l'Hermitage*, Aurora, 1987; identical to the one in the Louvre.

17) Private collection; illustrated in exh. cat. *Louis XIV*, Musée des Arts Décoratifs, May 1960, no. 47, pl. XV. The same composition as the two preceding armoires and identical central panel; the bronze mounts not as rich and without a cornice.

Armoires with figures of Aspasia and the Philosopher

18, 19) Musée du Louvre, Paris (OA9518 and OA9519): pair in première partie, possibly heightened in the eighteenth century. Provenance: formerly in the Duke of Hamilton's collection, Hamilton Palace, sale 17 June 1882, lots 672 and 673.

Armoires basses with figures of Aspasia and the Philosopher

20, 21, 22, 23) Versailles: three in première partie (one stamped Delorme and two unstamped) and a fourth in contrepartie stamped by Montigny. Provenance: confiscated during the Revolution from the Duc de Noailles or Lenoir du Breuil.

24, 25) Versailles, Roudinesco Bequest: pair in contrepartie, (stamped by Montigny). Provenance: sale Paris, 1 December 1966; probably Neo-classical copies made for Julliot.

26, 27) British Royal Collection: illustrated in W. H. Pyne, *History of the Royal Residences*, 1819, then in the blue Velvet Closet, Carlton House.

28, 29) Chatsworth, Derbyshire: Duke of Devonshire's collection: pair in contrepartie.

30, 31) Formerly in the collection of the Prince de Beauvau: illustrated in Douglas Cooper, *Trésor d'art des grandes familles*, p. 301: pair in première partie [32].

32, 33) Formerly in the Patino Collection, sale Sotheby's New York, 1 November 1986, lot 103: pair in première partie, the mounts struck with crowned 'C'. Formerly in the Rothschild Collection, sold in London 1937.

34) Ashmolean Museum: in première partie together with a copy.

35) Formerly in the Sheremetiev Collection: in contrepartie; illustrated in Denis Roche: *Le Mobilier français en Russie*.

36) Musée du Louvre: a single cupboard. Provenance: originally in the Tuileries.

37, 38) Palais de l'Élysée, Paris: pair from the Tuileries in the nineteenth century and before that a confiscation at the time of the Revolution.

39) Mobilier National, Paris: one armoire, with 8 medallions on the theme of the War with Spain.

Armoires basses with figures of the Seasons

40–43) Versailles: 4 low armoires, seized during the

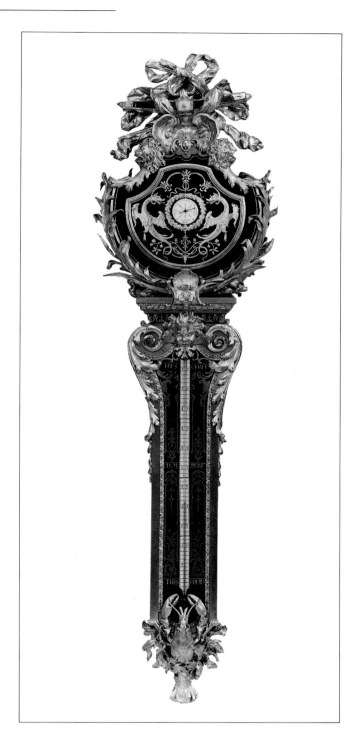

[57] *Thermometer; with its pair forming a barometer, datable c. 1720; the marine symbols (lobster and anchor), identical to those found on the Le Bon clock illustrated at [45], suggest that it was also made for the Comte de Toulouse, Grand Admiral of France. (Private collection)*

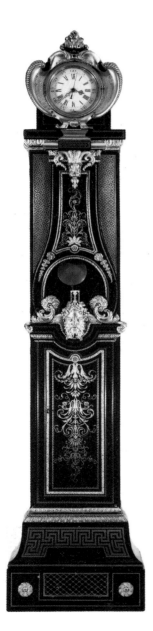

[58] *Long-case clock with Saturn mask, almost certainly the example bought from Boulle in 1707–8 by Prince Henry-Jules de Bourbon-Condé for the Petit Luxembourg, the movement being then by Rabby. (Sotheby's Monaco, 25 June 1982, lot 287)*

Revolution from the Duc de Noailles, corresponding to one of the plates in the engraved folio of Boulle's designs. Two are in première partie, the other two in contrepartie.

44, 45) Waddesdon Manor, Buckinghamshire (cat. nos 37, 38); pair in première partie with figures of Bacchus and Ceres, simpler examples than the previous ones, presumably altered in the eighteenth century.

Armoires basses of different design
46) Chatsworth, Duke of Devonshire's collection: armoire in première partie decorated on the front with figures of Mercury and Venus.

Tall bookcase
47) Sale Christie's London, 3 July 1986, lot 147, subsequently Galerie Fabre: cornice identical to the one on the armoire in the Louvre, the Hermitage and the Wallace Collection.

Low bookcases with glazed doors and figure of Pomona
48–53) Musée du Louvre: 5 decorated with figures of Pomona and one with the figure of Mars. Provenance: Duc de Bourbon at Chantilly. Heightened in the nineteenth century for the Gallery of the Château de Saint-Cloud.
54, 55) Wallace Collection (F386, 387) (stamped by Delorme). Pair in première partie decorated with figures of Pomona.
56, 56A) Formerly in the Anna Gould Collection: a pair in première partie, decorated with the figure of Pomona.
57, 58) Galerie Segoura: pair in première partie decorated with a figure of Pomona on one and Ceres on the other. Formerly in Mme Walter-Guillaume's Collection.
59, 60) Private collection, Geneva: pair in première partie, one decorated with figure of Pomona and the other with Bacchus. Formerly in the Helena Rubinstein Collection [19].

Low bookcases with glazed doors, decorated with putti
61, 62) Versailles (V2324): pair in contrepartie. Provenance: Duc de Brissac, seized during the Revolution.

63, 63A) Maurice Segoura Collection: pair in première partie. Provenance: de Blondel d'Azincourt, sold 10 February 1782, lot 414 [60].

Book-cases with glazed doors and a mask of Saturn
64) Formerly in the Kraemer Collection, sale Paris, 2 June 1913, lot 358; mounts marked with a crowned 'C'.
65) Versailles: Roudinesco Bequest; with an armoire on top, with glazed doors.

Low bookcase with two glazed doors
66, 67) Sale Paris, Étude Couturier Nicolaÿ, lot 151 (pair stamped by Delorme): in première partie.
68, 69) Formerly in the Boni de Castellane Collection: illustrated in Molinier, *Le Mobilier au XVII et au XVIIIe siècle*, pl. V: pair of bookcases.

Bureaux plats with 8 legs, dating from c.1690
70) Alexander & Berendt Ltd. Formerly in the Jacques Helft Collection; illustrated in exh. cat. *Louis XIV*, Musée des Arts Décoratifs, 1960, pl. XXXI. In fruitwood marquetry [50].
71) Longleat, Wiltshire: Marquis of Bath's collection: in fruitwood marquetry with lambrequins veneered in pewter and blue tinted horn.

Bureaux plats with six legs
72) Vaux-le-Vicomte, de Vogüe Collection (stamped by Levasseur): première partie with female heads at the corners. Corresponds to one of the plates in the engraved folio of designs by Boulle [25].
73) Formerly in the Ashburnham and Patino Collections; illustrated in *Connaissance des Arts*, August 1969, pl. 61: in première partie, with 3 convex drawers and masque en peltas on the sides. Corresponds to one of the plates in the engraved folio of Boulle's designs [26].

Bureaux plats with satyr heads and projecting central drawer
74) Boughton House, Northamptonshire: Duke of Buccleuch's collection: illustrated in *Connaissance des Arts*, October 1979, p. 78: with tortoiseshell

marquetry in première partie.
75) Formerly in the Roussel Collection, sale Sotheby's Monaco 22 July 1986, lot 550: marquetry in contrepartie of brass and ebony.
76) Private Collection, Neuilly: marquetry in première partie.
77) Formerly in the Tannouri Collection, sale, Ader, 15 November 1983, lot 42: marquetry in première partie in brass and ebony.

Bureaux plats with satyr head and recessed central drawer
78, 79) Louvre: pair of bureaux, one in première partie, the other in contrepartie, the legs terminating in jarrets d'animaux (animals' knuckles), corner-mounts formed of scrolls with satyrs' heads.
80, 81) Wallace Collection (F427): two bureaux, one in première partie, the other, in contrepartie.
82) J. Paul Getty Museum (85.DA.23), formerly in the Michel Meyer Collection: in contrepartie.
83) Museum of Decorative Arts, Budapest, formerly in the Festetics Collection: in contrepartie.
84) British Royal Collection: in contrepartie.
85) Frick Collection: in contrepartie.

Bureaux plats of a particular model
86) Private collection, Paris: illustrated in *Architectural Digest*, December 1979, p. 56.
87) Uppark, West Sussex: with a cartonnier set on top of the bureau; in première partie, scroll-shaped corner-mounts.
88) Sale Sotheby's New York, 3 May 1986, lot 158: bureau in ebony with serre-papiers; scroll-shaped corner-mounts.

Bureaux plats with Chinese heads
89) Sale Christie's Geneva, 18 November 1974, lot 54: in première partie, the sabots formed of foliate scrolls, decorated with masks of Heraclitus and Democritus.
90) Sale Sotheby's, 4 March 1989, lot 268: in contrepartie, identical to the preceding but with a top entirely in marquetry.

Bureaux plats with female heads

91) Private collection, Paris, formerly in the Duc de Gramont Collection: in première partie, illustrated in *Connaissance des Arts*, November 1963, p. 92.

92) Private collection, Paris; in première partie.

93) Formerly in the Marquis de Vogüe Collection, illustrated in *Les Ébénistes du XVIIIe siècle français*, Hachette *Connaissance des Arts*, p. 33: in première partie with a cartonnier surmounted by a clock with reclining figure of Time.

94) Formerly in the Foulc Collection, subsequently Wildenstein Collection, illustrated in Molinier, *Les Arts appliqués à l'industrie*, p. 69: in

première partie, with a serre-papiers on the desk surmounted by a clock in the form of a globe.

95) Sale Sotheby's London, 27 June 1988, lot 74: in première partie, decorated with masks of Democritus and Heraclitus.

96) Private collection, Paris: in contrepartie, the escutcheons in the form of cocks' heads.

97) Private collection, Geneva: formerly in the Prince de Wagram Collection; in contrepartie, the escutcheons decorated with female heads.

98) Sale Paris, 23 May 1924, lot 133: in contrepartie, with a cartonnier surmounted with a clock with the reclining figure of Time.

99) Formerly in the Fountains Abbey Collection: sale Christie's in 1966; private collection, Paris; in contrepartie; stamped Delorme.

100) Archives Nationales, Paris: bureau said to have belonged to Michelet.

101) Musée de Versailles; in première partie. Probably the bureau belonging to the Duc de Bourbon saved from the fire in Boulle's workshop in 1720 (information from C. Baulez).

Stands for coffers or cabinets

102) Chatsworth, Duke of Devonshire's collection: pair of stands with the front supports replaced by caryatids wearing turbans.

Cabinets on stands with figures of Hercules and Omphale

103) J. Paul Getty Museum

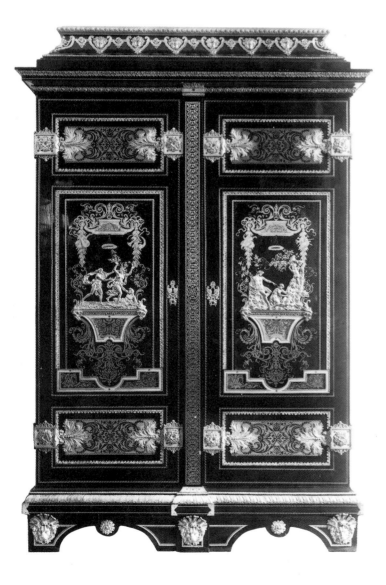

[59] Armoire portraying the legend of Apollo: the bas-reliefs portray Apollo and Daphne and Apollo flaying Marsyas, from Ovid's Metamorphoses *(Wallace Collection, London)*

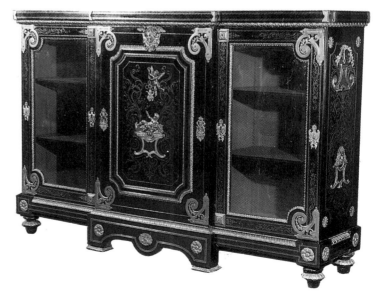

[60] Low bookcase, one of a pair which appeared in the Blondel d'Azincourt sale in 1782 where they were attributed to Boulle; a second pair belonged to the Duc de Brissac from whom they were seized during the Revolution, and these are now at Versailles. The motif of the recumbent child is found on the clock to the right in the second plate of the Boulle folio. (Maurice Segoura Collection, Paris)

(77, DA, 1): in tortoiseshell and fruitwood marquetry, decorated with fleurs-de-lys on the cornice; can be dated to *c.* 1693 [49].

104) Drumlanrig Castle, Dumfries and Galloway: Duke of Buccleuch's collection: almost identical to the preceding; can be dated to *c.* 1693; illustrated in *Connaissance des Arts*, December 1976, p. 81.

Cabinets decorated with floral marquetry

105) Wallace Collection (F16): in fruitwood marquetry with 14 drawers in the upper section, the cornice decorated with fleurs-de-lys; supported on a stand with figures representing the Seasons.

106) Cleveland Museum of Art: cabinet without its stand; almost identical to the one at Versailles with a parrot in marquetry on the door.

107) Drumlanrig Castle: Duke of Buccleuch's collection: almost identical to the preceding. A parrot in marquetry on the door, supported on a stand with figures representing the Seasons.

108) Private collection, Geneva, acquired from Perpitch: very similar to the preceding pieces, stand painted red.

109) Versailles: cabinet without stand, identical to the one at Drumlanrig, with small drawers in the cornice, acquired by Louis-Philippe in 1834.

Large domed cabinets

110) Boughton House: Duke of Buccleuch's collection: illustrated in *Connaissance des Arts*, October 1979, p. 76; supported on an English gilded stand. It bears the arms of a cardinal of the Colbert family.

111) Hermitage. Formerly in the Sheremetiev Collection: illustrated in Denis Roche, *Le Mobilier français en Russie*, pl. IV. Supported on a Louis XVI Boulle-marquetry base. Provenance: Grimod de la Reynière sale, 21 August 1797, lot 106 [39].

112, 113) Formerly in the Wallace Collection, Sir John Murray Scott sale, June 1913, lot 52, then Hillingdon Collection, sale Galerie Charpentier, Paris, 15 October 1953: pair of cabinets without bases.

Small low cabinets decorated with medals and lions' feet

114) Musée du Louvre, OA

5453: in première partie with medal of Louis XIV (stamped by Levasseur). Provenance: Lenoir du Breuil.

115) Musée du Louvre (OA 5454): pendant to the preceding piece in contrepartie with medal of Louis XIV. Same provenance (stamped by Levasseur).

116, 117) Wallace Collection (F391 and F392): pair of cabinets in contrepartie, decorated with medals of Henry IV on one and Sully on the other; on spiral feet.

118) Wanstead House, Essex: sale 10 June 1822, lot 17; with medal of Henry IV.

119) Victoria and Albert Museum: in première partie with medal of Henry IV (stamped by Weisweiler).

120, 121) Wrightsman Collection, New York; formerly in the Lady Baillie Collection: pair of cabinets with medal of Henry IV (one is supposed to be a copy of the other dating from 1785) [38].

122) Formerly in the Duke of Hamilton Collection, Hamilton Palace Sale 19 June 1882, lot 174, subsequently Kraemer Sale, Paris, 28 April 1913, lot 153: marquetry different from that on all other examples.

123, 124) Formerly in the Duc de Gramont Collection, sale Paris, 22 May 1925, lot 68: pair of cabinets decorated with medals of Henry IV and Sully, one in première partie, the other in contrepartie. Provenance: Earls of Essex, London, 1893.

Cabinets on stands

125, 126) Musée du Louvre, OA 5451 and 5452 (stamped by Levasseur): the top identical to preceding items; in première partie with medal of Louis XIV; stand with two square tapering legs decorated with rams' heads and a central splayed leg.

127, 128) Musée du Louvre, OA5468 and 5469: pair of cabinets in première partie, decorated with the figure of Louis XIV, stand with two supports of square section decorated with rams' heads and central splayed leg.

Cartonniers

129) Blenheim Palace, Oxfordshire: Duke of Marlborough's collections: large cartonnier in première partie surmounted by a set of shelves

with figures of the Fates and a sphinx clock.

130) Wallace Collection (F413): upper section of a cartonnier with the Fates, surmounted by a clock with the Fates and dial signed by Le Roy.

Sarcophagus-shaped coffers

131, 132) J. Paul Getty Museum (82. DA. 1–2): pair of coffers, one in première partie, the other in contrepartie, with differing bases, one on six square tapering legs, the other on two square tapering legs with central truncated support. One of these coffers was probably made by Boulle for the Grand Dauphin in 1684. [14]

133) Blenheim Palace: Duke of Marlborough's collections: coffer identical to the preceding examples. The base, identical to that of coffer [132] with which it may originally have formed a pair, has been altered; the square tapering legs have been replaced by caryatids with turbans; on the other hand the central support is not truncated. Possibly the example that appeared in the Julliot sale in 1777.

134) Sale Sotheby's Monaco, 23 June 1976, lot 20: small example which was included in the exhibition *Louis XIV*, Paris, 1960, no. 179.

Coffres de toilette

135–138) Boughton House: Duke of Buccleuch's collection: two pairs, one in première partie and the other in contrepartie.

139) Formerly in the Earl of Cathcart Collection, sale Sotheby's London, 20 June 1975, lot 38: in première partie.

140) Formerly in the Prince Belosselski-Belozerski Collection, St Petersburg; illustrated in Denis Roche, *Le Mobilier français en Russie*, pl. XLVIII (bronze mounts stamped with crowned 'C').

141) British Royal Collection.

142, 143) Wallace Collection (F411 and 412): pair, one in première partie, the other in contrepartie, with added globes and crowns.

144, 145) Formerly in the Achille Seillière Collection, sale Paris, 9 March 1911, lot 89: pair, one in première partie, the other in contrepartie.

146) Formerly in the de Vogüe Collection, then Segoura Gallery;

in contrepartie [41].

147, 148) Formerly in the Helena Rubinstein Collection, sale Parke Bernet: pair.

149) Sale Christie's London, 20 June 1985, lot 60.

150, 151) Houghton Hall: Collection of the Marchioness of Cholmondeley; pair of caskets.

Coffres de toilette on stands with curved legs

152, 153) Schloss Moritzburg, formerly in the Saxon Royal Collections. A pair, one in première partie, the other in contrepartie.

154) Sir [Robert Abdy] Collection, illustrated in *Connaissance des Arts*, October 1960: in première partie.

155) Blenheim Palace, Oxfordshire; Duke of Marlborough's collection.

Other coffres de toilette

156) Chatsworth: Duke of Devonshire's collection: small casket supported on an English giltwood table.

157) Galerie Gismondi: with small variations but similar to the usual type; clasps in the form of cranes (symbols of vigilance).

Commodes with doors decorated with a caduceus

158) J. Paul Getty Museum (84 DA 58), formerly in the Cholmondeley Collection, sale Christie's 12 April 1984: decorated with lions' masks and heads of bacchantes [65].

159) Hermitage.

Sarcophagus-shaped commodes with winged female heads

160, 161) Versailles: pair supplied by Boulle in 1708 for the Bedchamber of Louis XIV and placed in the Bibliothèque Mazarine after the Revolution.

162) Metropolitan Museum of Art: Linsky Collection: with a verde antico marble top, formerly in the Winston Guest Collection.

163, 164) Vaux-le-Vicomte, Comte P. de Vogüe Collection: pair, one stamped by Levasseur and the other by Saint-Germain.

165) Petworth House, West Sussex, from the Hamilton Palace Sale in 1882.

166) Formerly in the Jean Lombard Collection (see exh. cat. *les Deux Grands Siècles de*

Versailles, Musée d'Art et Histoire, Geneva, 1953, no. 8).

Commodes with lions' heads and masques in the form of peltas

167, 168) Formerly in the Wildenstein Collection, subsequently Ojjeh and Clore Collections, sale Christie's Monaco, 25 June 1979, lot 31: pair, one in première partie and the other in contrepartie (stamped by Levasseur); from the Julliot sale, 20 November 1777, lot 698 and 699, sold for 1,400L, both to Lebrun [44].

'Oval' (also called 'drum-shaped') commodes

169, 170) Wallace Collection (F403 and 404): pair in brass marquetry on a red tortoiseshell ground, 'rouge griotte' marble top.

171) Henry McIlhenny Collection, Philadelphia: pair, with marquetry in première partie, from the Hamilton Palace Sale, 19 June 1882, lots 1282 and 1283.

172) Formerly in the Marquise de Ganay Collection, sale Paris, 6 May 1922, lot 255: commode in ebony.

173) Sale Sotheby's London, 17 April 1964, lot 27: in première partie.

174) Sale Paris, Palais Galliera, 12 December 1964: marquetry in contrepartie, stamped by Levasseur.

175) Formerly in the de Pauw Collection, sale Sotheby's Monaco, 23 June 1986: with floral marquetry of fruitwood.

Commode of a unique type

176) Wallace Collection (F402): stamped by Levasseur, with two drawers; marquetry in première partie [43].

'Arch-shaped' commodes with fauns' heads

177) Musée du Louvre (OA 5477): in première partie with Portor marble top. Provenance: sale of the Cabinet of M. Le Boeuf, 8 April 1783, lot 207.

178) Musée du Louvre (OA 5478): in contrepartie, with marquetry top, also from the M. Le Boeuf sale, 8 April 1783, lot 206.

179) Château de Chaalis, formerly in the Jacquemart André Collection: in première partie.

180) Boughton House: Duke of Buccleuch's collection: illustrated in *Connaissance des Arts*, October 1978, p. 100.

181) Formerly in the Cholmondeley Collection, sale Christie's, 6 December 1979, lot 137: this piece was reveneered in mahogany in the 19th century.

182) Formerly in the Lady Ravensdale Collection, sale Christie's London, 22 June 1989, lot 108; in contrepartie.

183) Private collection, Paris: illustrated in *Le XVIIe Siècle français*, Hachette, p. 65; sold Galerie Charpentier, Paris, 1957.

184) Formerly in the Victor de Rothschild Collection, sale Sotheby's, 19 April 1947, lot 25.

185) Newby Hall, Yorkshire.

Octagonal pedestals

186, 187) Frick Collection: pair of pedestals, one in première, the other in contrepartie.

188, 189) Sale Sotheby's London, 20 June 1982, lot 163: pair of pedestals with concave sides in contrepartie.

190, 191) J. Paul Getty Musuem (88. DA. 75). Formerly in the Baron Alain de Rothschild Collection: sale Couturier-Nicolaÿ, 4 December 1987, lot 112: pair of pedestals in contrepartie, fitted with a door. Provenance: sale of the stock of the marchand-joaillier Alexandre Dubois, 18 December 1788, lot 168.

192, 193) Formerly in the Duke of Hamilton's collection, Hamilton Palace Sale, subsequently sale Sotheby's New York, 31 October 1987, lot 129: pair of pedestals in première partie. Provenance: sale of the stock of Dubois, 18 December 1788, lot 169.

Pedestals with aprons

194–99) Musée du Louvre: six pedestals (two stamped by Levasseur and Severin and another by Levasseur), four in première partie and two in contrepartie.

200, 201) Formerly in the Goudchaux Collection, Loudmer sale, Paris, 25 April 1979, lot 99: pair of pedestals in contrepartie on a pewter ground.

202–05) Stratfield Saye House, Hampshire: Duke of Wellington's collection: four pedestals.

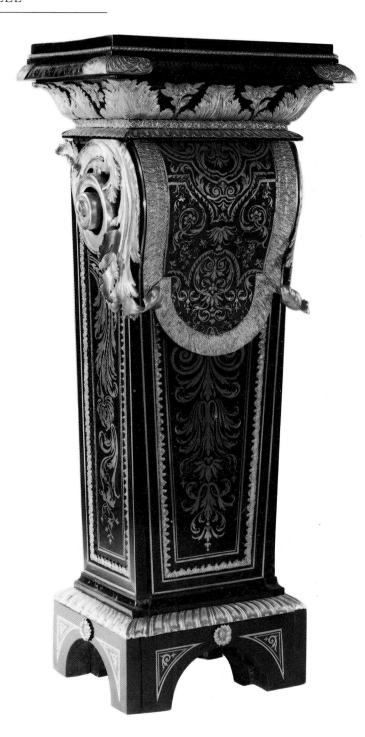

[61] 'Pedestal with apron' depicted in Mariette's engraved folio of Boulle's designs. This type was much repeated up to 1800. Several examples in the Louvre are stamped Séverin or Levasseur who restored them in the 1770s. (Archives Galerie Aveline, Paris)

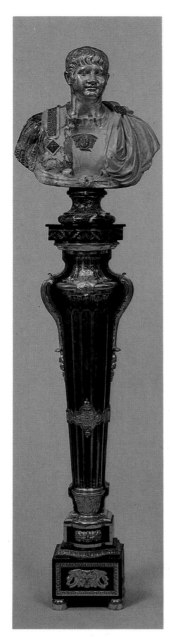

[62] *Pair of bow-fronted pedestals of the early eighteenth century: similar pedestals are mentioned in various eighteenth-century sales where they are all attributed to Boulle. (Galerie Aveline, Paris)*

206–09) Uppark, West Sussex: four pedestals in première partie.
210–13) Chatsworth: Collection of the Duke of Devonshire: four pedestals.
214, 215) Formerly in the Rothschild Collection, subsequently Caernarvon, sale Sotheby's London, 24 June 1988, lot 73: pair of pedestals in première partie.
216, 217) Formerly in the Tannouri Collection, sale Paris, 15 November 1983, lot 41 (one stamped by Levasseur): pair of pedestals in première partie.
218, 219) Formerly in the Lord Trevor Collection, sale Christie's, 14 April 1983, lot 93: pair of pedestals in première partie.
220, 221) Sale Couturier-Nicolaÿ, 16 June 1983, lot 56: pair of pedestals in première partie.
222–24) Versailles: three pedestals in contrepartie (in the apartments of Mme de Maintenon).

Bow-fronted pedestals
225, 226) Chatsworth: Collection of the Duke of Devonshire: pair in première partie.
227, 228) Formerly in the Baronne van Zuylen Collection, illustrated in *Connaissance des Arts*, April 1968: pair in contrepartie.
229, 230) Formerly in the Louis Guiraud Collection, sale Ader, Paris, 10 December 1971, lot 117: pair in première partie, also in exhibition *Louis XIV*, Paris, 1960.
231, 232) Formerly in the Hubert de Saint-Senoch Collection, sale Sotheby's Monaco, 4 December 1983, lot 219: pair in contrepartie.
233, 234) Formerly in the Lady Baillie Collection, sale Sotheby's London, 13 December 1974, lot 162: pair in première partie.

Square tapering pedestals
235, 236) Victoria and Albert Museum: Jones Collection: pair in première partie, with a small piece of paper bearing the date 1693 found under the veneer.
237, 238) Private collection, Geneva: pair in première partie, formerly in the J. Bloch Collection, sale 21 May 1957, lot 76.
239, 240) Formerly in the Charles Stein Collection,

illustrated in H. Havard, *Les Boulle*, p. 17.
241, 242) Formerly in the Marquis de Vogüe Collection, illustrated in *Les Ébénistes du XVIIe siècle*, Hachette, p. 33: pair in première partie.

Guéridons with scrolled feet and baluster stem
243–46) Musée du Louvre: Grog Bequest: two pairs of guéridons, one (OA 10450) stamped J.-L.-F. Delorme, the other (OA 10451) from the Dubois Chefdebien sale, 13 February 1941, lot 113.
247, 248) Formerly in the Dashwood Collection, West Wycombe House, sale Christie's, 20 June 1985, lot 72: pair of guéridons almost identical to the preceding examples. [25]
249–52) Formerly in the Earl of Warwick's collection, Warwick Castle, sale Christie's, 30 May 1968, lot 76: four guéridons.
253–54) Formerly in the Anna Gould Collection; a pair.
255, 256) Don Bartolomeo March Collection, Palma de Majorca: a pair.
257, 258) Wallace Collection (F417 and 418): pair of guéridons with stems differing from those of the preceding examples.

Guéridons with scrolled feet and three-sided stem
259, 260) J. Paul Getty Museum (87. DA. 5): pair.
261) Private collection, Paris: single guéridon.

Guéridons with pointed feet
262, 263) Formerly in the Anna Gould Collection, sale Sotheby's Monaco, 14 June 1982, lot 494; prototype found on pl. 4 of the folio of engraved plates of Boulle's designs.

Medal-cabinet
264) Residenz, Munich; Munzsammlung: large medal-cabinet with two doors with floral marquetry, illustrated in *Kurfürst Max Emanuel*, Munich, 1976, no. 412.

Small medal-cabinets
265, 266) Formerly in the Levy Gallery; pair of medal-cabinets in amaranth.
267, 268) Bibliothèque Nationale, Paris: pair of medal-

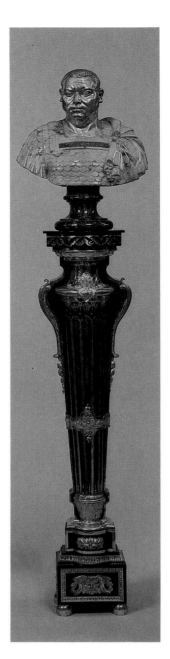

cabinets in première partie; confiscated during the Revolution from the Prince de Condé.

Mirror
269) Wallace Collection (F50): supplied by the dealer Delaroue to the Duchesse de Berry.

Side-tables with six legs and satyrs' heads
270, 271) Wallace Collection: pair of tables F424 (stamped Dubois) and F425 (stamped Leleu); top of one veneered with a triumphal carriage drawn by oxen, and the other with a bird-cage drawn by monkeys; stretcher with added Neo-classical vases.
272) Formerly in the Raoul Ancel Collection (stamped Dubois): with marquetry of tinted horn, sale Saint-Germain-en-Laye, 25 May 1986 [28].
273) Formerly in the Anna Gould, Duchesse de Talleyrand Collection, sale Sotheby's Monaco, 14 June 1982, lot 494: veneered with a triumphal carriage drawn by oxen; with scrolled acanthus feet of a different type [29].
274) Formerly in the Dennery Collection, sale Christie's London, 14 April 1983, lot 80: the foliate front feet struck with crowned 'C': in première partie veneered with a triumphal chariot drawn by oxen.
275, 276) Private collection, Paris: a pair with marquetry tops, exhibited by Maurice Segoura at the Biennale, 1982.
277, 278) Private collection, Paris: pair of consoles with marble tops, probably formerly in the Jules Strauss Collection.
279) Bayerisches Nationalmuseum: in première partie, the marquetry top replaced by a leather top, illustrated in exh. cat. *Kurfürst Max Emanuel*, Munich 1976, p. 179.

Side-tables with six legs decorated with female heads
280, 281) Galerie Michel Meyer: pair of consoles, exhibited at the Biennale in 1986.
282, 283) Formerly in the Earl of Harrington Collection, sale Sotheby's, 22 November 1963, lot 69: pair of consoles identical to the preceding examples but with marble tops.
284) Formerly in the Roussel Collection, sale Sotheby's Monaco, 22 June 1986, lot 554: certain of the bronze mounts struck with the crowned 'C', in contrepartie (stamped Séverin); veneered with the triumphal chariot.
285) Formerly in the Cornelia, Countess of Craven Collection, sale Sotheby's, 15 December 1961, lot 170.

Small consoles with lions' heads
286) Waddesdon Manor (cat. no. 84): marble top and three legs; close to the example in the Comte du Luc sale, 22 December 1777, lot 44 and the Le Boeuf sale in 1783, lot 213.
287) Wallace Collection (F56): with marble top and only two legs, the frieze decorated with lambrequins and a faun's mask in the shape of a pelta; an almost identical table (with rams' heads in place of lions' heads) is described in the Donjeux sale, 29 April 1793, lot 550, and earlier in the Randon de Boisset sale in 1777, lot 784.

Small corner-tables in the form of stools of a type made for the Ménagerie
288, 289) Victoria and Albert Museum: Jones Collection (cat. nos 1015–1015a–1882): pair with première partie tops [15].
290, 291) Longleat: Marquis of Bath's collection: pair with marquetry tops.
292, 293) Sale Paris, Couturier-Nicolaÿ, 2 December 1975: pair of tables in première partie with marble tops.

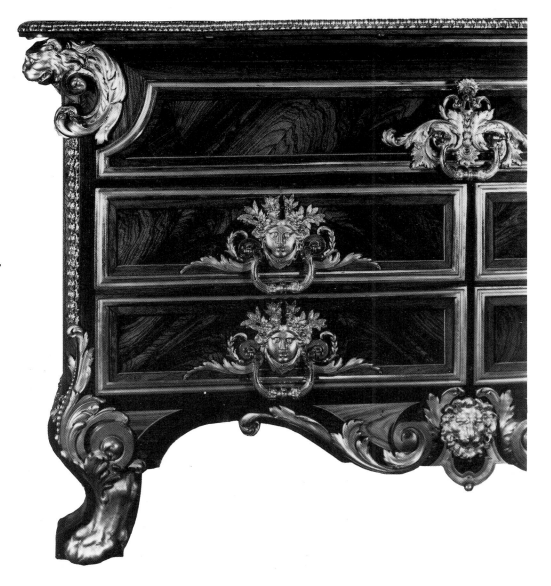

[63] Commode in palisander, in form close to a drawing in the Musée des Arts Décoratifs; the escutcheons are fashioned as masks of Daphne, a theme running through Boulle's work. (Sotheby's Monaco, 6 February 1978, lot 147)

Ebony consoles with two legs
294, 295) Formerly in the Lucien Guiraud Collection, sale Ader, Paris, 12 June 1973, lot 97: pair of consoles with central mask of an old man.

Small tables with cabriole legs
296) Formerly in the Armaillé Collection, subsequently Wildenstein, Akram Ojjeh sale, Sotheby's, 25 June 1979, lot 10 (stamped by N. Petit).
297, 298) Sale Paris, 10 June 1968, lot 63: pair of tables in première partie with pointed feet, featured in the exhibition *Le Cabinet de l'amateur*, 1956, no. 216.
299) Sale Sotheby's New York, 13 October 1983, lot 481.

Small tables en bureaux
300) Musée Condé, Chantilly: in première partie, with marquetry top. Confiscated during the Revolution from Lenoir du Breuil.
301) Sale Sotheby's New York, 7 May 1983, lot 207: in contrepartie with leather top. Same provenance as preceding.

Rectangular tables
302) Formerly in the Earl of Warwick Collection, subsequently de Pauw, sale Sotheby's Monaco, 23 June 1986: with square tapering legs.
303) Formerly in the Wildenstein Collection, sale Sotheby's Monaco, 25 June 1979; with scrolled legs crowned with winged female heads [54, 55].
304) Formerly in the Dashwood Collection, West Wycombe House, sale Christie's, 20 June 1985, lot 72: with scrolled legs decorated with female heads.
305) J. Paul Getty Museum (91. DA. 100): with scrolled legs.

306) J. Paul Getty Museum (83. DA. 22): with scrolled legs.

Tables 'en huches'
307) Formerly in the Lady Baillie Collection, sale Sotheby's London [64].
308) Formerly in the Earl of Craven Collection, sale Sotheby's London, 17 March 1963, lot 161 (stamped by Erstet), and subsequently sold New York, 28 October 1978, lot 110.
309) Wallace Collection (F426): stamped by Erstet who possibly altered it in the 1750s.

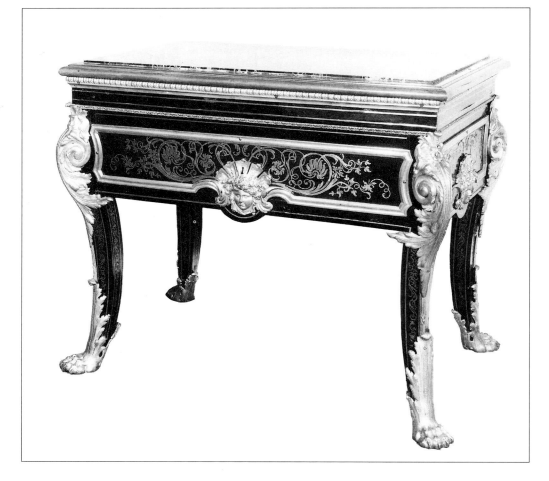

[64] 'Table en huche' (bread-bin shaped table), c. 1710. A table of this unusual shape is mentioned in the inventory taken after the death of Pierre Gruyn, a client of Boulle, in 1722. It is described as 'a work by Boulle'. (Archives Galerie Fabre, Paris)

[65] Commode with caduceus, c. 1700–20; with its pair now in the Hermitage, it belonged to the daughter of the goldsmith Delaunay, and was made to contain medals. (J. Paul Getty Museum, Malibu, California)

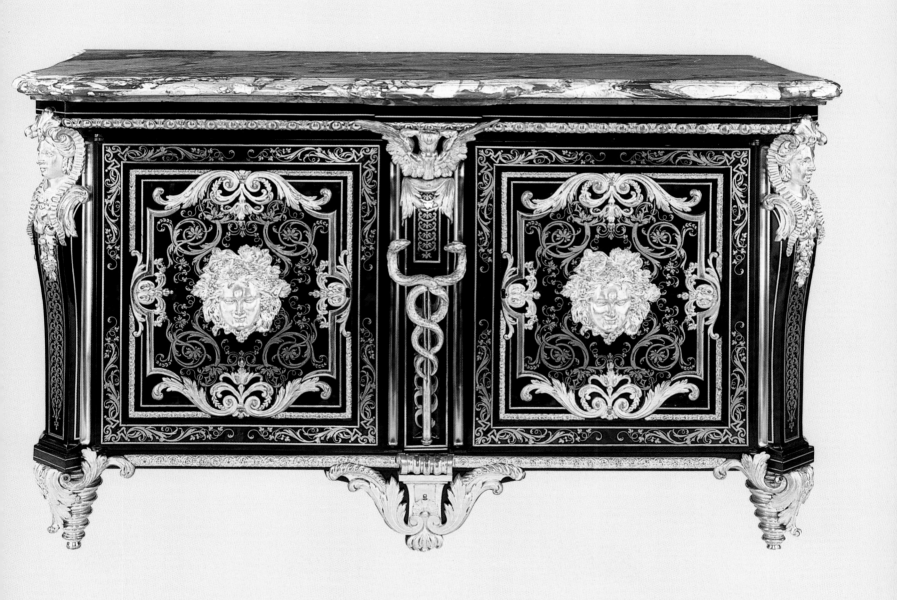

[66] *Bureau plat stamped*
N.G., c. 1732–36, in amaranth;
the female heads are copied from
models by Boulle, no doubt bought
from the sale after the latter's
death in 1732. (Sotheby's
London, 17 May 1963, lot 171)

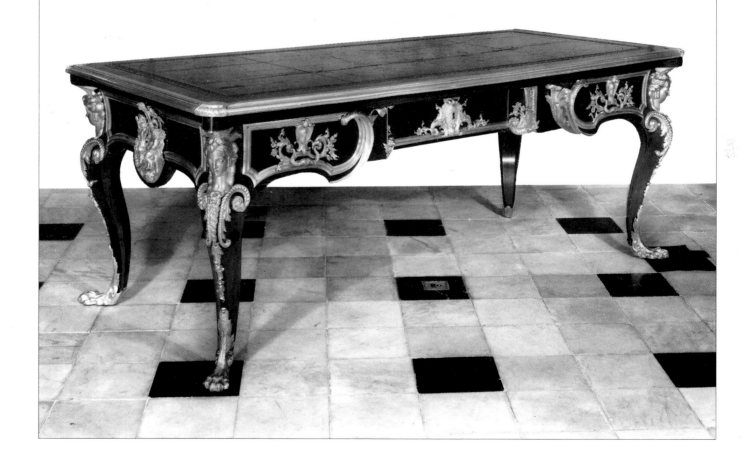

Noël Gérard
N.G.

Noël Gérard was the son of Nicolas Gérard and Marguerite Montigny, sister of Claude Montigny (grandfather of Philippe-Claude Montigny) and was born before 1690. On Nicolas Gérard's death, his widow married Louis Dubois, by whom in 1694 she had a son, Jacques Dubois, the renowned ébéniste, who was thus Noël Gérard's half-brother. The latter was apprenticed in 1701 to François Clabaux, at the houses 'Au nom de Jésus' and 'A la levrette', rue du Faubourg Saint-Antoine. He married Marie Colin on 14 December 1710, the widow of a 'menuisier en ébène' by the name of Jean Chrétien. Noël Gérard became both an ébéniste and a dealer. H. Vial records him as being established in 1719 in the rue du Faubourg-Saint-Antoine at the sign of the 'Cabinet-d'Allemagne'. In the same year he promised the Abbé Le Camus a 'bureau de travail' with cabriole legs. His business prospered and soon he moved into the sumptuous hôtel of the financier Jabach situated at the corner of the rue Saint-Martin in the quarter for finance and luxury goods. Besides his activities as an ébéniste he had become one of the most important marchands-merciers in Paris. His clientèle included not only the ex-King of Poland, Stanislas Leszczyński (who bought tapestries from him), but also a prince of the blood such as the Comte de Clermont (who owed him 139,672 livres in 1734) or the Président à mortier of the Parlement of Paris, Gabriel Bernard des Rieux (who owed him 4,800 livres in 1735) and Molé (1,110 livres). Other clients of his were the Comte de Watteville, the Chevalier d'Erlac, colonel of the Swiss Guards, the fermier général Le Riche de la Popelinière, the Duc de Bauffremont, the Prince de Carignan, M. Lenormand, advocate to the Parlement, the Comte de Gomecourt, and MM. Gaultier, Lollin, Gabriel, Guiral de Beaulieu and de Blanchefort.

Foreign ambassadors also bought furnishings from Gérard, including the ambassador of Spain, the Marquis de Castellas who owed him 108,000 livres as well as his secretary Don Ferdinand de Trevigno who owed him for more than 4,000 livres worth of furniture. The English ambassador Lord Waldegrave bought furniture to the value of 2,200 livres at his shop in 1733.

It is also recorded that Noël Gérard commissioned other ébénistes to provide him with his carcases. In 1713 he had a dispute with Charles Bernouville over two defective bookcases, and another in 1721 with Jacques Dieufait who provided him with commode carcases for 7 livres 8 sols each. Gérard died in mid-career in the spring of 1736. The inventory taken at the former hôtel of financier Jabach on 17 August 1736 lists a considerable stock of all branches of the furnishing trade. The interminable inventory describes in turn the shop of an ébéniste, tapissier, antique-dealer, ironmonger, picture-dealer, and dealer in arms, mirrors and lighting. Added to this he was a timber mer-

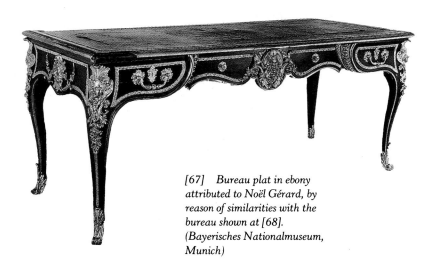

[67] *Bureau plat in ebony attributed to Noël Gérard, by reason of similarities with the bureau shown at [68]. (Bayerisches Nationalmuseum, Munich)*

chant: the inventory concludes with a list of stocks of wood which he stored on the quai de la Rapée (nearly 7,000 planks). The total assets were valued at 565,000 livres.

In the workshop there were seven work-benches fitted out with their tools as well as large stocks of exotic woods, proof that Gérard maintained his original craft of ébéniste. The list of these woods gives an interesting indication of their respective values at the time (see Appendix).

Of the furniture, apart from 80 clocks, there were more than 150 pieces in various states of completion. Clocks therefore represented a third of the workshop's total production. Among the cabinet pieces, commodes were most numerous: there were 38 examples listed, estimated at around 100 livres each, of which 16 were 'commodes en tombeaux' and seven 'à la Régence'. Of the woods used for commodes, palisander was the most common (13) followed by bois de Cayenne (seven) and kingwood (six). The commode in Gérard's bedchamber was described as 'in ebonized wood with brass stringing'. Apart from the commodes, the workshop mainly produced bureaux plats (23 are listed in ebonized wood, in kingwood and in amaranth) as well as encoignures (14 examples, of which six were in amaranth, two in palisander and two in bois de Cayenne). Several of the encoignures were tall 'with two small doors at the base and two further doors above', sometimes with a central drawer or an open recess with marble top. The prices varied between 24 livres for a pair of low encoignures and 300

livres for a pair of 'tall examples in amaranth'. Various games-tables are listed (trictrac in amaranth or a quadrille-table), but this was obviously not an important part of Gérard's production. No pieces in lacquer are mentioned, but there were a quantity of 'cabarets' or 'cabaret trays in japanned wood' or 'bois des Indes'. The inventory also lists 11 secrétaires, a then fashionable piece of furniture, as well as eight serre-papiers and the same number of armoires. There were 13 bookcases, some tall, others of breast height, of which four were with marquetry on a tortoiseshell ground, three in ebonized wood and two in amaranth.

The pieces of furniture with the highest values in the inventory were:

No. 155) Two large armoires with tortoiseshell marquetry with two large doors at the front and two small doors on either side, all decorated with gilt-bronze figures, priced at *4,000L*

One of these armoires later belonged to the minister Machault d'Arnouville and came to light recently (sale Christie's Monaco, 18 June 1989, lot 212). The long-standing attribution of this piece to Boulle cannot be sustained; it must be the work of one of his followers, perhaps Poitou or Cressent. Other items in Gérard's inventory are more reminiscent of Boulle, such as two chandeliers of a well-known Boulle type:

No. 250) An 8-branch chandelier representing Fame in gilt-bronze, priced at *450L*
No. 286) As above.

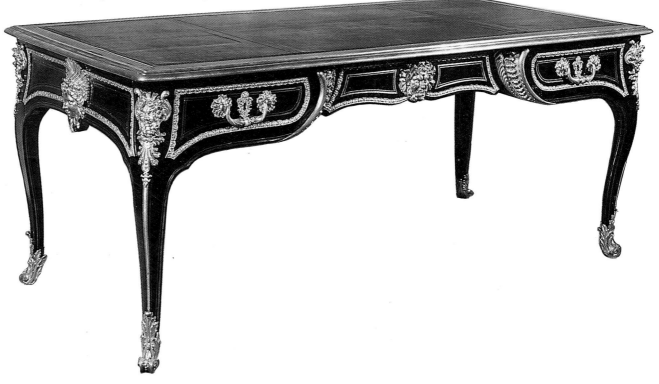

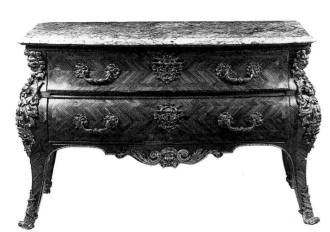

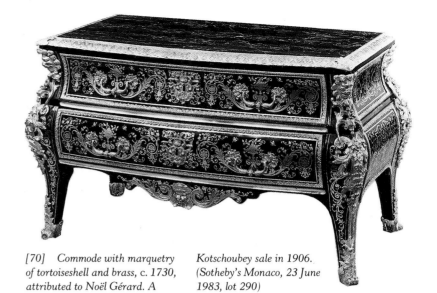

[69] *Commode stamped N.G.,
in palisander, c. 1730. (Mme
Camoin Collection, sale Paris, 2
April 1987)*

[70] *Commode with marquetry
of tortoiseshell and brass, c. 1730,
attributed to Noël Gérard. A
similar commode was in the*

*Kotschoubey sale in 1906.
(Sotheby's Monaco, 23 June
1983, lot 290)*

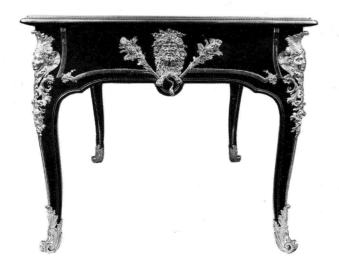

[68] *(left) Bureau plat in ebony
stamped N.G. The broken curve
at the top of the legs seems typical
of Noël Gérard. (Toledo Museum
of Art, Ohio)*

[71] *(above) Bureau plat in
ebony attributed to Noël Gérard.
(Archives Galerie Aveline, Paris)*

[72] *Side of the bureau plat
shown at [71], decorated with a
mask of Hercules*

Besides these chandeliers, Gérard offered sumptuous gilt-bronze or rock-crystal chandeliers to his clientèle at very high prices (altogether a dozen chandeliers priced between 400 and 6,000 livres) as well as mounted porcelain and busts in marble. He also had a huge assortment of artefacts in bronze: 41 pairs of wall lights are listed, mostly 'with two branches in gilt-bronze' but also 17 pairs 'in black bronze', that is, ready for gilding, and only four pairs 'in varnished bronze'. Forty-two pairs of chenets are mentioned, some of which can be recognized. These models are described as being in the form of 'a salamander', 'a goat', 'horses'; 'children and goats'; 'the wolf and the boar', 'the fable of the fox and the stork'; 'the hunt', 'an eagle', 'dragons', 'a trophy', 'rocailles with a lion's head'; 'dolphins' and 'farmyard'. The shop also stocked candelabra in gilt- or silvered-bronze of which there were twenty pairs and three pairs of girandoles.

Gérard stocked not only a number of 'mounts for commodes' in 'black (i.e. ungilded) bronze', but also quantities of bronze decorations and models, which are listed at the end of the inventory: '600 livres weight of bronze off-cuts, priced at *540L*'; '400 livres weight of lead and broken models, *60L*'; '200 livres weight of cast bronze, priced at *80L*'. It is probable that he was not infringing the guild rules in having bronzes chased in his own workshop for his own furniture. The inventory actually mentions 'a list of goods drawn up by Oliver de Rouvray and Louis Regnard, both master ciseleurs in Paris, rue des Arcis, whereby they would have admitted having in their possession all the rough casts of chenets, clocks, bases for girandoles and others, all belonging to sieur Gérard, which they had contracted to finish and chase as well as possible, for the price mentioned in the above document'.

The inventory describes a real upholsterer's stock. Entire sets of Brussels tapestries were offered for sale as well as suites of furniture: more than 100 chairs in gilt wood or walnut covered in damask or needlework and nearly 70 console tables in gilt wood with marble tops.

We believe it is possible to attribute to Noël Gérard a number of pieces stamped 'N.G.' and which date to the period 1720 to 1730. These pieces in ebony, palisander or amaranth are in a very particular style, thus facilitating the further attribution of a whole group of furniture to Noël Gérard which until now has remained anonymous. Thus the bureau plat in the Toledo Museum (stamped 'N.G.') [68] enables the attribution to Gérard to be made with regard to several other bureaux in ebony or amaranth with the same broken line above the legs and the same mounts: a bureau in the library at the Arsenal in Paris, another in the Bayerisches Nationalmuseum in Munich [67], another in the Residenz at Ansbach, and two further examples which have appeared recently at auction (sale, Sotheby's Monaco, 22 May 1978, lot 242 and New York, 7 May 1983, lot 210). Similarly, a commode in palisander was sold in Paris on 2 April, 1987, lot 133 [69] and is comparable with three other Boulle marquetry commodes: one in the Kotschoubey sale, Paris, 1906, the second in a Sotheby's Monaco sale, 23 June 1983, lot 290 [70], and the third at Longleat. Finally, the bureau plat sold at Sotheby's London on 20 November 1964, lot 121 with exaggeratedly projecting legs opens up the attribution to Gérard of several commodes with Boulle marquetry which have the same characteristics (sale, Paris, 26 November 1979, lot 64, Maître Oger). Until now experts have not paid attention to the stamp 'N.G.', no doubt taking it for a château mark. It is likely that many other pieces are stamped in this fashion and that much is still to be learnt about this ébéniste.

BIBLIOGRAPHY

Arch. Nat: Min. Cen. Et CXXI – 306: inventory taken after the death of Noël Gérard, 17 August 1736

J.-D. Augarde: 'Étienne Doirat', *The J. Paul Getty Museum Journal*, vol. XIII, 1985, p. 34, note 23

APPENDIX

INVENTORY OF WOODS FOUND IN NOËL GÉRARD'S WORKSHOP IN 1736

— 1,713 livres weight of palisander priced at 10L the hundred. *171L*
— 3,239 livres weight of seasoned amaranth, priced at 12L the hundred. *388L*
— 1661 livres weight of seasoned amaranth priced at 12L the hundred. *199L*
— 9,000 livres weight of bois de Cayenne priced at 12L the hundred. *1,080L*
— 650 livres weight of bois rouge of various types, priced at 12L the hundred. *78L*
— 1979 livres weight of kingwood priced at 40L the hundred. *790L*
— 737 livres weight of ebony priced at 20L the hundred. *147L*
— 2,150 livres weight of unseasoned amaranth priced at 25L the hundred. *537L*
— 100 planks of Dutch oak. *30L*

POITOU

PHILIPPE, *c.* 1642–1709; MAÎTRE MENUISIER EN ÉBÈNE BEFORE 1676
JOSEPH, *c.* 1680–1718; MASTER 1717

The earliest record concerning Philippe Poitou is his marriage contract with Constance Boulle, the sister of André-Charles Boulle, on 23 May 1672. There Poitou is described as 'menuisier en ébène, residing in the rue du Mouton in the parish of Saint-Jean-de-Grève, adult of more than thirty years, son of the late Jacques Poitou, gold and silver refiner in Paris, and of Catherine Lenormand'. The bride contributed a dowry of 1,000 livres in 'ready money, furniture, linen and effects'. The couple soon settled close to the Boulle parents-in-law in the rue des Sept-Voyes in the parish of Saint-Étienne-du-Mont, where they are recorded early in 1674. At this time both were employees of André-Charles Boulle. Under their contract they were required to work 'on all marquetry and any other work which Boulle might assign to them'. Their annual salary was 300 livres each. These conditions included a starting time of seven in the morning for Poitou, and eight o'clock for his wife (seven o'clock in summer) and finishing at the 'usual workers' hour'. Constance Boulle died in 1676. The division of her effects dated November 1676 describes Poitou as 'maître menuisier en ébène'. He was living in the Faubourg Saint-Victor, in the Grand-Rue in a house at the sign of Saint-Jean. We do not know whether Poitou continued to work for Boulle during the following two years. However, in 1678 his career took a new turn. On 25 April 1678 he remarried. His second wife was Catherine Sommer, daughter of the ébéniste Jacques Sommer (*d.* 1669) and Renée Combort. It was not long before he began to collaborate with his mother-in-law and received commissions to furnish the royal residences. The first mention of his name appears in the accounts of the Bâtiments du Roi on 18 December 1678, where he is recorded together with his mother-in-law and one Combort, probably her brother. The following year the name of Combort had disappeared. There was now only Poitou, in partnership with the widow Sommer, whose name in turn disappeared from the accounts by 1683, no doubt on her retirement.

For ten years, from 1678 onwards, Poitou worked for Louis XIV, engaged entirely in producing parquetry floors for the Louvre, Versailles and Fontainebleau. This parquetry almost always incorporated metal, ebony and brass, or brass and pewter, or again copper and pewter (see under Appendix). The term 'parquet' had a wider generic meaning in the seventeenth century than it has today, and could apply to low or tall vertical wainscot panels as well as to floors. In many cases, moreover, the accounts specify 'estrades de marqueterie' (platforms in marquetry) and 'parquets de marqueterie'. The term 'parquets' here could therefore just as well have applied to panelling for an alcove or a dado (such as those preserved in a circular closet in the Château de Maisons-Laffitte). While this work was in progress Poitou certainly had an atelier at the Gobelins, close to his home in the Faubourg Saint-Victor. A certificate drawn up in 1720 by the Duc d'Antin in favour of a certain Charles Sommer, perhaps a nephew of Poitou, indicates that the latter had 'worked in his trade of menuisier, ébéniste and marqueteur for ten years, six as an apprentice and four a journeyman in the service of the King at the Gobelins manufactory, under the supervision and discipline of Philippe Poitou, maître menuisier, ébéniste and marqueteur' (Arch. Nat. $0^1$1087).

After 1687 Poitou's name disappears from the accounts of the Bâtiments. He then worked for the Duc d'Orléans; in 1707, at the burial of his mother-in-law, he is recorded as 'ébéniste de Mgr le duc d'Orléans'.

Poitou also worked for Louvois or his son. In 1709 he rented a room in the Louvois house, rue de Richelieu, and owed 'Mme de Louvois 110 livres, deduction to be made for various works made for her'. The inventory drawn up after Poitou's death, on 23 May 1709, indicates a surprising poverty. The debts of 1,862 livres (together with 350 livres of receipts for work commenced) were balanced only by 200 livres in credit, which his widow doubted could be recovered, and goods valued at 150 livres. The only piece of furniture in stock was 'a commode in marquetery in contrepartie, unfinished'. This confirms that Poitou did not limit his output to floors. The workshop in the rue des Petits-Pères where Poitou died contained four workbenches, three with their tools, three sheets of copper engraved for the use of the ébéniste and weighing approximately 25 livres, and two pine boxes full of ébéniste's professional bronze models weighing 35 livres. In the annexe to the Louvois house were '30 engraved sheets of pewter weighing 40 livres', without doubt components of the panels designed for the Hôtel Louvois.

To date there is no furniture that can be attributed to Poitou, nor any floor made for the royal residences extant since they were probably cut up in the eighteenth century and reused to form panels on armoires, buffets or tables. One can only assume that after several years' collaboration between Poitou and Boulle, the style of their marquetry must have been fairly similar.

APPENDIX

EXCERPT FROM THE ACCOUNTS OF THE BÂTIMENTS DU ROI PUBLISHED BY GUIFFREY RELATING TO PHILIPPE POITOU

18 December 1678: to Poitou, Combord and the widow Somer, ébénistes, for 3 parquet panels in ebony for the Louvre. *1,050L*
26 July 1678: Somer and Poitou for 3 parquet panels with brass marquetry as made by them. *1,050L*
23 July–10 December 1679: to the widow Somer and Philippe Poitou, ébénistes, for 6 parquet panels in ebony and marquetry for the Louvre. *2,100L*
23 April–25 September: to the widow Somer and Poitou, ébénistes. for 6 parquet panels of ebony and brass marquetry, each 3 pieds square. *2,100L*

11 February 1680: to Philippe Poitou and the widow Somer, ébénistes, for 3 parquet panels with ebony and brass marquetry made for the Louvre. *1,050L*
28 July–27 October: to Poitou, ébéniste, for a wooden marquety dais for the Queen's Bedchamber in the State Apartments [at Versailles]. *2,100L*
27 April 1681: to Poitou, ébéniste, final payment of 5,855L for the marquetry dais made for the Queen's Bedchamber. *3,755L*
30 October: to the same for polishing the brass and pewter dais in the Queen's Bedchamber. *70L*
14 December: to the same for work on the marquetry in the King's Bedchamber [at Versailles]. *400L*
9 March 1682: to Poitou,

ébéniste, final payment of 1,311L for work on the dais of the King's Bedchamber. *911L*
12 July 1682: to the widow Somer and Poitou, her son-in-law, ébénistes, final payment of 1,274L for 6 ebony parquet panels with marquetry for the King. *674L*
14 February 1683: to Poitou, ébéniste, for repolishing and reinstalling the marquetry daises in the King's and Queen's Bedchambers in the State Apartments at Versailles. *118L*
23 January 1684: to Poitou, ébéniste, for repolishing and reinstalling two daises in the King's Bedchamber and in that of the Queen in the Château de Versailles. *300L*
25 November 1685: to Poitou for his payment for having taken up the marquetry dais of Mme la Dauphine and having repaired and reinstalled it. *182L*
15 July–21 October 1685: to the aforesaid Poitou, ébéniste, on account for the parquet made by him for the friezes for His Majesty's Cabinet. *2,600L*
18 August–3 November 1686: to

the aforesaid Poitou, ébéniste, final payment for parquet with copper and pewter compartments made by him for the alcove in the Queen's Bedchamber at Fontainebleau. *2,390L*
10 March–16 June 1686: to the aforesaid Poitou, marqueteur, and Clerin, engraver, complete payment of 9,685L for the parquet made by them, engraved and positioned in the Cabinet de Curiosités and the Blue Chamber at the Château de Versailles.
1 December 1686: to Poitou, for having restored and polished the parquets in marquetry in the Cabinets of the King, Monseigneur, and the dais in the Dauphine's Bedchamber. *157L*
9 November 1687: to Poitou, ébéniste, for repairs made by him to the marquetry parquets in the King's Cabinet and the dais in the Dauphine's Bedchamber. *351L*
24 August 1687 ('works in ebony'): to Poitou, ébéniste, for repairs to the parquet of the dais in the State Bedchamber in the Queen Mother's apartments at Fontainebleau. *50L*

JOSEPH POITOU

Philippe Poitou was survived by three sons, all of them ébénistes: the eldest, another Philippe, lived in the enclave of Saint-Jean-de-Latran, and the youngest, Jean, had settled in Orléans. The second son, Joseph Poitou, born between 1680 and 1685, started by working in his father's workshop, and he is mentioned as being there at the time of his marriage in 1708 to Claude Chevanne. He received as a marriage portion from his parents the value of a work-bench and set of tools. At this time the couple settled in the rue Notre-Dame-des-Victoires and Joseph Poitou became a marchand-ébéniste, taking over his father's establishment. The protection of the Duc d'Orléans was to 'underwrite their son to hold a warrant from Mgr. le Duc d'Orléans to open a shop and work at his said métier in this town'. Following this, Poitou executed works for the Duc d'Orléans at Saint-Cloud. A note in the inventory taken after his death in 1719 indicates that Cressent was owed '250L, with 40L due to the artisans who worked for the deceased at the Château de Saint-Cloud and 210L, partly for the payment of expenses incurred and partly to the business'. In 1717, on the

point of success, Poitou rented four houses in the rue Joquelet on the corner of the rue Notre-Dame-des-Victoires, establishing his shop at the junction of the two streets.

On 22 November of the same year Poitou was received master, but died at the end of 1718. The inventory drawn up after his death and completed on 2 June 1719 gives a picture of a very prosperous workshop. At the time, Poitou was a 'marchand-ébéniste' as is noted in the records, and the atelier boasted four work-benches. The assets were estimated at 2,745 livres with 2,400 livres' worth of furniture in stock. Like his father, Joseph Poitou owned his own bronze models. Described are:

Various lead models of different sizes and types, price *210L*
Copper bronze weighing 168 livres, price *168L*
The same gilt-bronze weighing 32 livres, price *32L*
A package with several sheets of amaranth.

These bronze models were probably supplied by Cressent. The man who is described as 'sculpteur to the King and of the Academy of St Luke' had close connections with the Poitou family. Collaborating with Joseph Poitou, he was named at the time of the succession as guardian to the Poitous' child. He lent money to Poitou's widow and eventually married her and took over the establishment in the rue Notre-Dame-des-Victoires.

The description of Joseph Poitou's stock of furniture shows clearly that, unlike his father, who specialized in Boulle marquetry, Joseph preferred the use of amaranth or palisander:

3 commodes, of which 2 in palisander-wood with ornaments and locks and the third in olive-wood decorated solely with locks and escutcheons. *85L*
3 commodes, of which 2 in amaranth and the other in Japanese wood, decorated with masks and figures in bronze-coloured brass, one of them being small, and all with their marble tops of different colour, priced together *650L*
An old cabinet in walnut . . . supported on twisted columnar legs. *12L*
An armoire in ebonized wood with 2 doors and fillets of bronze-coloured brass. *20L*
3 commodes in palisander-wood, viz. one embellished with handles, locks and escutcheons, the 2 others without mounts. *85L*
Another commode in bois des Indes with bronze mounts and marble top. *70L*

A commode in palisander wood mounted only with locks with marble top. *45L*
A low armoire in green ebony with metal frame. *35L*
4 commodes in palisander wood, of which 2 have their mounts and the other 2 almost finished. *120L*
2 corner armoires in acacia wood with marble tops. *50L*
A night-table in walnut. *6L*
A cabinet in wood from Grenoble [walnut] with cupboard underneath, the top with several drawers. *20L*
2 armoires, one in amaranth, the other in ebonized wood. *80L*
4 guéridons, of which two in walnut à la capucine [painted like natural wood], the other 2 in inlaid woods. *6L*
2 armoires, black, almost complete. *300L*

The furniture in Boulle marquetry is very much rarer:

A large toilet mirror with curved frame decorated with tortoiseshell marquetry, 2 toilet boxes and 2 pedestals also in marquetry decorated with gilt bronze. *90L*
A small marquetry table on cabriole legs decorated with bronze mounts. *30L*
A marquetry commode embellished with bronze locks and marquetry top. *80L*
2 toilet boxes and a mirror frame, all in marquetry. *20L*

Finally, certain pieces of furniture reflect the growing taste for chinoiserie:

2 cabinets, one large, the other small, in wood decorated in imitation Chinese lacquer. *12L*
6 shelves in wood decorated in imitation Chinese lacquer and ebonized, a small cabaret also in ebonized wood, two screens, altogether *36L*
2 cabinets in imitation Chinese lacquer with an ebonized base on twisted columns. *40L*
A small table in imitation Chinese lacquer

No piece of furniture can be attributed with certainty to Joseph Poitou; nevertheless, the numerous links with Cressent must encourage research in that direction.

BIBLIOGRAPHY
Arch. Nat. Min. Cent. XIII/199: Inventory after the death of Joseph Poitou, 2 June 1719
Arch. Nat. Min. Cent. VII/186: Inventory after the death of Philippe Poitou, 23 May 1709
Mlle Ballot: 'Charles Cressent' in: *Archives de l'Art Français,* vol. X, pp. 21–32
Jean-Pierre Samoyault: *André-Charles Boulle et sa famille,* Librairie Droz, 1979, pp. 36–37
H. Vial, A. Marcel and A. Girodie: *Les Artistes décorateurs du bois,* pp. 91 and 155

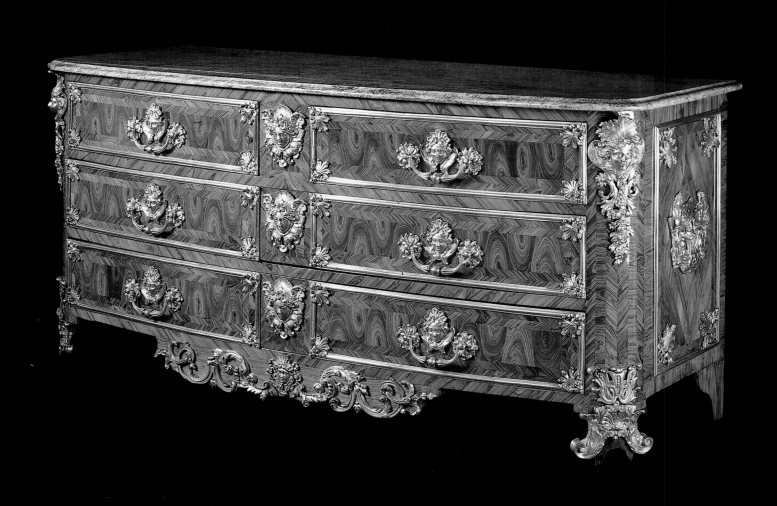

François
LIEUTAUD

BEFORE 1700–1748

The stamp 'F. L.' stands for François Lieutaud, the grandfather of Balthazar Lieutaud. Born in Marseille, François Lieutaud became a master ébéniste towards the end of the seventeenth century. From his marriage with Catherine Autran he had a son, Charles Lieutaud, who also became an ébéniste, settling in Paris where he married Etienette Dumondel in 1709, in the privileged precincts of the Abbey of Saint-Jean de Latran where his father later joined him. There were connections between the lat-

ter and A.-C. Boulle in about 1719, as he cites him as a personal expert-witness during legal proceedings at the time. These legal records reveal that Lieutaud cast his own bronze mounts for his furniture.

BIBLIOGRAPHY

Arch Nat.: Y 1899, 14 October 1719

J.-D. Augarde: 'Historique et signification de l'estampille des meubles', *L'Estampille*, 1985; *Ferdinand Berthoud, Musée de la Chaux de Fonds*, 1984, p. 254

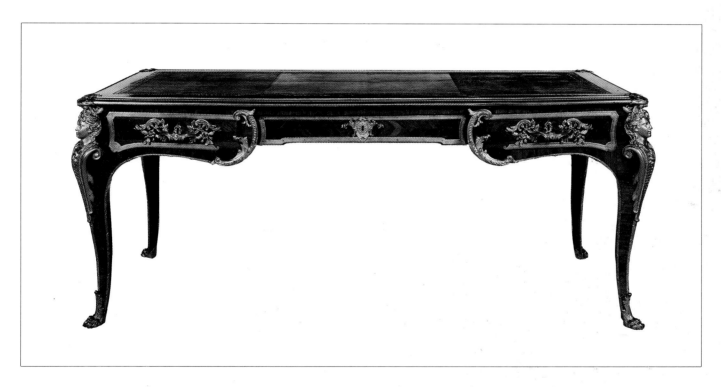

[73] (left) *Commode stamped F.L., in wave-patterned kingwood. The central winged mask is a copy of a Boulle model* *found on the Blondel d'Azincourt bookcases [60] (Archives Galerie Segoura, Paris)*

[74] *Bureau plat stamped F.L., in kingwood. (Waddesdon Manor, Buckinghamshire)*

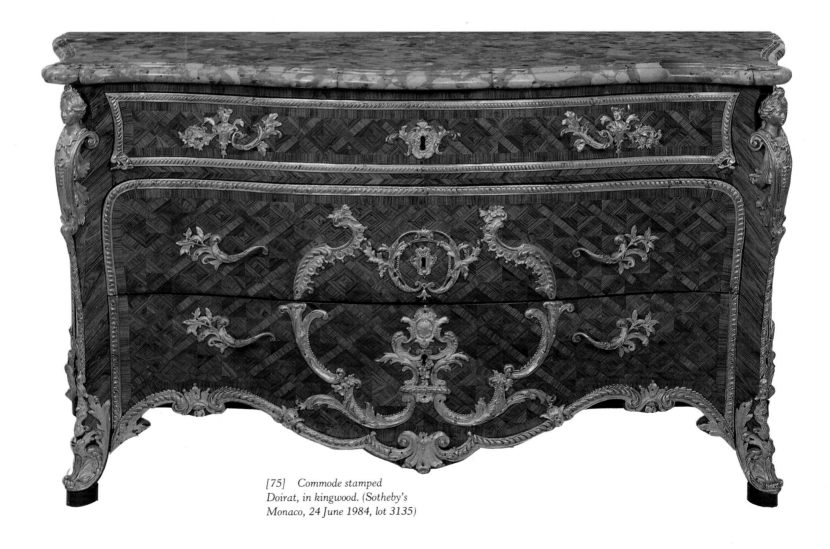

[75] Commode stamped
Doirat, in kingwood. (Sotheby's
Monaco, 24 June 1984, lot 3135)

Étienne DOIRAT

c. 1675–1732; LOUIS-SIMON PAINSUN, 1700–BEFORE 1748

Doirat (E.) has the distinction of being the only important ébéniste of the Régence who stamped his work, there being no stamped pieces by Cressent or Gaudreaus recorded. Thus the presence of a stamp facilitates the definition of a homogeneous output; this consisted almost entirely of commodes in palisander with trellis parquetry. Less frequently Doirat used amaranth and kingwood. The carcases of his furniture, generally fairly coarse, are in deal with walnut drawers. The repertory of gilt-bronze mounts is almost always identical, facilitating the attribution of a number of unstamped pieces: the same corner mounts in the form of wreathed female heads, festooned lambrequins and sphinx escutcheons and so on. The inventory taken after his death in 1732, published by M. Augarde, reveals that Doirat also produced types of furniture other than commodes: there are descriptions of bureaux plats, ebonized or in amaranth, bookcases with door-grills, bureaux called 'secrétaires' (secrétaires en pente) in amaranth, night-tables and encoignures, in all 200 varied pieces, finished or incomplete, of which 40 were veneered, including 21 in palisander, 11 in amaranth and four in kingwood. All the commodes either already had marble tops or were designed to take them, rather than marquetry tops.

The name of Gaudreaus appears among Doirat's debtors. He was certainly overburdened with commissions in his position of ébéniste to the Crown, and Doirat must have worked for him. Finally, the inventory reveals an interesting detail: '100 livres weight of imperfect lead casts used for garnitures for commodes and other pieces of furniture' . . . and then '250 livres of mounts, either chased or unchased, repaired for garnitures for commodes and other pieces'. Here is proof that Doirat kept exclusive control of his bronze casts, retaining not only the lead models but the unchased mounts and finished examples ready to be applied to the furniture. One is therefore on stronger ground when attributing certain pieces on the basis of the mounts. At the same time the inventory mentions only 'bronzes en couleur' (varnished) and not in gilt-bronze.

Doirat, born *c.* 1675–80, was married in 1704 while he was living in the Grand-Rue du Faubourg Saint-Antoine. He resided in this quarter all his life, settling in turn in the rue Saint-Marguerite in 1711, and the Grand-Rue again in about 1720, in a house under the sign of 'la Croix Rouge'. In 1726 he installed his workshop in the Cour de la Contrescarpe-des-Fossées-de-la-Bastille just within the Faubourg Saint-Antoine, in lodgings overlooking the trenches around the Bastille. His affairs would seem to have prospered, for in 1720 he provided his daughter Madeleine with a large dowry (2,500 livres). Moreover, in 1731 he leased premises in the Rue Saint-Honoré opposite the church of Saint-Roch, in order, no doubt, to sell his furniture. This quarter was considered a fashionable address by financiers and all retailers of luxury goods were established here. In 1732 Doirat was certainly a fashionable ébéniste. The inventory made on his death describes numerous pieces of furniture either completed or under construction and stocks of wood, and at least eleven work-benches.

His work was continued by his son-in-law, Louis-Simon Painsun (born 1700, died before 1748), who used the stamp L. S. P. Little is known of L. S. P.'s career: son of François Painsun, who was a master ébéniste living in the rue Saint-Nicolas in the Faubourg Saint-Antoine in 1727, Louis-Simon Painsun married Doirat's daughter in 1720 and probably worked with his father-in-law. On Doirat's death in

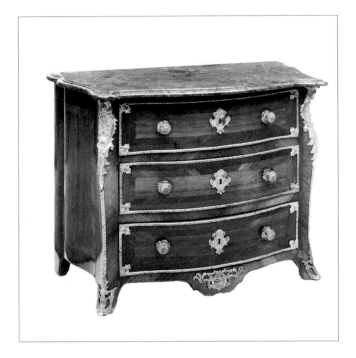

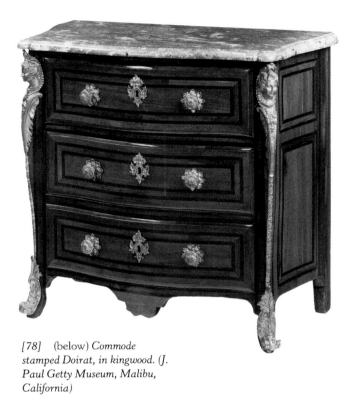

[76] Commode stamped
Doirat, veneered in bois satiné
and amaranth. (Sotheby's
Monaco, 26 November 1979, lot
256)

[77] Commode stamped
Doirat, in amaranth. (Sotheby's
Monaco, 23 June 1985, lot 822)

[78] (below) Commode
stamped Doirat, in kingwood. (J.
Paul Getty Museum, Malibu,
California)

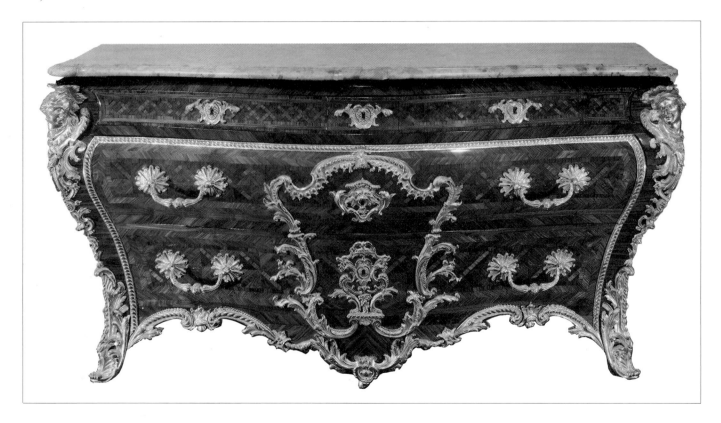

1732 Louis-Simon's father took over the lease and all the stock of Doirat's shop in the rue Saint-Honoré. It is likely that Louis-Simon took over the responsibility for the business. At the same time, L. S. P. must have supplied furniture to Migeon as their two stamps appear side by side on a table (Dalva Brothers, New York). L. S. P.'s style was also close to that of Migeon, with a preference for kingwood veneered in 'butterfly wings'. Numerous commodes by him are recorded with three rows of drawers separated by bronze flutings. A characteristic trait is the central drawer at the bottom which is recessed, an old-fashioned detail reminiscent of the form of the bureau from which the commode developed (sale Parke-Bernet New York, 13 May 1960, lot 314; sale Christie's London, 19 March 1970; sale Nicolaÿ, Paris, 12 March 1974, lot 174; sale Sotheby's Monaco, 9 December 1984, lot 995).

BIBLIOGRAPHY

Jean-Dominique Augarde: 'E. Doirat, menuisier en ébène', *The J. Paul Getty Museum Journal*, vol. XIII, 1985, note 11, p. 34

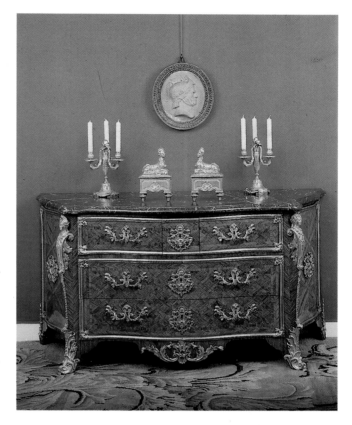

[79] *Commode attributed to Doirat, in kingwood; its pair is in the collection of the Prince of Hessen in Schloss Fasanerie at Fulda. (Archives Galerie Segoura, Paris)*

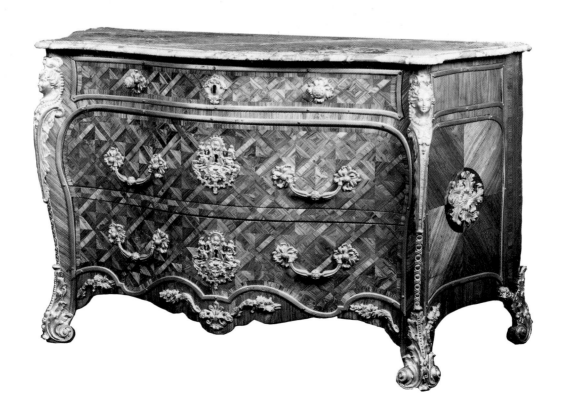

[80] *Commode stamped Doirat, in kingwood. (Private collection)*

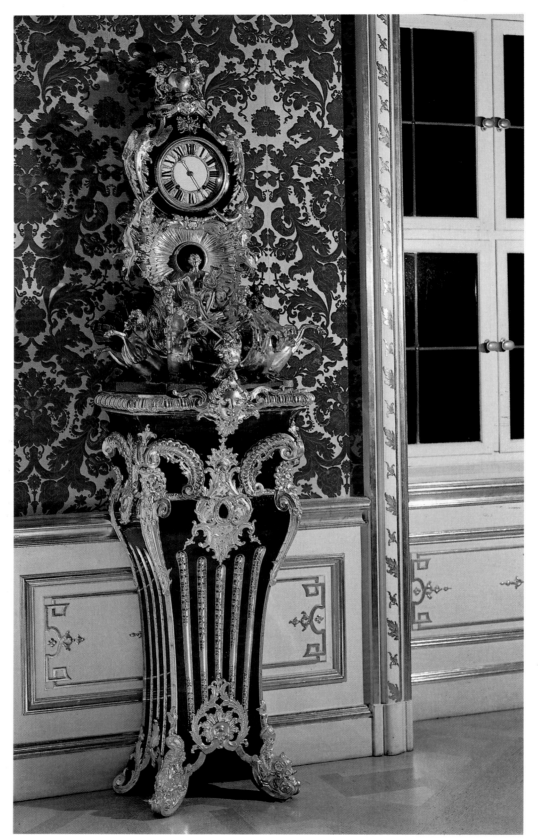

[81] *Pedestal in tortoiseshell,*
c. 1730; the bearded masks at the
corners are also found on a
number of other pieces of
furniture by the 'Master of the
Pagodas'. The clock with Apollo's
chariot of which there is another
example at Fontainebleau
(confiscated from Chantilly
during the Revolution) must be
attributed to Boulle; it appeared
in the Blondel de Gagny sale in
1776 and then again in 1783 in
the Blondel d'Azincourt sale,
attributed to Boulle with the
comment: 'made for the Regent'.
(Residenzmuseum, Munich)

THE 'PAGODA MASTER'

ANONYMOUS ÉBÉNISTE; ACTIVE 1730s

An entire group of furniture, among the most beautiful of the Régence, is still completely anonymous. None of these pieces is stamped or marked in any way, and it has not been possible yet to identify them from archival documents. Often attributed for no convincing reason to Cressent or Gaudreaus, they derive rather from the work of Boulle and are good examples of the taste for chinoiserie during the Régence. These pieces, commodes or bureaux plats, can be dated to *c.* 1730 for stylistic reasons as well as for the use of kingwood (and in rare cases bois satiné or palisander) veneers. Their stylistic relationships are accentuated by certain gilt-bronze motifs; the commodes usually have two rows of drawers and all of them are decorated with the same motif of a pagoda on the upper drawer and the same vase of flowers on the apron. The chinoiserie theme is echoed by the dragon motifs found on the central drawer of certain commodes en tombeaux and on the corner-mounts of two of the most spectacular pieces. Further dragon motifs are found on all the bureaux plats. The corner-mounts are of two kinds: corner-mounts with rococo scrolls and cabochons decorate almost all the commodes and the bureau in the Patino Collection. On the other hand, on almost all the bureaux there is a very unusual motif of mask with beard divided into two plaits ending in a fish tail. This is found on several commodes and on the celebrated pedestal of the Apollo clock in the Munich Residenz. Finally the drawer handles are of two types: with cross-bows, laurel leaves and escutcheons, or a simpler type with foliate details. This group comprises the following pieces:

Commodes à la Régence

1) Rijksmuseum, Amsterdam; formerly in the Dournovo Collection, St Petersburg, illustrated in Denis Roche, *Le Mobilier français en Russie*, vol. I, pl. XII.

2) Garbish sale, Sotheby's New York, 5 May 1985, lot 306, almost identical to the previous one except for the paw feet [83].

3) Former Guy de Rothschild Collection, sale Sotheby's London, 24 November 1972, lot 35: with dragon corner-mounts [84].

4) Private collection, Paris: with corner-mounts decorated with bearded masks.

Commodes en tombeaux

5) Ader sale, Paris, 14 March 1970.

6) Former Bensimon Collection, now in the United States: in tortoiseshell with dragon corner-mounts [87].

7) Sale Palais Galliera, 15 June 1971, lot 105: with small dragon motifs as found on the desks.

8) Galerie Fabre, Paris in 1988 [85]: in bois satiné; corner-mounts with bearded masks.

Pedestal for clock

9) Residenz, Munich: traditionally attributed to Cressent; in tortoiseshell.

Bureaux plats

10) Wrightsman Collection, New York, no. 145 in the catalogue.

11) Patino Collection, sale Sotheby's New York, 1 November 1986, lot 80 [86].

12) Earl of Normanton Collection, Christie's London, 1 July 1986; with feet similar to those on consoles by Boulle [82].

13) Private collection, Provence, formerly in the Comtesse Niel Collection. Illustrated in *Connaissance des Arts*, February 1980, p. 54.

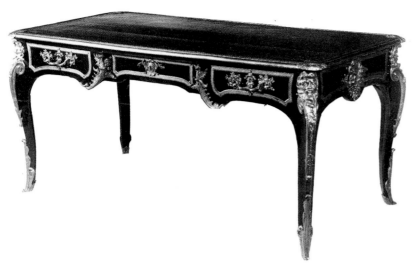

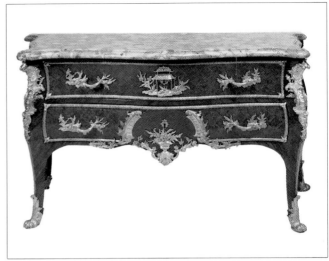

[82] Bureau plat in kingwood,
c. 1732–35, decorated with
motifs of dragons and bearded
masks. The pointed feet copy a
type of Boulle. (Christie's
London, 1 July 1986,
subsequently Galerie Segoura,
Paris)

[83] Commode in kingwood,
c. 1735, decorated with a
pagoda. Its pair is in the
Rijksmuseum, Amsterdam.
(Sotheby's New York, 5 May
1985, lot 306)

[84] (below) Commode in
kingwood, c. 1735, decorated
with dragons and pagoda.
(Archives Galerie Lupu, Paris)

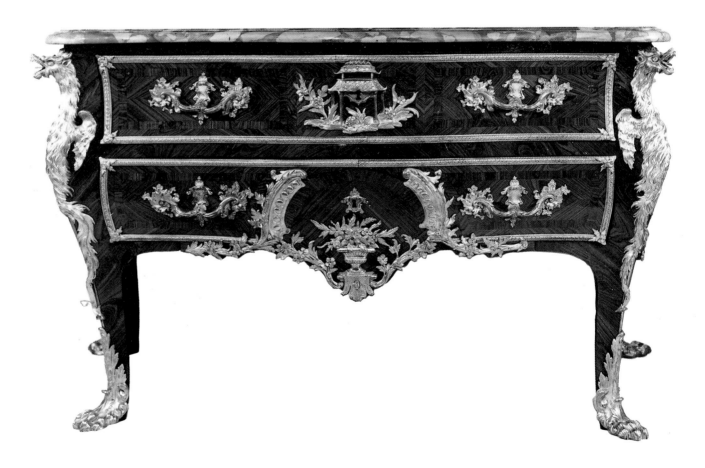

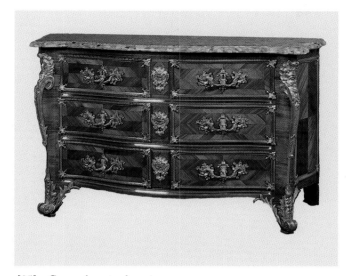

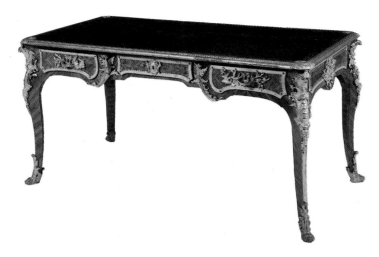

[85] Commode en tombeau in
bois satiné, c. 1730, with bearded
masks at the corners. (Galerie
Fabre, Paris)

[86] Bureau plat in kingwood,
c. 1735, decorated with small
dragon motifs. (Formerly
Wrightsman Collection. Sale
Sotheby's New York, 1 November
1986, lot 80)

[87] (below) Commode
veneered in tortoiseshell, c. 1735,
decorated with dragons,
chinoiserie figures and pagodas,
one of the most striking examples
of chinoiserie taste produced in
France during the rococo period.
(Private collection, United
States)

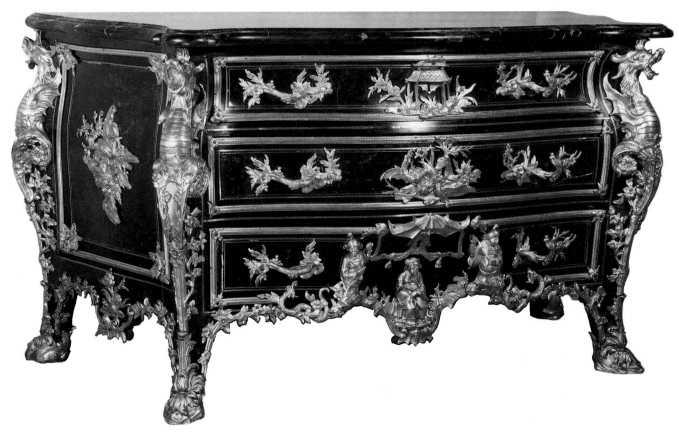

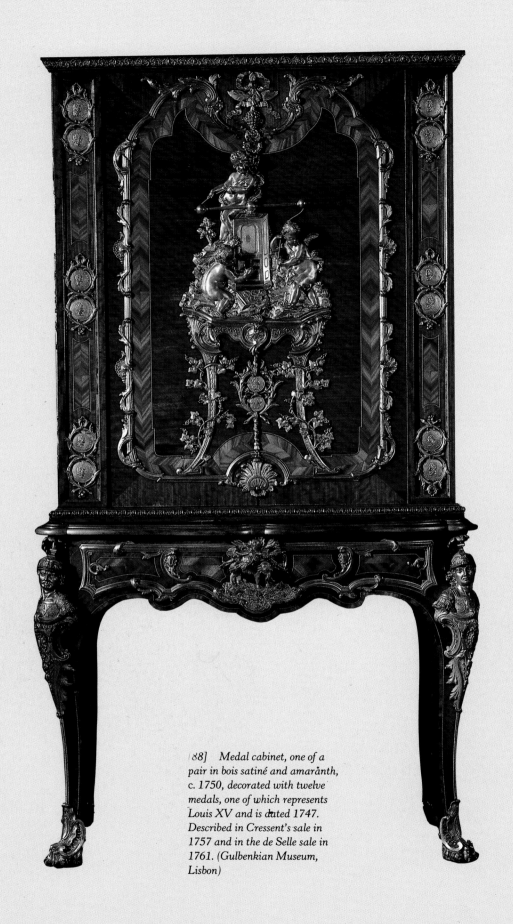

[88] Medal cabinet, one of a
pair in bois satiné and amaranth,
c. 1750, decorated with twelve
medals, one of which represents
Louis XV and is dated 1747.
Described in Cressent's sale in
1757 and in the de Selle sale in
1761. (Gulbenkian Museum,
Lisbon)

Charles CRESSENT

1685–1768; MARCHAND-ÉBÉNISTE AND SCULPTEUR

The active career of Charles Cressent spans the years between 1719 and 1757. He is certainly the ébéniste whose work is most representative of the Régence style, so much so that there is a tendency for all fine furniture of that period to be automatically attributed to him, to the detriment of his less celebrated contemporaries such as Carel, Doirat, and even Gaudreaus or Boulle's sons.

This tendency is easily explained by the fact that Cressent, established in the rue Notre-Dame-des-Victoires, never stamped his furniture. The only way to gain an impression of his work is through eighteenth-century sales catalogues or the list of bronzes confiscated from his workshop in 1723, 1733 and 1743. Besides the sales catalogues of his clients such as M de Selle there were three successive sales, in 1748, 1757 and 1765, of his collections of paintings and stocks of furniture. The detailed descriptions outline a very homogeneous production. Of the types of furniture listed, the greatest number were commodes, but there were also a number of bureaux plats, bookcases and armoires. The commodes were generally of the type called 'à la Régence,' on high feet with two drawers. He almost always used bois satiné or amaranth – often the two combined; they were often used for plain veneers or parquetry, sometimes to form a trellis or lozenge designs. The carcases of his furniture are in deal and the drawers in walnut. More rarely, kingwood is used and occasionally 'bois de Cayenne', a type of cerise-coloured bois satiné. Palisander, very fashionable in the years between 1710 and 1720, is never mentioned, neither is tulipwood which first appeared in France *c.* 1745–50.

In the 1748 sale, of 45 pieces of furniture described, 26 were in bois satiné or amaranth. The total absence of ebonized wood and the rarity of kingwood dis-

tinguish Cressent from his colleagues, who at that time frequently employed these woods. The marble tops came from French quarries: mainly 'marbre d'Antin' also called 'Verette', or 'Sarrancolin', also called 'Seracolin', sometimes also 'Brèche d'Alep', 'marbre de Rance' and some other marbles from Flanders. In the 1758 sale numerous types of marble from Italy were mentioned such as griottes, 'rouges de Sicile' and brocatelles.

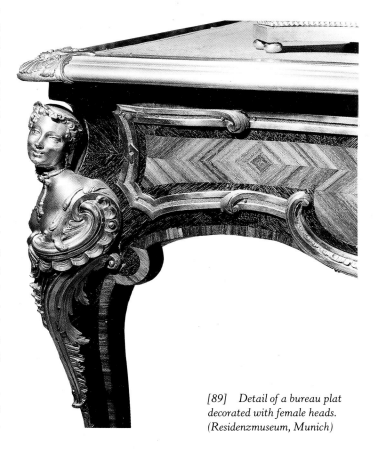

[89] *Detail of a bureau plat decorated with female heads. (Residenzmuseum, Munich)*

129

The bureaux plats are embellished with corner-mounts in the form of female heads with lace head-dresses which would seem to have escaped from the world of Watteau, or busts of vigorous warriors which recall the style of Oppenordt. They are accompanied by serre-papiers surmounted by a clock with groups of bronze figures representing Diana the huntress flanked by scenes of a stag and a boar at bay, or Time with his scythe – a motif which is often repeated on a series of long-case and wall clocks.

The production of bookcases and armoires was particularly important; under the Regency the prevailing fashion for cabinets des curiosités used this type of furniture to hold books and display medals or various collections. They had either glazed doors, grilles or solid doors, in which case they were richly decorated with gilt-bronze mounts and usually measured at least 1.30 metres high and more often between 2 metres and 2.60 metres. Placed on these pieces were busts and figures in bronze, vases in porcelain, porphyry, sometimes branches of coral and various shells.

The dominant theme in Cressent's work is the extensive rôle of sculptural decoration: his furniture is covered with such a profusion of gilt-bronze or varnished mounts that the ébénisterie is finally no more than a vehicle for displaying the decoration. This is not surprising as Charles Cressent, son of a sculpteur and grandson of a wood-carver, was also trained in this art. He became a master sculpteur in 1719 and a member of the Academy of Saint-Luc; he is alternately recorded as sculpteur or ébéniste to the Duc d'Orléans. The difficulties which he experienced with the guild of casters and gilders (fondeurs and doreurs) in 1722, and then in 1733 and 1743, confirm that Cressent chased and gilded the bronzes in his own workshop, even in a number of cases providing the casters with models actually made by himself. The charges brought by the casters' guild confirm that a considerable production of these gilt bronzes (one of the five casters used by Cressent attested that he had cast 24,000 livres worth of work for Cressent over a space of four years) was not just decoration for furniture but also included chenets, wall lights, chandeliers, mirror-frames, decorations for chimneypieces and house altars, thus infringing the prerogatives of their guild. These legal documents also give the names of those bronziers who carried out commissions for Cressent in their own workshops. In 1722 Noël Bros-

sart, 'caster to the King at the Gobelins', states that he cast decorative elements for a bookcase in the form of the Four Quarters of the World, the Seasons or Three Fates. Pierre Vandnesanne, fondeur-ciseleur at Saint-Nicolas-du-Chardonnet, chased espagnolettes for him.

Guillaume Lombard, fondeur-ciseleur in the rue des Arcis, was also employed to chase espagnolettes and mounts for clocks for Cressent.

Artus Oudain, caster, rue de la Tannerie, was employed to weld bronzes by Cressent from 1719.

Jean Perquet, caster, rue du Faubourg-Saint-Antoine, cast all types of works in bronze for Cressent for about four years, for which Cressent provided the models.

In 1743 it is known that Cressent used the caster Confesseur, established in the Petite-Rue-Taranne.

In 1757 it is recorded that Cressent owed 7,731 livres to the gilder Barthélemy Autin, established in the rue Pavée, for gilding work. On Cressent's death in 1768 he was still owed 1,071 livres.

Jean Trumel, senior member of the community of casters in the rue Saint-Jacques-de-la-Boucherie, was commissioned by Cressent in 1719 to gild or colour bronze mounts over a period of four years.

In 1733 the guild of 'gilders on worked metal' complained that Cressent was employing two master-gilders in his workshop, Léon-Jacques Cazobon, living in the rue des Fossés-Saint-Germain-l'Auxerrois, and François Bruyer, living in the rue des Fossés-Saint-Germain. Here is the evidence that Cressent employed bronze workers in his workshop. The guild was not accusing him of doing the work of others, but of having it carried out in his own workshop. In 1733 Cressent defended himself against the charges of the guild of gilders and the arguments exchanged during the course of the litigation are revealing. Cressent states the reasons why he carried out the gilding of the bronzes in his own workshop: 'There are lords and other people who wish to have work done on their own premises, either because gold is used, or because they fear that their models will be stolen.' It is clear that in a period when the ownership of models was not regulated and aftercasts were the general rule, the only way in which a sculpteur could ensure that his bronzes were not reproduced was to make them in his own workshop. This also allowed him continuously to supervise production and thus guarantee quality.

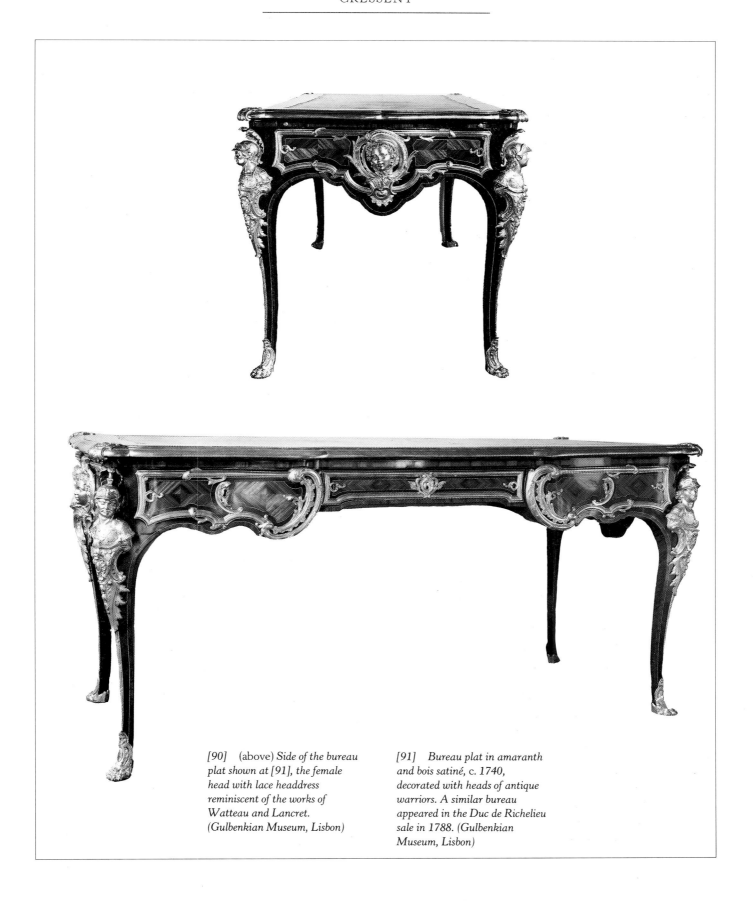

[90] (above) Side of the bureau
plat shown at [91], the female
head with lace headdress
reminiscent of the works of
Watteau and Lancret.
(Gulbenkian Museum, Lisbon)

[91] Bureau plat in amaranth
and bois satiné, c. 1740,
decorated with heads of antique
warriors. A similar bureau
appeared in the Duc de Richelieu
sale in 1788. (Gulbenkian
Museum, Lisbon)

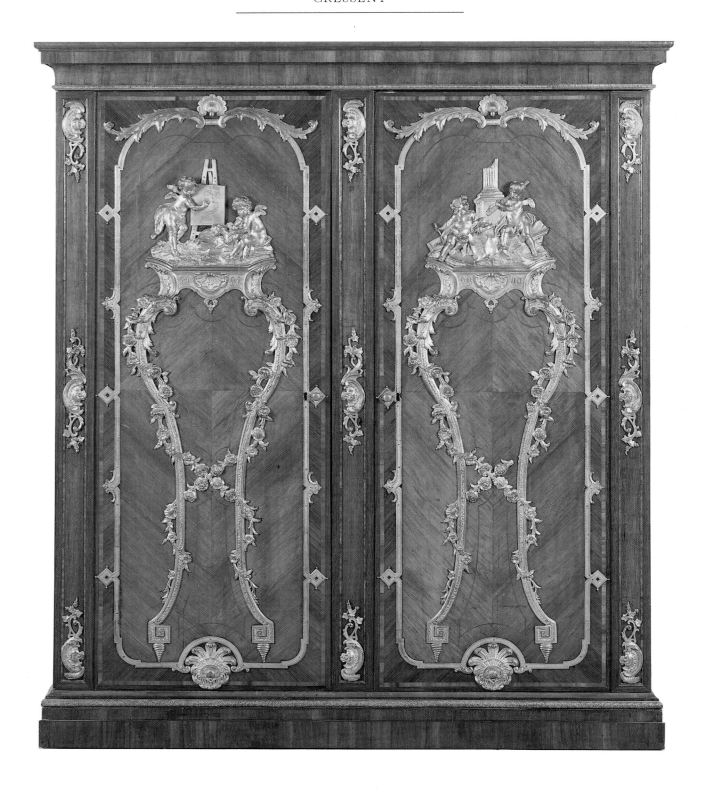

[92] *Armoire, one of a pair,*
c. 1750, in bois satiné and
amaranth, decorated with bas-
reliefs representing Painting and
Sculpture. It belonged to the

Treasurer General of the Navy,
M. de Selle, and was included in
his sale in 1761. (Musée du
Louvre, Paris)

[93] Bookcase in bois satiné
and amaranth, decorated with
busts symbolizing the Four
Quarters of the World. Probably
an early piece by Cressent
(Gulbenkian Museum, Lisbon)

[94] Corner armoire in
kingwood, c. 1730, decorated
with bas-reliefs representing
Painting and Music, from the M.
d'Ennery sale in 1786. (Sotheby's
New York, 13 October 1983, lot
477)

[95] Armoire, c. 1730, in bois
satiné, described with its pair
with glazed doors in the sale of
the stock of Cressent in 1749 (nos
3 and 4), and again in 1757 (nos
147 and 148). (Private collection)

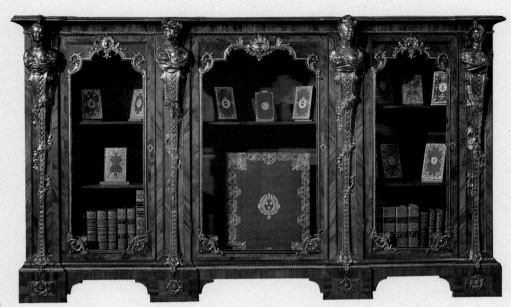

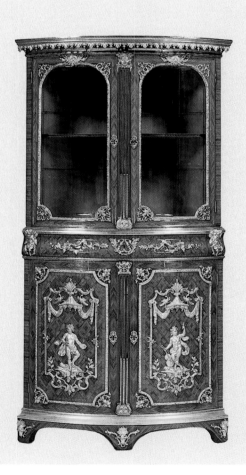

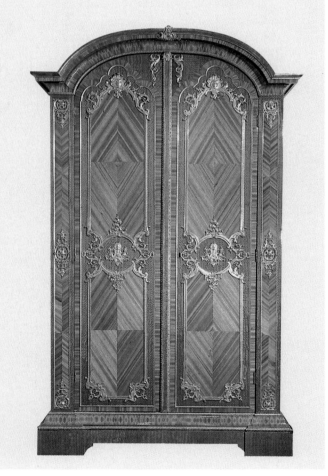

In theory, therefore, Cressent's bronze mounts should not be found on another ébéniste's furniture, and it is relatively safe to attribute furniture to Cressent according to the mounts. However, there are certain exceptions and several pieces are recorded, obviously by other ébénistes, with mounts typical of Cressent. The explanation is to be found in the catalogue of the sale in 1765: Cressent explains that he is now retired and selling his bronze models ('the sale will include [...] many uncompleted bronze models'). They were no doubt bought by his fellow ébénistes and were used by them on their own pieces, such as the figure of Danaë which is found on a secrétaire attributed to Montigny in the Musée des Arts Décoratifs [343].

It is not possible to describe Cressent's numerous bronze articles of which we get a glimpse in the confiscation of 1723 – chandeliers, wall-lights, mirrors, chenets, ornaments for chimneys and tabernacles – because of the absence of precise documentation, as, in transgressing the legal bounds of his profession, he was unable to seek publicity in his sale catalogues. However, it is possible to identify the chenets in the 1757 sale with 'two sphinxes, one playing with a cat, the other with a monkey', 'a pair of wall-lights with parrots and three branches' and the chenets modelled with a salamander on a hearth. Cressent remained all his life in the same house on the corner of the rue Notre-Dame-des-Victoires and the rue Joquelet. It had previously belonged to Joseph Poitou (1680–1718) whose widow Cressent had married. The ground floor was taken up by his workshops for ébénisterie and bronze-work, while on the first floor were the display rooms, two rooms hung in red damask and another in 'green satinade' where Cressent sold pictures and furniture. His own quarters were on the second floor. In 1757 he was 'forced to give up his craft completely owing to his advanced age (seventy-two) and his failing eye-sight' as he explains in the preface to the catalogue. His physical decline seemed to coincide with the declining demand for his work. If one compares the two last sales in 1757 and 1765, it appears that a large part of the furniture remained unsold in the 1757 sale and was reoffered in 1765. Doubtless Cressent's furniture was by then out of fashion; it should be remembered that at this time, c. 1760, Oeben was already conceiving his 'commodes à la grecque' for Mme de Pompadour.

Cressent died in 1768 and his assets were sold up in March of the same year.

BIBLIOGRAPHY

Mlle Ballot: 'Charles Cressent', *Archives de l'Art français*, vol. X, reprint by de Nobele, 1969

André Boutemy: 'Essais d'attributions de commodes et d'armoires à Charles Cressent', *Bulletin de la société de l'histoire de l'art français*, 1964, pp. 77–99; 'Cressent', *Connaissance des Arts*, June 1963, pp. 68–77

Theodore Dell: 'The Gilt bronze cartel clocks of Charles Cressent', *Burlington Magazine*, April 1967, pp. 210–15

Jean-Dominique Augarde: 'Charles Cressent et Jacques Confesseur', *L'Estampille*, September 1986, pp. 54–58

Daniel Alcouffe: exh. cat. 'Louis XV', Hôtel de la Monnaie, Paris, 1974, pp. 315–16; *Cinq années d'enrichissement du patrimoine national*, Paris, 1980, pp. 96–100; *Nouvelles acquisitions du département des objets d'art, 1980–1984*, pp. 73–75

[96] *Long-case clock in bois satiné and amaranth decorated with bas-reliefs representing the winds, dragon wings, and a winged figure of Time. (British Royal Collection)*

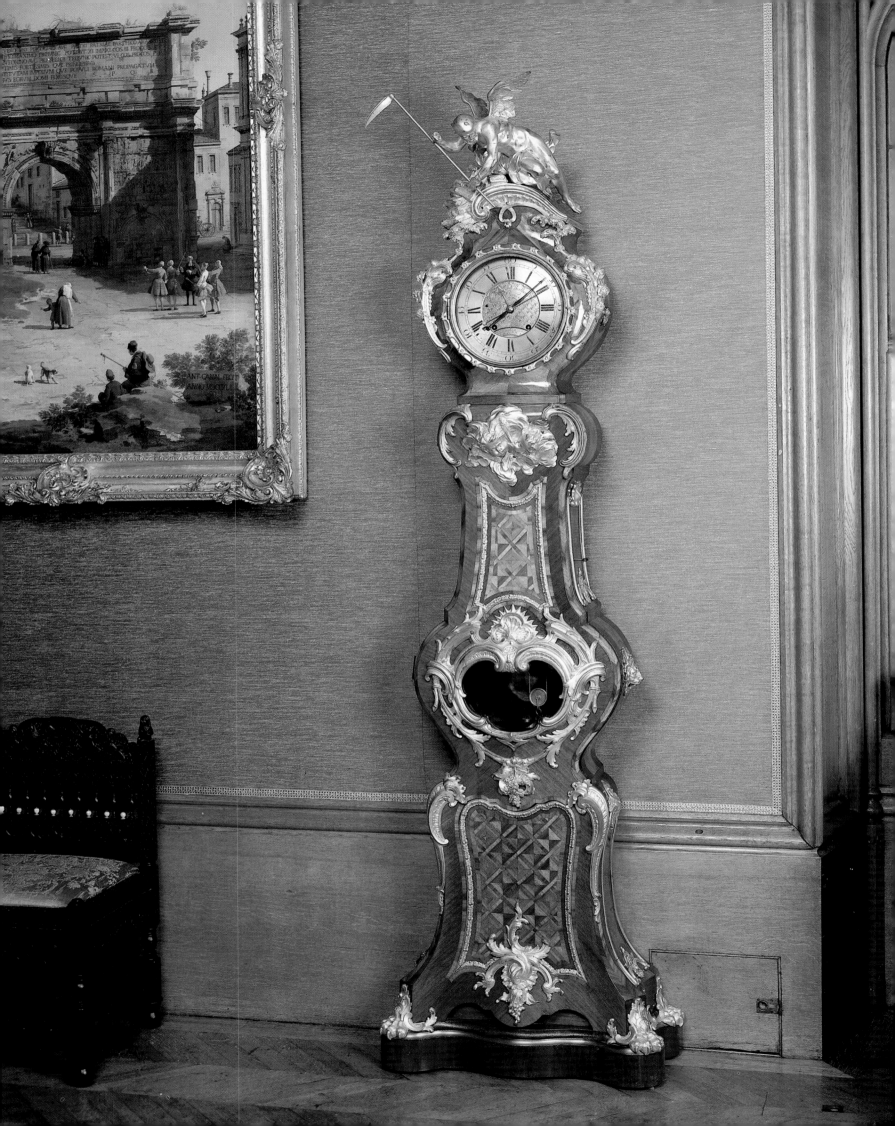

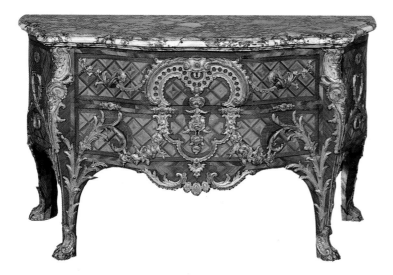

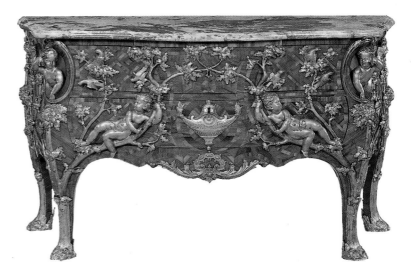

[97] Commode, c. 1730, in bois satiné and amaranth, probably corresponding to the models 'with palm-trees and flowers' described in Cressent's sales in 1749 (lot 38) and 1765 (lots 76 and 77). (Musée du Louvre, Paris)

[98] Commode, c. 1730, in bois satiné with motifs of children perched in oak branches; matching the encoignure shown at [100]. (Waddesdon Manor, Buckinghamshire)

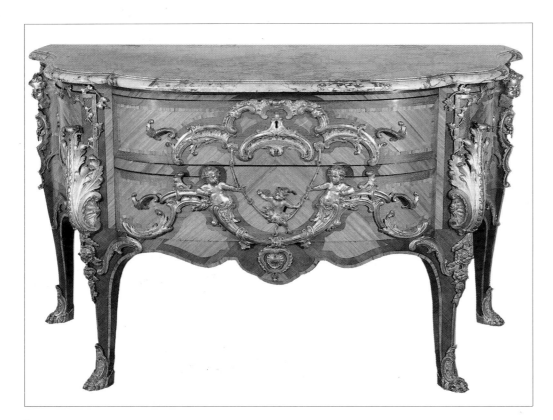

[99] Commode 'with children swinging a monkey', c. 1740–45, in tulipwood and amaranth, described in the sale of the stock of Cressent in 1749 (lot 7) as a novelty, subsequently in the sales of 1757 and 1765. (Musée du Louvre, Paris)

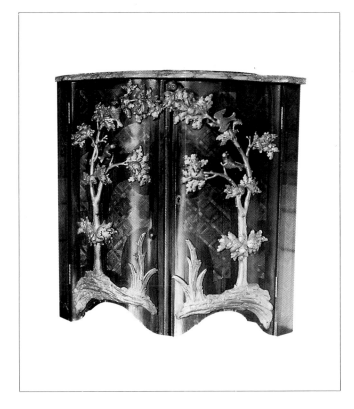

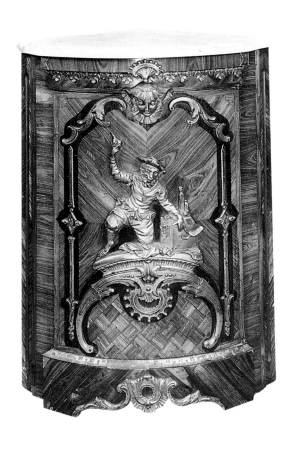

[100] Encoignure called 'The piping of the birds', described with three others in Cressent's sales of 1749 (lots 10 and 15), 1757 (lot 143 and 144), in 1765 (lots 86 and 89), and finally in the inventory drawn up after Cressent's death; these pieces formed an ensemble with the commode shown at [98]. (Private collection)

[101] Tulipwood encoignure, c. 1750, decorated with a head of a Chinesewoman and a monkey apothecary. (Sotheby's London, 26 November 1971, lot 60)

[102] (below) Medal cabinet in bois satiné, made by Cressent in about 1739 for Louis, Duc d'Orléans, son of the Regent. (Bibliothèque Nationale, Cabinet des Médailles, Paris)

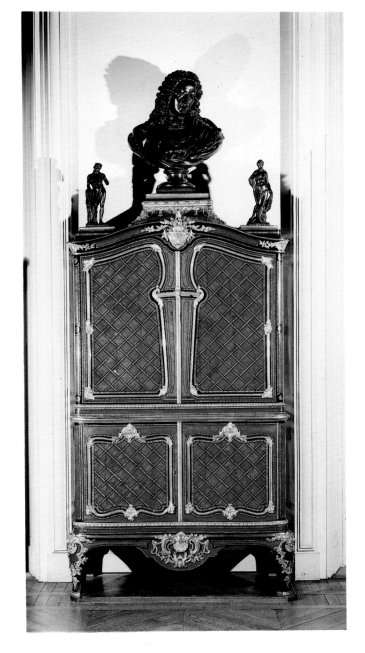

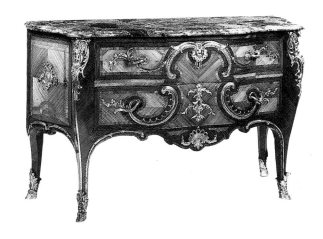

[103] Commode in bois satiné and amaranth, c. 1735. (Christie's London, 25 June 1979, lot 135)

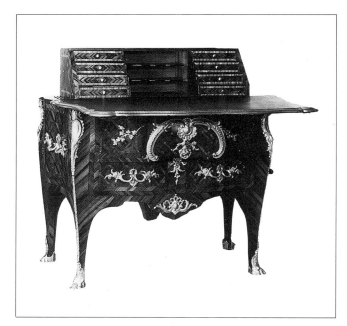

[104] Commode with hidden secrétaire compartment, c. 1740–1745, in bois satiné; described in the Cressent sales in 1749 (no. 22), in 1765 (no. 94) and then in the inventory after Cressent's death. (Archives Galerie Aveline, Paris)

[105] Commode decorated with palm fronds and ivy trails, the mounts struck with crowned 'C', c. 1745–49. (Sotheby's Monaco, 25 June 1979, lot 135)

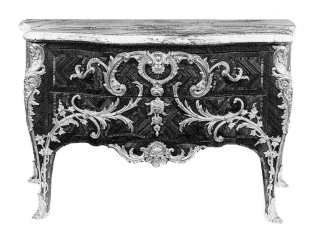

[106] (right) Commode 'with child musicians', c. 1730, in bois satiné; decorated with typical Cressent motifs (palm fronds, ivy trails and rose sprays and festoon motifs), this piece was probably acquired by the Elector Charles-Albert of Bavaria between 1730 and 1737 when redecorating his palace (Residenzmuseum, Munich)

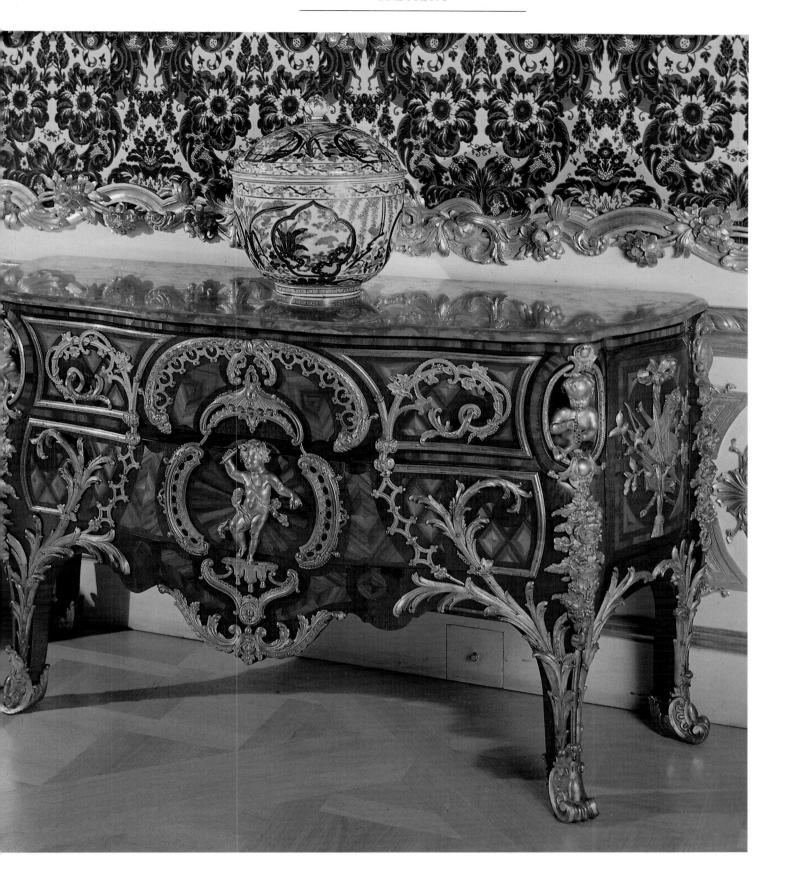

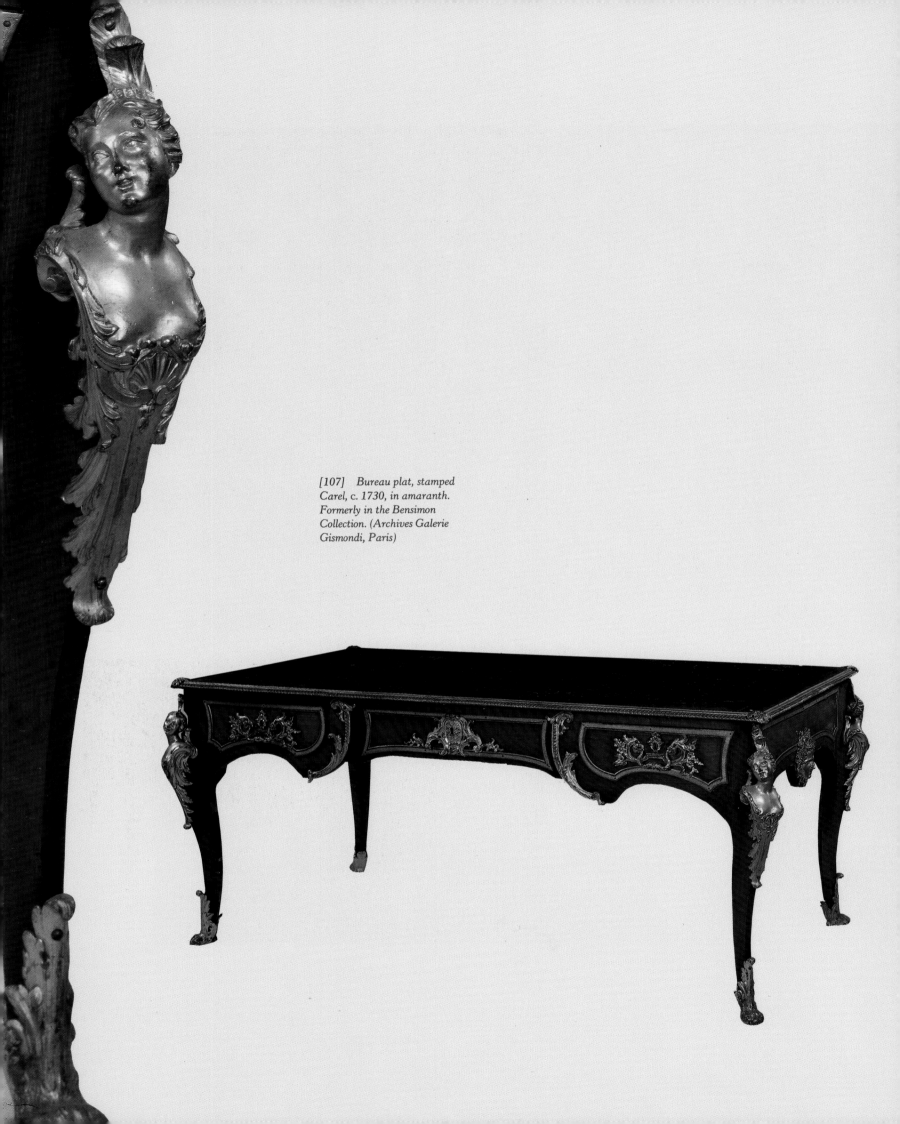

[107] *Bureau plat, stamped
Carel, c. 1730, in amaranth.
Formerly in the Bensimon
Collection. (Archives Galerie
Gismondi, Paris)*

Jacques-Philippe
CAREL

MASTER 1723; ACTIVE 1724–50

Carel became a master on 16 February 1723 by the purchase of one of the eight masterships created at the coronation of Louis XV. His stamp is found on a wide variety of furniture: a bureau plat in amaranth in the Bensimon Collection, very close to the work of Cressent; a table in the Ojjeh sale in the manner of Latz; a commode in the Swedish Royal Collections. This last piece is adorned with highly original mounts and may be dated to the 1730s. Two further commodes, identical to one another and both stamped by Carel, also date from the 1730s. One is in the Munich Residenz, and the other was sold in Paris on 12 June 1973, lot 127. The one in Munich has the trade label of the marchand-mercier Calley, rue de la Monnaie at the sign 'À la Descente du Pont Neuf'. The diversity of Carel's output makes it probable that he also sold the furniture of other ébénistes. It is quite likely that Carel worked around 1745 with the ébéniste I. D. F., as their two stamps are found side by side on a pair of encoignures (private collection, Paris) dating from 1745–50.

Carel must have been active until at least 1750, since his stamp is found on a small sécretaire en pente delivered by Gaudreaus in 1751 for the daughters of Louis XV at Versailles.

BIBLIOGRAPHY

Daniel Meyer: 'Un secrétaire de Mesdames Sophie et Louise de France', *Revue du Louvre*, 1970

Jean-Nerée Ronfort: 'Choisy et la commode du roi', *L'Estampille*, October 1988, p. 27, note 27

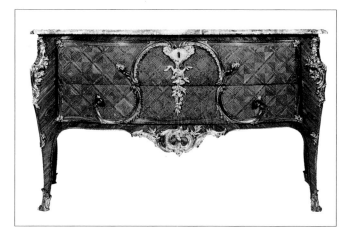

[108] Commode stamped Carel, c. 1735, in bois satiné. Its pair, now in the Residenzmuseum, Munich, has the trade label of the dealer Calley. (Sale Ader, Paris, 12 June 1973, lot 127)

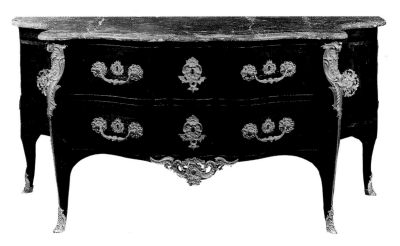

[109] Palisander commode stamped Carel, c. 1730, with bow-shaped front. (Archives Galerie Léage, Paris)

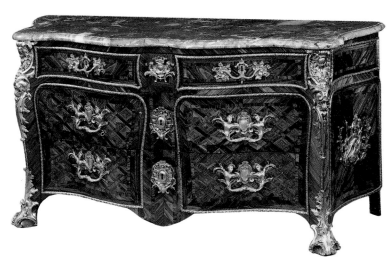

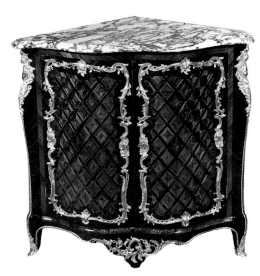

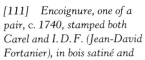

[110] *Commode attributed to Carel, c. 1730, veneered in kingwood, decorated on the sides with bas-reliefs of Apollo and Diana. (Galerie Aveline, Paris)*

[111] *Encoignure, one of a pair, c. 1740, stamped both Carel and I. D. F. (Jean-David Fortanier), in bois satiné and*

kingwood. (Sotheby's London, 30 June 1978, subsequently Galerie Perrin, Paris)

[112] *(below) Commode stamped Carel, c. 1730, in kingwood. (Swedish Royal Collections, Drottningholm)*

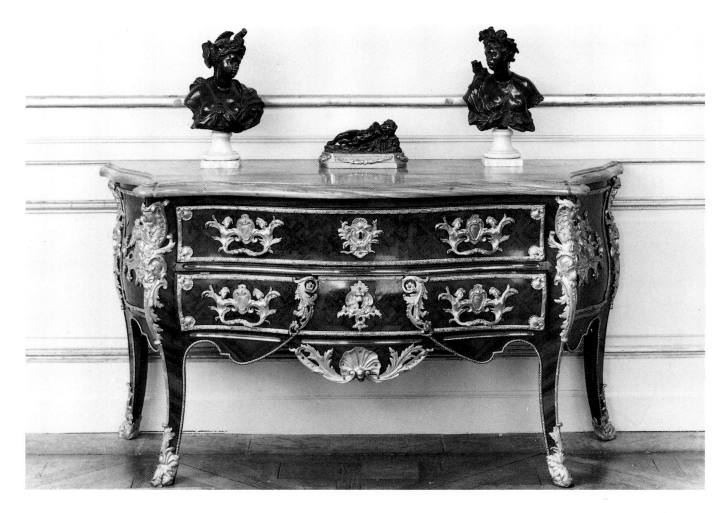

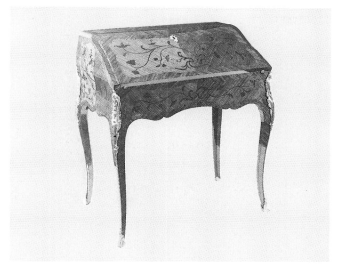

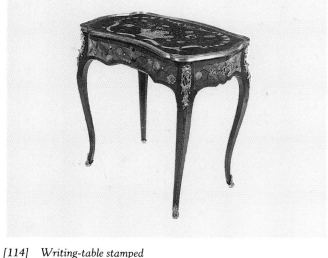

[113] *Secrétaire en pente stamped Carel, c. 1750, decorated with floral marquetry on a bois satiné ground, supplied by Gaudreaus in 1751 for Louis XV's daughters at Versailles, delivery nos 1640–2. (Musée de Versailles)*

[114] *Writing-table stamped Carel, c. 1750, with floral marquetry. (Formerly in the Ojjeh Collection; sale Sotheby's Monaco, 25 June 1979, lot 195)*

[115] *Commode stamped Carel, c. 1750, with floral marquetry in bois de bout on a bois satiné ground. (Frick Collection, New York)*

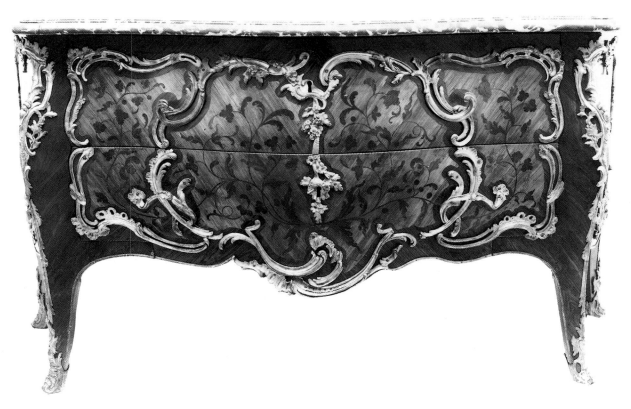

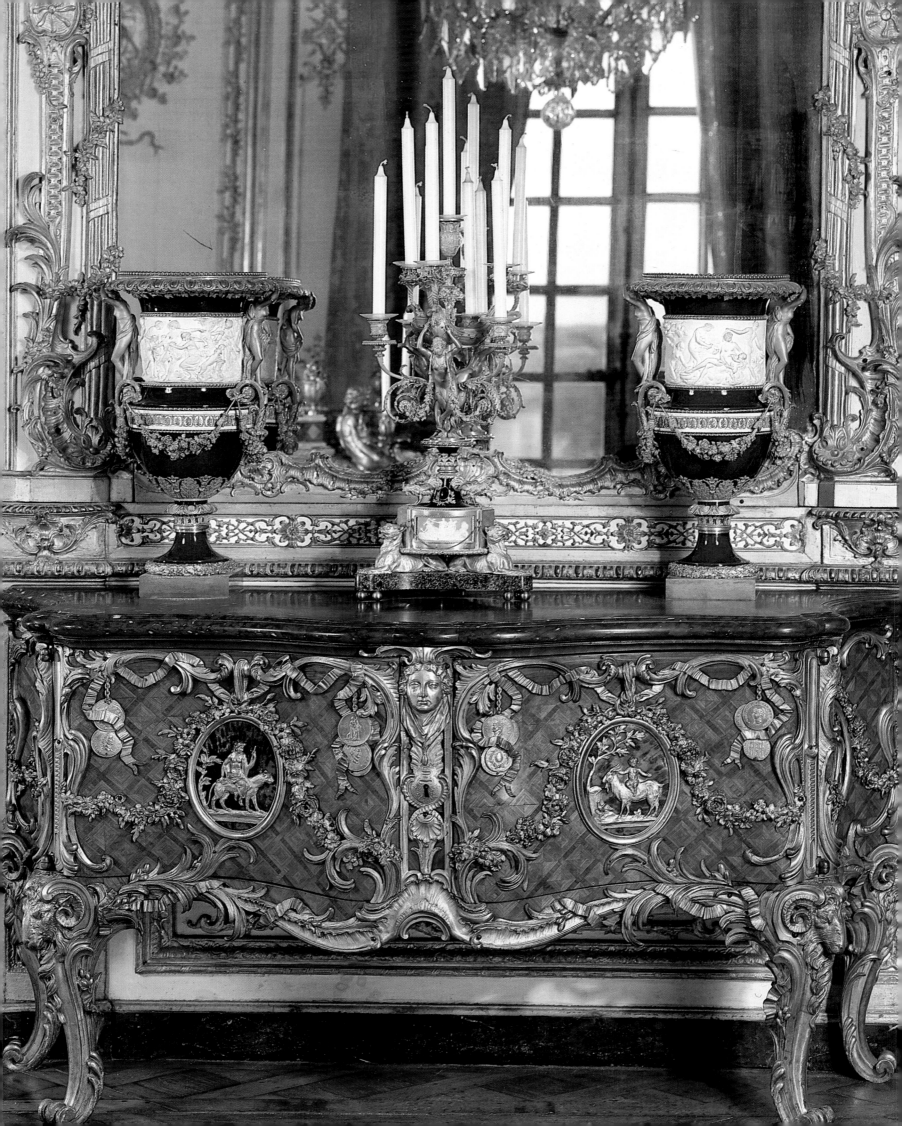

Antoine-Robert
GAUDREAUS

c. 1682–1746; MASTER 1708; SUPPLIER (WITH HIS SON) OF THE GARDE-MEUBLE ROYAL 1726–51

S on of a cobbler established in the Faubourg Saint-Antoine and descended from a family from Burgundy, Antoine-Robert Gaudreaus was born in about 1682. After an apprenticeship of three years, from 1699 to 1702, he began to work independently before gaining his mastership in 1708. In the same year he married Marie-Denise Maingot. She was provided with a dowry of 1,700 livres against his 2,000 livres, of which 800 livres was in cash and the remaining 1,200 livres was represented by five workbenches, tools and clothing. At the time of the contract, Gaudreaus was described as 'ébéniste in the rue du Faubourg-Saint-Antoine'. After his marriage he continued to live at the same address in a vast establishment which served as a workshop. The success which he soon enjoyed, as well as the respect of his fellow ébénistes, led to his election for two years, around 1720 or 1721, as book-keeper to the guild of menuisiers-ébénistes. He seems to have been close to his colleague Jean Coulon, since in 1721 he valued his furniture and in 1722 his assets on the death of his wife.

Increasingly prosperous, Gaudreaus decided to move to the centre of Paris to a large house in the rue Princesse, where he remained until his death. From 1701 onwards this house, which formerly belonged to the silversmith Nicolas de Launay, had been fitted with an ébéniste's workshop as well as a shop under the sign 'L'Image Sainte-Anne', later renamed 'Au Cabinet d'Italie'. Gaudreaus took it over from the ébéniste François Guillemard (who had retired in 1716

and sold his stock of furniture to another ébéniste, Pierre Quillart). Guillemard died on 8 April 1724 and initially Gaudreaus continued to use the latter's name for commercial purposes. In actual fact, the first furniture made by Gaudreaus for the Garde-Meuble Royal, in 1725–26, was supplied under the name of Guillemard.

In November 1726 the name of Gaudreaus appeared for the first time in the day-book of the Garde-Meuble Royal. This was the beginning of a collaboration which lasted twenty years, until Gaudreaus' death in 1746, and which was prolonged for a further five years by his son until 1751. When he started working for the Crown, Gaudreaus was forty-three. He was already, no doubt, a remarkable craftsman and this was probably the reason he was chosen, rather than any patronage of Nicolas de Launay or the widow Guillemard. He succeeded Hecquet as ébéniste to the Crown. The fashion in the 1720s was for furniture 'in olivewood with compartments forming circles or semi-circles'. He certainly produced furniture of this type; he also produced furniture in kingwood, palisander and above all, numerous pieces in 'plain walnut' or 'cherry with fillets'. This furniture for everyday use, such as commodes, bidets, night-tables, dressing-tables and commode-chairs represented the major part of the work of the ébéniste to the Crown. Thus between 1726 and 1746 Gaudreaus supplied more than 850 pieces of furniture, of which two-thirds were in walnut or cherry. To keep pace with these large orders he had probably to subcontract to his fellow ébénistes, as his successor Joubert would often do. However, as the habit of stamping furniture only became general after 1745 and Gaudreaus died in 1746, we have almost no proof that he did so. It is only clear from the inventory on the death of Doirat that he

[116] Medal cabinet in kingwood supplied by Gaudreaus in 1738 for the Cabinet Intérieur of Louis XV at Versailles. The *bronze mounts were modelled by the Slodtz brothers who probably also designed the piece itself. (Musée de Versailles)*

[117] *Kingwood commode supplied in 1739 by Gaudreaus for Louis XV's Bedchamber at Versailles, with the delivery no. 1150; the mounts signed by the fondeur-ciseleur Caffieri. (Wallace Collection, London)*

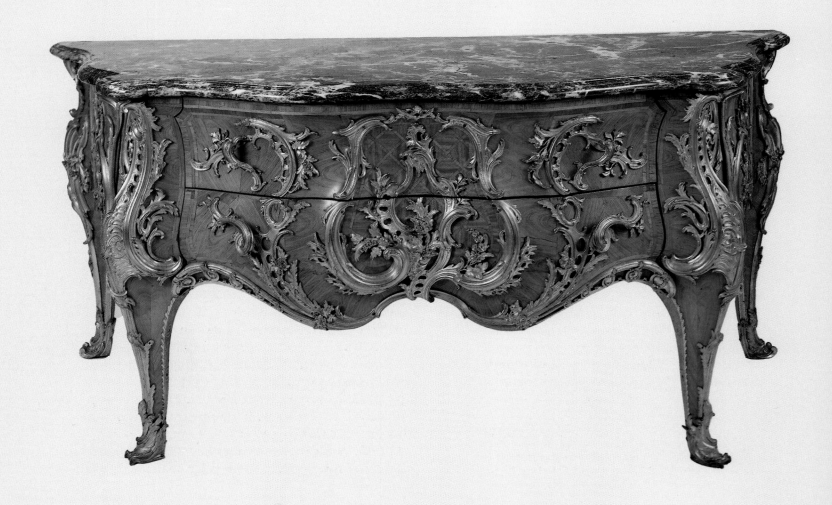

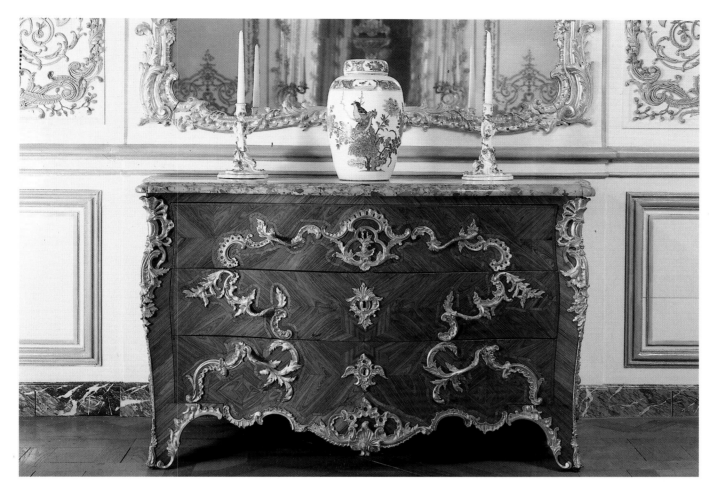

owed the latter 600 livres in 1732. It is therefore unwise to presume that he himself made all the furniture supplied by him to the Garde-Meuble Royal.

Nevertheless, this reservation being made, one may study his work through the day-book of the Garde-Meuble. It will be noticed that his consignments rose steadily between 1730 and 1745 as the royal family expanded. He supplied 380 pieces between 1740 and 1745, as opposed to 320 between 1730 and 1739. The important commissions came in 1739 when he supplied the commode for the King's Bedchamber, designed by Slodtz and decorated with mounts by Caffieri, and the medal-cabinet for the King's Cabinet Intérieur at Versailles. These were his masterpieces and are among the greatest examples of French furniture. They are both veneered in kingwood, as are most recorded pieces by Gaudreaus. In fact, his preference for kingwood can be observed in the day-book of the Garde-Meuble from 1737 onwards: from 1730 to 1739 there are 34 pieces in kingwood as opposed to 21

[118] *Kingwood commode en tombeau supplied in 1745 by Gaudreaus for the Dauphine's* *Bedchamber at Fontainebleau (delivery no. 1364). (Musée de Versailles)*

in palisander (then called 'palissante') and 15 in amaranth. From 1740 to 1745 this predominance of the use of kingwood became more marked, with 88 recorded pieces as against 22 in amaranth and 17 in palisander. Ebonized pearwood was still in use up to 1744, as well as olivewood with fillets of palisander. Tulipwood, rarely used, did not make an appearance until 1745 and then only gradually (three pieces, two of them commode chairs). Finally, the absence of marquetry on Gaudreaus' work is typical of furniture produced during the Régence. He used only plain veneer or marquetry with geometric effects in trellis, diamonds or butterfly wings. The pieces are described as 'veneered' or 'with small squares or lozenges' or 'veneered in mosaic patterns' or even 'with lozenge-shaped compartments'. Marquetry is first recorded in 1742, and then again in 1745 with a commode and a

table in bois satiné with kingwood flowers for the Dauphin and Dauphine at Marly. Obviously, he was no master of marquetry, and the royal family acquired this type of furniture through the marchands-merciers Hébert and Julliot from 1745 onwards.

Likewise, for furniture in oriental lacquer, the royal family went to Hébert from 1737 (or Julliot and Darnault) who supplied furniture made by Criard and B. V. R. B. Nevertheless, in 1744 Gaudreaus experimented in this new technique: he supplied a commode, two encoignures and a bureau 'in Chinese lacquer with a black ground' for the King's apartments at Choisy, a château already largely furnished with lacquer furniture supplied by Hébert. They were the only pieces he produced in lacquer, and, moreover, the bureau plat, now in the Archives Nationales, is probably the work of B. V. R. B.

The gilt-bronze mounts used by Gaudreaus to embellish his furniture are often heavier than those of his fellow craftsmen. On the very best pieces slashed rocaille is found, and particularly, as with Cressent, palm motifs; good examples are found on the medal-cabinet at Versailles as well as the lacquer commode at Choisy, and they are described in several entries in the day-book of the Garde-Meuble: thus the bureau (no. 1010) supplied in August 1732 for use in the closets above the Salon de la Guerre at Versailles, or the bureau (no. 1118) supplied in 1737 for the Cabinet du Roi at Versailles, which is 'enriched with decoration and mouldings outlined in palm fronds' as well as the commode 'decorated with palms' supplied in 1738 for the King's Bedchamber at La Muette (no. 1131). On

more ordinary furniture, which was the main part of his production, Gaudreaus used very few mounts: on his commodes there are only escutcheons and fixed handles and sometimes corner-mounts. Certain commodes as well as most of the tables and bureaux are mounted with 'chaussons de cuivre' (bronze sabots). Finally, these mounts were not mercury gilded but varnished on all but exceptional pieces. On the majority they were simply described as 'mis en couleur d'or' (varnished bronzes).

Commodes, a type of furniture conceived at the end of the seventeenth century, were an important part of Gaudreaus' production. Daniel Alcouffe has counted 375 in the day-book of the Garde-Meuble, making up almost half of his consignments, of which 111 were veneered, 252 in solid walnut and 12 in solid oak. The majority of the commodes were 'en tombeaux' with three rows of drawers, the uppermost drawers sometimes divided in two. Numerous other commodes were of the type called 'à la Régence', that is raised on high legs and with two rows of drawers. Finally, some of the most exceptional commodes had 'encoignures-fermées' (with cupboards on the sides) in the manner of Cressent. This applies to the commode for the King's Bedchamber at Versailles, the one for Choisy, an example supplied in 1738 for the King's New Bedchamber at La Muette (no. 1131), the one supplied in the following year for the King's Bedchamber at Compiègne (no. 1167) and a last one supplied in 1745 for the Dauphin's Bedchamber at Versailles (no. 1380).

Many pieces of furniture were made for the royal

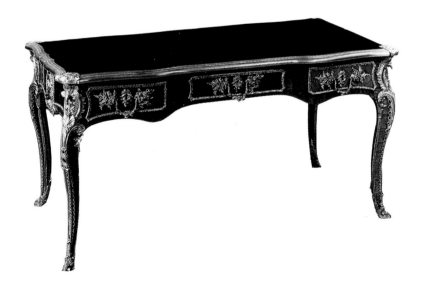

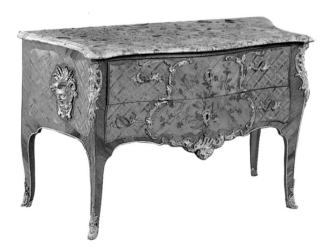

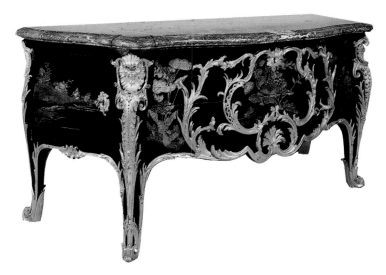

[121] *Commode supplied by Gaudreaus in 1744 for Louis XV's apartments at Choisy (delivery no. 1327); one of the rare recorded pieces in lacquer by Gaudreaus. (Sale Semenzatto, Venice, 13 March 1987, lot 107)*

[122] *(below) Low bookcase in kingwood, exact copy by Riesener of a piece supplied by Gaudreaus in 1744 for the Cabinet of Louis XV at Versailles. Boulle's influence can be detected in the composition of this piece, as well as the mounts. (Ministère de la Marine, Paris)*

garde-robes (wardrobe closets): encoignures, corner-shelves called 'tablettes' or 'gradins d'encoignure', bidets and commode chairs (some veneered in amaranth, palisander and kingwood) and night-tables. The bureaux plats which Gaudreaus supplied rarely were prestigious pieces made for the King or Dauphin only, and never for high officials or courtesans as would be the case later under Louis XVI.

Similarly, it is noticeable how few secrétaires (also called 'dos d'âne') are recorded. These first appeared in 1733, made for the Queen at Marly, and became fashionable after 1738. The painstaking way in which they were entered in the day-book of the Garde-Meuble clearly indicates a recent invention. Gaudreaus supplied a total of six of them, all between 1738 and 1746, a sign that they were not his speciality. On the other hand, games-tables were. Games were one of the most important activities of Court life and Gaudreaus supplied more than forty games-tables between 1730 and 1746. Almost all of them were veneered in kingwood or palisander although several were in cherry with palisander stringing. They were of all kinds and shapes: rectangular ones for piquet; square ones for quadrille; pentagonal ones for brelan and triangular ones for jeu d'ombre. Finally, there was one trictrac table in ebonized pearwood.

Gaudreaus did not work exclusively for the royal

[119] *(far left) Bureau plat in kingwood. The attribution to Gaudreaus is tentative since the records do not mention the maker of this piece, which belonged to Louis XV as early as 1740 (delivery no. 1279). (Musée de Versailles)*

[120] *(left) Commode supplied by Gaudreaus in 1749 for the dining-room of Louis XV's daughters at Versailles (delivery no. 1588); in kingwood and tulipwood. (Sotheby's London, 20 June 1986, lot 58)*

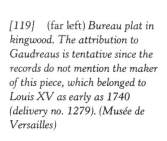

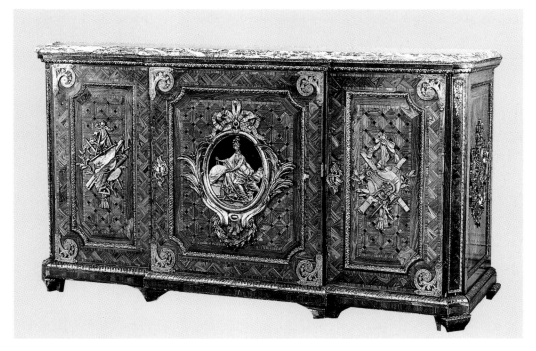

family but was patronized by an illustrious private clientèle including the Marquis d'Antin, the Comte de Clermont, the Duc de Bouillon, Saint-Simon, the Prince de Chalais and the Duc de Valentinois, whom he supplied with various pieces in kingwood (see Appendix) in 1730 for the sum of 500 livres.

Gaudreaus' successor was his son François-Antoine (c. 1715-1753) who was received master very young, before 1735. On the occasion of his marriage in 1739, he was given a third share in his father's business. Antoine-Robert died in 1746; however, the business, directed by his son in association with his widow, continued for another five years, supplying furniture to the Crown until 1751. In that year Gaudreaus' name ceases to feature in the day-book of the Garde-Meuble, being replaced by that of Joubert. It is likely that François-Antoine fell ill, as the assets of the business were sold in July 1751 and he died in 1753.

The inventory taken after Gaudreaus' death reveals a precarious financial situation. The ébéniste Mathieu Criard was among the creditors and was owed 3,000 livres 'for goods made and supplied by him'.

BIBLIOGRAPHY

Minutier Central, CII, 373: inventory taken after the death of François-Antoine Gaudreaus

Daniel Alcouffe: 'Antoine-Robert Gaudreaus et François-Antoine Gaudreaus ébénistes de Louis XV', in: *Mélanges Verlet, antologia di belle arti*, 1985, nos 27–28

Pierre Verlet: *Le Mobilier royal français*, Paris, vol. I (1945), pp. 4–15; vol. II (1955), pp. 43–56.

Jean-Nerée Ronfort: 'Choisy et la commode du roi', *L'Estampille*, October 1988, pp. 14–29

Exh. cat. *La rue de Varenne*, 1981, p. 35, no. 102

APPENDIX

Invoice for the pieces of furniture for the Duc de Valentinois, made and supplied by me, Gaudreaus ébéniste, 19 September 1730:
— Having supplied one commode in kingwood of 3 pieds 8 pouces long, the top the same, decorated with mounts varnished in a gold colour, for this, *235L*
— 2 guéridons in cherrywood, for this, *10L*
— 2 commodes à la Régence of serpentine shape in kingwood in a mosaic of small squares with small fillets of bois rouge, 3 pieds 1 pouce long, each to the same design, price fixed at *300L*
Total (reduced to): 500L
[Palace archives of the Prince of Monaco]

[123] *Commode, c. 1740–45; the form, mounts, the use of kingwood veneer and certain details of the construction (such as the use of oak for the carcase)* *suggest an attribution to Gaudreaus rather than Cressent. The piece belonged to M. de Selle, a client of Cressent, and was described in his sale as being by* *Cressent which suggests that the latter, who was also a dealer, occasionally resold furniture made by his fellow craftsmen. (Wallace Collection, London)* [124] (right) *Detail*

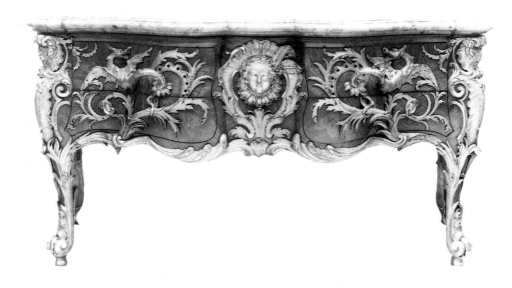

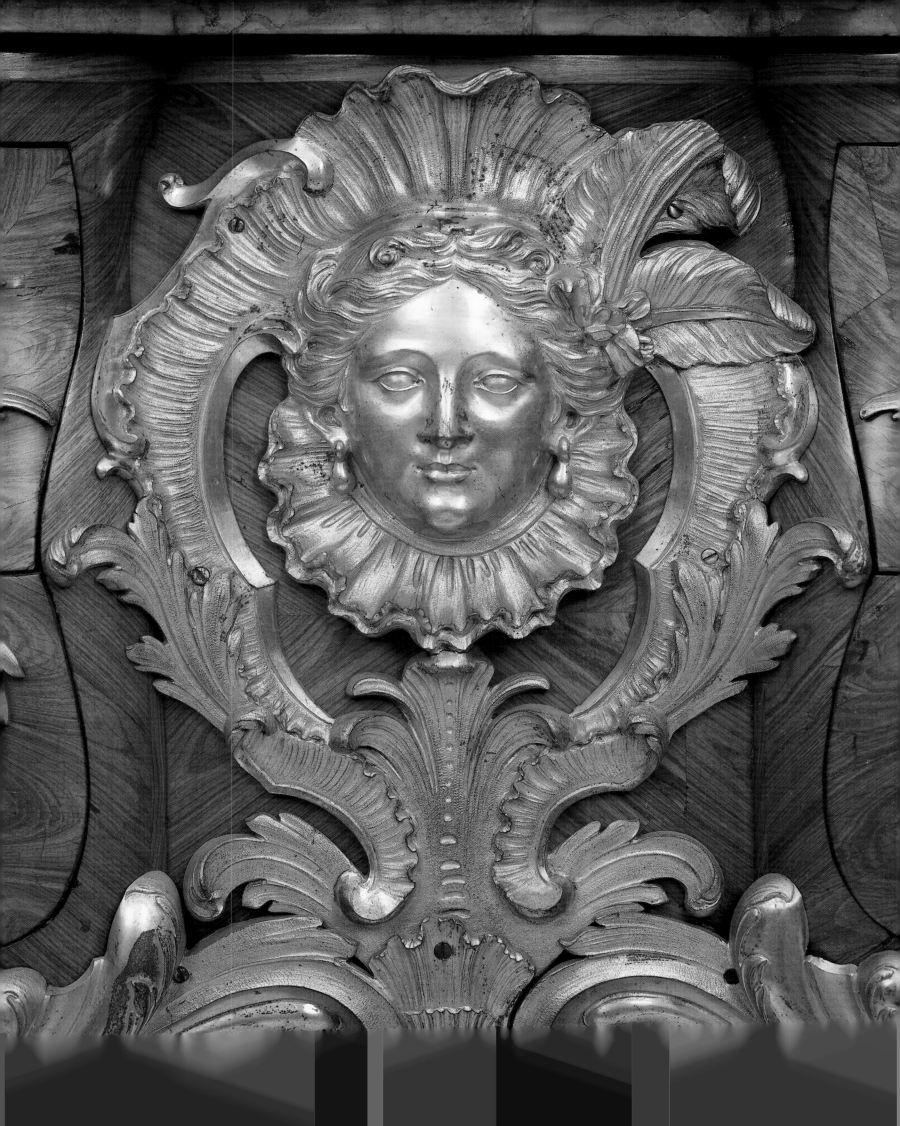

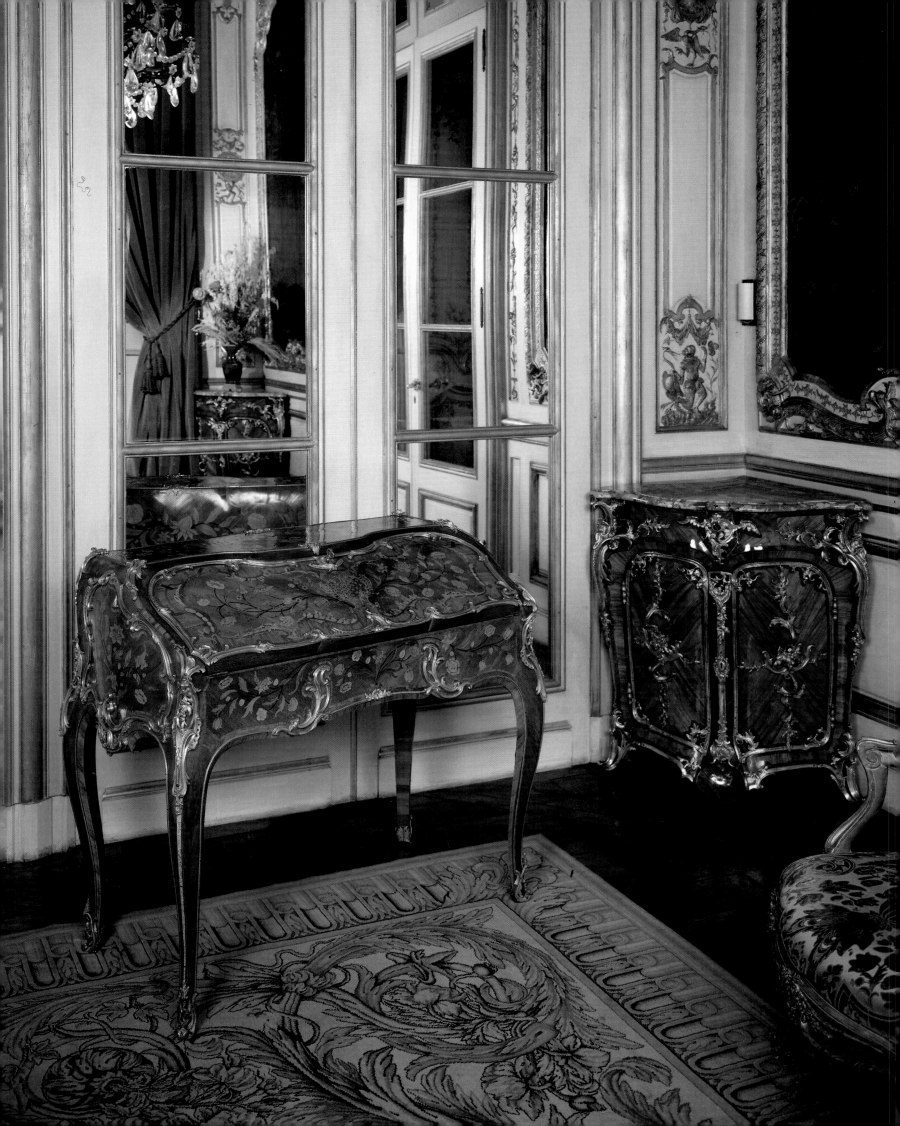

Jean-Pierre
LATZ

N ow recognized as one of the great ébénistes working in the Louis XV style, Jean-Pierre Latz is one of the most spectacular discoveries made in the last twenty years by Henry Hawley.

Born *c.* 1691 near Cologne, Jean-Pierre Latz settled in Paris from 1719 as an ébéniste. In 1736 he became naturalized and in 1739 married Marie-Madeleine Seignet, daughter of a prosperous property-developer. His wife's dowry of 10,000 livres and her relations (the Abbess of Saint-Antoine, Marie-Gabrielle de Bourbon-Condé and Sister Anne de Rohan, another abbess, both attended the marriage as witnesses) must have helped Latz to make his way. Before 1741 he obtained the warrant of 'ébéniste privilégié du roy' which enabled him to excercise his profession freely without becoming master. The couple settled into a house at the sign of the Saint-Esprit in the rue du Faubourg-Saint-Antoine opposite the Foundling Asylum. This comprised their living quarters and workshop, where the family remained until 1756, the date of the death of Latz's widow. From 1739, and apparently until 1754, his principal assistant was his nephew Jean-Pierre Tillmans. On Latz's death in 1754, the workshop was maintained by his widow who also kept the warrant of ébéniste privilégié granted to her husband until her own death in 1756 (after which it passed to Pierre Macret in 1757). As their only child was a girl of eleven, the workshop was closed.

The inventory drawn up a short time after Latz's

death in 1754 by Cressent and Joubert, and particularly the more detailed one drawn up in 1756 after the death of his widow by the ébénistes B. V. R. B. and Dubois, gives an accurate picture of the workshop's production. All these documents indicate clearly that the production of clock-cases constituted the main activity of the workshop. In 1754, 170 clock-cases were itemized, of which 100 incomplete models were out of fashion, while in 1756 there were no more than 92. At the same time the 1754 inventory lists 48 pieces of furniture other than clocks, while the 1756 one lists 33 pieces. In both cases, therefore, the production of clocks represents approximately three times that of other furniture. The greater part of the clocks described were wall clocks with their brackets, but some were also on a square tapering base ('no. 48: 2 clockcases, each mounted on its pedestal inlaid with marquetry of bronze, tortoiseshell and mother-of-pearl'). The veneers listed were almost always of Boulle marquetry of which Latz would seem to have made a speciality, although there are instances of veneering in kingwood and also floral marquetry. The 1756 inventory also itemizes pieces carried out entirely in bronze ('no. 45: 2 clocks and their pedestals, all in bronze'). Latz was in fact producing bronze mounts in his own workshop to decorate his furniture, contravening the rules of the guild.

In 1749 various ornaments in unchased bronze, bronze models and tools proving that Latz was casting and chasing gilt-bronze mounts designed for his own clocks and furniture on the premises, were seized from his workshop at the instigation of the bronze-casters' guild. The written report of the seizure, which enumerates no less than 2,288 models and bronze parts, confirms that Latz reserved the exclusive use of his models. It is difficult to tell whether he

[125] Secrétaire en pente stamped Latz, c. 1750, with floral marquetry on a bois satiné ground; and one of a pair of tulipwood encoignures attributed to Latz (but stamped by Roussel as retailer). (Private collection)

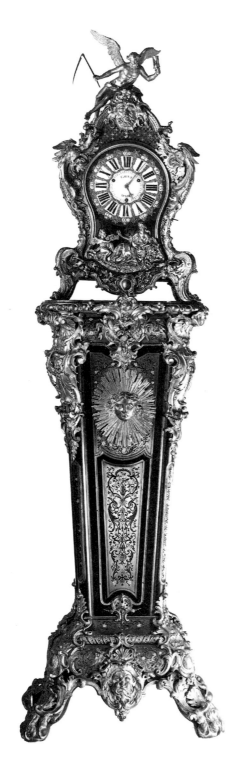

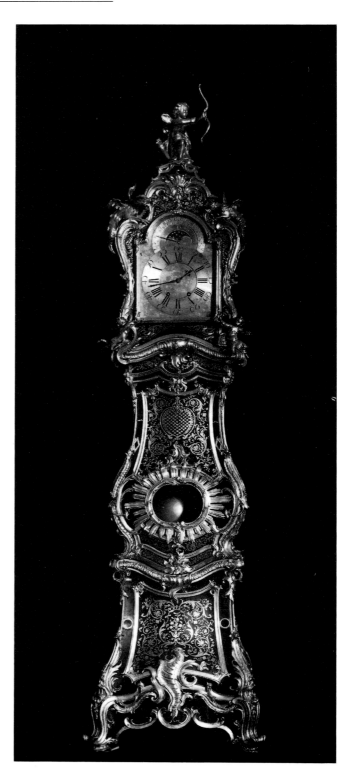

[126] Clock and its stand attributed to Latz, c. 1740–45, with marquetry in tortoiseshell, mother-of-pearl and stained horn on a brass ground. Originally owned by the Elector of Saxony at Dresden, this clock has a pair, now in Schloss Moritzburg. (Sotheby's Monaco, 14 June 1981, lot 57)

[127] Long-case clock signed Latz with tortoiseshell and brass marquetry, the mounts struck with crowned 'C' (1745–49). (Cleveland Museum of Art, John R. Severance Fund)

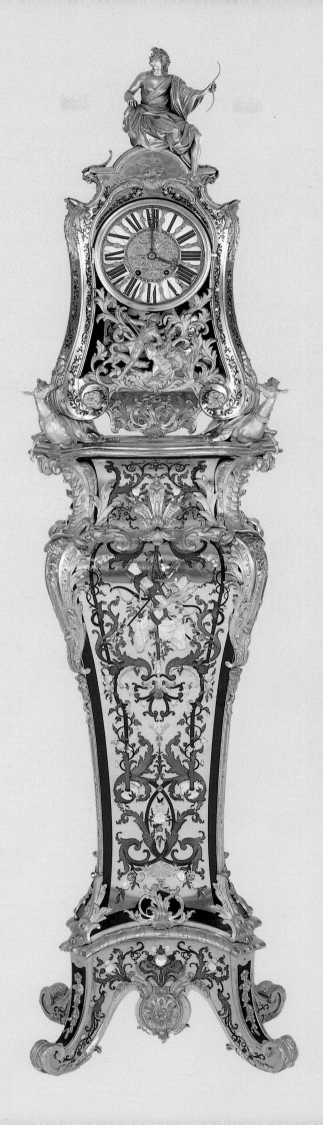

[128] Clock and its stand attributed to Latz, c. 1740, with mother-of-pearl and stained horn marquetry on a ground of brass. Two identical clocks are in Schloss Moritzburg, Dresden, and a third at Charlottenburg, Berlin. (Sotheby's New York, 17 November 1984, lot 175)

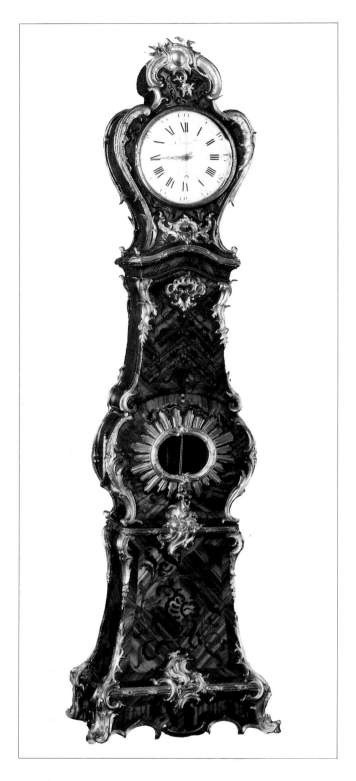

[129] *Long-case clock stamped Latz, c. 1749, with floral marquetry of bois de bout; several mounts struck with crowned 'C';* *movement by Cronier. (Waddesdon Manor, Buckinghamshire)*

continued to cast on the premises after this incident or not. In the 1754 inventory the experts Cressent and Jacques Confesseur list, besides the presence of three work-benches for chasing, 63 bronze statuettes 'serving as models for decorating clocks, bureaux, serre-papiers and other pieces of furniture', valued at 940 livres, as well as 2,424 livres weight of 'cast-bronze mounts used as models, and overcasts . . . to serve as decoration for clocks, commodes, encoignures, secré-taires and other ébénisterie valued at 3,636L'. One of the clock models is even described: 'One palm tree clock also of metal and bronze used as a model . . .' (In 1756 the description is now updated: 'One palm tree in bronze about 6 pieds in height made to take a sprung clock'.) The inventory also lists the amounts owed to different bronziers, the casters Chibou (72L), Javois (60L) and Vidi (762L), the chasers Boulle (Pierre Boulle? 9L), Defforges (42L and 61L to his brother-in-law), Déon (61L), Gavie (60L), Fennetaux (20L), Lefèvre (160L), Malassis (60L), Piault (58L), Salter (60L), the gilders Barthélemy Autin (nearly 6,000L) and Gobert (300L). The disparity of these debts shows that at that time Latz had to obtain, at least in part, his bronze mounts from outside his workshop. In any case it is clear that he held the exclusive rights to his models up until 1749; on the basis of the mounts, therefore, a quantity of unstamped pieces may be attributed to him. Up until now only three long-case clocks stamped by him have been recorded (one in the Cleveland Museum of Art, one belonging to Prince Louis-Ferdinand of Prussia at Charlottenburg, and the third at Waddesdon Manor).

In his catalogue Henry Hawley makes twenty further attributions. At the last count there were six recorded commodes stamped by Latz, while Henry Hawley attributes to Latz at least a further twelve, of very differing types. In the case of the encoignures produced by Latz, the group is stylistically very homogeneous, with characteristics repeated on all of them (very bombé in shape, two hinged doors with an apron forming a third foot in the front). Apart from the two pairs of stamped encoignures (one formerly in the Wildenstein Collection [130], the other formerly in the Burat Collection), Hawley attributes eight further pairs to Latz. No bureau plat stamped by Latz is recorded but eight examples can be convincingly attributed to him (for instance, the desk of Frederick II of Prussia now at Potsdam). This unorthodox method of

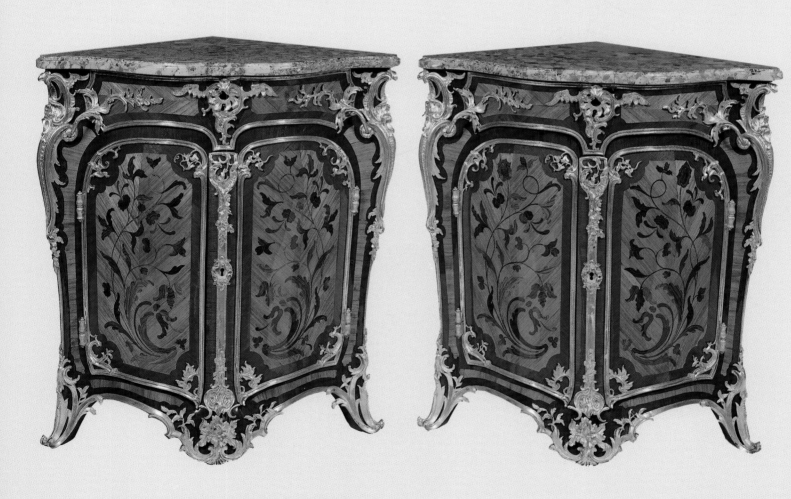

[130] *Pair of encoignures*
stamped Latz with the mark of
Château d'Eu, with marquetry of
bois de bout. (Sotheby's Monaco,
25 June 1979, lot 44)

[131] Bureau plat attributed to
Latz, the mounts struck with
crowned 'C' (1745–49); veneered
in tulipwood. (Woburn Abbey;
Duke of Bedford's collection)

attribution based on the similarity of mounts has led
to very plausible results and the delineation of a
homogeneous oeuvre which was very different from
that of other ébénistes.

LATZ'S STYLE

Latz's work is in the full rococo style, characterized by
free-moving forms of an exaggerated plasticity: the
commodes as well as the encoignures are bombé on all
sides. The restless lines are emphasized by highly con-
torted bronze mounts, by curves and countercurves
clashing one against another. These mounts some-
times evoke palm trees or branches, rockwork or birds'
wings. The marquetry consists as much of stylized
designs (trellis or wave motifs) as of panels of flowers
in bois de bout or panels of stylized flowers. Within
the latter the same elements are repeated: marquetry
composed of circular flowers, or small pomegranate
motifs in which the light tones stand out on a back-
ground of darker wood with foliage of a darker tone.
Bois satiné is often used as a base for these marquetry
panels, framed by amaranth. Finally, on a number of
pieces (the Burat encoignures, those in the J. Paul
Getty Museum, and the commode formerly in the
Rothschild Collection), there is a very different type of
marquetry, composed of sprays of realistic flowers of

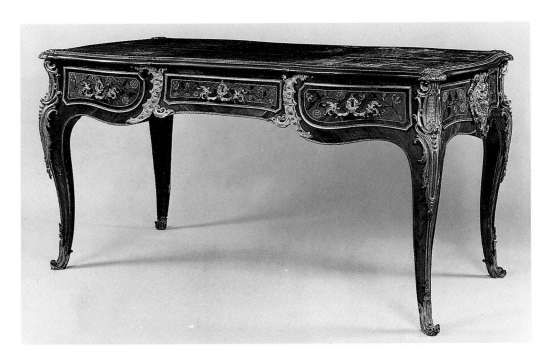

[132] Bureau plat attributed to
Latz, c. 1750, with floral
marquetry on a bois satiné
ground. (Sotheby's Monaco, 25
June 1984, lot 3236)

the sort found on furniture by J.-F. Oeben. These pieces pose the question of possible collaboration between Oeben and Latz (or his widow), unless Oeben bought up unfinished pieces in 1756 on the death of Latz's widow which he then completed. Another possibility is the existence of the same marquetry-maker who might have worked for Latz's workshop during these last years, between 1754 and 1756, and then for Oeben.

LATZ'S CLIENTÈLE AND INFLUENCE ABROAD

Ever since the eighteenth century very few works by Latz have been in France, and few have a French provenance: only the Wildenstein encoignures [130] and the Partridge examples which came respectively from the Châteaux d'Eu and d'Anet and belonged to the Duc de Penthièvre, probably a client of Latz in about 1750. Important pieces are in the Quirinal in Rome (two commodes, two pairs of encoignures and one bureau plat), originally part of the furnishing of the palaces of Colorno or Parma, ordered by Madame Infante, daughter of Louis XV, from Paris between 1748 and 1753. Otherwise, the largest collections of Latz furniture are to be found in Berlin and Dresden. Before the Seven Years War, the King of Prussia, Frederick II and the Elector of Saxony, August III (also King of Poland) are known to have ordered furniture from Paris, by preference from Latz. His Germanic origins no doubt facilitated contacts with the agents of German princes. At Potsdam, it seems that even Frederick the Great's desk was by Latz. The inventory after Latz's death records a clock valued at 1,450 livres intended for the King of Prussia, as well as amounts of 1,500 livres due to 'Mr Petit, commissioned agent for the King of Prussia' and 2,217 livres to 'Mr Leleux, agent of the King of Prussia' (this was in error in fact, as Leleu acted as the agent for the Elector of Saxony).

BIBLIOGRAPHY
Henry Hawley: 'Jean-Pierre Latz, cabinet maker', *The Bulletin of the Cleveland Museum of Art*, September–October 1970; 'A Reputation Revived', *The Connoisseur*, November 1979, pp. 176–82
Winfried Baer: 'Some clocks of Frederick the Great', *The Connoisseur*, May 1977, pp. 22–29

[133] Small bureau attributed to Latz, c. 1750, with marquetry of flowers and pomegranates typical of Latz's style. (Christie's London, 1 July 1976, lot 107)

[134] Pair of small tables stamped Latz, with marquetry of flowers and pomegranates. (Christie's London, 9 December 1982, lot 52)

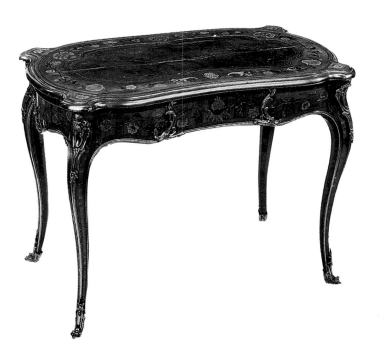

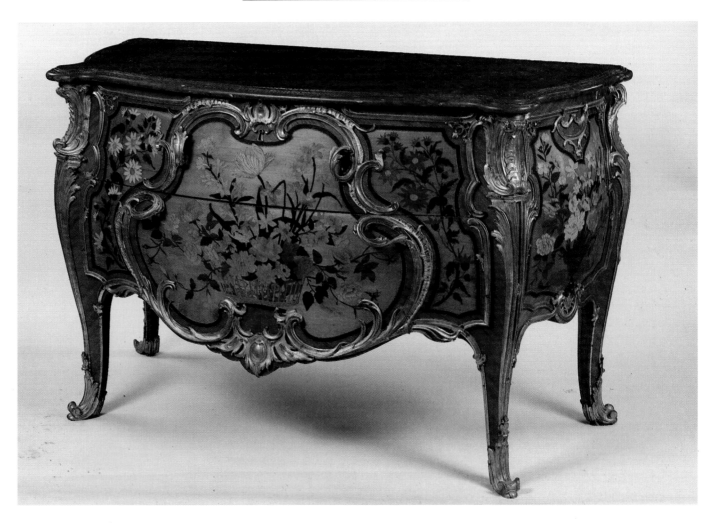

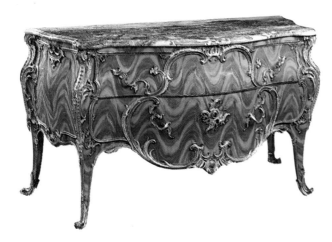

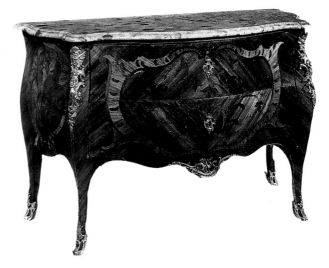

[135] Commode attributed to Latz, c. 1750, combining rococo mounts typical of Latz and realistic floral marquetry in the style of J.-F. Oeben. (Ader Picard Tajan, 19 March 1981, lot 249)

[137] Commode stamped Latz, with floral marquetry in bois de bout on a bois satiné ground. [Oger-Dumont sale, Paris, 25 October 1985)

[136] Commode attributed to Latz, c. 1745; the bois satiné veneering in a wave pattern was also employed by Joseph and Dubois. An identical commode, stamped Latz with crowned 'C' marks, is in the Quirinal Palace, Rome. (J. Paul Getty Museum, Malibu, California)

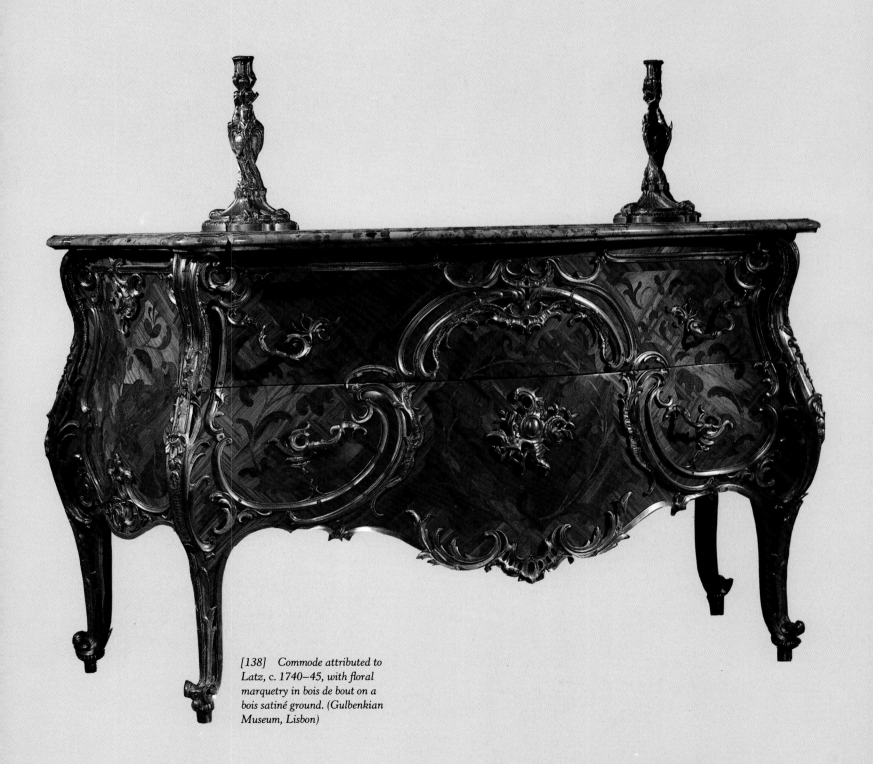

[138] Commode attributed to
Latz, c. 1740–45, with floral
marquetry in bois de bout on a
bois satiné ground. (Gulbenkian
Museum, Lisbon)

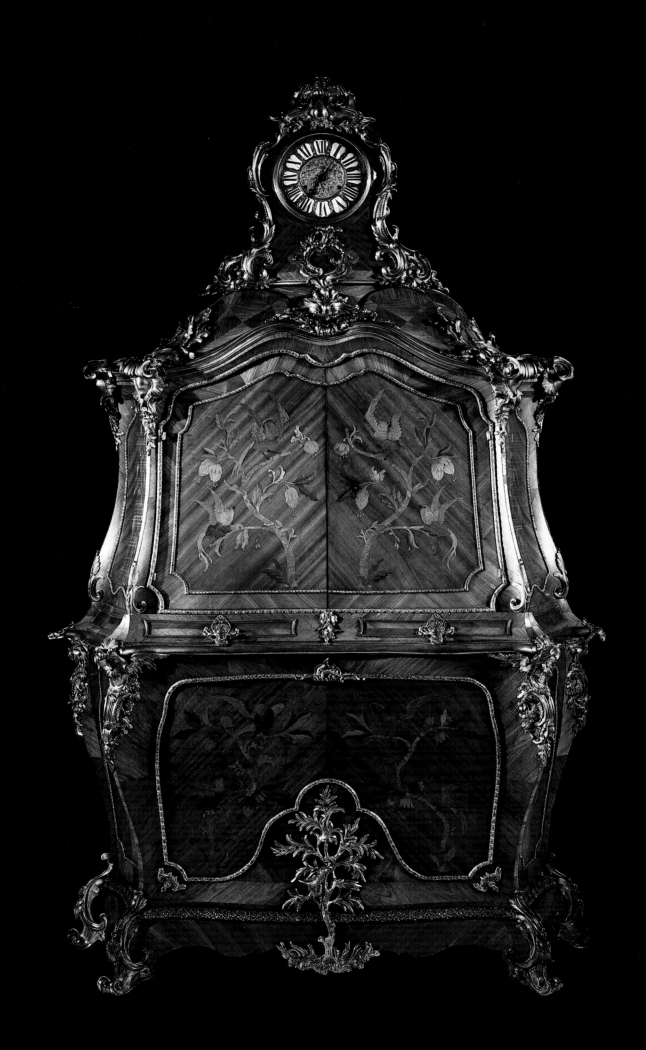

MIGEON

PIERRE I, *b. c.* 1670. PIERRE II, 1701–58; MARCHAND-ÉBÉNISTE
PIERRE III, 1733–75; MASTER 1761; MARCHAND-ÉBÉNISTE

The Migeon family were one of the important dynasties of Parisian Protestant ébénistes, consisting of three generations all with the same Christian name, 'Pierre', who succeeded each other at the same address in the Faubourg Saint-Antoine, in the rue de Charenton opposite the Convent of the English Sisters.

According to Salverte, Pierre I Migeon was born sometime between 1670 and 1675, and married the widow of the ébéniste François Collet in about 1700, his son Pierre II being born in 1701. The prosperity of the business is reflected in the day-book maintained between 1730 and 1736, which reveals a glittering clientèle including the dowager Duchesse de Bourbon, the Duc d'Orléans, son of the Regent, the Duchesse de Rohan for whom Migeon supplied one of the first examples of a secrétaire en armoire in 1731, the Maréchal de Noailles and numerous important figures at the Court and in the Church. The day-book also notes the consignment of several commodes 'en arbalète' (bow-shaped).

Pierre II married Madeleine Horry in 1732. At that time his assets were noted in the legal documents as being 43,000 livres, a considerable sum attesting to the prosperity of the family business, while his wife contributed a dowry of 10,000 livres (of which 9,600 livres was in cash). Two years later the young wife died. The resulting inventory which had to be drawn up itemized a workshop with nine work-benches, of which only four were equipped with tools. The stock comprised pieces of only low value (estimated at less than 100 livres), including commodes, encoignures, bookcases and secrétaires. According to Boutemy, secrétaires were one of Migeon's specialities. A note in the day-book records that 'between 2 March 1726 and 2 September 1731 secrétaires to the value of 30,833 livres have been supplied to various clients.' This is a considerable sum; if the average price of secrétaires was between 100 and 300 livres, it means that several hundred must have been delivered over a period of five years. Boutemy draws a further conclusion, as he would place the beginning of Pierre II Migeon's career in 1726.

Pierre II Migeon was a dealer as well as an ébéniste, selling pieces made by his colleagues. His success and the considerable number of pieces which passed through his hands are confirmed by the list of amounts paid to his suppliers between 1740 and 1760 (particularly in the 1750s), more than two hundred and fifty artisans and traders being mentioned. Among them are found the names of the ébénistes Topino, R. V. L. C., Duval, Mondon, Fleury, Delaitre, Criard, Landrin, Dautriche, Bircklé, Canabas, Macret, Bon Durand, Péridiez and others. In fact, on furniture stamped by Migeon, a second hidden stamp is often found, belonging to the maker. A famous example is the bureau 'de Vergennes', now in the Louvre, which, besides being stamped by Migeon, bears the stamp of Dubois, the maker of the piece, concealed on the carcase. Despite this wide range of suppliers, works carrying Migeon's stamp present great stylistic unity. It is therefore probable that he imposed this style on the ébénistes to whom he gave commissions. This style can be defined as a preference for veneering in geometric designs in dark woods (kingwood and bois satiné), for serpentine shapes and for rather heavy forms (commodes en tombeaux, low secrétaires).

[139] Cartonnier stamped Migeon; the unusual richness of this piece suggests that it was a special commission. (Sotheby's New York, 17 November 1984, lot 251)

[140] Commode stamped
Migeon, c. 1750; with floral
marquetry in bois de bout on a
bois satiné ground, the mounts
struck with crowned 'C'
(1745–49). (Formerly in the
Abdy Collection; archives Galerie
Segoura, Paris)

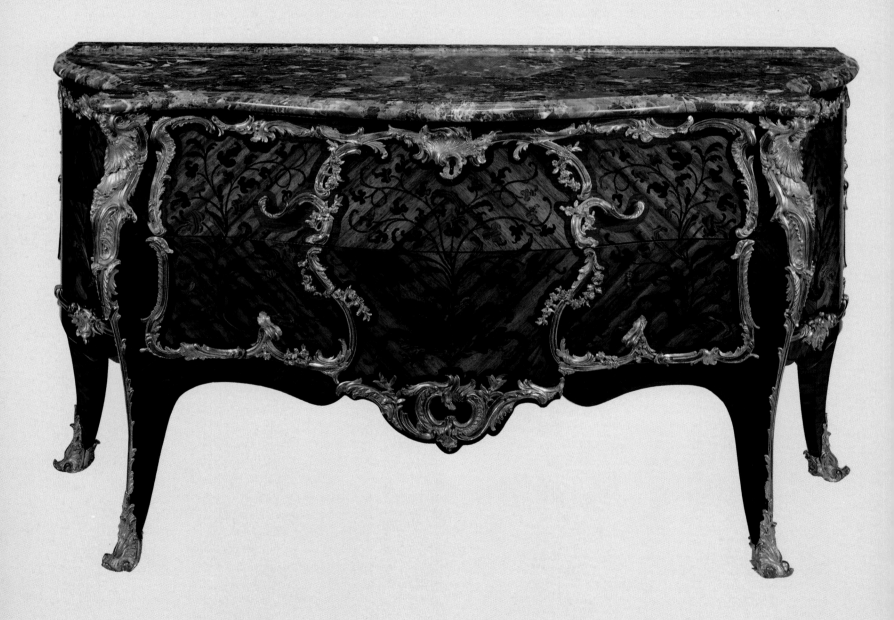

[141] *Commode stamped Migeon, c. 1750; with floral marquetry on a tulipwood ground. (Sotheby's Monaco, 14 June 1982, lot 366)*

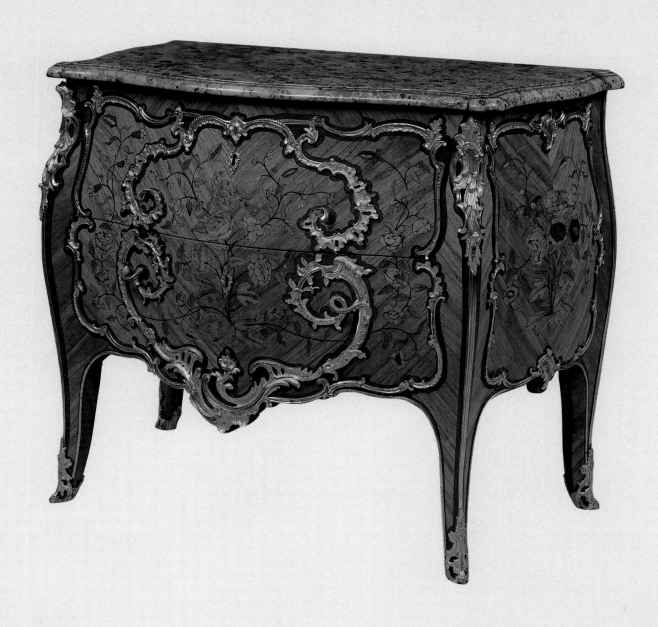

Migeon also worked for the Court, supplying from 1740, through the offices of the Menus Plaisirs, a 'bureau de musique in mahogany fitted with seven music stands and gilt candelabras'. Here is one of the earliest records of a piece in mahogany and he was probably one of the first to use this wood in Paris. Following this he supplied various functional pieces to the Garde-Meuble Royal. The first pieces were for Mme de Pompadour and coincided with the early days of her favour. In 1747 he supplied several encoignures and a night-table for her apartment at Marly. Gaudreaus was then ébéniste to the Crown, but Migeon supplied bidets and cunningly disguised commode chairs. This specialization in 'convenience' furniture earned the famous quip of d'Argenson, criticizing Mme de Pompadour's grant of a pension of 3,000 francs to Migeon 'for having made a fine chaise percée (commode chair) for the said marquise.'

Migeon died suddenly in 1758 aged fifty-seven, and the family business was taken over by his son, Pierre III Migeon, who was received master in 1761.

BIBLIOGRAPHY

Day-book of Migeon between 1730 and 1736: Bibliothèque Nationale, Ms, new acquisition no. 4765

List of suppliers of Pierre II Migeon: Archives de la Seine

Inventory taken after the death of the wife of Pierre II Migeon, Arch. Nat. Min. Cent. CI/309, 13 December 1734.

F. de Salverte: *Les Ébénistes*, pp. 232–33

Geoffrey de Bellaigue: *The James A. de Rothschild Collection at Waddesdon Manor*, vol. II. pp. 877–78

[142] Table à vantaux stamped Migeon and Lhermite (to whom Migeon must have subcontracted); in bois satiné. (Sotheby's Monaco, 8 February 1981, lot 222)

[143] Bidet in tulipwood, stamped Migeon; this type of commode chair was one of Migeon's specialities. (Sotheby's Monaco, 4 March 1984, lot 477) secrétaires).

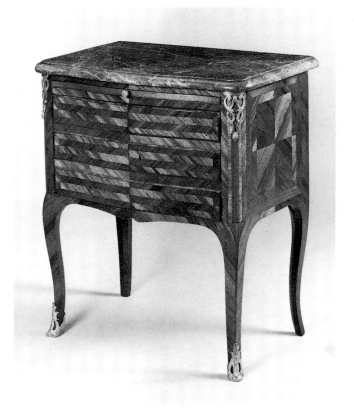

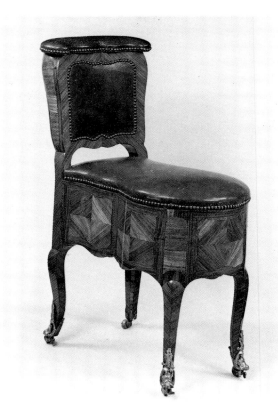

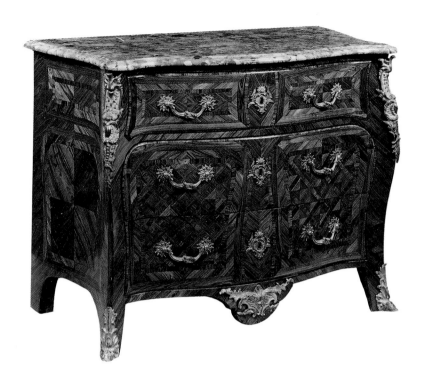

[144] Kingwood commode stamped Migeon. (Couturier-Nicolaÿ, Paris, 19 November 1981, lot 219)

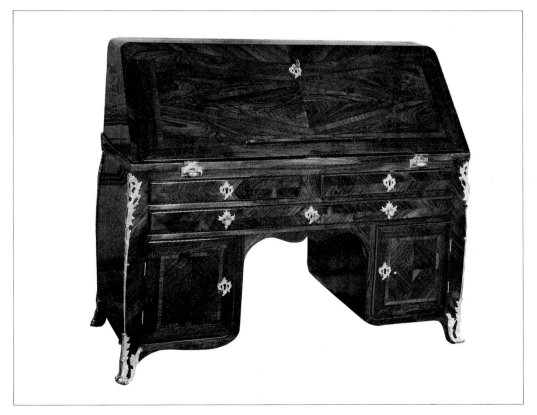

[145] Secrétaire en pente in kingwood, stamped Migeon, c. 1740. (Sotheby's Monaco, 5 February 1978)

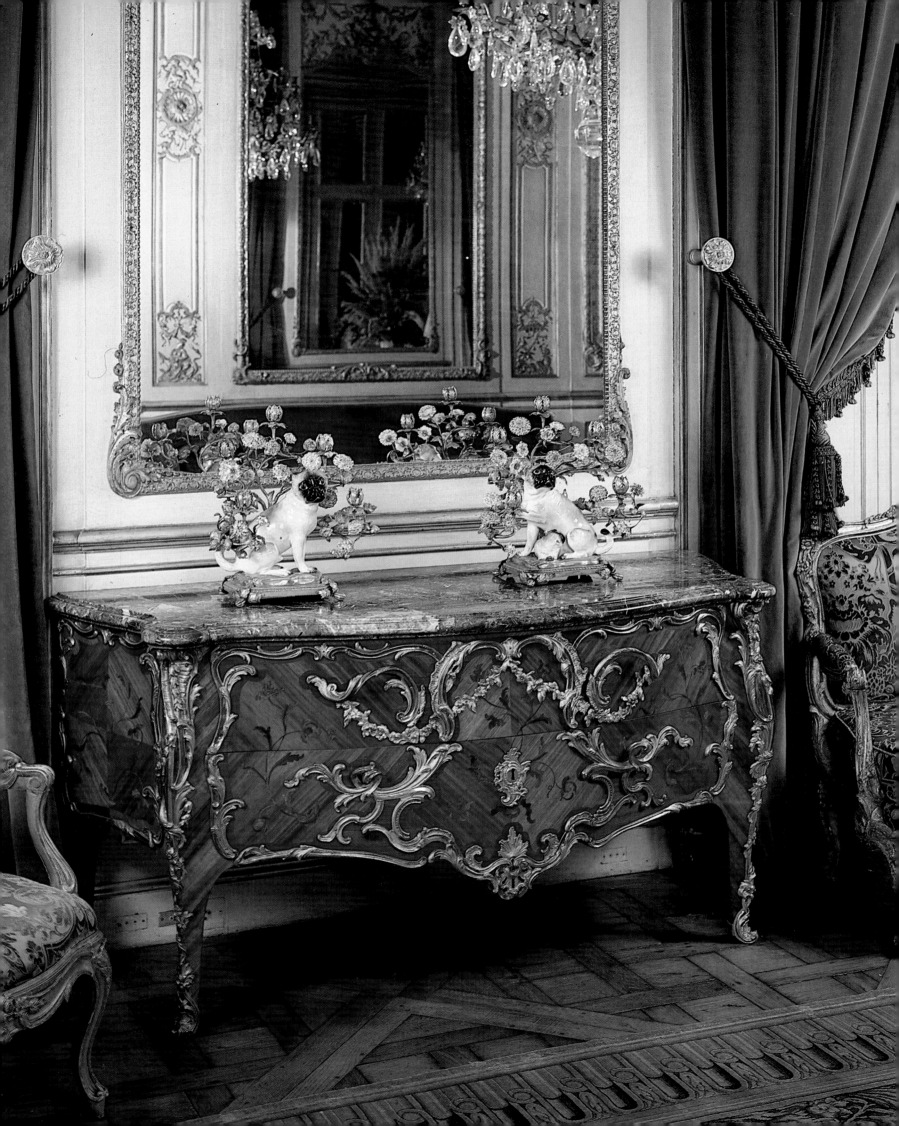

Jacques
DUBOIS

Jacques Dubois was born on 8 April 1694 in Pontoise. He was related through his mother to an important family of ébénistes, as Stéphane Boiron has discovered. His mother, née Marguerite Montigny (great-aunt of Philippe-Claude Montigny), was the widow of Nicolas Gérard, by whom she had a son, Noël Gérard, one of the most important ébénistes and dealers between the years 1720 and 1730. It was therefore most probably thanks to his half-brother, Noël Gérard, that Dubois settled in Paris and adopted the craft of ébéniste. In 1730 he was already resident in Paris when he married Marie-Madeleine Brochet, with Noël Gérard a witness.

The considerable importance of Gérard's workshop leads one to believe that Dubois must have worked there, unless he worked as an independent artisan in the Faubourg Saint-Antoine where he lived (in the rue de Charenton), selling his furniture to his half-brother. Whatever the case, Dubois did not become a master until very late in his career, in 1742, when he was forty-eight, by which time Gérard had been dead for six years. In 1752 he was elected adjudicator for his guild for two years. In 1763 he was chosen as expert on Jean-François Oeben's death. He was living in the rue de Charenton, opposite the Hôtel des Mousquetaires-Noirs. He died very suddenly, at the height of his career, in the same year as Oeben.

The inventory after his death was drawn up by his fellow ébénistes Landrin and Coulon and reveals a large workshop with twelve workbenches, describing about 127 pieces of furniture. The site comprised a store on the ground floor and a shop which served as a workshop. The production was extremely varied, consisting of bureaux (10 in number) among which were '4 small bureaux in ebonized wood', secrétaires en pente (5), secrétaires 'en armoire' (2), trictrac tables (8), pedestals (8), écritoires (6), bidets (7), clocks (2), coffers, spittoons and so on. There were numerous (21) small tables for various uses (writing, en chiffonnière, bedside-tables, à patins . . .); on the other hand there were few encoignures (6) or commodes (4). The brief descriptions make it impossible to identify specific pieces of furniture. In the inventory there is little mention of the type of wood used, which suggests that most of the furniture was waiting to be veneered or lacquered. The few woods described are very diverse: '2 trictracs with stands in kingwood, tulipwood and amaranth with wooden draughts-boards, one in ivory and the other in ebony, undecorated, 240L', or '2 secrétaires en armoire in tulipwood and amaranth mounted with bronzes, without marble [top], 22L', or '2 large bookcases in amaranth decorated with brass, 400L', 'one bureau in tulipwood and kingwood with its serre-papiers and cupboard underneath, with bronze mounts, 300L'; '2 small table "chiffonnières";' '2 toilet-tables in tulipwood, 200L'; 'one commode 4 pieds long in tulipwood, with bronze mounts, without marble [top], 100L'.

The stocks of wood for veneering described at the end of the inventory are again very diverse and briefly itemized under the general title of 'bois des Indes':

1,544 livres weight of bois des Indes. *544L*
3,949 livres weight of bois des Indes. *789L*
272 livres weight of bois des Indes in sheets. *272L*

[146] Commode, one of a pair,
c. 1750, stamped both Dubois
and Migeon (the latter as
retailer); floral marquetry in bois
de bout on a bois satiné ground.
(Private collection)

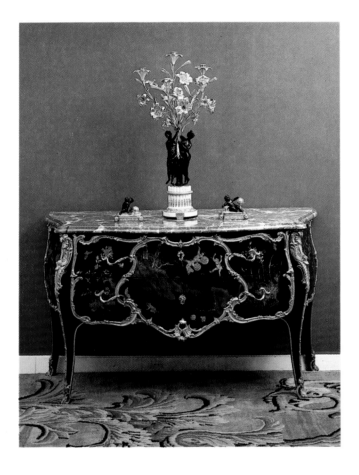

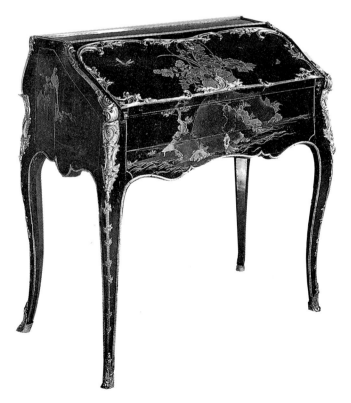

Only oak and pine are mentioned as being used for the carcases of his furniture ('244 planks of French oak, 446L...', and '411 planks of pine'.)

As in Oeben's workshop, mahogany was already in use: 'one bureau 5½ pieds in length in mahogany, undecorated, *80L*', and '3 secrétaires partly completed in solid mahogany, *150L*'.

Finally, a number of sumptuous pieces of furniture are described, all in Chinese or Japanese lacquer: 'one bureau in Chinese lacquer with gilt-bronze mounts, *220L*'; 'one small secrétaire in Japanese lacquer, priced *200L*'; 'one commode 4½ pieds in length in Chinese lacquer decorated "à grands cartels" [with large bronze mounts], 2 large encoignures also in Chinese lacquer "à cartels" [with mounts] priced *1,000L*' [with 2 serre-papiers]; 'one bureau, almost completed, with mounts "à cartel en noir" [ungilt] and veneered with lacquer, one secrétaire in Chinese lacquer with its bronze mounts, altogether *400L*'. Two clock-cases are mentioned, a sign that Dubois was also interested in this type of production, in which his son-in-law, Jean Goyer, would later specialize. One of them was valued so highly that it must in fact have been a long-case clock: 'One case for a clock with second-hand in bois satiné with floral veneer, with bronze mounts, *240L*'.

No indication is given as to the style of individual pieces of furniture, apart from a number of references to pieces 'à la grecque': 'one bureau 4½ pieds in length with lacquered wood executed à la grecque, without leather top, priced *72L*'; 'one commode à la grecque, priced [with other pieces] *67L*'; 'one table in amaranth à la grecque, *60L*'. At the end the inventory lists a very large stock of bronze mounts: '432 livres weight of bronze models, priced *1080L*', and '228 livres weight of unchased mounts'. This would indicate that Dubois was anxious to protect the exclusivity of his bronze models and stocked important quantities of bronze mounts unchased, kept in hand for use on his furniture and for supplying the chaser and gilder.

[147] (above left) Commode stamped Dubois, c. 1750, in Chinese lacquer. (Archives Galerie Segoura, Paris)

[148] Secrétaire en pente stamped Dubois, in Japanese lacquer; a precious piece probably made for a marchand-mercier. Mounts struck with crowned 'C', 1745–49. (Sotheby's New York, 6 May 1977, lot 176b)

CLIENTS AND DEALERS

Virtually no information can be gleaned about Dubois' clientèle from the records. We only know that he did not supply the royal family. The only piece that can be identified precisely is the celebrated encoignure in the J. Paul Getty Museum. We now know that it was made in about 1745 after a drawing executed twenty years earlier by Nicolas Pineau, and supplied in 1753 to Count Branicki in Warsaw. The discovery of the date 1744 on the inside of the clock face has solved all the problems of dating this piece. Nicolas Pineau was in Russia between 1716 and 1727 and it is known that on his return to France he maintained relations with his Russian clientèle up until about 1740. There is no doubt that he ordered the piece from Dubois.

The presence at Genoa in the Royal Palace of a commode by Dubois, originally from Colorno, is proof that, together with Latz, he was one of the suppliers to Madame Infante, daughter of Louis XV, between the years 1750 and 1753.

Dubois essentially produced luxury furniture, mainly secrétaires and bureaux in Chinese or Japanese lacquer, costly pieces probably destined for the marchands-merciers. The only dealer's name connected with Dubois is that of Bertin (whose label appears on a bureau formerly in the Cartier Collection), and the marchand-ébéniste Migeon: his stamp is found next to that of Dubois on several pieces of furniture including the bureau plat known as 'de Vergennes' in the Louvre [158] and the commodes shown at [146].

[149] *Bureau plat stamped Dubois, in Japanese lacquer; confiscated at the Revolution from the Duc d'Orléans at the Château du Raincy; the twisted design of the corner-mounts is typical of Dubois. (Musée du Louvre, Paris)*

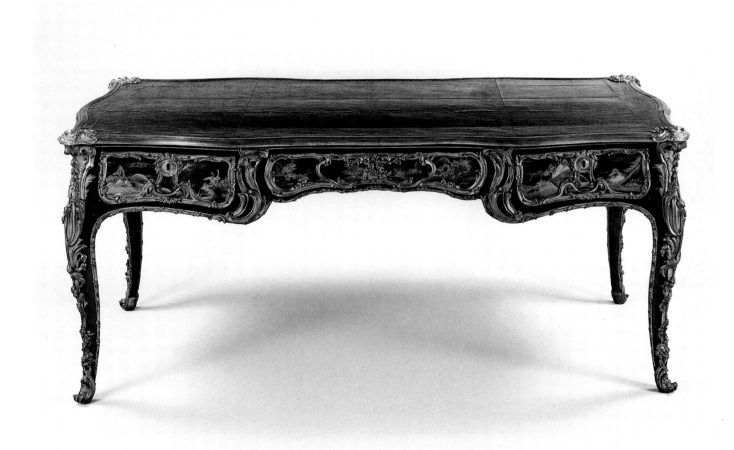

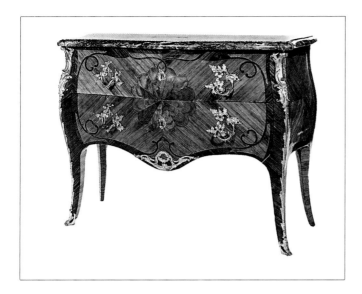

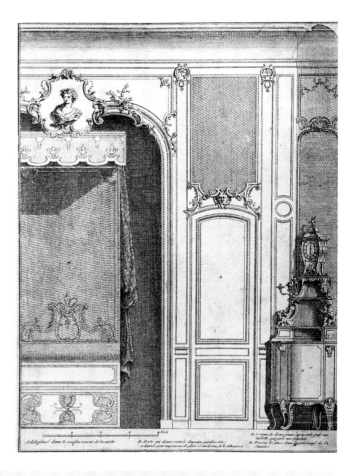

[150] *Tulipwood commode stamped Dubois. (Formerly in the Cartier Collection, sale Sotheby's Monaco, 25 November 1979, lot 164)*

[152] *Commode in bois satiné with wave pattern, stamped Dubois, c. 1750. (Waddesdon Manor, Buckinghamshire)*

[151] *Engraving by Mariette after a drawing by Pineau of a state bedroom, featuring the encoignure shown at [153]. Mariette abandoned his print-publishing business in 1734; the plate can thus be dated to c. 1730, more than ten years before the piece was made*

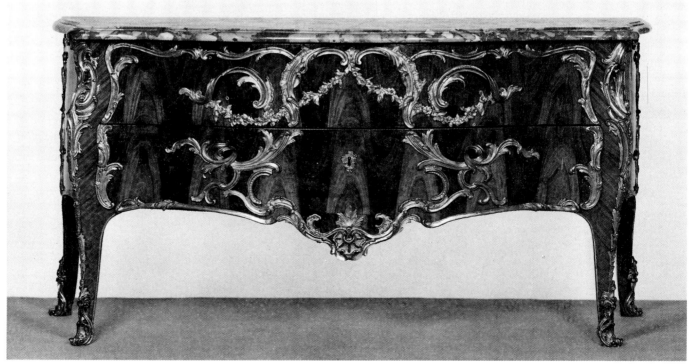

[153] Encoignure stamped
Dubois in floral marquetry in bois
de bout on a bois satiné ground.
The dial of the clock movement
by Etienne Lenoir is dated 1744.
The piece was only supplied in
1753 for Count Branicki, the
court chamberlain in Warsaw.
(J. Paul Getty Museum, Malibu,
California)

[154] Detail of mounts on the
encoignure shown at [153],
composed of putti subduing lions

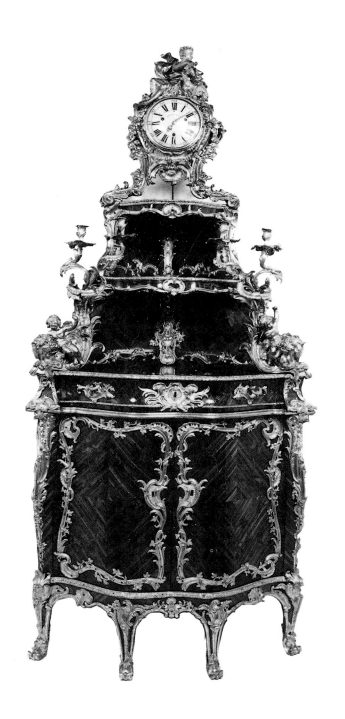

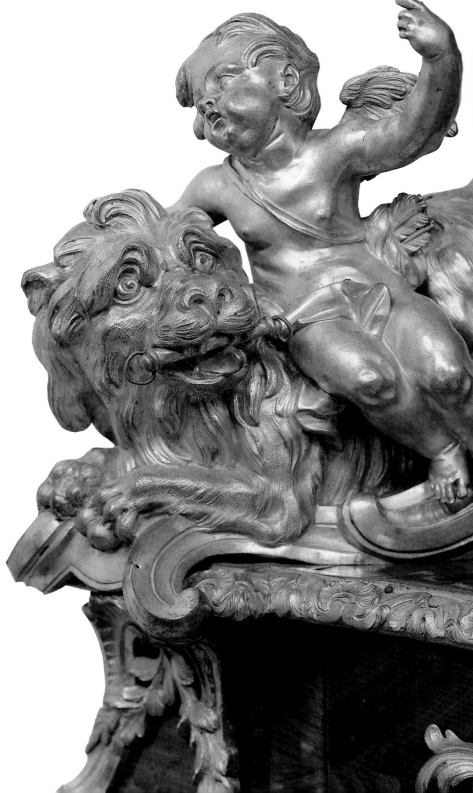

DUBOIS' STYLE

Although Dubois' production is large and very diverse, certain elements of the marquetry and mounts are repeated. As with B. V. R. B., Joseph and Lhermite, Dubois made marquetry in bois de bout with flowers in kingwood on a bois satiné ground and the designs of his marquetry are very distinctive. They are graceful, with long attenuated flowers and leaves sparingly placed on the panels. His commodes were only lightly bombé, the aprons with a pointed design. The mounts were designed in the most exuberant rococo style with flower sprays and contrapuntal curved mouldings. Certain motifs would seem particular to Dubois, such as the twisted corner-mounts which are found on most of the bureaux plats, as well as the frames on lacquer commodes. The design of the bureaux plats follows a particular rhythm, the drawers being separated by strong curves. The corners of the feet on certain pieces are often protected by a gilt-bronze sleeve sprinkled with florets.

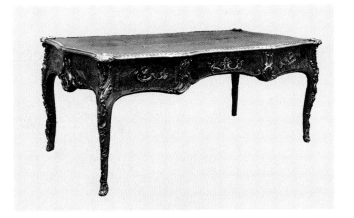

BIBLIOGRAPHY

Stéphane Boiron: master's thesis for the École du Louvre on Jacques Dubois, 1989

André Boutemy: *Meubles français anonymes du XVIIIe siècle*, pp. 45–56, 116–17 and 122–26

Pierre Kjellberg: 'Jacques Dubois', *Connaisance des Arts*, December 1979

Chiara Briganti: 'L'Ameublement de Madame Infante à Parme', *Connaissance des Arts*, July 1965, pp. 48–59

Gillian Wilson: *The J. Paul Getty Museum Journal*, vol. 8, 1980, pp. 1–3

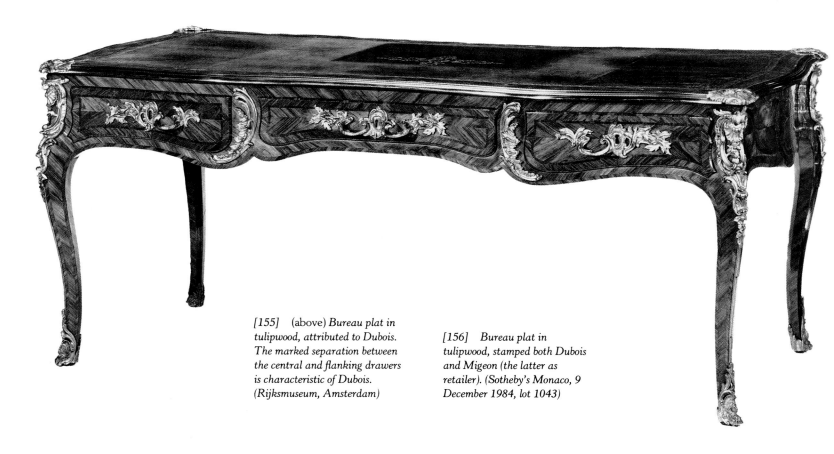

[155] (above) *Bureau plat in tulipwood, attributed to Dubois. The marked separation between the central and flanking drawers is characteristic of Dubois. (Rijksmuseum, Amsterdam)*

[156] *Bureau plat in tulipwood, stamped both Dubois and Migeon (the latter as retailer). (Sotheby's Monaco, 9 December 1984, lot 1043)*

[157] *Bureau plat with floral marquetry in bois de bout, stamped Dubois. Formerly in the Wendland Collection. (Archives Galerie Meyer)*

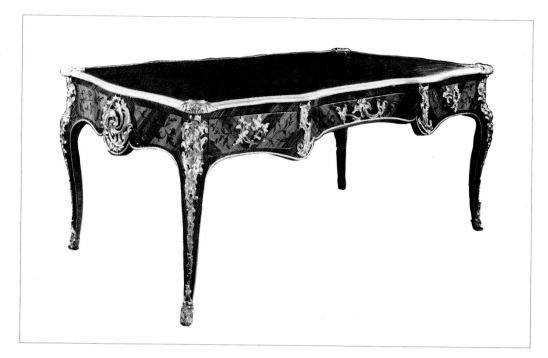

[158] *(below) Bureau plat in tulipwood, stamped both Dubois and Migeon (the latter as retailer). (Musée du Louvre, Paris)*

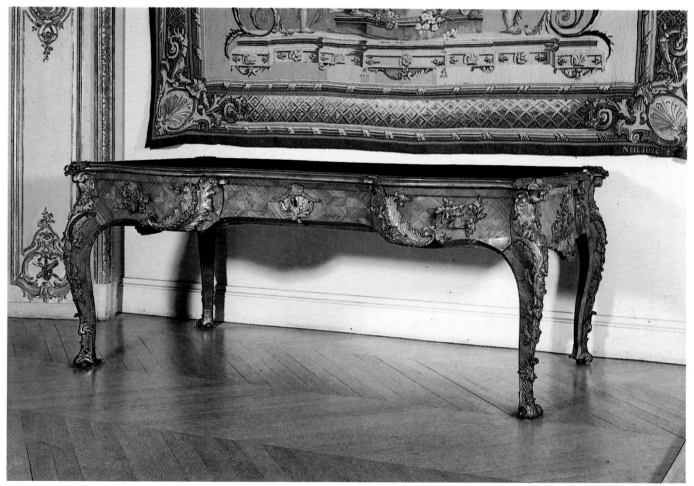

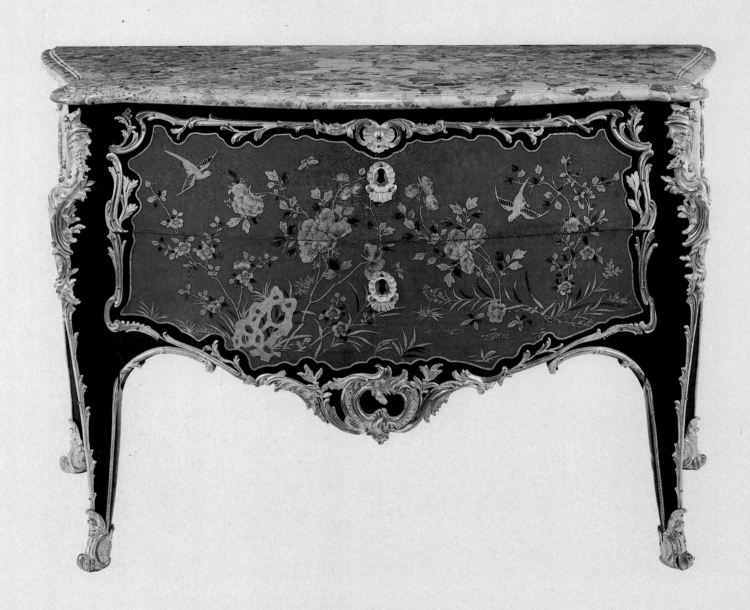

D.F.

ÉBÉNISTE ACTIVE *c.* 1740–50

The stamp 'D. F.' is found on a certain number of lacquer commodes, many of them with mounts struck with the crowned 'C', which dates them between 1745 and 1750 (see Appendix). This stylistically homogeneous group is mainly composed of commodes in either Japanese or Chinese lacquer, with the same decorative arrangement of bronze mounts, in particular the motif of a double bracket on the apron, the same rococo corner-mounts and the same frames around the panels on the fronts. Some also have S-shaped mounts, divided at the top and forming handles.

Salverte's hypothesis that the stamp 'D. F.' corresponded to a certain Jean Desforges would no longer seem tenable: there is no trace of a Jean Desforges. The only craftsman with this surname, Denis Desforges, is recorded between 1702 and 1720, much too early to be the maker of lacquer furniture. Moreover, no trace has been found of an ébéniste with

a Christian name beginning in 'D' and a surname beginning in 'F'. There remains, therefore, the hypothesis of a double surname, in which case a very plausible solution is that it refers to François Delorme-Faizelot, the father of Adrien Delorme. A master before 1735, he specialized in lacquer furniture. Established in the rue Tiquetonne in the quarter devoted to the sale of luxury goods, he sold furniture in chinoiserie vernis or in genuine Chinese lacquer.

The inventory after his death lists a number of lacquer pieces and carcases waiting 'to have lacquer applied to them.' The Delorme hypothesis is strengthened by stylistic evidence – the existence of a pair of lacquer commodes (Galerie Segoura), one bearing the stamp D. F. and the other that of A. Delorme who, becoming a master in 1748, worked alongside his father for twenty years. Furthermore, the Wrightsman Collection, New York (cat. vol. III, no. 295) has a commode stamped by Delorme, similar in design to

[160] *Commode stamped D.F.,* *from the middle of the*
c. 1750, decorated with precious *seventeenth century. (Gulbenkian*
panels of Japanese lacquer dating *Museum, Lisbon)*

[161] *Small commode in* *commode stamped Delorme.*
Chinese lacquer stamped D.F., *(Galerie Segoura, Paris)*
c. 1760; the pair to a second

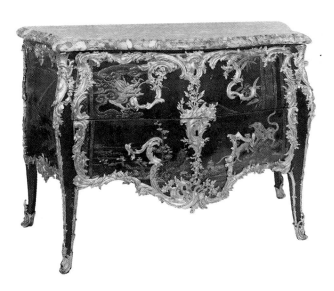

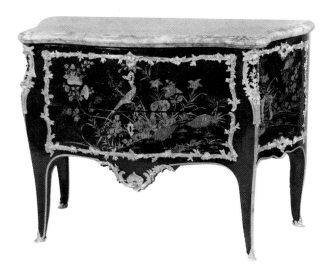

models by D. F. Moreover, collaboration between B. V. R. B. and D. F. as well as Delorme can be detected: one of the lacquer commodes by D. F. mentioned below (no. 8) is stamped 'B. V. R. B.', who no doubt made the carcase. Finally, two more commodes stamped 'Delorme' may be mentioned (one in marquetry, the other in Coromandel lacquer), both using a carcase and mounts by B. V. R. B. [164].

BIBLIOGRAPHY

F. de Salverte: *Les Ébénistes*, p. 90

APPENDIX

LIST OF COMMODES STAMPED 'D. F.'

1) National Gallery of Art, Washington, Widener Collection (stamped) in Chinese lacquer.
2) Houghton Hall, Norfolk; Marquis of Cholmondeley's collection (stamped; mounts with crowned 'C') in Chinese lacquer, illustrated in *La Maison française*

du XVIIIe siècle by Pierre Verlet, p. 156.
3) Former Alphonse de Rothschild Collection, Vienna (attributed); sale Sotheby's New York, 13 October 1983, lot 472; in Chinese lacquer [162].
4) Former Duchesse de Richelieu Collection (stamped; mounts with crowned 'C'), sale Sotheby's New York, 13 October 1983, lot 497; in red vernis Martin and gilding with black

borders [159].
5) Sale Sotheby's New York, 9 November 1985, lot 351 (stamped; mounts with crowned 'C'); identical to the preceding one, with which perhaps it originally formed a pair.
6) Private collection; illustrated in Nicolay, *l'Art et la manière des maîtres ébénistes* (stamped; mounts with crowned 'C'), former Genest d'Angoulême Collection; in Chinese lacquer.
7) Formerly in the Stieglitz Museum, St Petersburg (attributed); illustrated in Denis Roche: *Le mobilier français en Russie*, pl. XXII; in Chinese lacquer.
8) Former Josse Collection (stamped 'B. V. R. B.'), illustrated in E. Molinier: *Histoire générale des arts appliqués à l'industrie*, vol. III, p. 114; in Chinese lacquer and almost identical to the preceding one.
9) Sale Hôtel Drouot, 20 April 1921 (stamped); in Chinese lacquer.
10) Sale Sotheby's New York, 20 May 1987 (stamped); in

Chinese lacquer.
11) Gulbenkian Collection, Lisbon (stamped), formerly in the Larcade Collection; in Japanese lacquer, very rich gilt-bronze mounts [160].
12) Private collection, formerly Galerie Didier Aaron (stamped); in Japanese lacquer, almost identical to the last, but with fewer mounts.
13) Galerie Segoura (stamped); small commode in Chinese lacquer, a pair to another commode stamped 'Delorme' [161].
14) Sale Paris, Laurin-Guilloux-Buffetaud, 5 December 1980 (attributed).
15) Museum of the Legion of Honor, San Francisco (stamped) in Japanese lacquer; almost identical to the one in Lisbon but without handles.
16) Former Mme Douine Collection (stamped; mounts with crowned 'C'), sale, Paris, Galerie Charpentier, 12 April 1946, with corner-mounts identical to the ones on the Lisbon commode.

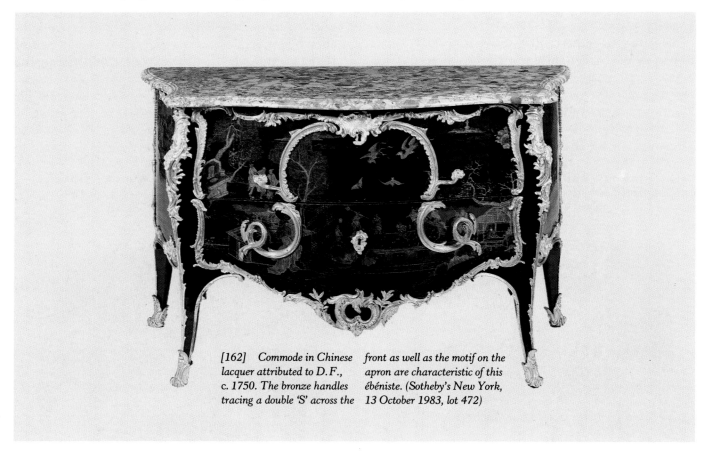

[162] Commode in Chinese lacquer attributed to D. F., c. 1750. The bronze handles tracing a double 'S' across the front as well as the motif on the apron are characteristic of this ébéniste. (Sotheby's New York, 13 October 1983, lot 472)

Adrien
DELORME

MASTER 1748; ACTIVE UNTIL 1783

The date of birth of Adrien Delorme is unknown. He belonged to a family of Parisian ébénistes, who added a second name, de Lorme or Delorme, to their surname of Faizelot. He was the oldest son of François Faizelot-Delorme (1691–1768), who was settled in the rue Tiquetonne and specialized in furniture in Chinese lacquer or pseudo-Chinese lacquer. Adrien in his turn produced furniture in Chinese lacquer of a pronounced rococo character, as can be seen in the commode in the Rijks-

museum in Amsterdam. Later on he specialized in marquetry pieces, developing his own idiosyncratic style of flowers in bois de bout on a ground in a light-coloured wood, almost yellow, with the darker grain placed in chevrons. A whole series of tables and a commode are recorded, so close in style to the work of B. V. R. B. (in form and mounts) that the possibility of a collaboration between the two ébénistes must be considered. Delorme's reputation as a craftsman in marquetry was such that he is mentioned in contem-

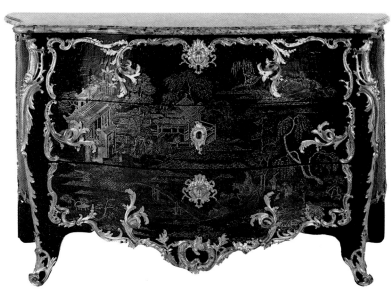

[163] Commode in Chinese lacquer stamped Delorme, c. 1750; the apron mount is usually found in D. F.'s work. (Sotheby's New York, 21 May 1988, lot 185)

179

[164] *Commode stamped Delorme: the zebra-striped veneer of light wood is characteristic of him; however, the form and mounts are typical of B.V.R.B. who must have made the carcase. (Palais Galliera, Paris, 18 June 1964, lot 184)*

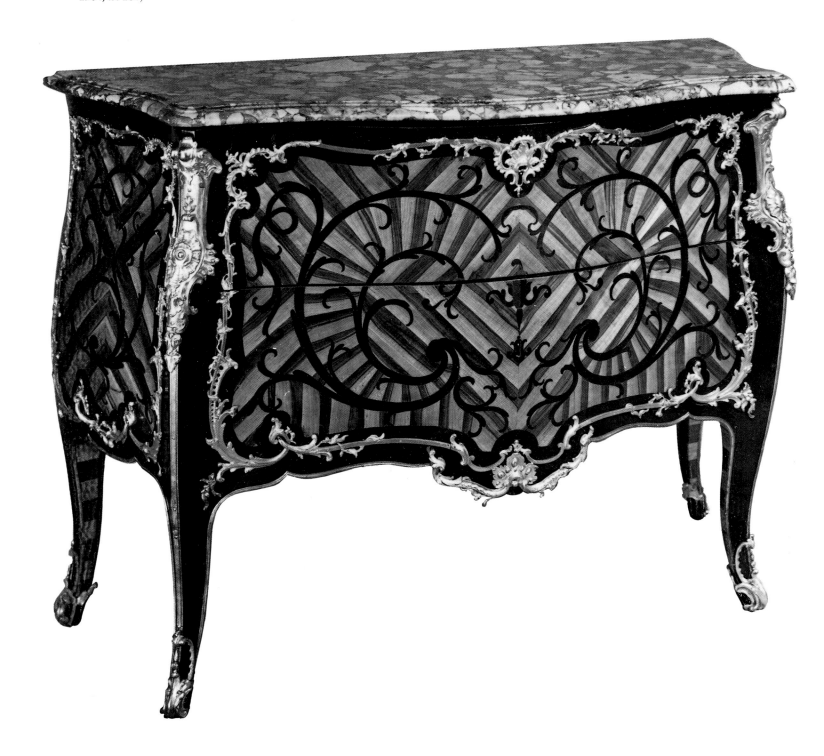

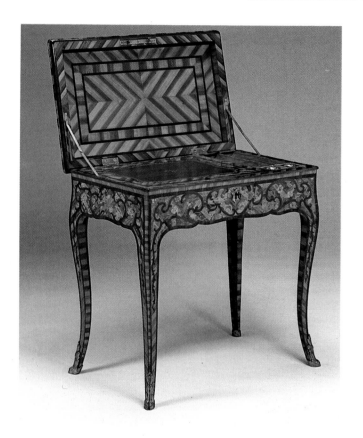

porary almanacs as 'one of the most adept and renowned in the production of marquetry'. He moved to the rue du Temple where he was both ébéniste and dealer. In 1768 he was elected adjudicator to his guild in the place of his father who had just died and who had exercised this function since 1766. On his retirement in 1783 a public auction was held of his stock which comprised 'a quantity of commodes, encoignures, serre-papiers and bureaux decorated with gilt-bronze mounts and tops of marble or alabaster' (*Annonces, affiches et avis divers*, 28 February and 29 April, 1783).

Delorme's two brothers were also ébénistes; the elder, Jean-Louis, received master in 1763, used his father's establishment in the rue Tiquetonne from 1768 to 1780 and specialized in the restoration and resale of Boulle furniture. Thus his stamp is found on a low bookcase in the Wallace Collection and on an armoire at Versailles. The second brother, Alexis, became a master in 1772 and specialized in the sale of furniture in the rue Saint-Denis until 1786.

BIBLIOGRAPHY

F. de Salverte: *Les Ébénistes*, pp. 90–91

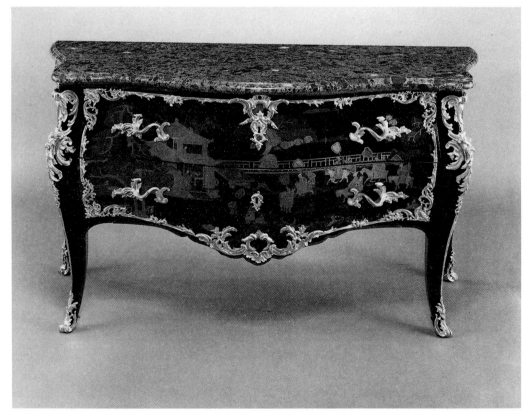

[165] (above) *Table stamped Delorme, with floral marquetry on a zebra-striped ground of light wood. (Sotheby's London, 11 July 1980, lot 157)*

[166] *Commode in Chinese lacquer stamped Delorme. (Sotheby's New York, 4 May 1985, lot 336)*

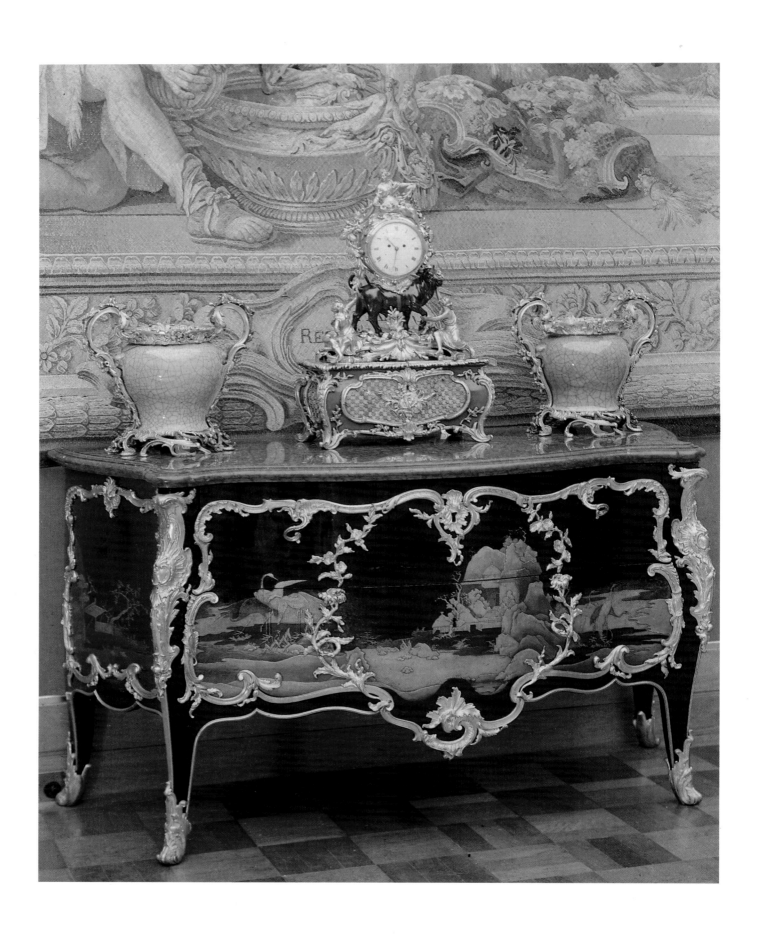

VANRISAMBURGH

BERNARD I, *d.* 1738; MASTER BEFORE 1722
BERNARD II KNOWN AS B. V. R. B., AFTER 1696–*c.* 1766, MASTER BEFORE 1730; BERNARD III, *c.* 1731–1800

Now regarded as the greatest ébéniste of the reign of Louis XV, B. V. R. B. was identified only in 1957 by J-P. Baroli, who discovered that the four mysterious initials of the stamp concealed a dynasty of ébénistes of Netherlandish origin, all with the same surname and Christian name and all settled in the Faubourg Saint-Antoine, the Vanrisamburghs.

Bernard I Vanrisamburgh (who does not in fact seem to have used the stamp 'B. V. R. B.') came from Groene in Holland. He settled in Paris before 1696, the date of his marriage to Marie-Jeanne Martel. The couple had a number of children, among them Bernard II, Joachim, an engineer who settled in Lyon in 1742, Pierre-Bernard who entered the Convent of religious penitents, and a daughter, Marie-Anne-Marguerite, who married Jean Charbonnier. The large dowry (4,000 livres) which she received on her marriage in 1722 reveals the prosperity of the Vanrisamburghs at that time. The father, Bernard I, specialized in the production of bracket, mantel and long-case clocks in Boulle marquetry and became a master before 1722. He settled in the rue du Faubourg-Saint-Antoine in a house with workshop and storage on the ground floor and a furniture store on the first floor. He died in 1738.

The inventory drawn up after his death on 7 January 1738 reveals a relatively prosperous business with 600 livres in ready money and silverware estimated at 1,433 livres. The stock-in-hand was valued by the ébénistes Germain Landrin and François Garnier. It con-

sisted entirely of clocks: more than 80 clock-cases, mostly valued at low prices (between 5 and 34 livres each). The few pieces valued at a higher price were clock-cases with mounts. The only mention made of veneers was of Boulle marquetry ('four clock-cases with tortoiseshell ground . . .' and 'four cases in tortoiseshell alone'). The shapes mentioned include rectangular, with concave cornice, and S-shaped (bracket clock hanging from a hook). There were 49 clock bases, most of them of the type described as 'en tombeaux' (sarcophagus-shaped). The store on the first floor behind the workshop contained a large quantity of unfinished clocks: the carcases of 117 clocks are itemized as well as 15 tall pedestals and 60 clock-brackets. Perhaps Vanrisamburgh the Elder sold his clock cases on to his fellow makers, which they in turn finished with either marquetry or lacquer. In any case, he was in possession of his own bronze models, described as '20 large figurines of putti and others, weighing altogether 64 livres', 'eight bronze terms with palm fronds' as well as '35 livres of mounts, unchased'. The name of the bronzier who supplied them is mentioned: an amount of 580 livres was owed to Sr Blondel 'for merchandise in the form of mounts which he supplied to the deceased, who told him that it was to be sent to *his son living in Lisbon*'. It is also noted that Vanrisamburgh the Elder employed an assistant ébéniste, Adrien Dubois, who lived under his roof and was owed the sum of 400 livres. Adrien Dubois was received master in 1741. The fact that his stamp is found principally on clocks with Boulle marquetry and on a console table in the Jones Collection in the Victoria and Albert Museum also in Boulle marquetry confirms the impression that the production of the first Vanrisamburgh must have been principally in this technique, so fashionable until about 1730.

[167] Commode in Japanese lacquer stamped B. V. R. B., c. 1745; B V. R. B. worked for the marchand-mercier Hébert who supplied, on two occasions, in 1745 and 1750, similar commodes in Japanese lacquer to the French royal family. (British Royal Collection)

Vanrisamburgh the Elder must have used mother-of-pearl on his Boulle marquetry. One finds 'a box full of burgo and other types of mother-of-pearl valued at 30 livres'. It is likely that before specializing in the production of clocks, he produced a variety of pieces of furniture with Boulle marquetry. The only piece of furniture described in the 1738 inventory is 'an old commode in brass and tortoiseshell marquetry valued at 24 livres'. The low estimate and the term 'old commode' may well suggest a type of furniture dating to the 1710s and long since out of fashion. Vanrisamburgh the Elder's workshop was definitely independent of that of his son, and his stock was sold off in January 1738, shortly after the inventory had been taken.

Bernard II Vanrisamburgh, who used the stamp 'B. V. R. B.', was born shortly after his parents' marriage in about 1696. He was apprenticed to his father and was received master before 1730. He had a separate workshop from his father, situated in the rue de Reuilly, in the Faubourg Saint-Antoine. It seems that he was in Lisbon between 1730 and 1738 and worked for the King of Portugal. A note in the inventory made after his father's death in 1738 mentions 'a bundle of 37 sheets which are notes, invoices and receipts for various goods asked for and supplied by the deceased for the Sieur Jean Laurent and Vanrisamburgh his son in Lisbon'. All trace of this early work by B. V. R. B. in Portugal was destroyed in the Lisbon earthquake in 1755. However, we know that Jão V, King of Portugal (1689–1750) commissioned works from the best Parisian craftsmen, as in 1733 Cressent made a cartel clock for him in the form of 'Love conquering Time', see p. 22.

In 1730 B. V. R. B. married Geneviève Lavoye, by whom he had six children. He remained all his life in the Faubourg Saint-Antoine, moving from the rue de Reuilly to the rue Saint-Nicolas, where he is recorded as living in 1754. In 1755 he was cited as an expert during a legal case against the ébéniste Lardin. Throughout his career he worked for the important marchands-merciers in Paris, such as Hébert in the early years, and then Lazare Duvaux and Poirier, specializing in luxury furniture in marquetry of bois de bout, lacquer or porcelain. As a result he had no direct contact with the elegant clientèle, nor did he acquire

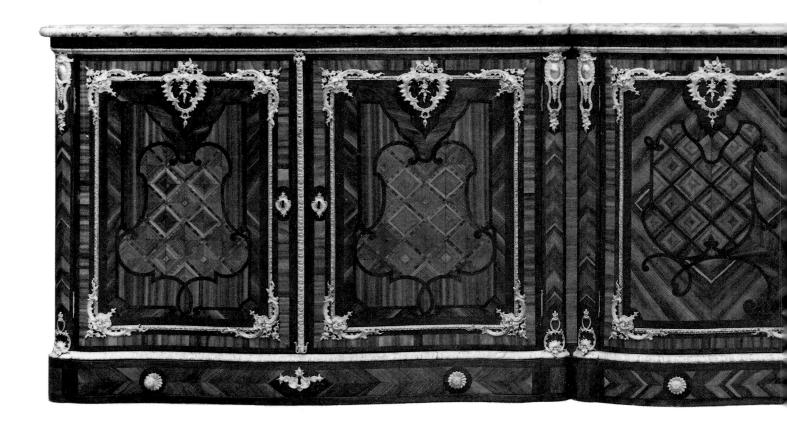

the renown enjoyed by Boulle and Cressent who had their workshops in the more central parts of the city. His name is rarely mentioned in eighteenth-century sale catalogues and then only by his Christian name, Bernard. Thus in the Blondel de Gagny sale in 1776, lot 177 is described as 'a fine commode in bois satiné and amaranth . . . by Bernard'.

In 1764 B. V. R. B. retired, selling the contents of his workshop to his son for 3,000 livres. The inventory taken then shows a small workshop fitted only with three work-benches, with twenty pieces of furniture in stock, almost all incomplete and unveneered (see Appendix). It would seem that furniture remained unveneered and unlacquered pending a specific order from the dealers. B. V. R. B. must have died before February 1767, the date of his son's marriage, as his name is not mentioned in the marriage contract.

B. V. R. B.'S PRODUCTION

The early work of B. V. R. B. may be studied, since he appears to have used his stamp from about 1735–37. Thus his stamp is found on the lacquer commode sup-

plied for the Queen at Fontainebleau in 1737 [187] as well as the bureau plat at Temple Newsam House, Leeds [173]. This piece, strongly imbued with the Régence style and that of Boulle, cannot be dated later than 1735. This is therefore the earliest piece identified as B. V. R. B.'s work. The same 'oyster' veneer copied from certain Anglo-Dutch coffers of the late seventeenth century is found on a writing-table in the Louvre [171] from the same period. As well as this bureau, various unstamped pieces of furniture are attributable to B. V. R. B., all similarly mounted: two commodes formerly in the Wildenstein/Ojjeh Collection [169], a commode in the Grog Bequest in the Louvre, a bureau plat in the Archives Nationales (supplied in 1744 by Gaudreaus for Louis XV at Choisy), two commodes in the Nymphenburg Palace and a bureau plat and two lacquer commodes in the Residenz in Munich. With the exception of the last two

[168] Low bookcase (width 4.68 m) attributed to B. V. R. B., c. 1735–40, in bois satiné; the cruciform mounts at the corners of the panels are typical of B. V. R. B. (J. Paul Getty Museum, Malibu, California)

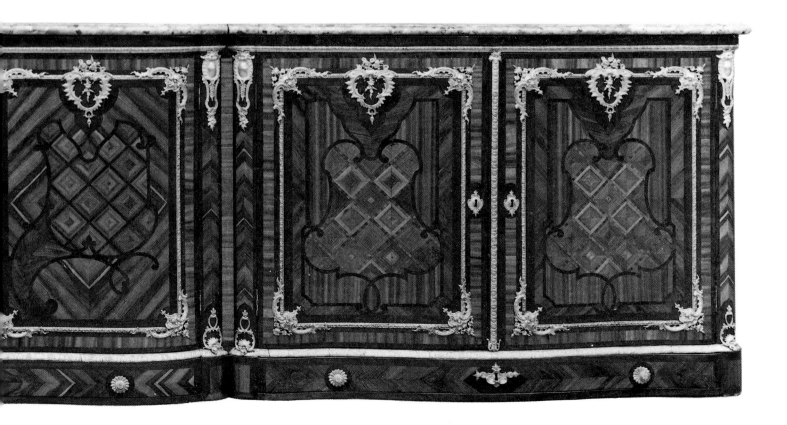

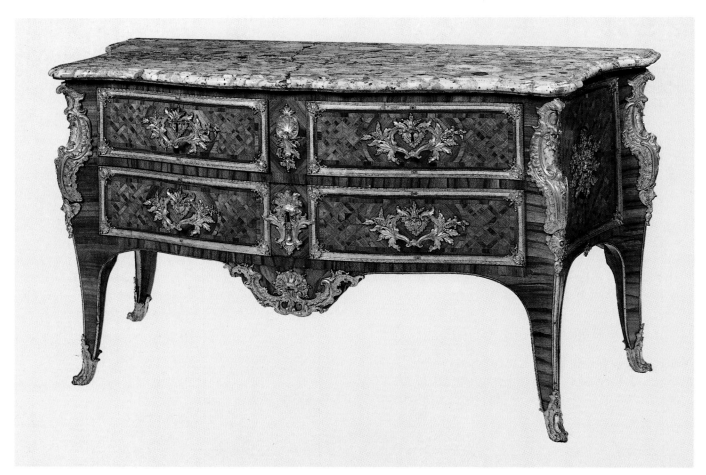

[169] Commode in bois satiné attributed to B.V.R.B., c. 1735. The mounts are typical of B.V.R.B. and are found on several works stamped him. (Sotheby's Monaco, 25 June 1979, lot 38)

[171] Writing-table, c. 1740, stamped B.V.R.B. in kingwood veneer in oyster pattern. There is an identical table in the Louvre. (Gulbenkian Museum, Lisbon)

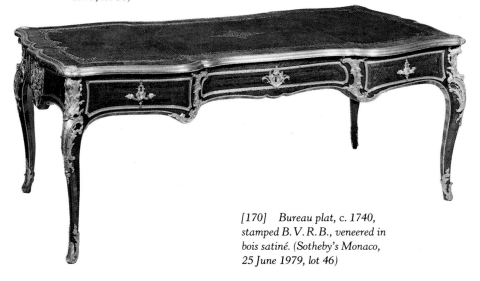

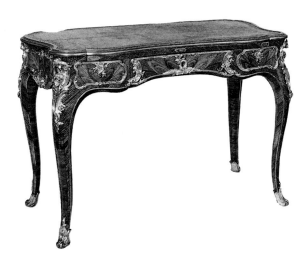

[170] Bureau plat, c. 1740, stamped B.V.R.B., veneered in bois satiné. (Sotheby's Monaco, 25 June 1979, lot 46)

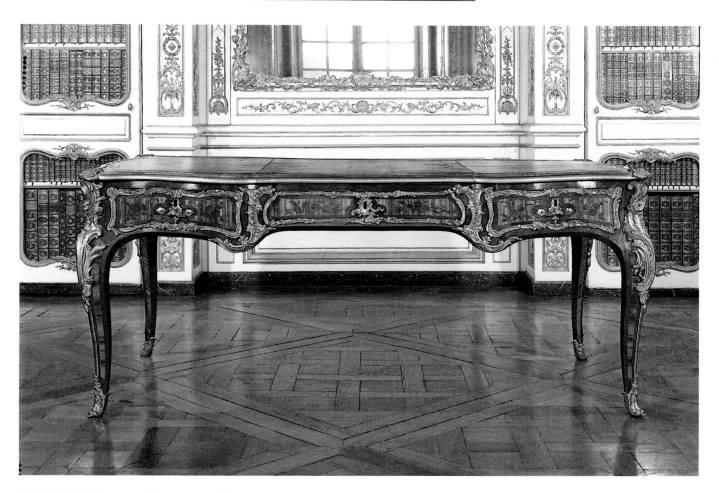

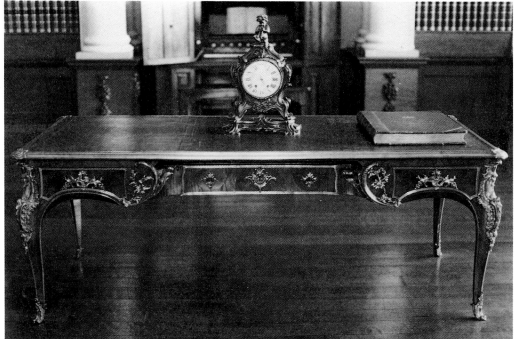

[172] Bureau plat attributed to
B.V.R.B., supplied in 1745 by
the marchand-mercier Hébert
(for whom B.V.R.B., worked)
for the Dauphin at Versailles.
One of the earliest examples of
floral marquetry delivered to the
French royal family. (Musée de
Versailles)

[173] Bureau plat, c. 1735, in
kingwood veneered in oyster
pattern, stamped both B.V.R.B.
and F.L. (François Lieutaud); as
early as 1746 it belonged to
Richard Arundale of Allerdon
Park, Yorkshire. A drawing by
the architect Vardy shows that it
originally possessed a serre-
papiers. (Temple Newsam House,
Leeds)

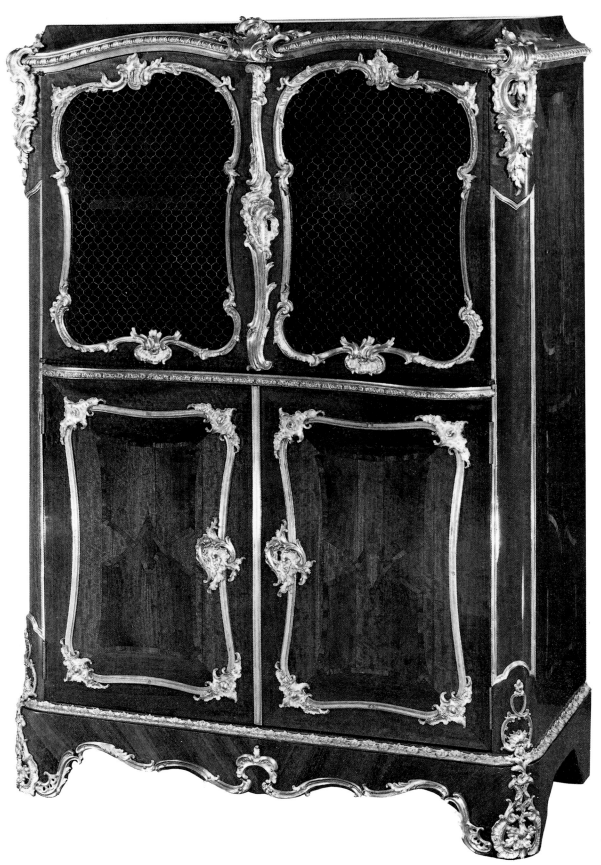

[175] (right) *Commode, one of a pair stamped B.V.R.B. Originally from Schloss Moritzburg, it was part of a matching set comprising three further large commodes and two encoignures; marquetry of kingwood on a bois satiné ground. (J. Paul Getty Museum, Malibu, California)*

[174] *Bookcase, one of a pair stamped B.V.R.B., c. 1750, in bois satiné. (J. Paul Getty Museum, Malibu, California)*

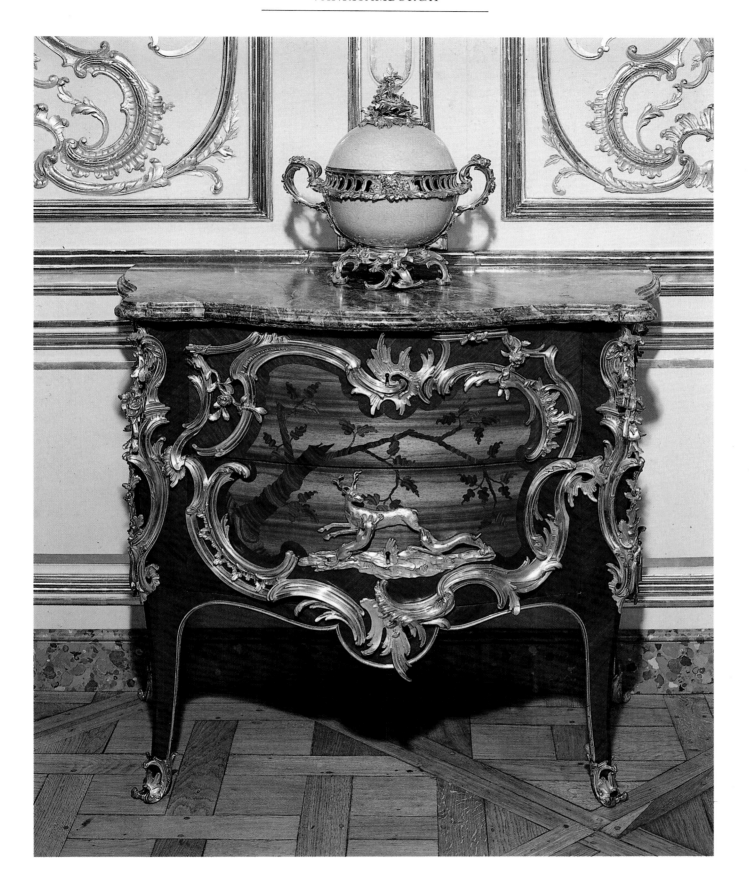

pieces, all the other pieces have the same kingwood marquetry designed in lozenges and diamonds, typical of the years 1730–40, used by B. V. R. B. in the manner of Criard, Migeon, Cressent and Carel.

During these years B. V. R. B. also used a plain veneer of bois satiné, as can be found on a bureau plat formerly in the Wildenstein/Ojjeh Collection, on the bookcases in the J. Paul Getty Museum [168] and on travelling trunks.

FLORAL MARQUETRY

After 1740 B. V. R. B. revived the art of floral marquetry, which had gone out of fashion in France by 1700. The first pieces of furniture in floral marquetry supplied to the Garde-Meuble Royal were those delivered by Hébert in 1745 for the Dauphin and Dauphine at Versailles. They were almost all pieces by B. V. R. B., who was one of Hébert's principal suppliers. B. V. R. B. perfected marquetry in bois de bout composed of flowers in kingwood standing out on a ground of light-coloured wood. In his early work he used bois satiné for the ground, sometimes framed in

amaranth. This can be seen on the bureau plat supplied in 1745 by Hébert for the Dauphin at Versailles [172], or the secrétaire supplied in the same year, also by Hébert, for the Dauphine [179] or on the mineral-specimen cabinet for Machault d'Arnouville dated between 1745 and 1749. The deliveries by Hébert for the Dauphin and Dauphine in January and February 1745 consisted moreover of others pieces of furniture in bois satiné and kingwood, also no doubt by B. V. R. B. Later, B. V. R. B. used tulipwood rather than bois satiné for his marquetry grounds. This can be seen on a large secrétaire delivered by Lazare Duvaux in 1755 for Louis XV at the Trianon [190]. The series of secrétaires à abattant [177] must date from the years between 1755 and 1764. They probably correspond to certain deliveries by Lazare Duvaux, the important marchand-mercier of the period, such as the following delivery in 1756 for Louis XV's Cabinet at Saint-Hubert:

No. 2163) A secrétaire en armoire in tulipwood veneered with flowers in kingwood, decorated with gilt-bronze mounts, the base having two hinged doors closed with a key. The front, also closed with a key, folds down to form

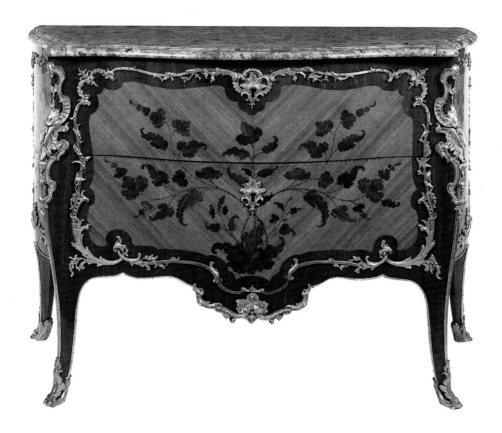

[176] Commode stamped B. V. R. B., c. 1755, with floral marquetry in bois de bout on a tulipwood ground. (Sotheby's New York, 6 November 1982)

[177] Secrétaire à abattant stamped B. V. R. B, with floral marquetry in bois de bout on a tulipwood ground, c. 1755–60. In 1758 Lazare Duvaux supplied Louis XV at the Château de Saint-Hubert with a secrétaire of this type at a cost of 1,320L. (Museé de Genève, Lord Michelham Bequest)

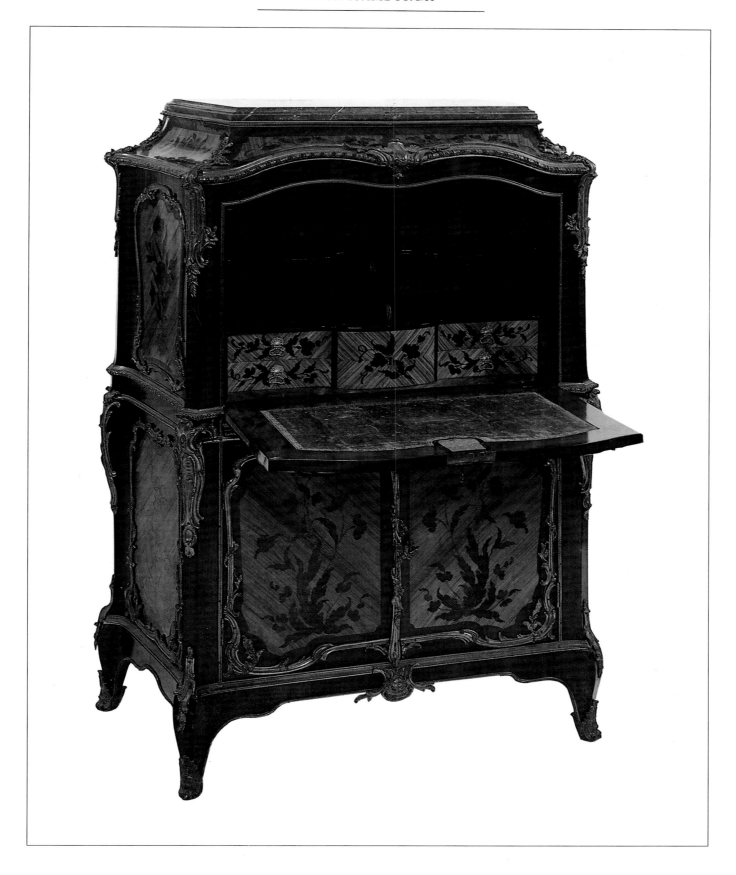

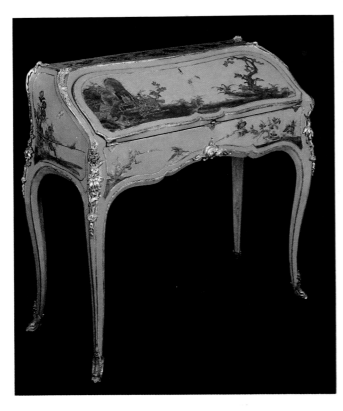

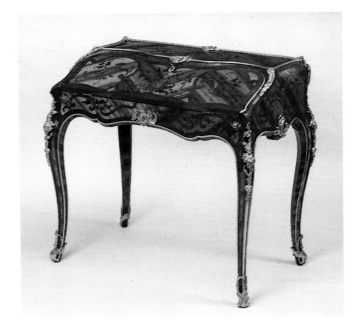

[179] Secrétaire en pente stamped B.V.R.B., supplied in 1745 by the marchand-mercier Hébert for the Dauphine at Versailles, along with a lacquer commode and a marquetry table also probably by B.V.R.B.; floral marquetry in bois de bout on a bois satiné ground. (Musée de Versailles)

[183] (right) Portrait of Mme de Pompadour painted by Boucher in 1756; on the right is a small table by B.V.R.B. which must have been bought through the marchand-mercier Lazare Duvaux. (Alte Pinakothek, Munich)

[178] Secrétaire en pente stamped B.V.R.B. in blue vernis imitating Japanese lacquer; mounts struck with crowned 'C' (c. 1745–49). (Archives Galerie Steinitz, Paris)

[180] Small writing-table stamped B.V.R.B., c. 1750–60, in tulipwood. (Sotheby's Monaco, 4 December 1986, lot 294)

[181] (below centre) Small table attributed to B.V.R.B., fitted with a Sèvres porcelain top dated 1760, bearing ink inscription 'Poirier, marchand, rue St-Honoré à Paris'. One of the very first pieces of furniture decorated with porcelain, of which Poirier was to make a speciality. (Christie's London, 29 November 1973, lot 106)

[182] Small secrétaire en cabinet, or jewel-cabinet, attributed to B.V.R.B., c. 1760; floral marquetry in bois de bout on a tulipwood ground. (Sotheby's Monaco, 22 June 1986, lot 634)

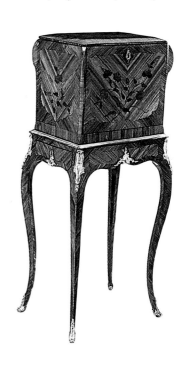

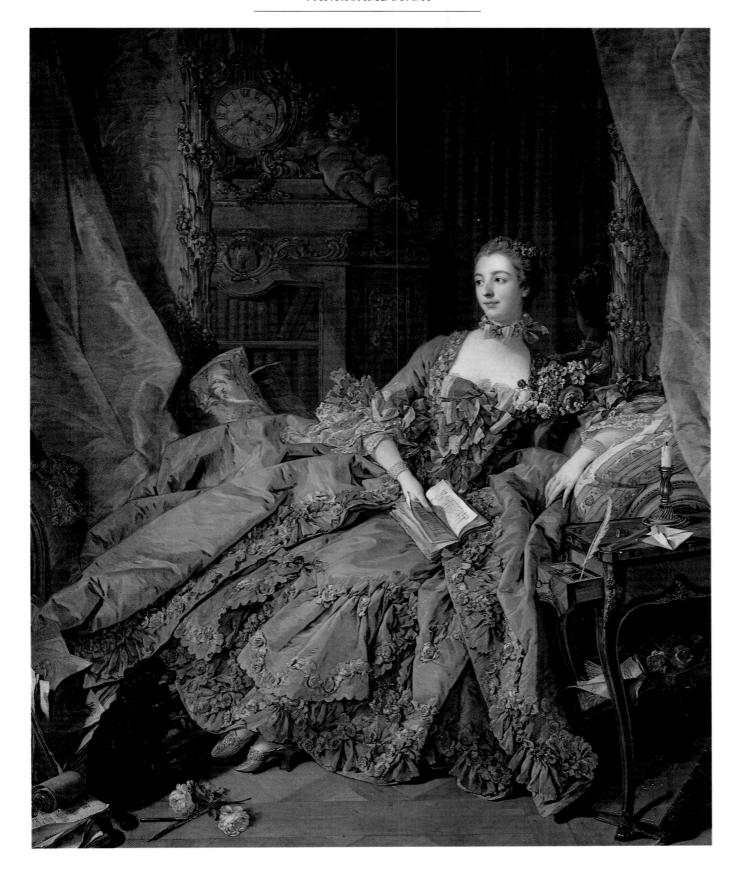

a writing surface covered in crimson velvet and fitted with five drawers opening with a button, one of which on the right is fitted with inkwell, powder-box and sponge-box in silver. The cupboard and drawers are lined with fabric, the secrétaire is 3 pieds 4 pouces long, 16 pouces deep and 4 pieds high. [Arch. Nat. $0^1$3317.]

The years 1745–49 mark the appearance of tulipwood furniture: it was in 1749 that the first examples of tulipwood furniture are noted in the records of Lazare Duvaux, while those of the Garde-Meuble Royal note the first delivery of tulipwood furniture in 1745. B. V. R. B. also made secrétaires à abattant for the dealer Poirier, who succeeded Duvaux as the presiding genius of 1760s Parisian fashion. At least two secrétaires by B. V. R. B. bear Poirier's handwritten inscription in ink: one in lacquer in the British Royal Collection, the other in marquetry in a Belgian private collection. We know that B. V. R. B. worked for Poirier before 1753, as his name features at this time in a list of creditors of Hécéguère and Poirier.

LACQUER FURNITURE

B. V. R. B.'s great speciality remained that of lacquered furniture, particularly furniture decorated with panels of Japanese lacquer. This type of furniture was the result of the initiative of the marchands-merciers Hébert, Darnault and Poirier, who made a speciality of it and who were among the few dealers who could afford oriental lacquer wares. As well as precious chests, Japanese screens and cabinets were cut up to form the main panels on commodes, the remaining surfaces being filled in with French lacquer imitating Japanese lacquer, a speciality of the Martin brothers. Hébert was the first to supply this type of furniture to the Garde-Meuble Royal; and he had certainly invented it. The very first delivery took place in 1737, consisting of a commode in Japanese lacquer stamped 'B. V. R. B.', made for Maria Leszczyńska's cabinet de retraite at Fontainebleau [187]. It is surely the earliest documented example of panels of oriental lacquer cut horizontally by drawer divisions. The furniture supplied by Hébert to the Crown was stamped either by Criard or B. V. R. B. who were his principal suppliers at the time. It would seem that the former preferred to deal in furniture in Chinese lacquer or vernis Martin, while the latter specialized in furniture decorated with

[184] Commode stamped B. V. R. B., c. 1750, in Japanese lacquer. The dealer Hébert supplied two pieces of this type for the royal family in 1745 and 1750 respectively. (Formerly in the Embiricos Collection, sale Sotheby's New York, 3 May 1986)

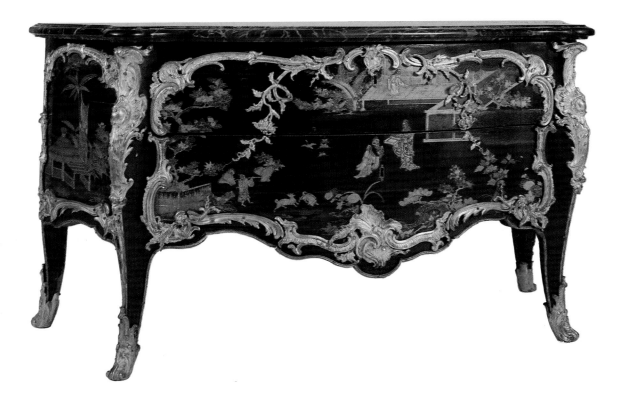

Japanese lacquer. (B. V. R. B. was the only maker, with Joseph Baumhauer and D. F., to have used Japanese lacquer at that time, but there is no proof that Joseph or D. F. worked for Hébert. Moreover, the lacquer commodes by Joseph must be later in date, around 1750–60, while the two known commodes by D. F. in Japanese lacquer date from the years 1745–50.) It is therefore likely that B. V. R. B. produced most of the furniture in Japanese lacquer which was delivered to the Garde-Meuble Royal in the years between 1737 and 1745. Thus on 27 January 1744 the Garde-Meuble sent to M. Hébert, 'marchand-bijoutier':

A six-leaved screen, 6 pieds 7 pouces in height, in black Japanese lacquer decorated with landscapes, flowers, trees and birds, polychrome and gilt . . . to use the black lacquer on a large commode and the fronts and panels of a console table, both for the King's Bedchamber at Choisy; to apply to a large bureau, 6½ pieds in length, 3 pieds 2 pouces in depth, without drawers; and to veneer also the drawers and panels of two console tables with two encoignures for the Council Chamber at the Château de Choisy. [Arch. Nat. 0¹3313.]

The results of this order are mysterious. It was not Hébert but Gaudreaus who supplied the lacquered furniture for Choisy in 1744: a commode, two encoignures and a bureau. To complicate matters further, it appears that the commode was actually Gaudreaus' own work [121], while the bureau, today in the Archives Nationales and reveneered, is obviously the work of B. V. R. B. What happened to the original order? Were the lacquer panels sent to Gaudreaus instead of Hébert? Had B. V. R. B. in the meantime made the lacquer consoles for Hébert? We do not know the answer, but the origin of the console in the Wrightsman Collection, the only known example in Japanese lacquer, lies perhaps at the heart of this mys-

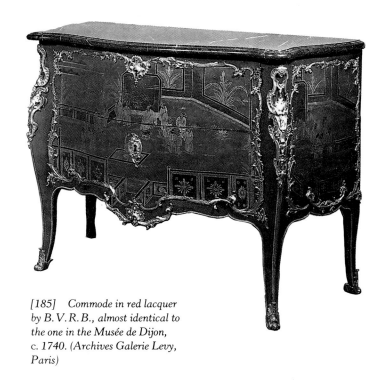

[185] Commode in red lacquer by B. V. R. B., almost identical to the one in the Musée de Dijon, c. 1740. (Archives Galerie Levy, Paris)

[186] Commode en console stamped B. V. R. B. in Japanese lacquer, c. 1745. (Metropolitan Museum of Art, New York; Wrightsman Collection)

[187] Commode in Japanese lacquer stamped B. V. R. B., supplied in 1737 by the dealer Hébert for the Queen at Fontainebleau; the earliest recorded piece of furniture in Japanese lacquer. (Musée du Louvre, Paris)

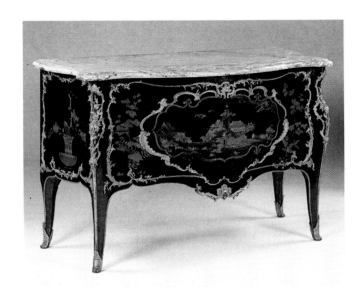

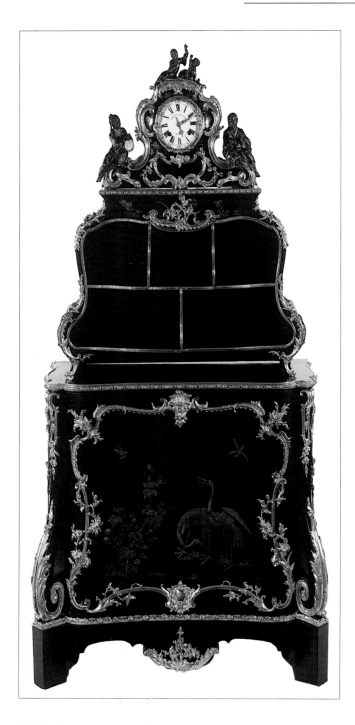

[188] Cartonnier stamped
B.V.R.B. and Cuvellier (the
latter as retailer) in Japanese
lacquer, the mounts struck with
crowned 'C' (1745–49); the clock
with movement by Etienne Le
Noir. (J. Paul Getty Museum,
Malibu, California)

[189] (right) Commode
stamped B.V.R.B., decorated
with ninety plaques of Sèvres
porcelain mostly dated 1758,
which were bought from the
manufactory by Poirier in 1760;
the piece belonged to Mlle de Sens
and later to the Prince de Condé.
(Private collection)

tery [186]. Hébert, in the following year, supplied another commode in Japanese lacquer for the Dauphine at Versailles:

No. 1343) A commode in old Japanese lacquer on a black ground with pagodas, birds and animals of that country; a top of brocatelle marble, bombé and of serpentine shape, having at the front two large drawers fitted with locks and enriched on the front and sides with gilt-bronze mounts forming compartments, and corner-mounts with matching sabots, 5 pieds in length by 25 pouces in depth in the middle and 32 pouces in height.

This entry almost certainly refers to one of the six large commodes in Japanese lacquer by B. V. R. B. (that in the British Royal Collection [167], that in the Farman sale, that in the Embiricos Collection [184], the example in the Museum für Kunsthandwerk, Vienna, and the two commodes exhibited at the Orangerie des Tuileries in 1946). A seventh commode, today in the Quirinal, was made between 1748 and 1753 for Louis XV's eldest daughter, Madame Infante, Duchess of Parma. In the time between this series of furniture dating from about 1745 and the commode delivered to Fontainebleau in 1737, the style of B. V. R. B.'s mounts had evolved considerably. The light decoration of 1737 comprising small stems, feathers and light floral scrolls had given way to a much richer style of large floral branches, rocaille work and cabbage-like motifs. Several small commodes such as that in the Dijon Museum may arguably be placed in the period between these two dates, as well as the ones in the Caen Museum and the J. Paul Getty Museum, where the lacquer panels cover the entire front which is not divided, but framed in gilt-bronze ornamentation. It was at this point that certain gilt-bronze motifs characteristic of B. V. R. B., such as the cruciform motifs at the corners of the panels, appeared.

FURNITURE DECORATED WITH PORCELAIN PLAQUES

Around 1758 Poirier conceived the idea of applying Sèvres porcelain plaques to furniture, for which he ordered the ébénisterie from B. V. R. B. or R. V. L. C. These were mainly small tables called 'chiffonnières' which could double up as table-cabarets or writing-tables. At least six examples by B. V. R. B. are known, of which most are lacquered with a trelliswork pattern

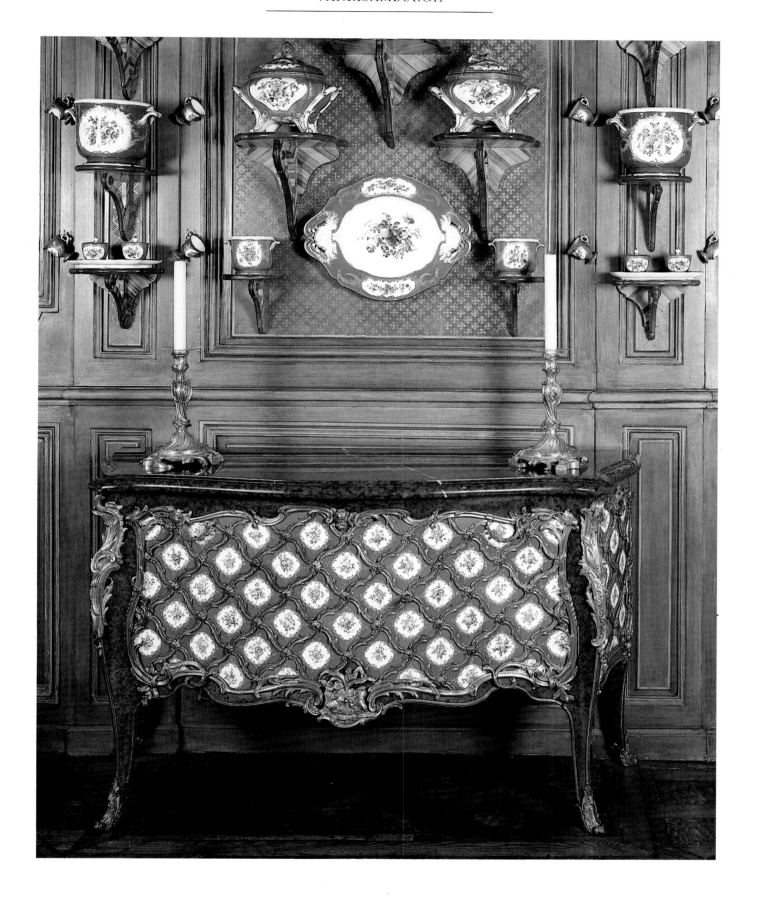

echoing the painting on the porcelain plaques. The plaques are the same shape and size as the trays sold by the Sèvres manufactory and it is clear that the original idea was to combine two previously disparate elements on one piece of furniture: the table and the cabaret. As early as 1748, Lazare Duvaux sold them as an ensemble and took care to match them as one may read in his *Livre Journal*: 'a table in green lacquer with flowers, covered with velvet and silvered cornets with a cabaret similarly glazed; four cups and saucers, sugar pot and Meissen teapot painted with natural flowers on a green ground'. The first, it would seem, and the most sumptuous of all his porcelain-mounted furniture, was the commode decorated with ninety

plaques, for the most part dated 1758, made for Mlle de Sens, which belonged later to the Prince de Condé [189]. Plaques with serpentine outline of this very special type continued to be made at Sèvres, but no other commode of this type was made, and the plaques were used to decorate the friezes on a number of bureaux by Joseph Baumhauer, with large gilt-bronze borders designed to mask the irregular outline.

Bernard III Vanrisamburgh, the eldest of Bernard II's six children, seems to have been born around 1731–32. In 1764 his father became ill and he bought his father's workshop with the furniture, finished and unfinished, that was in stock and the bronze models (see Appendix), at the same time renting part of the family home in the rue de Charenton. In 1767 Bernard III married Françoise Joitant, daughter of a menuisier, from Dourdan, with a dowry of 2,500 livres. At this time he was a journeyman ébéniste living with his mother. He did not receive his mastership, but, thanks to his mother's rights as the widow of a master, he was able to keep the workshop in operation until her death around 1774. He seems above all to have been a sculpteur and the creator of models for gilt-bronze mounts and devoted himself exclusively to this profession after 1775. He is mentioned in the documents of bankruptcy of a bronze-caster in 1786 as a 'modeller in plaster' and he was described as 'sculpteur' at the time of his death in 1800.

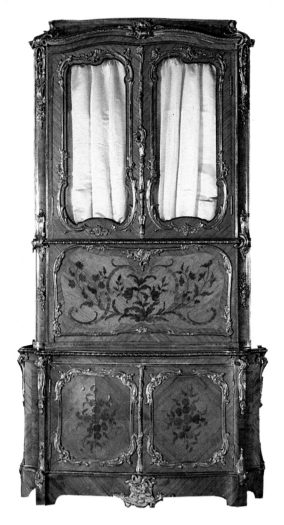

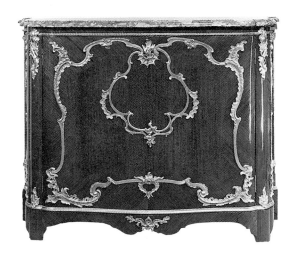

[190] *Secrétaire-bookcase, attributed to B.V.R.B., supplied in 1755 by Lazare Duvaux for* | *Louis XV at the Trianon; floral marquetry on a tulipwood ground. (Musée du Mans)*

[191] *Low cabinet in bois satiné, one of a pair stamped B.V.R.B., with the marks of the* | *Château de Bellevue. (Archives Galerie Aveline, Paris)*

198

A whole series of Neo-classical furniture, dating from after 1765 and stamped B. V. R. B., must be attributed to Bernard III, which would seem to indicate that he continued to use his father's stamp. These were also pieces in Japanese lacquer, which shows that he continued to work for the marchands-merciers: a commode à vantaux in the Metropolitan Museum of Art (Kress Collection), as well as a pair of small commodes à vantaux in the Frick Collection, a commode à vantaux and a matching pair of encoignures formerly in the Baron Lepic Collection (sale, Paris, 18 June 1887, lots 44–45) and another commode reproduced in *Paris Furniture* by Charles Packer (Newport, Monmouthshire, 1956, fig. 72). The similarity of these pieces to the commode by Joseph sold in 1766 by Poirier to the Marquis de Marigny [240] leads one to believe that all these pieces were also made for Poirier and can be dated around the years 1766–70.

BIBLIOGRAPHY

Arch. Nat. Min. Cent. Et/LXVI/432: inventory after the death of Bernard I Vanrisamburgh on 7 January 1738

J. P. Baroli: 'Le mystérieux B. V. R. B. enfin identifié', *Connaissance des Arts*, March 1957, pp. 56–63

James Parker: Note concerning B. V. R. B. in cat. *Decorative Art from the Kress Collection*, London, 1964, p. 164

Daniel Alcouffe: exh. cat. *Louis XV, un moment de perfection de l'art français*, Paris, 1974, pp. 323–24

APPENDIX

LIST OF WORKS, MOUNTS AND ÉBÉNISTERIE TOOLS SOLD BY BERNARD VANRISAMBURGH TO HIS SON BERNARD VANRISAMBURGH, 18 OCTOBER 1764; MIN. CENT. ET/XXVIII/389

1] Two old commode carcases of which one has the bronze frames for the doors and sides, as well as the upper and lower mouldings, still to be fixed

2] Item a bureau 5 pieds long ready to be lacquered and with its moulded bronze rim

3] Item a serre-papiers without stand or clock, with rich mounts

4] Item one commode 5 pieds long ready to be lacquered

5] Item 2 commodes 3 pieds and 2 pieds long also ready to be lacquered

6] Item 2 clock-cases for a serre-papiers with mounts

7] The carcase of a bureau 6 pieds long in rather poor condition

8] Another one of 4 pieds in the same condition

9] The carcase of a serre-papiers and its stand

10] Item the carcase of a commode 5 pieds long

11] Item 2 further commode carcases each 3 pieds long

12] Item 3 pairs of encoignures of different sizes

13] Item 2 bedside tables in tulipwood veneered inside

14] Item 2 small bureaux of 3 pieds in length, at carcase stage

15] Item the carcase of a table of 3 pieds in length, with shelves and drawers at each end

16] Item 3 small secrétaire carcases in poor condition

17] Item a small secrétaire carcase veneered inside

18] Item a carcase of a chiffonnier in oak

19] Item 2 chiffonnier carcases

20] Item 2 small carcases of 'mignonnette' tables

21] Item the small carcase of a commode with drawers fitted for jewels, with small divisions

22] Item the carcase of a poor example of an encoignure

Tools

23] Item 3 workbenches complete with tools

24] Item 12 saws, both hand and mechanical

25] Item 6 rods, 9 cramps, 12 clamps, 6 hot irons, 3 pots of glue, 5 candlesticks

26] Item 3 marquetry saws with different hand tools of all kinds

27] Item 4 vices on stands

28] Item one old hand vice, shears, files, hammers, stone drills and other tools

Mounts

29] Item 748 livres, some in models, some in overcasts, unchased bronze and raw metal at 40 sols the livre; item 216 livres of lead at 20L the 10; plus three cords of oak, more than 100 livres, altogether mounting to the sum of *3,000L*

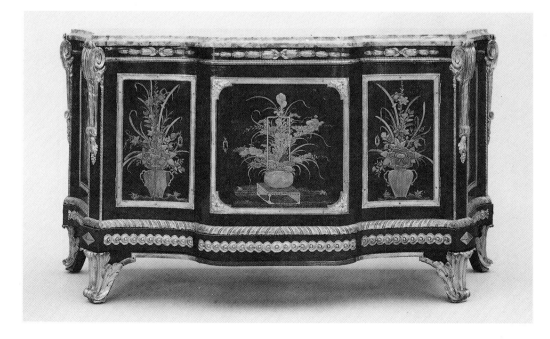

[192] *Commode stamped B. V. R. B., c. 1766–70, probably made by Bernard III Vanrisamburgh who made several other commodes and encoignures of the same model. (Metropolitan Museum of Art, New York: Kress Bequest)*

LANDRIN

c. 1710–*c.* 1785; MASTER 1738

Germain Landrin spent all his life in the Faubourg Saint-Antoine, first in the Grand-Rue and then the rue de Charonne. He did much work for his fellow ébéniste Pierre II Migeon, and was one of his main suppliers. Between 1742 and 1751 he supplied 85,000 livres' worth of furniture to him, indicating a large turnover (if one remembers that during the same period Lazare Duvaux sold his furniture at prices which ranged from 14 livres for a simple oak commode to 450 livres for a sumptuous piece of furniture with marquetry). Landrin also worked for Genty as he appears as a creditor of the latter after his bankruptcy in 1762. His name also appears in the inventory taken after J. F. Oeben's death in 1764 among the creditors, being owed the sum of 677 livres. The majority of stamped pieces by Landrin are close in style to Migeon, and, like his, in kingwood marquetry. Landrin became an adjudicator in his guild in 1746 and was elevated to principal in 1772. With the advent of success, he in his turn became a dealer, retailing furniture made by his fellow ébénistes, and was then assisted by his son.

BIBLIOGRAPHY
F. de Salverte: *Les Ébénistes*, p. 187

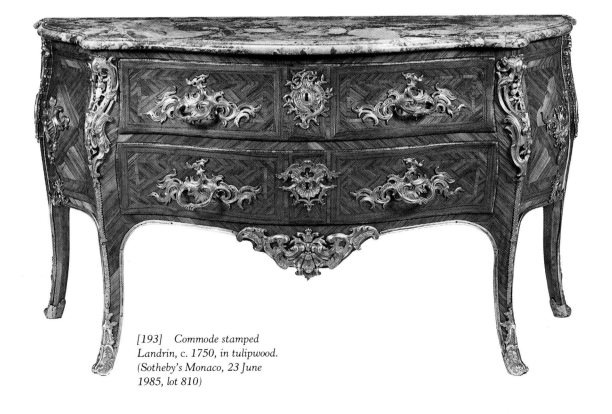

[193] *Commode stamped Landrin, c. 1750, in tulipwood. (Sotheby's Monaco, 23 June 1985, lot 810)*

Martin-Étienne
LHERMITE

c. 1730–c. 1765; MASTER 1753

Established in the rue de Charenton, opposite the Convent of the English Sisters, Martin-Étienne Lhermite carried out many commissions for his fellow ébéniste Migeon, to whom he supplied among other pieces, desks 'veneered in tulipwood with a "point de Hongrie" pattern' and a bedside table en cabaret with floral marquetry. He executed marquetry of a high standard with kingwood flowers in bois de bout on a tulipwood ground in vermiculated pattern, which is close in style to certain marquetry works by B. V. R. B. or Dubois.

BIBLIOGRAPHY
F. de Salverte: *Les Ébénistes*, p. 208

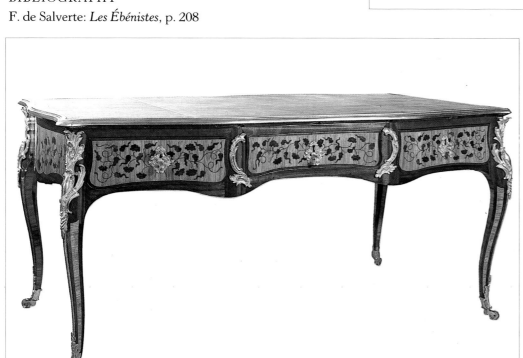

[194] Small commode stamped Lhermite with floral marquetry in bois de bout. (Sotheby's Monaco, 4 May 1985, lot 258)

[195] Bureau plat stamped Lhermite, c. 1750–55, with floral marquetry in bois de bout on a tulipwood ground. (Archives Galerie Gismondi, Paris)

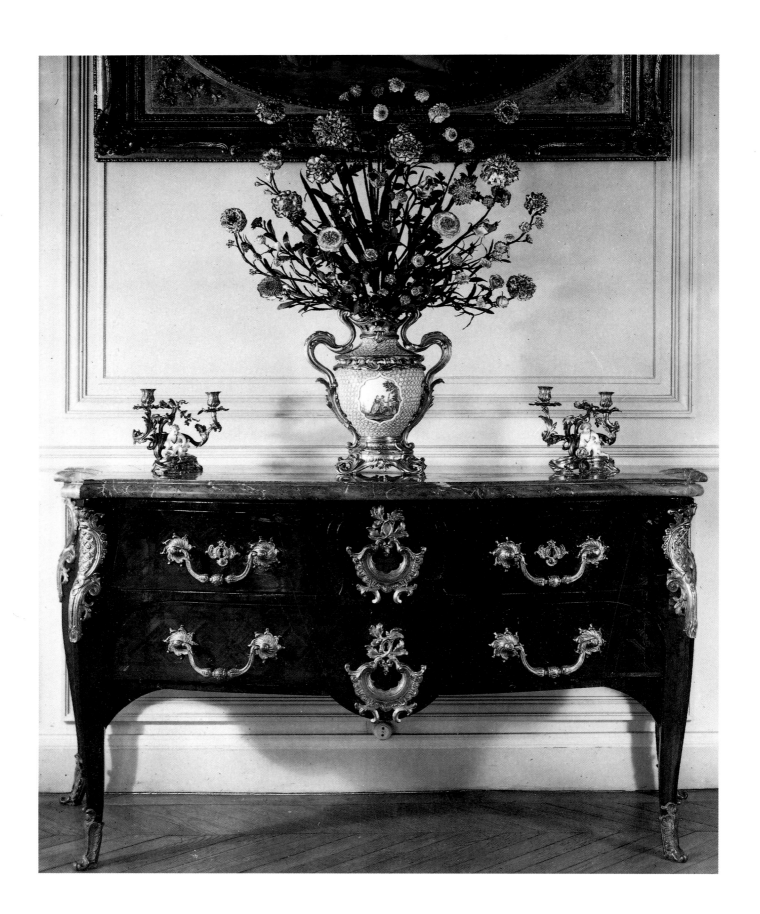

MONDON

FRANÇOIS, 1694–1770. FRANÇOIS-ANTOINE, MASTER 1770

François Mondon worked as an ébéniste at the sign of 'La Pie' in the rue du Faubourg Saint-Antoine opposite the rue Saint-Nicolas. He was an adjudicator for his guild from 1736 to 1738, and elevated to principal on 1 August 1764. He sold part of his production to other ébénistes such as Migeon whose day-book describes a variety of pieces bought from Mondon in 1743. The stamp F. M. D. found on Régence furniture in kingwood of fine quality could in all probability be attributed to him. He must have used this stamp at the beginning of his career, later using his surname, 'Mondon'. His son François-Antoine started his training in the paternal atelier. Having obtained his mastership in 1757, he did not register it until after the death of his father in 1770. He then moved to the rue de Charenton where he is recorded until 1785.

It is likely that there were family connections between these Mondons, ébénistes, and François-Thomas Mondon, ornemaniste in the rococo style (1709–55), at one and the same time 'dessinateur des Menus Plaisirs du roy' in about 1740, and a carver and chaser of snuff-boxes and watches at Ducrollay the silversmith's. This particular Mondon was from a metal-working family: his father Pasquier Mondon was silversmith and his brother Pasquier-Rémy was a silversmith and marchand in about 1755, while his cousin Edmé-Augustin Mondon was a master caster, and yet another Mondon, called 'le jeune', is also mentioned in 1778 as a master caster.

BIBLIOGRAPHY

F. de Salverte: *Les Ébénistes*, pp. 236–37

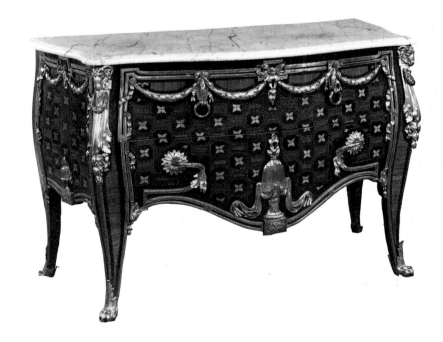

[196] Commode in amaranth and bois satiné stamped F. M. D., c. 1730, showing a marked separation between the upper and lower tiers of drawers. (Private collection)

[197] Commode stamped F. A. Mondon, c. 1770, with geometric marquetry; an interesting example of the 'Greek style' combining rococo forms with gilt-bronze mounts in Neo-classical style. (Sotheby's London, 26 November 1971, lot 72)

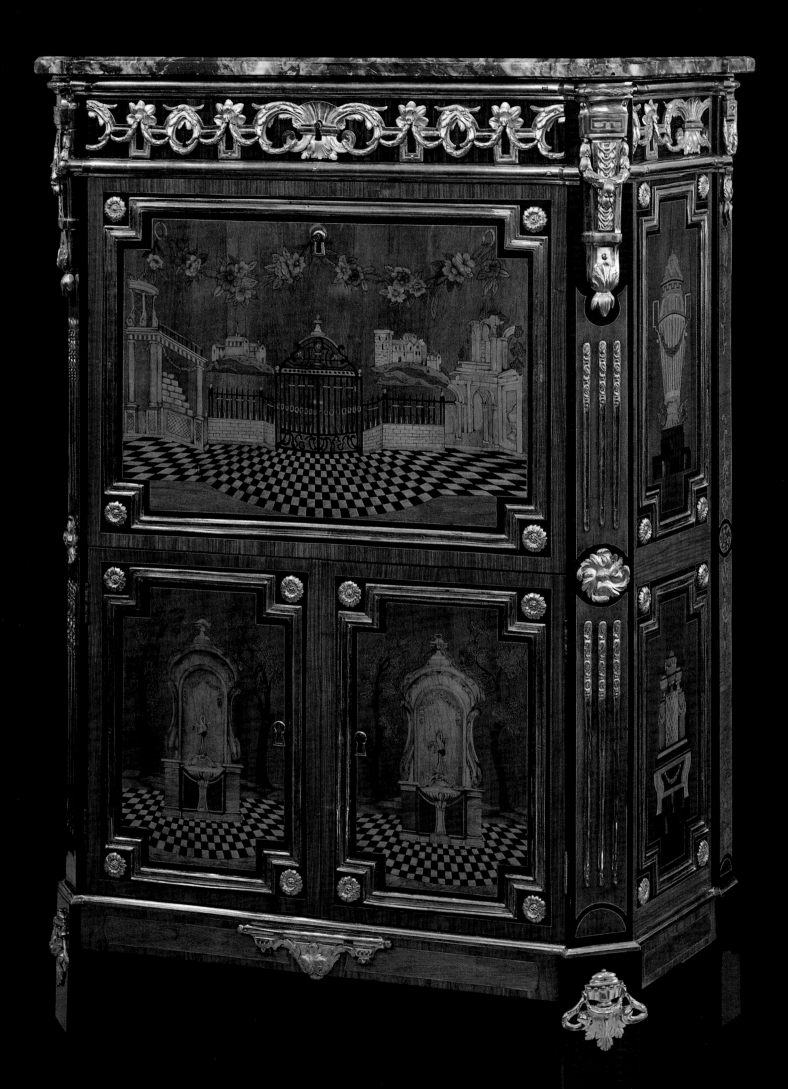

Pierre
ROUSSEL

1723–82, MASTER 1745; MARCHAND-ÉBÉNISTE

Pierre was the son of a journeyman ébéniste, Michel Roussel and of Barbe Dulin. His three brothers, Jacques, Michel and Louis, all became menuisiers. At the age of twenty Pierre Roussel married Marie-Antoinette Fontaine and became a master two years later. He settled in the Faubourg Saint-Antoine, in the rue de Charenton opposite the rue Saint-Nicolas in a house with a shop at the sign of 'L'Image de Saint Pierre'. During the 1760s his career prospered, and he held various high offices within the guild: in 1762 he was elected adjudicator, followed by deputy in 1777, assistant syndic in 1779 and syndic in 1780. According to Salverte, at the time that Roussel was chosen to arbitrate in 1767 during the course of litigation between two of his fellow ébénistes, he was considered one of the finest ébénistes of his period. Between 1775 and 1780 he worked for the Prince de Condé whom he supplied with 10,000 livres' worth of furniture.

He died suddenly at the age of fifty-nine. The inventory taken in March 1783 after his death, with the help of the ébénistes Leleu and Cochois, is particularly interesting as it reveals the contents of a workshop in full production. The building housed three workshops with seven work-benches as well as a storeroom and a shop. The very large stock comprised nearly 250 articles, 50 commodes, of which some were 'rectangular' and others 'circular', estimated at between 50 and 560 livres each for the more lavish examples, as well as commodes 'en tombeaux' and 'en console'. The other pieces described consisted of encoignures, dining-tables, 'tables à l'anglaise' and 'à la dauphine', oval tables, dressing-tables or night-tables, chiffonnières and games-tables. The most valuable piece was a bureau with its cartonnier, priced at 720 livres. Most of the furniture was in tulipwood marquetry, bois satiné or amaranth, several with star-shaped veneer, others in mahogany. Many pieces were in lacquer, some in 'red lacquer', others in 'imitation lacquer' or 'vernis moderne'. There were also examples in geometric marquetry or parquetry (cube or 'mosaic') as well as floral motifs and landscapes. The mention of numerous marble tops in the workshop confirms that the furniture was destined for sale in Roussel's shop, and not through another marchand-ébéniste. At the end, the inventory mentions, among the names of the creditors, that of the master menuisier Rosier, who no doubt made the carcases of Roussel's furniture, as well as the names of the bronziers Turchin (for 482L), Ravrio (for 200L) and the gilder Trufot (for 900L).

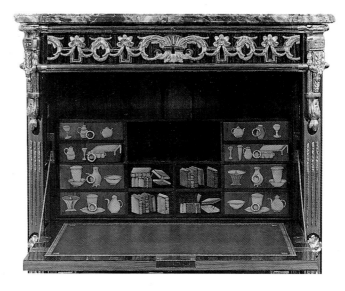

[198] *Secrétaire à abattant stamped Roussel, c. 1775–80; Roussel probably subcontracted the marquetry panels to Gilbert. (Galerie Perrin, Paris)*

[199] *Detail of the secrétaire shown at [198] with drawers veneered with utensils in the Chinese taste*

On Pierre Roussel's death his widow continued his business, helped by her sons Pierre-Michel (master in 1766) and Pierre 'the Younger' (master in 1771) for an unknown length of time (but at the latest until 1792). The output of the workshop at that date still bore Pierre Roussel's stamp, which had been kept by his widow. These consisted of pieces in mahogany of fine craftsmanship. Roussel's workshop also supplied furniture to the Garde Meuble Royal, delivering a mahogany bureau in 1787 for 360 livres, made for the library of the Comtesse de Provence at Versailles. At the same time the workshop was also supplying various pieces of furniture to the Dowager Duchesse d'Arenberg for her hôtel in the rue de la Ville-L'Évêque.

BIBLIOGRAPHY

Probate inventory after Pierre Roussel's death, 12 March 1783 (Arch. Nat., Min. Cent. LXIX, 768)

Geoffrey de Bellaigue: note on Roussel in cat. *The James A. de Rothschild Collection at Waddesdon Manor*, vol. II, pp. 879–80

F. de Salverte: *Les Ébénistes*, pp. 291–92

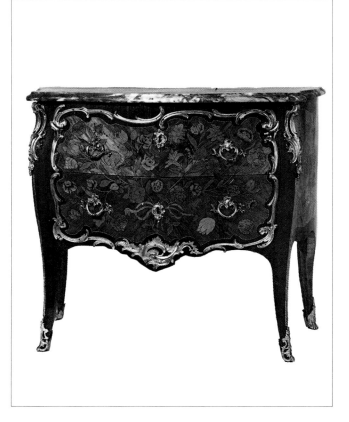

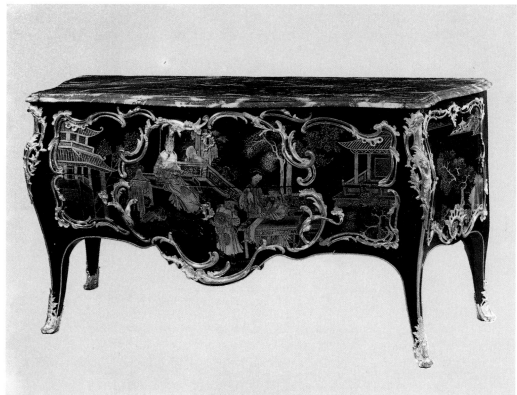

[200] (above) *Commode stamped Roussel, c. 1750, in tulipwood (Sotheby's, 25 June 1983, lot 66)*

[201] *Commode stamped Roussel, c. 1760, in Chinese lacquer. (Sotheby's Monaco, 23 June 1985, lot 823)*

MARCHAND

Nicolas-Jean

c. 1697–after 1757; MASTER BEFORE 1738

Nicolas-Jean Marchand, born *c.* 1697, became a master before 1738. Settled in the rue Saint-Nicolas in the Faubourg Saint-Antoine, he belonged to a family of casters, both his brother Pierre Marchand and the latter's son being master casters. Nicolas-Jean seems to have specialized in lacquer furniture: in 1755 Joubert, ébéniste du roi, supplied two pairs of commodes in lacquer by N. J. Marchand for Fontainebleau, one being for the bedchamber of Marie Leszczyńska. Of the first pair, one piece is now in the Wallace Collection (F. 88), while the other is in a private collection (see catalogue of the exhibition *France in the Eighteenth Century*, Royal Academy, London, 1968). The second pair was for the bedchamber of Louis XV, and both commodes are now reveneered (one is in the Wallace Collection – F. 70 – and the other was sold by Christie's on 1 July 1976). The sumptuous gilt-bronze mounts of these pieces were probably finished under the guidance of Marchand himself.

In 1796 Marchand came into conflict with the bronze-casters' guild for having employed a bronze maker named Bonnière. By then he was approaching sixty and had to retire from active work soon afterwards.

BIBLIOGRAPHY
F. de Salverte: *Les Ébénistes*, p. 121
Pierre Verlet: *French Royal Furniture*, 1963, pp. 107–08

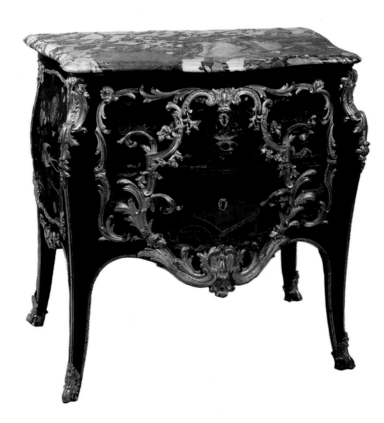

[202] Commode in Chinese lacquer stamped Marchand, supplied with its pair by Joubert in 1755 for the Queen's Bedchamber at Fontainebleau (delivery no. 2017). A second, identical pair was supplied in the same year for the King's Bedchamber. (Wallace Collection, London)

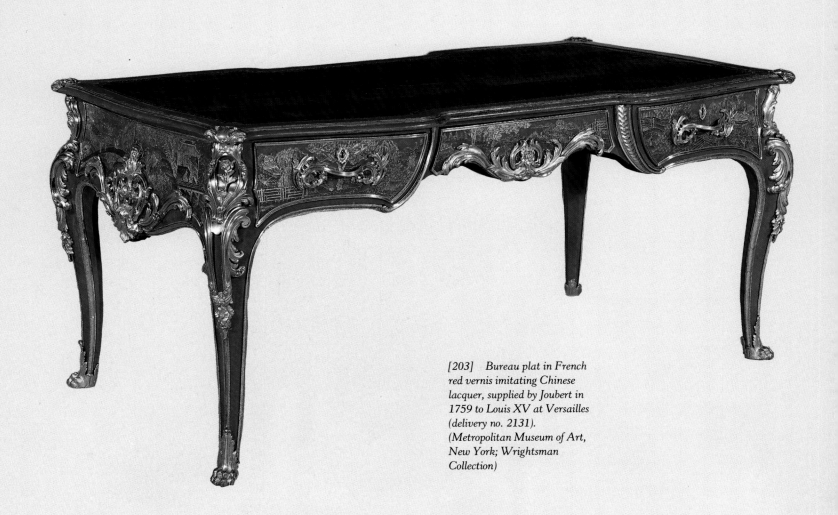

[203] Bureau plat in French
red vernis imitating Chinese
lacquer, supplied by Joubert in
1759 to Louis XV at Versailles
(delivery no. 2131).
(Metropolitan Museum of Art,
New York; Wrightsman
Collection)

JOUBERT

Born into a family of Parisian menuisiers settled in the Faubourg Saint-Antoine, Gilles was the son of Pierre Joubert and Thérèse Delanois. In 1702, at the age of thirteen, he was apprenticed to Pierre Dasneau, marqueteur in the Faubourg Saint-Antoine, for two and a half years. In 1714 he married Michelle Collet, daughter of Edmond Collet, an ébéniste of the Faubourg, and cousin of Pierre II Migeon. She brought with her a dowry of 634 livres while Joubert's marriage portion was fixed at 400 livres. The date on which Joubert became a master is unknown, but was probably between 1714 and 1722. He left the Faubourg for the centre of Paris, first settling in the Isle de la Cîté in the rue de la Savaterie, where he is recorded in 1714, and then the rue Saint-Honoré where he is mentioned as living in 1722. In 1757 he moved close to the Palais-Royal in the rue Saint-Anne on the corner of the rue l'Évêque in a house which he rented from one of the Duc d'Orléans' equerries, Jean-Jacques Fossier. The annual rent was 1,250 livres, and there he remained for the rest of his life. In 1749 he was elected a syndic of his guild for two years. In the preceding year Joubert had begun supplying furniture to the Garde-Meuble Royal including a small secrétaire for the Dauphin and various games-tables for Compiègne. At first small in number, the deliveries became more significant after 1751 when Gaudreaus the younger, who succeeded his father on the latter's death in 1748, ceased to work for the Crown. From this time on Joubert was the principal supplier of furniture to the Crown, and remained so for nearly twenty-three years. Important commissions were executed in 1755 with two encoignures [204] made to match the medal-cabinet by Gaudreaus in Louis XV's Cabinet Intérieur at Versailles, followed in 1759 by a red lacquer bureau [203] intended for the same room.

Joubert made many pieces of furniture for Versailles, Choisy, and La Muette, and took part in the furnishing of the Petit Trianon in 1768. The volume of royal orders mounted year by year, from more than 15,000 livres in 1764 to 27,000 livres in 1766, reaching nearly 50,000 livres in 1769 and 80,000 livres in 1771.

Between 1748 and 1774 Joubert delivered nearly 4,000 pieces of furniture to the Crown. His productive capacity was not sufficient to meet these demands and he often resorted to subcontracting work to his colleagues in order to fulfil the royal orders, bringing the habit of royal ébénistes of subcontracting to an unparalleled level. From 1758 his title was 'ébéniste ordinaire du Garde-Meuble': it was not until Oeben's death in 1763 that he gained the position of 'ébéniste du roi'. In 1771 his wife died.

The inventory drawn up on her death with the aid of his colleagues Balthazar Coulon and Pierre Denizot as experts reveals an active workshop with four work benches and equipment and a large stock of furniture: 266 pieces are listed in various stages of completion, estimated in total at 13,460 livres. Almost a third (78) are simple pieces in walnut or wild cherry (commodes, night-tables, bidets and commode chairs). Of the veneers, kingwood was that most commonly employed (on 15 pieces), which would seem an anachronism for the time, or else combined with the use of tulipwood (on 10 pieces). Tulipwood alone is also used on a dozen pieces. The stocks of wood confirm this predominance of king- and tulipwoods: '35 livres of tulipwood in sheets; 1,238 livres of tulipwood; approximately 30 livres weight of amaranth and other woods'. There are only two pieces in vernis de la Chine and one in vernis de Paris, although Joubert made several such pieces for the Crown. On the other hand there were 'a number of panels of vernis de la

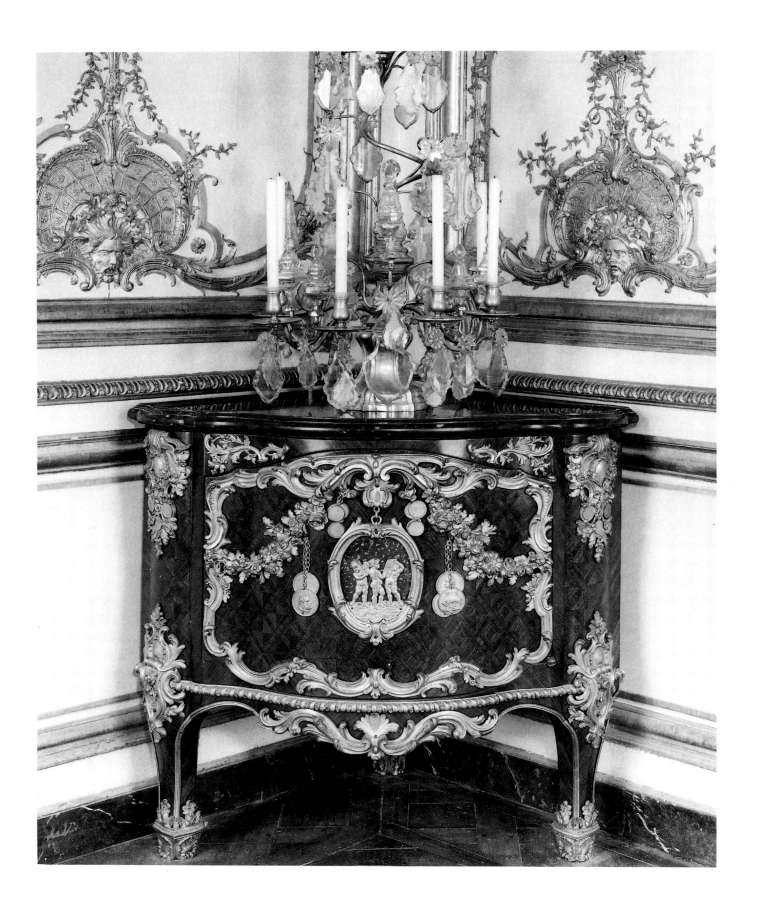

Chine' which proves that he could himself handle the production of this type of chinoiserie furniture without resorting to the marchands-merciers (unlike B. V. R. B. who had no lacquer panels in his possession, but received them from Hébert or Poirier as and when needed). No single piece in mahogany furniture is cited, although already in fashion, but Joubert had '6 bits of mahogany wood'. Of all the types of furniture mentioned, the commode is the most common. Thirty-five are listed in the inventory, certain of them with cabriole legs. Their value veers between 20 livres for those in walnut and almost 250 livres for those embellished with marquetry and gilt-bronze mounts. There are also numerous tables (78 tables for various purposes, 12 games tables, 26 tables de nuit and 7 dressing-tables), but all modestly valued. A few desks (18 examples) are cited, furnished for the most part with serre-papiers and their stands, 4 secrétaires en pente and as many secrétaires à abattant, fairly luxurious no doubt in view of their estimates at 250 livres each. The most expensive pieces of furniture are two armoires in vernis de la Chine (priced together with 4 encoignures and an armoire at 2,300 livres) while '2 large old cabinets decorated with gilt-bronze mounts with carved and gilded feet' were valued at 800 livres. These were the two cabinets representing 'The Sun' and 'The Twelve Signs' which Joubert had purchased at the sale in 1751 of the furniture of the Crown for 2,600L. There is no mention of style or marquetry, perhaps suggesting that Joubert was not working in floral marquetry at that period but rather in plain veneers or parquetry, which is confirmed by the Archives Royales. The only debit accounts mentioned are those for the King, and those for private clients are barely mentioned, or for small amounts. There is also no trace of litigation or payments overdue as is found in inventories of other ébénistes dealing with private clients. This would seem to indicate that Joubert had for many years worked on royal commissions alone, and hardly worked at all now for private clients.

Finally the inventory gives the names of those ébénistes who worked for Joubert and to whom he owed

money 'for deliveries made to him'. The main one was Roger Vandercruse (1,250 livres); there is also the name of Sieur 'Laus, ébéniste' (Deloose?) for 900 livres, Macret (320 livres), Boudin (632 livres), Denizot (1,190 livres) and a certain 'Bailler ébéniste' (François Bayer?) for 106 livres. Joubert owed 313 livres to a certain Delorme (perhaps Alexis Faizelot-Delorme or one of his brothers) and 960 livres to Joubert 'the younger' (without doubt his brother Pierre Joubert, menuisier in the Faubourg Saint-Antoine who would have made the carcases of his furniture). A note indicates that Péridiez, a son-in-law of the latter and therefore Joubert's nephew, owed his uncle 500 livres 'which he was obliged to pay in work which Joubert had ordered from him'. He paid off his debt, as Christian Baulez has discovered, by making a pair of encoignures for his uncle which the latter delivered to Madame Victoire at Versailles in 1769 [210]. Finally the names of the bronze casters used by Joubert are given: the widow Forestier (618 livres) as well as the gilders Le Franc (350 livres) and Deudeville (1,233 livres).

Joubert still supplied numerous pieces of furniture for the Crown after 1771, almost all made by R. V. L. C. He retired in 1774 aged 85, succeeded in the post of 'ébéniste du roi' by Riesener. He died in 1775 and in the same year there took place the 'sale of furniture and effects of the late Sr Joubert, ébéniste du roi, rue Sainte-Anne, on the hill of Saint-Roch'.

PRODUCTION

Joubert's work is difficult to define. He seems to have made very little use of the stamp, from the use of which he was exempt on becoming 'ébéniste du roi' from 1763. In theory we should study his production from the furniture he supplied to the Garde-Meuble Royal. However, these pieces, made for the Crown from 1751 onwards (he was already sixty-two years old) are often stamped by younger ébénistes to whom he would subcontract, such as Antoine-Mathieu Criard, Jacques Dubois, François Mondon, Cramer, Léonard Boudin, Pierre-Antoine Foullet, Nicolas-Jean Marchand, Louis Péridiez and especially Roger Vandercruse. All that can be attributed with certainty to Joubert are half-a-dozen pieces bearing his stamp, or unstamped furniture made for the Crown. However, we must also attribute to him other furni-

[204] *Encoignure, one of a pair supplied in 1755 by Joubert for Louis XV at Versailles, matching the medal cabinet by Gaudreaus [116]; an effort has been made* *with the kingwood veneer and the mounts to copy the medal cabinet, but the rococo style is subdued. (Musée de Versailles)*

ture commissioned from Joubert, but stamped by his colleagues, in that they either completed a suite already begun by him, or followed his prototypes or mounts. It is very obvious that there is a 'Joubert style' which applies to his work as much as to that of Criard and Vandercruse. It could be described as a restrained rococo style and, in the years 1769–74, as Neo-classicism tempered by rococo. In the 1760s Joubert hardly used floral marquetry: it is only found on the commode of M. de l'Averdy [213] and on a small table made for Madame Victoire at Fontainebleau. He preferred to use tulipwood veneer framed by strips of kingwood, which can be seen as much on the commodes for La Muette in 1754 as on the commode which was supplied by Riesener in 1784. Equally Joubert used marquetry designed in a lozenge pattern throughout his career. The curves of his furniture are soft and the mounts are of a calm and symmetrical design. The same scrolled cartouche is found on the front of several of his commodes, as well as the lacquer ones made by Marchand for the Queen's Bedchamber at Fontainebleau in 1755 [202] and those produced in the previous year by Criard for the Pavilion at La Muette [224]. The corner-mounts of these pieces often have large symmetrical motifs, often a pierced bouquet of flowers. In the two recorded desks, the one in red lacquer made for the King in 1759 [203] and the

fall-front example delivered in 1755 for Choisy, the same characteristic line is found, abruptly separating the side drawers from the central one.

Between the years 1769 and 1774 Joubert bowed to the new fashion in perfecting a new style of furniture for the Royal Residences, elegantly Neo-classical in its décor of gilt-bronze mounts and its marquetry, but in its form still bearing the imprint of the rococo taste. For instance, several commodes of this period were designed with doors on the sides like the furniture of Gaudreaus or Cressent. Also the central break-front section, typical of all Transitional commodes, is marked in Joubert's examples by curved lines reminiscent of rococo taste. On the other hand the mounts on all these pieces are designed in the new style: friezes of Vitruvian scrolls or interlaced ovals with rosettes, rectangular frames to panels with rosettes in the canted corners, the apron decorated en cul de

[206] Secrétaire à abattant stamped Carlin and Kintz bearing the mark of the Château de Bellevue; the marquetry of 'interlaced hearts and losenges', as well as the mounts of standing female figures, is characteristic of

Joubert who used them in 1773 on two commodes for Marie-Antoinette at Versailles; the record of the delivery of this piece has not yet been found. (Private collection)

[205] Encoignure, one of a pair with marquetry of 'interlaced hearts and losenges', bearing the mark of the Château de Bellevue;

probably supplied by Joubert, c. 1774. (Galerie Gismondi, Paris)

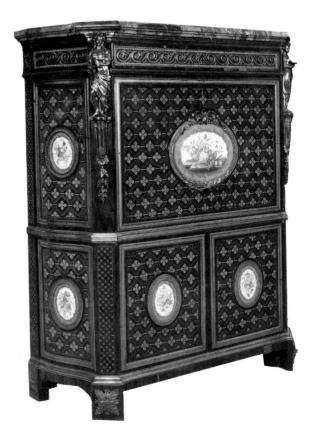

lampe. It is in the design of the corner-mounts that these pieces reveal their character and richness. The simplest have plaques decorated with laurel garlands. In the richest there are four variants: classical female busts (which Riesener used again on the commode for Louis XVI's Cabinet Intérieur at Versailles in 1774) are to be found in 1769 on the commode made for Madame Louise at Versailles (J. Paul Getty Museum) as well as on the secrétaire à abattant (whereabouts unknown) also made for Madame Louise. Infant tritons, one holding birds, the other flowers, appear on a commode made for Marie-Antoinette at Fontainebleau (whereabouts unknown) as well as on a commode for the Comtesse de Provence at Fontainebleau (formerly in the Ingersoll Collection) and on three pieces of furniture delivered in 1774: the secrétaire for the Comte d'Artois at Compiègne (formerly in the

[207] Secrétaire à abattant with corner mounts in the form of infant tritons stamped R.V.L.C., who made the piece under Joubert's supervision. The latter supplied it in 1774 to the Comte d'Artois at Compiègne

(delivery no. 2753). (Christie's London, 19 March 1970, lot 100)

[208] Detail of the infant tritons on the secrétaire shown at [207].

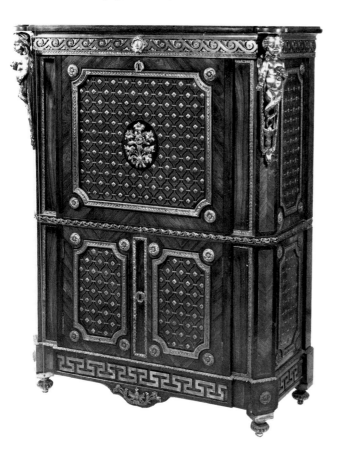

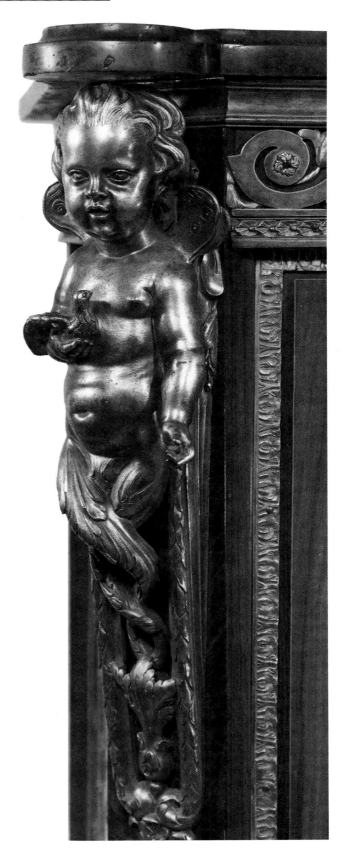

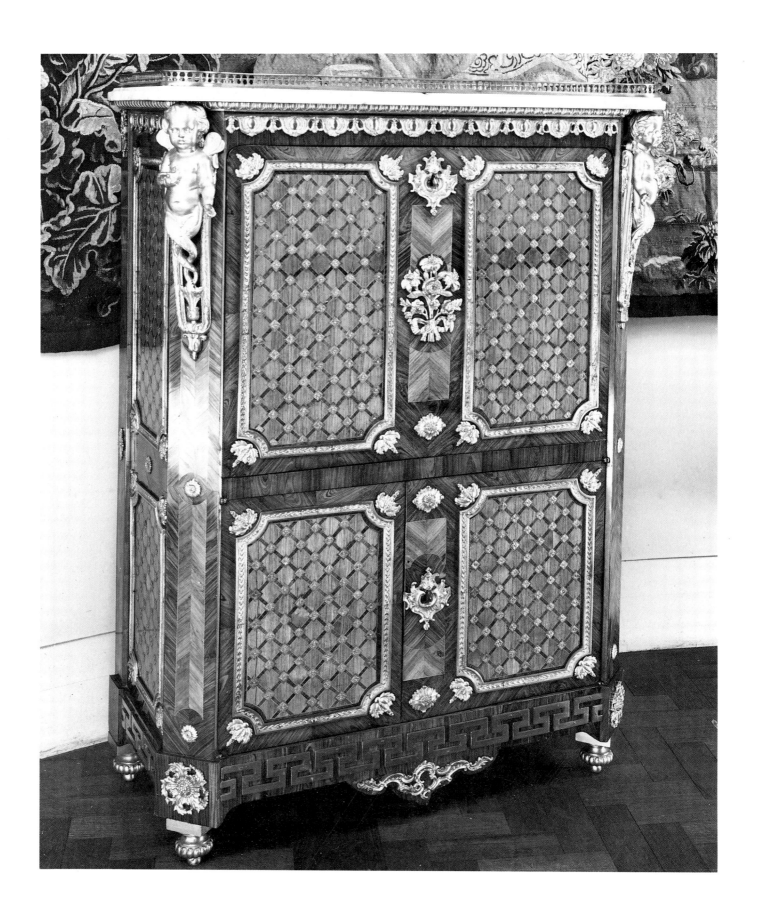

collection of Lord Wharton), the example delivered 'for the Royal Residences', and the commode for Madame Adélaïde at Marly (the latter two pieces now in the Victoria and Albert Museum) [209, 211].

The motif of standing female figures composed of bacchantes holding cups was employed in 1771 on two commodes for Marie-Antoinette at Versailles (whereabouts unknown) and on a secrétaire made at an unknown date for Bellevue (formerly in the collection of the Duke of Abercorn). Finally, another motif consisted of the figures of Bacchus and Hebe, which are found on two commodes made for the Comte and Comtesse d'Artois at Versailles and on a third commode made for the Comte d'Artois at Compiègne (the whereabouts of all three are unknown).

For the most part the veneering on these pieces is geometric (described as 'mosaic') and of two distinct types: lozenges in kingwood framed in tulipwood with small gilt-bronze rosettes at the cross-sections, a motif particular to Joubert; and 'hearts and lozenges intertwined', a type of rounded lozenge imitating metal trelliswork and commonly used by Joubert as well as other ébénistes at this time such as Carlin and R. V. L. C. A characteristic detail of Joubert's work is the presence of small gilt-bronze rosettes in the centre of the lozenges. A third type of veneering found on this series of royal furniture belonging to the years between 1769 and 1774, floral marquetry, was not carried out by Joubert but by R. V. L. C. It is found on numerous pieces of furniture executed by R. V. L. C. for private clients.

The fact remains that Joubert's work cannot be studied before his first deliveries to the Garde-Meuble Royal in 1748 when he was nearly sixty. Nothing is known of his production before this date.

BIBLIOGRAPHY

Arch. Nat., Min. Cent. Et/CXVII/852: inventory following the death of Joubert's wife, 16 March 1771; and Et/CXVII/872: inventory following the death of Gilles Joubert, 25 October 1775

Daniel Alcouffe: Exh. cat. *Louis XV, Hotel de la Monnaie*, Paris, 1974, pp. 319–21

Svend Eriksen: *Early Neoclassicism in France*, p. 193

Hugh Roberts: 'Gilles Joubert as subcontractor', *Journal of the Furniture History Society*, 1985, xxi, pp. 32–35

Gillian Wilson: 'Two newly discovered pieces of royal French furniture', *Les Mélanges Verlet, Antologia di belle arti*, 1985, nos 27–28, pp. 64–68

[210] Encoignure, one of a pair with trellis marquetry supplied by Joubert in 1769 (delivery no. 2557) for Madame Victoire at Versailles, stamped Peridiez who made it under Joubert's supervision. (Musée de Versailles)

[211] Commode with infant tritons supplied by Joubert in 1774 together with the secrétaire shown at [209] for use in the royal residences. (Victoria and Albert Museum, London)

[209] (opposite) Secrétaire with infant tritons supplied by Joubert in 1774 'for use in the royal residences' (delivery no. 2768); veneered with trellis marquetry; some of the mounts seem to be later additions. (Victoria and Albert Museum, London)

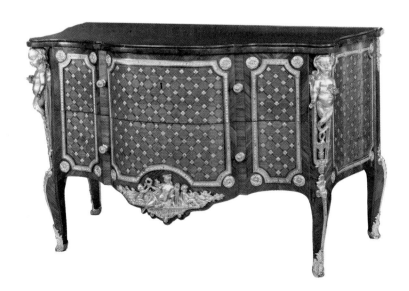

APPENDIX

I. LIST OF FURNITURE MADE BY GILLES JOUBERT OR MADE UNDER HIS SUPERVISION

A. Furniture stamped 'Joubert':

1) Kidney-shaped table with floral marquetry top; the mounts struck with a crowned 'C' [Sotheby's London, 17 May 1963, lot 172].

2) Commode with marquetry of lozenge shape with modified mounts, bearing the number 1909–3 and delivered in 1753 [sale Sotheby's London 1969 and 24 November 1972, lot 90; sale Versailles 25 May 1976, lot 93] [215].

[212] Commode à encoignures supplied in 1769 by Joubert for Madame Victoire at Compiègne (delivery no. 2550), stamped by R.V.L.C. who made it under Joubert's supervision. (Frick Collection, New York)

3) Commode with lozenge-shaped marquetry almost identical to the previous piece. [Château d'Ussé illustrated in: *Merveilleux meubles de France*, 1988, p. 78].

4) Commode with floral marquetry delivered in 1766 to M. de la Laverdy in Paris [Gallery Gismondi] bearing the number 2395 [213].

5) Lacquer commode [Museum of Fine Arts, Boston].

6) Commode veneered in tulipwood delivered in 1784 by Riesener [illustrated in *Les Ébenistes du XVIIIe siècle français*, Hachette, 1963, p. 69]; small stamp of second type framed by two fleur-de-lys.

7) Bureau de dame, formerly in the collection of the Vicomte Beuret, identified by Salverte from the small stamp.

8) Games table, formerly in the collection of the Baron de Gunzbourg, identified by Salverte.

9) Commode in fish-scale marquetry [Boston Museum of Fine Arts], stamped only with the letters 'I O U B'; bearing the mark of the Château de Rambouillet] [217].

10) Commode à vantaux

veneered in kingwood and amaranth [sale Christie's New York, 13 June 1987, lot 112].

B. Furniture delivered by Joubert to the Garde-Meuble Royal, unstamped

11) Commode in white and red vernis Martin delivered in 1755 for Madame Adélaïde at Versailles, no. 1965 [Musée de Versailles]. [214.]

12) Secrétaire en pente, originally in lacquer, now with Boulle marquetry, delivered in 1755 to the Château de Choisy bearing the number 1971 [J. B. Speed Museum, Louisville, Kentucky].

13) Table with lozenge-shaped marquetry delivered in 1755 for Madame Adelaïde at Choisy, private collection.

14) Bureau plat in red lacquer no. 2131 delivered in 1759 for the Cabinet Intérieur of Louis XVI at Versailles [Metropolitan Museum of Art].

15) Commode with lozenge marquetry, delivered in 1764 for the Comte d'Artois at Fontainebleau, bearing the number 2321 [sale Lille, 23 April 1989, lot 158].

16) Commode en tombeau

delivered in 1765 'for the various needs of the Château de Fontainebleau' [sale Sotheby's London, 11 July 1980, lot 133] bearing the number 2374.

17) Large commode with lozenge marquetry delivered in 1769 for Madame Louise at Versailles [J. Paul Getty Museum] with the number 2556.

18) Writing-table with floral marquetry delivered in 1770 for Madame Victoire at Fontainebleau [Louvre] with the number 2589.

19) Small commode with marquetry of interlaced hearts and lozenges, delivered in 1774 for the Comte d'Artois for his private study at Compiègne [private collection, Paris]; this piece was copied in 1787 by Benneman.

20) Pair of encoignures with marquetry of interlaced hearts and lozenges bearing the mark of the Château de Bellevue, probably delivered in about 1774 [Galerie Gismondi] [205].

21) Commode delivered for the bedroom of the Comtesse d'Artois at Versailles in 1773 with the number 2718. [Floors Castle, Kelso: Duke of Roxburgh's collection] [304].

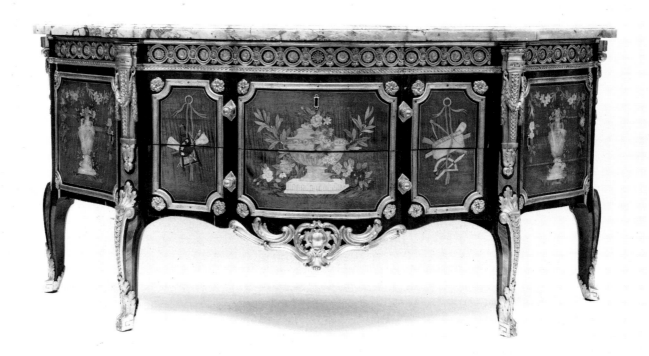

22) Commode 'with infant tritons'. With geometric marquetry, delivered in 1774 for Madame Adélaïde at Marly [Victoria and Albert Museum] with the number 2767 [in fact delivered by Riesener] [211].

23) Secrétaire à abattant 'with infant tritons' in lozenge-marquetry delivered in 1774 'to be used in the royal household', with the number 2768 [209].

24) Secrétaire à abattant stamped Carlin and Kintz matching the encoignures also bearing the mark of the Château de Bellevue, but also adorned with oval porcelain plaques [formerly in the collection of the Dukes of Abercorn, sale Christie's London, 1966] [206].

[213] Commode stamped Joubert and supplied by him in 1766 for M. de l'Averdy, Comptroller of Finance in Paris. A comparison with the example shown at [212] highlights the stylistic evolution of Joubert's work between 1766 and 1769. (Galerie Gismondi, Paris)

C Furniture supplied by Joubert stamped by other furniture-makers but executed under his supervision or in his style

25) Commode veneered in tulipwood, stamped 'Criard', delivered with three others in 1754 for Louis XV to the Château de la Muette, number 1939 [sale Sotheby's London, 5 July 1985, lot 74].

26) Lacquer commode stamped 'Marchand' delivered in 1755, one of a pair for the bedroom of the Queen at Fontainebleau [Wallace Collection] [202].

27) Large commode with encoignures stamped 'R. V. L. C.' with marquetry with flowers and trophies delivered in 1769 for Madame Victoire at Compiègne [Frick Collection] with the number 2550 [212].

28) Pair of encoignures with lozenge marquetry stamped 'L. Péridiez', with the number 2557, delivered in 1769 for Madame Victoire at Versailles [Musée de Versailles] [210].

29) Marquetry commode with flowers and a mask of Mercury, stamped 'Cramer', delivered with its pair in 1771 for the Comte de Provence at Fontainebleau [Anthony de Rothschild Collection, Ascott], with the number 2630.

30) Commode with floral marquetry 'with infant tritons', stamped R. V. L. C., delivered in 1771 for the Comtesse de Provence at Fontainebleau, bearing the number 2636 [sale Christie's, New York, 11 November 1977, lot 128].

31) Secrétaire à abattant 'with infant tritons', with marquetry with hearts and interlaced lozenges stamped 'R. V. L. C.,' delivered on 1 June 1774 to the Comte d'Artois at Compiègne, recorded in 1787 in the cabinet of the Comte d'Artois at Compiègne [formerly in the collection of Lord Wharton, sale Christie's London, 19 March 1970, lot 100] with the number 2753 [207].

D. Furniture supplied by Joubert, stamped by other ébénistes and executed in their individual styles

32) Night-table, stamped A. M. Criard, numbered 2006, supplied in 1755 for Madame de Pompadour at Choisy [Musée des Arts Décoratifs, Paris].

33) Night-table, stamped A. M. Criard, with the number 1952, supplied in 1754 for the Dauphine at Fontainebleau [sale Sotheby's Monaco, 5 February 1978].

34) Bureau plat in bois satiné, stamped F. Mondon, with the number 2071, the mounts stamped with a crowned 'C' [1745–49], supplied in 1757 for the Comte de Saint-Florentin at the Louvre.

35) Night-table, stamped 'J. Dubois', with the number 2235, supplied in 1763 for 'the princes' at Compiègne [sale Sotheby's Monaco, 11 February 1979, lot 211].

36) Encoignure, stamped 'A. M. Criard,' supplied for Compiègne [Château de Saumur].

37) Small marquetry commode, stamped 'L. Boudin,' with the number 2631, supplied in 1771 for the Comte de Provence at Fontainebleau. [Christie's, Godmersham, 6 June 1983.] [249].

38) Bureau plat, stamped 'L. Boudin,' in Greek key-pattern marquetry, with the number

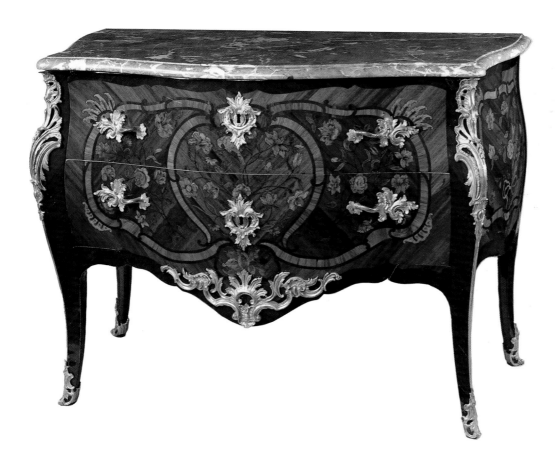

[214] Commode in white and red vernis Martin, supplied by Joubert in 1755 for Madame Adélaïde at Versailles (delivery no. 1965). (Musée de Versailles)

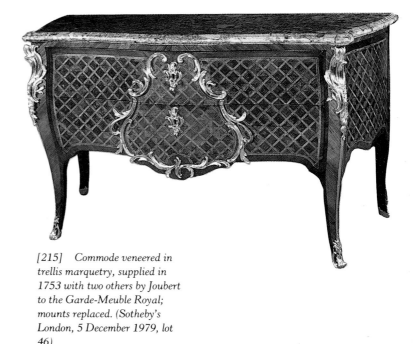

[215] Commode veneered in trellis marquetry, supplied in 1753 with two others by Joubert to the Garde-Meuble Royal; mounts replaced. (Sotheby's London, 5 December 1979, lot 46)

2620, supplied in 1771 for the Comte de Provence at Compiègne [private collection, Paris] [293].

39) Commode decorated with floral marquetry, stamped 'R. V. L. C.,' with the number 2622, delivered with its pair in 1771 for the Cabinet of the Comtesse de Provence at Compiègne [sale Ader, 5 December 1979, lot 109].

40) Commode with floral marquetry, stamped 'R. V. L. C.,' with the number 2666, delivered with its pair in 1772 for the Salon de Compagnie of Mme du Barry at Versailles [Manchester Museum].

41) Cylinder bureau stamped 'Riésener', delivered in 1773 for the Comtesse de Provence at Versailles, bearing the number 2729 [Gulbenkian Foundation, Lisbon].

42) Pair of encoignures attributed to P. A. Foullet delivered in 1773 to the Comte d'Artois at Versailles [Wallace Collection] with the number 2727, possibly reveneered [298].

II. EXTRACT FROM THE INVENTORY FOLLOWING THE DEATH OF JOUBERT'S WIFE ON 16 MARCH 1771

Inventory of the furniture, merchandise and utensils in the workshop on the first floor overlooking the rue St Anne by Balthazar Coulon and Pierre Denizot

1] 2 large old cabinets decorated with gilt-bronze mounts with carved and gilt legs, priced together *800L*

2] One bookcase in amaranth, with 2 sections, one tric-trac table in the English style, 2 tables à patin of kingwood, one table 'en pupitre à limaçon' also in kingwood, one table for playing quadrille, 2 dual-purpose tables, altogether *312L*

3] 6 commodes in tulipwood and kingwood, one with its marble and mounts, altogether *256L*

4] 5 commodes comprising 3 of 4¹/₂ pieds and 2 of 4 pieds in length of which 4 are decorated with ungilded mounts and the other is not decorated at all, altogether *1,180L*

5] 8 commodes comprising: 2 of 4¹/₂ pieds in length decorated with ungilded mounts, the corner-mounts with figures and the 6 others without mounts of which one is decorated with vernis de Paris, altogether *1,500L*

6] One large armoire in kingwood and tulipwood with 3 doors decorated with rich bronze mounts, 2 other armoires in Chinese lacquer decorated with gilt-bronze mounts and 4 encoignures also decorated with their mounts, altogether *2,300L*

7] 4 secrétaires en armoires, different sizes, one decorated with its mounts, one partly decorated and the other 2 undecorated with one other secrétaire à cylindre undecorated, altogether *1,210L*

8] 3 commode chairs in kingwood, 8 tables de nuit in coloured woods with marble tops, 3 encoignures in different kinds of wood, without mounts, 4 open shelves, altogether *482L*

9] One bureau in tulipwood in Antique style with its quart-de-rond, 2 tables in tulipwood undecorated, 3 tables à potterie decorated with mounts, of which 2 with gilt-bronze mounts, altogether *781L*

10] 12 tables in different kinds of wood and of different forms and sizes. *303L*

11] 3 kidney-shaped tables, one reading table, 2 toilet-tables, of which one decorated and one heart-shaped table also decorated and one other table with stand,

altogether *628L*

12] One commode en armoire with its top in brèche d'Alep marble, one clock case with its base, one encoignure in reddened wood, two small shelves or tablettes with doors in kingwood and one small shelf, altogether *380L*

13] 10 coffers in various woods and in different sizes and three skins of black morocco from Rouen, altogether *72L*

14] 2 piquet tables, 3 quadrille tables, each covered in velvet, one table for brelan, 3 for tri and one for piquet, each covered in cloth, altogether *72L*

15] 16 walnut writing-tables, altogether *72L*

16] 7 night-tables in walnut, 6 in cherrywood, 2 of which with marble tops, 5 commode chairs in walnut, altogether *118L*

17] 5 walnut commodes, altogether *120L*

18] 2 old encoignures in kingwood, one kingwood table à patin, one dual purpose secrétaire, 4 tables of which 2 are in cherrywood and one folding table, one tilting table and one table en corbeille, altogether *233L*

19] 2 large bookcase carcases with 3 doors each and veneered

in kingwood and tulipwood, one old bookcase in amaranth with brass flutings, one secrétaire en pente with armoire in amaranth, one small armoire in coloured wood and one small bureau with gradin, altogether *672L*

20] 4 commode carcases, veneered in tulipwood, in different sizes, of which one has its mounts, one encoignure in cherrywood with gradin, 2 chests in walnut, altogether *193L*

21] 5 bureaux in coloured wood, one of 6 pieds in length with its serre-papiers and stand, one of $5^1/_2$ pieds with its caisson, another of 5 pieds and 2 of $4^1/_2$ pieds without any mounts, altogether *450L*

22] A number of pieces of Chinese lacquer as well as tulipwood in sheets weighing 35 livres, 4 marble slabs finished for use as consoles, one old black reading stand and 2 bidet syringes, altogether *305L*

23] 3 commodes in walnut, 11 reading stands and adjustable candle-holders, altogether *90L*

24] 5 walnut bedside-tables with marble tops, 12 bidets of which 2 are covered in morocco, 7 commode chairs in cherrywood, one walnut chair covered in morocoo, 16 cherrywood tables for writing and 2 secrétaires en pente in walnut, one small table in coloured wood, with one table en vide-poche, altogether *340L*

25] 2 four-leaved wooden screens, 6 wooden fire-screens, one triangular table, 2 tables de tri, one toilet-table and one demi-toilette, 2 toilet-tables, 6 other tables, one black with screen and one à limaçon, altogether *97L*

26] 6 pieces of mahogany and 7 pieces of various exotic woods, altogether *407L*

27] 69 cords of oak, altogether *75L*

28] Approximately 1,328 livres of tulipwood, kingwood and ebony, altogether *496L*

29] Approximately 30 livres weight of amaranth and other wood from India. *36L*

30] 66 pairs of brass cornets and 64 bowls altogether *76L*

31] One 3-foot commode in walnut without mounts. *18L*

32] One commode carcase of 5 pieds in kingwood. *200L*

33] One unfinished commode of 5 pieds in oak. *48L*

34] One kingwood and tulipwood sécretaire partly finished. *72L*

35] One carcase of a small bureau, 3 serre-papiers and 2 stands for serre-papiers and other half-finished carcases, altogether *42L*

36] A number of off-cuts of different thicknesses, altogether *12L*

37] 4 work benches together with their tools, 3 saws à presse, 9 hand-saws, one vice, 6 clamps, 6 jointers' cramps and 2 pots of glue, altogether *96L*

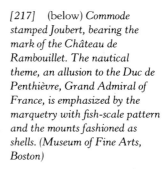

[216] Table supplied in 1770 by Joubert for Madame Victoire at Fontainebleau (delivery no. 2589). (Musée du Louvre, Paris)

[217] (below) Commode stamped Joubert, bearing the mark of the Château de Rambouillet. The nautical theme, an allusion to the Duc de Penthièvre, Grand Admiral of France, is emphasized by the marquetry with fish-scale pattern and the mounts fashioned as shells. (Museum of Fine Arts, Boston)

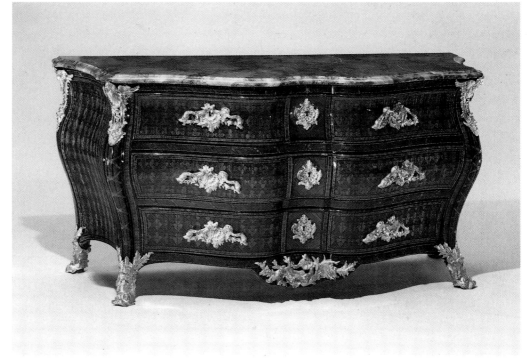

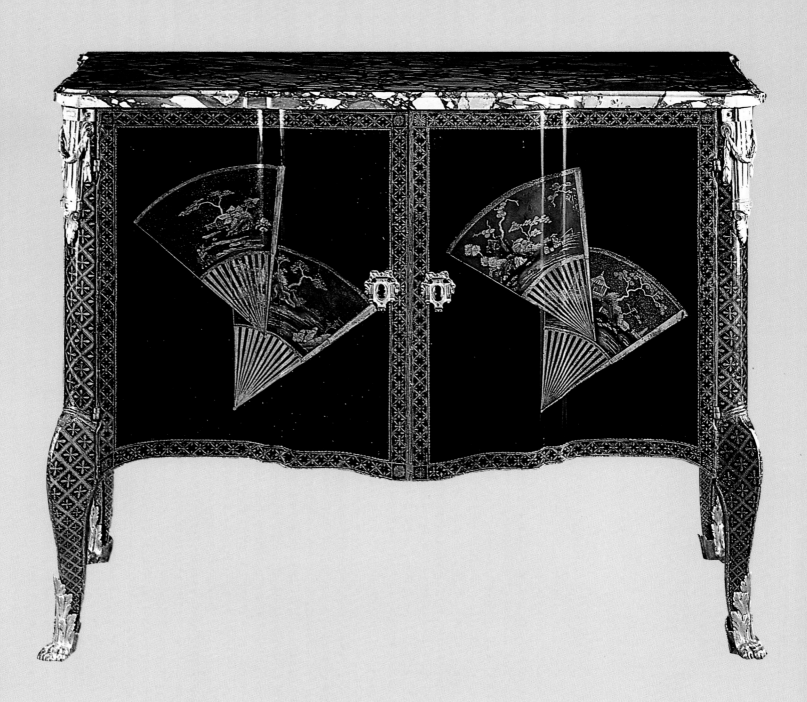

[218] *Commode attributed to Macret, c. 1770, stamped by Lutz who must have made the carcase; the panels of lacquered tôle are probably the work of Samousseau, who in 1767 had patented a process of lacquering on metal. (Galerie Segoura, Paris)*

Pierre
MACRET

1727–*c.* 1796; MARCHAND-ÉBÉNISTE PRIVILÉGIÉ DU ROI 1756

Pierre Macret never became a master, receiving, however, in 1756 the warrant of 'marchand-ébéniste privilégié du roi suivant la cour' in succession to Latz's widow. At the beginning of his career he supplied pieces to Lazare Duvaux (who in 1758 owed 1,169 livres to him) and to his fellow ébénistes Genty, Boudin, Provost and Chevalier. Between 1764 and 1771 he was 'fournisseur ordinaire des menus plaisirs du roi'. His business flourished, to the extent that he was able to set up in 1771 as a marchand-mercier and move to the rue Saint-Honoré. Soon afterwards he gave up producing furniture in order to specialize in the sale of luxury furnishings. Macret worked for the Marquis de Marigny, to whom he supplied various pieces of furniture in 1770, amounting to 1,890 livres. In December 1774, and then in May 1775, he put his stock of ébénisterie up for sale. In 1781 he was described as 'bourgeois de Paris', and retired from business in 1787.

The most noteworthy pieces by Macret consist of a suite of furniture in lacquered tôlework with chinoise-rie scenes, including two commodes (one at Versailles, one sold at Saint-Germain-en-Laye on 3 June 1985), and an encoignure sold in Paris on 23 March 1984. The three pieces are branded with the initials 'G. R. C.' and a crown, supposedly the mark of Marie-Antoinette's personal garde-meuble at Compiègne. Mention should also be made of a commode in lacquered tôlework (Gallerie Maurice Segoura), decorated with fans, which can be dated between 1772 and 1773. Panels of lacquered tôlework were a novelty and appeared in the 1770s on furniture by Saunier or Macret. This new technique was perfected by the painter Gosse in 1760 and developed by his son-in-law Samousseau who received a royal warrant in 1767 for the manufacture of imitation Chinese lacquer.

BIBLIOGRAPHY

Bibliothèque historique de la Ville de Paris, Marigny archives, NA 106 bis

F. de Salverte: *Les Ébénistes*, pp. 214–15

[219] *Encoignure stamped Macret, decorated with panels of* *lacquered tôle. (Sale Solanet, Paris, 23 March 1984, lot 101)*

[220] *Commode stamped Macret, en suite with the* *encoignure [219]. (Sale Saint-Germain-en-Laye, 3 June 1985)*

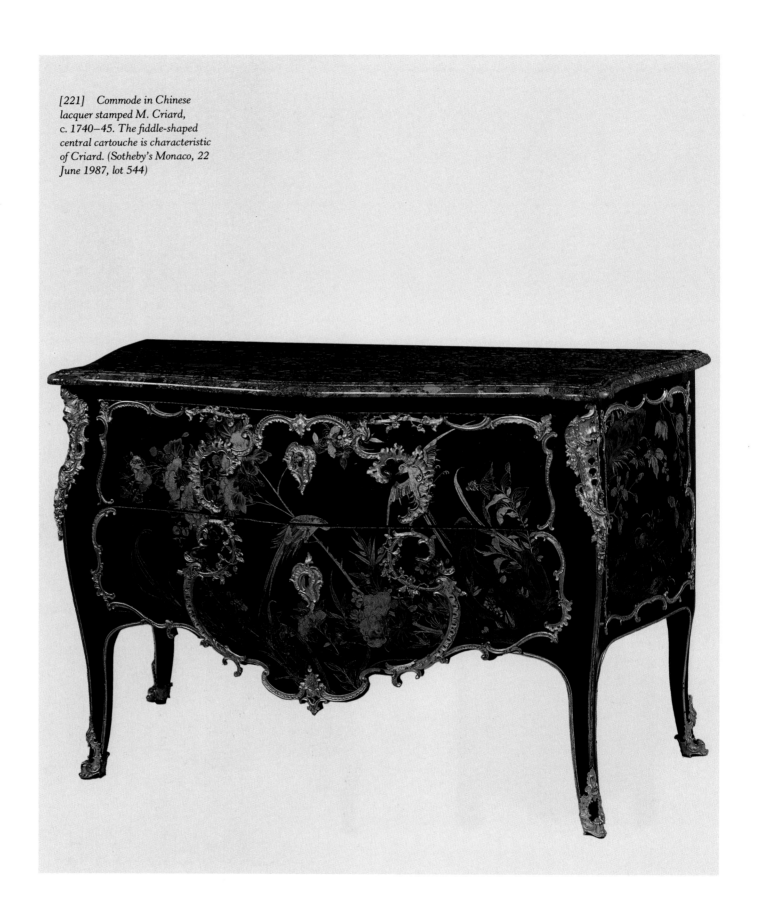

[221] *Commode in Chinese lacquer stamped M. Criard, c. 1740–45. The fiddle-shaped central cartouche is characteristic of Criard. (Sotheby's Monaco, 22 June 1987, lot 544)*

CRIARD

MATHIEU, c. 1689–1787; MASTER 1738. ANTOINE-MATHIEU, 1724–87; MASTER 1749
SÉBASTIEN-MATHIEU, 1732–96; MARCHAND-MERCIER 1762

Born *c.* 1689, Mathieu was the son of 'Jean Criard, bourgeois from the town of Brussels'. We know nothing of his youth, his training, or when he settled in Paris. The first record of Criard is his marriage contract with Jacqueline Godelart on 7 September 1721. He is then recorded as an ébéniste living in the rue Sainte-Marguerite in the Faubourg Saint-Antoine. His wife was the daughter of François Godelart and grand-daughter of Henry Godelart, both ébénistes in the Faubourg Saint-Antoine. She was provided with a dowry of 500 livres in furniture and linen as well as 200 livres in cash. The couple had two sons, Antoine-Mathieu (1724–87) and Sébastien-Mathieu (1732–96). Criard spent his life in the Faubourg Saint-Antoine. In about 1723 he was first established in the rue Saint-Nicolas, moving in 1732 to a house in rue Traversière which he rented for 500 livres a year. The house comprised two shops, back-rooms, a yard and a garden, two upper floors each with four rooms, two attics and a cellar. In 1733 Criard also rented a piece of adjoining land, probably in order to extend his workshop. He became a master in 1738 at the age of forty-nine. He must have rapidly become prosperous, as in 1748 he gave his eldest son a marriage portion of 6,000 livres and gave the same amount in 1761 to his younger son. Furthermore, in 1756 he paid 2,000 livres for a sixth share of the house he was leasing.

Mathieu Criard worked during the 1740s for the dealer Hébert, who at that time was supplying sumptuous furniture to the Garde-Meuble Royal. His stamp is found on several sumptuous pieces supplied by Hébert during this period to the royal residences: the encoignure now in the Louvre [222] in blue-and-white lacquer, as well as a commode now in a private collection, the former supplied in 1742 and the latter

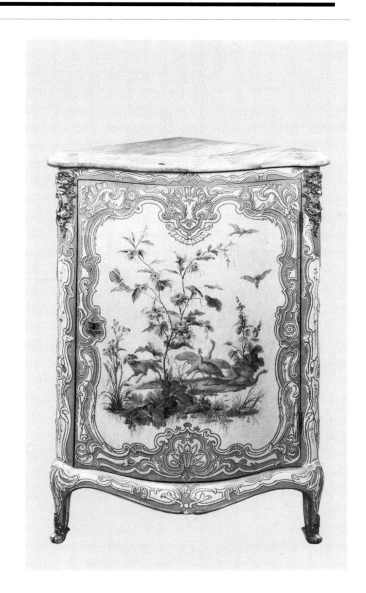

[222] *Encoignure in blue and white vernis Martin, stamped M. Criard, supplied in 1743 (delivery no. 1294), to the marchand-mercier Hébert for the apartment of Mlle de Mailly at Choisy which was hung in matching blue and white watered silk. (Musée du Louvre, Paris)*

223

in 1743 for the apartments 'furnished in blue and white silk' at Choisy. For the same apartments Hébert also supplied a 'writing-table with a white lacquer ground painted with flowers, plants, birds and blue decorations...' its whereabouts unknown today, but also certainly by Criard.

The kingwood commode in lozenge marquetry supplied by Hébert in 1748 for the Cabinet of the Dauphin, still today at Versailles, is also stamped by Criard. The same marked indented mounts are found on other commodes in lacquer by him and it is probable that Hébert supplied him with many models; certain bronze motifs (corner-mounts, or flattened stems around which curl sprays of flowers) are found on work by B. V. R. B. who was also one of Hébert's suppliers. Furthermore, he supplied furniture to Gaudreaus: a debit note drawn up between Gaudreaus' widow and Criard on 2 September 1751 states that the Gaudreaus owed him 3,000 livres 'for the payment of various items of ébénisterie made by Criard and supplied to the widow Gaudreaus and Sieur Gaudreaus, her son, as well as in settlement of their account'. The links between the two families are also confirmed by the presence of widow Gaudreaus and her son as witnesses at the marriages of Mathieu Criard's sons in 1748 and 1761.

Between 1755 and 1765 Criard worked for Gilles Joubert who had succeeded Hébert and Gaudreaus as supplier to the Garde-Meuble Royal. Several pieces delivered by Joubert bear Criard's stamp: a commode supplied in 1754 for the Château de la Muette [224] as well as a night-table supplied in 1755 for Mme de Pompadour at Choisy (Musée des Art Décoratifs), a small encoignure of 1756 for the Dauphine at Compiègne (Musée de Saumur), and in 1768 a small writing-table for the Comptroller General (Ader sale, Paris, 14 June 1983, lot 200).

Criard's wife died in August 1767. An inventory of the workshop was drawn up on 2 April 1768. Criard's assets were estimated at 12,414 livres (of which 6,460 livres were in cash, 2,893 livres in stock and tools, 1,619 livres in furniture and linen and 773 livres in jewellery and silver). The house on the rue Traversière included a workshop, a storehouse and a shop; in the courtyard and garden there were several wooden sheds which served as workshop and shops. Criard employed numerous assistants: 13 work-benches are itemized (estimated with their tools at 256 livres); the stocks of wood comprised mostly pine (68 planks) but also oak (57 cords), a smaller quantity of walnut (33 pieces) and of cherry and beech (16 planks). Of the 71 pieces in stock, 46 were in French woods (10 in wal-

[223] *Commode stamped M. Criard, c. 1740–45, veneered with trellis marquetry in kingwood, identical to the* *commode made by Criard for the Dauphin in 1748. (Sotheby's Monaco, 23 June 1985, lot 814)*

[224] *Tulipwood commode stamped M. Criard, supplied in 1754 by Joubert for the Château de la Muette (delivery no. 1939).* *The mounts are recognizably in the style of Joubert, particularly the fiddle-shaped cartouche. (Sotheby's London, 5 July 1985)*

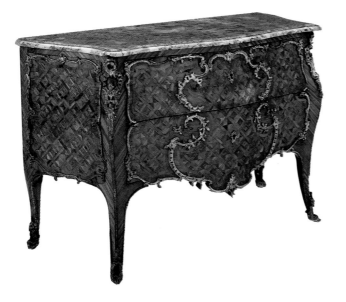

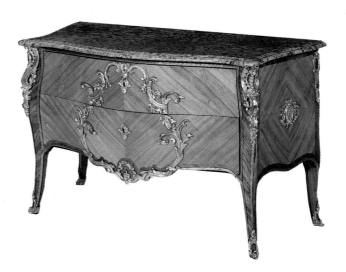

nut, 11 in cherrywood, 25 in walnut and beech) and 21 were veneered in exotic woods; tulipwood was always used, combined with palisander (on 11 pieces), kingwood (6 pieces) or amaranth. Criard's production consisted mainly of commodes (33, forming nearly half the stock); there were 17 tables (of which 8 were games-tables in cherrywood and 9 were dressing-tables). There were also 4 marquetry encoignures, 6 chiffonnières, 8 armoires and 2 secrétaires. On the other hand, there is only one bureau and no secrétaire à abattant. The commodes are described as being 's'-shaped or 'à tombeau' or 'with round feet'; it is probable therefore that they were all in the rococo style. The values given for the furniture were very low (between 14L and 85L) and there is no mention of any bronze mounts. Among Criard's debtors, the name of Héricourt is mentioned (certainly the marchand-mercier Nicolas Héricourt, 1729–90) for a debt of a thousand livres and there is also a record of a list of 18 sheets of 'items made by Sr Criard on credit for Sr Héricourt'.

Mathieu Criard was 78 years old when this inventory was drawn up. The inventory does not therefore reflect the workshop at the height of its success (1745–55). There is therefore no mention of lacquer commodes, although he did specialize in them earlier

[225] Commode stamped A. (Sotheby's Monaco, 23 June
M. Criard, c. 1750, with floral 1985, lot 744)
marquetry in bois de bout.

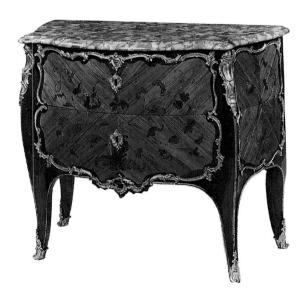

in his career. On the commodes in imitation Chinese lacquer the same gilt motifs are found of pierced rocaille and the same peony sprays, proof that a single hand, perhaps one of the Martin brothers, worked on them all. Another of Criard's specialities, which the inventory of 1768 does not mention, were the commodes in kingwood parquetry forming trellis and diamond patterns. Nearly all the recorded veneered commodes by Mathieu are of this type and it is probable that he never executed pieces in floral marquetry.

Mathieu Criard ceased production in 1770 and sold his stock of furniture and his equipment to his younger son Sébastien-Mathieu in exchange for an annuity of 500 livres. He lived for a while with his son, but after many disagreements between them, he moved to the house of his eldest son Antoine-Mathieu in the rue de Grenelle where he died in 1776 at the age of 87. Unlike the case of other ébénistes' dynasties, Antoine-Mathieu did not take over the father's workshop but had his own business and his production should therefore be examined separately.

ANTOINE-MATHIEU CRIARD

Born in 1724, this eldest son of Mathieu-Criard became a master on 31 July 1749. On 5 August 1748 he married Marie-Suzanne Chevallier, daughter of the ébéniste Jean-Mathieu Chevallier and niece of the ébénistes Charles Chevallier and Jean-Charles Saunier. Young Criard received a portion of 6,000 livres from his parents while his bride received 5,300 livres. At first the young couple settled in the rue du Temple, and then from 1750 in the rue de Charenton. The house they rented comprised a workshop as well as living quarters, indicating that even at that time Antoine-Mathieu worked for himself and not for his father. He probably sold his own furniture on his premises as his lease permitted this trade. The son used the same stamp as his father, 'M. Criard', but with much smaller letters.

His business soon flourished and Criard the Younger moved to the elegant quarter of the Palais-Royal where the luxury trade was concentrated. He first settled in 1758 in the rue de Richelieu opposite the Palais-Royal, in a small house with a shop on the street. Then in 1768 he moved to the rue Saint-Thomas-du-Louvre, close to the rue Saint-Honoré, where almost all the marchands-merciers were to be

found. In 1770, while still keeping the shop in the rue de Richelieu, the couple moved again, to the rue de Grenelle, close to the Chevallier in-laws with whom Antoine-Mathieu Criard certainly had a close working relationship. Here his wife died on 5 July 1777.

The inventory taken after her death, dated 23 July 1777, describes a workshop in full production with six work-benches in operation (Criard was then aged 53). The considerable assets comprised 463 pieces of furniture valued at almost 10,000 livres, as well as 4,012 livres in cash. Criard's personal assets were estimated at 3,184 livres of furnishings, 2,067 livres of silver and 612 livres of jewellery. The house on the rue de Grenelle had a store on the ground floor with a shop giving onto the street and a second display area on the first floor. Most of the furniture in stock was veneered (at least 141 pieces were itemized) mainly in tulipwood (68 pieces) sometimes combined with kingwood (15 pieces) or amaranth (15 pieces); 11 pieces were in bois satiné and 14 pieces in mahogany (tables or stands). Marquetry motifs are not usually mentioned: only 9 commodes and 7 encoignures are veneered in 'floral marquetry'; 28 pieces in lacquer are described, mostly encoignures: red and yellow are the preferred colours, but there is also a commode 'painted in the

[226] Commode stamped M. Criard and Delorme (the latter definitely in the role of retailer), with trellis kingwood marquetry, mounts struck with crowned 'C', c. 1745–49. (Musée d'Art et d'Histoire, Geneva)

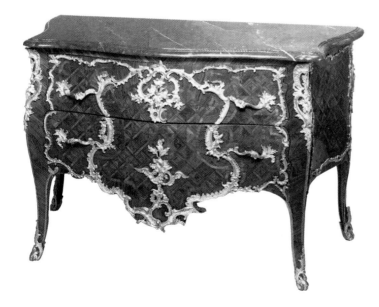

manner of green lacquer'. Of the types of furniture listed, there is a predominance of tables of a variety of types (games-tables, writing-tables, tables 'à l'anglaise', chiffonnières, night-tables, toilet-tables, guéridons, serving-tables, dressing-tables, in all 137 pieces). There were also commodes listed as 'à la régence', 'en tombeau', 'en S', or 'à l'antique'. There were 41 encoignures, most of them lacquered. The stock, which was very varied, also included 33 secrétaires (of which 13 were secrétaires à abattant, 10 secrétaires en pente and 5 secrétaires à cylindre), as well as chests and screens. The considerable quantity of merchandise on the one hand and the absence of any mention of mounts or marble on the other, as well as the low stock of wood and tools, is curious. Did Criard finish his furniture somewhere else, perhaps in the shop in the rue de Richelieu? Or did he mainly supply furniture to his fellow ébénistes who fitted their own mounts before selling them on? The documents of 1777 give the names of three ébénistes among Criard's debtors, which may perhaps shed light on this matter; Chevallier (528L), Landrin (211L) and Ledoux (36L).

Whatever the case, the inventory of 1777 reveals that Criard had a private clientèle. The following names are found; the Duc de Cossé (4,248L), Mme de Monteynard (833L), the Duc d'Avaray (575L), the Comte de la Marche, future Prince de Conti (various bills relate to him from 1774 for a sum of 945L), the Comte de Bussy (291L), and the Comte de Montausier (111L), as well as the actors LeKain and Mlle Arnoult.

Antoine-Mathieu Criard went on working until 1783, still at the same address in the rue de Grenelle. He was still working for the Princesse de Craon in 1782 (bill of 234L). Later he retired to a simple room in the rue du Bac where he died on 24 December 1787. The inventory taken after his death on 2 January 1788 (LXV-489) reveals that he was not very well-off. His assets amounted to 1,261 livres, one-fifteenth of his worth in 1777 at the time of his wife's death.

SÉBASTIEN-MATHIEU CRIARD

The second son of Mathieu Criard, Sébastien-Mathieu, was born in 1732 and married Marie-Louise-Antoinette Gubillon on 20 September 1761. They each received a dowry of 6,000 livres. Before 1762 the

couple were settled in the rue du Roule, in the parish of Saint-Germain-l'Auxerrois. In 1764 Criard rented a shop with outhouse in the rue Froid Manteau, where he later set up a business as a marchand-mercier. At that time he is variously described as 'marchand-mercier', 'marchand-ébéniste' or 'maître-ébéniste'. His business must have flourished, as in 1768 Sébastien-Mathieu was able to acquire a house in the rue Traversière in the Faubourg Saint-Antoine for the sum of 8,000 livres.

On the death of his wife in 1777, Sébastien-Mathieu's financial situation was precarious. Large debts amounting to 28,877 livres forced him to sell his house in the rue Traversière, part of which he had already let, but where he still had a business and a workshop fitted with four work-benches. The inventory taken on 11 April 1777 after the death of his wife mentions 60 pieces of furniture, including 14 commodes, 2 carcases of encoignures, 7 tables, 1 bureau and 3 small secrétaires. The stock would appear to have been of poor quality; it was barely worth 930 livres and Sébastien-Mathieu was declared as having

'no cash'. He stated that 'he had not kept a record book of his commercial transactions as over the previous few years he had sold all his work for cash.' It seems likely therefore that he did not sell to a very affluent clientèle, but rather to more humble people, or to other dealers such as Héricourt (whose name is mentioned in the inventory). Sébastien-Mathieu then moved to the rue du Faubourg Saint-Antoine and died in the rue Cerutti in February 1796.

BIBLIOGRAPHY

Inventory taken after the death of Mathieu Criard's wife, Jacqueline Godelart, 2 April 1768 (XXVIII-408)

Inventory taken after the death of the wife of Antoine-Mathieu Criard, Marie-Suzanne Chevallier, 23 July 1777, Arch. Nat. Min. Cent. (XXXV-797)

Inventory taken after the death of the wife of Sébastien-Mathieu Criard, Marie-Louise Antoinette Gubillon, 11 April 1777, Arch. Nat. Min. Cent. (XXVIII-462)

Geneviève Attal: master's thesis for the University of Paris IV in 1987: *Mathieu, Antoine-Mathieu et Sébastien-Mathieu Criard, études d'une famille d'ébénistes du XVIIIe siècle à partir des documents d'archives*

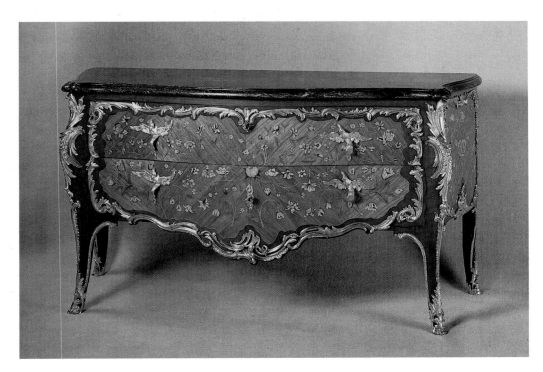

[227] Commode stamped M. Criard, with floral marquetry, c. 1750; the gilt-bronze handles are in the form of birds. (Formerly in the Camoin Collection; Galerie Segoura, Paris)

GENTY

MASTER 1754; MARCHAND-ÉBÉNISTE; ACTIVE UNTIL 1770

Denis Genty, who was established in the Faubourg Saint-Antoine, became a master in 1754. A short time afterwards he leased a shop at 9 rue de l'Echelle-Saint-Honoré called 'A la Descente des Tuileries' where he sold ébénisterie. Among his clients were Mme de Pompadour, the Marquise de Houchin, the Marquis de Nesles, and de Chambonnas and the Comtesse de L'Hospital. Although his business flourished his considerable expenditures forced him into bankruptcy in 1762. Among his creditors were his fellow ébénistes Macret, Hédouin, Dautriche and Lacroix who supplied him with furniture, besides the vernisseur Regnault. The business was taken over by Louis Moreau and the shop renamed 'A la Petite Boule Blanche'.

Genty also commissioned pieces from the provincial ébéniste Hache. This is confirmed by a bombé commode now in a private collection in France, which can be attributed to Hache from its idiosyncratic marquetry in burr-walnut, but which is stamped by Genty. The fine gilt-bronze mounts on this piece are not typical of Hache, and would have been added later by Genty to suit a Parisian clientèle.

BIBLIOGRAPHY
F. de Salverte: *Les Ébénistes*, pp. 136–37

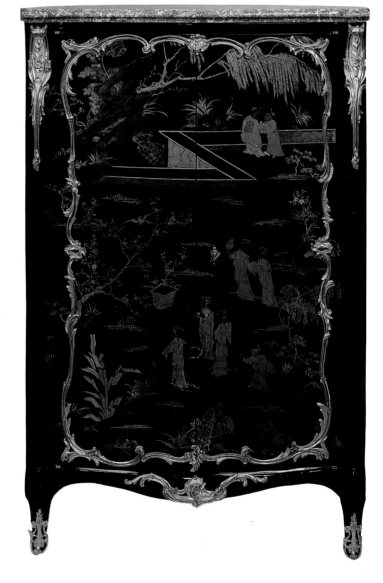

[228] Tall amoire d'encoignure, one of a pair in Chinese lacquer, stamped Genty. (Galerie Gismondi, Paris)

Pierre
DENIZOT

1715–82; MASTER 1760

Pierre Denizot was the son of an ébéniste who was also a dealer, living in the rue de Richelieu. He obtained his mastership in 1740 but did not register until twenty years later, probably continuing to work until then in his father's workshop, as has been suggested by Salverte. Later on he settled in the rue Neuve-Saint-Roch in a workshop which also doubled as a shop, where he remained until his death. An ébéniste of reknown, he became the book-keeping adjudicator to his guild between 1764 and 1766 and in 1776 became main supplier to the Comte d'Artois, to whom he delivered a wide range of furnishings between 1776 and 1782 for the Palais du Temple, Bagatelle, Saint-Germain-en-Laye and Maisons. To the young Duc d'Angoulême he supplied a large commode in solid mahogany. At the same time Denizot was working for the Comte de Provence. According to Salverte he left at the time of his death 'four commodes ordered for Monsieur which are still incomplete' (Arch. Nat. Y 13974). In fact, the marchand-mercier Philippe-Ambroise Sauvage, who apparently supplied the Comte de Provence with the four commodes by Stockel (see p. 406) was none other than Denizot's son-in-law. It is therefore possible that the celebrated commodes by Stockel/Benneman could have originally had carcases by Denizot.

The inventory drawn up after Denizot's death itemizes jewellery and works of art, evidence of his prosperity. An auction of his assets took place soon after his death in July 1782, and the advertisement in the *Annonces* indicates the size of his stock and notes that he had in his possession 'bronze mounts and models' ('Sale of the furniture of the late Sieur Denizot, ébéniste, today and the following days. A quantity of tulipwood, amaranth, mahogany, ebony and other woods. . .').

BIBLIOGRAPHY
F. de Salverte: *Les Ébénistes*, pp. 93–94
Pierre Verlet: *Le Mobilier royal français*, vol. II, p. 111, note 18

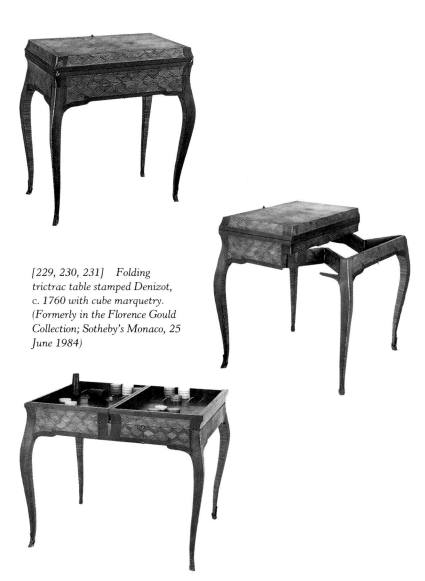

[229, 230, 231] *Folding trictrac table stamped Denizot, c. 1760 with cube marquetry. (Formerly in the Florence Gould Collection; Sotheby's Monaco, 25 June 1984)*

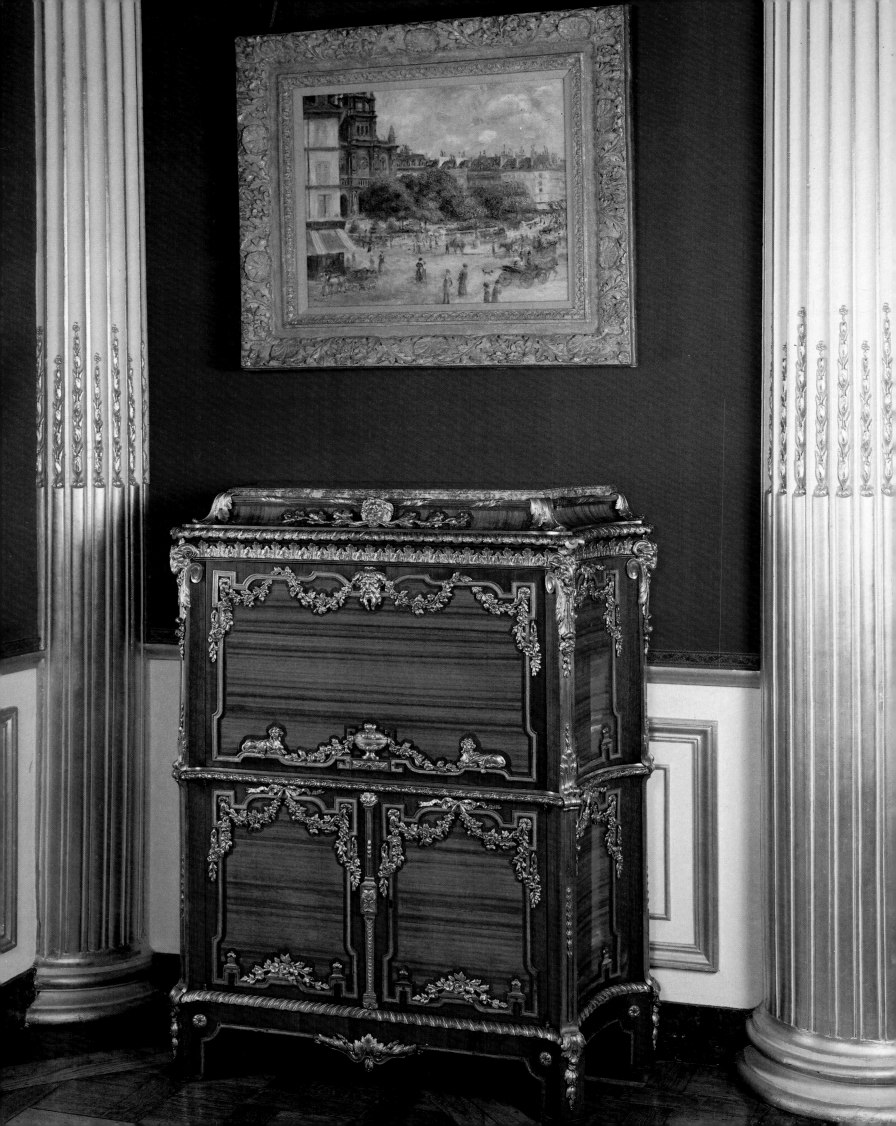

BAUMHAUER

d. 1772; ÉBÉNISTE PRIVILÉGIÉ DU ROI c. 1749

Nothing is known of Baumhauer's youth apart from the fact that he came from Germany and settled in Paris at an unknown date before 1745, the date of his marriage to Reine Chicot, daughter and sister of menuisiers. In 1747 the couple had a son, Gaspard-Joseph, who succeeded his father on the latter's death. Joseph Baumhauer was never a master ébéniste but became instead 'marchand-ébéniste privilégié du roi' in about 1749. As his surname was unpronounceable by his contemporaries he used his Christian name and stamped with it as well. He had a prosperous workshop in the rue du Faubourg-Saint-Antoine at the sign of 'La Boule Blanche' with eight work-benches at the time of his death in 1772.

The inventory taken after his death by the ébénistes Carlin and Dufour lists very few pieces – fifteen in all – all in the process of construction, which would indicate, considering the size of the business, that he worked on commission or mainly for dealers who bought his furniture as soon as it was finished. Four bureaux plats are described; the one with the highest valuation (960 livres), with a cartonnier, is described as 'contourné' (in the Louis XV style), while another bureau '6 pieds in length veneered in ebony, with fluted tapering legs... priced at 800 livres' corresponds to a type of Neo-classical bureau by Joseph of which at least three examples are recorded [246]. The remaining stock comprised three armoires, five commodes 'à la Régence' (that is on tall legs), a veneered console table, a small table with square tapering legs and two secrétaires en armoire. The

stock was valued altogether at nearly 4,000 livres. The absence of cash or credit notes is recorded and particularly the fact that Joseph did not keep an account-book. All this indicates that Joseph did not have access to a private clientèle but sold the greater part of his furniture through the marchands-merciers. His output consisted solely of sumptuous furniture embellished with costly materials – Sèvres porcelain plaques, pietra-dura, panels of Japanese or Chinese lacquer with richly ornamented gilt-bronze mounts – materials that only the marchands-merciers could have supplied to him.

JOSEPH AND THE DEALERS

The names of the dealers to whom Joseph supplied furniture are known. During the first part of his career he worked for Lazare Duvaux, as is shown by the inventory taken after Duvaux's death at which time he owed Joseph 1,726 livres. Moreover, a tall writing-desk by Joseph has been identified as the one supplied by Duvaux in 1758 for the Comte de Cobenzl [235]. It is possible that Joseph also made the marquetry commode supplied by Duvaux to the same client in 1756. At the same time Joseph was also working for the marchand Darnault: the lacquer commode in the J. Paul Getty Museum, the two commodes in the National Gallery, Washington, and the upper section of the cartonnier in the Hermitage all bear his label.

Between the years 1760 and 1770 he was commissioned by Poirier to make a number of pieces of sumptuous Neo-classical furniture such as the lacquer commode supplied to the Marquis de Marigny in 1766 and the suite of furniture supplied to the Marquis de Brunoy. Moreover, all the porcelain-mounted bureaux were certainly made for Poirier as the latter

[232] *Secrétaire à abattant, one of a pair attributed to Joseph, c. 1765–70, in bois satiné and amaranth. In the Grog Bequest to the Louvre there is an identical secrétaire stamped by Joseph. (Private collection)*

held a quasi-monopoly over the purchase of these plaques from the Sèvres manufactory (a number of identical models are recorded, one at Waddesdon Manor, and two others in the Huntington Library). They are the first examples of ladies' bureaux plats, well before those produced by Carlin in about 1775–80. All these bureaux are mounted with the same porcelain plaques of serpentine outline obviously designed for curvilinear commodes such as that by B. V. R. B. [189] and not ideally suited to the flat surfaces of Joseph's pieces, a fact which he was forced to mask with heavy gilt-bronze framing. This awkward treatment has led certain experts to suggest that the plaques were nineteenth-century additions. However, the repetition of this feature on many bureaux would exclude this hypothesis. The explanation could be that Poirier ordered specially fitted plaques for Carlin's furniture while to Joseph he supplied second-choice plaques to be mounted on less costly furniture. The few dated plaques which it has been possible to find on these pieces place them between 1760 and 1765, that is, just a little earlier than the porcelain-mounted pieces by Carlin (his earliest bonheur-du-jour dates from 1765).

Léger Bertin was another dealer for whom Joseph worked between 1750 and 1760: his label is found on the marquetry commode from this period in the Musée Jacquemart-André. For Julliot, who specialized in the sale of Boulle furniture (furniture made by Boulle as well as later copies), Joseph made two low bookcases, one of which is now in the Wallace Collection, the other at Alexander and Berendt Ltd. These two pieces are recorded among the sale of Julliot's commercial assets in 1777 and later belonged to the Comte de Vaudreuil. Their strongly emphasized Neoclassical style makes it possible to date them to the 1770s, near the end of Joseph's career. Other furniture in Boulle marquetry by Joseph is recorded and must have been made for Julliot, including the two cabinets decorated with pietra-dura for the Duc d'Aumont (now at Versailles) and the secrétaire made for Randon de Boisset (now reveneered in mahogany) also at Versailles. Finally, there are records of other dealers for whom Joseph worked: Hébert, Héricourt, Hécéguère, Foulon, Manet and the ébéniste Roussel.

CLIENTÈLE

Through these dealers, Joseph's furniture was acquired by a glittering clientèle. In France the Marquis de Brunoy bought a suite of furniture from Poirier before 1775 comprising a low cabinet and two encoignures (Louvre: Grog Bequest), the Duchesse de Mazarin's sale in 1782 included a suite identical to the Brunoy one but in Japanese lacquer now in the British Royal Collection, and the Marquis de Marigny bought a commode in Japanese lacquer from Poirier in 1766 (private collection). The financier Beaujon

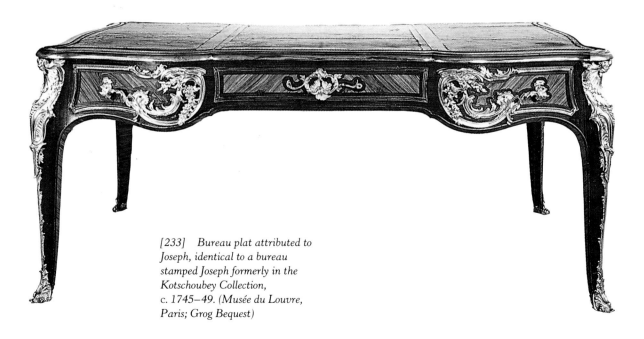

[233] Bureau plat attributed to Joseph, identical to a bureau stamped Joseph formerly in the Kotschoubey Collection, c. 1745–49. (Musée du Louvre, Paris; Grog Bequest)

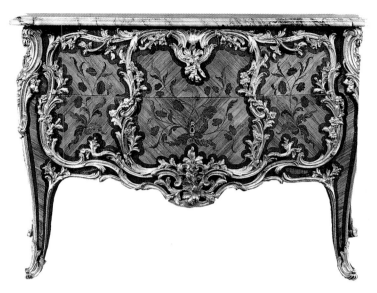

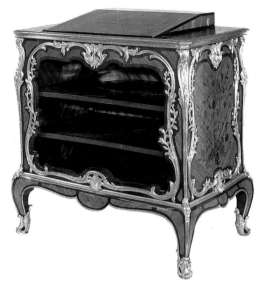

[234] Commode stamped
Joseph, c. 1755, with floral
marquetry in bois de bout on a
tulipwood ground; it seems to
match the writing-cabinet [235]
which belonged to the Comte de
Cobenzl, and may well also come

from him since he was known to
have purchased a commode of
this type from the dealer Lazare
Duvaux in 1756. (Toledo
Museum of Art, Ohio)

[235] Pupitre à écrire debout
attributed to Joseph, c. 1758,
with floral marquetry; it is
without doubt the piece sold by
Lazare Duvaux to the Comte de

Cobenzl, Austrian minister
plenipotentiary, in Brussels in
1758. (Formerly Wildenstein
Collection. Sale Sotheby's
Monaco, 25 June 1979, lot 141)

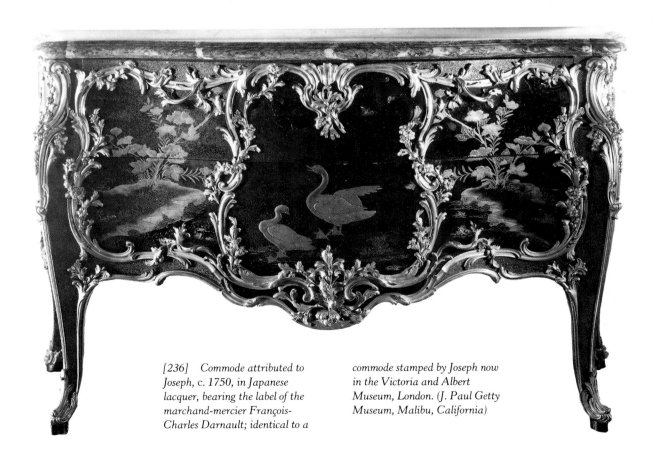

[236] Commode attributed to
Joseph, c. 1750, in Japanese
lacquer, bearing the label of the
marchand-mercier François-
Charles Darnault; identical to a

commode stamped by Joseph now
in the Victoria and Albert
Museum, London. (J. Paul Getty
Museum, Malibu, California)

[237] *Bureau plat and curved cartonnier with glazed doors stamped Joseph, c. 1765, with floral marquetry in bois de bout on a tulipwood ground. (Metropolitan Museum of Art, New York; Wrightsman Collection)*

[238] *(below) Bureau plat stamped Joseph, c. 1765, in Japanese lacquer; the gilt-bronze flat bands covering the whole length of the legs would seem characteristic of Joseph's style. (Musée du Louvre, Paris; Grog Bequest)*

[239] *(opposite) Secrétaire à abattant attributed to Joseph, c. 1760, with floral marquetry in bois de bout on a tulipwood ground. Joseph made a series of small secrétaires identical to this example, several of which are stamped. (Formerly in the Currie Collection; Alexander & Berendt Ltd, London)*

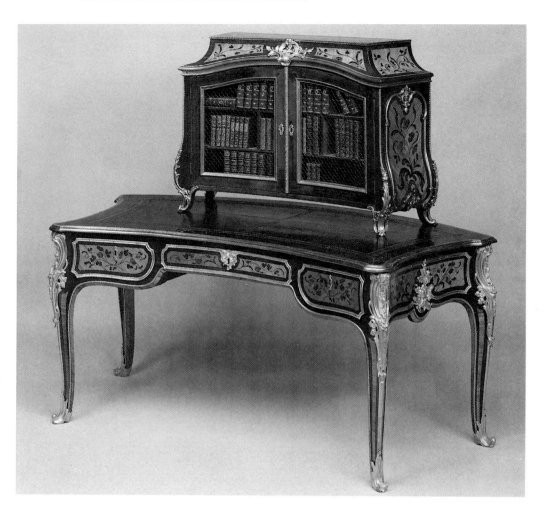

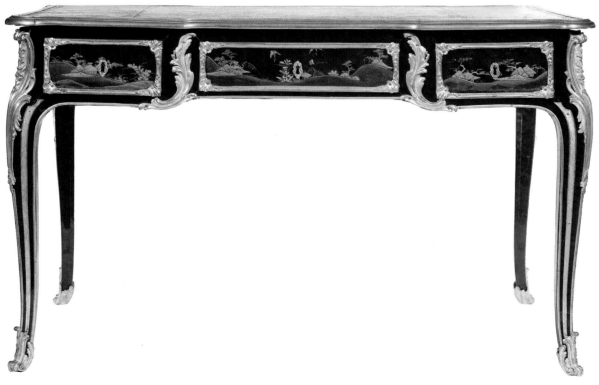

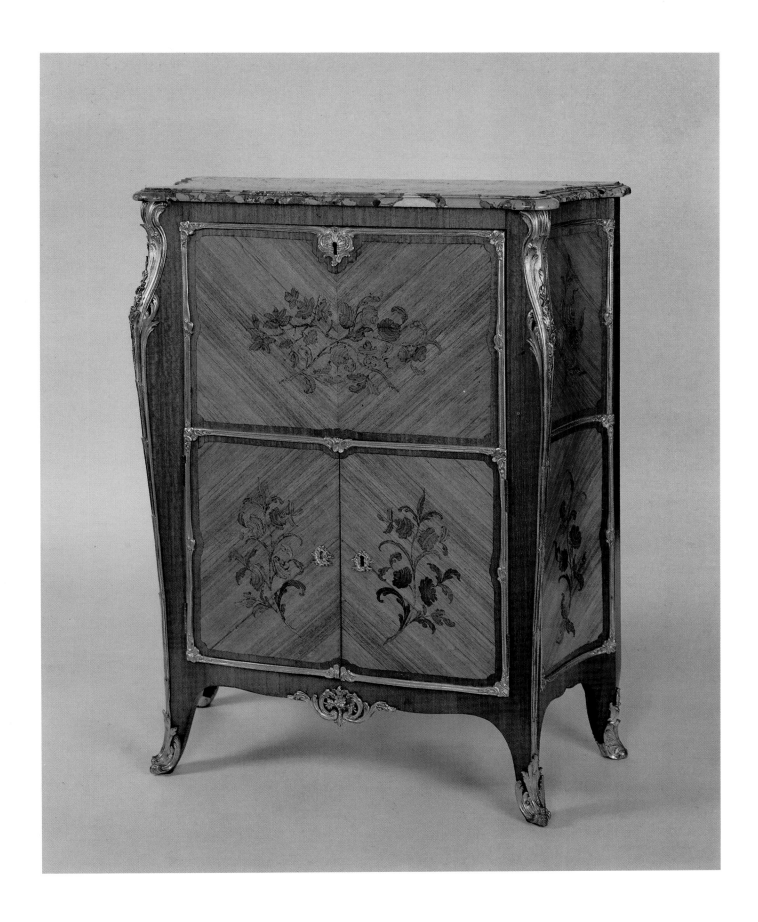

owned a Joseph commode at the Élysée which must have been supplied by his architect Boullée, to the latter's designs. Outside France, besides the Comte de Cobenzl, plenipotentiary minister to the Austrian Netherlands mentioned above, there was definitely one if not more Russian clients: this would seem to be conveniently confirmed by the Russian provenance of several important pieces of furniture in the rococo style by Joseph (the cartonnier in the Hermitage and the bureau plat with its cartonnier in the Kotschoubey sale in 1906).

JOSEPH'S STYLE

Joseph's style evolved from sober rococo in the 1750s to an academic Neo-classicism in the 1770s, following a similar course to that of the B. V. R. B. workshop. The earliest pieces date from about 1749: the lacquer encoignures in the National Gallery, Washington, and the Kotschoubey bureau. The lines of his furniture are sinuous, generous and perfectly symmetrical. On the series of lacquer or marquetry commodes dating from 1750–60 the vigorous gilt-bronze mounts are composed of broad mouldings around which curl luxuriant flower sprays. These mounts are stylistically comparable with the famous wall lights that François-Thomas Germain made in 1756 for the Palais-Royal, where foliate motifs are treated in a richer and more naturalistic manner than before.

The marquetry panels from this period are composed of kingwood floral sprays, cut in bois de bout on a tulipwood ground. The floral sprays are very luxuriant and cover most of the surface. On later furniture made in the 1760s the forms become more restrained: the lacquer or porcelain-mounted bureaux plats are designed with softer curves. The mounts are now simpler and consist merely of a foliate border which fol-

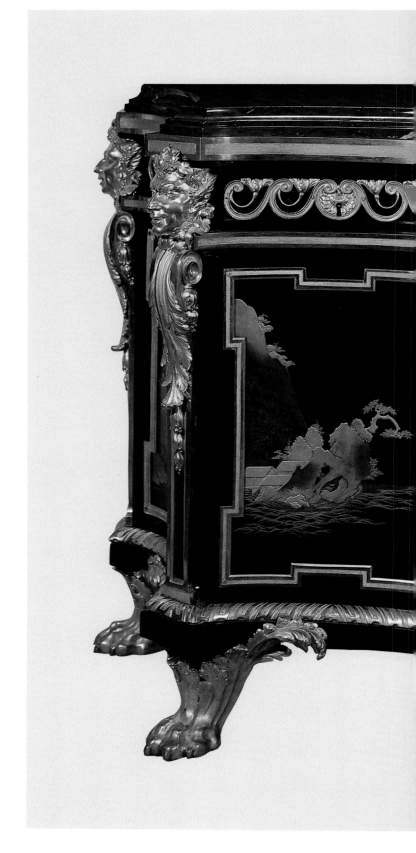

[240] *Commode in Japanese lacquer, stamped Joseph, sold for 4,000L in 1766 by the marchand-mercier Poirier to the Marquis de Marigny, enthusiastic supporter of the Neo-classical movement, friend and patron of Soufflot and Cochin.*

This piece, one of the very first landmarks of early Neo-classicism and one of Joseph's most successful works, has the vigour of a manifesto of a new style. (Archives Galerie Aveline, Paris)

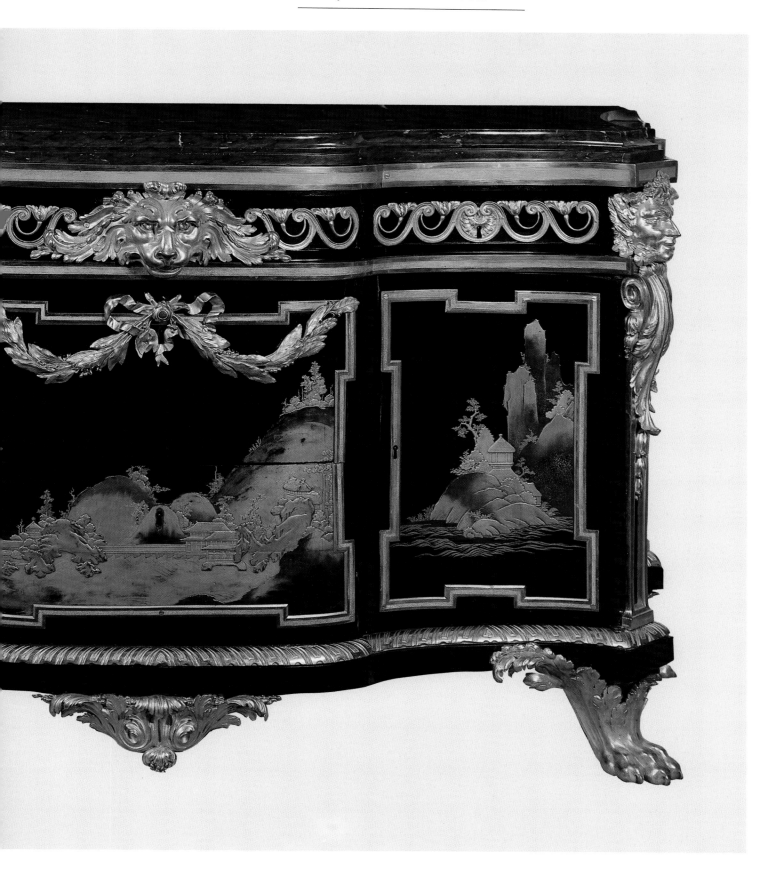

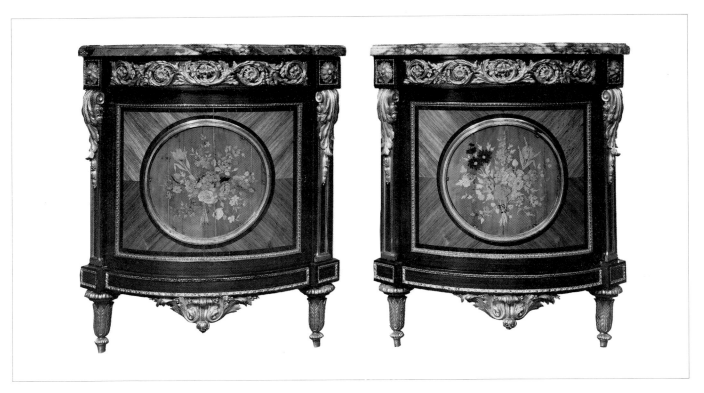

[241, 242] Pair of encoignures
and commode with doors stamped
Joseph, sold through Poirier to the

Marquis de Brunoy before 1775,
the year in which the latter's
collection was seized by his

creditors. (Musée du Louvre,
Paris; Grog Bequest)

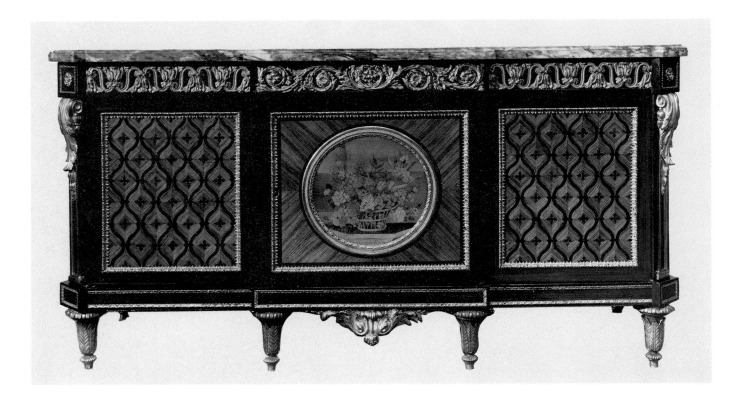

[243] Commode with doors in Japanese lacquer, stamped Joseph, c. 1770, originally together with a pair of matching encoignures, in the Collection of the Duchesse de Mazarin, sold in 1781 (lots 218–219). Acquired in 1825 by George IV, it was then altered; the central porcelain plaque originally decorating the piece was replaced by a lacquer panel. (British Royal Collection)

[244] Low bookcase stamped Joseph, c. 1770–75, made for the marchand-mercier Julliot before 1777; it then belonged to Vaudreuil and appeared in his sale in 1787. (Alexander and Berendt Ltd, London)

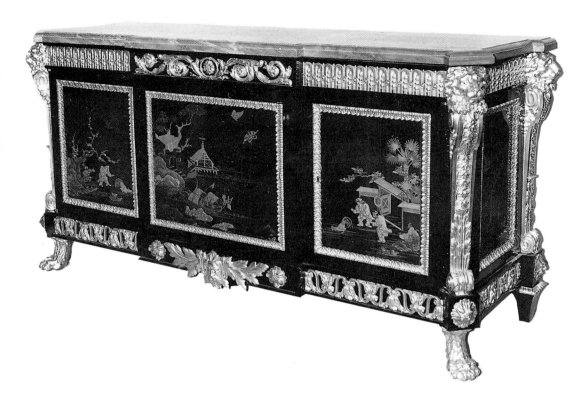

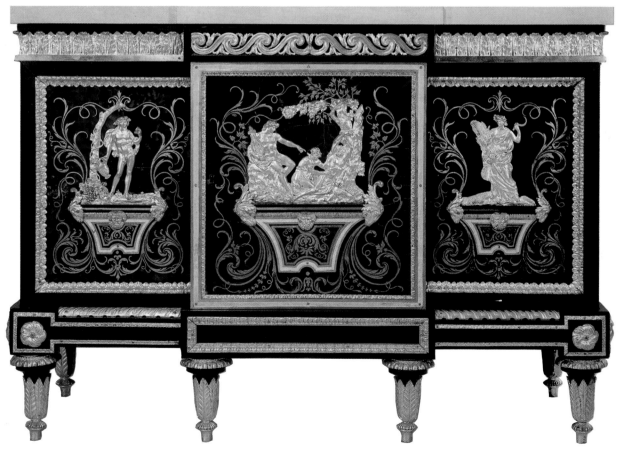

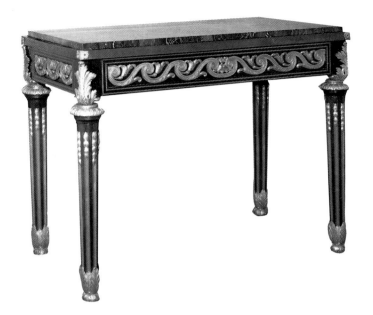

[245] Ebony centre table, stamped Joseph, c. 1770; the frieze of Vitruvian scrolls was one of Joseph's favourite motifs. (Galerie Levy, Paris)

[246] Bureau plat and cartonnier in ebony, attributed to Joseph, owned by Lord Malmesbury who bought it in 1796. Two bureaux of this type are described in the inventory drawn up after Joseph's death in 1772. (Sotheby's Monaco, 14 June 1981, lot 144)

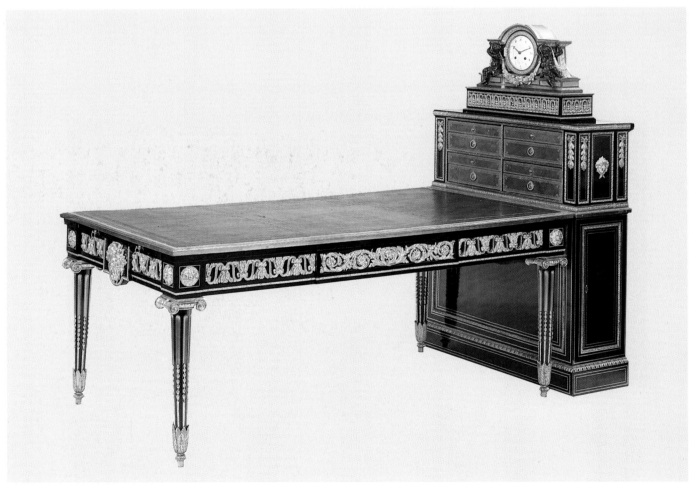

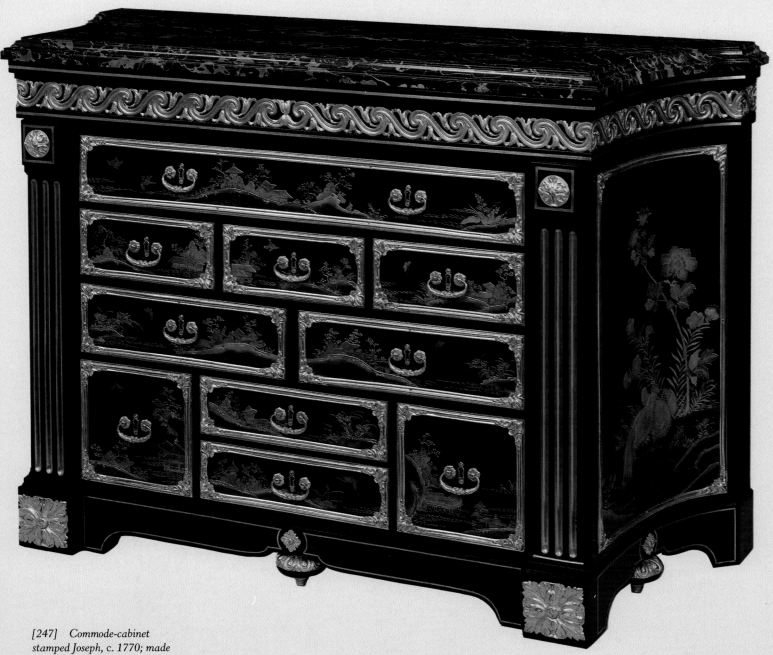

[247] Commode-cabinet
stamped Joseph, c. 1770; made
from a Japanese lacquer cabinet,
the drawers of which were
incorporated in a Neo-classical
carcase, using the doors for the
sides. (Formerly Warwick Castle;
Earl of Warwick's collection)

lows the contours with small corner-mounts at the corners and sabots en chaussons similar to those found on furniture of the same period by Oeben. Simple mouldings frame the drawers. A flat gilt-bronze band covers the fronts of the legs, a detail characteristic of Joseph's furniture but found nowhere else. Then, around 1765, he adopted the Neo-classical style, applying it not only to straight outlines but also to the bronze mounts: a good example is the Marigny commode (1766) with its Vitruvian scrolls, lion's mask, laurel garlands bound with ribbon, or the Blondel de Gagny cabinets (datable before 1766) with their Greek key pattern friezes. On the series of secrétaires à abattant dating from these years (Louvre: Grog Bequest, and two others in a private collection) the rigorous Neo-classical vocabulary is tempered with garlands of flowers. Floral marquetry is replaced by plain veneer of bois satiné with horizontal grain very characteristic of Joseph. This technique can be found on all the secrétaires dating from this period, as well as on a series of low cabinets [250], all decorated with the same Greek key-pattern frieze.

THE FINAL YEARS OF THE JOSEPH WORKSHOP

It is not certain whether the last pieces of furniture stamped by Joseph are actually his work. His son Gaspard Baumhauer (1747–?) is known to have taken over his workshop after his death, keeping his stamp for five years until 1777. The warrant of 'ébéniste privilégié' could be passed on to children and Gaspard also took this over in 1772. Following this he was beset by illness and financial problems, so much so that he was obliged to ask for an agreement with his creditors in 1776. It is possible, in view of the size of the accumulated debts (22,070 livres in addition to 3,000 livres of losses, although the stock was estimated at 10,600 livres and the credits at 7,640 livres), that Gaspard Baumhauer was forced to suspend his activities from that time, between 1777 and 1778, but we have no evidence of this.

BIBLIOGRAPHY

Jean-Dominique Augarde: 'Joseph', *L'Estampille*, no. 204, June 1987, pp. 14–15

André Boutemy: 'Joseph', *Connaissance des arts*, March 1965, pp. 82–89

APPENDIX I

EXCERPT FROM THE INVENTORY TAKEN AFTER THE DEATH OF JOSEPH BAUMHAUER, 28 MARCH 1772 (FURNITURE AND TOOLS IN THE WORKSHOP)

In a room on the first floor overlooking the courtyard
1] One large bureau, 6 pieds in length, veneered in ebony with fluted tapering legs, mounted with its bronzes ungilt. *800L*
2] Another bureau of the same size without bronze mounts, priced *400L*
3] A small armoire 3 pieds in height with 2 drawers, veneered in ebony embellished with its mounts and the front decorated with two small lacquer panels and two on the sides. *300L*
4] Another small cupboard nearly 3 pieds in height, 4 pieds in width, veneered in ebony with polished brass fillets, no mounts, priced *140L*
5] Item, another small bureau 3¹/₂ pieds in length, veneered in tulipwood decorated with bronze mounts, ungilded, 2 slides at the sides and 3 drawers at the front. *150L*

In the shop below
6] A large serpentine-shaped bureau, 6 pieds in length, veneered in amaranth parquetry and tulipwood, embellished with its 'carderon' and mounts, with its serre-papiers on top of a stand with 2 small doors at the sides. The 3 pieces matching, all decorated with their mounts, ungilded, priced *960L*
7] A commode à la Régence 4 pieds in length veneered in amaranth parquetry and bois satiné with a bronze motif, ungilded, priced *250L*
8] A console table 4 pieds in length with 5 drawers veneered

in tulipwood and bois satiné, embellished with ungilt mounts. *120L*
9] A small table with a drawer, square tapering legs with fillets of polished brass with capitals and sabots, the whole incomplete and not gilded. *60L*
10] Carcase of a secrétaire en armoire, 3 pieds in length veneered in amaranth and tulipwood, unpolished, mounted with some of its bronze mounts ungilded and without its back, priced *250L*
11] Another carcase of a secrétaire en armoire 3 pieds in length; veneered in amaranth and bois satiné, unpolished and without mounts, priced *150L*
12] A small cupboard 3 pieds in length, partly veneered in ebony and without mounts. *70L*

In the cellar
— 200 livres weight of tulipwood priced at 35L the hundredweight, amounting to *70L*
— 150 livres weight of amaranth. *27L*
— 20 livres of ebony in the raw and a small part in sheets. *10L*
— 40 livres of mahogany. *7L*

In a room on the second floor at the front
13] 2 carcases of commodes à la Régence. *36L*
14] 2 more carcases of poorer quality, same dimensions. *24L*
15] 2 old cabinets varnished on the inside. *2L*

Plus
— 10 livres of tulipwood and kingwood and bois satiné sawn en semelle. *36L*
— 15 livres of emery powder. *15L*
— A section of marquetry in contrepartie. *6L*

[248] Commode stamped Joseph, c. 1770, in sycamore, decorated with bouquets of flowers painted by Leriche or Prevost; probably designed by the architect Boullée, it belonged to *the financier Beaujon in his Paris residence, now the Elysée, and was included in his sale in 1787 (lot 509). (Christie's New York, 10 April 1980, lot 222)*

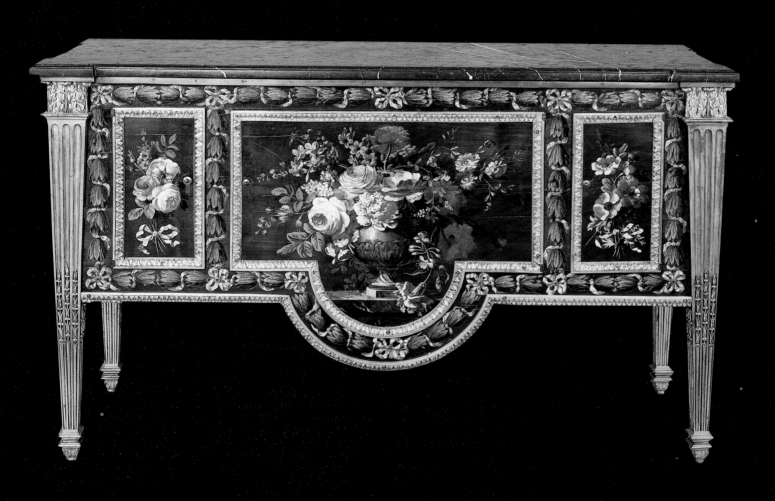

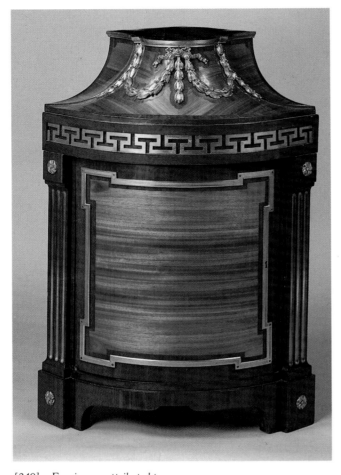

[249] Encoignure attributed to
Joseph, c. 1770; the veneer in
horizontal bands of bois satiné,
the fluted pilasters topped by
rosettes in squares, the Greek-key
frieze in gilt-bronze are all
characteristics of Joseph.
(Sotheby's Monaco, 25 June
1983, lot 303)

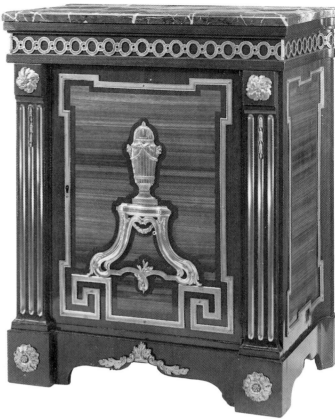

[250] Cabinet attributed to
Joseph, c. 1770, in bois satiné and
amaranth, identical to a series of
cabinets stamped by Joseph.
(Galerie Léage, Paris)

APPENDIX II

LIST OF THE PRINCIPAL WORKS
BY JOSEPH

A. Commodes in the Rococo style

Lacquer
1) Victoria and Albert
Museum: Jones Collection
(attributed) in Japanese lacquer.
2) J. Paul Getty Museum
(attributed) in Japanese lacquer
[236].
3) Museum of Applied Arts,
Budapest (attributed) in French
imitation lacquer.
4) British Royal Collection.
With marquetry
5) Musée Jacquemart-André,
floral marquetry (attributed) with
Bertin's label.
6) Palace of the Legion of
Honor, San Francisco with wave
marquetry.

7) Royal Pavilion, Brighton
(stamped), floral marquetry with
very rich mounts.
8) Stein-Dutasta Collection
(stamped) with floral marquetry.
9) Toledo Museum (stamped)
with floral marquetry [234].
10, 11) National Gallery,
Washington (stamped), a pair
formerly in the Duke of Leeds
Collection, in floral marquetry
with Darnault's label.

B. Commodes and low cabinets in Neo-classical style

Lacquer
12) Marigny's commode
(stamped) supplied in 1766 by
Poirier for the bedchamber of the
Marquise de Marigny, Japanese
lacquer [240].
13) 'Commode à portes'
belonging to the Duchesse de
Mazarin (stamped), in Japanese
lacquer, British Royal Collection;

originally in 1781 mounted with
a central circular porcelain
plaque later replaced by a lacquer
panel [243].
14) Commode 'cabinet', from
Warwick Castle (stamped) with
ten drawers and Vitruvian-scroll
frieze, Japanese lacquer [247].
15) Commode 'cabinet', private
collection (attributed), illustrated
in *Connaissance des arts*, January
1967, p.70, in Japanese lacquer
with ten drawers.
16) J. Paul Getty Museum
(stamped) with doors in
Kijimakie lacquer.
17) 'Beaujon' commode
(stamped) decorated with
bouquets of flowers painted by
Leriche or Prevost, probably
designed by Boullée in about
1770 for the financier Beaujon
[248].
18) Ephrussi de Rothschild
Foundation (stamped),

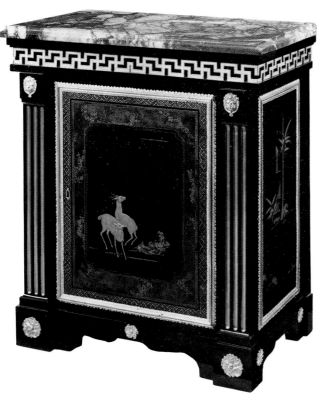

[251] Cabinet in Japanese lacquer, one of a pair, c. 1760–65; made for the financier Blondel de Gagny, these cabinets are mentioned in a description of Paris in 1766 by Hébert as being 'with mouldings and gilt mounts in the Antique taste'. (Galerie Aveline, Paris)

commode with doors in lacquer on a white ground (possibly relacquered).

With marquetry
19) Louvre: Grog Bequest (stamped), commode with doors, with marquetry sold to the Marquis de Brunoy before 1775 [241].
20) Burat sale (attributed) with doors and Vitruvian-scroll frieze with strapwork marquetry.

With Boulle marquetry
21) Wallace Collection (stamped) in contrepartie, supplied to Julliot before 1777, having been owned after this date by Vaudreuil.
22) Alexander and Berendt Ltd (stamped), the pair to the preceding piece, in première partie [244].

C. **Bureaux plats with cabriole legs**
Lacquer
23) Private collection, Paris (stamped).
24) Formerly in the Rothschild then Gonçalvez Collection (attributed) in Japanese lacquer.
25) Louvre: Grog Bequest (stamped) in Japanese lacquer, dated between 1765 and 1770 [238].

With marquetry
26) Louvre: Grog Bequest (attributed), identical to the one in the Kotschoubey sale [233].
27) J. Paul Getty Museum: from the imperial Russian collections at Oranienbaum, the mounts struck with crowned 'C'. The matching cartonnier is now in the Hermitage (see further no. 68).
28) Kotschoubey Collection,

Paris sale, 1906 (stamped); with a cartonnier.
29) Wrightsman Collection, New York (stamped) of waisted form [237].

With porcelain mounts
30) Huntington Library (stamped), plaques all modern replacements; the piece originally in lacquer or marquetry.
31) Huntington Library (stamped Joseph and Saunier), plaques of assymetrical outline dated 1763, possibly supplied by the dealer Baldock in 1830.
32) Waddesdon Manor, Buckinghamshire (stamped), plaques with assymetrical outline, some dated 1760.
33) Gulbenkian Museum, Lisbon, some plaques dated 1760.
34) Metropolitan Museum of Art (stamped), plaques undated with green border.
35) Philadelphia Museum (attributed), plaques with green border.
36) Robert Lehman Collection, New York (attributed).
37) Boughton House, Northamptonshire: Duke of Buccleuch's collection (stamped), identical to the one at Waddesdon.
38) Paris sale, 9 June 1976 (stamped), identical to the Waddesdon example; possibly the one sold by Viscount Clifden, Christie's, 5 May 1893, lot 156.

D. **Bureaux plats in Neo-classical style**
39) Lady Baillie Collection (attributed), sale Sotheby's London, 13 December 1974; with its cartonnier [246].
40) Alexander and Berendt Ltd (attributed).
41) Edmund de Rothschild Collection, sale Christie's, 20 June 1985 (attributed), veneered in palisander.

E. **Cabinets in Neo-classical style**
42–43) Paris trade, pair of cabinets made for Blondel de Gagny before 1766 (stamped) in Japanese lacquer [251].
44–45) Pair of cabinets in pietra-dura (stamped), Versailles.
46–47) Private collection, London (one stamped), ex-Ader sale, Paris, 13 June 1978, lot 92, in bois satiné.
48–49) Private collection, Paris (stamped), identical to the

previous pair, in bois satiné.
50) Galerie Léage (attributed), a single one, identical to the preceding pair, with a gilt-bronze mounted apron [250].

F. **Secrétaires à abattant**
51) Louvre: Grog Bequest (stamped), veneered in bois satiné.
52–53) Pair, Niarchos Collection (attributed), identical to the preceding pair [232].
54) J. Paul Getty Museum (stamped) with classical frieze, veneered in parquetry.
55) Private collection, Paris (stamped), classical frieze and veneered in bois satiné.
56) Musée de Versailles (stamped), made for Randon de Boisset, originally in Boulle marquetry, reveneered in mahogany.

G. **Encoignures**
57–58) National Gallery, Washington (attributed), in French lacquer, mounts with crowned 'C'.
59–60) Gallerie M. Segoura (stamped), in Boulle marquetry.
61–62) Louvre: Grog Bequest (stamped), in marquetry, en suite with the Brunoy commode [242].
63–64) Veil-Picard Collection, with floral marquetry.
65–66) British Royal Collection (stamped), en suite with commode no. 13 and made with it for the Duchesse de Mazarin after 1768.
67) Private collection, sale Sotheby's Monaco, 26 June 1983, lot 303 (attributed), veneered in bois satiné [249].

H. **Various**
68) Upper section of a cartonnier, Hermitage (stamped), with Darnault's label (the base of the cartonnier stamped 'B. V. R. B.').
69) Large centre table in ebony (stamped), sale, Sotheby's London, 5 June 1964, private collection, Brussels.
70) Clock-base with figure of Clio (stamped), works by F. Berthoud, private collection.
71) Clock-base with figure of Clio (stamped), dial by Julien Le Roy (perhaps from Strawberry Hill: Horace Walpole Collection), sale Parke Bernet, 23 May 1970, lot 23.
72) Clock base with figure of Clio (stamped), dial by Julien Le Roy, sale Sotheby's Monaco, 3 May 1977, lot 18.

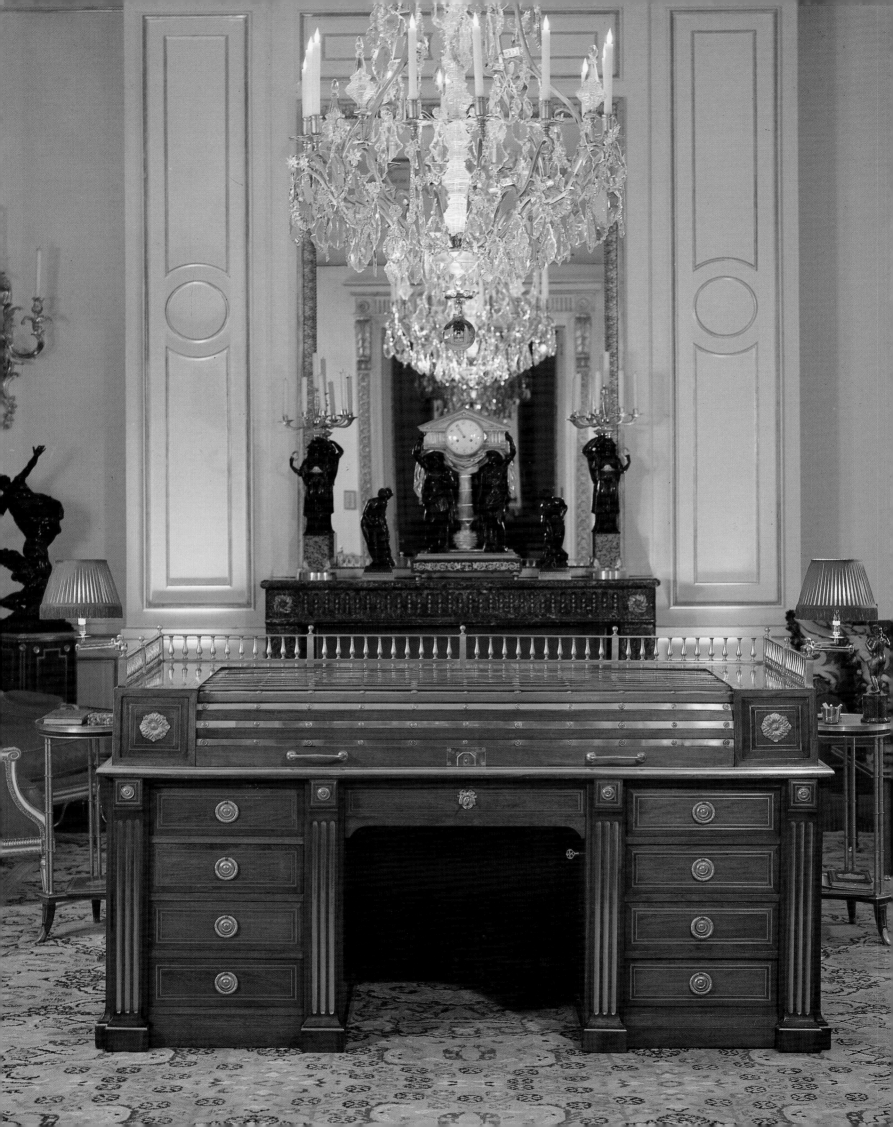

Pierre
GARNIER

c. 1720–1800; MASTER 1742; MARCHAND-ÉBÉNISTE

Pierre Garnier was born in 1720 in Paris, the son of François Garnier, ébéniste in the rue du Faubourg Saint-Antoine who was active from 1720 to 1774, using the stamp 'F. G.'. He became a master in 1742, and moved from the Faubourg-Saint-Antoine to the rue Neuve-des-Petits-Champs in the financial quarter of the city. His success was soon recorded in the *Almanach général des marchands*. Although he produced several pieces in the Louis XV style most of his work was carried out in the Neo-classical style of which he was one of the pioneers, together with Oeben and Joseph. As early as 1761 he produced furniture in the Neo-classical style after designs by the architect de Wailly, which were exhibited at the Salon in the same year. The first piece is described as follows: 'A table in lapis lazuli with legs in bois des Indes decorated with gilt-bronze mounts. This table supports a granite urn in the Antique taste. They are both of a beautiful shape, the mounts are rich and in noble taste, and far removed from the frivolous style of our furniture which has been in fashion far too long.' (*L'Avant-Coureur*, 1761.) Garnier supplied another piece, not described in detail, but 'executed in the best Boulle manner', and a secrétaire belonging to Mme la Présidente Desvieux. The allusion to 'Boulle manner' surely suggests a piece of furniture in ebony, laden with gilt-bronze mounts, probably of the type of the Lalive de Jully bureau.

In the same years Garnier made a series of celebrated bureaux plats (one that belonged to Talleyrand was formerly at the Château de Sagan, another

belongs to the Marquis of Bath at Longleat, a third is in the Gulbenkian Museum in Lisbon, a fourth in the Huntington Library, while a fifth is in a private collection). These bureaux can be dated around 1762–65, as they are all decorated with the same mounts, drawer-handles with Greek patterns, Antique oil lamps and triglyphs such as those found in drawings by Carmontelle, dating from about 1760. The pair of commodes stamped by Garnier and Bon Durand, inscribed with the date 1768, now in the Swedish Royal Collections in the castle of Gripsholm, also have the same classical gilt-bronze mounts [257].

At the same time as Oeben, Garnier perfected a type of roll-top desk of which two examples are recorded [252]. One of them is dated 1767, that is, two years before Riesener delivered the 'bureau du Roi'. It is evident that in form Garnier's bureau is much more innovatory and 'modern' than that of the 'bureau du Roi', deriving its inspiration directly from the bureau of Lalive de Jully made in about 1756, from which it borrows the same squares with double inlay of brass stringing and fluted pilasters. The stylistic similarities are so striking that it is tempting to attribute the Lalive de Jully bureau to Garnier rather than Joseph.

From 1769 the Marquis de Marigny was one of Garnier's principal clients. He supplied him with many different types of furniture including, in 1778, a series of 36 caned chairs in mahogany. Some of these chairs, which have now been identified, are stamped by Garnier and some by Cosson to whom Garnier subcontracted part of the order (Cosson was apprenticed to François Garnier in 1750). In 1779 Marigny ordered a complete series of pieces of furniture in mahogany or ebony from Garnier for his house in the Place des Victoires; for the library, an ebony table covered in green cloth with a stand supporting an

[252] *Cylinder bureau with tambour slide in amaranth, stamped Garnier. The date 1767 inscribed inside places the piece* *very early in the development of the Neo-classical movement, thus making Garnier a pioneer of the new style. (Orinoco Foundation)*

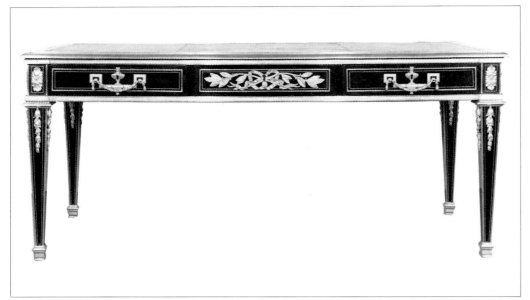

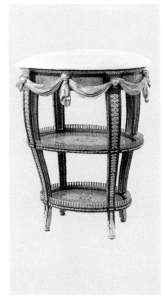

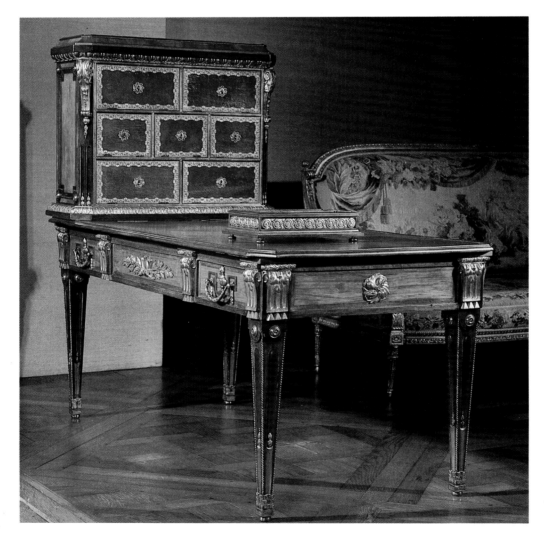

[253] (above left) *Bureau plat in ebony, stamped Garnier, c. 1762–65; the handles in the form of Greek motifs are typical of Garnier; they appear on bureaux depicted in drawings by Carmontelle dating from the early 1760s (Archives Galerie Aveline, Paris)*

[254] (above) *Marquetry serving-table stamped Pierre Garnier, one of a suite of three (Archives Galerie Aveline, Paris)*

[255] *Bureau plat and cartonnier in tulipwood and amaranth, stamped Garnier: Garnier produced five examples of this type of desk, which can be dated between 1762 and 1765 from its appearance in drawings by Carmontelle from these years. (Gulbenkian Museum, Lisbon)*

architectural model of the Louvre colonnade as well as another table in ebony; for the 'cabinet à pans' on the ground floor, three low cabinets in mahogany with glazed doors and rounded sides, without gilt-bronze mounts. Garnier was made to submit drawings for all these pieces. In the case of the chairs, Marigny even asked for models. There are numerous indications in the correspondence between Marigny and Garnier that Garnier owned his bronze models which he had designed himself. M. Godefroy was another client of Garnier. In his sale in 1785 two fine pieces by Garnier appeared, one a secrétaire decorated with miniatures (see Appendix) and a pair of encoignures which are now in the J. Paul Getty Museum. We also know that Garnier furnished the Château de Montgeoffroy for the Maréchal de Contades in about 1775 with sets of furniture, simple commodes, tables and desks. Some were stamped by both Garnier and Durand like the Gripsholm commodes, further proof of the collaboration between these two ébénistes.

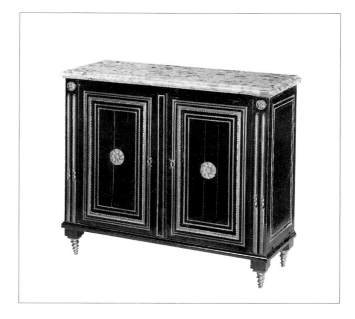

[256] *Bas d'armoire in ebony, one of a pair stamped Garnier, c. 1775–80; Marigny owned three bas d'armoire in the gallery of his town house of a type very close to this example. (Christie's London, 10 June 1985, lot 64)*

[257] *Commode in tulipwood and amaranth, one of a pair stamped Garnier and Bon Durand, dated 1768. (Swedish Royal Collections, Gripsholm)*

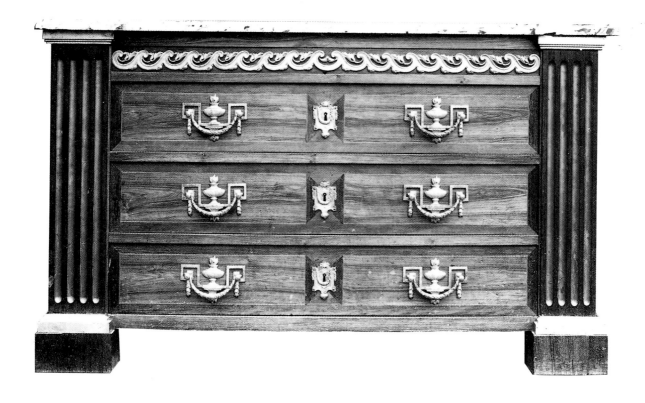

Finally, Salverte mentions consignments of furniture made by Garnier for the Duchesse de Mazarin before 1781 and Germain Baron, Receiver-General of Finance between 1784 and 1789. Garnier remained active until the Directoire and died in 1800. Following his death a notice appeared in the *Petites Affiches* announcing the sale of his stock of furniture.

BIBLIOGRAPHY

F. de Salverte: *Les Ébénistes*, pp. 130–31

Svend Eriksen: *Early Neo-classicism in France*, pp. 71–72 and 83–85; 'Marigny-Garnier correspondence', *Furniture History Society Bulletin*, 1972

A. Pradère: 'L'ameublement du Marquis de Marigny vers 1780', *L'Estampille*, no. 193, June 1986

APPENDIX

GODEFROY SALE, 25 APRIL 1785

238) One secrétaire in marquetry decorated with gilt-bronze mounts with four glazed doors which open with a single key, and behind which the depth is sufficient to place pictures or medals. Behind the two glazed panels on the base are 18 butterflies, very well painted, by Mme Vallayer Coster which may be removed and replaced with other decoration. Between the two mirrors above there are four small pictures in bronze frames; one landscape in oil on copper by M. — ; a miniature in the style of Clinchetel; a young girl holding a bottle, refusing to give a drink to a boy by J. B. Massé; a miniature representing a sleeping woman naked to the knees, by M. Charlie after a painting of Deshays; the fourth in enamel represents the bust of a young Italian woman by Courtois after Taraval.

This fine piece, beautifully executed, was made 12 years ago by Garnier. *805L*

238b) 2 very fine encoignures in the shape of square pedestals with ebony ground, decorated with garlands and gilt-bronze friezes of rosettes. The rest of the front is veneered in palisander. They are surmounted by white marble tops, 2 pouces thick. Total height 4 pieds, width 2 pieds 3 pouces. *498L*

[258] *Secrétaire à abattant in Japanese lacquer stamped Garnier, c. 1775–80. The motifs of gilt-bronze discs in Antique style can also be found on a series of mahogany chairs made by Garnier for Marigny in 1778. (Christie's London, 4 December 1975, lot 89)*

[259] *Secrétaire à abattant in Japanese lacquer stamped Garnier, confiscated at the time of the Revolution from the town house of the Marquis de la Vaupalière now in the Avenue Matignon. (Musée du Louvre, Paris)*

[260] *(right) Secrétaire à abattant in bois satiné stamped both Garnier and Dautriche (to whom Garnier must have subcontracted the order), c. 1775. (Private collection)*

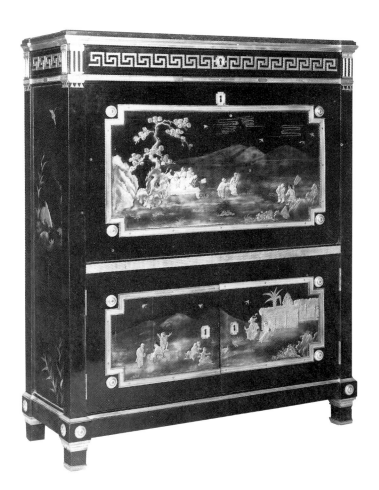

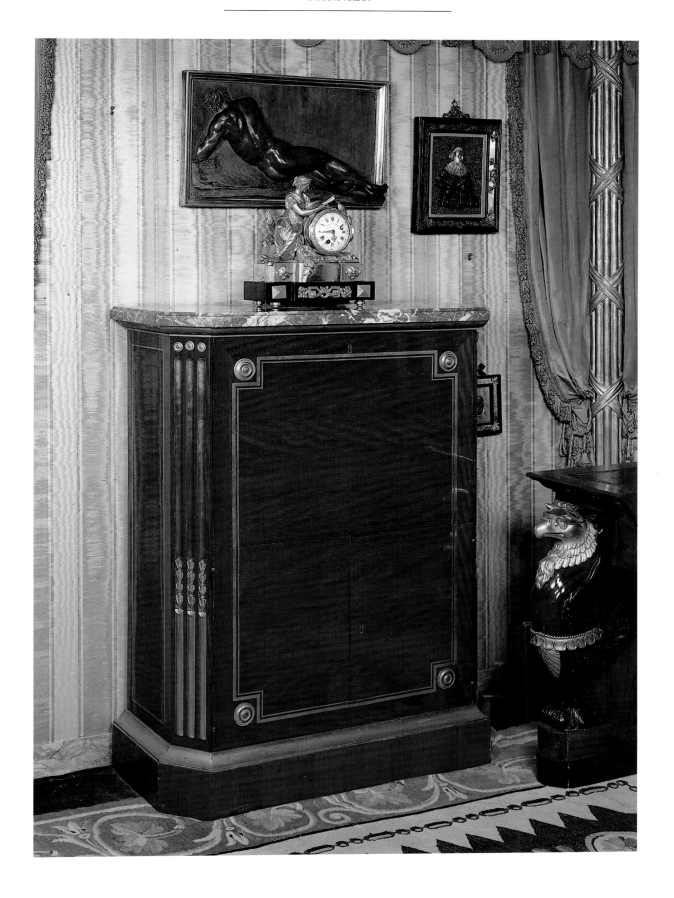

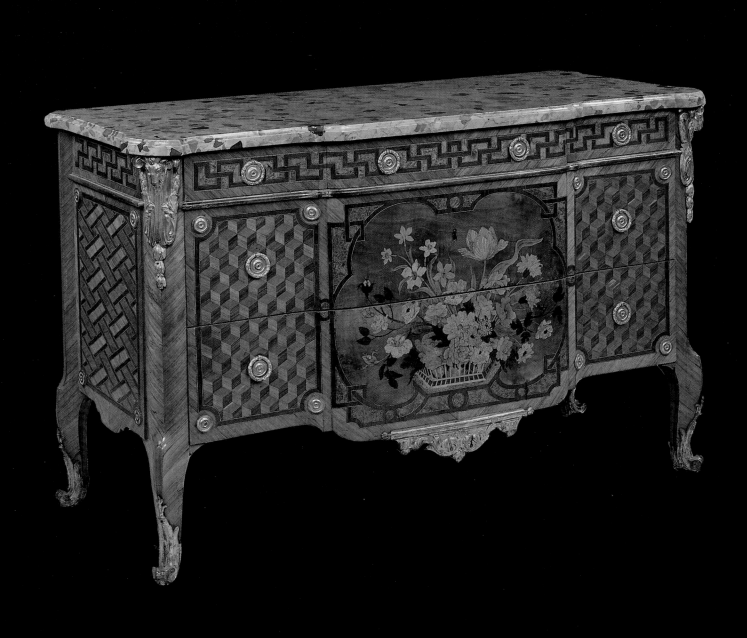

Jean-François

OEBEN

1721–63; MASTER 1761

Jean-François Oeben, son of a Catholic postmaster, was born on 9 October 1721 at Heinsberg near Aix-la-Chapelle and the ·Dutch frontier. Nothing is known of his youth but it is probable that he started his apprenticeship at the usual age of fourteen or fifteen, that is in about 1735–36, and would have finished in about 1740–42. It is likewise impossible to know if this apprenticeship took place in the Rhineland or in Paris. On the other hand, we know from his marriage contract in 1749 that he had already been established in Paris for a number of years, as he is described as a journeyman ébéniste living in the rue du Faubourg Saint-Antoine. It is probable that he had settled among the circle of Flemish ébénistes which included the Criards, the Vanrisamburghs, the Vandercruses and Dautriches, a circle which also included Latz, for whom he probably worked. Panels of very detailed floral marquetry characteristic of Oeben's work are found on some pieces typical of Latz in their exaggerated rococo form and their gilt-bronze mounts. This is the case with a commode [135] and four encoignures now in the J. Paul Getty Museum, and also a secrétaire in the Residenz, Munich [274]. Of course, it is possible that on Latz's death Oeben bought unfinished furniture, with its bronze-gilt mounts, which he would then have veneered. The marriage contract includes an inventory of 'goods, furniture, clothes, linen and personal apparel' in his possession to the value of 600 livres. Oeben married Françoise-Marguerite Vandercruse, daughter of an ébéniste, sister of R. V. L. C., and sister-in-law of Carlin. He therefore became

a member of one of the principal families of Parisian ébénistes.

Between 1751 and 1754 Jean-François Oeben worked as an independent artisan in Charles-Joseph Boulle's workshop and rented a mezzanine at the Louvre. This is confirmed by a document in the hand of Marigny in 1759. On the death of Charles-Joseph Boulle in 1754, Oeben could no longer remain at the Louvre. However, on 15 December 1754 he was granted the title of 'ébéniste du roi' and obtained lodgings and a workshop at the Gobelins where he remained until 1761. Numerous advantages were connected with his establishment at the Gobelins; after six years working in the Royal Manufactories an ébéniste could become a master without paying the usual fees (536 livres for a foreigner). After ten years a foreign artisan could become a naturalized Frenchman and have the right to will his assets to his children.

With regard to the prestige and importance of Oeben's workshop at the Gobelins, we have an interesting glimpse in a letter of recommendation of a Swedish ébéniste, Karl Peter Dahlström, which states that he 'has worked as head of the workshop of the court ébéniste Jean-François Oeben, famous at the English and French Courts as well as at the Imperial court in Vienna and the Tsar's court in Russia'. Certain pieces of furniture by Oeben dating from the 1750s, now at the Residenz in Munich and which probably once belonged to a prince of Saarbrucken, serve to illustrate the extent of the renown which he already enjoyed beyond the frontiers of France [274].

From 1752 the name of Jean-François Oeben appears in Lazare Duvaux's day-book for some frames, proof that he was a craftsman worthy of working for the greatest dealer of the time and principal

[261] Commode stamped J.-F. Oeben, c. 1760–63, in cube marquetry; a similar commode is described in the inventory drawn up after Oeben's death in 1763. (Sale Couturier-Nicolaÿ, Paris, 18 November 1981, lot 99)

supplier to Mme de Pompadour. From then on Oeben supplied furniture to her. The first important work that can be identified is a mechanical table of the same design as the one in the Louvre which is seen in the portrait of Mme de Pompadour with her daughter Alexandrine by François Guérin, painted shortly before (or shortly after) 1751, the date of Alexandrine's death. Certain other important pieces by Oeben can be dated stylistically to this period: for example, the mechanical table in the Linsky Collection [263] which is embellished with gilt-bronze corner-mounts in the form of towers, the armorial emblem of the Marquise de Pompadour.

In 1756 Oeben was given extensive accommodation as well as a workshop at the Arsenal, which was virtually a dependency of the Gobelins manufactory. The Arsenal was very conveniently placed for the shipping of furniture, being close to the port of Saint-Nicolas. The workshop at the Gobelins remained in operation with the assistance of his brother Simon Oeben, who also took over the accommodation. In the same year, on 14 June 1756, he made his first delivery to the Garde-Meuble Royal, consisting of a commode with doors for the Cabinet of the Dauphin at Versailles. Presumably furniture of that period still followed the lines of the rococo style; the uninterrupted curves of these pieces are strongly accentuated, particularly in the case of the tables. They are in a very

sober and mature rococo style, with few mounts, their appeal coming mainly from the perfection of their lines and the refinement of the marquetry. During the years between 1750 and 1760 this consisted mainly of floral marquetry – baskets of flowers, sprays of carnations – treated in a realistic manner and contrasted on a striped sycamore ground. These panels are delineated by an interplay of sinuous bands of amaranth bounded by double fillets in black and white. On Oeben's later works this type of floral marquetry is replaced by geometric marquetry: cubes, interlaced circles, fan motifs, directly inspired, as has been noted by Sir Francis Watson, by Japanese lacquer boxes. A transitional phase is marked by the combination of a central bouquet of flowers flanked by parquetry panels in cubes, as can be seen on the Bensimon commode, on the table in the Louvre, or the one in the Widener Collection.

While gaining renown for his ability in marquetry, Oeben was also specializing in mechanical furniture: in order to make the necessary metal fittings and mechanisms for them, he was given permission to build a forge in the courtyard of the Arsenal. At that time this type of furniture was a speciality of German craftsmen, such as Abraham and David Roentgen, who excelled in this work. Oeben, however, surpassed his compatriots in this field. He perfected a mechanical table which was both a dressing-table and a writing-table. The top slides backward at the same time as the drawer pulls forward, which allows the release of a reading stand and panels. Oeben also conceived an ingenious system of locking all the drawers of a piece

[262] *Mechanical table stamped J.-F. Oeben, made for d'Argenson, c. 1760. The marquetry top contains allusions* *to the Ecole Militaire which d'Argenson had helped to finance. (Gulbenkian Foundation, Lisbon)*

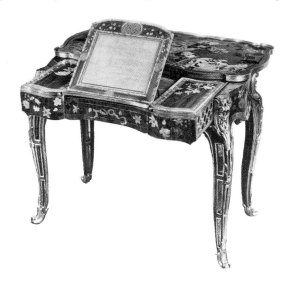

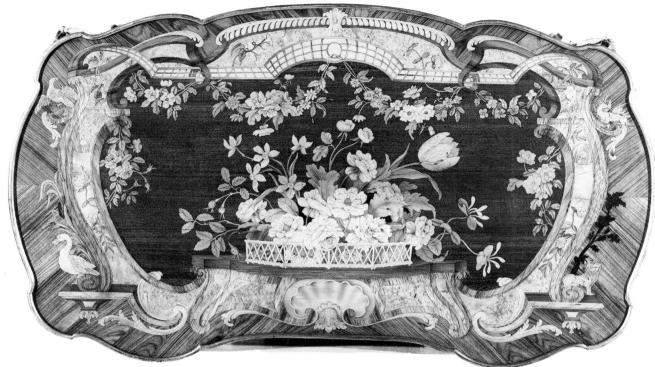

[264] Top of a mechanical table stamped J.-F. Oeben, identical to the one featured in the portrait of Mme de Pompadour by Guérin which can be dated before 1754. Oeben's floral marquetry re-established a realistic style, which was that of Boulle before 1700. (J. Paul Getty Museum, Malibu, Calif.)

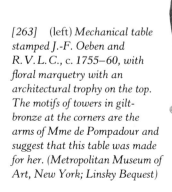

[263] (left) Mechanical table stamped J.-F. Oeben and R.V.L.C., c. 1755–60, with floral marquetry with an architectural trophy on the top. The motifs of towers in gilt-bronze at the corners are the arms of Mme de Pompadour and suggest that this table was made for her. (Metropolitan Museum of Art, New York; Linsky Bequest)

[265] Mechanical toilet-table by J.-F. Oeben, c. 1755, with floral marquetry on a sycamore ground. (Partridge (Fine Arts) plc, London)

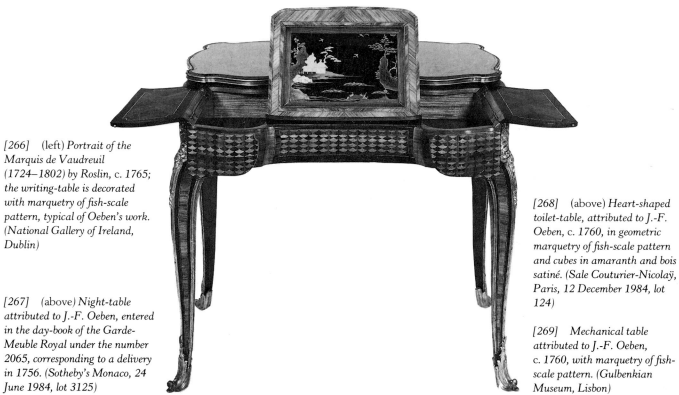

[266] (left) Portrait of the
Marquis de Vaudreuil
(1724–1802) by Roslin, c. 1765;
the writing-table is decorated
with marquetry of fish-scale
pattern, typical of Oeben's work.
(National Gallery of Ireland,
Dublin)

[267] (above) Night-table
attributed to J.-F. Oeben, entered
in the day-book of the Garde-
Meuble Royal under the number
2065, corresponding to a delivery
in 1756. (Sotheby's Monaco, 24
June 1984, lot 3125)

[268] (above) Heart-shaped
toilet-table, attributed to J.-F.
Oeben, c. 1760, in geometric
marquetry of fish-scale pattern
and cubes in amaranth and bois
satiné. (Sale Couturier-Nicolaÿ,
Paris, 12 December 1984, lot
124)

[269] Mechanical table
attributed to J.-F. Oeben,
c. 1760, with marquetry of fish-
scale pattern. (Gulbenkian
Museum, Lisbon)

at the same time with a single turn of a key. The title of 'ébéniste mécanicien du roi', granted in 1760, attests to his abilities in this sphere. In the same year Oeben supplied an invalid chair for the Duc de Bourgogne, elder brother of the future Louis XVI, which could be wheeled, turned and regulated in height, with trays for reading and eating. For this he received a medal and an award.

Finally, in 1760, Oeben received the most important commission of his career, a 'secrétaire à cylindre' for the King [448]. Oeben was certainly the first in France to design this type of furniture; the other ébénistes who produced this type of desk, such as Teuné, Roussel and Boudin, were not innovators and their desks date at the earliest from the years around 1765 (Teuné, for example, became a master only in 1766). The clumsy description of such desks by Joubert and Dubois in the inventory made after Oeben's death in 1763 further indicates that this type of desk was new to France. It is likely, moreover, that Oeben had already made an example before 1761, or the Garde-Meuble Royal would not have given him the order. The decoration was so rich and the mechanical fittings so complex that it took eight years to make, being completed by Riesener in 1769 and signed by him (in the marquetry). This desk, like all the other cylinder desks by Oeben, has cabriole legs and is still rococo in form. This would appear anachronistic for the time but can be explained by the fact that it was designed for the Cabinet of Louis XV, a room which already contained such rococo pieces as the medal-cabinet by Gaudreaus [116] and the encoignures by Joubert [205]. From 1760 Oeben did however follow the taste of the time for Neo-classicism: he produced furniture of massive form with straight lines, commodes or secrétaires à abattant veneered with geometric marquetry. The gilt-bronze mounts were also in the new taste: friezes of interlaced circles, corner-mounts with rams' heads, simple discs or rosettes at the corners of panels and ring handles.

The mention of 17 'commodes à la grecque' in the inventory of Mme de Pompadour's possessions drawn up on her death in 1764, described in her lodgings at

[270] Portrait of Pâris de Montmartel, engraved after La Tour, showing a cylinder desk which can be attributed to J.-F. Oeben; the engraving is dated 1772, but the bureau is described in a Pâris de Montmartel inventory in 1766. (Private collection)

[271] Small cylinder desk attributed to J.-F. Oeben, c. 1760. An identical bureau and of the same dimensions, but with a tier between the legs, is described in an inventory at the time of Oeben's death in 1763 as belonging to Mme de Pompadour. (Musée Nissim de Camondo, Paris)

[272] Commode-shaped
bookcase stamped J.-F. Oeben,
c. 1760. (Private collection)

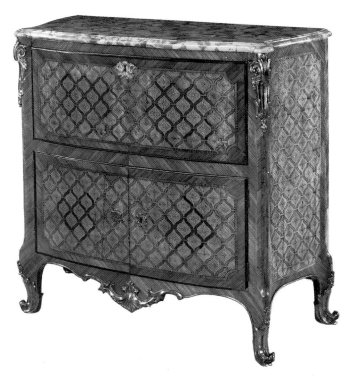

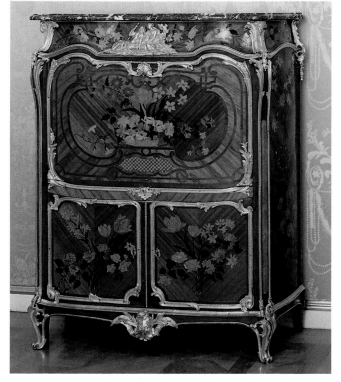

[273] Secrétaire à abattant
stamped J.-F. Oeben, c. 1755;
the first stage of the Transitional
style combines rococo mounts and
shapes with geometric marquetry

of 'interlaced hearts and lozenges'
imitating metal trelliswork.
(Sotheby's London, 22 November
1963, lot 131)

[274] Secrétaire à abattant
attributed to J.-F. Oeben,
c. 1755; the fall-front is
decorated with the same

marquetry panel with realistic
flowers which is found on the tops
of mechanical tables
(Residenzmuseum, Munich)

Versailles, Ménars and the Château d'Auvilliers, and which Oeben had supplied since 1761, has long intrigued researchers. This mysterious term can be explained by reference to the inventory of the Marquis de Marigny, Mme de Pompadour's brother and heir, who kept his sister's furniture at Ménars. These commodes were of various types, the most sumptuous of them being in Mme de Pompadour's former bedroom: 'A commode with 3 upper drawers, 2 in the middle and cupboards at the sides, in bois rose satiné with gilt-bronze mounts and Italian marble top.' Almost all the commodes at Ménars were of this type, with three drawers in the frieze, but in mahogany instead of bois satiné. Some, however, had no drawers in the frieze and two or three in the central section. They are thus described: 'Commode in mahogany with two large drawers and cupboards at the sides with gilt-copper rings and Italian marble top', or 'Commode in figured mahogany with 3 central drawers and two cupboards at the sides.' (Arch. Nat. Min. Cent. XCIX–657, 1 June 1781; inventory of the Château de Ménars.)

It is thus clear that the term 'commode à la grecque' denotes a type of commode of rectangular form with a central break-front with drawers, and doors on either side. A number of these commodes are recorded, stamped by Jean-François or sometimes by his brother Simon Oeben, which means that they were not made exclusively for Mme de Pompadour. Most are in mahogany, some in bois satiné and a few in marquetry with geometric motifs which would seem to correspond to the more sumptuous types with which the Marquise furnished her apartment at Versailles. Mahogany was a recent introduction: in Lazare Duvaux's day-book the first pieces in solid mahogany are recorded in 1752 and six mahogany commodes were supplied to Mme de Pompadour in 1753. It was also an expensive wood, and in the case of the pieces which she commissioned from Oeben, she provided the mahogany herself. In the inventory after Oeben's death is an entry for '710 livres weight of mahogany in 4 planks and one sheet of the same wood 9 pieds long. . .', which is recorded as being 'the remains of the mahogany bought by Oeben on the orders and to the account of the Marquise de Pompadour, and to whom it belonged.' In Oeben's workshop there were also two other commode carcases à la grecque 'in solid mahogany without tops, 30 pouces in height, 4 pieds in length, 17 pouces in depth, fitted with three drawers in the middle, 2 small doors at the side.'

While the commodes 'à la grecque' still bear the imprint of the rococo style in the form of their cabriole

[275] Commode 'à la grecque' in mahogany, stamped J.-F. Oeben, c. 1760. Mme de Pompadour furnished all the rooms of her Château de Ménars with this type of commode which must have seemed of a very advanced taste at the time. In the inventory drawn up after her death in 1764, the seventeen commodes 'à la greque', in mahogany or bois satiné, were valued at between 200 and 400L each. (Private collection)

legs, the secrétaires à abattant, which Oeben perfected over the same period, are resolutely Neo-classical in style and perfectly rectilinear. These secrétaires were often made in pairs, one forming the secrétaire à abattant, the other the chiffonnier or tambour-front: a good example may be seen in a gouache by Van Blarenberge depicting the Duc de Choiseul's bedroom in Paris [279].

Despite his success and his prestigious clientèle, Oeben's financial situation remained precarious. After his death in January 1763 his widow was not able to avoid bankruptcy, the eventual fate of many ébénistes in the eighteenth century. The balance of credits stood at 56,840 livres, of which more than half (31,237 livres) represented amounts owed by clients and other debtors; the stock of furniture, completed or under construction, amounted to 13,321 livres, while Oeben's personal effects were valued at 4,200 livres and the equipment of his workshop at 8,084 livres. The debts amounted to 55,385 livres. Oeben's widow made over the amounts due to the business to her creditors, as well as the proceeds of the sale of the completed furniture. However, she kept her personal effects as well as the stock of furniture still incomplete and the tools in the workshop. The remaining debts, approximately 20,000 livres, were never honoured.

The inventory, drawn up after his death in 1763, reveals that the workshop contained eleven work-benches with tools and one bench without tools, which corresponds to roughly the dozen workers employed. This was a large number for the period (the great workshops, such as those of Weisweiler or Molitor, had seven or eight at the most) which gives the measure of the importance of Oeben's workshop. The names of some of his colleagues are known: his brother Simon Oeben from 1754, followed by a Swede, Karl Peter Dahlström, already mentioned, from about 1754 to 1756, the Flemish craftsman Wynant Stylen, a great specialist in marquetry, and finally Riesener and Leleu who in 1765 would fall out over the management of the workshop.

According to Pierre Verlet, an average workshop with three or four work-benches produced about twenty or thirty pieces of each type of furniture a year. On this basis Oeben's annual production can be estimated at about 60 to 80 pieces of each type of furniture (commodes, secrétaires, and so on). This enormous number is substantiated by the number of

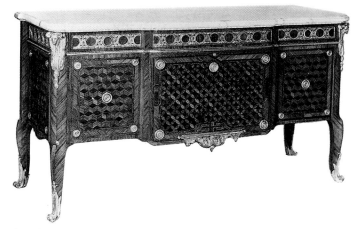

[276] Commode 'à la grecque' stamped J.-F. Oeben with cube marquetry, c. 1760; a commode of this type 'veneered in tulipwood in a dice pattern' is described in the inventory drawn up after Oeben's death in 1763, valued at 250L. (Private collection)

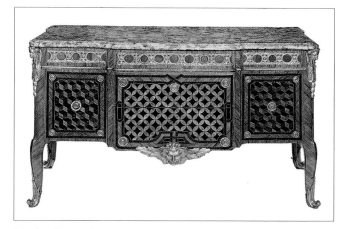

[277] Commode 'à la grecque' stamped J.-F. Oeben, with cube marquetry, c. 1760. (Christie's New York, 11 November 1978, lot 136)

[278] Commode 'à la grecque' stamped J.-F. Oeben with cube marquetry, c. 1760. (J. Paul Getty Museum, Malibu, California)

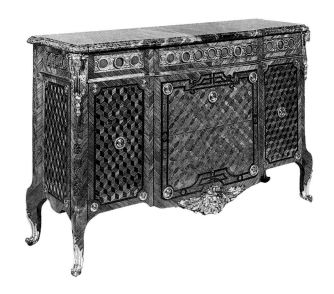

pieces described in the inventory after his death: more than 120, some finished, some incomplete, were found in the workshop, shop and Oeben's apartment, which included more than 50 tables, 12 commodes, 14 encoignures, 2 secrétaires à cylindre and 10 secrétaires à abattant. These figures related, of course, only to his last year in business, but they give a good idea of Oeben's total production. Tables were his great speciality and there were many different types: 'writing-tables with compartments that pull forward' or 'dual-purpose tables' 'tables with stands', 'tables with slides', 'bedside-tables', 'heart-shaped dressing-tables', 'cabaret-tables', 'occasional trictrac-tables', 'dressing-tables', etc. The remainder of the production was divided between commodes and secrétaires à abattant. There is no mention of any secrétaire en pente and only one book-case, described as being 'in classical floral marquetry', indicating that it was an old-fashioned piece. The marquetry is seldom described; the furniture is sometimes 'veneered in a dice pattern', that is, in cubes, or 'encrusted with shaded flowers' or 'in mosaic of rose bleu on a satiné ground'.

Oeben's furniture was usually in tulipwood but it was sometimes associated with amaranth or more rarely with bois satiné. Mahogany was used as a veneer on furniture with some parts in solid wood, for example, the drawer-fronts and the styles. The carcases are almost always in oak, very rarely in pine or beech. Hardly any of the pieces found in the workshop had marble tops, and the majority were not fitted with gilt-bronze mounts, indication that Oeben was unable to stock finished pieces but worked primarily to order. The only mounts described are ring handles on the commodes, balustrades around the tops of the secrétaires à cylindre, sabots 'en chaussons' and corner-mounts with rams' heads. However, Oeben seems to have maintained the exclusive right to certain mounts, of which he had lent the models to his chaser Hervieux. In addition to mounts intended for the Bureau du Roi, Hervieux had stored many kinds of bronzes belonging to Oeben and 53 plaster moulds.

OEBEN'S SUPPLIERS

The list of creditors noted in the inventory taken after his death gives the names of the bronziers and ébénistes who were working for Oeben at the time; for example, the chaser Hervieux was owed the enormous

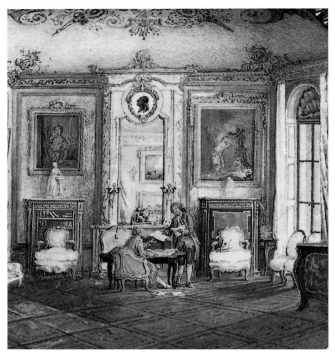

[279] (above) *Gouache by Van Blarenberghe, c. 1770, depicting the bedroom in the Paris house of the Duc de Choiseul. Choiseul was one of the Oeben brothers'* most important clients and on the right the secrétaire illustrated at [280] can be identified. (Musée du Louvre, Paris)

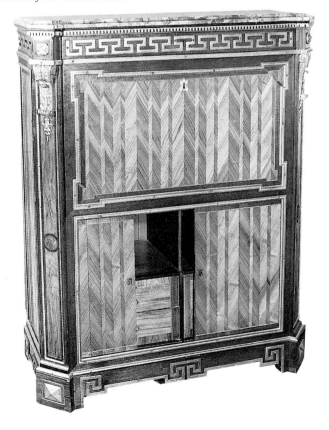

sum of 7,721 livres which indicates the importance of his work for Oeben. Another chaser, Duplessis, was owed 1,112 livres, and Forestier 4,179 livres. The names of the casters Gratelier and Guinand are noted (2,282L) as well as those of the gilders Jubbert and Delaporte (2,428L). The names of the sculpteurs Martin, Deaubo and Sautray were recorded. They were doubtless the makers of various models for gilt-bronze mounts. Several ébénistes' names are noted for small sums, proof that Oeben must have sub-contracted some of his commissions to them. In order of significance these were: Widow Lacroix (1,832L), noted separately from Lacroix (664L); Landrin (677L); Carlin (395 and 70L); Canabas (382L); Simon Ledoux (252L); Jean-Charles Saunier the Elder (242L); Criard the Elder (141L); Simon Oeben (113L); Pioniez (101L); Porquet (83L); Boichot (25L), and Mongenot (87L). The presence of the Lacroix on this list is to be expected as Oeben's work and that of his brother-in-law R. V. L. C. are so similar. The men-tion of Carlin and Saunier is more surprising. Canabas must have supplied him with functional furniture in solid mahogany such as serving-tables and so on, a speciality of his.

OEBEN'S CLIENTÈLE

The 1763 inventory also lists Oeben's clientèle. It was made up of the high nobility and the Court. The prin-cipal debtors, besides the Garde-Meuble Royal (8,000L), were the Duc d'Aumont (1,500L), the Duchesse de Lauraguais (1,397L), the Duchesse de Grammont, sister of Choiseul (968L), M. de Valen-tinois (1,535L) and 'Monsieur le Premier' (1,176L). The only fermier-général mentioned is Grimod de la Reynière (written as 'la Reignière'), but we know from other sources that Gaignat owned a secrétaire by him (lot 198 in his sale in 1768). The ministers Choiseul and D'Argenson were also clients. Mme de Pompa-dour, as we have seen, was one of his important clients from 1750 onwards. Oeben also supplied the Duchesse de Brancas. For this demanding clientèle he created sophisticated pieces of furniture which are almost all unique pieces; in fact, although his work is homogeneous in style, which might suggest that he created his own designs, his pieces of furniture always differ from each other, however small the changes.

BIBLIOGRAPHY

Inventory taken after the death of Jean-François Oeben, *Archives de l'art français*, vol. XV, 1899, pp. 298–367

Rosemarie Stratmann: thesis on Oeben, University of Heidelberg, July 1971; 'Design and mechanisms in the furniture of J. F. Oeben', *Furniture History Society Bulletin*, vol. IX, 1973, pp. 110–13; 'Notices biographiques inédites sur la famille Oeben', *Gazette des Beaux-Arts*, March 1980, pp. 125–28

Sir Francis Watson: 'A note on French marquetry and Oriental lacquer', *J. Paul Getty Museum Journal*, vol. IX, 1981, pp. 157–60

Alexandre Pradère: 'Mme de Pompadour et le goût grec', *Connaissance des Arts*, December 1989, pp. 106–09

[280] (opposite) *Secrétaire à abattant stamped J.-F.Oeben, c. 1760–63, which corresponds to the piece depicted in Choiseul's bedroom. (Private collection)*

[281] *Secrétaire à abattant, stamped J.-F. Oeben; six secrétaires of this type are described in the inventory drawn up after Oeben's death in 1763. (Sotheby's London, 25 June 1982, lot 149)*

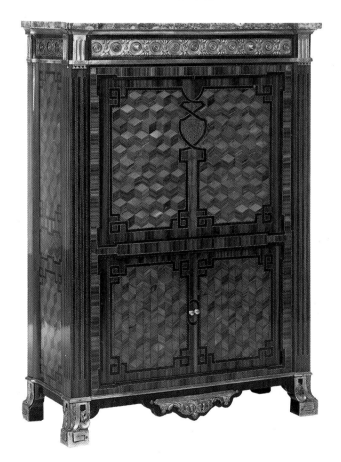

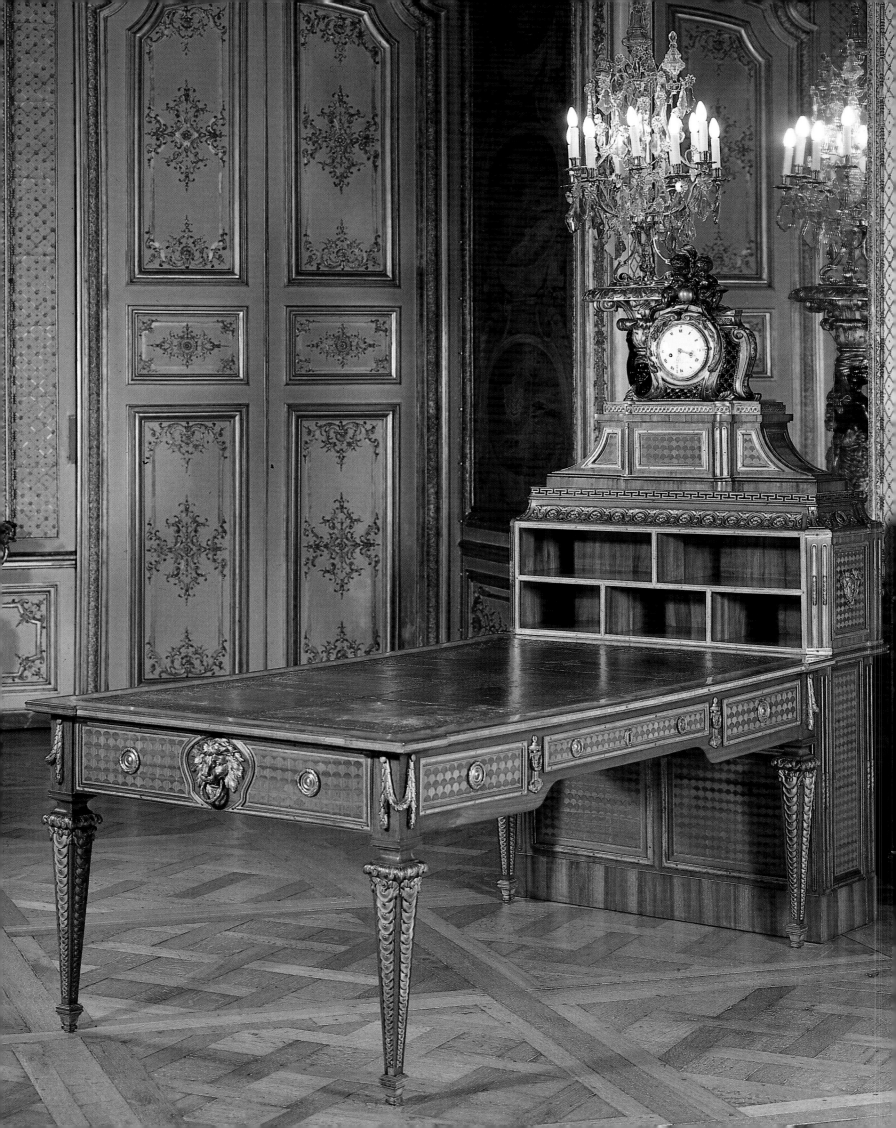

The younger brother of Jean-François Oeben followed the latter to Paris and is recorded in 1759 working at the Gobelins as head journeyman in his brother's workshop. When Jean-François moved to the Arsenal in 1756, Simon took over his lodgings as well as the actual management of the Gobelins workshop, but he did not receive the title until the death of his brother in March 1763. In the same month Marigny presented him with a certificate confirming that he had worked at the Gobelins 'since the month of October 1754 until 21 January 1763, a period of 8 years and 3 months, in the post of head journeyman to the late Jean-François Oeben, his brother, maître ébéniste du Roy... and it is in order for him to enjoy the privileges accorded by His Majesty and to be received as master without paying the customary fee.' Simon Oeben only made use of this certificate six years later when he finally became a master in 1769.

It is inevitable that Simon Oeben's production at the Gobelins should be confused with that of his elder brother at the Arsenal, at least until the latter's death. The links between the two brothers must have been strengthened by their marriage to two sisters (Simon married Marie-Marguerite Vandercruse, while Jean-François married Francoise-Marguerite Vandercruse). The appearance of Simon Oeben's name among the creditors of his brother's estate for a sum of 113 livres clearly shows that he supplied him regularly with furniture. Jean-François Oeben's work between

1760 and 1763 was in fact continued by his brother Simon. Numerous commodes in mahogany or bois satiné stamped by Simon Oeben [283] are based on the 'commodes à la grecque' designed by Jean-François for Mme de Pompadour at Ménars in about 1760. Certain of these commodes bear the mark of Chanteloup, the neighbouring château to Ménars, and were part of the furnishings of the Duc de Choiseul, Simon Oeben being his principal ébéniste. Moreover, a portrait of Choiseul [284] shows him seated at a desk by Simon Oeben almost identical to one in the Jones Collection in the Victoria and Albert Museum [285]. Another bureau in the museum in Tours [287] also

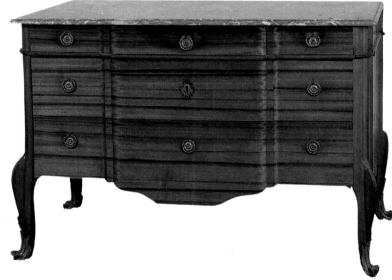

[282] *Bureau plat and cartonnier attributed to Simon Oeben, c. 1765–70, which originally belonged to Choiseul and can be recognized in one of* *the gouaches by Van Blarenberghe of the interiors of Choiseul's Paris house c. 1770. (Château de Chantilly; Musée Condé)*

[283] *Commode in bois satiné, stamped Simon Oeben, c. 1765; made for Choiseul, it was placed in the bed-chamber of Mme de* *Brionne at Chanteloup, as indicated by various marks. (Private collection)*

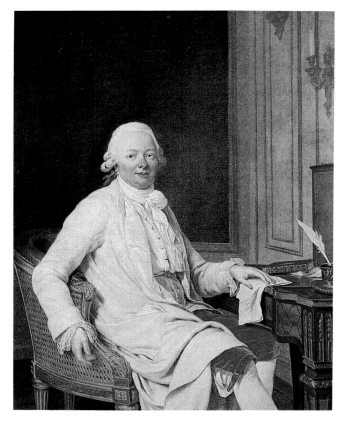

[284] Portrait of the Duc de
Choiseul by A. Labille-Guiard,
dated 1786; Choiseul is seated at

a bureau by Simon Oeben who
was his favourite ébéniste.
(Private collection)

came from Choiseul and should be attributed to Simon Oeben. Finally, the celebrated bureau with its cartonnier at Chantilly which is represented in a miniature of the Duc de Choiseul in Paris, by Van Blarenberghe, should also be attributed to Simon Oeben, with its square tapering legs characteristic of his work and its fish-scale marquetry which is typical of the production of the Oeben brothers [269]. The Duc du Châtelet reminisced after Simon Oeben's death that 'this artist worked for all the important people, in particular M. le Duc de Choiseul. . .' (April 1786, letter to d'Angivillers). Simon Oeben also worked for the Marquis de Marigny; various payments were made, first in 1764, and then from 1768 to 1773 for a total of 6,000 livres for furniture supplied for the Hôtel de la Surintendance, rue Froidmanteau and then for the Château de Ménars.

At the Gobelins Simon Oeben was allocated extensive space including a workshop as well as a shop, in the area between the courtyard and the garden. Between 1772 and 1777 he advertised as follows: 'Hobenne at the Gobelins maintains a large workshop and retail outlet for ébénisterie and delivers to the provinces and abroad' (Tablettes royales de renommée, 1772 and 1774; Almanach Dauphin, 1777).

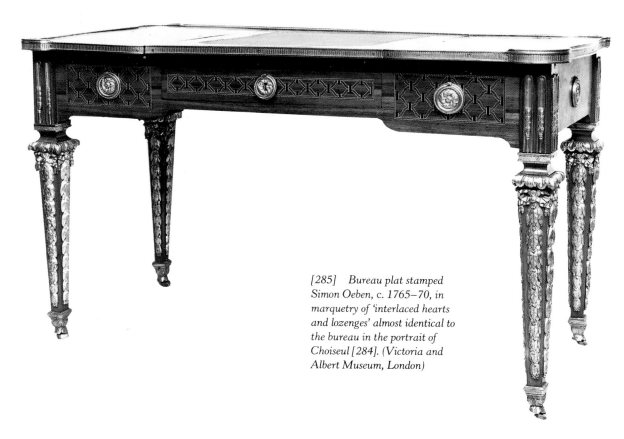

[285] Bureau plat stamped
Simon Oeben, c. 1765–70, in
marquetry of 'interlaced hearts
and lozenges' almost identical to
the bureau in the portrait of
Choiseul [284]. (Victoria and
Albert Museum, London)

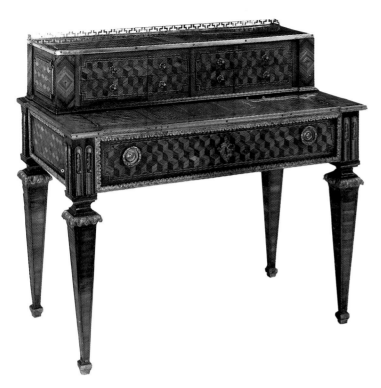

Between 1770 and 1772 Simon Oeben was an adjudicator for his guild and he died in 1786, leaving his wife and children in a parlous state of affairs. His widow obtained permission to keep the workshop at the Gobelins but was forced to close it a year later.

Simon Oeben's production consisted above all of commodes of the Transitional type in mahogany or in bois satiné, as well as marquetry bureaux with square tapering legs. He seems to have had a preference for certain marquetry motifs such as 'interlaced hearts and lozenges'. Another characteristic of his desks is the presence of two prominent brass flutings on the corners at the top of the leg.

BIBLIOGRAPHY

F. de Salverte: *Les Ébénistes*, pp. 248–49

Svend Eriksen: *Early Neo-classicism in France*, pp. 209–10

Alexandre Pradère: L'Ameublement du marquis de Marigny vers 1780', *L'Estampille*, no. 193, June 1986, pp. 44–57

Rosemarie Stratmann: 'Der Ebenist Simon Oeben', *Aachener Kunstblätter*, No. 18, 1972, p. 276, fig. 7

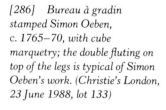

[286] *Bureau à gradin stamped Simon Oeben, c. 1765–70, with cube marquetry; the double fluting on top of the legs is typical of Simon Oeben's work. (Christie's London, 23 June 1988, lot 133)*

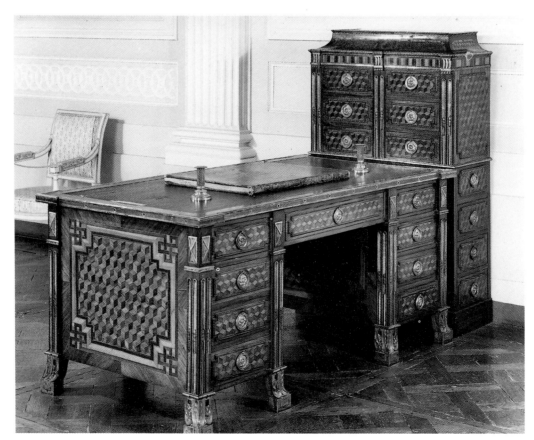

[287] *Bureau plat and cartonnier, attributed to Simon Oeben, c. 1770, from the Château de Chanteloup, originally the property of Choiseul. Typical double fluting is found here again. The shape of the piece reflects the influence of English taste. (Musée des Beaux-Arts, Tours)*

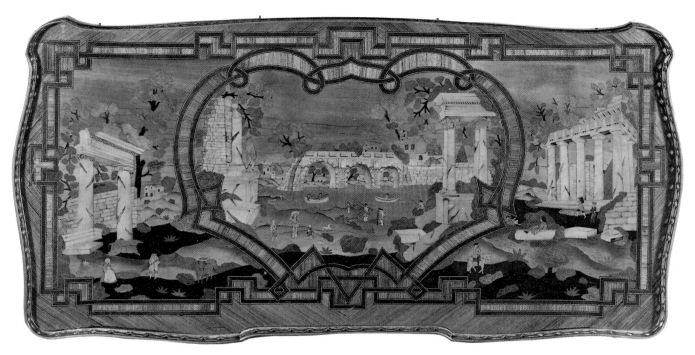

[288] *Detail of the top of table shown at [289]. This type of marquetry depicting ruins imitating painting is found on a number of other unstamped pieces, as well as on stamped furniture by such different ébénistes as N. Petit, P. Roussel, A. Gilbert and D. Deloose. It has been suggested that the same marquetry specialist retailed marquetry panels to different ébénistes, probably Gilbert. who specialized in them*

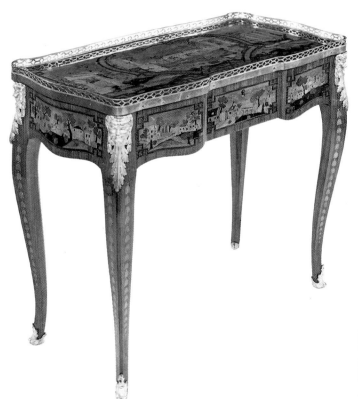

[289] *Mechanical table stamped Dautriche, c. 1777 (Cartier Collection; Sotheby's Monaco, 25 November 1979, lot 143)*

Jacques
DAUTRICHE

d. 1778; MASTER 1765

This ébéniste was born in the Low Countries. His name was originally Van Oostenryk which he gallicized to Dautriche when he settled in Paris before 1743. At first Jacques Dautriche was an independent journeyman, not becoming master until 1765. He was by then a marquetry specialist of repute. The striking similarity between his work and that of J.-F. Oeben leads us to suppose that he must have worked for the latter, even though his name is not mentioned in the legal papers connected with Oeben's estate. Their stylistic similarity is to be seen not only in the marquetry (cubes and interlaced circles are common to the two makers), but also the mounts (the rams' heads, apron mounts with leafy masks and cul-de-lampe) as well as the shape of the furniture. Finally, the play of parallel bands interlaced in sections which outline the marquetry panels is common to the two makers. Collaboration between Oeben and Dautriche is strongly suggested by the date of the latter's mastership, 1765, two years after Oeben's death, as though Dautriche had then been forced to become independent. Almost all the pieces bearing his stamp are in the Transitional style with geometric parquetry. Continuing ideas perfected by Oeben around 1760–63, they may be dated anywhere between 1765 and 1778.

Dautriche worked for the Comte d'Artois, and collaborated in the furnishing of his Parisian residence, the Palais du Temple. He was established for a long time in the rue Traversière, and towards the end of his life in the rue du Faubourg Saint-Antoine.

According to Salverte, on Dautriche's death in 1778 his workshop was taken over by his widow Elizabeth Hannot in conjunction with her son Thomas-Jacques Dautriche, who from 1783 was in sole charge of the workshop. It is possible, therefore, that, as in the case of other dynasties of ébénistes, Dautriche's stamp was taken over by his son and used after 1778. Thomas-Jacques Dautriche, born in 1744, was never received master. In 1789 he took part in the storming of the Bastille. His revolutionary zeal precipitated him in 1793 into the position of 'président par intérim des sections du Faubourg Saint-Antoine', and into joining the French army on the Western front.

BIBLIOGRAPHY

F. de Salverte: *Les Ébénistes*, pp. 81–82

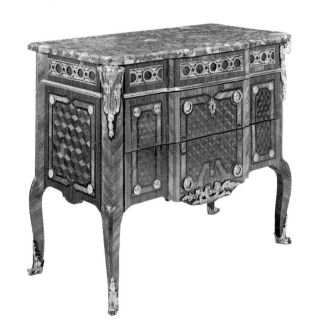

[290] Commode stamped Dautriche, c. 1765. The marquetry of interlaced circles and cubes is also found on pieces by the Oeben brothers and R.V.L.C. (Sotheby's Monaco, 14 June 1981, lot 123)

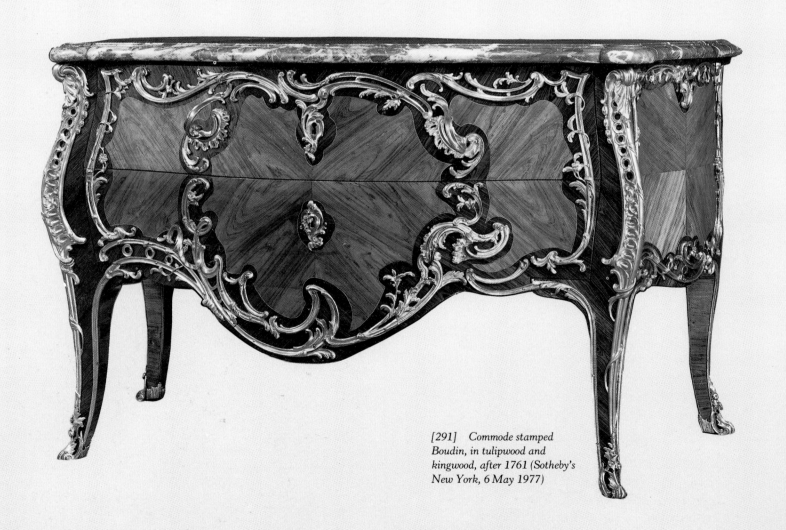

[291] Commode stamped
Boudin, in tulipwood and
kingwood, after 1761 (Sotheby's
New York, 6 May 1977)

Léonard
BOUDIN

1735–1807; MASTER 1761; MARCHAND-ÉBÉNISTE

At the start of his career Boudin was an independent craftsman, settled in the Faubourg Saint-Antoine, first in the rue du Faubourg, then the rue Saint-Nicolas until 1767, working for his fellow ébéniste Migeon, to whom he supplied furniture in floral marquetry and in chinoiserie lacquer, as well as for Gérard Péridiez and Louis Moreau. It is also likely that he worked for Pierre-Antoine Foullet who owed him 5,232 livres in 1767. He obtained his mastership in 1761 and became an artisan of repute as indicated in *L'Almanach Dauphin* in 1770. In the following year he made a bureau plat [293] for Joubert who delivered it to the Comte de Provence at Compiègne as well as a commode for the Comte de Provence at Fontainebleau [294]. Success was soon followed by sizeable commissions and Boudin became a marchand-ébéniste before 1775, taking a shop in the rue Froidmanteau. In his turn he now commissioned furniture from fellow ébénistes Gilbert, Foullet, Bayer, Topino, Tuart, Bircklé, Macret, Chevallier, Cordié and Evalde, whose stamps are found on a number of pieces, restamped by Boudin in his role as retailer. Boudin also sold 'old furniture' on which he put his stamp, such as a pair of encoignures also stamped by Latz, which must date from before 1754.

In 1777 Boudin transferred his business to the cloister of Saint-Germain-l'Auxerrois. The notice in the *Avis* announcing his change of address reveals that besides furniture he also sold various items in bronze and chandeliers. He contributed to the furnishing of the Duchesse d'Arenberg's house in the rue de la Ville-l'Evêque. At the time of his first wife's death in 1777, Boudin had already abandoned his activities as an ébéniste, since no work-bench is described in the inventory. In 1807, in addition to his main premises, he also had shops at 35 rue de Grenelle St Honoré, 12 Cour-des-Fontaines and 14 rue du Mail.

BIBLIOGRAPHY
F. de Salverte: *Les Ébénistes*, pp. 31–32
Patricia Lemonnier: 'Boudin *L'Estampille*, June 1989, pp. 38–43

[292] *Secrétaire à abattant stamped Boudin, c. 1765; combining floral marquetry with the Greek key pattern as well as* Neo-classical corner mounts. An identical piece is in the Cleveland Museum of Art. (Sotheby's London, 25 June 1982, lot 132)

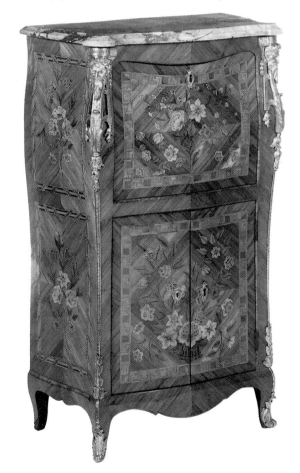

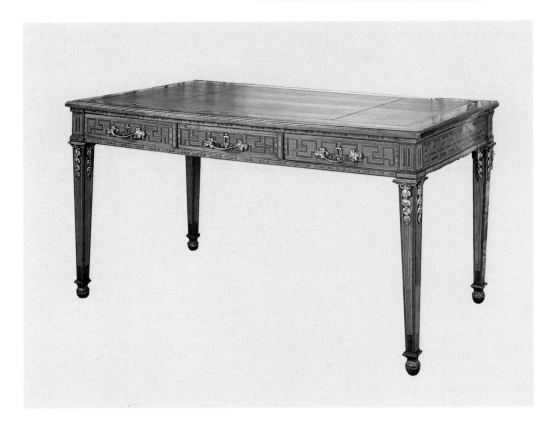

[293] Bureau plat stamped
Boudin; supplied by Joubert on 1
July 1771 (delivery no. 2620) for
the Comte de Provence at
Compiègne. (Private collection)

[294] Commode with floral
marquetry stamped Boudin,
supplied by Joubert in 1771 for
the Comte de Provence at
Fontainebleau (delivery no.
2631). (Christie's, sale at
Godmersham House, Kent, 6
June 1983)

[295] Commode stamped both
Boudin and Tuart (the latter as
retailer), c. 1775. (Archives
Galerie Lupu, Paris)

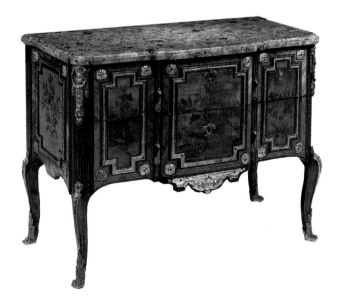

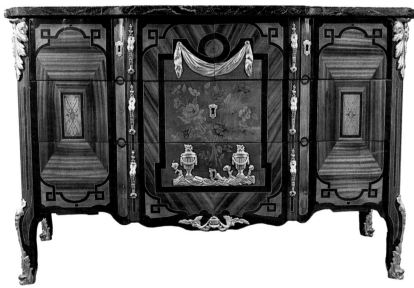

TUART

JEAN-BAPTISTE I, *c.* 1700–*c.* 1767; MASTER 1741; MARCHAND-ÉBÉNISTE
JEAN-BAPTISTE II, *b. c.* 1720; MARCHAND-MERCIER

Members of a dynasty of Parisian ébénistes and dealers, the Tuarts, father and son, had the same Christian name, Jean-Baptiste. The father, born in about 1700, became a master in 1741 and remained active until about 1760. The son, born in about 1720, worked with his father from 1743. He did not become a master ébéniste but a 'maître tabletier et marchand-mercier'. He first established himself in the rue Froidmanteau; his business soon flourished and he moved to a smarter address in the rue Saint-Honoré, between the rue du Four and the rue des Prouvaires. Salverte assumed that he was a practising ébéniste, but this is not certain. A label found on one of his pieces mentions only his activities as a dealer or restorer

'Au Château de Bellevue', rue Saint-Honoré, between the rue des Poulies and Les Filles-de-l'Oratoire. The house of citizen Poupart, next to the Hôtel des Amériquains, no. 611. Tuart, marchand, has a shop for ébénisterie, mirrors, chenets, wall-lights, clocks in matt or burnished gilt-bronze, crystal chandeliers, girandoles, candlesticks, mechanical lamps, coal scuttles, ice-buckets, warming bricks, engraved silverware and mahogany commodes, trictrac-tables, travelling bidet chests, travelling and indoor foot-warmers . . . screens, fire-screens, he also restores old furniture in marquetry and the mounts, and mirrors . . .

His stamp is often found beside the stamp of the ébéniste who made the piece. Bury's stamp is often found (1740–95, a master from 1775). Tuart's are all fine Neo-classical pieces of furniture, such as the armoire-chiffonnier in the Davray sale, Paris, 14 April 1986, lot 114 [296] or several small roll-top desks in tulipwood.

BIBLIOGRAPHY
F. de Salverte: *Les Ébénistes*, p. 320

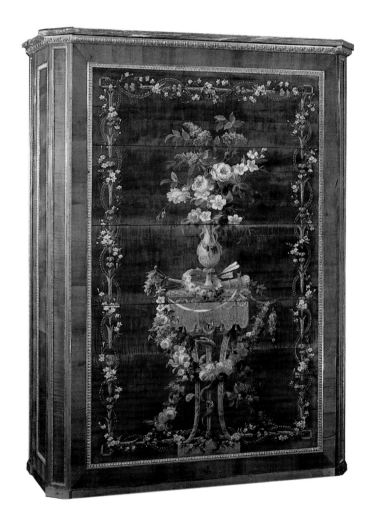

[296] *Armoire-chiffonnier stamped both Bury and Tuart (the latter as retailer), c. 1770; decorated with a painted décor on a sycamore ground attributed to Jean-Louis Prevost, c. 1740–c.1810. (Galerie Gismondi, Paris)*

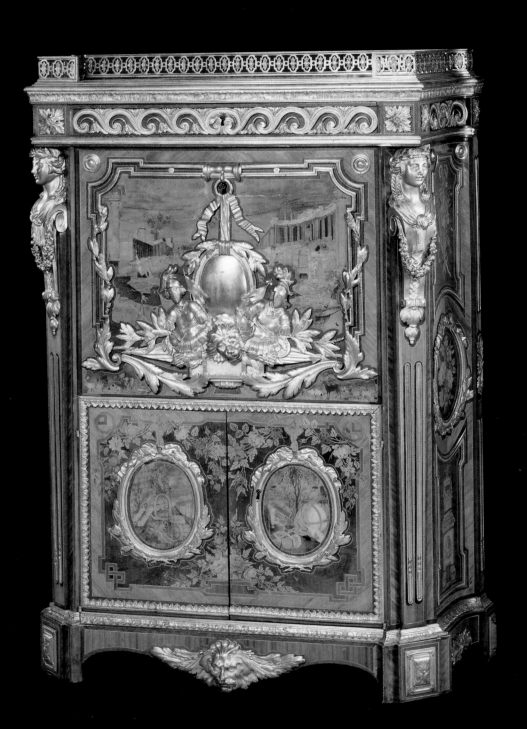

FOULLET

ANTOINE, *c.* 1710–75; MASTER 1749
PIERRE-ANTOINE, *b. c.* 1732; MASTER 1765

Antoine Foullet was married to Geneviève Bailleul at the end of 1730 or early in 1731. They had three children: the eldest, Pierre-Antoine, who followed in his father's footsteps; Antoine-André who became a clock-maker, and Marie-Geneviève who married the bronze-caster André-César Vallée.

Antoine Foullet began his career as journeyman or independent ébéniste, but did not become a master until 1749 when he was approaching forty. In 1756 he was elected adjudicator to his guild. He settled in the rue du Faubourg Saint-Antoine opposite the rue Saint-Nicolas, and specialized in the production of cases for long-case and other clocks decorated with fine Boulle marquetry, a style he followed throughout his career. His stamp is thus found on clocks with cases in rococo taste such as the one in contrepartie marquetry sold in Paris on 23 June 1978 (Étude Couturier-Nicolaÿ, lot 102) as well as examples in Neoclassical taste in the same technique such as that in the J. Paul Getty Museum which can be dated around 1765–70. Antoine Foullet was settled towards the end of his life at another address in the rue du Faubourg Saint-Antoine giving onto the Cour des Enfants-Trouvés (now Square Trousseau). There he died in 1775.

The inventory taken after his death by his colleagues Balthazar Lieutaud and François Duhamel (see Appendix below) itemizes an atelier in full production with six work-benches equipped with tools as well as a large stock of clocks, either completed or in the course of completion, the whole estimated at 2,718 livres. In the workshop were forty clock-case carcases and carcases for the pedestals of twenty-four clocks, while the storeroom contained twenty completed clocks, a few entirely in bronze, and twenty more clocks which Foullet had labelled according to their decoration ('case with fox', 'case with peacock', 'case with dog and cock'). As Foullet could not produce clocks entirely in bronze himself, it seems that he was selling merchandise outside his trade. The workshop also contained stocks of models of gilt-bronze mounts (more than two hundred kilos) and pieces of red tortoiseshell, ready to apply to the clock-cases. The papers detailed at the end of the inventory give the names of the bronze-workers employed by Foullet (Héban, Rue des Arcis and Caron senior), and above all, the names of Foullet's clients. Among the professionals the most important seems to have been the Sieur Dubois, also called 'Dubois and company'. This must certainly refer to the marchand-ébéniste René Dubois with whom Foullet was constantly doing business. Also to be found are the names of Abraham-Louis-Droz, François Caranda (clock-maker active between 1741 and 1789), Turpin (a Parisian clock-maker), Chevallier (ébéniste), the 'sieur Gentil' (the ébéniste Denis Genty?), Allard, Masson, Plumet, Robert, Parquet, Verneuil, Fortier, Geoffroy de Vandières, Pelleton, Fumel and Bailly.

It appears that Foullet sold part of his production to private clients, for one finds mention of a file of 134 sheets with the names of customers to whom he sold his works on credit, starting from the year 1765. The inventory certainly confirms that Foullet the Elder produced only clocks. The only commode recorded bearing his stamp (next to that of Boudin), in the

[297] *Secrétaire à abattant attributed to P.-A. Foullet, c. 1775; an identical secrétaire signed by Foullet in the marquetry is in the Wallace Collection. (Sotheby's London, 24 November 1988, lot 25)*

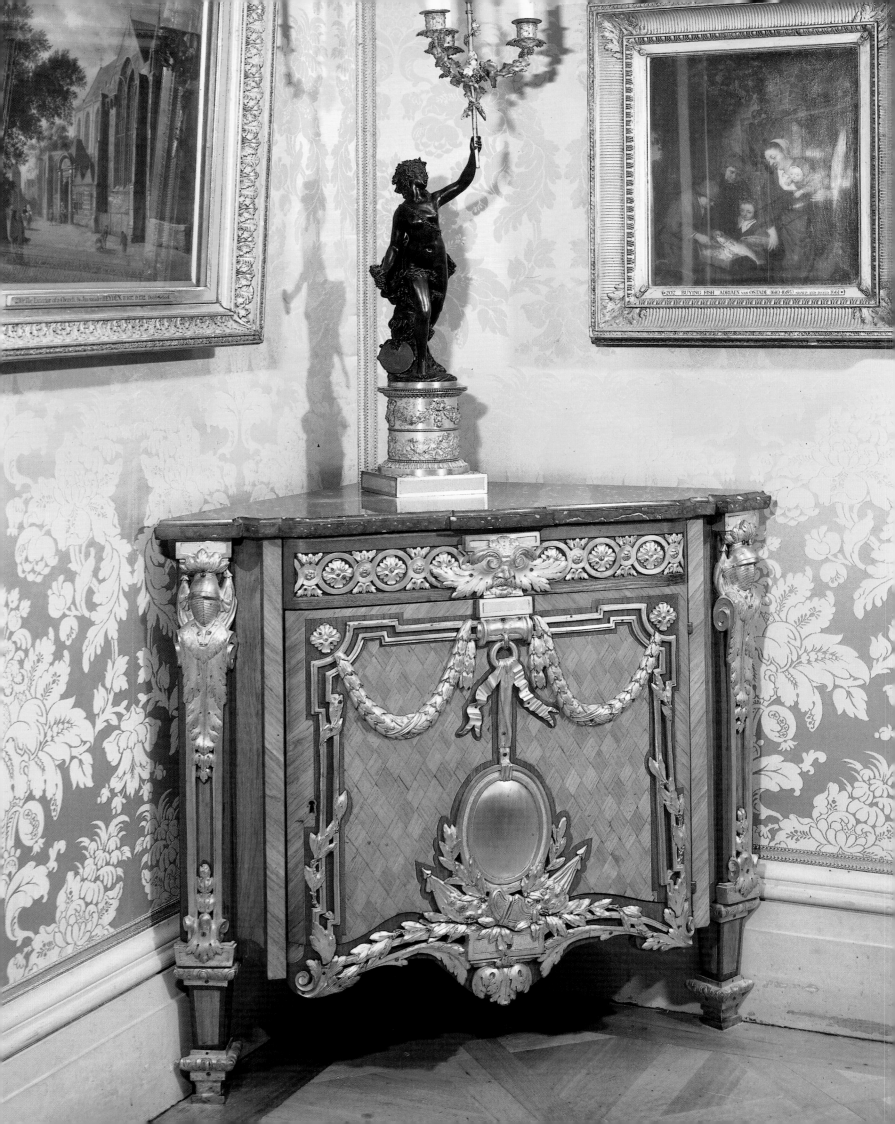

Nationalmuseum, Stockholm, is wholly in the style of his son, who must have been the maker. Finally, among a group of drawings of clocks dating from about 1770 in the Bibliothèque Doucet in Paris there are a number of examples of rococo and Neo-classical clocks. Although these are stated to be models belonging to Foullet's son, Pierre-Antoine, they correspond exactly to the father's production, and are certainly the best illustrated record of his work.

Pierre-Antoine Foullet, born in about 1732, became a master in 1765 and also settled in the rue du Faubourg-Saint-Antoine. His financial situation rapidly became precarious. Already in 1767 he owed 5,232 livres to his fellow ébéniste Léonard Boudin, from whom he possibly purchased furniture. Antoine Foullet was forced to stand surety for his son and pay a part of his debts, which did not prevent the latter from going bankrupt in January 1769. At the time of Foullet the Elder's death in 1775, Pierre-Antoine Foullet was still in debt to Boudin, to whom he had all his rights to his father's estate transferred. This transfer of debts would explain the double stamp (Foullet the Elder/Boudin) found on the commode in Stockholm mentioned earlier. As opposed to his father's speciality in clocks, Pierre-Antoine Foullet seems to have made only the most luxurious furniture. His stamp is found almost always on commodes in Transitional style, more rarely on secrétaires à abattant or encoignures. These pieces are almost always decorated with oval medallions in minutely-detailed marquetry featuring bouquets of flowers or Neo-classical urns emphasized by frames made up of gilt-bronze medallions surrounded by bands of tulipwood. The gilt-bronze mounts, always very rich, include the same elements: besides the oval medallions already mentioned and forms of laurel fronds, the motif of a smoking cassolette is often found on the apron, heavy vertical fluting around the central break front and a frieze of inter-laced circles and rosettes on the upper drawers. The most sumptuous pieces by Foullet the Younger are three secrétaires à abattant, one in the Wallace Collection, the other sold at auction in London (Sotheby's, 24 Nov. 1988, lot 25), and the third in the Nationalmuseum, Stockholm. They are decorated on the fronts with large marquetry panels with architectural subjects. The example in the Wallace Collection bears Foullet's signature incised in the marquetry, indicating that he himself was the maker of these marquetry pictures. In 1773 a number of pieces by Foullet were delivered through Joubert for the Comte d'Artois' apartments at Versailles. A pair of encoignures bearing the number 2727 were thus delivered on 30 September [298]. Now in the Wallace Collection, these unstamped cabinets are unmistakably the work of Foullet. On 8 September a commode was delivered by Joubert to the same apartment, the description of which also points to Foullet as the maker:

No. 2717) [for the Comte d'Artois' bedroom] A commode à la Régence with kingwood and tulipwood marquetry, the top in 'Griotte d'Italie' marble, having two large drawers and three small ones above, all locked with the same key, richly decorated with escutcheons with rings, the corners formed by pilasters capped by helmets, grilles, friezes and mouldings, the front ornamented with garlands with medallions together with trophies of arms and on the sides of the aprons and feet, the whole in richly overgilt or moulu, length 4½ pieds, 25 pouces deep and 35 pouces high. . . [Arch. Nat. 0¹3319]

After 1770 Foullet moved to the rue de Charonne where he worked until about 1780. No furniture bearing his stamp can be dated later than 1780, which probably implies that he ceased work or died around this date.

BIBLIOGRAPHY

Arch. Nat. Min. Cent. Et /XXVIII/452: Inventory taken after the death of Antoine Foullet, 30 September 1765

Svend Eriksen: *Early Neo-Classicism in France*, 1974, p. 182

Gillian Wilson: *Clocks in the J. Paul Getty Museum*, 1976, p. 63

F. de Salverte: *Les Ébénistes*, p. 124

Jean-Dominique Augarde: 'Jean-Joseph de Saint-Germain', *Vergoldete Bronzen*, Munich, 1984, vol. II, pp. 521–38

[298] *P.-A. Foullet worked for the 'ébéniste de la couronne' Gilles Joubert; this encoignure, one of a pair attributed to Foullet, was supplied in 1773 (delivery no. 2727) by Joubert for the Comte d'Artois at Versailles, together with a commode – whereabouts unknown – also by Foullet. (Wallace Collection, London)*

APPENDIX

EXCERPT FROM THE INVENTORY
TAKEN AFTER THE DEATH OF
ANTOINE FOULLET (ARCH. NAT.
MIN. CENT. ET/XXVIII/452)

List of merchandise, tools and
implements of his profession of
the late M. Foullet, found in the
chamber adjoining his workshop;
drawn up with the aid of
Balthazar Lieutaud living in the
rue d'Enfer in the city and
François Duhamelle living in the
Grand-rue du Faubourg Saint-
Antoine, both master ébénistes
in Paris, experts appointed by the
executors:

1] 1 cartel clock with drapery
in brass, value *60L*
2] 1 cartel clock with lion-skin
also in bronze. *50L*
3] 1 rope-shaped cartel clock
with rich garlands. *50L*
4] 1 cartel clock, the dial of 4
pouces by S. Osmont. *24L*
5] 1 small clock with second-

hand, unvarnished, decorated
with its mounts, all in bronze.
40L
6] 1 mantel clock called 'La
Dormeuse' ['The sleeping
woman']. *80L*
7] Another called 'Le Gros
Enfant' ['The plump child'], also
in bronze. *60L*
8] Another called 'La Prudence
et la Fidélité'. *40L*
9] Another called 'Les Tritons'.
60L
10] Another called 'Louis
Seize'. *45L*
11] 1 clock with elephant, with
its musical box. *60L*
12] 1 mantel clock with bull.
24L
13] 1 mantel clock called 'Le
Repas de chasse' ['The hunting
lunch']. *60L*
14] 1 mantel clock called 'La
Dormeuse'. *80L*
15] 1 mantel clock called 'César
Auguste', prototype. *144L*
16] 1 clock called 'Les Tritons',
prototype. *50L*

17] 1 clock, model with bower.
45L
18] 1 mantel clock called 'la
Prudence et la Fidélité',
prototype. *30L*
19] 1 model of a garniture for
clock-case à la grecque, the dial
12 pouces. *48L*
20] 1 large ébénisterie clock,
the dial 12 pouces, unveneered,
mounts with bower. *130L*
21] Mounts cast from those of
an ébénisterie clock in the
Antique fashion. *45L*
22] Model of a small clock-case
with bower, 8 pouces. *15L*
23] Model in bronze of a clock-
case with second hand. *12L*
24] Model of a small clock-case
with handles. *15L*
25] Model of a clock in
Antique style with wooden case.
50L
26] Model 8 pouces, with
laurel, veneered in marquetry of
red tortoiseshell. *80L*
27] Model of a case of 10
pouces (new). *36L*

28] Model of a clock-case with
second hand, 5 pouces. *18L*
29] Model of a case with laurel,
of 6 pouces. *24L*
30] Model of a clock-case with
circles, 11 pouces. *48L*
31] Two models of clock-cases,
one of 8 pouces, one of 9 pouces.
24L
32] Model of a long-case clock,
the dial of 11 pouces. *40L*
33] Model of a long-case clock,
depicting the Four Seasons, of 12
pouces. *150L*
34] Model of a clock in metal
with wooden case 11 pouces.
80L
35] Another clock gilded, the
same model. *40L*
36] A model of a clock-case
with fox, 10 pouces. *24L*
37] Another model of a clock-

*[299] Commode stamped P.-A.
Foullet, c. 1775. (Christie's New
York, 12 November 1981, lot
214)*

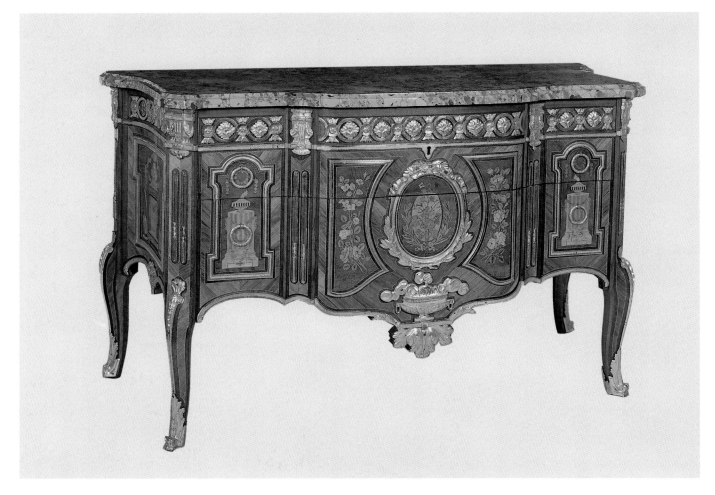

case with peacock, 10 pouces. *20L*

38] A small model of a clock-case with pierced rocaille, 9 pouces. *30L*

39] Model of a clock-case with sunrise, 11 pouces. *30L*

40] Model of a clock-case with dog and cockerel, 11 pouces. *30L*

41] Model of a clock-case with fox and stork, 12 pouces. *36L*

42] Model of a clock-case with vines, 6 pouces. *15L*

— 25 livres of mixed cast bronze valued individually at 25 sols to the livre. *30L*

— 25 livres of mixed cast bronze valued individually at 20 sols to the livre. *25L*

— 32 livres of cast bronze made up of figures of children and ornaments at 24 sols to the livre, amounting to *38L*

— 30 livres of cast bronze made up of bas-reliefs for clocks and other ornaments valued each at 24 sols to the livre. *36L*

— 32 livres of cast bronze made up of various mixed ornaments priced each at 20 sols to the livre. *32L*

— 32 livres of cast bronze made up of old models each valued at 20 sols to the livre. *32L*

— 32 livres of cast bronze comprising clock doors and various ornaments for a variety of uses. *32L*

— 32 livres of cast bronze comprising clock doors and various ornaments, partly unpolished. *32L*

— 32 livres of cast bronze comprising various ornaments for a variety of uses, partly unpolished. *32L*

— 60 livres of cast bronze comprising various ornaments, unpolished. *60L*

— 52 livres of cast bronze comprising various pieces each priced at 20 sols to the livre. *52L*

— 1 clock garniture of unpolished cast bronze, 15 livres. *16L*

— 13^1/$_2$ livres of cast bronze comprising examples of mouldings and small case garnitures priced at 22 sols to the livre. *14L*

— The marquetry of 3 clock-cases in red tortoiseshell, that is, one complete and 2 others without feet. *24L*

— 18 livres of various pieces of bronze and tortoiseshell marquetry, each valued at 18 sols to the livre, the lot *16L*

— 1^1/$_4$ livre of various pieces of red tortoiseshell. *3L*

In the workshop next to the chamber (where the merchandise listed above was found), overlooking the rue Saint-Antoine:

— 6 work-benches of different sizes, together with their presses: 3 trying-planes, 4 jack-planes, 2 rabbets and half a trying-plane, 1 toothed plane, 1 round plane and other moulding tools all valued with 6 clamps. *54L*

[and various tools . . .]

— 40 clock cases valued minus feet each at 30 sols the lot. *67L*
— 24 wooden clock bases valued each at 15 sols. *18L*

2,655L

[300] *Commode stamped P.-A. Foullet, c. 1775. The very detailed marquetry of the oval panels strives to imitate painting, an effect accentuated by the mounts which suggest giltwood picture frames. (Sotheby's New York, 4 May 1984, lot 65)*

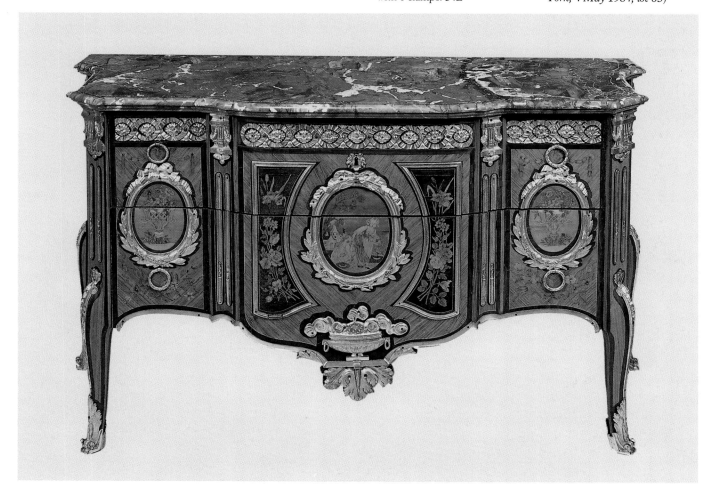

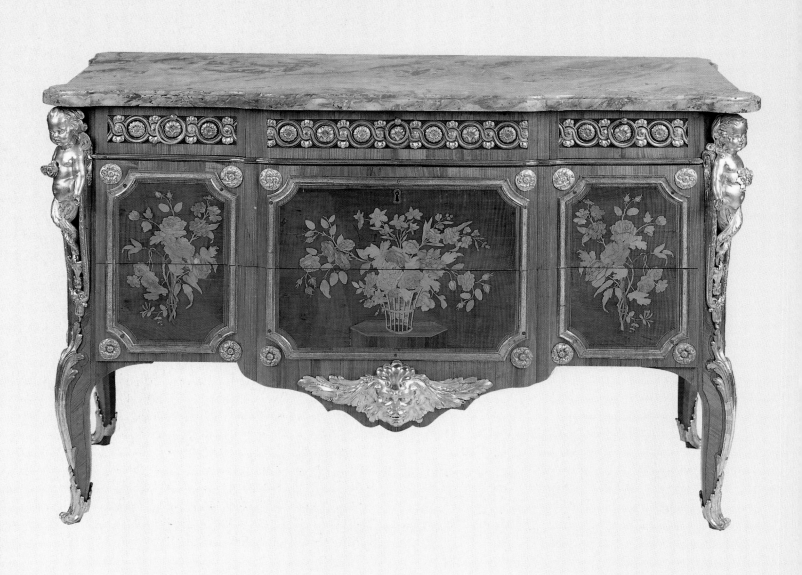

R.V.L.C

ROGER VANDERCRUSE, KNOWN AS LACROIX, 1728–99; MASTER 1749

Born in 1728, son of an independent artisan-ébéniste in the Faubourg Saint-Antoine, Roger Vandercruse belonged to the most important dynasty of ébénistes of the eighteenth century. Of his five sisters, three married ébénistes; Françoise-Marguerite married first Jean-François Oeben and then Riesener; Marie-Marguerite married Simon Oeben, and Anne married Simon Guillaume. In 1750 Roger Vandercruse married the daughter of the ébéniste Jeanne Progain; their son Pierre Roger followed his father's profession and became a master in 1772, while their daughter married Pierre-Étienne Levasseur, son of Étienne Levasseur, who, like his father, practised the art of Boulle marquetry. Finally, through his wife, Roger Vandercruse was related to the ébénistes Pierre Pioniez and Jean Marchand, both of them being her brothers-in-law. His name became gallicized as Lacroix or Delacroix, and he used the stamp 'R. V. L. C.' (Roger Vandercruse La-Croix).

In 1750, at the time of his marriage, Roger Vandercruse was living with his parents in the Faubourg Saint-Antoine opposite the rue Saint-Nicolas, where he probably remained for the rest of his life. In 1755, not long before his father died, he took over his business. In 1799 the sale after his own death also took place in the 'rue du Faubourg Saint-Antoine, no. 52, near the rue Nicolas'.

At the time of his marriage the family business was still modest; he was apportioned 800 livres of linen

and cash and a fixed dowry of 600 livres. Shortly after his marriage, and even before becoming a master, Vandercruse supplied furniture to the marchand-ébéniste Pierre II Migeon. Migeon's day-book has survived and gives the prices, though no details, of the consignments by Vandercruse between 1751 and 1757: in 1751, 1,165L; in 1752, 1,296L; in 1753, 3,464L; in 1754, 2,781L; in 1755, 2,636L; in 1756, 3,352L; in 1757, 2,946L; and in 1758 up to 3 September, the date of Migeon's death, 2,539L. The consignments for 1758 consisted mainly of light pieces of furniture; two toilet-tables, two games-tables, five writing-tables, one dressing-table, one loom, and two encoignures. There was also a secrétaire, a commode, a chiffonnier, two cabinets and a bookcase. The veneers used were for the most part of tulipwood, bois satiné, amaranth and kingwood. R. V. L. C. then mainly used floral marquetry in kingwood and sometimes geometric motifs described as 'point de Hongrie'.

There is no doubt that Roger Vandercruse worked for his brother-in-law, Jean-François Oeben. Striking similarities on numerous pieces of furniture suggest this, as well as the presence of R. V. L. C.'s name among Oeben's creditors in the inventory after his death. Certain geometric motifs, overlapping circles, lozenges, or 'interlaced hearts and lozenges', are common to the work of both ébénistes in the 1760s.

Between 1769 and 1774 R. V. L. C. supplied furniture to the Garde-Meuble Royal through Joubert. Numerous pieces of furniture delivered by Joubert to the royal family actually bore the stamp of R. V. L. C. as Joubert frequently subcontracted his commissions to him. Disregarding the stamp, certain pieces in this study have been attributed to Joubert and others to R. V. L. C. In fact, certain pieces with the stamp of

[301] R.V.L.C. was one of the principal subcontractors of Joubert, 'ébéniste de la couronne,' during the 1770s. On this commode stamped R.V.L.C., which Joubert supplied in 1771 (delivery no. 2636) for the

Comtesse de Provence at Fontainebleau, Joubert simply added on a typical piece by R.V.L.C. corner mounts with infant tritons, of which he owned the model. (Christie's London, 9 December 1982, lot 64)

R. V. L. C. are not in his style while they correspond exactly to designs conceived by Joubert and complete suites of furniture supplied by the latter (this is the case with the commode in the Frick Collection and the secrétaire sold by Christie's on 19 March 1970, lot 100). Other pieces supplied by Joubert and stamped R. V. L. C. are absolutely in the latter's style and are unmistakably Vandercruse's work; this is the case with the two commodes made for the Comtesse de Provence [301], and the commode of the Comtesse d'Artois [304]. Their design is made of three panels, either of floral marquetry or of 'interlaced hearts and lozenges' on the front within gilt-bronze frames, gilt-bronze rosettes at the corners, and a gilt-bronze frieze of interlaced circles. The motifs on the apron (mask of Mercury) are found on numerous other pieces by R. V. L. C. and are characteristic of his work.

R. V. L. C. also worked for the marchand-mercier Poirier. Several small secrétaires decorated with porcelain plaques (Metropolitan Museum: Kress Collection) originated from his workshop as well as small tables, some of which may be dated to around 1760 [312], and are identical to examples by B. V. R. B. There are others in Neo-classical style with circular or oval tops which can be dated to about 1770 as well as those with torchères with articulated candle-arms. Poirier had the monopoly of the use of porcelain plaques on furniture in the years 1760–75. Moreover, it is recorded that Poirier sold at least two pieces of furniture veneered with cornflowers, a technique typical of R. V. L. C. One was 'a corner cupboard veneered on a white ground with marquetry of blue mosaic and small cornflowers, richly garnished with gilt-bronze mounts, 380L', sold to Mme du Barry on 4 September 1770; the other was 'a secrétaire with corner cupboard at each side, veneered on a white ground with cornflowers and blue mosaic, 768L', sold on 3 March 1777 to the Comte d'Artois, which may be compared to the example now at Waddesdon Manor [317].

R. V. L. C. also sold directly to private clients; in 1779 he supplied the Vicomte de Breteuil with 'an antique bureau in the manner of Boulle in tortoiseshell marquetry, with straight fluted legs . . .' for 300L. Two years before, he had supplied him with an encoignure, a bonheur-du-jour, a table and a commode which had been lacquered in imitation Chinese lacquer by Lemaire, and fitted with bronze mounts by

Ravrio. In this case it is interesting to note that the client had paid the ébéniste, the lacquerer and the bronzier separately.

R. V. L. C. was respected within his guild. He was made adjudicator between 1768 and 1770 and then syndic and deputy in 1784. His son Pierre-Roger, born in 1757, became a master in 1771. He moved to Versailles and was employed by the Garde-Meuble Royal mainly in the maintenance and repair of furniture. It is possible that it was his son who used the stamp 'R. Lacroix'. Thus, if one accepts that he would have supplied his father with furniture, it would explain the joint appearance of the two stamps 'R. V. L. C.' and 'R. Lacroix' on certain pieces, a phenomenon difficult otherwise to explain, unless one believed that Vandercruse had changed his stamp 'R. V. L. C.' to 'Lacroix' during the course of his career. In 1787 and in 1788 Vandercruse, possibly with the help of his son, supplied the Garde-Meuble Royal with several pieces

[302] *Oval table stamped* *marquetry centred by florets.*
Lacroix, c. 1775 with trellis *(Archives Galerie Aveline, Paris)*

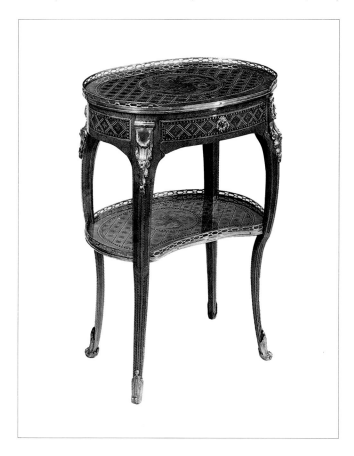

of mahogany furniture (see Appendix). These would seem to have been amongst his last commissioned work, as he retired in 1798, the same year in which his son died. In the meantime he retained all his ébéniste's equipment, which was not sold until after his death on 19 May 1799.

R. V. L. C.'s work is stylistically homogeneous: the commodes are almost all of Transitional type, of rectangular form with central break-front and cabriole legs, the apron with a characteristic line of nine consecutive curves, and decorated with a head of Mercury. There are numerous examples of bonheurs-du-jour, some in chinoiserie taste with marquetry of small vases of flowers and various objects deriving from motifs on Chinese Coromandel lacquer screens; these motifs were perhaps Topino's work – he sold panels of marquetry to his colleagues. The chinoiserie character is also accentuated by the brass gal-

lery encircling the superstructure, the T-shaped fretwork being directly inspired by Chinese motifs. These bonheurs-du-jour could also be embellished with geometric marquetry.

Equally prolific was R. V. L. C.'s production of small tables in which he made use of the repetition of certain motifs: overlapping circles, chequered patterns enclosing florets, chequered patterns with carnations (called 'barbeaux' – cornflowers – in the inventories of the period), overlapping lozenges, vertical yellow and green striations imitating straw marquetry, and twisted chequerwork representing metal latticework. For these tables R. V. L. C. developed a type of leg with double curve fitted at the level of the apron with a cross-piece, which is completely original.

In the 1770s R. V. L. C. frequently used light-coloured wood and citronnier as the ground for his marquetry work. By this means he created warm-coloured harmonies very similar to those on English furniture of the same period.

[303] Oval table stamped Lacroix, c. 1780–85; probably commissioned by the dealer Daguerre, it is comparable to various tables made by Carlin or Saunier who also worked for Daguerre. (Christie's London, 9 December 1982, lot 49)

BIBLIOGRAPHY

Arch. Nat. 0^1 3646, 0^1 3650

Arch. Nat. Min. Cent. LX/353: deed of distribution of the estate of Marie-Françoise Dupuis, widow of François Vandercruse, 18 July 1764

Geoffrey de Bellaigue: biographical note on R. V. L. C. in cat. *The James A. de Rothschild Collection at Waddesdon Manor*, pp. 337–40, 484–88, 882

André Boutemy: 'Essai d'attribution de quelques meubles anonymes à R. V. L. C.', *Bulletin de la Société de l'histoire de l'art français*, 1966, pp. 155–67

Pierre Kjellberg: 'R. V. L. C.', *Connaissance des arts*, January 1967

APPENDIX

CONSIGNMENTS TO VERSAILLES, 1788 (ARCH. NAT. 0^1 3646 (2)): NOTE BY LACROIX

23 November 1787 – no. 1
For M. le duc d'Harcourt:
A low armoire 4 pieds by 9 pouces, 2 pieds wide, height 33¹/₂ pouces, with 2 doors of which one is panelled in 2, with mirror, fluted feet, in mahogany, with a shelf inside, with gilded capitals and feet and white veined marble top 17 pouces thick and 3

mirrors. *400L*
For M. Lambert, Controller-General:
To supply 2 trictrac tables in mahogany with their boards, the tops in morocco leather, at 130L each. *260L*

28 April – no. 4
Saint-Cloud: Second Antechamber of the Queen:
To supply a large armoire with six doors in mahogany 7 pieds high, 14 pieds 7 pouces wide, 83 pouces deep. The doors inlaid in

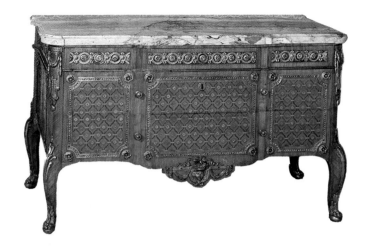

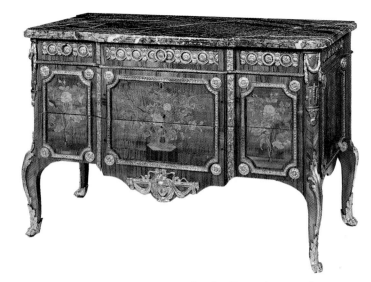

German brass, bronze hinges, bronze escutcheons with 6 doors above and below; 12 coat-stands in mahogany with gilt-bronze hooks. Gilt rod and 9 hanging shelves. Interior mahogany coloured; the said armoire fitted with a mahogany plinth, the parquets roughly cut. . . *2,520L*

5 May – no. 5
Billiard-hall:
3 consoles in mahogany on columnar feet, the top also in wood pierced with holes to store billiard cues, 1 shelf below. Legs with gilt-bronze sabots, one with 2 drawers, of which one has a shelf fitted with inkwell, powder-box and sponge-box in silvered bronze. . . *534L*

[304] (above left) *Commode attributed to R.V.L.C., supplied by Joubert in 1773 (delivery no. 2718) for the bed-chamber of the Comtesse d'Artois at Versailles. (Floors Castle, Kelso, Scotland; Duke of Roxburgh's collection)*

[305] *Commode stamped R.V.L.C., c. 1770; this maker made several such pieces with floral marquetry or marquetry of 'interlaced hearts and lozenges'. (Formerly Wildenstein Collection; sale Sotheby's Monaco, 25 June 1979, lot 75)*

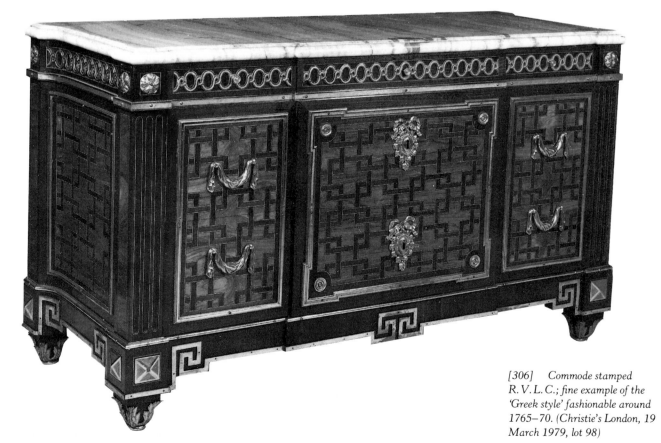

[306] *Commode stamped R.V.L.C.; fine example of the 'Greek style' fashionable around 1765–70. (Christie's London, 19 March 1979, lot 98)*

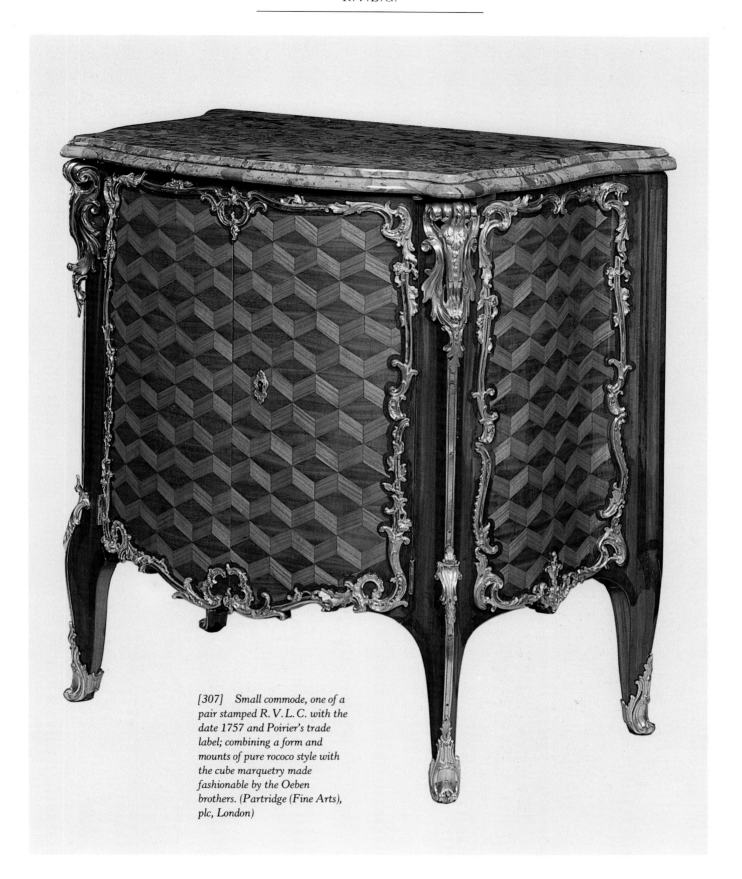

[307] *Small commode, one of a pair stamped R.V.L.C. with the date 1757 and Poirier's trade label; combining a form and mounts of pure rococo style with the cube marquetry made fashionable by the Oeben brothers. (Partridge (Fine Arts), plc, London)*

[308] Secrétaire à abattant stamped R.V.L.C., c. 1775; the marquetry on a satinwood ground with chinoiserie motifs inspired by Chinese lacquer screens. (Christie's London, 29 June 1972, lot 49)

[309] Secrétaire with tambour front, stamped R.V.L.C., c. 1760 with floral marquetry. (Musée du Petit Palais, Paris)

[310] (right) Secrétaire à abattant stamped R.V.L.C., c. 1780, veneered in geometric marquetry of trelliswork and florets on a tulipwood ground. (Archives Galerie Gismondi, Paris)

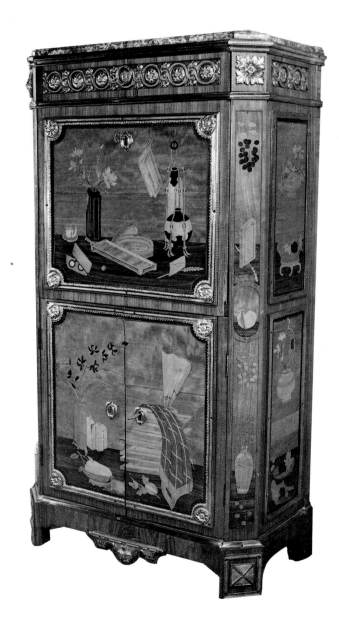

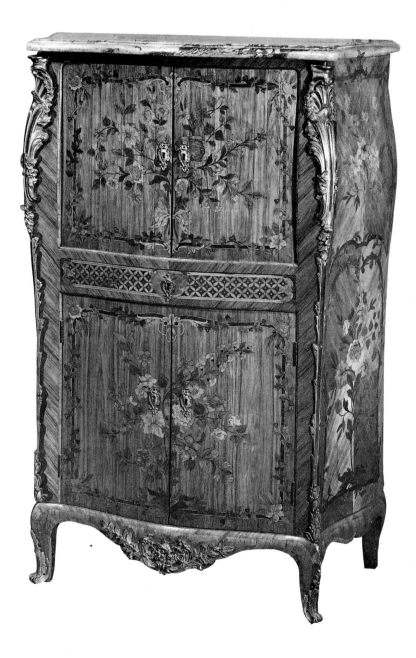

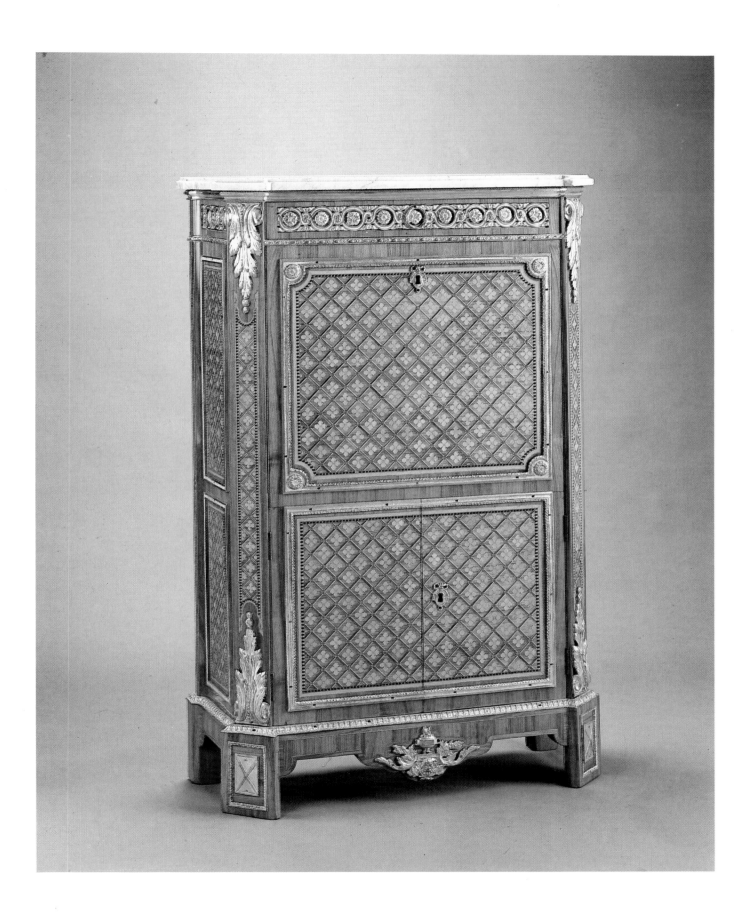

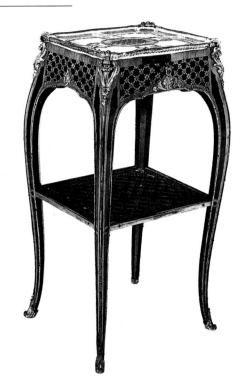

[311] Writing-table stamped Lacroix, c. 1765, with marquetry imitating trelliswork. (Sotheby's Monaco, 24 June 1984, lot 3185)

[312] Table attributed to R.V.L.C., with a Sèvres porcelain top signed by Etienne-Henry Le Guay, c. 1760. The trelliswork pattern in the marquetry echoes the motifs on the tray. A comparable table stamped R.V.L.C. is in the Musée Nissim de Camondo. (Formerly in the Alfred de Rothschild Collection; sale Christie's London, 19 May 1925, lot 295)

[313] (below left) Table with reading-stand stamped R.V.L.C., the marquetry with chinoiserie motifs. (Sotheby's Monaco, 25 June 1979, lot 36)

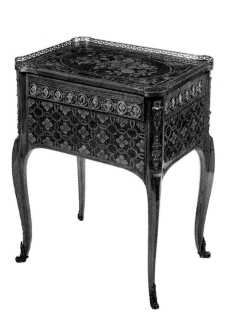

[314] (right) Mechanical table stamped R.V.L.C., c. 1770, doubling up as a writing-table and dressing-table. (Formerly in the Lurcy Collection; sale Parke Bernet, New York, 1963)

[315] Writing-table, stamped R.V.L.C., c. 1760, with marquetry of overlapping circles. (Sotheby's Monaco, 25 June 1979, lot 65)

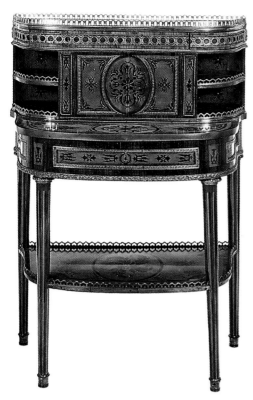

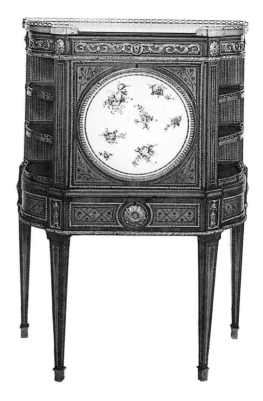

[316] Bonheur-du-jour, stamped Lacroix, c. 1785, with marquetry on a satinwood ground. (Sotheby's London, 25 June 1982, lot 171)

[317] Secrétaire en cabinet stamped Lacroix and R.V.L.C., c. 1775, decorated with a porcelain plaque dated 1774. (Waddesdon Manor, Buckinghamsire)

[318] (below left) Writing-table stamped R.V.L.C., veneered to imitate straw marquetry in alternating bands of satinwood and green stained wood (Private collection)

[319] (below centre) Writing-table, one of a pair stamped R.V.L.C., c. 1780, with marquetry on a satinwood ground. (Christie's New York, 12 November 1981, lot 213)

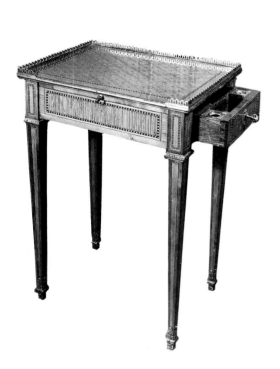

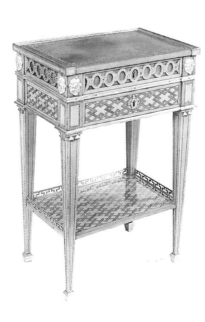

[320] Table with a deep rim stamped R.V.L.C., c. 1785, with trellis marquetry on a satinwood ground. (Sotheby's Monaco, 24 June 1986, lot 3117)

Balthazar
LIEUTAUD

c. 1720–80; MASTER 1749

As the son and grandson of Parisian ébénistes, Balthazar Lieutaud in his turn adopted this profession. Becoming a master in 1749, he settled in the rue de la Pelleterie in the Île de la Cité, the clock-makers' quarter. He was one of the most renowned clock-case-makers of his day, supplying clock-makers such as F. Viger, Bouchet, J. Tavernier, J. Leroy, J. B. Dutertre, J. B. Baillon, N. Balthazard, F. Clément, H. Voisin, J. Gudin, Sylvestre, J. B. Samson, Lepaute, Robin, Bourdier, Lory, Jouanain, Baret, etc. During this period he produced long-case clocks in rococo style such as the example at Rockford Museum, Illinois, with mounts attributed to Duplessis. Between 1765 and 1770 he produced long-case clocks in Neo-classical style. The example in the Frick Collection [321] and that at Versailles made for the Marquis de Pange are dated 1767 and bear the signature of the bronze-maker Caffieri the Elder (1714–74). Lieutaud collaborated with other bronziers such as Charles Grimpelle and Edme Roy. In 1772 he moved to the rue d'Enfer, also in the Île de la Cité, where he died in 1780. His widow maintained his workshop for another four years until 1784. One of the rare examples of Lieutaud's production outside the field of clocks is a commode in the Fitzwilliam Museum, Cambridge.

BIBLIOGRAPHY
Arch. Nat. Min. Cent. LXXXIV/558: Inventory taken after the death of Lieutaud, 2 May 1780
Jean-Dominique Augarde: *Ferdinand Berthoud,* Musée de la Chaux de Fonds, 1984, pp. 72–74

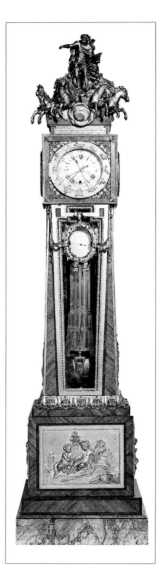

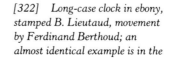

[321] Long-case clock in tulipwood stamped B. Lieutaud and dated 1767, the movement by Ferdinand Berthoud and the mounts signed by Philippe Caffieri; it featured in the M. Feyt sale in June 1790. (Frick Collection, New York)

[322] Long-case clock in ebony, stamped B. Lieutaud, movement by Ferdinand Berthoud; an almost identical example is in the Wallace Collection. (Christie's London, 6 April 1978, lot 59)

290

François-Gaspard

TEUNÉ

b. 1726; MASTER 1766

This ébéniste worked in the Faubourg Saint-Antoine, first in the rue Traversière and then in the rue de Charonne. Teuné specialized in the production of secrétaires à cylindre; this type of furniture which was first made in France by Oeben, Garnier and Boudin, appeared between 1760 and 1765, shortly before Teuné became a master. In the manner of Oeben and Boudin, his first secrétaires à cylindre were produced in the rococo style, and curved lines predominated. A number of similar examples are recorded, veneered in tulipwood with amaranth borders: one example is now in the Museum of Fine Arts, Budapest, two others at Vaux-le-Vicomte. The one in the Musée des Arts Décoratifs is unique in having a superstructure with glazed doors.

Between 1775 and 1780 Teuné's desks followed the Neo-classical fashion for straight lines with square tapering legs with triglyphs and gilt-bronze drapery at the corners. The secrétaire à cylindre now in the British Royal Collection includes within the marquetry the arms of the Comte d'Artois for whose apartment at Versailles Teuné supplied several pieces of furniture in 1775. Besides this secrétaire à cylindre and a second one supplied for the library in the same year Teuné also supplied four tulipwood serving-tables of convex form for the Prince's dining-room.

BIBLIOGRAPHY

F. de Salverte: *Les Ébénistes*, p. 314
La Folie d'Artois, 1988, p. 100, fig. 9

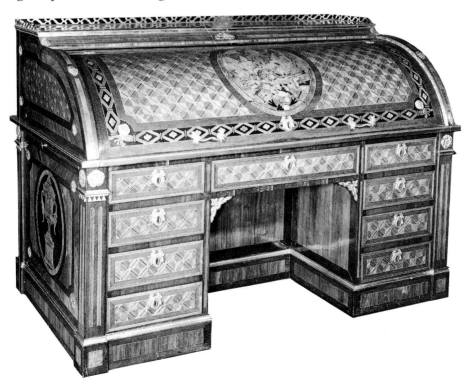

[323] *Secrétaire à cylindre stamped Teuné, c. 1775, with trelliswork marquetry. (Private collection)*

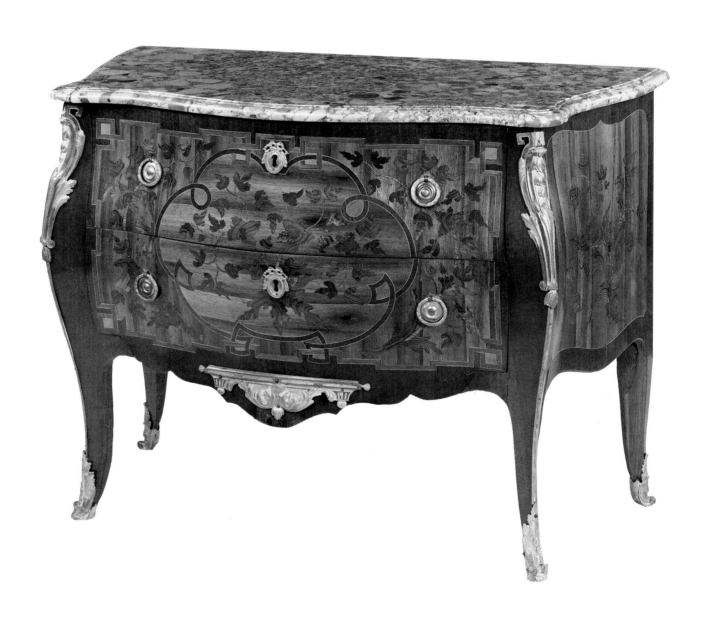

Nicolas
PETIT

1732–91; MASTER 1761; MARCHAND-ÉBÉNISTE

Nicolas Petit started as an ébéniste and furniture-seller in the rue du Faubourg-Saint-Antoine in an establishment called 'Au Nom de Jésus'. In 1758 he married Marie-Magdeleine Dignoir who died in 1765. The inventory taken after her death describes 8 work-benches, denoting an important activity, but with few pieces of furniture in stock: '2 carcases of toilet-tables, 1 clock-case, 2 carcases of secrétaires en armoire, 1 night-table, 5 tables 'mignonettes', 1 encoignure veneered with tulipwood, 1 toilet-table. This scarcity, along with the absence of private clients mentioned, confirms that the output of the workshop was purchased immediately by dealers or fellow ébénistes. Petit produced many cases for long-case clocks, mostly for the clock-maker Lepaute, who owned him 31,115L in 1782, but also for Lépine. In the last part of his career he concentrated on his activities as dealer (marchand-ébéniste). The inventory taken after his death in 1791 describes a large stock of furniture – almost 400 pieces – and mentions important private clients, such as the Duc d'Orléans (3,405L), the Duc de Bouillon (839L), the Princesse de Hesse, the Comte de Vergemont, M. Randon de Lucernay, M. de Sartine, M. de Saint Julien, the Comtesse de Schacookoy.

BIBLIOGRAPHY

F. de Salverte: *Les Ébénistes*, pp. 251–52

Patricia Lemonnier: 'Nicolas Petit', *L'Estampille*, January 1990

[324] *Commode stamped N. Petit, c. 1765, with floral marquetry in bois de bout on tulipwood ground. (Sotheby's Monaco, 21 February 1988, lot 291)*

[325] *Long-case clock stamped N. Petit, c. 1770, in tulipwood, movement by Lepaute. The sunflower was modelled by the sculpteur Cauvet. (Galerie Fabre, Paris)*

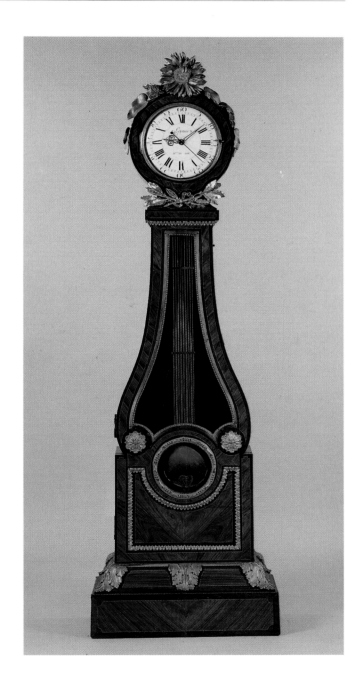

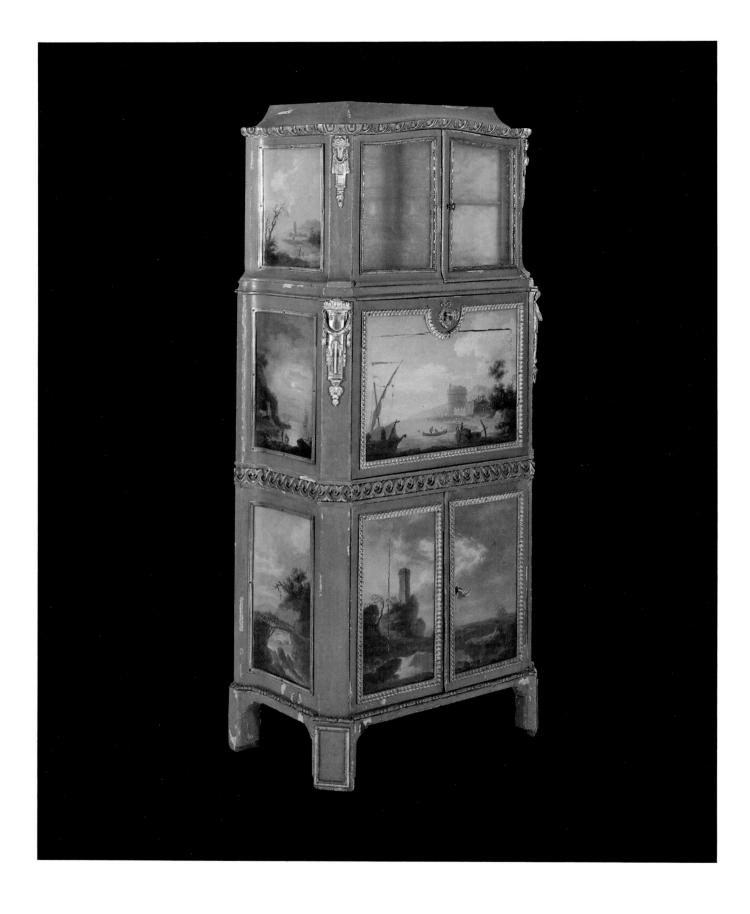

René
DUBOIS

1737–99; MASTER 1755

Jacques Dubois' two sons, Louis (born in 1732) and René (born in 1737), both qualified as master ébénistes in 1755. The elder son was quick to change profession, becoming a master stove-modeller. He was also accepted as a member of the Academy of Saint-Luc.

On the death of Jacques Dubois the workshop was taken over by René who was twenty-six, under the nominal control of his mother Marie-Madeleine Brachet. On 4 October 1772 he married Barbe-Marguerite Anthiaume, daughter of the silversmith Jacques Anthiaume, who brought with her a dowry worth 10,000 livres. In July 1772 the widow Dubois relinquished nominal control of the workshop to René, selling him the existing stock for 25,002 livres.

The inventory taken at that point indicates a very prosperous business with about eighty pieces of furniture either finished or unfinished: 28 secrétaires (of which 3 were à abattant), 12 encoignures, 4 bookcases, 25 commodes, 10 bureaux, one chiffonnière, 2 stands, one toilet-table and various games-tables, écritoires and screens. The most valuable pieces were a pair of bookcases at 1,800 livres and 'two console-tables richly decorated in ebony, without gilding, valued together at 1,200 livres', tables which have recently been identified [336]. The production of lacquer furniture, of which Jacques Dubois had made a speciality, continued; the inventory mentions 12 lacquered pieces of furniture of which 7 were in imitation Chinese lacquer and 2 in Chinese lacquer. Of the veneered pieces, 7 were in ebony, 3 in amaranth, 4 in

bois satiné, one in tulipwood and amaranth, and one marquetry-table with flowers in kingwood. Two column-shaped encoignures mentioned in the inventory can be identified as those sold at auction in New York on 13 October 1983 [327], while 'two bureaux plats in the Antique taste' surely correspond to a type perfected by Dubois and Montigny during those years [334]. Dubois also sold second-hand furniture, as is confirmed by the mention of a bureau plat in amaranth by Cressent priced at 600 livres.

As in the inventory of 1763, the workshop contained a large stock of bronze models and unfinished bronze mounts valued at 1,000 livres. The names of the bronziers are also given: the mounts were cast by Nicolas Franche (who was owed 315L), chased by the Rabut brothers (credit of 800L) and gilded in the workshop of the widow Noël (credit of 536L), a well-known atelier which carried out commissions for the Duc de Penthièvre and the Comte d'Artois. Other sums were owed by Dubois to various ébénistes such as Ancellet (1,060L), Sar (204L), Ferdinand Bury (155L), Fromageau (86L), Séverin (178L), Bon Durand (132L) and Petit (Nicolas Petit? 170L) whose work he sold.

Finally, the inventory mentions what is now considered René Dubois' speciality: furniture painted en camaïeux in tones of beige on a green ground. Eighteen pieces of this type are described, some of which were decorated with 'pictures' or 'landscapes'. Some of these pieces were painted with scenes after Vernet as can be seen on the small commode at Waddesdon Manor or the secrétaire à abattant [326]. It is possible that René's cousin, the painter Dubois, already mentioned in the accounts of 1772 as being owed 214 livres, could have painted these camaïeux. The pieces had high valuations:

[326] René Dubois specialized in the production of painted furniture, such as this secrétaire (stamped) in green lacquer decorated with landscapes in the style of Joseph Vernet, dating to around 1772. (Formerly in the Anthony de Rothschild Collection; sale Christie's London, 13 June 1923, lot 54)

2 more secrétaires painted green with scenes on the panels valued at *1,200L*

4 more secrétaires en pente with square tapering feet, painted in green with various pictures *1,200L*

2 encoignures painted with landscapes on the doors, valued together *300L*

2 commodes of 2 pieds 6 pouces painted in green, valued together *400L*

It is probable that Dubois was making these costly pieces of furniture for various marchands-merciers. The Waddesdon Manor commode, painted with landscapes after Vernet, is marked with the label of the shop 'Au Petit Dunkerque', which was owned by Charles-Raymond Granchez, quai de Conti, on the corner of the rue Dauphine. In 1772 Granchez advertised 'secrétaires in chinoiserie taste with painted scenes and mounts' in *L'Avant-Coureur*, of a type which it is tempting to identify with the one in the Linsky Collection [332].

René Dubois also worked with his brother-in-law Jean Goyer. Their two stamps appear side by side on the huge secrétaire-régulateur at Waddesdon Manor dating from about 1770 and which is reputed, without any proof, to have been ordered by Catherine II of Russia. The mounts on this piece are monumental and the gilding alone cost 5,000 livres. Goyer, trained

as an ébéniste, specialized in the production of clock-cases, as had his father, and must have played an important part in the making of the mounts for this piece of furniture. Before qualifying as an ébéniste he was apprenticed to the fondeur-ciseleur Jean-Joseph de Saint-Germain, and was accused in 1765 of being in breach of the guild regulations in employing a craftsman to chase bronze mounts in his own workshop. The collaboration between Dubois and Goyer is recorded when the latter went bankrupt in 1776. Goyer stated at this time that Dubois had signed various guarantees against his debts for the sum of 11,410 livres 'without receiving any surety, receipts or endorsements but merely to help Sr Goyer'. Goyer's financial difficulties obviously rebounded on Dubois for in 1778 Dubois' wife demanded a legal separation, fearing that her husband's weak business management would dissipate her inheritance.

In 1779 René Dubois was mentioned in the *Almanach général des marchands* as 'ébéniste to the Queen', although up until now no piece of furniture by Dubois has been identified as having belonged to the Queen. For a further length of time the workshop continued; then at the end of the 1780s Dubois moved to the rue Montmartre on the corner of rue Saint-Eustache and concentrated on selling furniture. His business was ruined by the Revolution and he died in poverty in 1799, having been supported in his last years by his wife.

DUBOIS' PRODUCTION

René Dubois used the same stamp as his father, 'I DUBOIS', which makes the attribution of certain pieces problematic. But as Jacques Dubois died in 1763 (and despite the fact that the inventory after his death mentions several pieces 'à la grecque'), it is reasonable to attribute the furniture in rococo taste to the father,

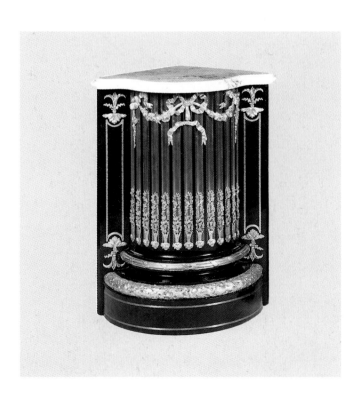

[327] Ebony encoignure, one of a pair stamped Dubois; probably those described in the inventory of stock of the widow Dubois in 1772 as 'column-shaped encoignures'. (Sotheby's New York, 13 October 1983, lot 449)

[328] Large armoire-secrétaire stamped Dubois and J. Goyer in Japanese lacquer. Stéphane Boiron has discovered the contract drawn up in 1774 between Goyer and the gilder Denis Joseph Rabut for the gilding of the mounts of this piece at the enormous cost of 5,000L. (Waddesdon Manor, Buckinghamshire)

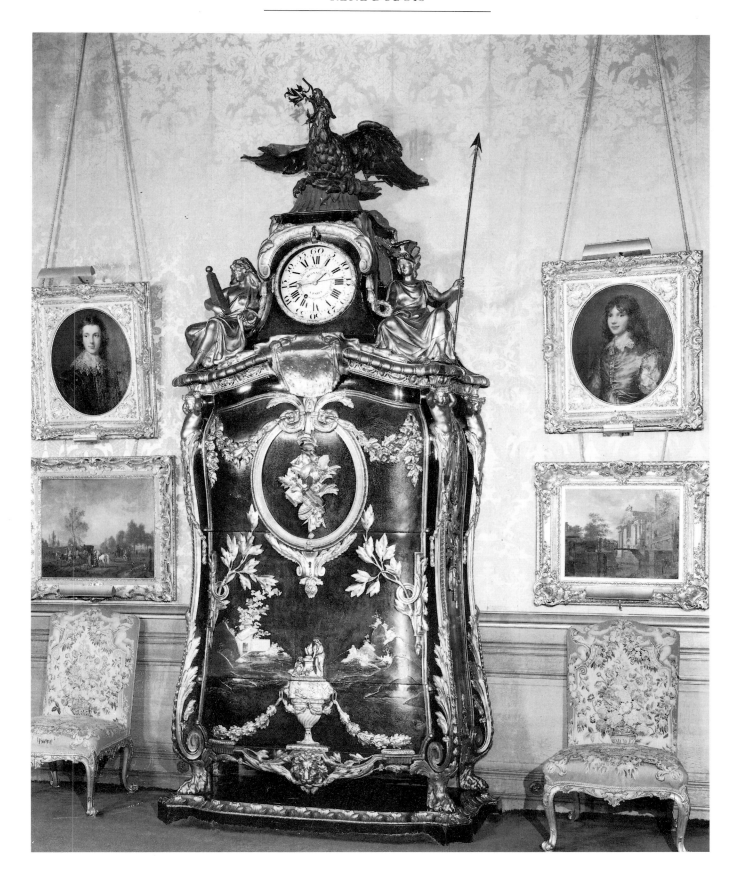

and those pieces in Neo-classical taste to the son. In any case the green-painted furniture mentioned in the 1772 inventory does not appear in the inventory after Jacques Dubois' death. These pieces therefore must be by René Dubois. His work consisted mostly of pieces of furniture designed for women: secrétaires à abattant, sometimes surmounted by display cabinets, secrétaires, small semi-circular commodes and bonheurs-du-jour. They are decorated with scenes of putti, in the manner of Louis-Félix de La Rue (1731–65), painted en camaïeux in tones of beige. More rarely, certain pieces were decorated with harbour scenes after Vernet: this decoration is found on a commode at Waddesdon Manor, and a secrétaire display-cabinet formerly in the Anthony de Rothschild Collection (sale Christie's, 13 June 1923, lot 54) [326]. A number of these pieces were bought at the time by foreigners: the bureau plat and cartonnier in the Wallace Collection [340] were originally in the Prince Kourakin Collection before 1810, while a secrétaire à abattant at Schloss Ludwigsburg was acquired in about 1775 by the Landgrave of Hesse. René Dubois also made more sumptuous furniture in Japanese lacquer such as the commode with doors and matching encoignures in the Cleveland Museum of Art [335, 337], made in about 1770, and another identical commode now at Waddesdon Manor (bearing both Dubois' and Montigny's stamps). The taste for chinoi-

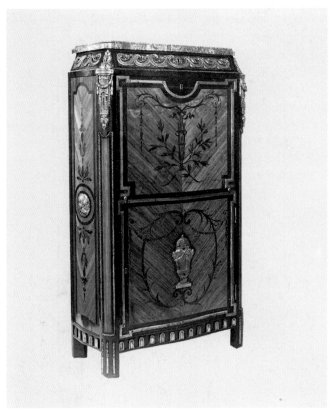

[329] (above) *Secrétaire à abattant in tulipwood stamped Dubois, c. 1770. (Christie's London, 14 June 1970, lot 103)*

[330] *Detail of the corner-mounts in the shape of mermaids on the commode illustrated at [331].*

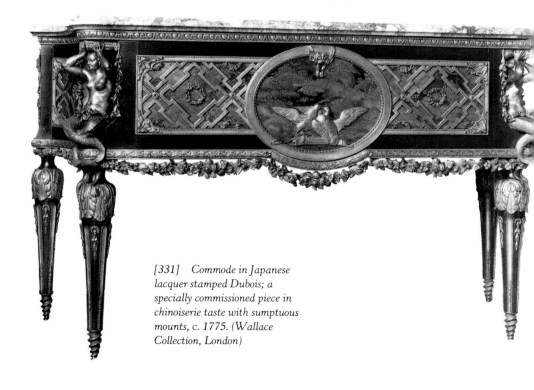

[331] *Commode in Japanese lacquer stamped Dubois; a specially commissioned piece in chinoiserie taste with sumptuous mounts, c. 1775. (Wallace Collection, London)*

serie is exemplified on several lacquered pieces: the commode in the Wallace Collection [331] with Japanese lacquer and two identical secrétaires surmounted by a pagoda-shaped open set of shelves of which one was sold by Parke Bernet, 9 October 1971, and the other is in the Linsky Collection [332].

Finally, a series of small bureaux plats are recorded, veneered with Greek key patterns and standing on square tapered legs, stamped by Dubois and almost identical to other ebony bureaux stamped by Montigny. The latter, who was Dubois' first cousin and on

[332] This secrétaire à abattant stamped Dubois in imitation Chinese lacquer can be linked to an advertisement which appeared in L'Avant-Coureur of 1772 for 'secrétaires in the Chinese taste decorated with paintings and mounts' which could be found at the dealer Granchez's shop. An identical secrétaire was sold by Parke Bernet, New York, 9 October 1971, lot 232. (Metropolitan Museum of Art, New York: Linsky Collection)

[333] Secrétaire à abattant stamped Dubois, c. 1770, in imitation Japanese lacquer, close to examples in chinoiserie taste sold by Granchez. (Private collection)

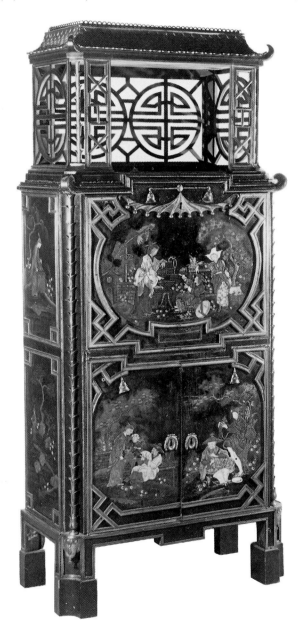

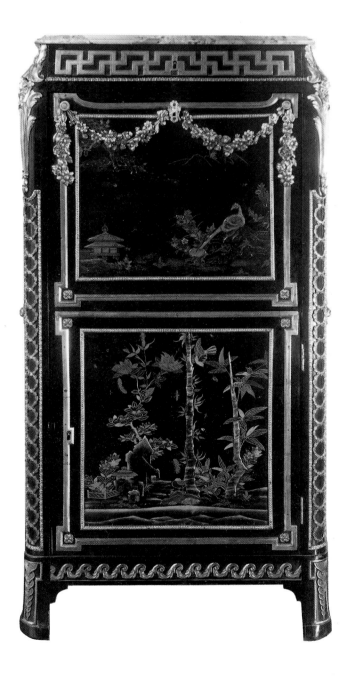

very close terms with him (he was a witness at Dubois' marriage in 1772), was probably the maker of all these desks. This series of furniture must be dated very early, from about 1765–70: Svend Eriksen has identified one of these desks at Croome Court, supplied by Poirier to the Earl of Coventry on 12 March 1765.

The ornamentation of the gilt-bronze mounts on Dubois' furniture is often extremely rich, but above all very diverse, and it is difficult to single out characteristics. The majority of motifs, Greek key pattern, Vitruvian scroll borders, lions' heads, strapwork and piastres, are all part of the vocabulary of early Neoclassical decorative ornament between 1765 and 1775. The influence of Boulle is patent in the use of massive gilt-bronze mounts on furniture in ebony or black lacquer. Moreover, Dubois restored a number of Boulle pieces in his workshop, probably with the intention of reselling them. Two small cupboards at Waddesdon Manor bear Dubois' stamp, and he must have restored them as well as probably altering them. A number of other Boulle pieces, dating from about 1700, also carry his stamp: a console table in the Wallace Collection and a console table formerly in the Ancel Collection. Montigny's workshop was mainly engaged in this work, and, having close connections with Dubois, Montigny collaborated with the latter in the making of

a number of pastiches of Boulle furniture. The pair of low armoires in the Wallace Collection bear the stamps of Dubois, Montigny and Levasseur, one beside the other.

René Dubois' work is extremely eclectic and bears the imprint of numerous influences: this applies even to the gilt-bronze mounts which sometimes include elements by Cressent, bought at the latter's sale in 1769. The secrétaire at Schloss Ludwigsburg is decorated with the motif of Antiope and the eagle which came from Cressent's stock of bronzes, and the same motif of the eagle is found on a secrétaire in the Farman sale (15 March 1973) [341].

BIBLIOGRAPHY

Arch. Nat., Min. Cen. CXXII, 779: inventory of Dubois' workshop in 1772

Stéphane Boiron: memoir for the Ecole du Louvre on the Dubois family, 1989

Geoffrey de Bellaigue: note on René Dubois in cat. *The James A. de Rothschild Collection at Waddesdon Manor*, vol II, pp. 870–71

[334] *Bureau plat in amaranth stamped Dubois. As early as 1764, in the inventory drawn up after Jacques Dubois' death, mention is found of 'a*

table in amaranth in the Greek style, 60L', which enables us to date this piece c. 1765. (Christie's London, 29 June 1972, lot 83)

[335] *Encoignure, one of a pair in Japanese lacquer stamped Dubois, c. 1770. (Cleveland Museum of Art, Ohio)*

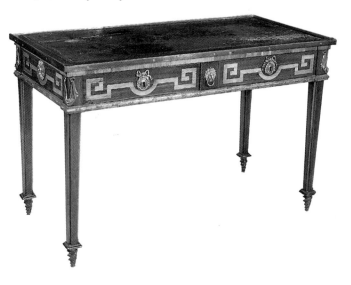

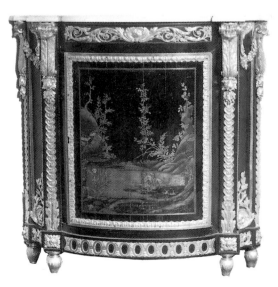

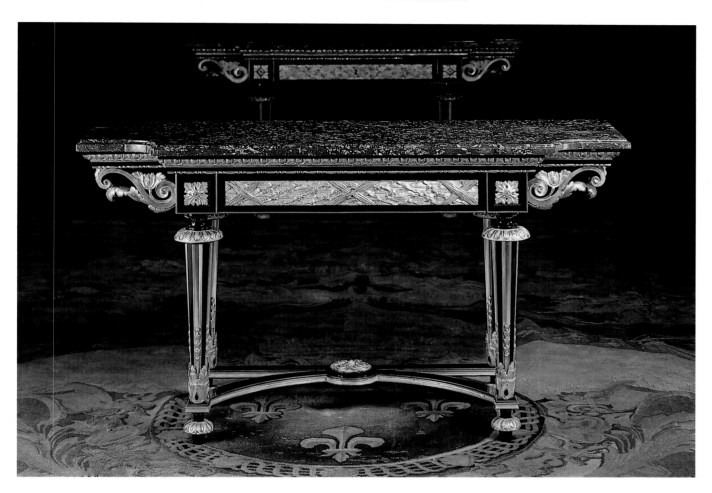

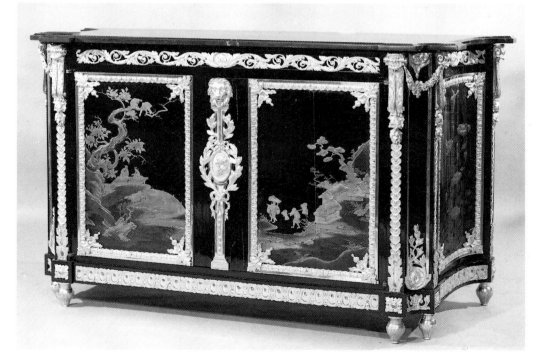

[336] Console table in ebony, one of a pair stamped Dubois, c. 1770; they can be identified in the inventory of the widow Dubois in 1772 from their high valuation – '2 tables en console richly decorated in ebony ungilded, valued together 1200L'. Another pair, identical but with white marble tops, formerly in the Stroganoff Collection in St Petersburg, can be recognized in a drawing, now in the Hermitage, showing the gallery of Count Stroganoff c. 1790. (Galerie Segoura, Paris)

[337] Commode in Japanese lacquer stamped Dubois, c. 1770. An almost identical piece, stamped Dubois and Montigny, is at Waddesdon Manor (Cleveland Museum of Art, Ohio)

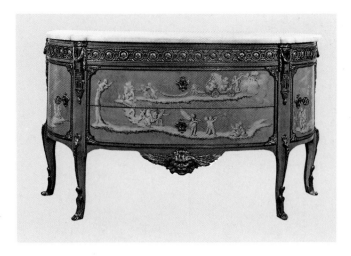

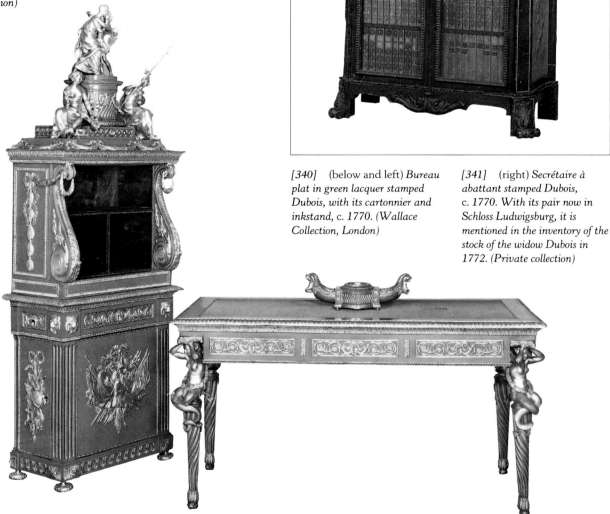

[338] Commode stamped
Dubois, c. 1775; the painted
décor in cameos of beige on a
green ground was a speciality of
René Dubois. The scenes of
children are inspired by the work
of Louis-Félix de La Rue.
(Private collection)

[339] (right) The same scenes
of children in cameos of beige and
green as shown at [338] are
found on this secrétaire stamped
Dubois, c. 1772. (Christie's
London, 29 June 1967, lot 77)

[340] (below and left) Bureau
plat in green lacquer stamped
Dubois, with its cartonnier and
inkstand, c. 1770. (Wallace
Collection, London)

[341] (right) Secrétaire à
abattant stamped Dubois,
c. 1770. With its pair now in
Schloss Ludwigsburg, it is
mentioned in the inventory of the
stock of the widow Dubois in
1772. (Private collection)

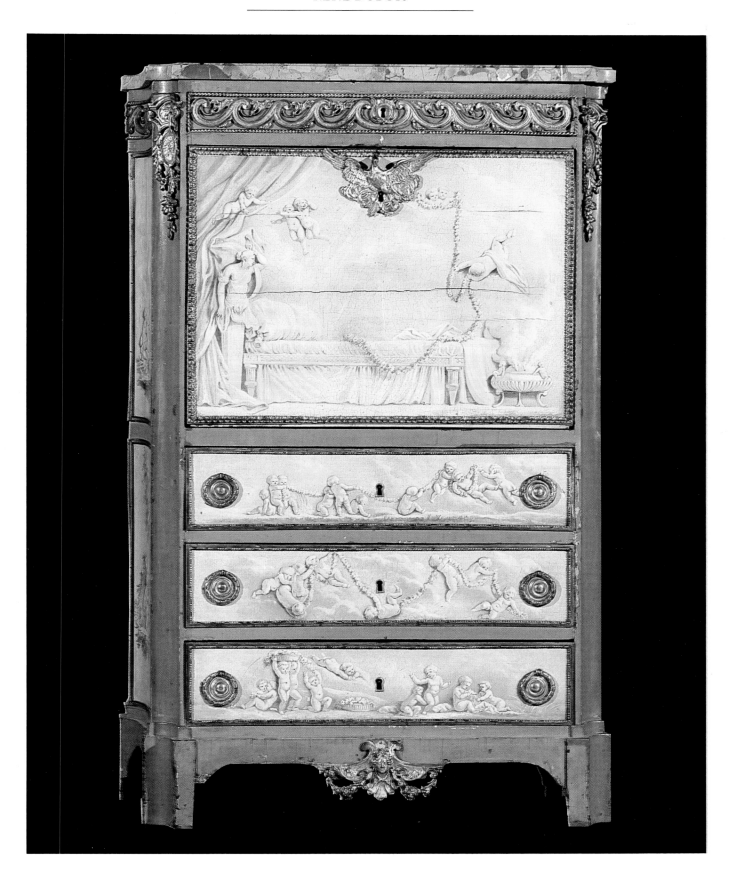

Philippe-Claude
MONTIGNY

1734–1800; MASTER 1766

Born in Paris, Philippe-Claude Montigny was the son of Louis Montigny, ébéniste and privileged artisan in the Faubourg Saint-Antoine. He became a master in 1766 aged thirty-two and took over his father's workshop in the Cour de la Juiverie at the foot of the Bastille, where he remained for the rest of his life. He married and had a son, Jacques-Philippe. Montigny specialized in restoring Boulle furniture. The *Almanach Dauphin* describes him as 'one of the most highly recommended for furniture in tortoiseshell, silver, ebony or brass of the type made by the celebrated Boulle'. Montigny not only restored furniture made by Boulle, but also copied it (see page 33). He also made Boulle pastiches, such as the secrétaire à abattant in the J. Paul Getty Museum [347], where old marquetry panels were reused.

The influence of Boulle can be felt in all Montigny's work. In a series of secrétaires à abattant in tulipwood (one in the Musée des Arts Décoratifs in Paris, a second from the Chappey sale in 1907, and another which featured in an exhibition held in 1955 of the work of Parisian ébénistes and menuisiers of the eighteenth century), gilt-bronze corner-plates are found on the corners, copied from those on armoires by Boulle. In a series of bureaux plats executed by Montigny between 1770 and 1780, the combination of ebony and gilt-bronze appears as a conscious pastiche of Boulle's style. The desks are decorated with gilt-bronze rosettes in square compartments and with very rich

gilt-bronze friezes, such as that of Vitruvian scrolls on the bureau at the Banque de France and the example in the Bardac Collection (sale Paris, 9 December 1927, lot 112), or a frieze of arabesques, or again a frieze of interlaced ovals and rosettes, as on the Woburn Abbey desk and cartonnier [342] and one formerly in the Galerie Perrin. On simpler models the drawers are framed with a brass fillet let into the ebony and separated by square compartments with centred rosettes. These distinctive and easily-identified pieces are on square tapering or octagonal legs, always with the

[342] Bureau plat and cartonnier in ebony, stamped Montigny, c. 1775. (Woburn Abbey; collection of the Duke of Bedford)

[343] Secrétaire à abattant in tulipwood, stamped Montigny, c. 1770. The mounts are inspired by Boulle; however, the central motif, of Jupiter and Antiope, is after the motif on a clock by Cressent. (Private collection.)

same capitals of laurel festoons.

Another series of smaller desks with marquetry with gilt-bronze drapery motifs at the corners sometimes bears Montigny's stamp, and sometimes that of Dubois, for whom Montigny must have worked. As a number of other pieces bear both their stamps it seems that they were commissioned by or sold to Dubois from Montigny. This is the case with a lacquer commode at Waddesdon Manor identical to other furniture by Dubois, and with a low cabinet in ebony in the Wallace Collection (its pair is stamped by Levasseur with whom Dubois must have placed the second order). Montigny was related to René Dubois, being his first cousin and exact contemporary (both were born in 1734): in 1772 he was a witness at Dubois's marriage. Montigny 'also makes clockcases

of various sorts' according to his trade label, and he made furniture for Jean-François Coulon who had a shop, 'A la Toilette Royale', in the rue Princesse. Montigny died on 24 June 1800.

BIBLIOGRAPHY

F. de Salverte: *Les Ébénistes*, pp. 237–38
Geoffrey de Bellaigue, in: *The James A de Rothschild Collection at Waddesdon Manor*, vol. II, p. 878

[346] (below) *Cartonnier in tulipwood and bois satiné, stamped Montigny, designed to match a bureau of the type illustrated at [344]. (Sotheby's London, 13 April 1965, lot 113)*

[347] (opposite) *This secrétaire à abattant stamped Montigny is a Boulle pastiche constructed with old panels of marquetry, incorporated in a Neo-classical framework. It appeared in the M. de Billy sale in 1784 and subsequently in the Comte de Vaudreuil sale in 1787. (J. Paul Getty Museum, Malibu, California)*

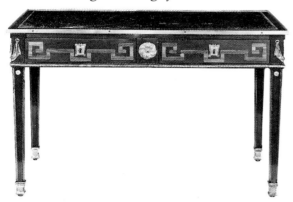

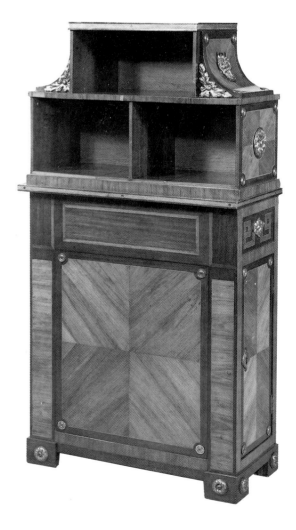

[344] *Bureau stamped Montigny, which can be dated around 1765–70, as on 12 March 1765 the dealer Poirier supplied 'a bureau à la grecque' of this type to the Earl of Coventry. (Private collection)*

[345] (below) *Small bureau plat stamped Montigny, c. 1775–80, in tulipwood and sycamore stained green; the drapery frieze is reminiscent of Carlin. (Musée du Louvre, Paris; Grog Bequest)*

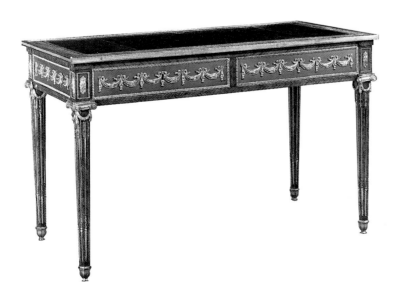

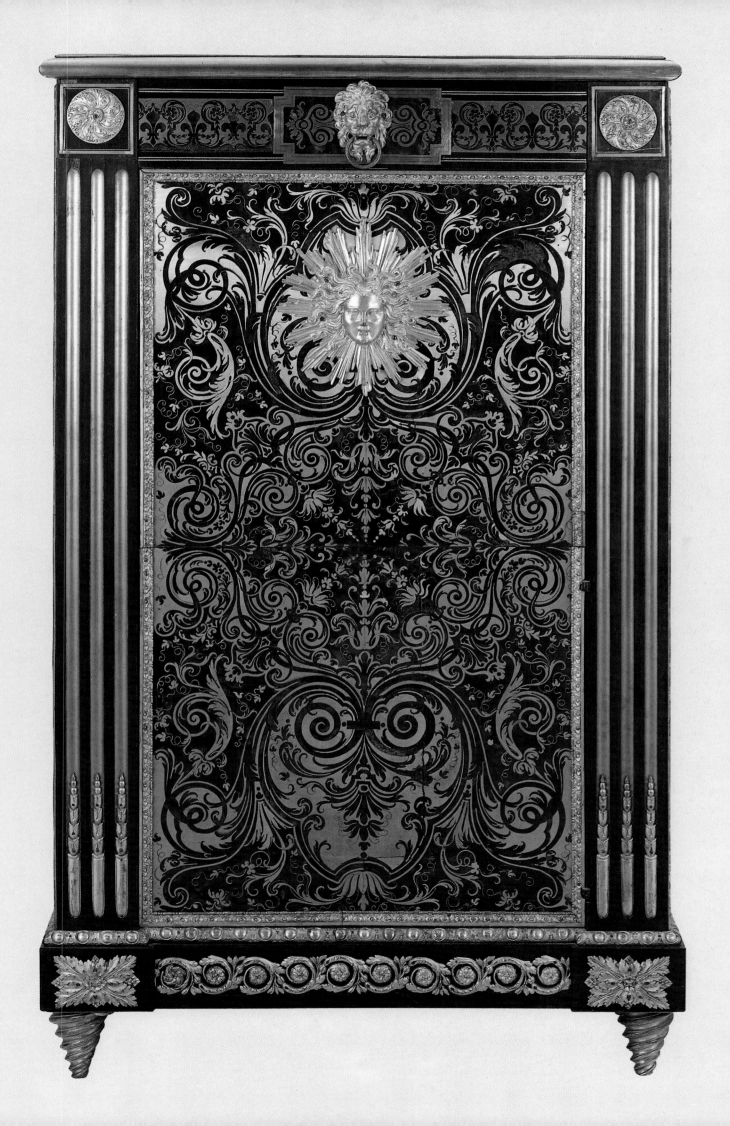

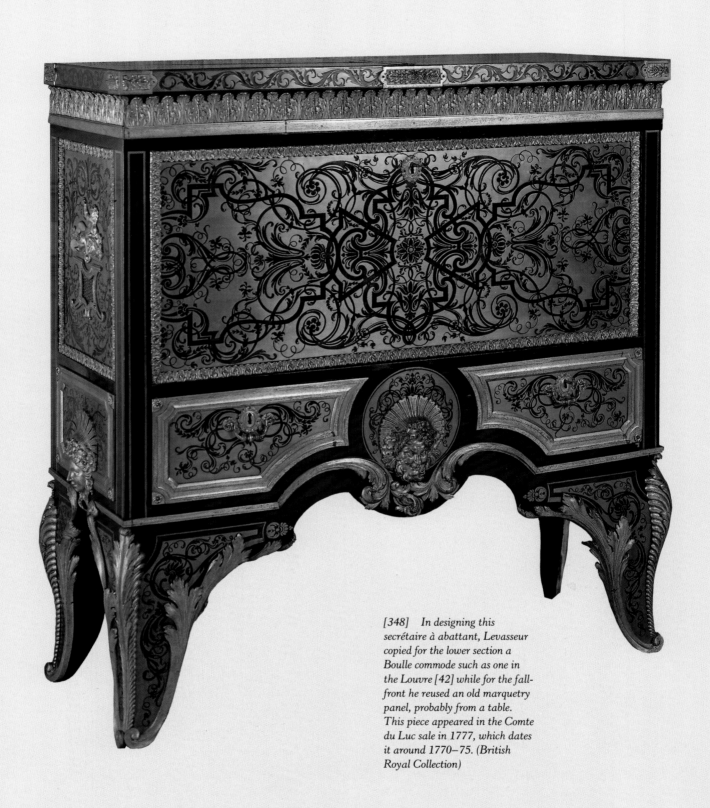

[348] In designing this
secrétaire à abattant, Levasseur
copied for the lower section a
Boulle commode such as one in
the Louvre [42] while for the fall-
front he reused an old marquetry
panel, probably from a table.
This piece appeared in the Comte
du Luc sale in 1777, which dates
it around 1770–75. (British
Royal Collection)

Étienne
LEVASSEUR

1721–98; MASTER 1767

One of the most important ébénistes of his time, Etienne Levasseur is also one of the least known. We know nothing of his formative years apart from the assertion made by his grandson in an advertisement in the *Bazar parisien* in 1822 that he was trained by Boulle. This is certainly fanciful, as Levasseur was only eleven years old at the time of Boulle's death in 1732. It is more likely that he was apprenticed in the 1740s with one of Boulle's sons, such as André-Charles, known as 'Boulle de Sève' (died 1745) or Charles-Joseph (died 1754). He began his career as an 'ouvrier privilégié' at 'Au Cadran Bleu' in the rue du Faubourg-Saint-Antoine. He then married the daughter of the ébéniste Nicolas Marchand

and was himself made a master in 1767, benefiting from the favourable conditions accorded to the sons-in-law of a master. He worked almost exclusively for the marchands-merciers, producing luxury furniture in Japanese lacquer, in mahogany, and above all in Boulle marquetry. He was mainly concerned with the restoration of Boulle furniture. His stamp is therefore found on a great many Louis XIV pieces which he restored. This is the case with many cabinets and pedestals in the Louvre, various pieces at Versailles and in the Wallace Collection, and several pieces at Vaux-le-Vicomte and in English country houses.

The principal intermediary in the trade of Boulle

[349] *Cabinet, one of a pair stamped Levasseur, c. 1775. The mounts in the form of masks have* *been moulded from Boulle models. (Sale Couturier-Nicolaÿ, Paris, 14 March 1972, lot 122)*

[350] *Cabinet, one of a set of four, stamped Levasseur. The bases and capitals of the pilasters are in a new style heralding the* *Directoire style and date them c. 1790–95 (Sotheby's New York, 7 May 1983, lot 212)*

furniture was Julliot, and Levasseur was one of his suppliers, as were Montigny, Joseph Baumhauer, Jean-Louis Faizelot-Delorme and Weisweiler. Julliot would not only resell period Boulle furniture repaired by Levasseur but also commission pastiches of this style. Inspired by an example by Boulle made for the Duc de Bourbon at Chantilly [19], Levasseur created a whole series of low bookcases with two glazed doors flanking a solid door, some decorated with fauns' heads, others with oval medallions [352, 354]. Levasseur made at least four examples of each model. Of the model with fauns' heads, a pair is in fact recorded in the collection of the Duke of Wellington at Stratfield Saye, Hampshire, while a second pair is in a private collection in Paris (formerly in the Londonderry Collection) [352]. Of the second type, with medallions, a pair is listed in the sale of the stock of Julliot

in 1777, while a second pair (or perhaps the same pair) was included in the Comte de Vaudreuil's sale in 1787 [354].

While Levasseur was transforming cabinets-on-stands by Boulle into low cabinets [37, 38], he was also making pastiches in that style during the 1770s [349]. These cabinets, of a new type, had a single door or a front with three drawers and their construction was much simpler than the cabinets of Boulle. They were very popular and were often repeated by Levasseur and after him by Weisweiler. Levasseur also produced a secrétaire à abattant in the same technique, the lower half of which was based on a Boulle commode. This secrétaire came from Julliot and was included in the Comte du Luc sale in 1777. In the same year the Comte d'Artois acquired another piece by Levasseur again from Julliot, the commode destined for the

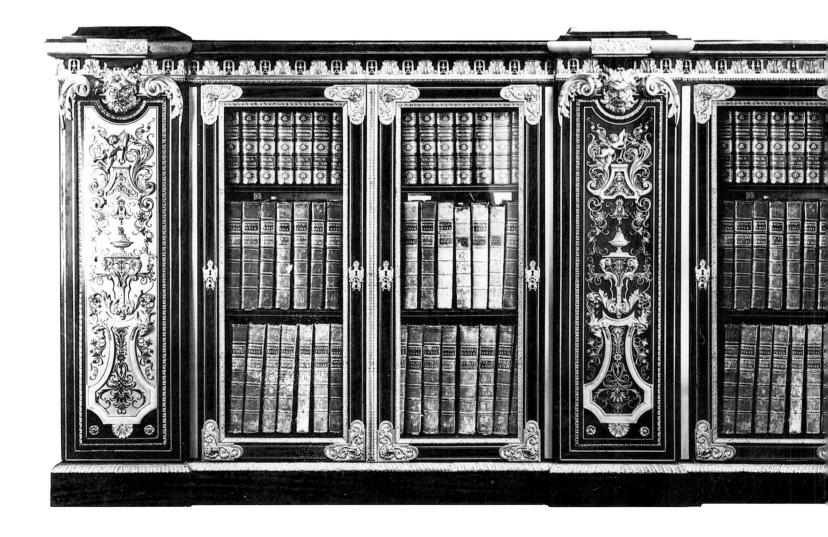

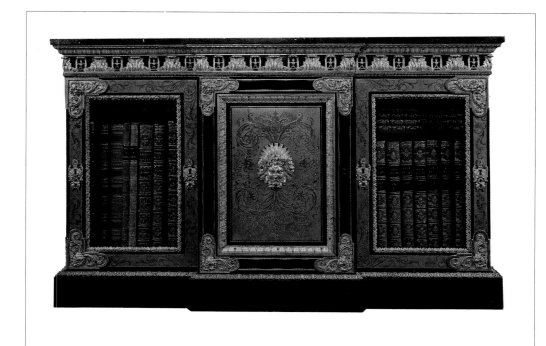

[351] (below) *Large bookcase stamped Levasseur, c. 1770. The marquetry panels are copied from a piece by Boulle, now lost, the design of which existed in Berlin. (Wallace Collection, London)*

[352] (left) *This bookcase, one of a pair stamped Levasseur, once in the collection of the Marquess of Londonderry, is a pastiche of a set of bookcases by Boulle [19]; the faun's mask has been moulded from a motif frequently employed by Boulle. However, the gilt-bronze cornice is typical of Levasseur, as is the plinth. (Private collection)*

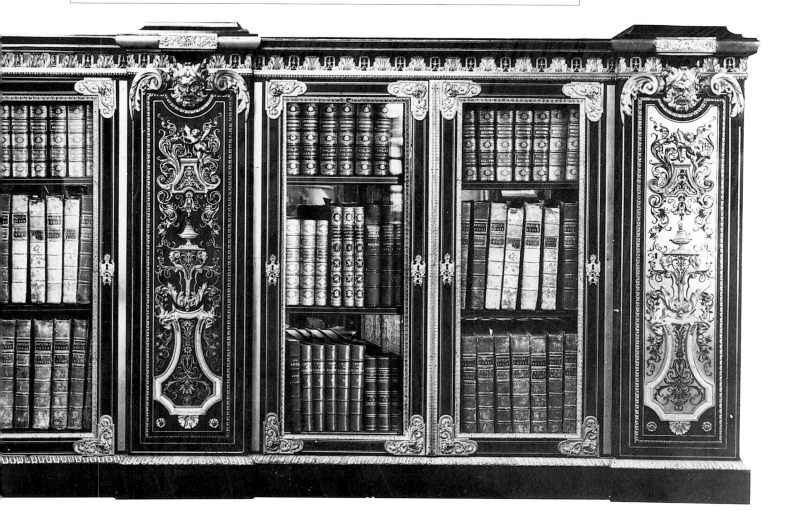

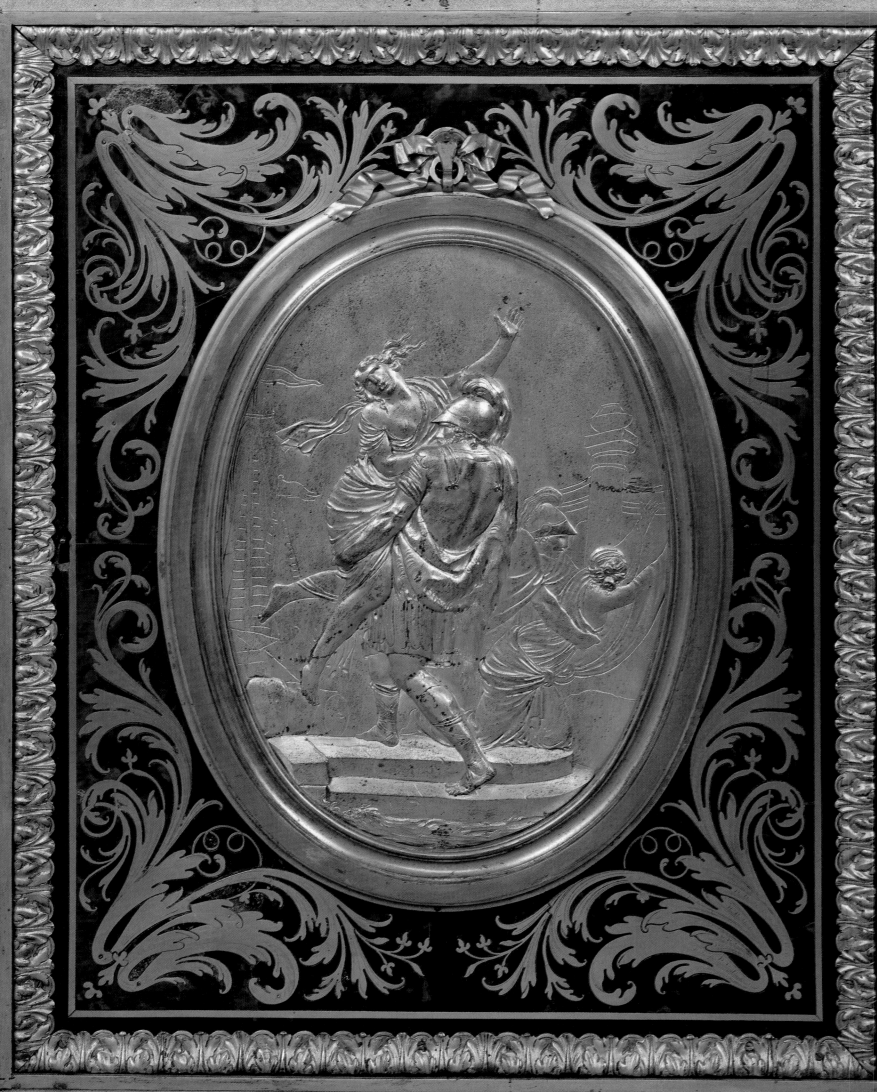

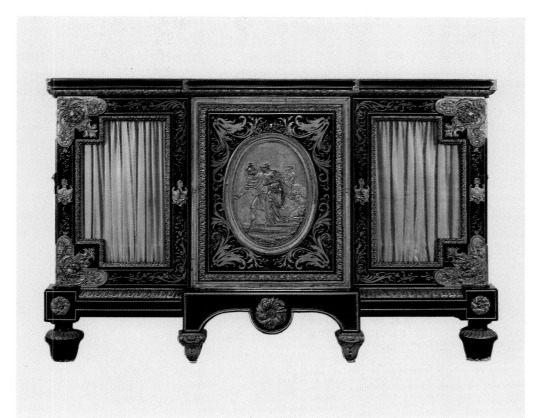

[353] (opposite) *Medallion decorating the bookcase forming the pair to the one illustrated at [354], representing the Abduction of Io, attributed to the sculpteur Foucou*

[354] *Bookcase, one of a pair stamped Levasseur, c. 1775, identical to another pair in the Wallace Collection. This type was apparently designed for the dealer Julliot, as one of the pairs first appeared in the sale of his stock in 1777. This same pair later featured in the Baron de Saint-Julien sale in 1784 (lot 186), and in the Vaudreuil sale in 1787. A third example was in the Comte du Luc sale in 1777 and then in the Comte de Merle sale in 1784. (Private collection)*

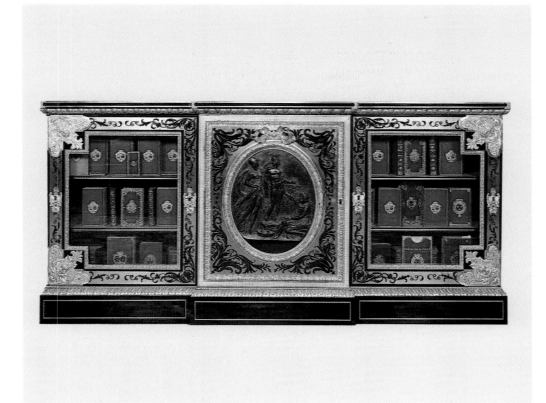

[355] *Bookcase stamped Levasseur, originally part of the furnishings of Mme Vigée-Lebrun's house, 8 rue du Sentier, built between 1785 and 1787 by the architect Raymond, assisted by the sculpteur Foucou. The latter designed the oval bas-relief representing Prometheus creating Man out of clay which was chased by Thomire according to the Lebrun sale catalogue in 1791. This bookcase was one of a set of six, all with different medallions, representing allegories of the arts. The others were 'Dibutade', 'Alexander and Apelles', 'The death of Leonardo da Vinci', 'Charles V and Titian' and 'The Victor of Rhodes'. (Private collection)*

Palais du Temple (Musée de Versailles). On these pieces, architecture dominated the Boulle marquetry decoration. While in Boulle's work the architecture is simple and the emphasis is on the surface orna-mentation, where the marquetry appears as an ex-tension of the gilt-bronze mounts, Levasseur concentrated on the architectural elements. The cor-ners are emphasized by jutting pilasters with bronze bases and capitals, the frieze forms a dominant cornice and the base is emphasized by the use of large mould-ings. Certain characteristic elements are repeatedly found on most of these pieces: the small circular masks set half-way up the pilasters, or the gilt-bronze frieze composed of openwork gadroons alternating with foliate motifs. The theme of gilt-bronze med-allions or oval cartouches in the centre of the front panels is also characteristic of his work.

Besides the restored 'antique' furniture and the Neo-classical pastiches, there is a group of furniture peripheral to Levasseur's production, of uncertain date and which for the most part consists of genuine Louis XIV furniture remodelled in the 1770s. An ex-ample is an armoire in the British Royal Collection. Though almost identical to the armoires in the Louvre and in the Wallace Collection by Boulle, the Windsor armoire is decorated with two oval medallions typical of Levasseur, surrounded by dense marquetry. It is probable in this instance that Levasseur replaced the central section of the armoire with panels to his own design.

[356] *This commode stamped Levasseur, supplied by Julliot in 1777 to the Comte d'Artois for the Palais du Temple, is a further confirmation of the collaboration between Levasseur and Julliot. The mounts on this specially commissioned piece are almost all original models. (Musée de Versailles)*

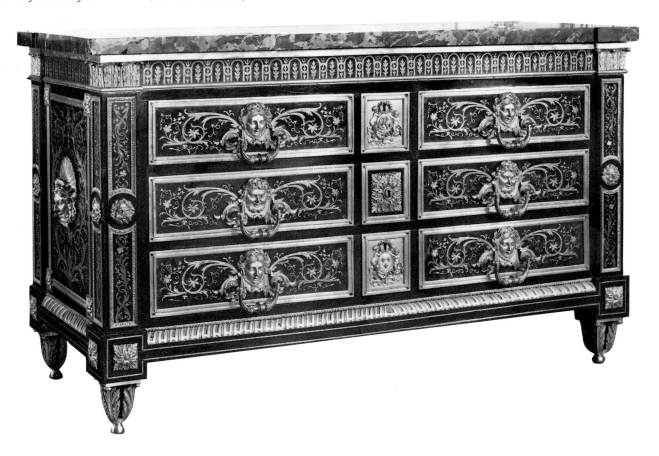

Besides Boulle marquetry, Levasseur produced a number of rare pieces in marquetry, as well as others in Japanese lacquer and mahogany. The most beautiful lacquer pieces are two cabinets in Japanese lacquer which are inserted into a Boulle marquetry structure [357]. They belonged to Randon de Boisset and featured in his sale in 1777, lot 772. Following this, they next appeared in the Hamilton Palace sale in 1882. Of the furniture in mahogany, an exceptional group is recorded, now dispersed among several French museums. It consists of a bureau with gradin and a commode with doors (Louvre) and a pair of encoignures with shelves and a table (Versailles). All these pieces came from the Château de Bellevue where they belonged to the King's aunts, Mesdames Adélaïde

and Victoire. In 1794 they were deposited with the Darnault brothers, the dealers who had already supplied many other fine pieces by Carlin to Bellevue [403, 420], which suggests that they too had been supplied by the Darnaults and therefore that Levasseur would have worked for them. A final piece in this series, the secrétaire à abattant in the Louvre, which bears the marks of Bellevue and Madame Adélaïde, is decorated at the corners with caryatids identical to

[357] This cabinet in Japanese lacquer stamped Levasseur is one of a pair made in about 1770, which appeared in the sale of the financier Randon de Boisset in 1777. Here a lacquer cabinet has *been retained within a Neo-classical framework of Boulle style. The sides have been set with the sides or doors of the original lacquer cabinet. (Private collection)*

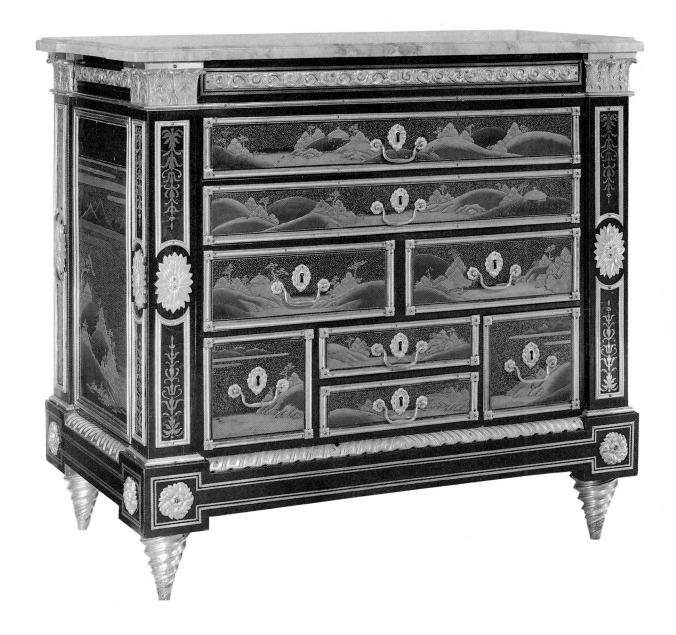

those found on furniture by Weisweiler made for Daguerre between 1787 and 1788. Was it in fact made by Levasseur for Daguerre, or for Darnault? Whatever the case it must be dated about 1789, just before the Revolution.

Levasseur became an adjudicator for his guild in 1782. In 1785 and in 1789 he supplied fairly simple pieces of furniture in mahogany or walnut to the Garde-Meuble Royal. It would seem that he did not continue working after the Revolution but remained in the rue du Faubourg-Saint-Antoine where he died on 8 December 1798. His son and grandson followed in his footsteps and extended the production of Boulle marquetry in Paris into the 1820s. His son, Pierre-Étienne, born of Levasseur's second marriage to Marie-Louise Montraud in about 1770, was not made a master, probably owing to the upheavals of the Revolution. He married a daughter of Roger Vandercruse and moved in 1798 to 15 rue Martel, later to 182 Fau-

bourg Saint-Martin where he is recorded in 1807, and finally to 114 Faubourg Saint-Antoine where his son succeeded him in about 1823. The latter, known as Levasseur the Younger, placed an advertisement in the *Bazar parisien* in 1822 in which he described himself as perhaps the only ébéniste making and repairing Boulle furniture in Paris, 'furniture seldom seen but avidly sought by collectors and dealers'. It would appear that neither son nor grandson stamped his work.

[359] *Secrétaire à abattant in Japanese lacquer stamped Levasseur, c. 1780. (Private collection)*

[360] (right) *Commode in Japanese lacquer stamped Levasseur, c. 1780. (Sotheby's London, 17 April 1964, lot 51)*

[358] *Mahogany encoignure, one of a pair stamped Levasseur, c. 1785, belonging to a series of mahogany furniture made by Levasseur for the Château de Bellevue which was stored with the dealer Darnault during the Revolution. (Musée de Versailles)*

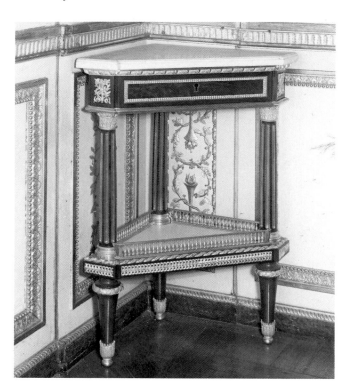

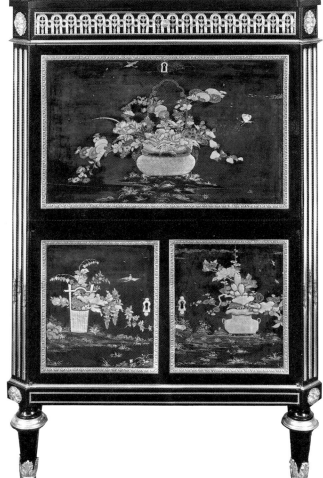

BIBLIOGRAPHY

F. de Salverte: *Les Ébénistes*, pp. 206–07

Denise Ledoux-Lebard: *Les Ébénistes du XIXe siècle*, pp. 432–33

Pierre Verlet: *La Revue des arts*, 1953, pp. 241–43

F. J. B. Watson: 'The great duke's taste for French furniture', *Apollo*, July 1975

Alexandre Pradère: 'Boulle, du Louis XIV sous Louis XVI', *L'Objet d'Art*, no. 4, pp. 28–43

Daniel Alcouffe: exh. cat. *Cinq Années d'enrichissement du patrimoine national 1975-1980*, p. 104

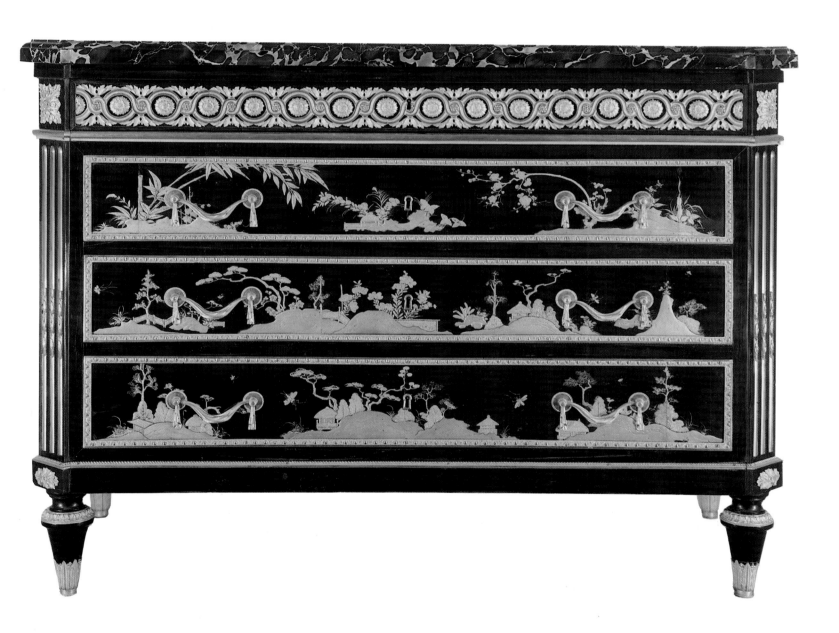

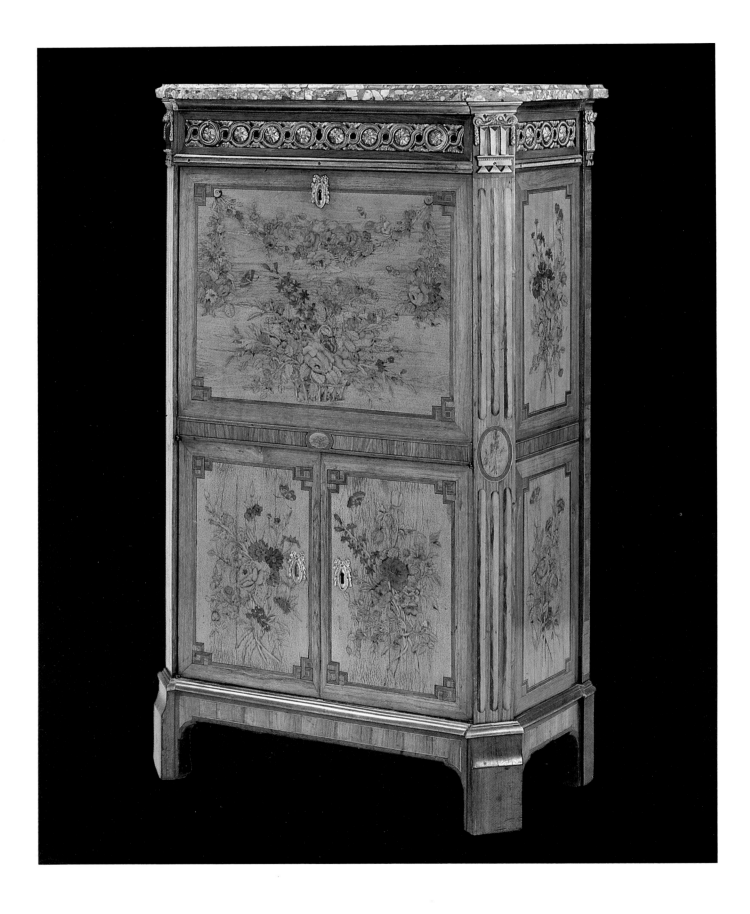

Charles
TOPINO

MASTER 1773

B orn around 1735, Topino worked for a long time as an independent craftsman before being received master in 1773. Settled in the rue du Faubourg-Saint-Antoine, he specialized in pieces of light furniture, small tables, bonheurs-du-jour and chiffonnières, and perfected a type of bonheur-du-jour of oval form for which he seems to have had the monopoly. The marquetry decoration which is the chief attraction of these pieces consists of two types:

— Still-lifes with teapots, vases and various utensils in chinoiserie taste, derived from motifs on Coromandel lacquer screens. These would seem to have been very fashionable between 1770 and 1775.

— Garlands and bouquets of flowers highlighted on a ground of pale wood, citronnier or yellow-stained maplewood, found on furniture between 1775 and 1780.

Among his clientèle he counted members of the French aristocracy, but above all his colleagues the marchands-ébénistes Héricourt, Dautriche, Migeon, Denizot, Moreau, Delorme, Tuart and Boudin. For the latter he made light tables in lacquer or marquetry and bonheurs-du-jour. Topino's day-book preserved in the Archives de la Seine contains orders from all these marchands-ébénistes, and makes clear that Topino sold marquetry panels to his colleagues. Topino also worked for Joubert. The description of a

small bonheur-du-jour delivered by the latter in June 1774 gives the unmistakable impression of a piece of furniture by Topino (see Appendix).

The gilt-bronze mounts with which Topino embellished his furniture were cast by Viret, chased by Chamboin and Dubuisson, and gilded by Bécard, Gérard and Vallet.

In 1782 Topino was elected deputy of his guild, a measure of the esteem in which he was held. Nevertheless, his finances were, according to Salverte, in the greatest disorder, a chronic state of affairs exacerbated by the Revolution, so that in December 1789 he was declared bankrupt.

BIBLIOGRAPHY

Topino's Livre Journal, Archives de la Seine, Reg. 395
F. de Salverte: *Les Ébénistes*, p. 317
Geoffrey de Bellaigue: *The James A. de Rothschild Collection at Waddesdon Manor*, vol. II, pp. 880–81

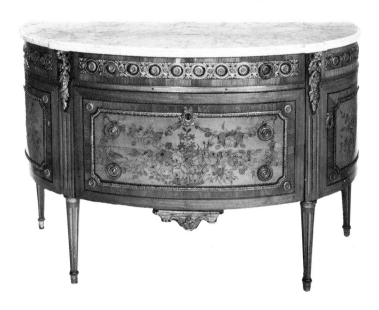

[361] Secrétaire à abattant stamped Topino, c. 1780; the floral marquetry stands out on a ground of stippled light-coloured wood. (Christie's London, 3 July 1986, lot 117)

[362] Semi-circular commode, one of a pair, c. 1780, stamped Topino. The floral marquetry stands out on a ground of stippled light-coloured wood. (Formerly Mentmore House, Earl of Rosebery's collection; sale Sotheby's, 25 May 1977, lot 467)

APPENDIX

Journal du Garde-Meuble Royal (Arch. Nat. 0¹3319), delivery by Joubert on 1 June 1774: No. 2764: For the use of M. le Comte d'Artois at the Château de Compiègne

A small jewel secrétaire in tulipwood decorated with baskets of flowers, fruits and tea-cups in the Chinese style, all in marquetry, on both sides over the table a small door with a key, with a drawer inside. Between the two doors is a third drawer; at the front there is a slide covered in blue moiré bordered with narrow silver braid, with a compartment on the right for an inkwell, powder-box and sponge container in silvered brass. The secrétaire is embellished above and below with a balustrade in Classical Greek style and other ornaments in chased and richly gilt bronze. Length: 24 pouces. Depth: 15 pouces. Height: 3 pieds 2 pouces.

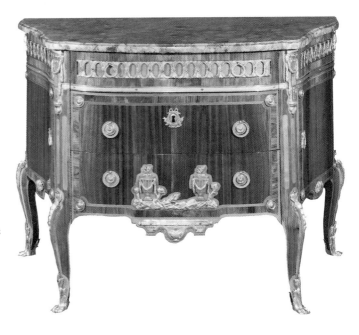

[363] (right) *Commode in tulipwood stamped Topino, of a type which he repeated several times. (Archives Galerie Fabre, Paris)*

[364] (below left) *Oval bonheur-du-jour stamped Topino, c. 1775, with marquetry of teapots and ware of Chinese taste. (Sotheby's London, 23 June 1985)*

[365] (below right) *Bonheur-du-jour attributed to Topino, c. 1775, the marquetry with vases and other ware of Chinese taste, on a tulipwood ground. (Sotheby's Monaco, 26 May 1980, lot 697)*

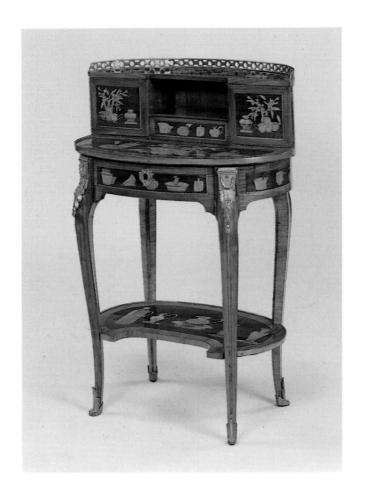

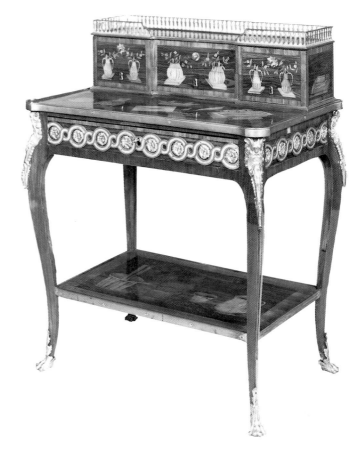

PIONIEZ

According to Salverte, Pierre Pioniez appeared in about 1758 as a privileged artisan in the Faubourg Saint-Antoine, and moved, after he became a master in 1765, to a workshop in the rue Michel-le-Comte in the Marais where he would remain for the rest of his life. The majority of furniture bearing his stamp is in Transitional style, commodes and tables of rectangular form with cabriole legs. On certain tables and bonheurs-du-jour a type of scroll-topped leg is found which would seem characteristic of Pioniez's work. The marquetry often consists of pictorial motifs such as vases and utensils in chinoiserie taste deriving from motifs on Coromandel lacquer screens. The same marquetry is found on pieces by his brother-in-law Vandercruse (R. V. L. C.) and Topino, so much so that one wonders if all three used the same marquetry-maker, or if Topino perhaps made these marquetry panels for his colleagues.

Salverte cites other ébénistes with the name of Pioniez, of which one, Louis-Michel, is recorded in the rue du Faubourg Saint-Antoine in 1786, and another (perhaps the same one) is mentioned in 1797 after his death as 'Pioniez the Elder' at the sale of his furniture, mounts, mirrors and marbles. The last-mentioned was described as 'ébéniste, rue Grenier-Lazare, no. 685' and was the father of two ébénistes still working under the Empire.

BIBLIOGRAPHY

F. de Salverte: *Les Ébénistes*, pp. 264–65

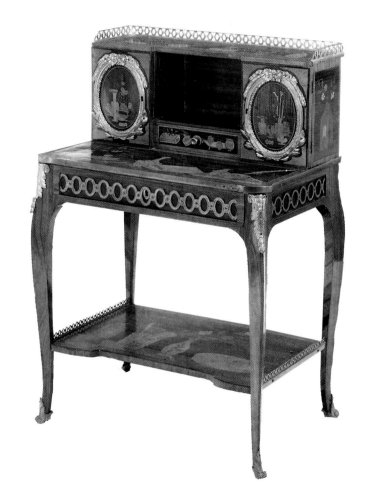

[366] *Bonheur-du-jour stamped Pioniez, c. 1775; the marquetry with Chinese vases and other ware is identical to that of Topino, who was known to retail ready-made marquetry panels to fellow ébénistes. (Sotheby's London, 25 June 1982, lot 123)*

Jacques BIRCKLÉ

1734–1803; MASTER 1764

Having first worked as an independant artisan in the Faubourg Saint-Antoine, Bircklé became a master in 1764. Established in the rue Saint-Nicolas, in 1785 he began working for the Garde-Meuble Royal, supplying it with regular consignments of simple furniture. In January of 1787 he supplied for the Comtesse de Provence at Versailles '2 commodes $3^1/_2$ pieds long veneered in tulipwood with 4 drawers fitted with locks, decorated with ring-handles, capitals, gilded sabots, with white marble top at 132 livres each'. On 10 June 1787 he supplied for the Queen's use at Saint-Cloud

no. 156) A commode 4 pieds in length in mahogany with 5 drawers fitted with locks, decorated with a frieze of flutes and florets. Gilt-bronze sabots and capitals. Top in white veined marble. A semi-circular console, 4 pieds long in the same wood and matching the commode, and with 2 white veined marble slabs. For the 2 pieces *680L.* 4 commodes $3^1/_2$ pieds long in bois satiné with 5 drawers fitted with locks, decorated with gilt-bronze ring-handles, escutcheons, sabots and capitals, the top of Flanders marble, at 120L each, *480L.*

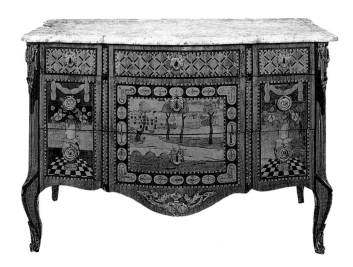

Bircklé also made chiffonnières; in 1787 he delivered one in walnut 'for use in Paris' and another 'of 4 pieds by 3 pieds', veneered in tulipwood, for the Baron de Breteuil at Versailles. In 1788 he worked for the Dauphin at Meudon, to whom he supplied '3 secrétaires en armoire in walnut with tops in wood, and 6 small chiffonnières called guéridons in walnut' while at the same time restoring various pieces of furniture. In the same year Bircklé supplied to the Garde-Meuble Royal, through the offices of Hauré, various items which, considering the prices, must have been fairly modest pieces of furniture:

— 13 writing-tables in mahogany. *546L*
— 1 commode in tulipwood. *96L*
— 4 commodes in bois satiné. *500L*
— 1 commode in bois satiné. *216L*
— 4 fire-screens in mahogany. *48L*
— 2 commodes in tulipwood. *192L*
— 1 commode in mahogany. *125L*
— 2 secrétaires in walnut. *120L*

In 1789 he also supplied furniture at modest prices, chiffonnières, writing-tables and secrétaires for a total of 3,626 livres. At this time his address was in the rue du Faubourg-Saint-Antoine. With the Revolution his consignments to the Crown ceased, although the activities of his workshop continued. It was taken over by his son and remained in operation until 1825.

BIBLIOGRAPHY
Arch. Nat., 0^13646, 0^13648, 0^13649, 0^13651
F. de Salverte: *Les Ébénistes*, p. 25

[367] *Commode with landscape marquetry stamped Bircklé, c. 1775. (Ader, Paris, 28 March 1984, lot 84)*

André-Louis
GILBERT

1746–1809

André-Louis Gilbert became a master in 1774 after an apprenticeship under L.-N. Malle, one of the principal marquetry-makers in Paris. He then settled first in the rue Traversière, then in 1785 in the Grand-Rue du Faubourg Saint-Antoine and was active until 1789. Like his former master he specialized in marquetry pieces and particularly in architectural scenes in the manner of Hubert Robert.

His furniture is generally simple in form, decorated on the front with rectangular panels of minutely detailed marquetry scenes of townscapes with numerous buildings, the windows highlighted with mother-of-pearl. The compositions are often centred on a portico, an arcade or a temple. These marquetry pictures are seldom of the same size as the panels making up the piece, and the remaining sections are made up with lozenges and rosettes. This would imply that the marquetry panels were made up in advance, without a specific commission in mind, and could be used without distinction on tables, secrétaires or encoignures. It is also likely that Gilbert sold them on to other ébénistes such as Bircklé, Boudin, Roussel and Dautriche for use on their own furniture, as this marquetry is found on the work of several fellow ébénistes ([198, 288, 367]).

In July 1780 Gilbert placed an advertisement in the *Petites Affiches* concerning a roll-top desk topped by a bookcase with panels depicting ruined temples.

BIBLIOGRAPHY
F. de Salverte: *Les Ébénistes*, p. 139

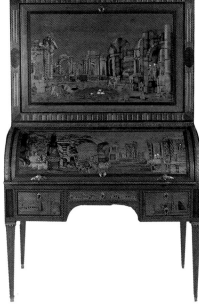

[368] Cylinder desk with marquetry of ruins with ivory inlays, stamped Gilbert, c. 1780. (Sotheby's New York, 6 November 1982, lot 203)

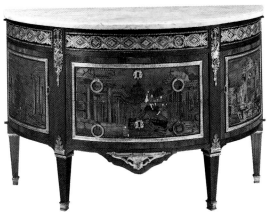

[369] Commode with marquetry of ruins, with ivory inlays, stamped Gilbert, c. 1780. (Christie's London, 23 June 1988, lot 96)

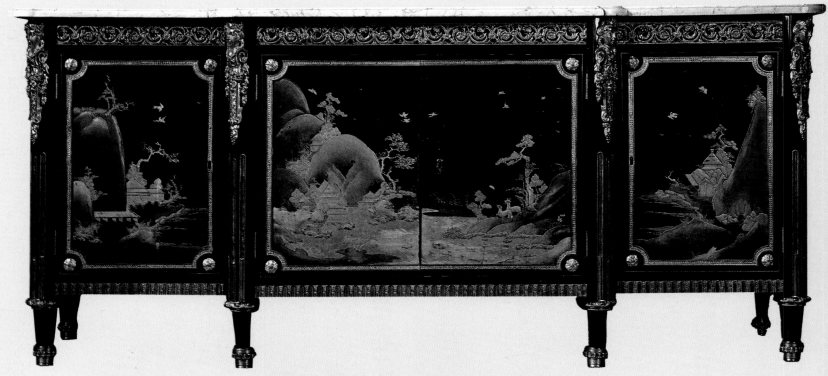

[370] *Buffet in Japanese
lacquer stamped Cramer,
c. 1780. (Gulbenkian Museum,
Lisbon)*

CRAMER

Mathieu-Guillaume

d. 1804; MASTER 1771; MARCHAND-ÉBÉNISTE

Born at Grevenbroich in the northern Rhineland, an area in Germany from which many eighteenth-century ébénistes originated, Mathieu-Guillaume Cramer settled in Paris at an unknown date. When he married in 1771 he was already established as an independent ébéniste in the rue du Faubourg Saint-Antoine; he was close to Carlin who was a witness to his marriage contract. He married one of the daughters of the ébéniste Isaac-Edmond Collet, living in the same quarter. Cramer contributed a portion fixed at 3,500 livres mainly in stock and tools, a sign that he had been active in his profession for some time. The bride, Marthe-Suzanne-Françoise Collet, brought a dowry of 2,600 livres. She came from a dynasty of ébénistes including not only her father and grandfather, but her uncle

Jean-Michel Collet, marchand-ébéniste, and an uncle by marriage, Gilles Joubert. Cramer, no doubt with the help of all these connections, was able to obtain his mastership soon after his marriage, on 4 September 1771. A few years later he moved to the rue du Bac where he established himself as a marchand-ébéniste.

The inventory taken after the death of his wife in 1783 by Vandercruse (R. V. L. C.) and N. Petit gives a good idea of the state of his business and his production. More than two hundred pieces of furniture are described in it, either finished or unfinished, of which the majority were in mahogany, tulipwood, bois satiné or marquetry. They mostly comprised a variety of tables (tea, games, writing, guéridons) but also commodes, encoignures, secrétaires, chiffonniers, spinning wheels, tapestry frames and néces-

[371] *Bureau plat stamped Cramer, c. 1775–80, in trellis marquetry with florets, on a yellow wood (satinwood or stained* *maple ground). Formerly Derek Fitzgerald Collection. (Archives Galerie Aveline, Paris)*

[372] *Cylinder desk with marquetry stamped Cramer, c. 1780, made for the King of Sardinia. Cramer sold on pieces by his fellow ébénistes; it is likely* *that this piece was made by Riesener, and that Cramer simply applied some original mounts to it. (Musée du Louvre, Paris)*

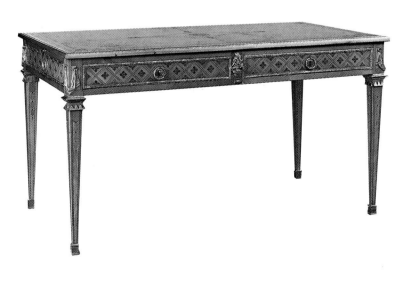

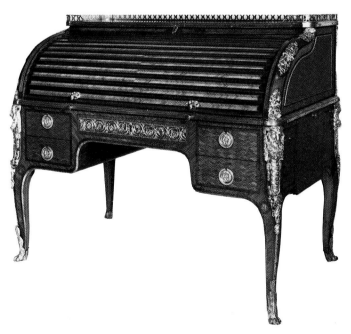

saires. The marquetry pieces were described as being in bois gris with flowers (probably striped sycamore) or tulipwood with pale rosettes. There is no mention of what are considered today to be characteristic motifs of Cramer: marquetry of rosettes on a ground of bois jaune (satinwood or maplewood stained yellow).

The workshop was fitted with five work-benches, a sign of prosperous activity. Cramer also commissioned furniture from his fellow ébénistes such as Ancellet, Canabas, Dautriche, Feuerstein, Vandercruse (R. V. L. C.), Petit, Roussel, Topino and Vassou, their names appearing on the list of creditors for 'furniture supplied'. His debts, however, were considerable. His clientèle included the Duc de Montmorency, the Duchesse du Châtelet and the Prince de Broglie. Cramer, ruined by the Revolution, went bankrupt in 1790 and died in poverty in the rue de Harlay in 1804.

BIBLIOGRAPHY

Min. Cen. X/861, 17 September 1783, inventory taken after the death of Mme Cramer

F. de Salverte: *Les Ébénistes*, p. 70

Daniel Alcouffe: exh. cat. *Défense du patrimoine national*, 1978, pp. 73–74

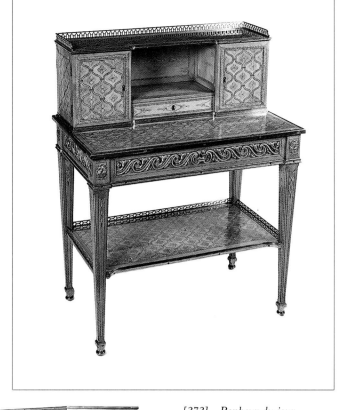

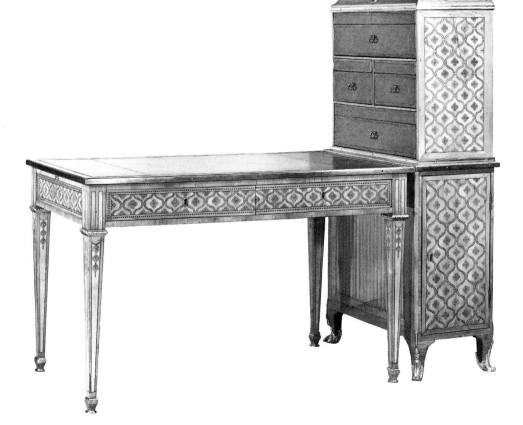

[373] Bonheur-du-jour stamped Cramer c. 1775–80 with marquetry of 'interlaced hearts and lozenges' on a bois jaune ground. (Sotheby's Monaco, 25 June 1979, lot 55)

[374] Bureau plat and cartonnier stamped Cramer, 1775–80, with marquetry of 'interlaced hearts and lozenges' on a bois jaune ground. (Sale Palais Galliera, Paris, 28 November 1972, lot 142)

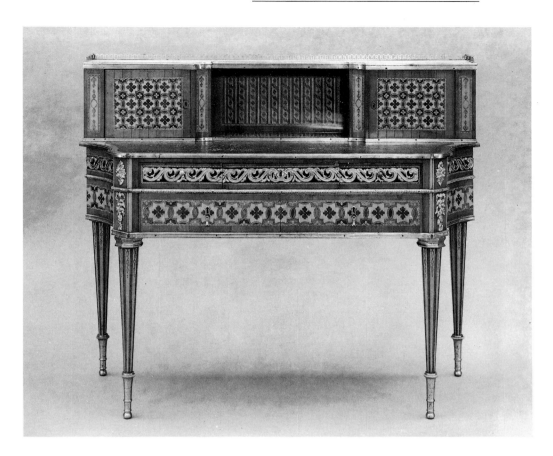

[375] *Secrétaire à gradin stamped Cramer, c. 1780 with marquetry of overlapping four-lobed motifs on a satinwood ground. (Metropolitan Museum of Art, New York)*

[376] *(below left) Commode, one of a pair stamped Cramer, c. 1772–75, with marquetry, including the top, of four-lobed motifs. The shape as well as the mounts are typical of the work of R.V.L.C. who was among Cramer's subcontractors and must have provided the carcases of some of his furniture. (Christie's New York, 5 November 1986, lot 202)*

[377] *Small table stamped both Pioniez and Cramer, the latter as retailer, c. 1775–80, with marquetry of four-lobed motifs. (Private collection)*

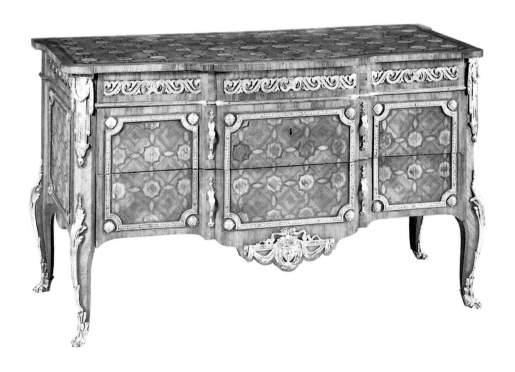

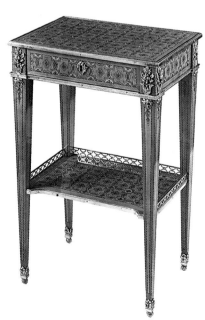

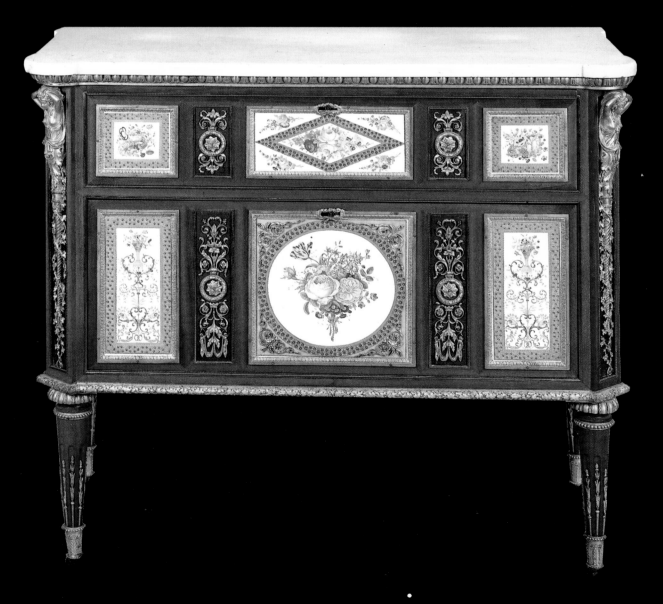

Godefroy
DESTER

MASTER 1774

This ébéniste was active until at least 1790, working in the rue du Faubourg-Saint-Antoine. His work, which is very distinctive, usually takes the form of light pieces of furniture, tables and bonheurs-du-jour with marquetry in a lozenge pattern, the centres decorated with a florette. The woods used, satinwood, and stained maplewood, create a harmonious blend of pale-gold and green. The shapes are simple and the decorative use of gilt-bronze mounts is restrained. Godefroy Dester also made a number of pieces in mahogany as well, close in style to the work of Weisweiler and Benneman. The mounts are very sober, the distinction resting largely in the beauty of the woods. The only recorded piece of elaborate furniture by Dester is a commode formerly in the Collection of the Earl of Plymouth. In this, highly ornate gilt-bronze mounts are combined with plaques of Paris porcelain. This commode formed one of a pair bought by the Comte d'Artois in 1785 from the marchand-miroitier Delaroue, established at 4 rue de Verrerie at the sign 'A la Toilette Royale'. They adorned the bedroom of the prince at the Palais du Temple, Paris, and were designed for his toilette; for this purpose they were fitted with boxes lined in blue chamois to hold toilet utensils. It seems that Delaroue was seeking to emulate the porcelain-mounted pieces in which Daguerre specialized.

[379] *Mahogany commode à vantaux stamped Dester, copying the 'commodes à brisure' produced c. 1785 by Weisweiler for Daguerre. (Archives Galerie Perrin, Paris)*

[380] *Mahogany secrétaire à abattant stamped Dester, c. 1785. (Christie's London, 6 April 1976, lot 49)*

[378] (left) *Toilet commode stamped Dester, decorated with Paris porcelain plaques (the largest also shown enlarged), made under the supervision of the marchand-miroitier Delaroue who sold it in 1785 to the Comte d'Artois for his bedchamber at the Temple. (Christie's London, 17 June 1987, lot 70)*

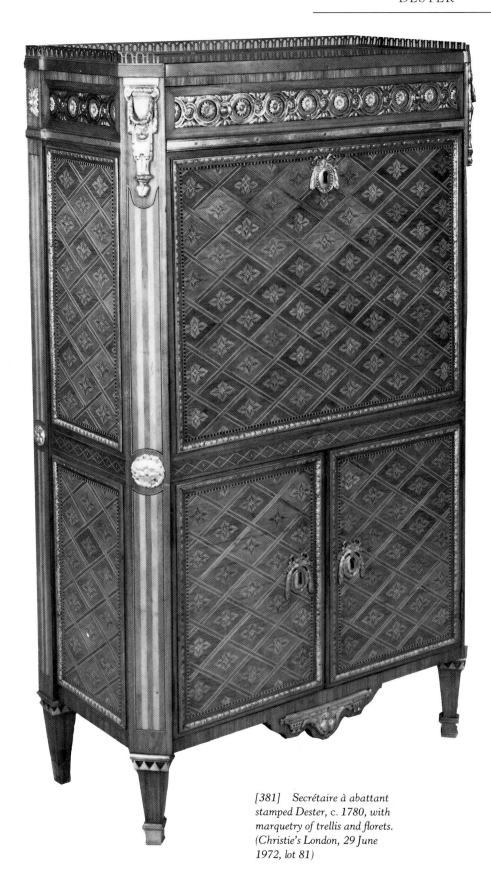

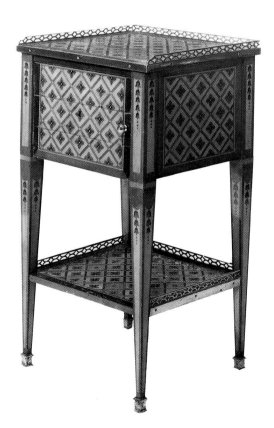

[382] *Chiffonnière table stamped Dester, c. 1780, with marquetry of trellis and florets. (Sotheby's, 25 May 1977, lot 441)*

[381] *Secrétaire à abattant stamped Dester, c. 1780, with marquetry of trellis and florets. (Christie's London, 29 June 1972, lot 81)*

BIBLIOGRAPHY
Jean-Jacques Gautier: 'Le Garde Meuble' in: *La Folie d'Artois*, 1988, p. 115
F. de Salverte: *Les Ébénistes*, p. 96

[383] Bonheur-du-jour stamped Dester, c. 1780. (Archives Galerie Perrin, Paris)

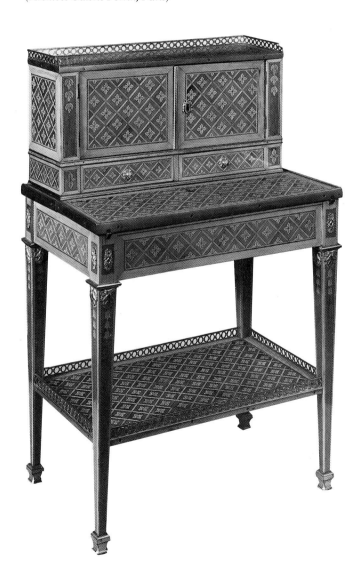

[384] Commode stamped Dester, c. 1780. En suite with the secrétaire illustrated at [381]. (Christie's London, 29 June 1972, lot 80).

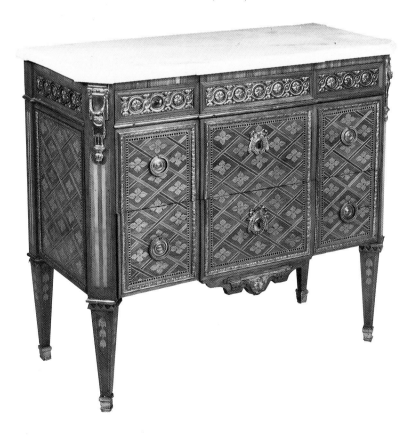

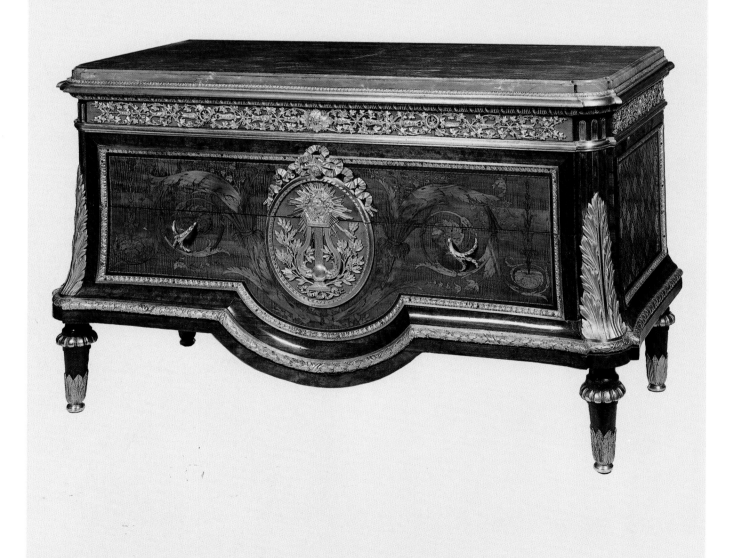

[385] *Commode stamped Leleu, c. 1780; the marquetry of arabesques in bois satiné on a sycamore ground and the large oval cartouche are designed to mask the horizontal division of the drawers. (Sotheby's Monaco, 26 May 1979, lot 33)*

Jean-François
LELEU

1729–1807; MASTER 1764

Jean-François Leleu was born in Paris and was first apprenticed in the workshop of Jean-François Oeben at the Arsenal. When the latter died in 1763, Leleu, aged thirty-four, seems to have wished to take over the workshop, but was supplanted by his younger colleague Riesener, who eventually married Oeben's widow. Leleu thereafter held a long-standing grudge against Riesener; Salverte cites a complaint by Riesener to the police in August 1765 claiming to have been assaulted by Leleu. Leaving Oeben's workshop, Leleu settled in the chaussée de la Contrescarpe opposite the Bastille, and became a master ébéniste on 19 September 1764.

He soon thrived and moved to a larger workshop in the rue Royale-Saint-Antoine (now rue de Birague) near the Place des Vosges. During this period he made several porcelain-mounted pieces, including two cylinder top desks (one in the Huntington Library which can be dated to 1767, the other formerly in the Lady Hillingdon Collection). Shortly afterwards he became official ébéniste to the Prince de Condé, to whom he supplied furniture between 1772 and 1777 for a total sum exceeding 60,000 livres (see Appendix). Some of these pieces are today in the Wallace Collection, others in the Petit Trianon and the Louvre. During the same period Leleu supplied furnishings for the Château du Marais and collaborated in the furnishing, in very advanced taste, of the Château de Méréville for the Court banker, the Marquis de Laborde. He also made some furniture for the Duc

d'Uzès who had his hôtel in Paris altered by Ledoux c. 1769.

Leleu was elected adjudicator of his guild for two years in 1774, syndic in 1776, and continued to hold office in the guild until the Revolution. Many pieces of furniture stamped by him were in fact made by the ébéniste Charles-Antoine Stadler, who also lived in the house in the rue Royale, and had married his step-daughter Anne-Louise Retrou in 1767. This is confirmed by the mention in the inventory on the latter's death in 1776 of 'a book in which Stadler inscribes the pieces he makes for Sr. Leleu his father-in-law, the total [...] amounting to 834 livres.'

Leleu's style is one of strict Neo-classicism applied to imposing designs where architectural elements are often emphasized by fluted pilasters at the corners and robust feet. The commodes are strictly rectangular in form with a flat front (or occasionally slightly bombé) but without the central breakfront section so often a feature on furniture of that period. In the case of the commodes, the two lower drawers are separated from

[386] *Mahogany cabinet stamped Leleu, c. 1785; of ingenious design, probably made to stand between two windows, it opens at the sides while the tambour of the fluted column reveals further drawers. (Sotheby's Monaco, 14 June 1981, lot 156)*

the frieze drawer and surrounded by a heavy gilt-bronze frame. Certain details of his decorative mounts are characteristic of Leleu: the interlaced ivy frieze appears on a commode in the Louvre [398] and on the commode formerly in the Wildenstein Collection [385]. Friezes of Vitruvian scrolls are found on the Palais-Bourbon commode [399] and on the secrétaire in the Wallace Collection [388]. These two pieces are mounted with feet forming robust lions' paws similar to those found on the bureau plat made for Lalive de Jully at Chantilly (which, though not by Leleu, must have been restored by him when being resold to the Duc de Chaulnes in 1770).

Leleu's speciality was marquetry, not only marquetry pictures (baskets of flowers and trophies) but

marquetry of arabesques on a striped sycamore ground, or geometric marquetry. Its excellence and minute detail are equalled only by Riesener. Certain geometric patterns in marquetry are also characteristic of this master, such as the octagonal motifs enclosing rosettes which are found on a secrétaire and commode in a private collection [391, 394], on a piece in the Musée Nissim de Camondo and on another formerly in the Rosebery Collection [392]. Moreover, Leleu was cited as 'ébéniste-marqueteur' in the *Almanach général des marchands du royaume* of 1779 and again in subsequent years.

BIBLIOGRAPHY

Arch. Nat., Min. Cent., LXXXIX, 715; inventory of Anne-Louise Retrou, daughter-in-law of Leleu, October 1776

Archives Condé, Chantilly, A.C.6., A.C.7: Leleu's invoice

[387] *Bureau plat stamped Leleu, c. 1780, bearing the mark of the Château de Bellevue with the monograms J.B. and M.V. in gilt bronze; marquetry of* *arabesques on a sycamore ground probably designed by an architect such as de Wailly. (Sotheby's London, 13 December 1974, lot 215).*

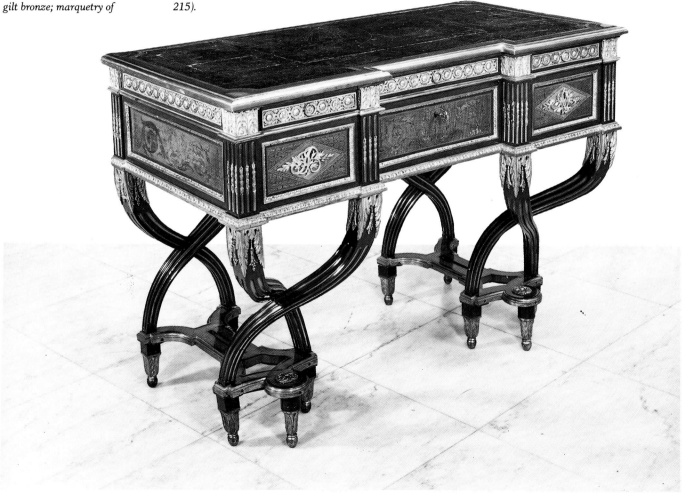

for furniture supplied to the Prince de Condé in 1772 and 1773

L'Estampille, September 1989, pp. 66–75

F. de Salverte, *Les Ébénistes*, pp. 198–200

Svend Eriksen: *Early Neoclassicism in France*, p. 201

Pierre Verlet: *La Maison française du XVIIIe siècle*, pp. 166–67

Michel Gallet: 'Ledoux et Paris', *Cahiers de la Rotonde*, 3, 1979, pp. 73–76

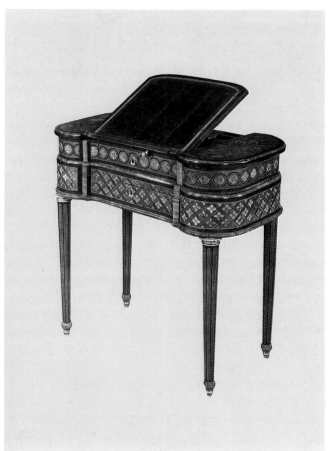

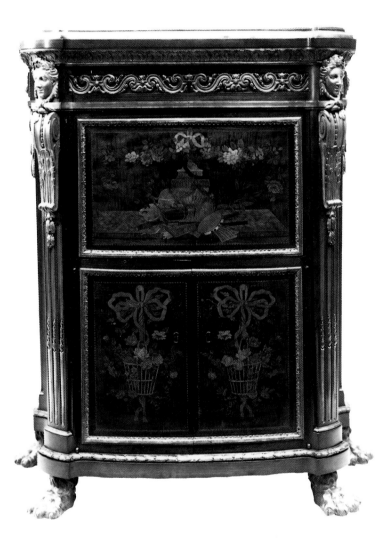

[389] Table d'accouchée stamped Leleu, c. 1775, with marquetry of florets. (Christie's London, 8 June 1961, lot 77)

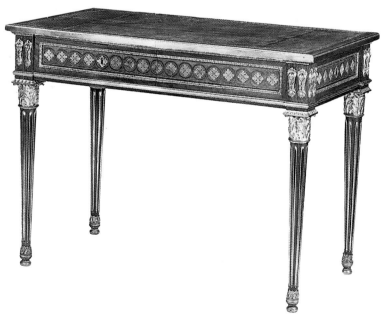

[388] Secrétaire à abattant with marquetry stamped Leleu, c. 1772. The frieze mounts are identical to those on the commode shown at [399]. (Wallace Collection, London)

[390] Writing-table, stamped Leleu, c. 1772, the marquetry with interlaced motifs and florets; Leleu supplied an almost identical table on 24 May 1772 for the Palais-Bourbon. (Sotheby's Monaco, 9 December 1984, lot 1054)

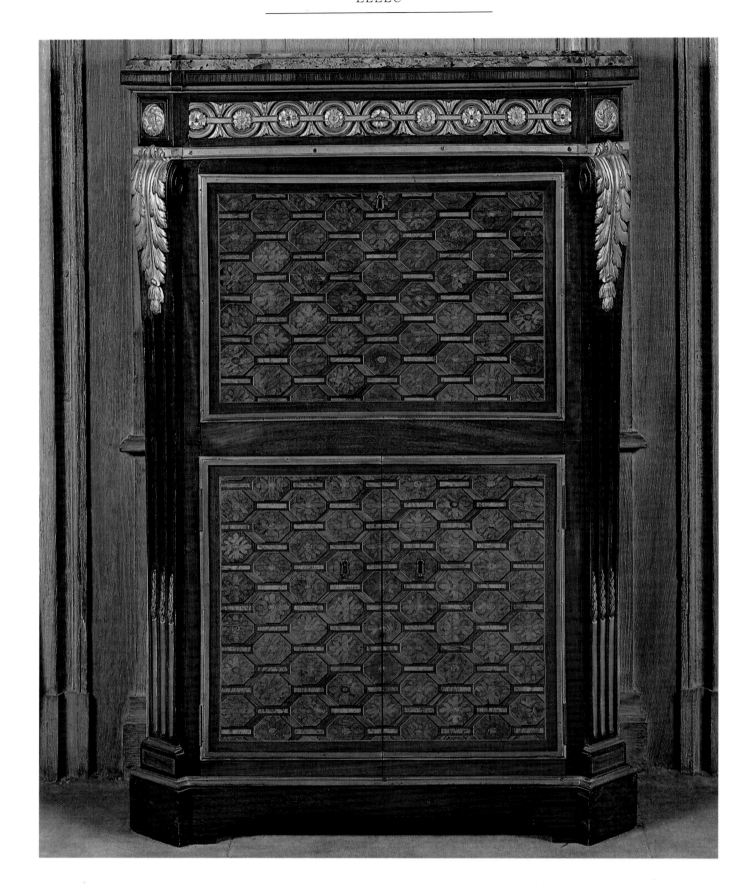

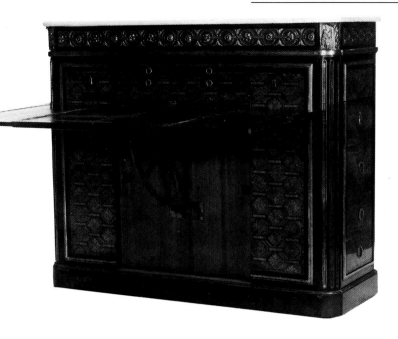

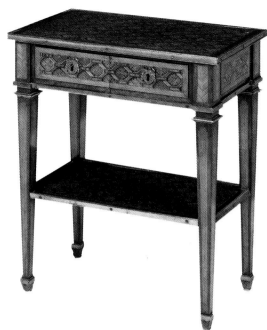

[391] (left) Secrétaire à abattant attributed to Leleu, c. 1770–75, with marquetry of florets within a pattern of hexagonal links. (Sale Galerie Petit, Paris, 26 May 1913, lot 62)

[392] Library cabinet attributed to Leleu with the date 1770 inscribed in ink. (J. Paul Getty Museum, Malibu, California)

[393] Writing-table stamped Leleu, c. 1770–75. (Sotheby's London, 5 June 1986, lot 71)

[394] (below) Commode en suite with the secrétaire illustrated at [391], stamped Leleu. (Sale Galerie Georges Petit, Paris, 26 May 1913, lot 61)

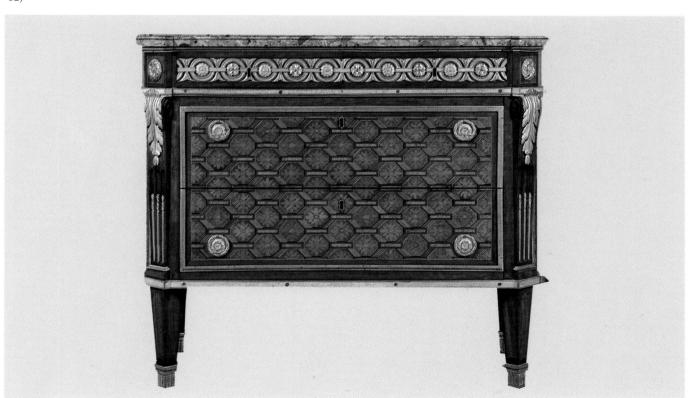

APPENDIX

ACCOUNTS RENDERED BY SR.
LELEU ÉBÉNISTE (MAÎTRE
ÉBÉNISTE IN THE RUE AND CLOSE
TO THE PLACE ROYALE) FOR THE
PALAIS BOURBON, THE YEARS
1772 AND 1773
(ARCHIVES CONDÉ, CHANTILLY,
A.C.7)

*30 April 1772, Cabinet of His
Serene Highness:*
1) To supplying a secrétaire for
the Palais Bourbon, 3 pieds 2
pouces in height, 3 pieds 6
pouces in width and 15 pouces in
depth, all in oak from the
Vosges. In the upper section
there is a gradin comprising 8
drawers in solid bois satiné, each
one with a handle. In one of the
drawers is an escritoire (with 3
compartments), well finished and
mounted in mercury-gilded
bronze. In the middle is a section
with 4 drawers with secret
opening device, the aforesaid
gradin veneered in tulipwood.
The fall-front is closed with 2 gilt
swing hinges, serrure à pignon,
key chased, and decorated with
black velvet. The base section
comprises a gradin and two
drawers and a strong-box in solid
bois satiné with their handles.
The gradin and front veneered in
tulipwood and amaranth as well
as the doors; the said doors are
fitted with 4 hinges, serrures à
bascules and demi-bascule with
rim lock, all well finished and
gilded. *890L (reduced to) 730L*
2) Also for fixing and fitting all
the mounts and screws. *60L*

*23 June, cabinet of Mgr le Duc de
Bourbon:*
3) To supplying a secrétaire en
pente of 2 pieds 8 pouces long by
1 pied in height and 13 pouces in
depth, fitted into panelling with
strong hinges and a closing
mechanism. The door is
decorated in bois des Indes.
Inside the cupboard is fitted with
a shutter with 2 hinges. The
interior of the said secrétaire
contains 4 drawers of which one

[395] *Secrétaire à abattant
stamped Leleu, c. 1770–75, with
floral marquetry and cube
marquetry on the sides, the
monogram M.L.C. or M.L.J. on
the fall-front. (Archives Galerie
Levy, Paris)*

is decorated with 3 gilt-bronze
feet and veneered in tulipwood.
The fall-front covered with
morocco leather and a gold
braid, 2 hinges à repos and a
serrure à pignon. The exterior is
veneered in tulipwood and
amaranth with black and white
stringing, decorated with rings,
escutcheons and knob gilt in or
moulu. *395L (reduced to 330L)*
4) To supplying a screen of 3
pieds 6 pouces in height by 20
pouces wide with 4 leaves, of
double thickness at the base, in
solid tulipwood and 4 frames in
oak, the edges in amaranth fitted
with 6 double hinges in gilt-
bronze. *250L (reduced to 200L)*
5) To supplying an identical
screen to the above for Chantilly.
250L (reduced to 220L)
6) To having widened the fall-
front of the painted secrétaire by
6 pouces, veneered in tulipwood,
the interior re-covered in black
velvet, fitted with 2 oak hinges
with gilt heads, for this *55L
(reduced to 38L)*

*30 November, the Pink Salon of
His Serene Highness:*
7) To supplying a cylinder desk
of 2 pieds 6 pouces in length, 18
pouces deep and 3 pieds 3
pouces in height. The upper
section is fitted with 6 drawers in
solid bois satiné veneered in a
mosaic pattern, and the slide
fitted with a mechanism which
operates the fall-front and
covered with black velvet. The
lower section comprises 5
drawers in solid mahogany in
which there is an oval fitted with
a lock which locks the whole
piece by means of other
mechanisms; the said secrétaire
is on square feet with indented
corners; up above are consoles in
solid amaranth fluted and inlaid
in brass, the legs veneered in
amaranth and tulipwood with
black and white stringing, the
panels and fall-front in shaded
mosaic patterns; 2 keys, one à
l'anglaise, the other chased and
with coats of arms. The said
secrétaire is decorated with 4
ball-shaped sabots and lotus
leaves. The angles of the feet
with 14 ends of garlands of oak
leaves; above, 8 double lotus
leaves, the squares made up of
beads, 12 lions' heads, a single
moulding for the pilaster, 18
rods and bay florets, 6
ornamental leaves, 10 leaf

rosettes with scrolls. On the sides
and front are 5 frames in bay
leaves of which one is oval, in the
middle a sun; the quart-de-rond
with an acanthus-leaf moulding.
On the upper section the sides
decorated with 2 semi-circles in
double Vitruvian scrolls. The
curved part at the front and the
frieze with the same
ornamentation. On the top is a
single moulding acting as the
surround for the marble, all well-
finished and in mercury-gilded
bronze, for this *4,760L (reduced
to 3,940L)*

*Bed-chamber of His Serene
Highness:*
8) To supplying a commode 3
pieds 10 pouces in length, 32
pouces in height and 23 pouces
in depth with cut angles, the
carcase in oak from the Vosges
veneered in amaranth and bois
satiné with black and white
stringing. The sides and 2 panels
of the front in mosaic marquetry.
In the middle is an oval of bay
and a basket of flowers, all
shaded. The drawers lined in
blue moiré silk, fitted with a key
for all 3 locks, and 2 keys, one
chased. The said commode is
decorated with 4 fluted pilasters
inlaid with brass and with 4
leaves. In the frieze is a
Vitruvian scroll. Above is a
concave moulding with a flat
border above. On the panels 3
decorated frames, 4 rings and
rosettes. On the base a moulding
and zigzag moulding; the feet in
the form of 4 lions' paws, all
well-finished and in mercury-
gilded bronze. *2,950L (reduced to
2,460L) [399]*

13 November:
9) To supplying a commode of
3 pieds 6 pouces in width, 23
pouces in depth and 32 pouces in
height including the marble,
veneered in tulipwood and
amaranth, panels of cube-
patterned marquetry, black and
white stringing, fitted with its
gilt-bronze chased mounts and
top of brèche d'Alep marble.
565L (reduced to 465L)
10) Plus a commode of 3 pieds
3 pouces in width, 17 pouces in
depth, 31 pouces in height,
veneered in tulipwood, black and
white stringing fitted with its
gilt-bronze mounts and cervelas
marble top, for this *380L
(reduced to 330L)*

14 November:
11) To supplying 2 adjustable
fire-screens in tulipwood, 31
pouces in height and 15 pouces
in width covered in crimson
taffeta. *52L (reduced to 44L)*
12) Plus 6 fire-screens in
mahogany 30 pouces high on
stands, 4 covered in green taffeta
and 2 in crimson taffeta, at 10L
each. *60L (reduced to 54L)*
13) Plus 6 other fire-screens in
reddened walnut of the same
proportions, of which 4 are
covered in green and 2 in
crimson, at 7L 10s each. *45L
(reduced to 39)*
14) Plus 2 screens with 4 leaves
in bois satiné, 30 pouces in
height by 1 pied in width covered
in green taffeta, at 52L each.
104L (reduced to 90L)
15) Plus supplying 4 whist
tables of 34 pouces, of which 3
are in walnut and one in wild
cherry at 36L each. *144L (reduced
to 128L)*
16) To supplying a set of steps
in walnut. *80L (reduced to 66L)*
[…]

18 November:
29) To supplying two trictrac
tables in walnut. *64L (reduced to
56L)*
Plus two panier boxes, painted
with decorative surround, for
this. *30L (adjusted to 34L)*

28 November:
30) To repairing a table en
secrétaire with opening
mechanism, refitting the gold-
coloured mounts, reburnishing as
new, fitting screws, for this *38L
(reduced to 33L) For collecting and
delivering: 3L*
31) To supplying a commode 5
pieds 10 pouces in width, 3 pieds
in height, 2 pieds 6 pouces in
depth, the carcase in oak from
the Vosges. The front has 3
drawers, of which one is in the
frieze with a lock fitted with a
mechanism which locks the 2
large drawers below. The 2
curved sides are fitted with 2
doors, veneered inside in bois
satiné and amaranth with black
and white stringing, and 3
drawers in each veneered in
tulipwood. In the upper frieze
are 2 drawers each with its own
key. All the insides lined in blue
moiré silk. The said doors fitted
with metal hinges and gilt-
bronze lock. The frieze on the
said commode veneered in

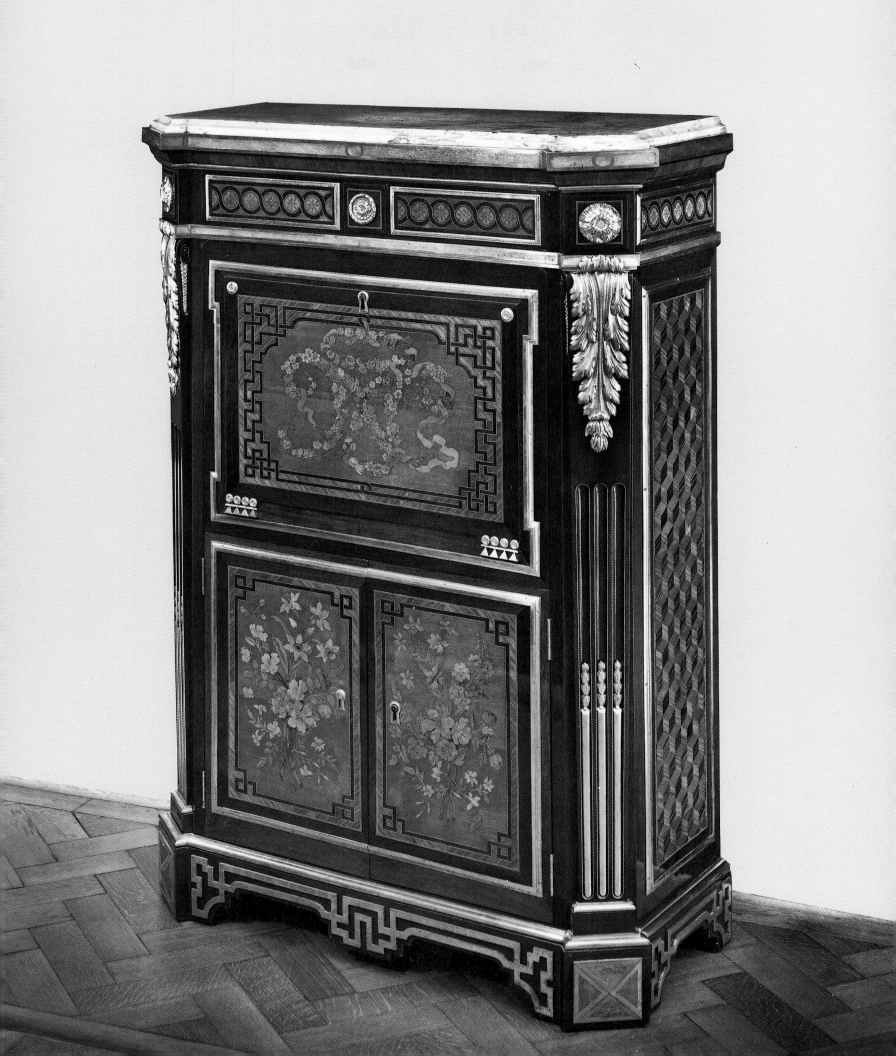

amaranth with black and white stringing. On the front panel is a moulded oval, with blue ground and inlaid cipher, 2 garlands of flowers, 2 olive-branches. The curved sides with 2 bouquets of flowers. The side panels veneered in varied fleurs-de-lys patterns. The said commode is decorated with 6 sabots ball-shaped and water foliage, columnar legs with bronze flutes, 6 capitals, 6 interlaced circles and rosettes, 6 large ornamental leaves. Above is a large moulding with oval motifs, a fretwork frieze, a flat ribbon moulding, another moulding of fillets above capitals; 5 frames of water foliage, 4 handles; all fitted with screws. The said mounts moulded from wax, well chased and gilt in gilt-bronze and 2 keys, one chased. For this. . .*10,715L (reduced to 8,970L)*

1 May 1773:
32) To supplying 2 commodes of 2 pieds 9 pouces in width by 33 pouces in height and 19 pouces in depth, the carcase of oak from the Vosges with 3 drawers each, of which one in the frieze is fitted with the mechanism to lock the lower 2 and 3 keys of which one is chased, the interiors lined in moiré silk, legs of circular section fluted with gilt bronze inlay; the said commodes veneered, the friezes with amaranth, black and white stringing, the side panels in mosaic of shaded fleurs-de-lys; the fronts in blue wood; in the centre are 2 lozenges with toothed mouldings and fleurs-de-lys motif, all shaded. Each of the said commodes fitted with 4 sabots, 4 capitals, 4 double Vitruvian scrolls on the legs, 14 pouces in height and 2 in width, 4 garlands above, flowers and fruits. On the frieze a double foliate motif, on the front 4 handles, a large decorated frame and 2 on the sides, 3 plain mouldings applied with screws, all well fitted, chased and mercury gilded, for this *7,470L (reduced to 6,085L)* [396]

[Description of commodes in the Petit Trianon]
33) To supplying a commode chair 18 pouces in height, 18 pouces in depth and 15 pouces in width on circular legs with brackets, veneered in bois satiné, black and white stringing, solid

wooden mouldings, the top with two metal hinges gilt in gold leaf, sabots and handles mercury-gilded, the seat and back covered in crimson velvet with gold braid, with its pot, for this *188L (reduced to 151L)*

24 May:
34) To supplying a bureau 2 pieds 8 pouces in width, 18 pouces in depth and 27$\frac{1}{2}$ pouces in height, with 2 drawers lined in moiré silk and gold braid, and fitted with their locks in brass and key. The said bureau veneered in amaranth with black and white stringing. The frieze with interlaced circles and rosettes shaded, circular feet with flutes with inlaid brass, fitted with 4 sabots, 4 astragals, 4 cut-out fleurs-de-lys, 2 plain mouldings, a quadrant, 4 foliate frames, all chased and mercury-gilded, the top covered in green velvet, for this *780L (reduced to 635L)*
35) Plus supplying a night-table of 19 pouces in width, 13 pouces in depth and 32 pouces in height, with canted corners, round fluted legs, all veneered in tulipwood and amaranth, black and white stringing, and on top a wooden motif; the said table decorated with 4 sabots, 4 astragals, 2 handles, 4 rosettes and a balustrade, all chased and gilt in gilded-bronze, for this *220L (reduced to 185L)*

11 September:
36) To supplying a bidet of 21 pouces in width, 14 pouces in depth and 18 pouces in height, all veneered in tulipwood, black and white stringing on the false back, fitted to slide with 6 plaques in gilt metal. The top closes, and the mouldings in solid tulipwood, the top covered in red velvet and 2 wash-basins from Rouen, for this *215L (reduced to 183L)*

30 September
37) To restoring a writing-table in walnut and its top for Monseigneur le Duc de Bourbon, 3L (reduced to 2L 10s)

Total: 31,653L (reduced to 26,276L 10s)

Noted on 23 February 1776 by Bellisard, architect of the Houses of the Prince de Condé at the Palais de Bourbon

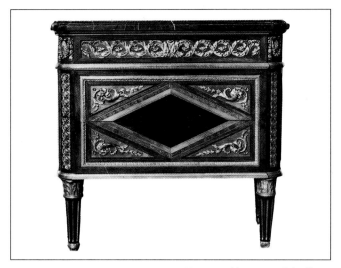

[396] *Commode, one of a pair delivered by Leleu on 1 May 1773 for the bed-chamber of the Duchesse de Bourbon in Paris.* *The central lozenge, originally veneered with a fleur-de-lys motif, was reveneered during the Revolution (Musée de Versailles)*

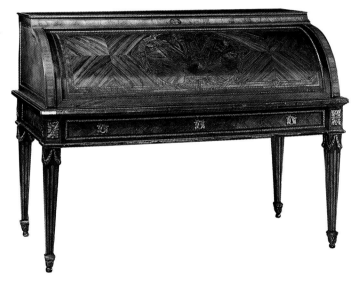

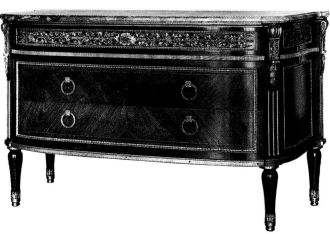

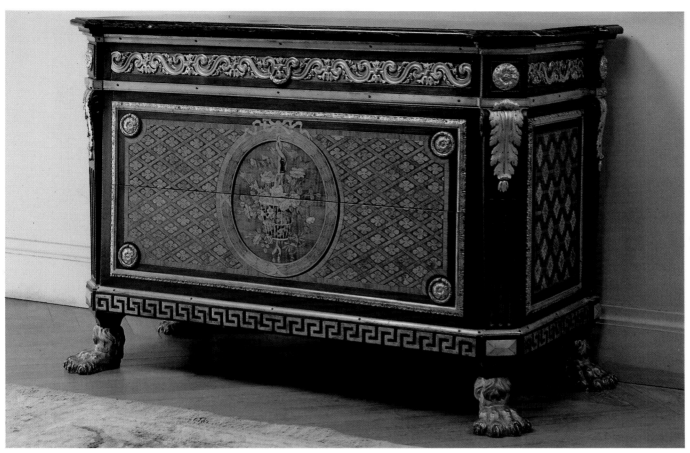

[397] (left) Secrétaire à
cylindre in tulipwood parquetry,
c. 1780, stamped Leleu.
(Christie's London, 20 June
1985, lot 88)

[399] (above) Commode with
trelliswork marquetry with
florets, stamped Leleu, delivered
on 9 November 1772 for the bed-
chamber of the Duc de Bourbon

in Paris; the vigorous lion's paws
are found on several other pieces
by Leleu. (Musée du Louvre,
Paris)

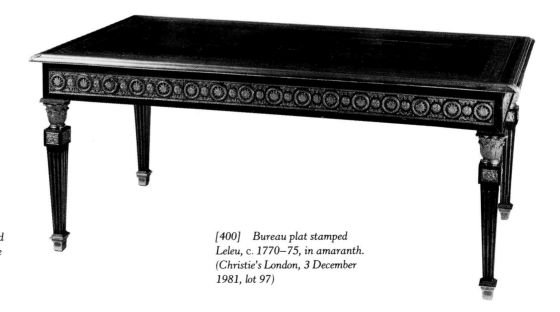

[398] (left) Commode stamped
Leleu, c. 1780, in tulipwood, the
front slightly bombé. (Musée de
Versailles)

[400] Bureau plat stamped
Leleu, c. 1770–75, in amaranth.
(Christie's London, 3 December
1981, lot 97)

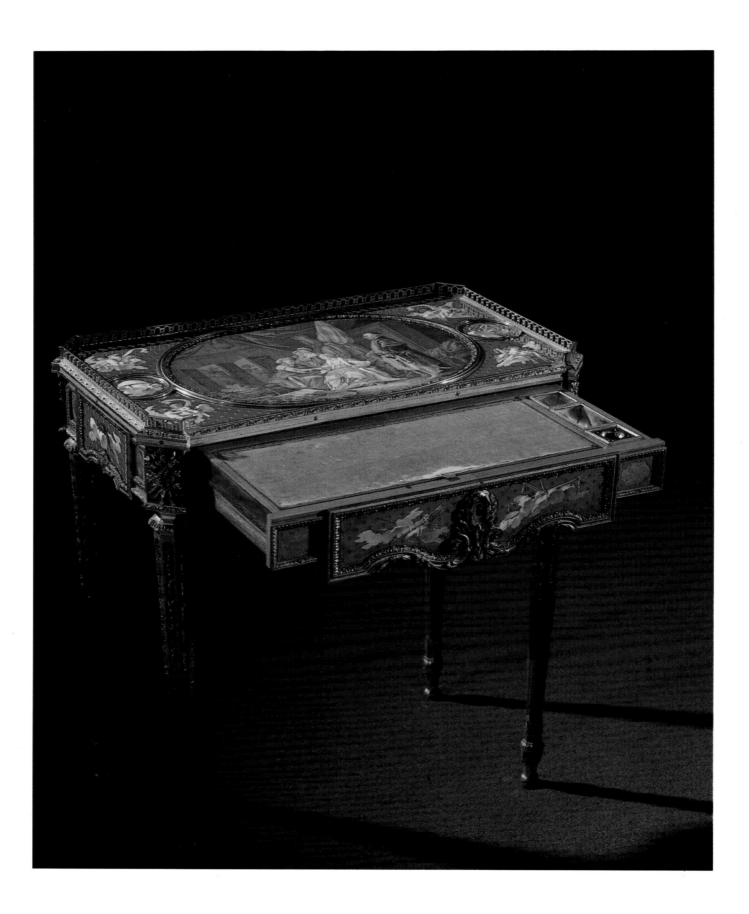

Martin
CARLIN

c. 1730–85; MASTER 1766

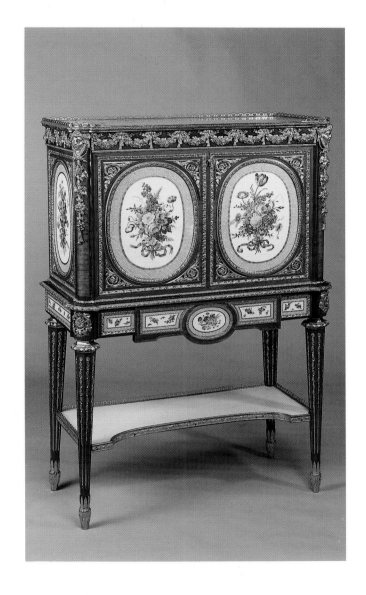

orn probably around 1730, in the principality of Baden, Martin Carlin was the son of Trouper Carlin, carpenter in Fribourg-en-Brisgau. Nothing is known of his apprenticeship or when he came to Paris, except that by 1759 he was settled there in the company of other German and Flemish ébénistes such as the Oeben and Vandercruse families. On 26 February 1759 he married Marie-Catherine Oeben, Jean-François Oeben's sister. Roger Vandercruse and Oeben attended the wedding as witnesses. The contract reveals that Carlin was still a dayworker living on the quai des Célestins. The proximity to the Arsenal and Oeben's own workshop suggests that he must have worked for the latter, particularly as Carlin's name appears among the creditors at the time of Oeben's death in 1763. He was owed the sum of '515 livres still owing from 1,734 livres for the supply of furniture and related merchandise'. The links between the two ébénistes were strengthened by the fact that Oeben had married Vandercruse's sister, who was a friend of Carlin's (Vandercruse became guardian to Carlin's children on the latter's death). At the time of his marriage, Carlin's assets together with those of his wife were valued at the relatively modest sum of 700 livres.

As early as 1763 the couple were living in the Grand-Rue du Faubourg Saint-Antoine at the sign of 'la Colombe' where Carlin is cited in the inventory taken after Oeben's death. Carlin was working at the time as an independent craftsman. He soon began supplying furniture to the marchand-mercier Simon-

[401] Table stamped Carlin, c. 1772; the porcelain plaque signed by Dodin and dated 1771; sold by Poirier to Mme du Barry for 5,500L. Subsequently the table belonged to Queen Maria-Carolina of Naples. (Gulbenkian Museum, Lisbon)

[402] Secrétaire à abattant stamped Carlin; the porcelain plaques dating from 1778 are the only known plaques with a mauve border: they were sold to the dealer Daguerre on 10 June 1778. (Archives Galerie Mikaeloff, Paris)

Philippe Poirier, no doubt on the recommendation of Roger Vandercruse who already worked for him. The first piece of furniture by Carlin decorated with porcelain plaques, the bonheur-du-jour in the Bowes Museum, can be dated from the plaques to 1765. On 30 July 1766 Carlin became a master ébéniste. Over the next twelve years, from 1766 to 1778, he made porcelain-mounted furniture for Poirier, certainly after designs provided by Poirier and using mounts and porcelain plaques also supplied by him. These are almost always small-scale pieces: small tables, guéridons, music-stands, jewel-cabinets, bonheurs-du-jour and secrétaires en cabinet. They amount to eighty pieces, almost a third of Carlin's known production.

After 1775 the production of porcelain-mounted furniture decreased considerably. Carlin still made a console-desserte [421] for Daguerre in 1784 as well as a commode à encoignures which would later belong to George IV (dated around 1783–84). Between the years 1781 and 1783 he also perfected a small rectangular table with a shaped plaque on the front (of which there are examples in the Frick Collection, Wallace Collection, Huntington Library and Waddesdon Manor). Only a dozen pieces of porcelain furniture were produced after 1778. At this period furniture in Japanese lacquer was very fashionable, and Carlin produced sumptuous pieces for the marchands such as the sons of Darnault. An early group, comprising a commode-secrétaire and two encoignures, was bought from Darnault by Mesdames (the aunts of Louis XVI) for the Château de Bellevue in 1781 (now in the Louvre, the commode reveneered in ebony). But the finest group, also made up of a commode and two encoignures [420], was not delivered by

[403] *Bureau plat stamped Carlin and Schneider (who must have completed it) in Japanese lacquer, c. 1785–86; originally in the Cabinet of Madame Victoire at Bellevue. (Musée du Louvre, Paris)*

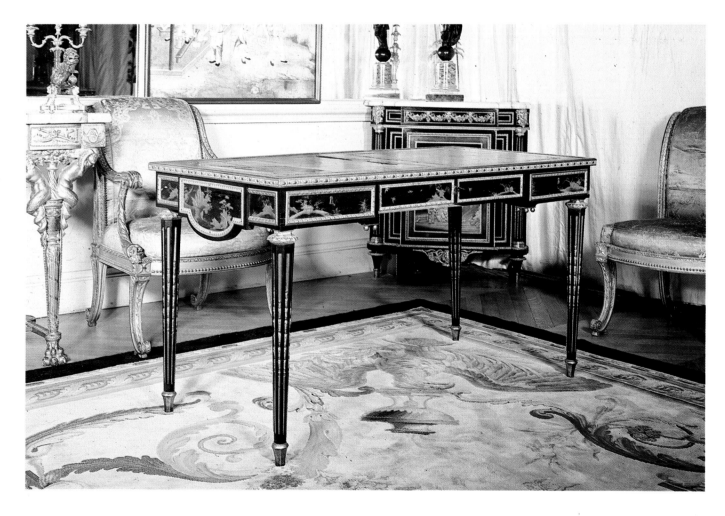

Darnault for Madame Victoire at Bellevue until after Carlin's death in 1785. These well-documented pieces of furniture confirm the theory that the lacquer (also the mounts in many cases) was supplied to the ébéniste by the marchand who had received the commission. Their valuable Japanese lacquer panels came in fact from a chest belonging to the Duc d'Aumont which was sold to Darnault in 1782 for 2,449 livres when his collection was dispersed. The commode itself was sold on to Madame Victoire for 6,500 livres and the encoignures for 5,400 livres.

Carlin also made lacquered furniture for Daguerre. The commode à encoignures in the Louvre, formerly the property of Mme de Brunoy [419], was certainly sold by Daguerre; it is almost identical to certain examples by Saunier [441] who was also working for Daguerre at that time.

Carlin died on 6 March 1785. His three children were still minors, two daughters and a son, Simon Carlin. Roger Vandercruse took charge of their education. Less than a year after his death, his widow married the ébéniste Gaspar Schneider.

Carlin had two successive addresses in the same street. The first, identified by Salverte, is on a piece of furniture incribed 'M. Carlin, grande-rue du Faubourg Saint-Antoine in the large gate near the Charonne fountain'. This was no. 59. At the time of his death he was actually living at no. 127 in the same street in a house called 'Saint-Esprit' or 'La Colombe' opposite the Foundling Asylum.

The inventory after his death was drawn up on 20 April 1785 by the ébénistes Leleu and Nicolas Petit and the casters André Ravrio and Joachim Provost.

[404] *Bureau plat and cartonnier in Japanese lacquer stamped Martin Carlin, c. 1780–85. Madame Adélaïde had in her Cabinet at Bellevue a bureau plat with cartonnier of this design, the legs of which, however, were octagonal. (Christie's London, 9 December 1982, lot 75)*

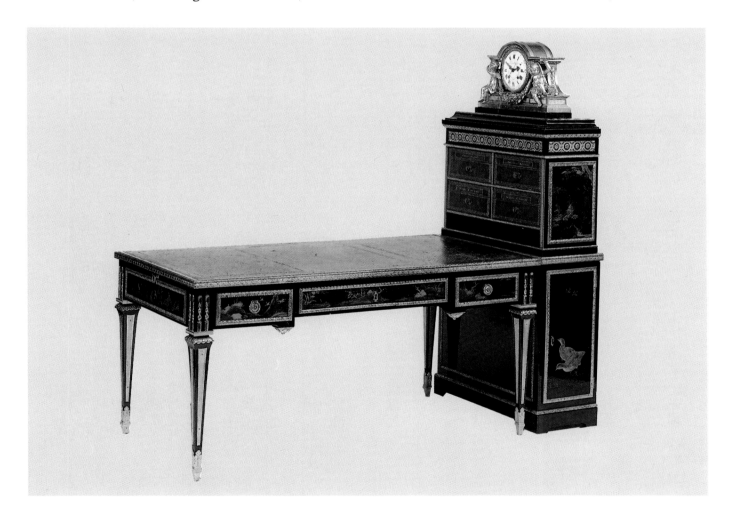

They itemized a prosperous concern with assets valued at 12,000 livres and no debts. The workshop was fitted with seven work-benches, five with their tools, and contained stocks of wood – mostly tulipwood and bois jaune, amaranth, bois satiné and mahogany, as well as 'nine bundles of hollywood in sheets'. They found thirty pieces of furniture in the two workshops in various stages of completion, valued altogether at 4,500 livres. The most important piece was a lacquer commode valued at 1,500 livres [420], the one which Darnault supplied to Bellevue, with its mounts described as 'original models, prepared and chased, ready to be gilded'. Other valuable pieces of furniture included an ebony bureau plat with four drawers and its serre-papiers, valued at 700 livres, and a plum-pudding mahogany bookcase with glazed doors, valued at 350 livres. The remaining stock comprised a secrétaire in plum-pudding mahogany with columns decorated with gilt-bronze drapery mounts, seven oval or circular marquetry tables, two mechanical tables with 'fitted drawers for toiletry', a trictrac-table, eight tapering legs veneered in tulipwood and two encoignures still to be fitted with lacquer panels. The workshop also contained stocks of bronze mounts as yet unchased or gilded to be mounted on furniture (450 livres of 'unsorted bronze casts') valued at 735 livres, as well as a number of bronze models.

The records mentioned at the end of the inventory confirm that Carlin worked exclusively for the marchands-merciers. There is no mention of private clients but a thick stack of bills alludes to furniture supplied to Daguerre (24 sheets written on both sides) for a total of 3,117 livres. The name of the ciseleur-doreur used by Carlin is quoted as 'S. Prevost ciseleur' to whom Carlin owed 679 livres 'for professional services carried out by him for Sieur Carlin'. These were the only debts in his well-regulated financial affairs.

Carlin's output consisted mainly of luxury furniture; besides the eighty porcelain-mounted pieces of furniture representing about a third of his known work (see Appendix), there were also pieces in Japanese lacquer and pieces in mahogany or marquetry. Among the veneers, tulipwood was the most highly favoured and was sometimes used in sunburst motifs with a refinement particular to Carlin. The supports of guéridons were often veneered in a spiral pattern. The design of the marquetry does not make use of flowers but rather of abstract arabesques or geometric motifs:

lozenges, pointed trelliswork, octagons with florets and interlaced ovals. Between 1780 and 1785, towards the end of his life, Carlin used plum-pudding mahogany, as is indicated by various mentions in the inventory made after his death and by the existence of such pieces, bureaux plats and a secrétaire en cabinet bearing his stamp.

On the lacquered pieces of furniture Carlin used ebony to frame the lacquer panels, unlike Weisweiler who used mahogany. Certain stylistic characteristics are worth pointing out: the raised feet are almost always in octagonal section with bronze fluting. The low feet are often toupie feet. Carlin often designed his furniture with a central break-front, emphasizing it on the lower edge of tables with a curvilinear frieze, sometimes with gilt-bronze balls. Sumptuous mounts, certainly supplied by the marchands-merciers, are of

[405] *Secrétaire en cabinet in 'plum-pudding' mahogany stamped Carlin, c. 1780. The* *frieze of gilt-bronze drapery is characteristic of Carlin's work. (Sale Galerie Charpentier, Paris)*

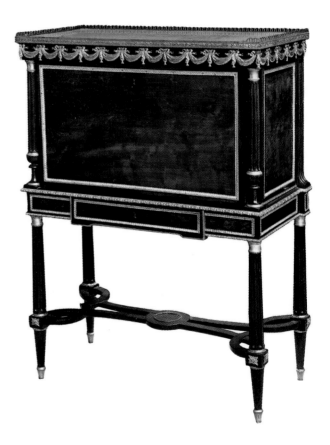

identical types. Festoon drapery was often used [405] as well as a small frieze of bayleaves mounted on the edge of table-tops. Garlands of fruit and flowers attached to tied ribbons form the frieze on numerous commodes [408]. Fringed lambrequins, derived from Boulle, are found on a number of bureaux plats in lacquer. Identical busts of vestal virgins are found on a number of commodes and secrétaires (in the Ojjeh/Clore Collection [414], the Riahi Collection, the Duc de Vendôme's secrétaire sold in Paris on 4 December 1931, now in a private collection [406], and a lacquer commode in the British Royal Collection).

The main part of Carlin's output consisted of small pieces of furniture, in particular, an infinite variety of tables – writing-tables, toilet-tables, work-tables, music-stands, guéridons, tea-tables, trictrac-tables, often with applied precious materials. Only a few

secrétaires à abattant are recorded, but above all, Carlin introduced a new type of secrétaire, in the form of a cabinet raised on a high table. This design, which perhaps derived from the late seventeenth-century Spanish vargueños, seems to have been invented by Carlin or the dealers for whom he worked. He designed a number of variants of this piece and it continued to be produced by his successor, Weisweiler, for the dealers.

His porcelain-mounted jewel-cabinets were of a type created earlier by B. V. R. B. in marquetry for the marchands-merciers, while his bonheurs-du-jour appeared in about 1765 at the same time as those by R. V. L. C., Pioniez and Topino. The lighter pieces of furniture made by Carlin were almost always designed for women. The names of his clients are known from sale catalogues from the end of the eighteenth century

[406] Secrétaire à abattant. Several similar examples with the same corner mounts were made by Carlin: one belonged to the Duc de Vendôme (sale Paris, 4 December 1931, lot 99); another is illustrated in Connaissance des Arts, October 1953, p. 36. (Archives Galerie Fabre, Paris)

[407] On 30 December 1773 Poirier sold to Mme du Barry 'a secrétaire with French porcelain with a green border, richly decorated with mercury-gilded gilt-bronze mounts, 2,640L' which probably corresponds to the example illustrated here, as the plaques with green border are dated 1773. (Metropolitan Museum of Art, New York; Kress Collection)

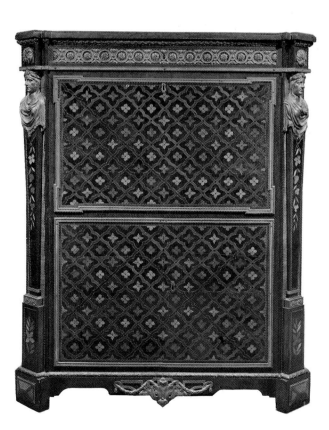

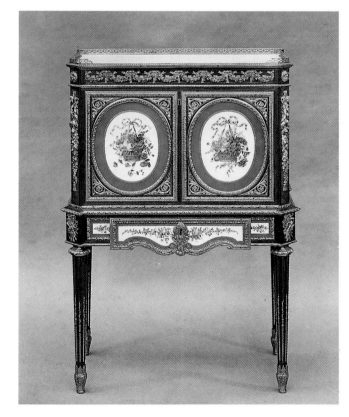

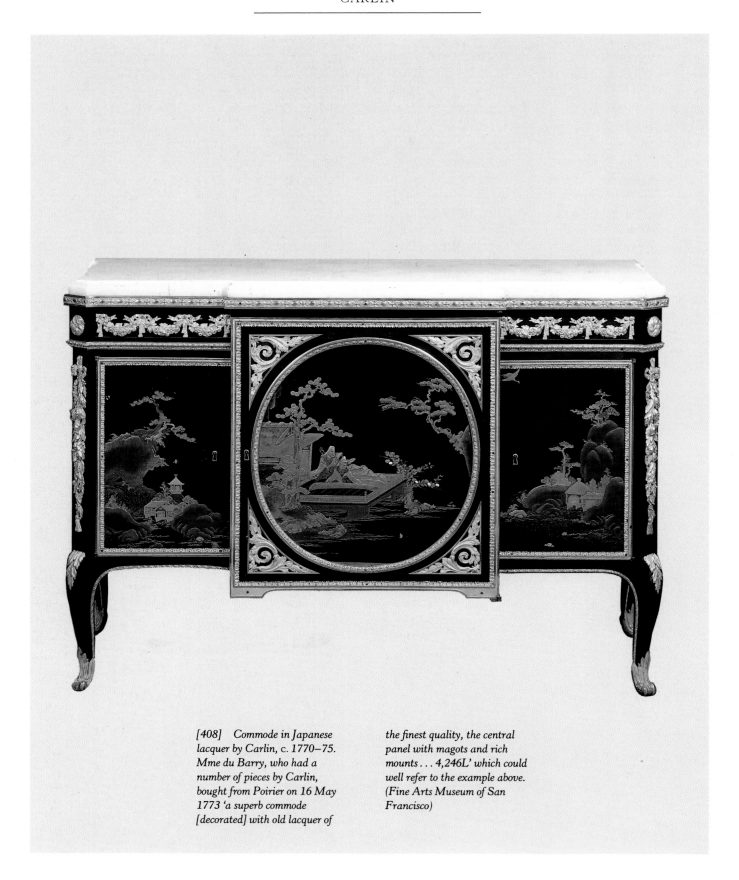

[408] Commode in Japanese
lacquer by Carlin, c. 1770–75.
Mme du Barry, who had a
number of pieces by Carlin,
bought from Poirier on 16 May
1773 'a superb commode
[decorated] with old lacquer of
the finest quality, the central
panel with magots and rich
mounts . . . 4,246L' which could
well refer to the example above.
(Fine Arts Museum of San
Francisco)

or the confiscations of the Revolution. Mme du Barry bought numerous pieces by Carlin mounted with porcelain or lacquer through Poirier, as did another courtesan, Mlle Laguerre, who owned a commode in pietra-dura [415], a lacquer secrétaire [410] and a porcelain-mounted example. The Duchesse de Mazarin owned a trictrac-table with porcelain plaques by him. Louis XVI's sisters-in-law, the Comtesse d'Artois and the Comtesse de Provence, also had secrétaires or jewel-cabinets with porcelain plaques as did the Duchesse de Bourbon. Marie-Antoinette's sisters, Maria-Carolina, Queen of Naples and the Duchesse de Saxe-Teschen also collected this type of furniture; the former bought (through Daguerre) a porcelain-mounted table previously commissioned by Poirier for Mme du Barry [401] and the latter had a whole series of porcelain-mounted furniture at Laeken, bought from Daguerre who provided Carlin with the designs. Drawings for these, now in the Metropolitan Museum, are the most significant records concerning Carlin available today (see Introduction, pp. 5, 38–39).

BIBLIOGRAPHY

F. de Salverte: 'Documents inédits sur les ébénistes Martin Carlin et G. Jacob', *Bulletin de la Société de l'histoire de l'art français*, 1928, pp. 84–111 [in which Salverte published the inventory taken after Carlin's death].

Patricia Lemonnier: Les commodes de Martin Carlin', *L'Estampille*, July 1984, pp. 6–19

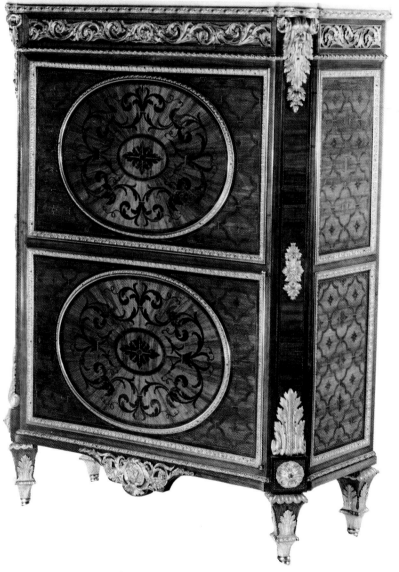

[409, 410] Commode and secrétaire à abattant with tulipwood marquetry stamped Carlin, c. 1775. (Huntington Art Gallery, San Marino, California)

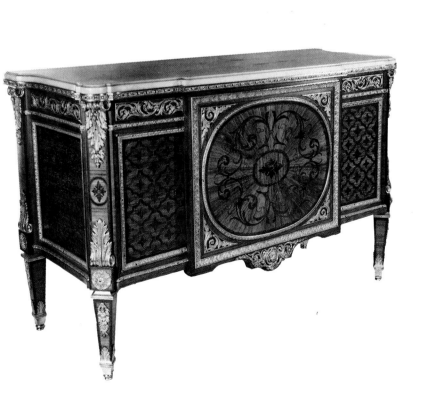

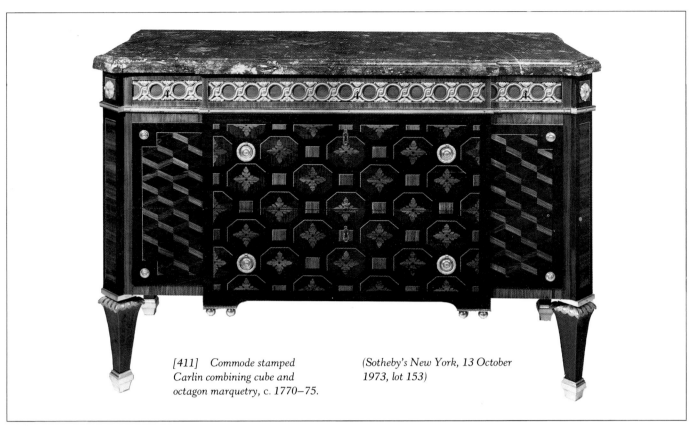

[411] Commode stamped
Carlin combining cube and
octagon marquetry, c. 1770–75.

(Sotheby's New York, 13 October
1973, lot 153)

[412] (below left) Small
commode with octagon marquetry
stamped Carlin, c. 1766–70.
(Sotheby's Monaco, 21 May
1978, lot 154)

[413] (below right) Chevron
marquetry as found on work by
the Oeben brothers is less
frequently found on Carlin's
work. Commode stamped Carlin,
c. 1766–70. (Sotheby's Monaco,
13 February 1983, lot 504)

[414] (right) Commode à
vantaux stamped Carlin,
inscribed 'Poirier marchand rue
St-Honoré à Paris'. Here Carlin
uses marquetry of 'interlaced
hearts and losenges' on a wavy

bois satiné ground. The mounts in
the form of vestal virgins appear
on other commodes and
secrétaires by Carlin. (Christie's
New York, 6 December 1985, lot
54)

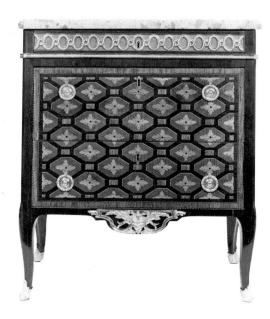

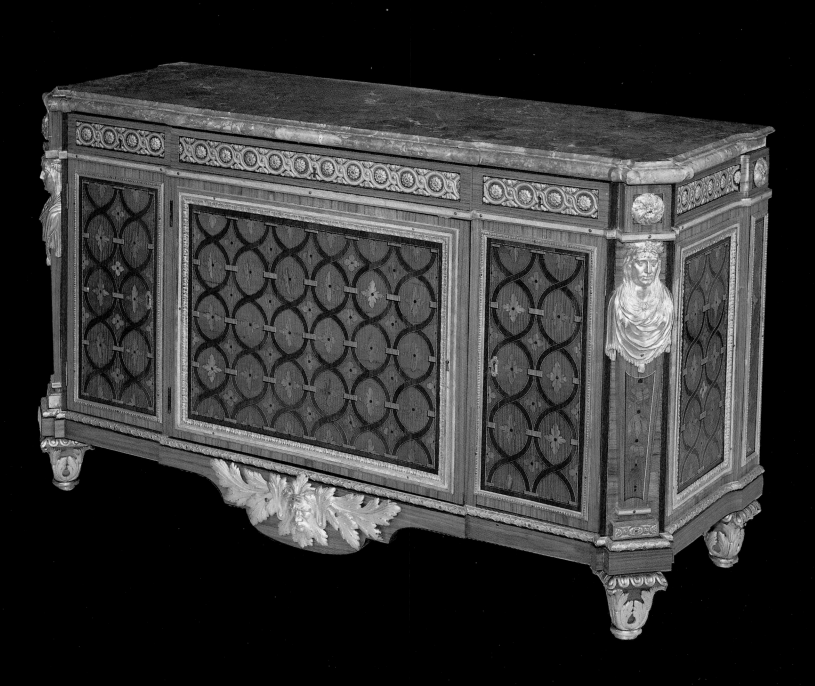

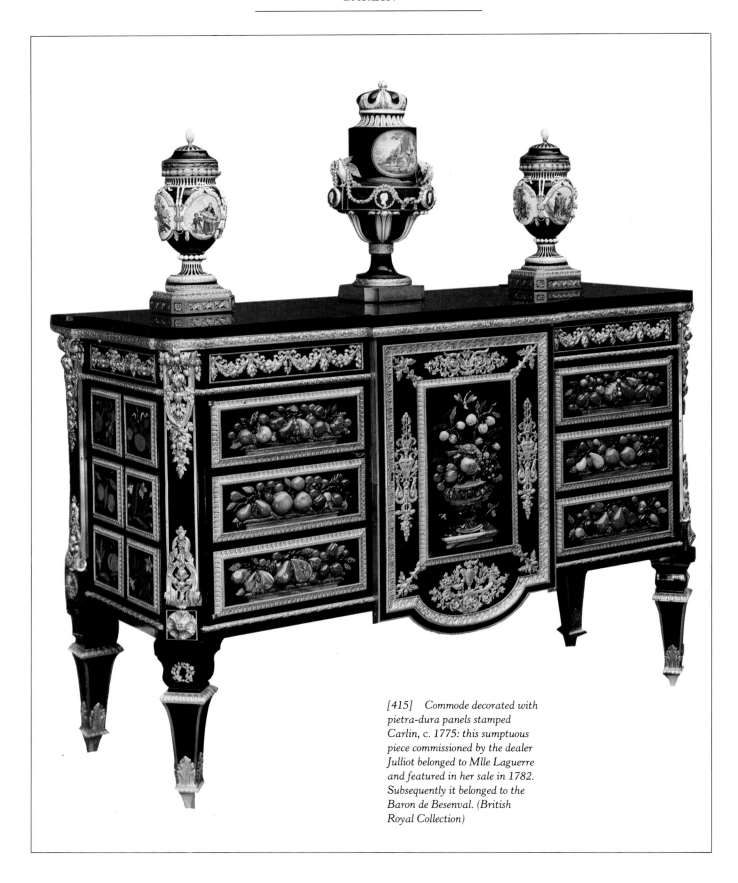

[415] *Commode decorated with pietra-dura panels stamped Carlin, c. 1775: this sumptuous piece commissioned by the dealer Julliot belonged to Mlle Laguerre and featured in her sale in 1782. Subsequently it belonged to the Baron de Besenval. (British Royal Collection)*

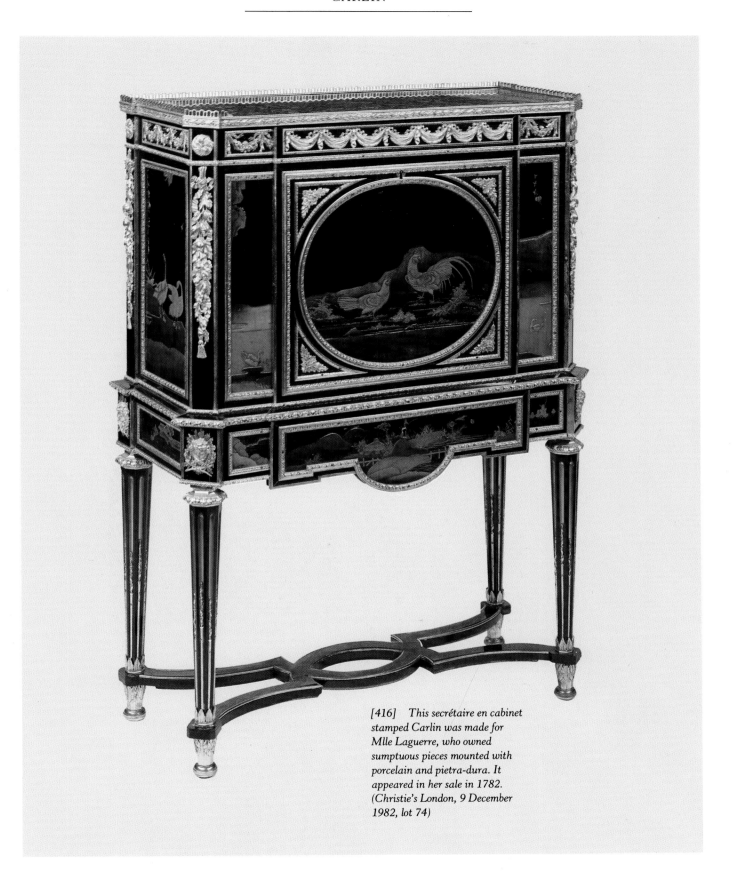

[416] *This secrétaire en cabinet stamped Carlin was made for Mlle Laguerre, who owned sumptuous pieces mounted with porcelain and pietra-dura. It appeared in her sale in 1782. (Christie's London, 9 December 1982, lot 74)*

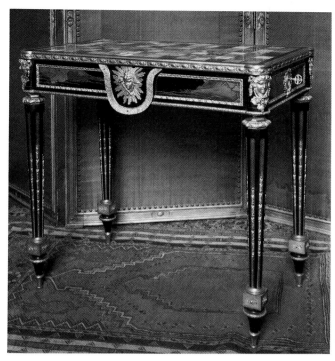

[417] *This small table stamped Carlin combines Japanese lacquer and pietra-dura; the top is composed of specimens of various types of marble. (Archives Galerie Fabre, Paris)*

[418] *Carlin made several examples of this luxurious type of night-table with marquetry which is also mentioned in the inventory drawn up after his death. Table stamped Carlin, c. 1765–70. (Fine Arts Museum of San Francisco)*

APPENDIX I

EXCERPT FROM THE INVENTORY TAKEN AFTER CARLIN'S DEATH

In the workshop

A bookcase veneered in plum-pudding mahogany 5 pieds in length, 17 pouces in depth and 3 pieds in height, with columns on the front with inlaid brass fluting, the doors ready for glazing; the aforesaid is ornamented with framing and mouldings ready for gilding, estimated at the sum of 350L

A commode 5 pieds in length, 20 pouces in depth and 2 pieds 10 pouces in height, veneered in ebony with lacquer panels; the interior fitted with a strong-box with 4 drawers all veneered in bois satiné, 2 columns at the front in very rich bronze; the aforesaid is fitted with its mounts, specially designed and chased, ready to be gilded, estimated at the sum of 1,500L

The oak carcase of a small secrétaire, 3 pieds 6 pouces in height, 13 pouces in depth, 26 pouces in width, estimated at 30L

In the second workshop

3 circular tables and an oval one with stretchers and tiers between the legs veneered in marquetry, fitted with their mounts ungilded, estimated all 4 together at 400L

Plus a bureau [plat] of 5 pieds in length, 32 pouces in depth with 4 drawers fitted with locks; 4 octagonal tapering legs with 8 flutes in inlaid bronze, plus serre-papiers and stand, all in ebony decorated with its mounts fitted and roughly chased, estimated at 700L

Plus 2 encoignures in oak of 29 pouces in height, 22 pouces in depth, the frames in ebony, with brass bands and pewter surrounds, estimated together at 120L

Plus 8 tapering legs, veneered in tulipwood, fluted with 7 flutes in inlaid brass, estimated together at 104L

Plus 9 inkstands veneered in tulipwood and fluted and 2 without flutes, estimated together at 24L

Plus an oval table with shelf in solid wood, the rest veneered, with its mounts ungilded, valued at 130L

Plus an oval bedside-table with 2 marble tiers; veneered in mosaic parquetry, estimated at 48L

Plus an incomplete circular table veneered in tulipwood, estimated at 90L

Plus 2 mechanical tables 30 pouces by 15 pouces, veneered in marquetry, the fluted legs inlaid in brass, the drawer at the front fitted for toilette, estimated together at 336L

Plus a trictrac-table veneered in tulipwood, incomplete, estimated at 72L

Plus a secrétaire in plum-pudding mahogany, the lower section with free-standing columns in front of canted corners, and fillets, the upper section also with 2 columns, all decorated wtih mounts roughly chased and the draperies chased but ungilded, estimated at 400L

Item, 100 livres of old raw copper at 19 sols the livre, that is *95L*

100 livres of oddments of bronze casts at 1 livre 45 sols the livre, that is *170L*

100 livres of similar metal at 1 livre 40 sols the livre, that is *170L*

100 livres idem at 1 livre 10 sols the livre, that is *150L*

100 livres idem at 1 livre 12 sols the livre, *160L*

100 livres of old raw bronze at 19 sols the livre, that is *95L*

50 livres of assorted raw metal at 34 sols the livre, that is *85L*

Bits of assorted raw bronze estimated at 48L

2 table rims and 2 corner-mounts in the shape of drapery with fringes, that is *50L*

Assorted small models, weight 28 livres, estimated at 100 sols the livre, that is *140L*

Circular table with decorative mounts, with its rim and supported on 3 legs in solid bronze in the form of lion's paws, estimated at 150L

3 vices, one large and 2 small, all 4 at 36L

Tools as follows: a trepan, a hand vice, a drawing plate, 4 hammers, all estimated at 21L

A clock in the workshop estimated at 24L

A shovel and bellows in poor condition, a metal stove fitted with 4 brass balls measuring 14 pouces by 19 pouces, estimated altogether at 21L

Item, 20 livres of scrap filings at 15 sols the livre. The said quantity at the said price of 15L

And the said Sr. experts signed at the end of their appraisal and Mr Raffye at the end of his valuation
RAVRIO, PETIT, PROVOT, LELEU, RAFFYE, EDON, LARDIN

[419] Closely similar to certain pieces of furniture by Saunier who also worked for Daguerre, this commode 'à l'anglaise' stamped Carlin, confiscated from the Comtesse de Brunoy during the Revolution, differs in details distinctive of Carlin's work: the drapery frieze and the octagonal legs. (Musée du Louvre, Paris)

[420] (bottom) Commode in Japanese lacquer stamped Carlin, bearing the marks of the Château de Bellevue; made under the direction of the dealer Darnault who supplied it to Madame Victoire in 1785 for 5,500L; it is described in the inventory taken on Carlin's death (see Appendix I). The Japanese lacquer panels came originally from two boxes bought by Darnault at the Duc d'Aumont's sale. (Musée du Louvre, Paris)

APPENDIX II

LIST OF WORKS BY CARLIN MOUNTED WITH PORCELAIN PLAQUES

Jewel-cabinets
1) Metropolitan Museum of Art: Kress Collection (attributed), the plaques with a green border dated between 1768 and 1770. Perhaps the one delivered by Poirier for Mme du Barry in September 1770 at a cost of 1,800 livres.
2) Private collection, Paris (?); the plaques with a green border must have been made for the Comtesse de Provence at Versailles.

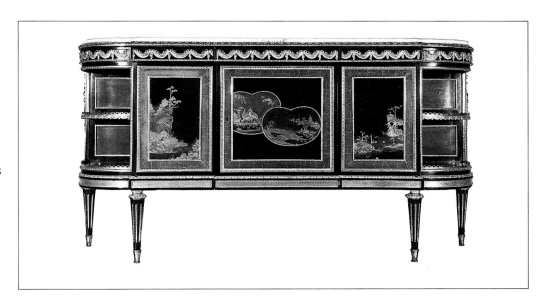

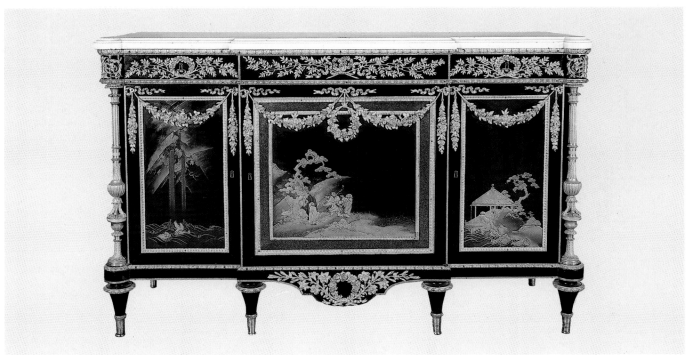

3) Metropolitan Museum of Art: Wrightsman Collection (attributed), one single plaque dated 1774; the plaques with a blue border.

4) Detroit Museum: Dodge Collection, formerly in the Russian Imperial Collection at Pavlovsk (stamped); the plaques with sprigged decoration, bought by the Comtesse du Nord from Daguerre c. 1782.

5 and 6) Private collection, Paris (stamped); one with plaques decorated with turquoise oeil-de-perdrix [422], the other with turquoise plaques.

7) Kress Collection (attributed), the plaques undated, probably of 1775.

8) Sale, Christie's New York, 19 November 1977 (stamped by Schneider who completed it), about 1785 (the top may correspond to the example made for the Duchesse de Saxe-Teschen). [516]

Bonheurs-du-jour
9) Barnard Castle: Bowes Museum (attributed), the plaques dated 1765; therefore the earliest example.

10) Musée Nissim de Camondo (stamped), the plaques for the most part dated 1766.

11) Waddesdon Manor, Buckinghamshire [stamped], the plaques mostly dated 1766, with a green border; made for the Prince de Soubise.

12) Boughton House, Northamptonshire: Duke of Buccleuch's collection (stamped); plaques with a green border dated 1768.

13) Kress Collection (attributed); the plaques dated 1768, with a green border; perhaps the one delivered to Mme du Barry by Poirier in 1768.

14) Formerly in Lord Astor of Hever's collection (attributed); sale, Christie's, 29 June 1967, lot 95; plaques all dated 1769 except one dated 1768.

15) Formerly in Lord Astor of Hever's collection (stamped); sale Christie's, 29 June 1967, lot 95; the plaques all dated 1770 except one dated 1771.

16) Waddesdon Manor (stamped); plaques all dated 1770 except for one dated 1771.

17) Huntington Library (stamped); several plaques dated 1771.

18) Huntington Library (attributed); some of the plaques dated 1771.

19) Kress Collection (stamped); majority of plaques dated 1774; probably the one made for the Comtesse d'Artois at Versailles.

Bonheurs-du-jour with high superstructure
20–21) Museum of Arts, Philadelphia (one stamped, the other attributed); the plaques with sprigs of roses, one dated 1776, the other 1776–77.

Secrétaires à abattant
22) Kress Collection (stamped); oval plaques with a green border, dated 1773; perhaps the one sold in 1773 by Poirier to Mme du Barry for 2,640 livres [407].

23) Waddesdon Manor (stamped); in sycamore stained yellow, the oval plaques with a ground of blue oeil-de-perdrix; around 1775.

24) Royal Palace, Madrid (attributed); plaques in the form of medallions with a green border; the base stripped of its plaques; perhaps the one sold by Poirier to Mme du Barry in 1772 for 2,400 livres.

25) Formerly in the Victor de Rothschild Collection (stamped); rectangular plaques by Commelin, c. 1775. Sale Sotheby's, 19 April 1937, lot 400.

26) Formerly in the Alphonse de Rothschild Collection (stamped); oval plaques with border in mauve oeil-de-perdrix, dated 1778; about 1789. Sale Sotheby's, New York, 31 October 1986, lot 84 [402].

Secrétaires à abattant with side shelves
27) Wrightsman Collection, New York (attributed), with rectangular porcelain plaques with a turquoise-blue ground dated 1776, and tôlework plaques imitating porcelain, once belonging to Maria Fyodorovna, who probably bought it from Daguerre while in Paris in 1782. Previously it had belonged to Mlle Laguerre.

28) J. Paul Getty Museum (stamped); rectangular plaques dated 1776 and 1777.

29) J. Paul Getty Museum (stamped); with central circular plaques signed by Pierre the Younger and dated, as well as the other plaques, 1775.

30) Wallace Collection (stamped); with central circular plaque dated 1766.

Consoles-dessertes
31) Formerly in the Lord Rothschild Collection; sale Sotheby's London, April 1937, lot 205; sale Christie's London, 29 November 1973, lot 105 (attributed); the plaques dated 1787.

32) Kress Collection (stamped); the central plaque signed by Jean-Baptiste Tandart, between 1775 and 1780.

33) Formerly in the Anella Brown Collection (attributed); sale Sotheby's New York, 23 April 1977, lot 204. Plaques dated 1776 and signed by Jean-Jacques Pierre.

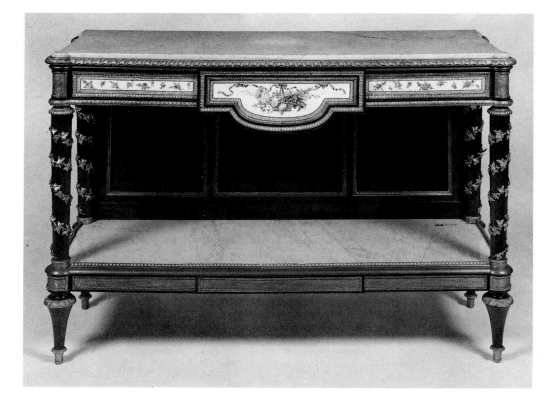

[421] Console-table stamped Carlin, c. 1785; the porcelain plaques decorated round the edge in green oeil de perdrix are dated 1784. (Formerly in the Earl of Harewood's collection; Sotheby's Monaco, 26 June 1979, lot 201)

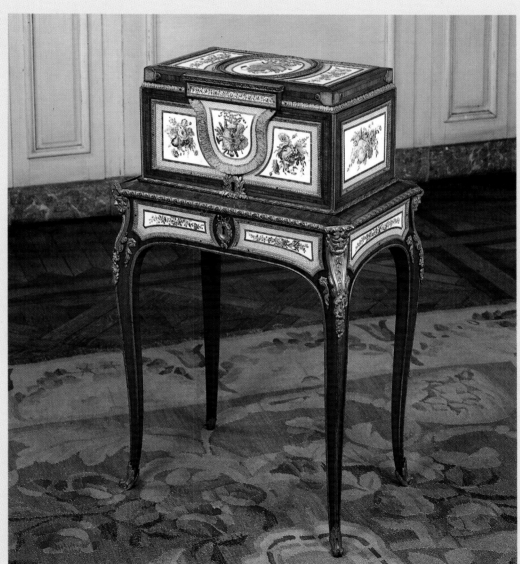

[422] Detail of the jewel-cabinet at [423] showing a plaque in oeil de perdrix on a blue ground

[423] Jewel-cabinet stamped Carlin, c. 1770–75. Among the models submitted to the Duke of Saxe-Teschen by Daguerre, there featured a drawing of a comparable jewel-cabinet (see p. 5). (Formerly in the Alfred de Rothschild Collection (cat. 1884, vol. 2), nos 99 and 100)

34) Formerly in the collection of the Earl of Harewood, then Wildenstein Collection (stamped); sale Sotheby's Monaco, 25 June 1979; the plaques dated 1784 and signed by Laroche. [421]

Trictrac-tables
35) Formerly in the Mannheimer Collection (?), sold in Amsterdam in 1952, illustrated in *Connaissance des Arts*, October 1953. Perhaps the one supplied by Poirier in 1771 to Mme du Barry.
36) Formerly in the Lansdowne Collection (stamped); twelve plaques dated 1775. Probably belonged to the Duchesse de Mazarin.

Rectangular tables and small bureaux
37) Gulbenkian Museum, Lisbon (attributed), decorated with a turquerie scene after Leprince; the central plaque dated 1771 and signed by Dodin; formerly in the possession of Mme du Barry, then Maria-Carolina, Queen of

Naples. [401]

Bureaux plats
38) Waddesdon Manor (stamped), cat. no. 91. Several plaques dated 1766 and signed by Noël, one inscribed 'Poirier'. Together with a cartonnier also stamped, decorated with eight plaques dated 1780 and signed by Tandart.
39) J. Paul Getty Museum (stamped), sale Christie's London, 1 January 1983, lot 54 with Daguerre's label; some plaques dated 1778. Bought c. 1782 by Maria Fyodorovna after her stay in Paris.

Commodes
40) Private collection, Switzerland (attributed); decorated with plaques painted with scenes after Lancret, Pater and Van Loo. Supplied in 1772 by Poirier to Mme du Barry at Versailles.
41) Formerly in the Grog Collection (stamped), formerly Guy de Rothschild Collection; plaques dated 1774–75 and signed by Levé and Meraud [430].

42) British Royal Collection (stamped); plaques dated 1783; a piece sold to George IV by Daguerre for Carlton House before 1812.

Large guéridons
43) Musée du Louvre (stamped), the plaques dated 1774 and signed by Dodin; central plaque with scene of the Turkish Concert after Van Loo; supplied in 1774 to Mme du Barry at Louveciennes.
44) Royal Palace, Warsaw (attributed), depicting the story of Telemachus; the plaque dated 1777 and signed by Dodin; the table sold in 1780 to the Comte d'Artois by the Sèvres manufactory for 6,000 livres.

Small rectangular tables with plaques in the shape of lambrequins
45) Waddesdon Manor (attributed); undated plaques signed by Vincent. According to Geoffrey de Bellaigue, the table was made after Carlin's death to be mounted with porcelain plaques ordered in 1790.
46) Huntington Library

(attributed); with the marks for 1781, formerly belonged to the Elector of Saxony.
47) Wallace Collection, F. 327 (stamped); the plaques marked 1783.
48) Frick Collection (stamped); the plaques unmarked but may be dated to 1781; formerly in the Duke of Alba Collection.
49) Victoria and Albert Museum: Jones Collection (stamped); reputed to have been given by Marie-Antoinette to Lady Auckland in 1786.

Small rectangular tables with porcelain tops
50) Kress Collection (stamped); plaque unmarked but attributed to Bouillat, about 1784.
51) Musée du Louvre: Grog Bequest (stamped); plaque marked 1784, signed by Bouillat.

Small work-tables en guéridons
52) Wrightsman Collection (attributed); plaque dated 1784.
53) Robert Lehman Collection (stamped).

[424] *Guéridon with double tier and central stem, attributed to Carlin, c. 1780; the upper tier consists of a circular plaque surrounded by 6 small porcelain*

plaques (Rijksmuseum, Amsterdam)

[425] *Guéridon with pair of candle-holders, stamped Carlin.*

The porcelain plaque is dated 1775; the marquetry with carnations is typical of R.V.L.C. to whom Carlin must have subcontracted this piece. (Sotheby's New York, 9 December 1972, lot 905)

[426] *Guéridon attributed to Carlin; with double tier and central stem, the plaque unmarked. (Sotheby's Monaco, 22 May 1978, lot 18)*

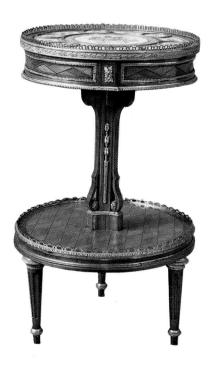

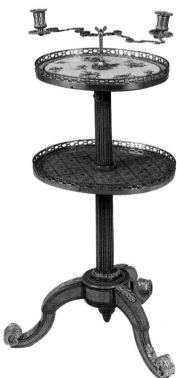

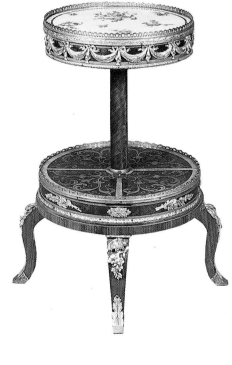

Music stands with a rectangular plaque
54) Waddesdon Manor (stamped); plaque unmarked, but can be dated to 1775.
55) Jones Collection; stamped by Carlin and Pafrat, c. 1785.

Candle-stands and -holders ('tables en marmottes')
56) Waddesdon Manor (attributed); the plaque dated 1774 (or 1776) and signed by Nicquet.
57) Formerly in the Deane Johnson Collection (stamped), sale, Sotheby's, 9 December 1972, lot 905 [425].
58–59) Museum of Arts, Philadelphia; 2 tables (one stamped, the other attributed); the plaques painted with roses and dated 1779.

Guéridons with two shelves and central column
60) Jones Collection (stamped by Carlin and Pafrat); the plaque dated 1775 but the table must have been completed by Pafrat after Carlin's death; the lower shelf inlaid with arabesques;

supported on 4 straight feet [427].
61) Rijksmuseum (attributed); the top comprising one central circular plaque surrounded by six small circular plaques and six trapezoidal plaques; supported on four straight feet [424].
62) Formerly in the Edouard de Rothschild Collection (attributed), sale Sotheby's Monaco, 22 May 1978, lot 18; the plaque unmarked; supported on four cabriole legs [426].
63) Cleveland Museum of Art (stamped); plaque unmarked.

Oval tables
64) Frick Collection (attributed); with porcelain top and undertier in tôlework.
65) Formerly in the Fribourg Collection; sale Sotheby's London, 28 June 1963, lot 190 (attributed).

Jardinière
66) Museum of Arts, Philadelphia (stamped); the plaque undated, signed by Taillandier; Mme du Barry bought a similar table in 1773.

Small circular tables 'en auges' or 'en chiffonnières'
67) Wrightsman collection (stamped), with two shelves with inlay of sunburst marquetry; plaques in segments of a circle dated 1771. '
68) Wrightsman Collection (stamped); with small circular plaques set into the two tops; plaques unmarked.
69) J. Paul Getty Museum (stamped), with a porcelain top dated 1773 and a lower tier with sunburst marquetry.
70) J. Paul Getty Museum (attributed); with a porcelain top dated 1765 and a marble shelf.
71) Formerly in the Edouard de Rothschild Collection (stamped); sale Sotheby's Monaco, 22 May 1978; the top and lower tier with sunburst marquetry; plaques unmarked [428].
72) Formerly in the Alix Lacarré Collection (stamped), sale Sotheby's Monaco, 14 June 1981, lot 122; plaques unmarked.
73) Niarchos Collection (attributed), illustrated in *Louis*

XVI Furniture by Francis Watson.
74) Robert Lehman Collection, New York.
75) Musée Nissim de Camondo, cat. no. 133 (attributed); with a porcelain top and a lower tier with sunburst marquetry.
76) Musée du Louvre (stamped); Salomon de Rothschild Bequest, top of porcelain and lower tier of sunburst marquetry.
77) Grog Bequest (stamped), with porcelain top; the frieze is not mounted with porcelain plaques; ebony veneering.
78) Formerly in the Russian Imperial Collection (stamped); sale Christie's, Geneva, 8 May 1973, with a porcelain top, the lower tier veneered with marquetry of lozenges and dots [429].
79) Chefdebien sale, Paris, 13 February 1941, lot 112 (stamped).
80) Penard y Fernandez sale, 7 December 1960, lot 129, with two shelves with marquetry.

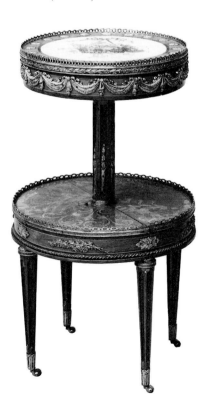

[427] Guéridon with double tier and central stem stamped Carlin and Pafrat; the plaque is dated 1775. (Victoria and Albert Museum, London)

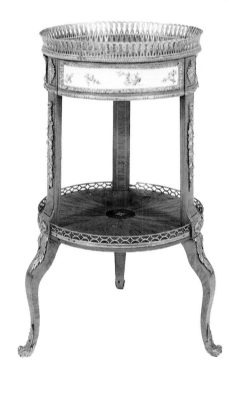

[428] Table 'en chiffonnière' stamped Carlin, c. 1770–75. (Sotheby's Monaco, 22 May 1978, lot 15)

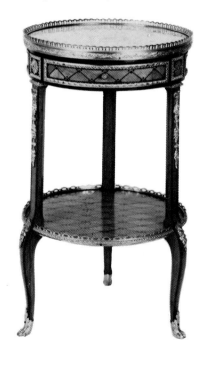

[429] Table 'en chiffonnière' stamped Carlin with the mark of the Palace of Pavlovsk; almost certainly bought by the Grand

Duchess Maria Fyodorovna during or after her stay in Paris in 1782. (Christie's Geneva, 8 May 1973, lot 61)

APPENDIX III

EXCERPT FROM THE REGISTER OF THE SÈVRES MANUFACTORY RELATING TO PURCHASES OF PORCELAIN PLAQUES BY POIRIER

Prices (L): Unit Total

Item	Unit	Total
1760: 1 January–1 April		
77 plaques with flowers on a green ground	15	1155
19 id. plain	6	114
1760: 1 April–31st December		
No plaques		
1761: 1 January–25 October		
No plaques		
1761: October quarter		
1 id. (tray) courteilles or for a chiffonnière		300
24 plaques green flowers	12	288
1762		
top for a chiffonnière		168
1 id.		216
1 id.		300
1762: 1 October–31 December		
24 plaques green ground	12	288
2 id.	18	36
10 id	9	90
1763		
1 chiffonnière top		60
2 id.	432	864
1764: first six months		
1 chiffonnière top		360
2 plaques	36	72
10 id.	18	180
1764: last six months		
83 plaques	12	996
4 id.	24	96
6 id.	7,10	45
29 id.	12	348
2 plaques for écritoires	24	48
10 id.	12	120
2 id.	72	144
4 id.	18	72
24 id.	9	216
1765: first six months		
No plaques		
1765: last six months		
1 plaque		168
2 id.	72	144
3 id.	60	180
2 id.	48	96
6 id.	36	216
3 id.	24	72
4 id.	15	60
14 id.	12	168
2 id.	6	12
1766: first six months		
No plaques		
1766: last six months		
10 plaques	9	90
16 id.	10	160
70 id.	12	840
2 id.	18	36
6 id.	24	144
2 id.	36	72
2 id.	48	96
2 id.	60	120
2 id.	72	144
1767: first quarter		
1 circular plaque		72
1767: third quarter		
1 plaque		66
3 id.	54	162
2 id.	42	84
3 id.	21	63
8 id.	12	96
1767: last quarter		
4 plaques	9	36
4 id.	12	48
3 id.	15	45
8 id.	30	240
3 id.	36	108
4 id.	42	168
1768: first six months		
No plaques		
1768: last six months		
1 large circular plaque		216
2 plaques	10	20
18 id.	9	162
16 id.	12	192
4 id.	18	72
6 id.	24	144
2 id.	30	60
5 id.	36	180
8 id.	48	384
8 id.	60	480
2 id.	72	144
1 id.		96
1769: first six months		
1 picture		840
1769: last six months		
2 circular plaques	216	432
2 id.	72	144
3 id. square	96	288
6 id.	60	360
4 id.	48	192
4 id.	30	120
2 id.	24	48
3 id.	18	54
10 id.	12	120
7 id.	7,10	52,10
1770: first six months		
2 different plaques	10	20
4 id.	24	96
3 id.	30	90
2 id.	48	96
13 id.	60	780
1 id.		72
1 id.		216
1770: last six months		
2 plaques	6	12
4 id.	7,10	30
15 id.	10	150
14 id.	12	168
3 id.	15	45
1 id.		18
7 id.	24	168
4 id.	30	120
4 id.	42	168
8 id.	48	384
10 id.	60	600
1 id.		72
1 id.		96
1771		
3 quarters of a circle	15	45
7 plaques	7,10	52,10
1 id.		10
37 id.	12	244
6 id.	15	90
4 id.	21	84
2 id.	27	54
9 id.	30	270
6 id.	39	234
3 id.	42	126
1 id.		48
8 id.	51	408
1 id.		54
2 id.	60	120
1 id.		72
1 id.		192
1 id.		216
1772		
2 plaques	10	20
4 id.	12	48
6 id.	18	108
2 id.	24	48
4id.	42	168
6 id.	48	288
8 id.	60	480
2 id.	78	156
4 id.	144	576
1 id.		1440
4 long plaques	60	240
7 quarters of a circle	15	105
2 quarters of a circle	15	30
2 plaques for écritoires	24	48
2 id. squares	12	24
8 id.	10	80
1773: first six months (Poirier & Daguerre)		
1 plaque		10
26 plaques	12	312
1773: last six months		
2 plaques	10	20
2 id.	18	36
2 id.	24	48
10 id.	36	360
2 id.	39	78
3 id.	42	126
2 id.	51	102
1 id.		54
2 id.	78	156
7 quarters of a circle	15	105
2 parts of quarter circle	15	30
3 quarters of a circle	15	45
1774		
6 plaques	7,10	45
2 different plaques	60	120
2 different plaques	72	144
1 id.		78
1 plaque		7,10
2 id.	10	20
4 id.	12	48
2 id.	24	48
2 id.	30	60
2 id.	45	90
2 id.	48	96
1 id.		54
2 id.	60	120
1 id.		66
3 id.	72	216
4 id.	80	320
4 id.	84	336
5 id.	96	480
2 small plaques	7,10	15
4 id.	12	48
3 quarters of a circle	15	45
6 quarters of a circle	15	90
2 plaques	66	132
1775		
1 plaque		7,10
3 id.	10	30
75 id.	12	900
3 id.	15	45
2 id.	18	36
2 id.	21	42
7 id.	24	168
4 id.	27	108
2 id.	33	66
8 id.	36	288
2 id.	39	78
7 id.	42	294
4 id.	48	192
2 id.	51	102
1 id.		54
4 id.	60	240
52 small plaques for tables	6	312
9 quarters of a circle	15	135
2 circular plaques	84	168
2 id.	192	384
2 id.	216	432
2 id. square	96	192
2 id.	132	264
1 id. oval		66
2 id.	96	192
2 id.	80	160
1 id.		54
1 id.		60
4 quarters of a circle	30	120
2 bands	30	60
2 id.	12	24
2 id.	45	90
1 plaque		216
1 id.		150
2 oval plaques	96	192
2 id.	80	160
1775: last six months (Poirier & Daguerre)		
1 circular plaque		84
8 id. small	18	144
6 small plaques	7,10	45
2 id.	42	84
2 id.	39	78
2id.	36	72
4 id.	30	120
2 id.	18	36
2 circles	30	60
2 id.	18	36
1776: first six months		
1 square plaque		216

2 id.	132	264
2 id.	120	240
2 id. oval	84	168
8 quarters of a circle	24	192
4 quarters of a circle	30	120
4 small plaques	12	48
1 garniture of plaques		
for a barometer		168
2 small plaques	12	24
2 oval plaques	66	132
1 plaque for a		
barometer		120
1 id.		72
2 id.	15	30
1 id.		15
6 quarters of a circle	24	144
1776: last six months		
(Poirier & Daguerre)		
1 oval plaque		78
1 oval plaque		288
2 id.	96	192
2 id.	90	180
10 plaques bombées	72	720
8 id.	60	480
1 oval plaque		288
2 square plaques	120	240
1 round plaque		84
2 long plaques	30	60
4 id.	24	96
2 id.	18	36
2 id.	10	20
2 plaques	120	240
12 square plaques	12	144
1 picture		360
1777: first six months		
(Daguerre)		
2 plaques	120	240
3 id.	66	198
4 id.	54	216
1 id.		60
2 id.	36	72
2 id.	30	60
5 id.	10	50
2 plaques	120	240
1 id.		240
1 plaque		48
1 id.		66
2 id.	36	72
1 id.		48
2 id.	10	20
3 plaques	84	252
4 id.	36	144
6 id.	10	60
1 plaque		66
1777: last six months		
1 plaque		54
1 id.		26
1 plaque		78

[430] *It would seem that Carlin made only four commodes with porcelain plaques. This one is decorated with oval plaques probably originally designed for a secrétaire, dated 1774–75 and signed by Levé and Meraud. (Formerly in the Guy de Rothschild Collection; Sotheby's London, 24 November 1972, lot 33)*

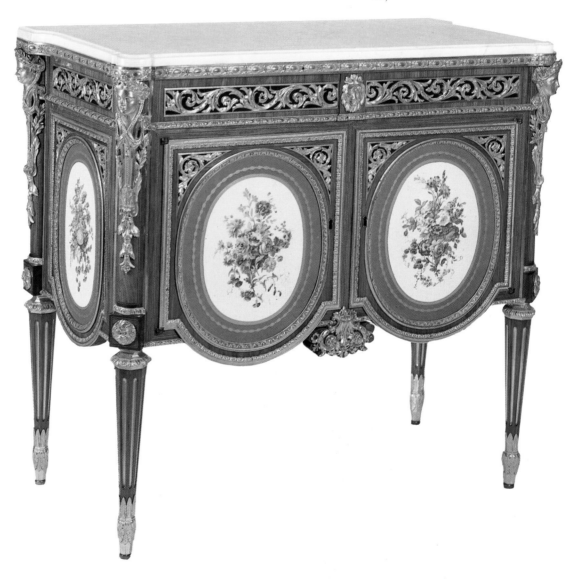

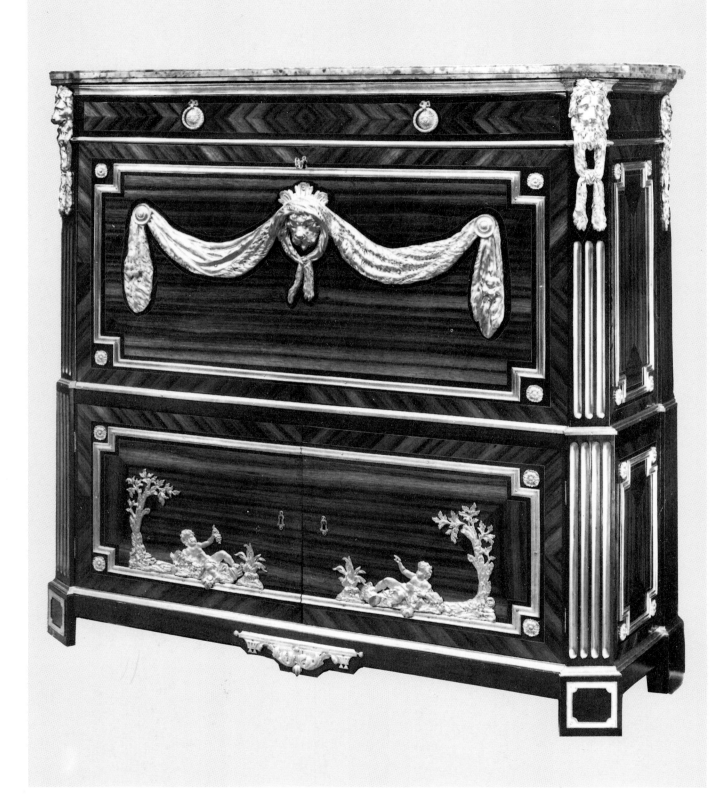

MEWESEN

MASTER 1766

This ébéniste was probably of Scandinavian extraction. On 26 March 1766 he became a master in Paris, where he was active for virtually the next twenty years. He settled at La Main d'Or in the rue du Faubourg Saint-Antoine. The furniture bearing his stamp is in the Transitional style and dates from c.1770–80. Most of his output is ornamented with geometric marquetry, especially octagonal parquetry, similar to that found in Carlin's work.

BIBLIOGRAPHY
F. de Salverte: *Les Ébénistes,* p. 230

[431] *Secrétaire à abattant in bois satiné stamped Mewesen, c. 1770. On this piece Mewesen has combined mounts in Neo-classical style and copies of Boulle motifs, such as the recumbent putti. (Archives Galerie Levy, Paris)*

[432] *Commode stamped Mewesen of which the pair is in the Gulbenkian Museum. Octagon marquetry is typical of Mewesen's work but is also found on that of Carlin. (Private collection)*

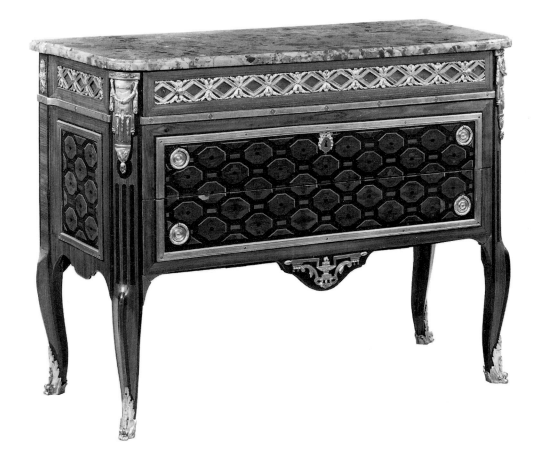

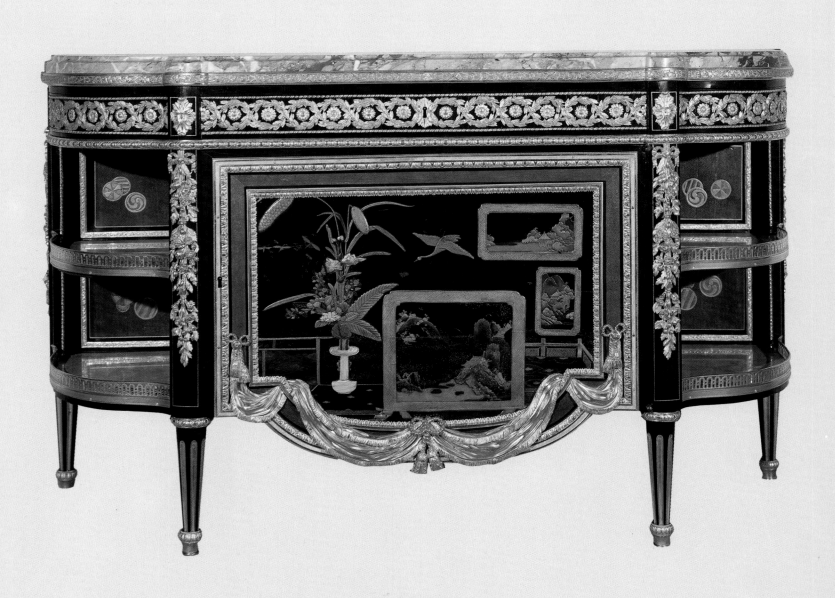

Claude-Charles
SAUNIER

1735–1807; MASTER 1752

Born into a family of ébénistes established in the rue du Faubourg Saint-Antoine, Saunier obtained his mastership very early but did not register it until 1765 when he took over the family workshop in which he had previously been working. He kept this workshop in the rue du Faubourg Saint-Antoine opposite the rue Saint-Nicolas at least until 1799, producing luxury furniture, all in Neo-classical taste. These veneered pieces are marked by their sobriety of line and the beauty of their wood, mainly tulipwood applied in large sheets in horizontal strips. Between 1765 and 1775 Saunier frequently produced a type of transitional commode with rectangular shape and lightly curved legs using tulipwood with a wide horizontal grain. He used fashionable woods such as ebony and mahogany as well as satinwood from 1785 onwards. On all these pieces the wood is arranged to form contrasting colours; tulipwood and ebony or satinwood and amaranth. He produced bureaux plats of simple form, the architectural details of which were emphasized by square tapering legs and the presence of gilt-bronze triglyphs between the drawers. From 1785 to 1790 Saunier perfected a type of bonheur-du-jour in satinwood with a stand fitted with glazed doors of which the lower part forms a console-desserte with rounded corners [439].

Certain rare pieces exist which are stamped by Saunier and decorated with Sèvres porcelain plaques. In the Wildenstein Collection, for example, there was a small table from the Château de Bellevue dating from 1786. Here is proof that Saunier must have worked for the marchand Daguerre, who had the monopoly of the supply of porcelain plaques from Sèvres. Collaboration between Saunier and Daguerre is further indicated by the existence of several pieces signed by

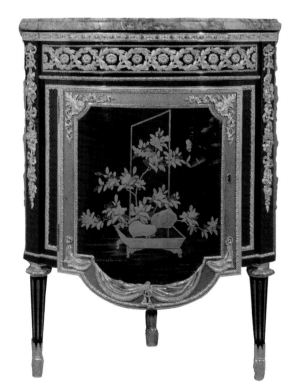

[434] Encoignure, one of a pair in Japanese lacquer matching the commode shown at [433].
(Archives Galerie Aveline, Paris)

[433] Commode 'à l'anglaise' in Japanese lacquer, attributed to Saunier, c. 1780. Pierre Verlet illustrates an identical commode in Les Meubles français du XVIIIe siècle, fig. 99, stamped Saunier. The apron mount made of draperies and fringes can be found on both Carlin's and Saunier's works. However, detail of their respective works differs. (Archives Galerie Aveline, Paris)

Saunier at Althorp in the Spencer Collection, which Daguerre supplied in about 1790. Finally, various pieces in citronnier supplied by Daguerre in 1786–87 to the Garde-Meuble Royal seem to be identifiable with works by Saunier, such as the two bonheurs-du-jour in bois jaune (also called 'noyer de la Guadeloupe'), one delivered to the Queen at Choisy in 1786 for 648 livres (Arch. Nat. 0¹3646) and the second in March 1787 for the Duchesse d'Harcourt, wife of the Master of the Dauphin's Household at Versailles, for 624 livres (Arch. Nat. 0¹3641) together with a complete suite of furniture in bois jaune (also probably his work, unless it is by R.V.L.C. or possibly by Weisweiler, further suppliers of Daguerre). One piece of furniture in bois jaune from this series which it is poss-

ible to identify today is the secrétaire à abattant sold at Sotheby's London on 12 November 1965, lot 41 [440]. This secrétaire, stamped by Saunier, also bears the ink mark of the Château de Versailles and corresponds to the 'secrétaire en armoire, 3 pieds in length, in noyer de la Guadeloupe' supplied on 10 March 1787 to the Duc d'Harcourt at Versailles for 672L.

Saunier was also the maker of numerous pieces in lacquer, some Chinese or more rarely Japanese, and some in tôlework imitating Japanese lacquer. This technique, perfected by Samousseau in about 1767, sought no doubt to circumvent the problems of European lacquer on wood which was easily damaged. However, as metal is even more susceptible than wood to the rapid contractions and expansions caused by

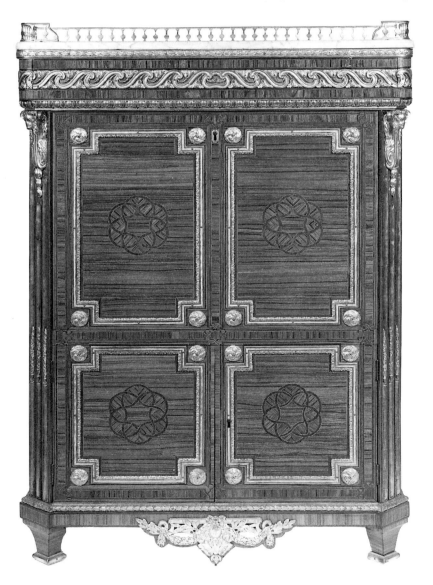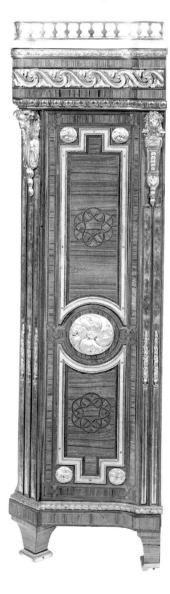

temperature change, the result is that these tôle-work panels are covered in innumerable small cracks. The best-known examples are the commode à l'anglaise in the Biron Collection [441] and a cylinder bureau formerly at Mentmore [445]. Saunier's career continued into the Directoire – he is recorded in the almanacs until 1799. He retired to the rue Saint-Claude and died in 1807.

BIBLIOGRAPHY

F. de Salverte: *Les Ébénistes*, pp. 297–98

Pierre Kjellberg: 'Saunier', *Connaissance des Arts*, March 1969, pp. 78–82

Peter Thornton and John Hardy: 'The Spencer furniture at Althorp', *Apollo*, no. 88, October 1968, 274–77

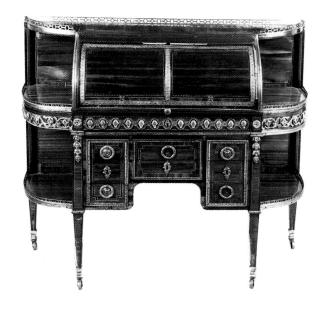

[435, 436] *Secrétaire à abattant stamped Saunier, c. 1775; noteworthy here is veneering in horizontal strips of tulipwood, typical of Saunier. (Sotheby's Monaco, 25 June 1979, lot 25)*

[437] *Rare form of secrétaire combining the desserte à encoignures and the secrétaire à cylindre: stamped Saunier, c. 1775. (Christie's London, 17 April 1980, lot 199)*

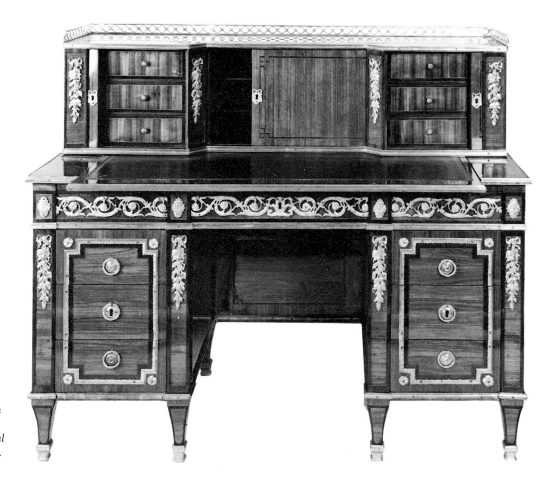

[438] *Bureau à gradin stamped Saunier. The effect of this piece of furniture comes from the harmony between the tulipwood veneering in horizontal strips and its strong architecture. (Galerie Didier Aaron, Paris)*

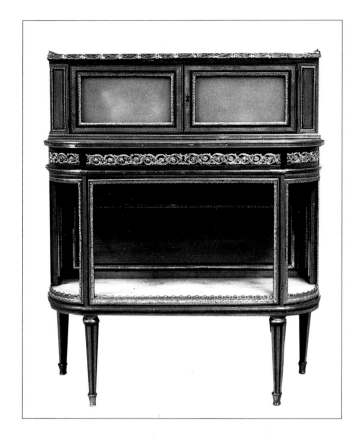

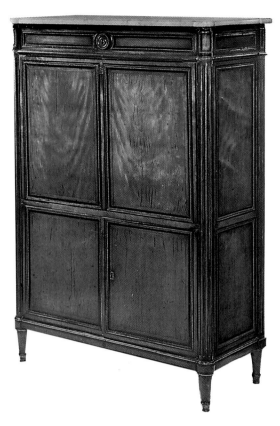

[439] Saunier made a series of bonheurs-du-jour in satinwood identical to this example, with shutters, mirrored or glazed, all c. 1786. (Galerie Lupu, Paris)

[440] Secrétaire in satinwood stamped Saunier; bearing the mark of the Château de Versailles; it tallies with a delivery by Daguerre on 10 March 1787 for the Duc d'Harcourt, who was in charge of the Dauphin's education. (Sotheby's London, 12 November 1965, lot 41)

[441] (below) Commode à l'anglaise stamped Saunier: in lacquered tôle. (Formerly in the Biron Collection; Archives Galerie Aveline, Paris)

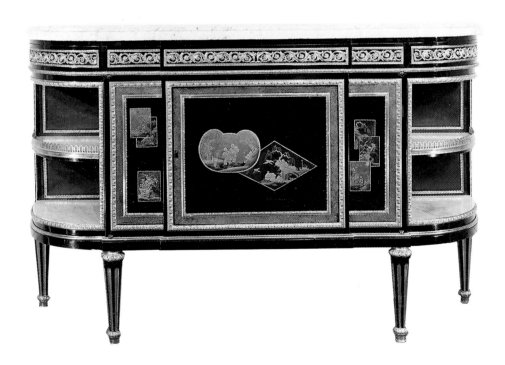

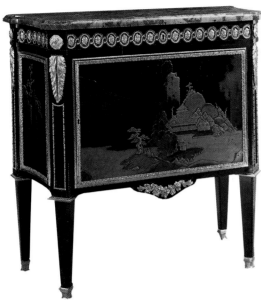

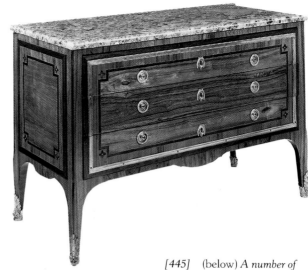

[442] Commode in Japanese lacquer, one of a pair stamped Saunier; a similar one is in the Nymphenburg Palace, Munich. (Archives Galerie Aveline, Paris)

[443] Saunier often repeated this type of commode veneered in horizontal strips of tulipwood; this example is stamped. (Sotheby's Monaco, 14 June 1981, lot 126)

[444] (below left) Table stamped Saunier, bearing the mark of the Château de Bellevue; the porcelain plaque is dated 1786. (Sotheby's Monaco, 25 June 1979, lot 171)

[445] (below) A number of pieces of furniture by Saunier are thus panelled in tôle lacquered in imitation of Japanese lacquer according to a technique perfected by Samousseau in 1767. (Formerly in the Earl of Rosebery's collection; Sotheby's London, 24 November 1978, lot 184)

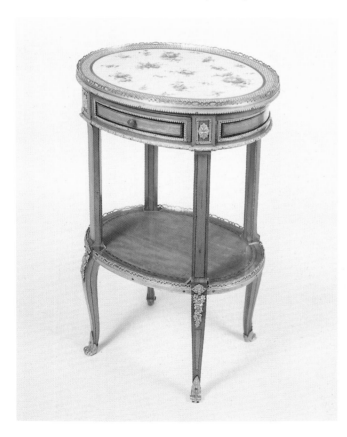

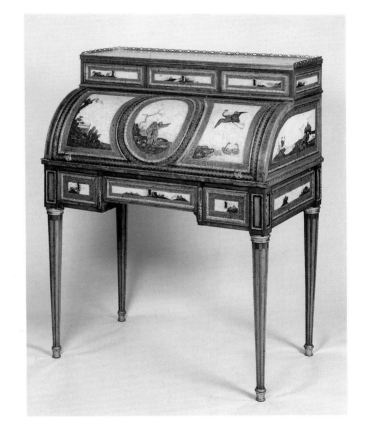

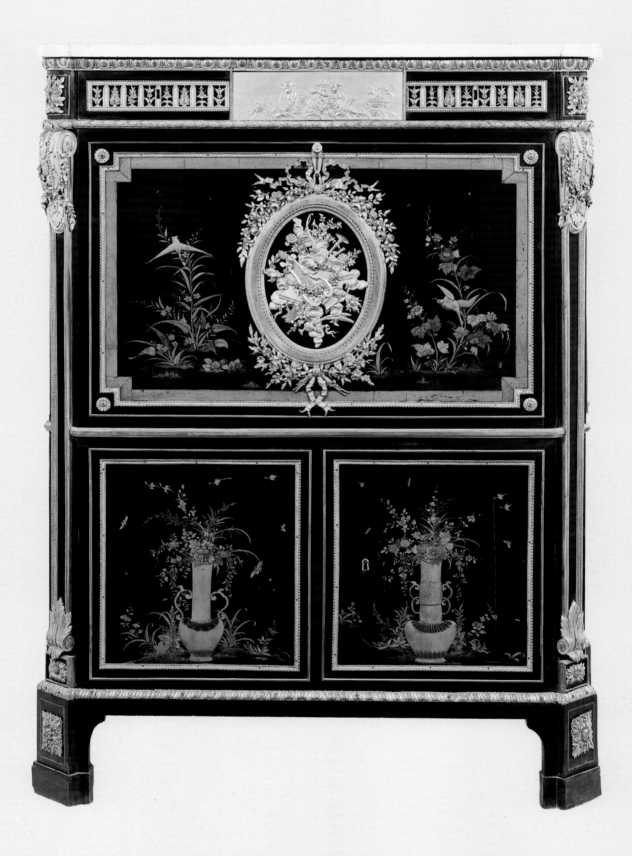

Jean-Henri RIESENER

1734–1806; MASTER 1768; SUPPLIER OF THE GARDE-MEUBLE ROYAL 1774–85

R iesener is one of the few ébénistes of his time whose fame has extended beyond the limits of his profession. Together with Boulle and Cressent he is one of the very few ébénistes mentioned in eighteenth-century sale catalogues. In contrast to them, Riesener was a recent immigrant from Westphalia. He was born in Gladbeck in 1734, son of a chair-maker, and moved to Paris at a fairly early age, possibly around 1754, to be apprenticed to Jean-François Oeben at the Arsenal. At the time of Oeben's death in 1763 Riesener was one of his principal employees and took over the direction of the workshop in 1765, if not earlier, on behalf of Oeben's widow, until he himself became a master in 1768. For a period of five years, therefore, between 1763 and 1768, the products from Oeben's workshop, though bearing his stamp, were actually the work of Riesener and his assistants. Numerous pieces of furniture in early stages of construction, described in the inventory drawn up at Oeben's death as mere carcases, were therefore completed by Riesener. A famous example is the 'bureau du Roi' [448] begun in 1760 by Oeben and delivered by Riesener (who stamped it) in 1769 after nine years of painstaking work to bring it to perfection. At the same time that he was putting the finishing touches to the 'bureau du Roi', Riesener produced another secrétaire à cylindre, equally sumptuous, for the Comte d'Orsay (Wallace Collection), which as Christian Baulez has supposed, may have served as the prototype for the royal piece.

Not content with securing the direction of Oeben's workshop, Riesener married his widow in 1767 and took over his quarters at the Arsenal which remained his home and workshop for more than thirty years, at

[446] This secrétaire à abattant is part of an ensemble comprising a commode and an encoignure which belonged to the dealer Maelrondt and featured in his sale in 1824. (Sotheby's Monaco, 3 May 1977)

[447] Detail of the gilt-bronze frieze on the secrétaire illustrated at [446], depicting putti allegoric of the Arts.

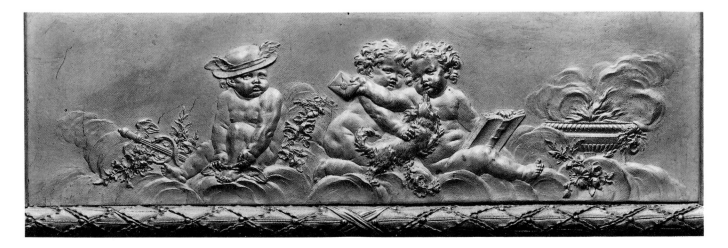

371

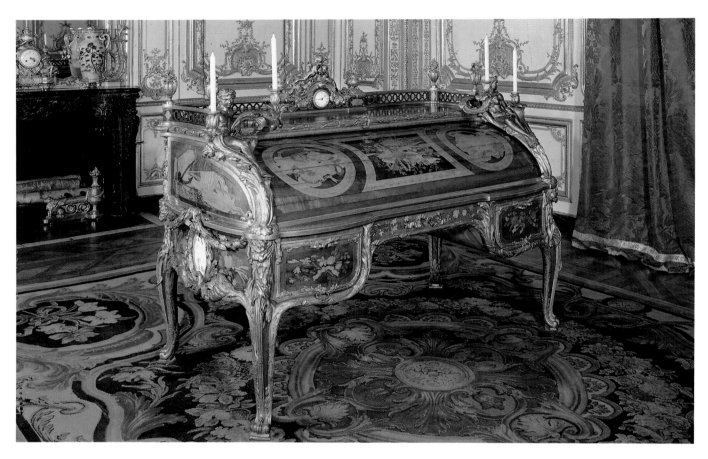

least until 1798. The Arsenal was a privileged enclave exempt from the regulations restricting the guilds (in particular that forbidding ébénistes to cast or chase mounts in gilt-bronze in their own workshops); Riesener therefore enjoyed similar privileged conditions to Oeben and Boulle before him. Thanks to his marriage to Oeben's widow Riesener became a member of one of the principal dynasties of ébénistes in Paris of that time, for she was no less than the sister of R. V. L. C. and the sister-in-law, by her first marriage, of Simon Oeben, and of Martin Carlin who had married one of Oeben's sisters.

Riesener brought to the marriage a dowry estimated at 1,200 livres, while his bride's assets were calculated at 18,200 livres, including stock and furniture in process of completion. The inventory appended to the marriage contract indicates however that Oeben's workshop had declined. At the time of his death there were twelve work-benches, whereas on his widow's remarriage there were only six remaining. It is true, however, that one of his most important patrons, Mme de Pompadour, had died in 1764. The work-

[448] Secrétaire à cylindre begun in 1760 by J.-F. Oeben and completed by Riesener in 1769 who inscribed his signature in the marquetry and supplied it for the Cabinet of Louis XV at Versailles for the considerable sum of 62,000L. All the gilt-bronze mounts were specially designed by Duplessis and cast and chased by Hervieu. (Musée de Versailles)

shop still seems to have preserved the social cachet it enjoyed under Oeben. The *Tablettes royales de renommée* for 1772 announces that '[Widow] Hobenne at the Arsenal keeps an impressive ébénisterie shop.'

Riesener did not lose time in recapturing royal patronage. His first delivery to the Garde-Meuble Royal was consigned on 5 February 1771: among large deliveries by Joubert there was a 'bureau mécanique' of a type for which Riesener had gained a reputation with the 'bureau du Roi'. During the following years other commissions, including a number of 'bureaux mécaniques', are recorded in the Journal of the Garde-Meuble. In June 1774 Gilles Joubert, now eighty-five years old, formally relinquished his office of 'ébéniste du roi' to Riesener.

There now followed a decade of great success and

prosperity from 1774 to 1784. During this period Riesener delivered more than 938,000 livres worth of furniture to the Garde-Meuble Royal, an annual amount twice that of his predecessor Joubert. To the Queen, particularly after the birth of the Dauphin, Riesener supplied furniture of an incredible luxury and inexhaustible ingenuity in its combination of precious materials such as Japanese lacquer, mother-of-pearl and marquetry with the richest of chased and gilded mounts.

To keep pace with his success and the pressure of orders from the Court, Riesener was forced to subcontract to a large extent, a practice common among former 'ébénistes du roi', such as Joubert and Gaudreaus. However, Riesener further insisted on a unity of style. A note by a clerk from the Garde-Meuble Royal in April 1786 comparing the workmanship and charges of Riesener and Benneman reveals the practice of subcontracting and suggests it as a cause of weakness in certain pieces: 'I notice with regard to Benneman that Riesener buys his furniture in the Faubourg Saint-Antoine and thus, if instead of this they were made in Benneman's workshop, they would consequently be more robust and need replacing less frequently' (Arch. Nat. 0¹3640).

Here is a plausible explanation for certain pieces of furniture delivered by Riesener whose technical perfection is not up to the expected standard. Among the ébénistes to whom Riesener would subcontract, Weisweiler in particular must be mentioned: their two stamps are found side by side on mahogany pieces entirely in Riesener's style. Sometimes only Weisweiler's stamp is found on a piece of furniture typical

of Riesener, of which the pair bears Riesener's stamp. These pieces, consisting chiefly of commodes delivered to Fontainebleau around 1784–86, were constructed with panels framed with mahogany mouldings together with certain gilt-bronze mounts also typical of Riesener.

In 1776 Riesener's first wife died. The inventory drawn up at the time has disappeared. But we are provided with an equally interesting record in the form of the inventory drawn up in 1783 on his remarriage. This ébéniste had become a man of substance with assets estimated at 10,000 livres, an annual income of more than 6,000 livres, a stock estimated at 30,000 livres, and equipment valued at 6,000 livres. The turnover of the business reached the considerable figure of 504,571 livres, in cash or in sums owed by the Crown and private clients. His expenses amounted to 145,000 livres, which indicates the importance of his business. It was at this period that Riesener had his portrait painted by Vestier (see p. 9), holding a furniture- (or marquetry-)designer's pen rather than a vulgar saw or artisan's chisel. Here is evidence of his obvious ambition to raise himself to the level of the artist.

[449] Secrétaire à cylindre, c. 1773–76, unstamped but with the remains of Riesener's trade label; an identical desk was supplied to the Comtesse de Provence by Riesener in 1773. (Waddesdon Manor, Buckinghamshire)

[450] Secrétaire à cylindre stamped Riesener, delivered on 28 March 1774 (delivery no. 2737) for the Comte de Provence at Versailles. (Waddesdon Manor, Buckinghamshire)

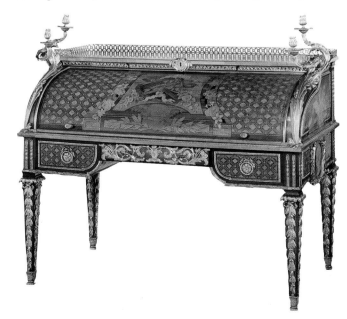

Riesener's career started to decline from about 1785. In 1784 Thierry de Ville d'Avray had succeeded M. de Fontanieu as head of the Garde-Meuble Royal. The new director completely reformed the Garde-Meuble, replacing the old numbering system of the Journal of the Garde-Meuble with a system of order books and labelling, as well as instituting the compilation of inventories of all the royal châteaux. Organization and economy were the order of the day under the new régime, and partly for reasons of economy Riesener was dropped in favour of his young colleague Benneman. By 1785 it was equally true that taste had changed. The 'style arabesque' was currently in fashion and the royal family was buying lavish furniture by Weisweiler through the dealer Daguerre. Moreover, in his own fields of 'meubles à mécanisme' and intricate marquetry, Riesener had been superseded by Roentgen, for whose work the royal family had a passion. Finally, the Queen herself turned to Schwerdfeger to create her finest furniture before the Revolution.

At a time when the Garde-Meuble Royal was scrutinizing Riesener's charges in an effort to find a replacement, the officials published a report, dated 1786, which is worth quoting (see Appendix). This report is of interest on more than one account: first, it gives a résumé of Riesener's current production and shows to what extent it was sterotyped (giving for instance a range of three commodes of varying degrees of sumptuousness). Further interesting details arise: mahogany furniture in current taste was finished in rempli ciré ('wax-polished on the inside as well as the exterior') and not varnished. Moreover, the bronze mounts were described as varnished ('en couleur d'or') and not 'gilt' ('doré d'or moulu'), that is, mercury-gilded. Finally, the report mentions numerous pieces of furniture in walnut (the full list is not given here). At the time of writing, to the author's knowledge, there are no recorded pieces in walnut stamped by Riesener. Various explanations are possible: either all Riesener's common furniture has vanished; or the pieces in walnut were upgraded by modern reveneering; or even these simple pieces were farmed out to second-rate ébénistes and Riesener did not stamp them.

The Revolution brought about the ruin of Riesener's business; during the sales of Crown and other property under the Revolution he bought back at deri-

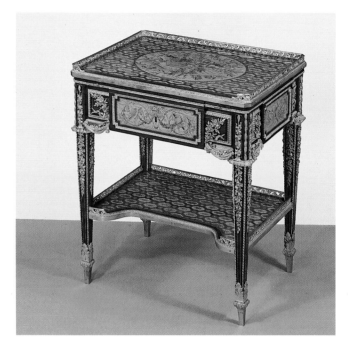

[451] On certain pieces made by Riesener for the Queen the mounts attain a jewel-like quality. This table was supplied in 1782 for the Queen's boudoir de la Méridienne at Versailles. The gilding alone, by Remond, cost 1,050L. (Waddesdon Manor, Buckinghamshire)

[452] Detail of a secrétaire supplied in 1783 to Marie-Antoinette by Riesener for the Trianon. Riesener here uses marquetry with sunflowers on a bois jaune ground. The lozenges of bois satiné are bordered by black and white fillets, as is found on work by Oeben. (Wallace Collection, London)

sory prices numerous pieces he had supplied to the Crown in hopes that he would be able to sell them at a profit when times were more auspicious. But the demand for this type of lavish furniture had completely dried up. Because of the desperate state of his finances he was forced to advertise the sale of his stock in 1794. This was not a great success, however, as he was forced to repeat the operation in 1797–98. During this period he must have removed the royal cipher and arms on a number of important pieces: thus on the commode in Louis XVI's bedchamber he substituted geometric marquetry for the fleurs de lys. On the celebrated 'bureau du roi' he replaced the royal ciphers on the sides with plaques imitating Wedgwood and the central medallion with the profile bust of Louis XV was replaced by that of Minerva. In January 1806, at the time of his death, Riesener had left the Arsenal and moved in with his son on the rue Saint-Honoré in the Enclos des Jacobins.

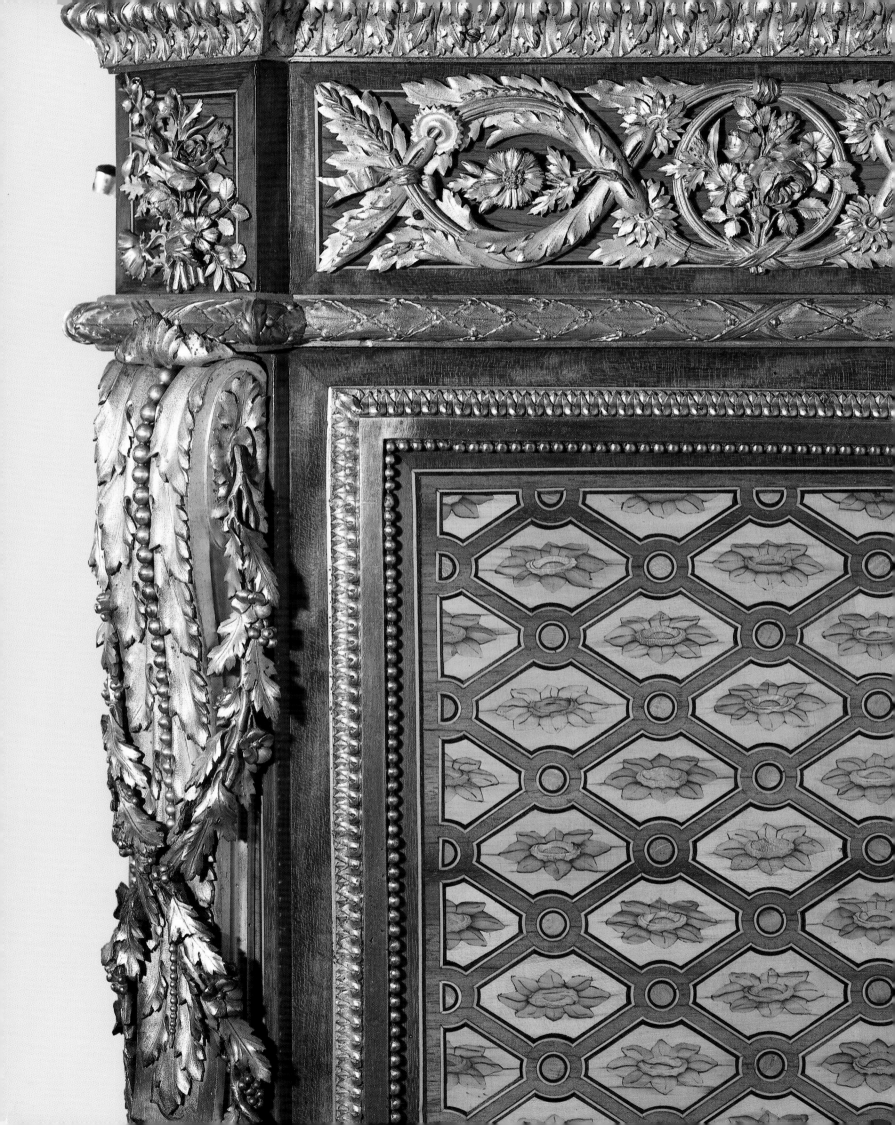

[453] *Commode delivered by Riesener on 30 March 1776 (delivery no. 2842) for the bed-chamber of the Comtesse de Provence at Versailles: priced at 7,400L. One of the most sumptuous pieces by Riesener, combining geometrical and floral marquetry. (Waddeson Manor, Buckinghamshire)*

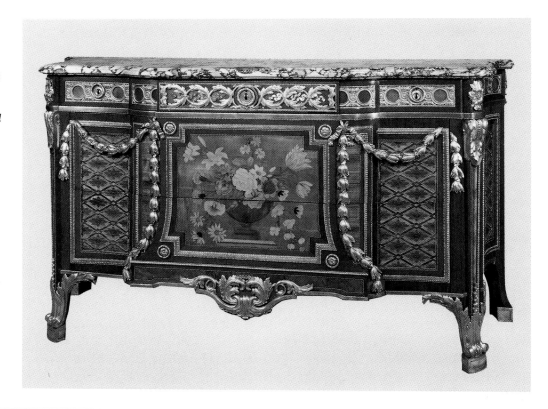

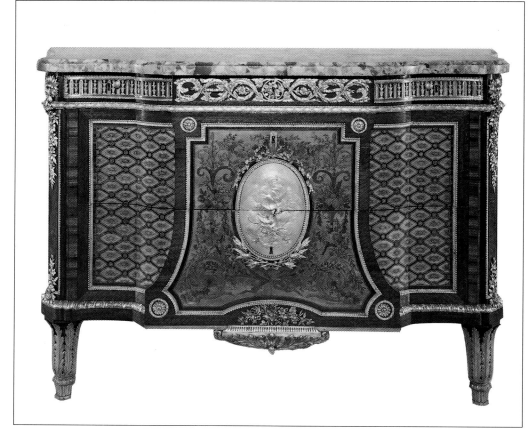

[454] *Commode with marquetry of lozenges and sunflowers; the inscription 'Riesener Ft. 1791' in the marquetry of the central part, according to M. Th. Dell, refers to the date when the central section was reveneered and enriched with a bronze medallion by Riesener. (Frick Collection, New York)*

[455] *(right) Commode attributed to Riesener, c. 1776; here Riesener combined marquetry of lozenges and sunflowers with a large central trophy. (Gulbenkian Museum, Lisbon)*

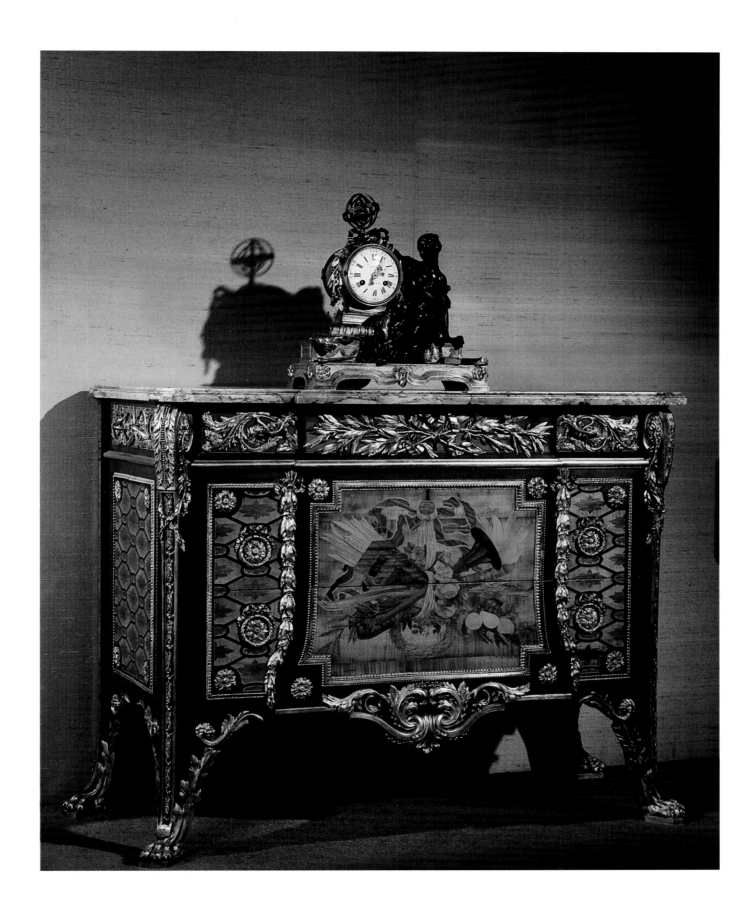

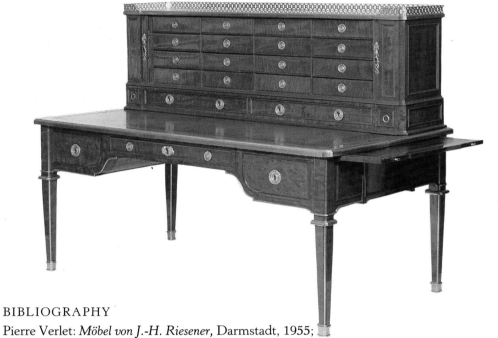

[456] *Bureau à gradin in plum-pudding mahogany stamped Riesener, c. 1780–85. (Archives Galerie Levy, Paris)*

[458] (below) *Writing-table in mahogany stamped Riesener with the marks of the Petit Trianon, supplied in 1777 (delivery no. 2909) 'for the King's use'; it corresponds to a standard type estimated by Riesener at 100L in his price list of 1786. (Sotheby's Monaco, 23 June 1985, lot 770)*

[457] *Commode stamped Riesener, c. 1785, in plum-pudding mahogany, corresponding to a standard model estimated by Riesener at 600L in his price list of 1786. (Sotheby's Monaco, 21 February 1988, lot 827)*

[459] (right) *Mahogany secrétaire en cabinet stamped Riesener, c. 1785–89; this piece was influenced in its form and mounts in arabesque style by the cabinets made by Weisweiler for Daguerre. (Archives Galerie Aaron, Paris)*

BIBLIOGRAPHY

Pierre Verlet: *Möbel von J.-H. Riesener,* Darmstadt, 1955; *French Royal Furniture,* London, 1963, pp. 117–51, 158–59

Geoffrey de Bellaigue: *The James A. de Rothschild Collection at Waddesdon Manor,* vol. II, p. 878

Frances Buckland: 'Jean-Henri Riesener, ébéniste to the Court of Louis XVI', *Kunst und Antiquitäten,* VI/80

Svend Eriksen: *Early Neo-classicism in France,* p. 219

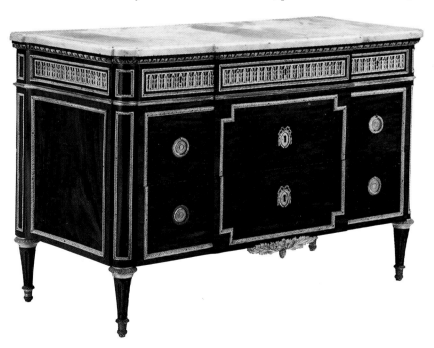

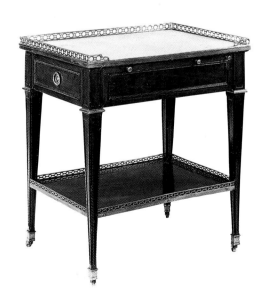

APPENDIX

SUBMISSION OF PRICES FOR
STANDARD FURNITURE BY
RIESENER IN 1786 (ARCH. NAT.
0¹3640)

Pieces in mahogany

Commodes
— Commode (4 pieds in length)
with 5 drawers wax-polished
inside and outside and decorated
with sabots, capitals, escutcheons
and rings in gilt-bronze, the top
of ordinary marble. *300L*
— The same, of 3 pieds in
width. *280L*
— More elaborate commode
with wooden moulding
surrounding the panels, a gilt-
bronze moulding below the
frieze; decorated with consoles,
chased capitals, sabots,
escutcheons and rings in gilt-
bronze. *400L*
— More elaborate commode
than the preceding with bronze
mouldings around the panels, a
gilt-bronze moulding below the
frieze; decorated with consoles,
chased capitals, sabots,
escutcheons and rings in gilt-
bronze. *600L*

Secrétaires
— Secrétaire en armoire, well
made in mahogany, wax-
polished inside and outside,
decorated with sabots, capitals,
escutcheons and rings, with gilt-
like varnish. *240L*
— Secrétaire en armoire,
completed, wax-polished inside
and outside, with silvered
écritoire and the decorations in
gilt-bronze, of 2¹/₂ by 3 pieds.
300L
— Secrétaire en armoire,
complete, wax-polished inside
and outside, with silvered
écritoire and decorations in gilt-
bronze, 3 by 4 pieds with white
marble top. *400L*
— Secrétaire in plum-pudding
mahogany with 3 mouldings of
which one forms the frieze, the
other the base and the third in
the centre with frames
surrounding the panels in
mahogany, recessed pilasters
with sunken panels, decorated
with rings and escutcheons in
gilt-bronze, 3 by 4 pieds. *500L*

Encoignures
— Encoignures en suite with the
commodes (no. 1); each worth

¹/₃ of matching commode. *100L*
— Encoignure in plum-pudding
mahogany in the same style as
the commode with which it is to
be used, with two gilt mouldings
around the circumference, that
is, one forming the base and the
other the frieze, with rings and
escutcheons in gilt-bronze. Each
worth ¹/₃ of the matching
commode. *130 or 200L*

Toilet-tables
— A toilette in mahogany fitted
with 6 pots in porcelain, bottles,
powder-boxes, mirrors and all
accessories, decorated with
sabots, button-handles, rings and
rosettes. *200L*
— A toilette in plum-pudding
mahogany with more elaborate
mounts, with wooden mouldings
surrounding the panels. *240L*
— A toilette in plum-pudding
mahogany with chased
mouldings surrounding the
panels. The mirror and
accessories more elaborate, the
inside in blue taffeta trimmed
with a narrow braid. *360L*

Bureaux plats
— Bureau in ebonized wood
with drawers fitted with locks
and garniture in imitation
gilding, the top covered with
black morocco leather, 4 feet
long. *80L*
— Similar desk, 3 feet long. *72L*

Writing-tables
— Writing-table in mahogany
having a drawer at the side,
furnished with a silvered

écritoire, decorated with gilt
capitals, sabots and escutcheons,
30 pouces, fitted with a leather
top. *100L*

Night-tables
— Bedside-table in mahogany
with 2 shelves of veined white
marble. *50L*

Commode chairs
— Commode chair with pot à
oeil. *66L*
— Commode chair with faïence
pot, fitted with brass hinges and
hooks. *66L*

Games-tables
— Trictrac-table of the best
type, in plum-pudding
mahogany, all the panels framed
with mouldings in the same
wood, the top covered in cloth on
one side and morocco leather on
the other, embellished with
capitals, sabots and 4 rings in
gilt-bronze, the checkers in green
and white ivory, covered on one
side in cloth, with dice and all
accessories, including the
checkers in ivory.
— Folding quadrille-table in
mahogany, the top in plum-
pudding figure with fillets round
the edge. *96L*
— Picquet and trictrac-table in
the same wood. *96L*
— Folding brelan-table in
mahogany covered in green
cloth, with a central stand on
which to place candles and cards,
the top veneered with a panel of
figured wood framed by a fillet.
180L

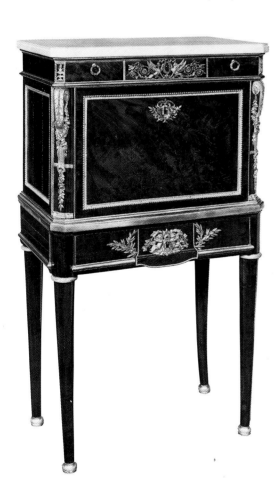

[460] *Backgammon table in
plum-pudding mahogany
stamped Riesener, c. 1785,*

*one of Riesener's standard
models. (Sotheby's Monaco, 15
June 1981, lot 128)*

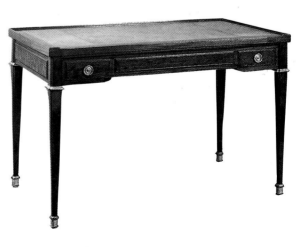

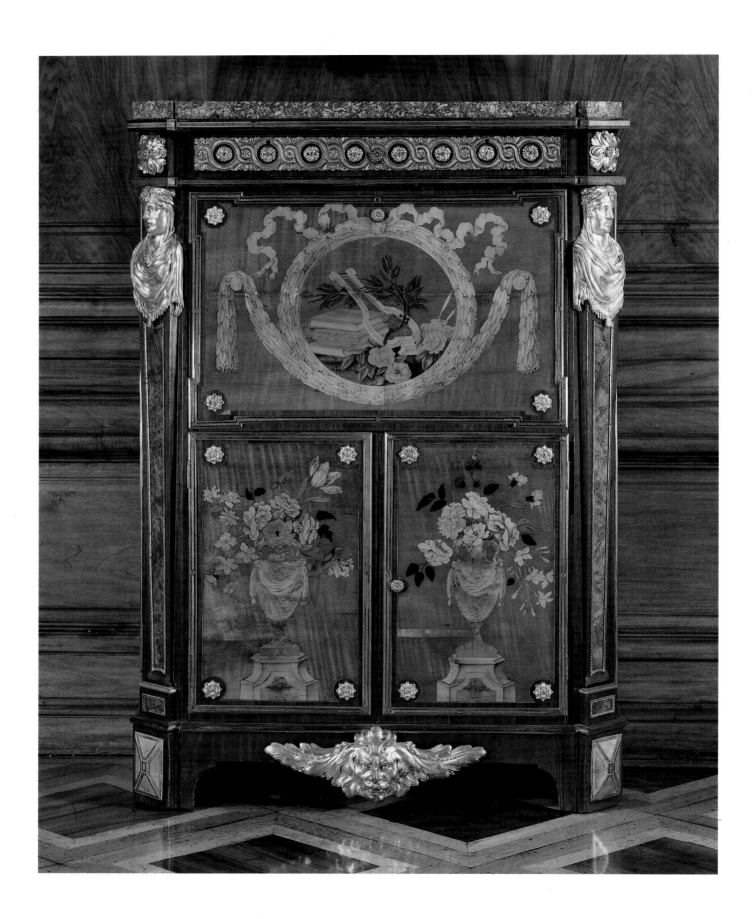

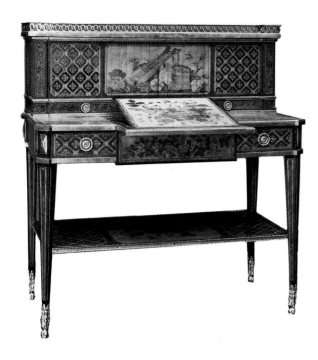

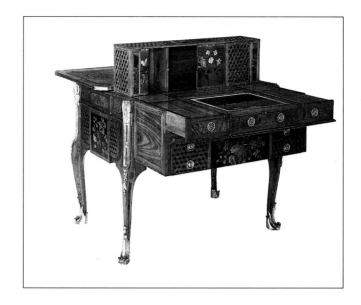

[463] (above) *Riesener made a speciality of mechanical tables; this one is stamped both Riesener and Cosson; once the drawers are pulled out, the complex mechanism releases a superstructure with marquetry which has kept its original colour (see p. 432). (Formerly in the Anthony de Rothschild Collection; Christie's London, 23 June 1923, lot 49)*

[464] (below) *Commode supplied by Riesener in 1780 for the second Cabinet Intérieur of Marie-Antoinette at Compiègne. Riesener here played on the contrast between the large horizontal strips of bois satiné veneer and the finely detailed marquetry in the centre on a pale sycamore ground. (Palais de Compiègne)*

[461] (left) *Secrétaire à abattant stamped Riesener, c. 1775; the marquetry has retained something of its freshness, from which the intensity of the original colours may be imagined. The corner-mounts in the form of vestal busts are more often found on Carlin's*

work, and their models certainly belonged to Poirier. (Musée d'Art et d'Histoire, Geneva; Michelham Bequest)

[462] (above left) *Bonheur-du-jour stamped Riesener, c. 1780. (Rijksmuseum, Amsterdam)*

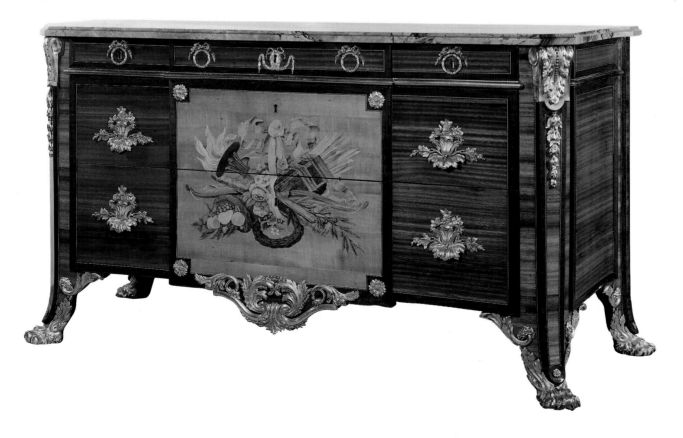

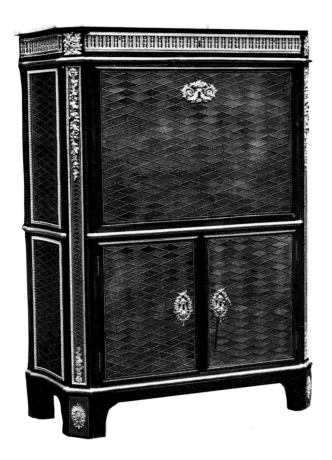

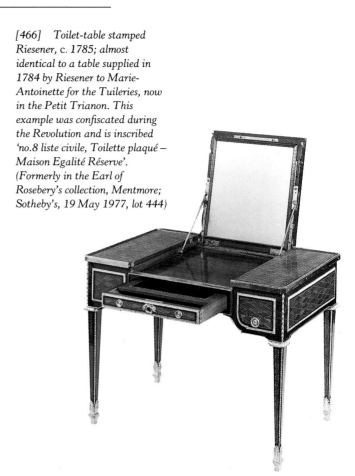

[466] Toilet-table stamped Riesener, c. 1785; almost identical to a table supplied in 1784 by Riesener to Marie-Antoinette for the Tuileries, now in the Petit Trianon. This example was confiscated during the Revolution and is inscribed 'no.8 liste civile, Toilette plaqué – Maison Egalité Réserve'. (Formerly in the Earl of Rosebery's collection, Mentmore; Sotheby's, 19 May 1977, lot 444)

[465] (above) Secrétaire à abattant stamped Riesener. The fashion around 1785 was for plain veneers and restrained marquetry. Riesener invented a marquetry of lozenges delineated by black and white fillets on a sycamore ground called 'satiné gris'. (Archives Galerie Segoura, Paris)

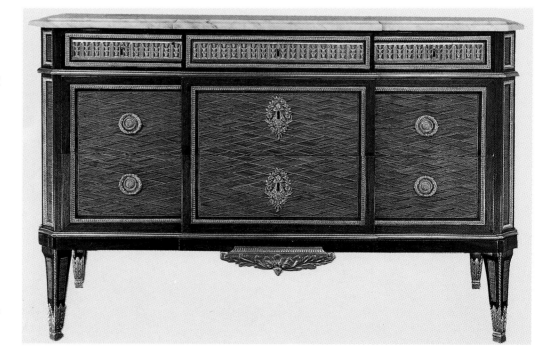

[467] Commode stamped Riesener, c. 1785, bearing the marks of the Petit Trianon and the number '35', with marquetry of lozenges in tulipwood. (Petit Trianon, Versailles)

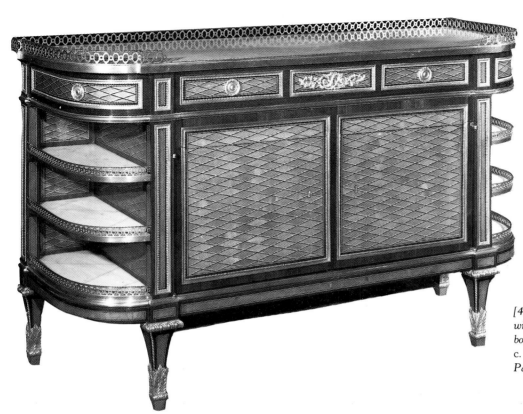

[468] 'Commode à l'anglaise' with marquetry of lozenges in bois satiné, stamped Riesener, c. 1785. (Archives Galerie Levy, Paris)

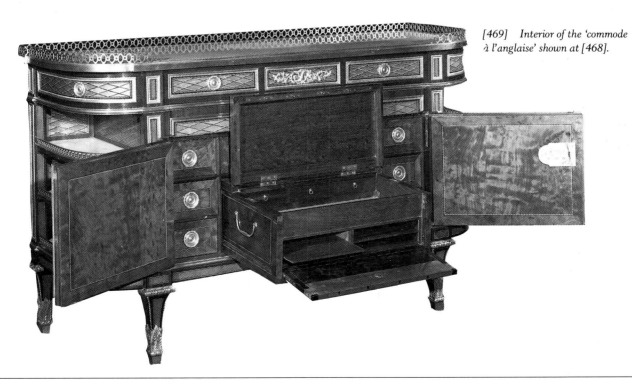

[469] Interior of the 'commode à l'anglaise' shown at [468].

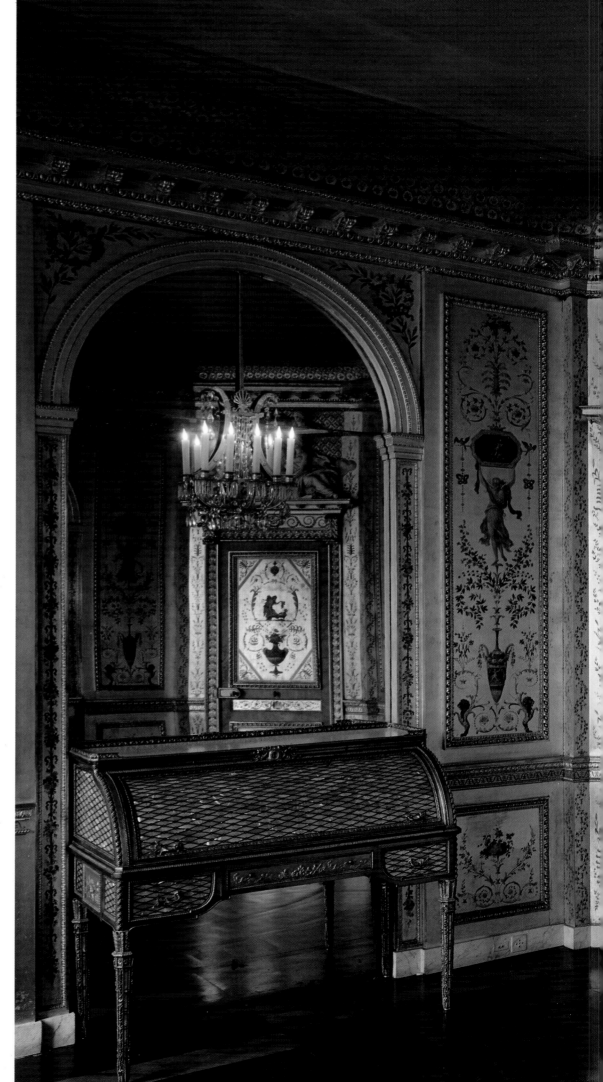

[470] For Marie-Antoinette's boudoir at Fontainebleau, which was redecorated by the Rousseau brothers in 1786, Riesener conceived a suite of furniture in metal and mother-of-pearl comprising a secrétaire à cylindre and a sewing-table. Here again the lozenge motif is used but the mother-of-pearl has replaced the 'satiné gris' [465] and the borders are in silvered bronze instead of amaranth. The harmonies in silver and gold thus obtained matched the colours of the wall-paintings. (Château de Fontainebleau)

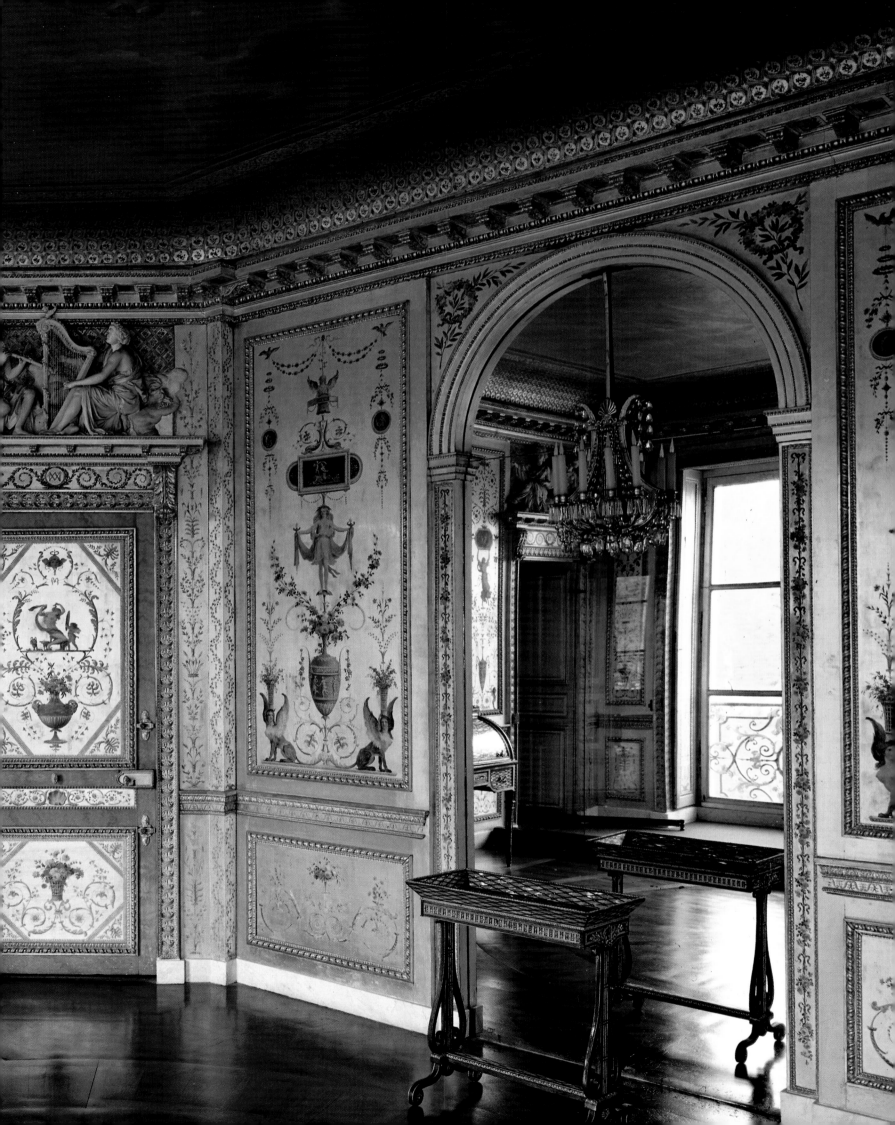

[471, 472] For Marie-Antoinette Riesener created some of his most sophisticated furniture; the Queen collected Japanese lacquer which she placed in her Cabinet Intérieur at Versailles; Riesener made this commode and secrétaire for that room in 1783, together with an encoignure. All bear the mark of the Château de Saint-Cloud, where they were subsequently sent in 1788. The quality of the chasing on the mounts and their extraordinary lightness are of a jewel-like quality. (Metropolitan Museum of Art, New York)

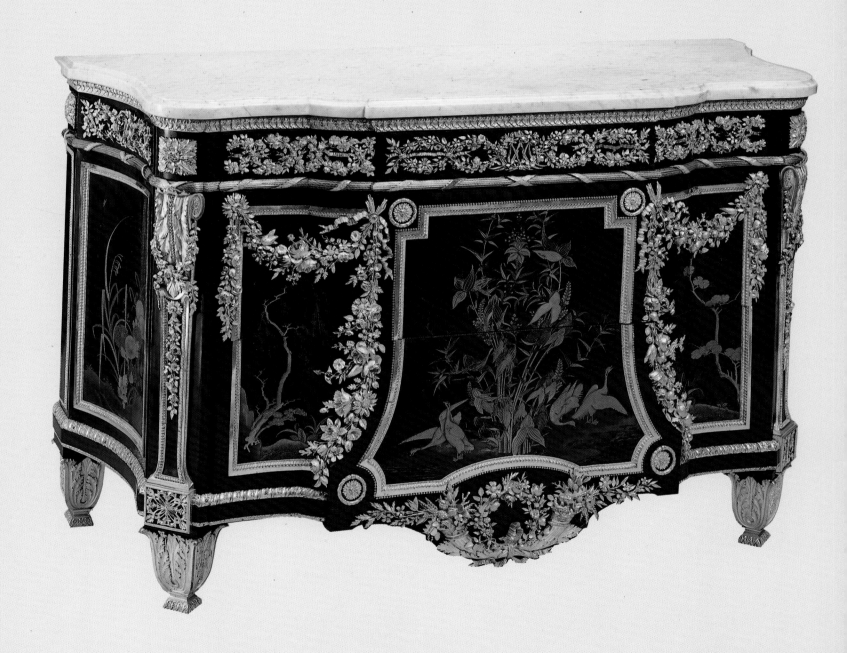

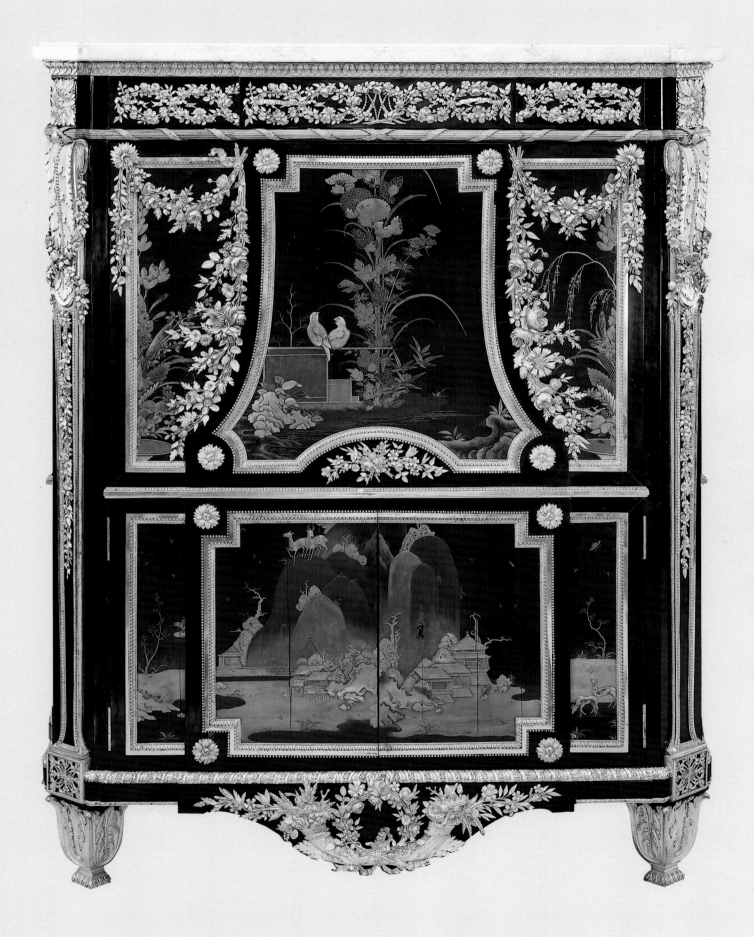

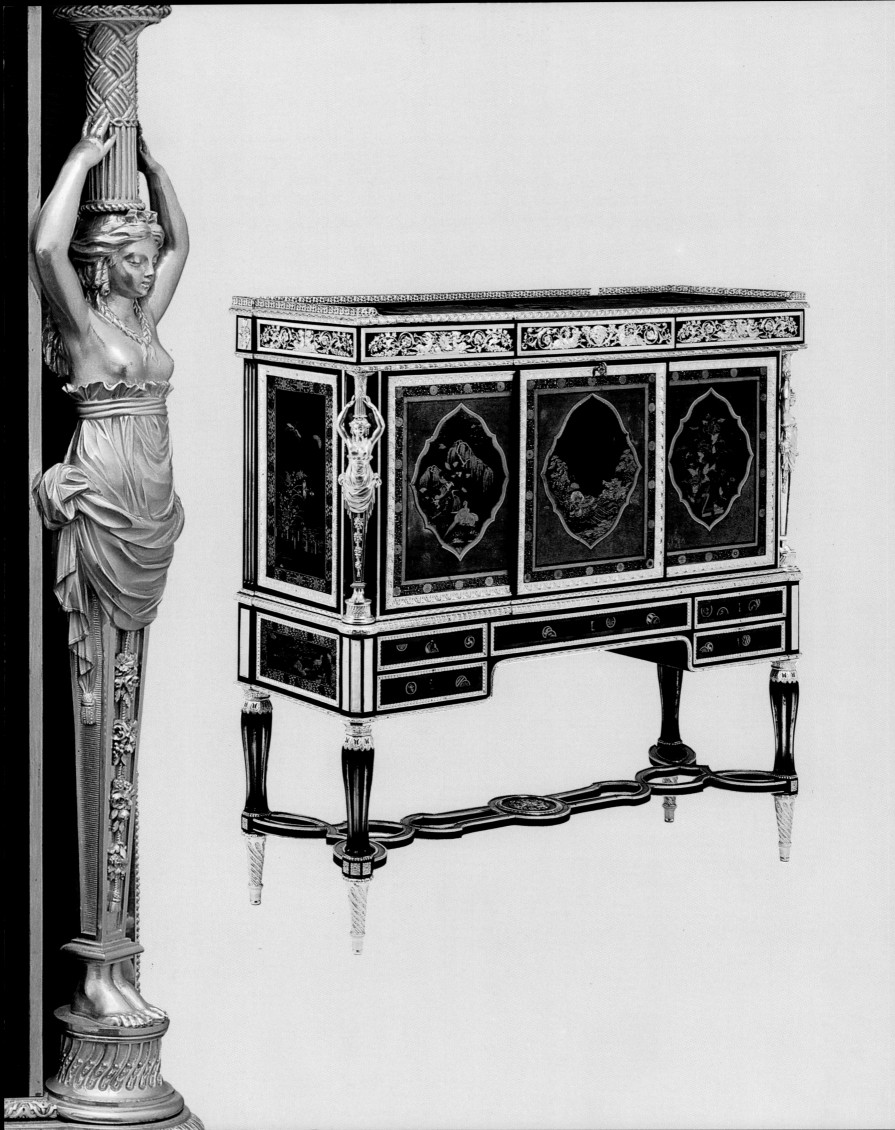

Adam
WEISWEILER

1744–1820; MASTER 1778; ACTIVE UNTIL 1809

L ike so many other important ébénistes of the period, Adam Weisweiler originated from the Rhineland. He came from an area bordering on Belgium and the Netherlands. Concerning his apprenticeship and the date of his arrival in Paris we know nothing. The tradition that he was trained in Roentgen's workshop at Neuwied is not based on any evidence; at the same time it is worth noting the proximity of Neuwied to his birthplace of Korschenbroich. One thing is certain: in 1777, when he married, he was already established in Paris, in the rue du Faubourg Saint-Antoine, and is described in the marriage-contract as 'ébéniste working for the mastership'. He became a master in the following year on 26 March 1778. The groom, thirty-three years old, contributed 1,500 livres of 'clothes, furniture, linen, personal apparel and cash from his earnings' as well as a fixed dowry of 500 livres, indicating that he had been working to save money for some time. The couple moved into 67 rue du Faubourg Saint-Antoine, a house in which he remained until 1797. It was therefore in the Faubourg Saint-Antoine that all Weisweiler's work

was carried out. This artisan quarter, which sheltered the greatest concentration of ébénistes in the capital, was far removed from the centres of luxury commerce situated in the rue Saint-Honoré near the Louvre, and it is probable that Weisweiler was not then in personal contact with his elegant clientèle.

Most of his output was sold through the intermediary of the marchand-merciers, or fellow-ébénistes of renown such as Riesener or Benneman. The few documented pieces by Weisweiler were almost all supplied by the marchand-mercier Daguerre who must have had a quasi-monopoly over Weisweiler's luxury pieces: for example, the lacquer table supplied in 1784 for Marie-Antoinette at Versailles and later placed at Saint-Cloud or the lacquer secrétaire of the same year for Louis XVI's Cabinet Intérieur at Versailles, or the mahogany commode of 1788 with three panels for the Cabinet Intérieur of Louis XVI at Saint-Cloud. More-

[473, 474] *An early example of a piece in the 'style arabesque', this secrétaire attributed to Weisweiler was supplied on 11 January 1784 for the Cabinet Intérieur of Louis XVI at Versailles. The richness of the mounts – the corner caryatids and frieze of arabesques probably specially modelled – justified the price of 7,200L. Daguerre's invoice mentions the Japanese lacquer panels on drawer and sides but not those of much higher*

quality on the fall front, presumably supplied to Daguerre by the Garde-Meuble Royal. (Sotheby's London, 8 July 1983, lot 85)

[475] *Table in Japanese lacquer stamped Weisweiler, supplied in 1784 by Daguerre to Marie-Antoinette who placed it in her Cabinet Intérieur at Saint-Cloud. Daguerre's bill indicates that the mounts were specially designed. (Musée du Louvre, Paris)*

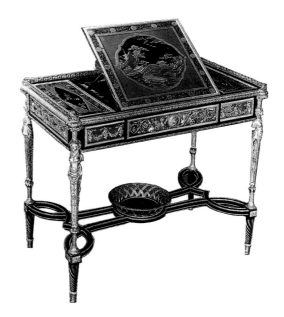

over, if a study is made of Daguerre's invoices, not only to the Garde-Meuble Royal but also to his private clients between the years 1784 and 1790, it will be seen that the descriptions correspond mostly to furniture by Weisweiler; as Carlin, Daguerre's principal supplier, had died in 1785, Weisweiler must have stepped into his shoes. The stylistic similarities between the work of Carlin and Weisweiler are striking enough to make one wonder if the latter might even have been trained by his older colleague. Another hypothesis, the most plausible, is that the stylistic similarities between the two craftsmen had their origins in Daguerre, who must have provided both with the designs for the furniture and models of the bronze mounts, porcelain plaques and panels of lacquer and pietra-dura.

Weisweiler's clientèle was therefore essentially that of Daguerre: the French royal family, the nobility (the Duc d'Aiguillon, the Marquise de Brunoy, the Maréchal de Castries, the Duc de Guiche, the Duchesse de Fitzjames, the Comtesse Diane de Polignac) and foreign royalty (the Queen of Naples, Maria-Carolina owed Daguerre 14,225 and the King of Naples 5,977 livres). These large sums certainly correspond to the black-lacquer pieces [477] today in the Metropolitan Museum of Art, which originally stood in Caserta: they appear in the old inventories of the palace, and when they were sold by the Italian royal family they were replaced with copies which have mahogany borders around the lacquer panels. The Russian Court was also among his clients, as is indicated by the porcelain-mounted secrétaire [485] formerly at Pavlovsk, acquired by Maria Fyodorovna during or after her stay in Paris in 1782 under the pseudonym of 'Comtesse du Nord'. An account of this trip is given in the memoirs of the Baronne d'Oberkirch, in which she recorded that the Comtesse du Nord bought numerous pieces of furniture, 'bijoux' and porcelain from the marchands-merciers, among them Daguerre. Several pieces today at Pavlovsk or in the Hermitage must be attributed to Weisweiler. Decorated with Wedgwood plaques, they date from after 1783 and correspond to those sent by Daguerre to the Russian Court after the Comtesse du Nord's visit to Paris. In England, Lord Malmesbury and Lady Holderness were Daguerre's clients, and above all the Prince of Wales, the future George IV, for whom he furnished Carlton House in the 1780s with pieces in chinoiserie and arabesque style.

[476] Meuble d'entre-deux, one of a pair stamped Weisweiler, in Japanese lacquer, c. 1785. The columns in chinoiserie taste are found on numerous pieces by Weisweiler, but also on a commode with porcelain plaques by Carlin in the British Royal Collection. (Musée du Louvre, Paris; Grog Bequest)

[477] (right) Secrétaire en cabinet, one of a pair in Japanese lacquer stamped Weisweiler, with aventurine borders, c. 1785. This secrétaire was part of an ensemble comprising a commode à vantaux and a secrétaire à cylindre belonging to Maria-Carolina, Queen of Naples. The pieces were sold by the Italian royal family and replaced at Caserta by copies which have mahogany borders around the lacquer panels. This was the original decorative scheme confirmed by the original inventories. (Metropolitan Museum of Art, New York; Wrightsman Collection)

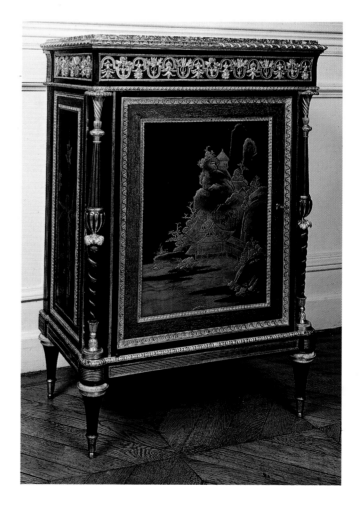

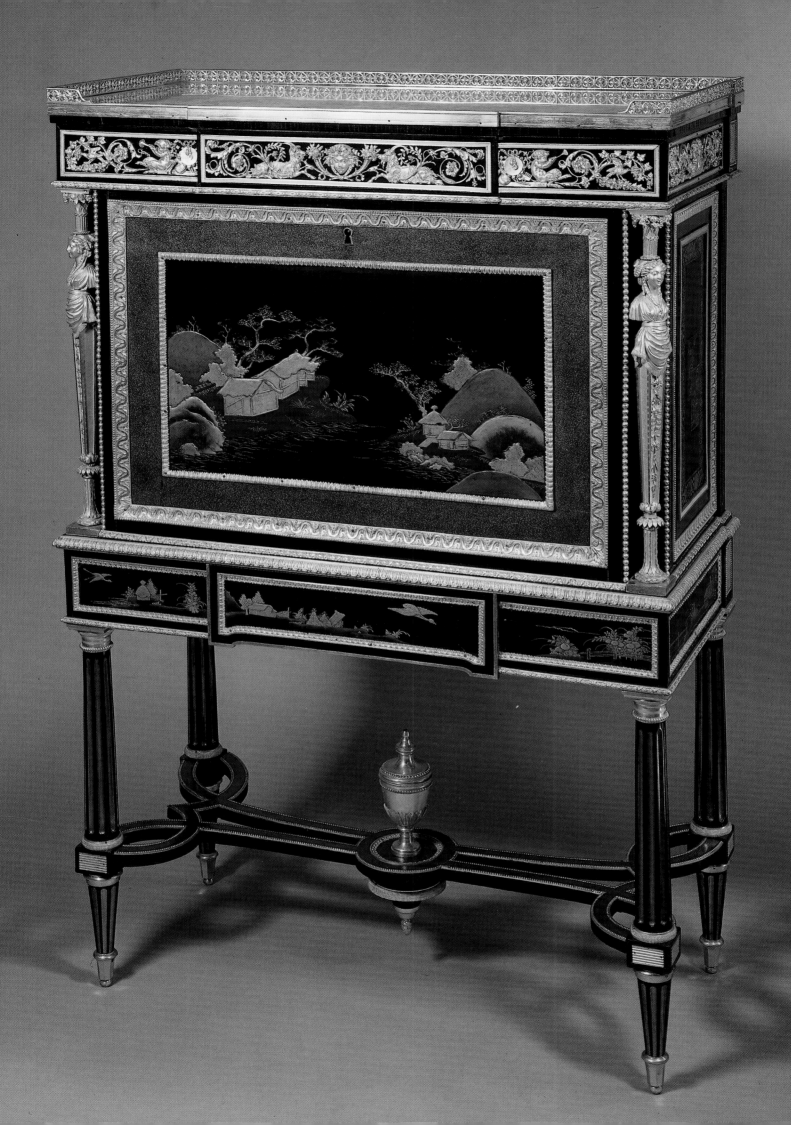

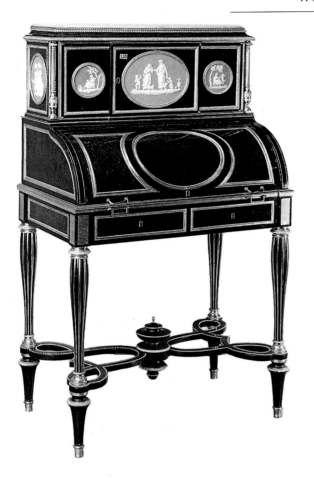

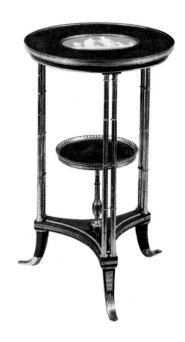

[479] (right) *Guéridon attributed to Weisweiler, c. 1780; in burr-thuya decorated with Wedgwood biscuit plaques, the legs in the form of double bamboo in gilt-bronze. As early as 1777 Daguerre sold a table of this type to Mme du Barry (see p. 38). (Couturier-Nicolaÿ, Paris, 6 December 1983, lot 75)*

[481] (opposite) *Secrétaire attributed to Weisweiler, c. 1790, mounted with a Sèvres porcelain plaque and fifteen Wedgwood medallions; this may be the secrétaire that belonged to Marie-Antoinette: however, Daguerre had a second version made which appeared in his sale in London in 1791. The mounts are by François Rémond. (Metropolitan Museum of Art, New York)*

[478] (above) *Secrétaire à cylindre attributed to Weisweiler, c. 1785, in burr-thuya decorated with blue and white Wedgwood biscuit plaques. The dealer Daguerre had the idea of mounting these Wedgwood plaques on furniture and even obtained their import monopoly in 1787. (Galerie Charpentier, Paris, 2 December 1955, lot 130)*

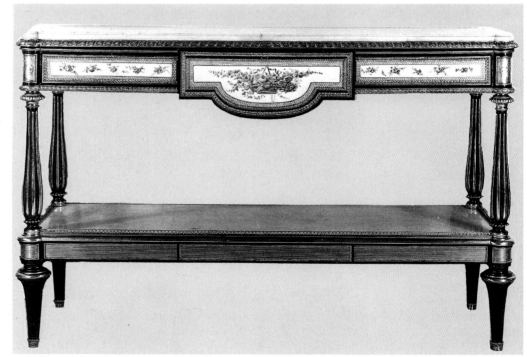

[480] *Console-table attributed to Weisweiler, in mahogany decorated with Sèvres porcelain plaques with borders in blue oeil de perdrix, dated 1787. Formerly in the Victor de Rothschild Collection. (Archives Galerie Aveline, Paris)*

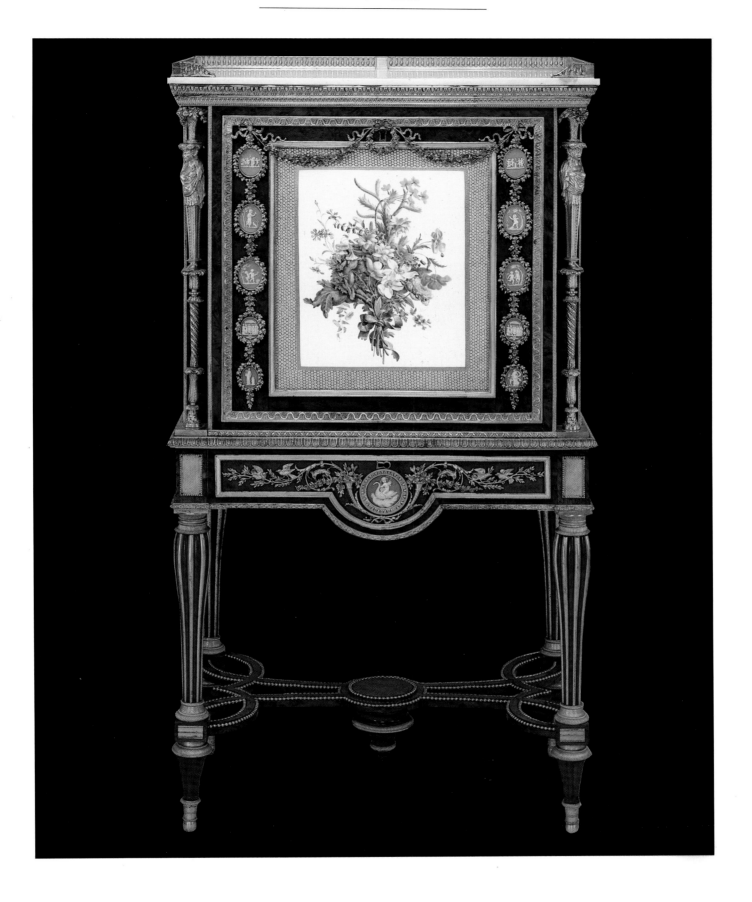

Besides Daguerre, Weisweiler probably worked for the marchand-mercier Julliot, making sumptuous pieces for him incorporating pietra-dura, of which the latter had made a speciality. The drawing in the Musée des Arts Décoratifs (see p. 35) for a commode in pietra-dura entirely in Weisweiler's style was made in 1784 'under the direction of Julliot the Younger'. Pieces by Weisweiler can be identified among the four commodes with panels of pietra-dura that figured in Julliot's forced sale in 1802.

At least during the first part of his career, from 1778 to 1785, Weisweiler must have worked with Riesener. The presence of both stamps on certain pieces of furniture illustrates the problem of joint authorship:
— The secrétaire en cabinet in mahogany (sale Sotheby's Monaco, 22 June 1986, lot 635).
— A mahogany commode with 3 panels 'à brisure' – that is, with the central panel hinged on the right-hand one (reproduced in *Belles Demeures de Paris*, p. 86).
— A table in plum-pudding mahogany (illustrated in *Weisweiler* by Patricia Lemonnier, p. 38).
— A mahogany commode in the style of Riesener, in the Musée Carnavalet: Bouvier Collection.
Moreover, three mahogany commodes are recorded stamped 'Weisweiler', but designed entirely in Riesener's style, which bear the mark of the Château de Fontainebleau and were supplied by the latter in 1786. One of them belonged to Anna Gould, Duchesse de Talleyrand and two others were in the Cornet-Épinat Collection. In all these instances it is clear that it was Weisweiler who was the author of the pieces (sometimes in his own style and sometimes that of Riesener), and Riesener who sold them on. Between the

[482] Secrétaire en cabinet in Japanese lacquer stamped Weisweiler, c. 1785; the composite columns in chinoiserie taste and the frieze pierced with lozenges emphasize the exotic aspect of this piece. (Huntington Art Gallery, San Marino, California)

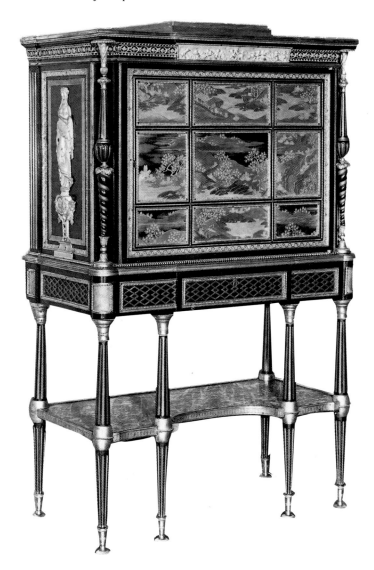

[483] Bureau plat stamped Weisweiler, c. 1785, decorated with gouache panels under glass, a rare technique also found on a secrétaire by Weisweiler in Schönbrunn. (Formerly Alfred de Rothschild Collection, subsequently Countess of Carnavon: Christie's London, 19 May 1925, lot 302)

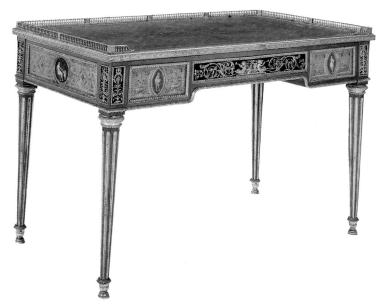

years 1778 and 1785 Riesener was at the height of his success. Overwhelmed with orders, from the royal family as well as private clients, he had to subcontract in order to keep abreast of his affairs.

After 1785 a working partnership developed with Benneman. Their stamps are to be found side by side on several pieces of furniture – Weisweiler-Benneman. For example, their joint stamps have been found on a mahogany long-case clock and barometer that belonged to Marie-Antoinette, as well as the two pairs of consoles shown at [493]. The hypothesis that the two ébénistes worked side by side seems unrealistic. That this marks a repair by one of them is equally unacceptable for chronological reasons. There remains the explanation that one stamped the other's work at the time of resale. As these pieces are entirely in Weisweiler's style it must be accepted that they were made by him and supplied by Benneman.

Unlike so many of his trade, Weisweiler did not go bankrupt during the Revolution. Salverte has suggested that this was due to the fact that, not having a private clientèle, he was not owed large sums of money. It is more likely that he continued to sell his work through Daguerre who had a shop in London, and could continue working for export. In any case, in Messidor II (1794) he bought a house in the rue Charlot for 40,000 livres, and then a farm in Seine-et-Marne in 1797 for 24,000 francs. In the same year he bought another house, no. 176 rue des Tournelles, for 40,000 francs into which he moved. It had a shop and Weisweiler now became a dealer in fine furniture.

In the sale-contract of the farm in 1797 Weisweiler is described as a marchand-ébéniste, and in 1805 he is mentioned in *L'Almanach des commerçants de Paris* at his new address. As Daguerre had died in 1794, Weisweiler had probably decided to sell his furniture himself. At the same time he also worked for Thomire and Duterme who owed him 4,800 livres for ébénisterie supplied in 1808. In 1809, on the death of his wife, an inventory was drawn up which gives us an insight into the state of his workshop. The stock consisted above all of wood; planks of oak, off-cuts, planks and sheets of mahogany in large quantity, planks of satinwood and various small pieces of amaranth, ebony and yew. Numerous sheets are described as 'of mottled wood', or 'figured' or 'burr-wood' without greater detail. The workshop was fitted with six large workbenches and two smaller ones, indicating that he must have em-

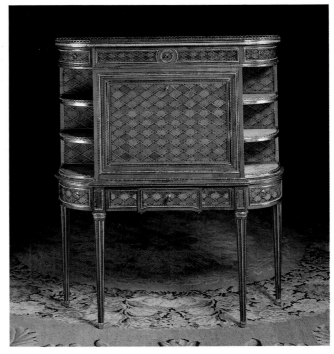

[484] Secrétaire en cabinet stamped Weisweiler; the marquetry of lozenges and dots is one of the rare examples of marquetry by this ébéniste. (Galerie Segoura, Paris)

[485] Secrétaire en cabinet stamped Weisweiler, originally at Pavlovsk and acquired in Paris at Daguerre's by the Grand Duchess Maria Fyodorovna, no doubt during or after her stay in 1782. (Sotheby's London, 24 Nov. 1988, lot 33)

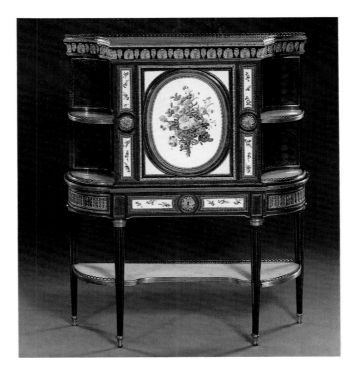

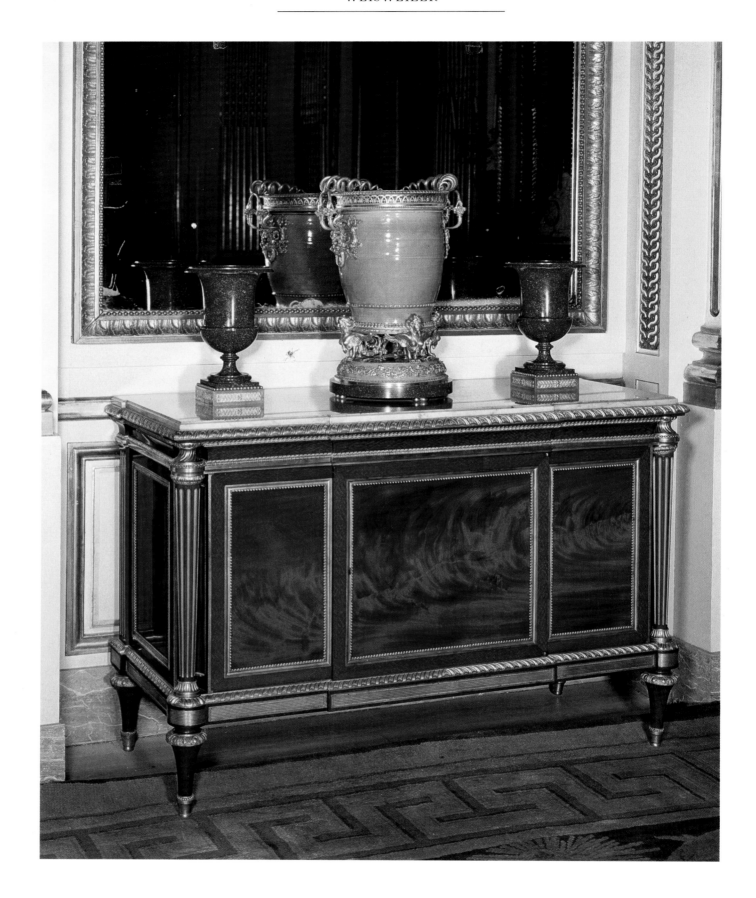

ployed at least eight workmen until 1809. The stock amounted to 20,187 francs, the credits to 9,984 francs and cash in hand of 644 francs. Very few pieces of furniture either finished or in the process of completion are found amongst the stock, a probable indication that the workshop was in decline. Moreover, not long afterwards, in 1809, Weisweiler is described in a legal document as 'former ébéniste'.

In 1812 Weisweiler sold his house in the rue des Tournelles and moved to an apartment in the same street. The inventory after his death makes no mention of any ébéniste's tools which he must therefore have sold in the interim.

Commodes à vantaux (with panels) made up the major part of his output. Of the fifty commodes listed by Patricia Lemonnier, forty-three have panels, while only seven are fitted with drawers. These commodes were usually made with three panels of which only two opened, the central panel moving across the right-hand panel by means of a flying hinge. Weisweiler made numerous examples of this type in mahogany or in burr-thuya and a number decorated with lacquer or pietra-dura. The advantage of the commode à vantaux is that the panels of lacquer or pietra-dura are not disfigured by the interruption of drawers or keyholes. This type of furniture was called a 'commode à brisure'.

Secrétaires 'en cabinet' were another of Weisweiler's specialities. Daguerre must surely have designed the prototype as Carlin made a good number before 1785 and Weisweiler merely carried on Carlin's production. This piece of furniture, which owed so much to both the jewel-cabinet in its minute size and exquisite detail, and to the secrétaire à abattant in its fitted interior and its function as a writing-table, enjoyed great popularity as a lady's desk between 1770 and 1800. Of 37 secrétaires listed by Patricia Lemonnier, 28 are 'en cabinet' while six are 'en armoire' (with fall-front), and only three are of the cylinder type. These cabinets are mostly decorated with porcelain plaques painted with vases of flowers and sometimes with Wedgwood medallions. One of this type was owned by Marie-Antoinette; Mme Campan mentions it briefly in her memoirs and it can be identified today as one in the Metropolitan Museum of Art, described in *Les Affiches, annonces et avis divers des ventes révolutionnaires* [481]. Certain other secrétaires are also decorated with precious panels in Japanese lacquer such

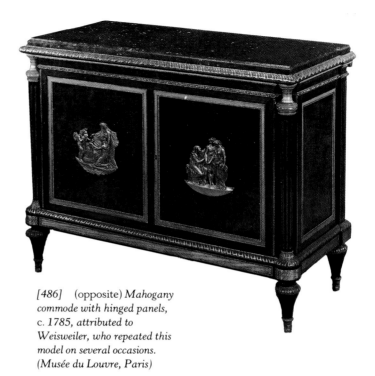

[486] (opposite) *Mahogany commode with hinged panels, c. 1785, attributed to Weisweiler, who repeated this model on several occasions. (Musée du Louvre, Paris)*

[487] (above) *Burr-thuya commode with panels, attributed to Weisweiler, bearing the château mark of Versailles; probably supplied by Daguerre in 1789 for the Cabinet de la Garde-robe of Louis XVI at Versailles. (Formerly in the Earl of Rosebery's collection; Sotheby's London, 30 June 1978, lot 119)*

[488] *Burr-thuya commode with hinged panels attributed to Weisweiler. The bas-relief of a fountain is found on other furniture by Weisweiler such as the commode in the Swedish Royal Collections [490]. (Formerly Earl of Rosebery's collection; Sotheby's London, 17 April 1964, lot 53)*

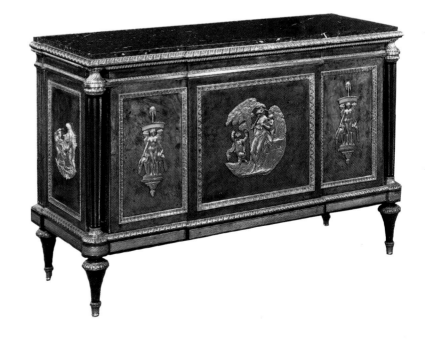

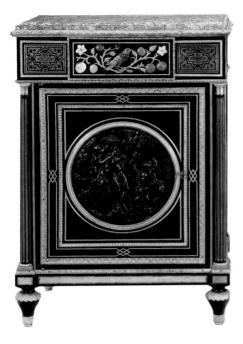

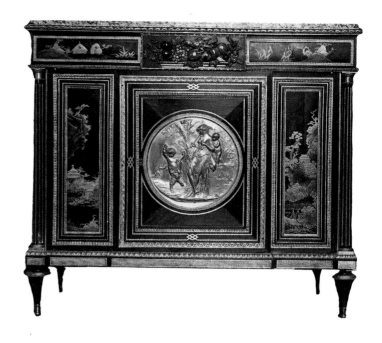

[489] Ebony cabinet, one of a
pair attributed to Weisweiler,
c. 1785, decorated with a pietra-
dura panel and drawer fronts
from a seventeenth-century
cabinet; this piece was no doubt

conceived under Daguerre's
direction – bronze medallions of
this type are mentioned in the
inventory drawn up after his
death in 1797. (Sotheby's
Monaco, 22 June 1986, lot 640)

[490] Commode, one of a pair
attributed to Weisweiler,
c. 1785, combining Japanese
lacquer with a panel of pietra-
dura originally from a
seventeenth-century cabinet; on
an ebony ground with pewter
fillets. (Swedish Royal
Collections, Stockholm)

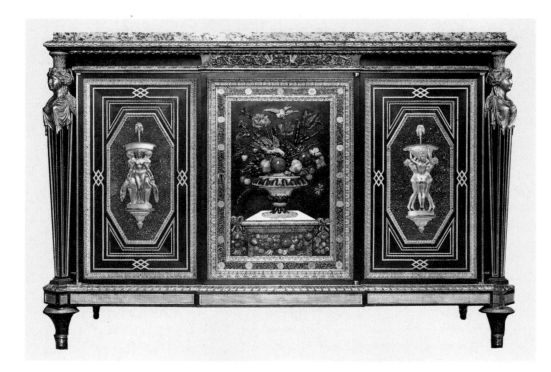

[491] Commode with panels
attributed to Weisweiler,
c. 1785, in ebony with pewter
fillets and porphyry plaques; the
plaque in raised pietra-dura is
signed by Giachetti, one of the
lapidaries at the Gobelins, and
certainly from a cabinet
belonging to Louis XIV; it can be
recognized in a drawing by Julliot
dated 1784 (see p. 35). (Swedish
Royal Collections, Stockholm)

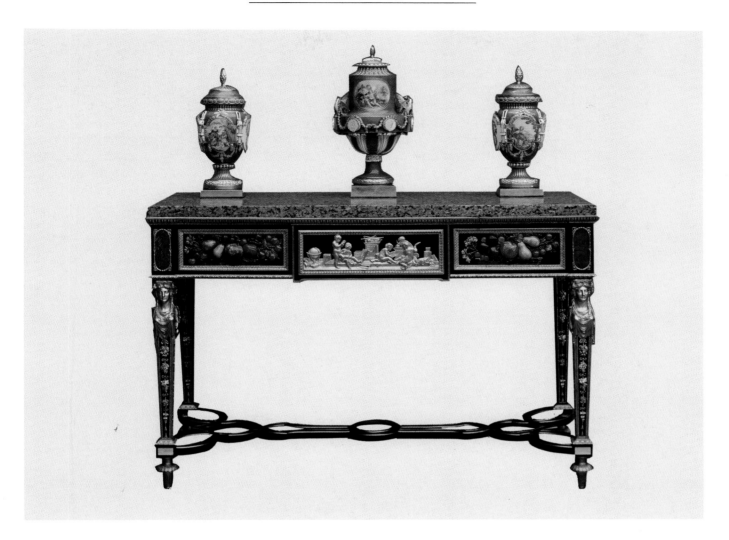

[492] Console-table stamped
Weisweiler, c. 1785; the plaques
in raised pietra-dura come
certainly from a seventeenth-
century cabinet; this piece
belonged to the Princess de Salm
(British Royal Collection)

as those belonging to the Queen of Naples, Maria-Carolina [477]. Veneered side-tables made by ébénistes were a new development and replaced the traditional console made by the menuisier as part of the panelling in the salon. Weisweiler produced some very varied examples, including consoles with drawers in the frieze and fretwork stretchers, which were no more than display pieces, and consoles with several marble shelves designed as side-tables for the dining-room.

Finally, commissioned by Daguerre, Weisweiler produced numerous small pieces of ladies' furniture: work-tables, tea-tables, writing-tables, bonheurs-du-jour, decorated with precious materials, lacquer, porcelain, ebony or Wedgwood biscuit. He designed a particular type of guéridon supported on gilt-bronze columns imitating bamboo, with a stand in burr-thuya decorated with Wedgwood plaques.

Marquetry is almost completely absent from Weisweiler's work. He preferred to use a combination of sombre veneers such as ebony or mahogany. Geometric marquetry is found on the sides of the secrétaire from Pavlovsk and on a table in the Wallace Collection: these are almost the only examples. The effect of his furniture arises above all from the richness and quality of its gilt-bronze decoration. Mounts are frequently designed as arabesques with facing goats, a mask of Apollo, or child satyrs playing the trumpet. These decorative elements, as well as the frieze of acanthus leaves, are almost hallmarks of Weisweiler's work.

The presence of caryatids at the corners of the most luxurious pieces is another stylistic signature: most of them are in the form of female figures in classical dress without arms and with braided hair. These models date from after 1784 as we find them for the first time on a lacquer table at Saint-Cloud. Daguerre's invoice reveals that the ornaments were 'specially commissioned'. Yet the models for these mounts definitely belonged to Daguerre as they are found on a few examples by other ébénistes, such as a console in the British Royal Collection stamped by Carlin and a secrétaire by Levasseur in the Louvre. Weisweiler did not therefore have exclusive use of them. For royal commissions these caryatids were varied in detail. On the lacquer secrétaire for Louis XVI at Versailles, they have raised arms [473, 474]. On the porcelain-mounted secrétaire belonging to the Queen, they take the form of hermas, without arms, and with feet below. They all carry baskets of fruit which serve as capitals. The commodes, which demanded a more robust type of caryatid, also have plump children with raised arms. Sometimes they are replaced by small composite columns in the Chinese taste [476], twisted at the base and of fluted baluster shape higher up, which are also characteristic of Weisweiler's work.

Brass-reeded plaques were not Weisweiler's exclusive prerogative but they are almost always used on the bases of his commodes. Finally, on all his furniture, panels are surrounded by gilt-bronze frames which range from plain mouldings or beading on simple furniture to friezes with undulating motifs.

The general impression, even on the largest pieces by Weisweiler, is of lightness bordering on fragility. The detached columns at the corners, the toupie feet and the frail bracketed stands accentuate this impression of fragility enhanced by precious materials such as Japanese lacquer and porcelain plaques.

BIBLIOGRAPHY

Patricia Lemonnier: *Weisweiler*, ed. Maurice Segoura, 1983

Geoffrey de Bellaigue: note on Weisweiler in cat. *The James A. de Rothschild Collection at Waddesdon Manor,* vol. 2, p. 883

[493] Mahogany console stamped both Weisweiler and Benneman, one of a set of four consoles; the frieze of arabesques with goats is found on several pieces by Weisweiler commissioned by Daguerre. (Christie's London, 14 April 1983, lot 98)

[494] Mahogany encoignure stamped Weisweiler, sold to the Garde-Meuble Royal in 1787 by the Duchesse de Polignac. The ribbed frames (cadres brettés) as well as the chinoiserie columns are characteristic of Weisweiler's work. (Musée de Versailles)

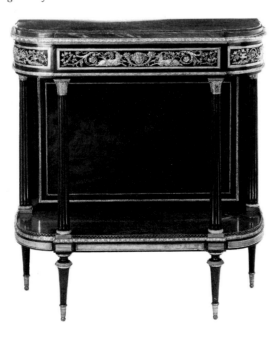

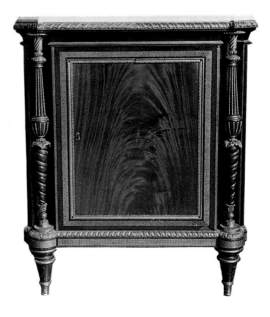

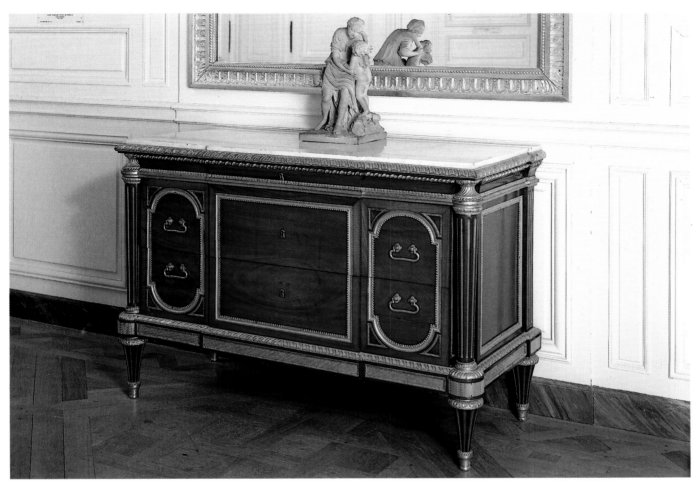

[495] *Commode stamped Weisweiler, delivered in 1788 for the Comtesse de Provence at Versailles (Château de Versailles)*

[496] (below) *Ebony console stamped Weisweiler, c. 1785. (Formerly in the Chester Beatty Collection)*

[497] (below) *Commode with hinged panels stamped Weisweiler; an identical commode was supplied by* Daguerre in 1788 for the Cabinet Intérieur of Louis XVI at Saint-Cloud for 3,000L. (Christie's London, 19 March 1970, lot 99)

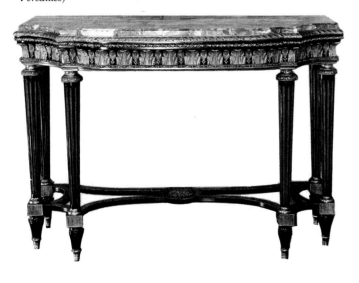

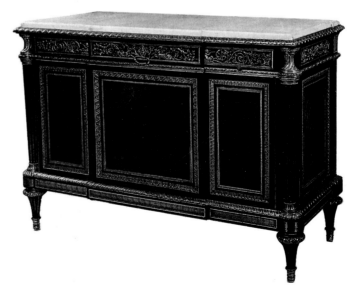

[498] Commode with hinged
doors stamped Weisweiler,
decorated with pietra-dura
plaques with borders of Boulle
marquetry of pewter and brass on
a tortoiseshell ground; probably
originally in the sale of
Daguerre's stock in London in
1791 (lot 59). (British Royal
Collection)

[499] (opposite) Sewing-table
stamped Weisweiler, c. 1787,
with marquetry of lozenges and
dots, decorated with Wedgwood
medallions, at one time belonging
to the Empress Josephine.
(Wallace Collection, London)

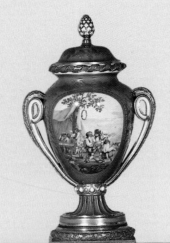

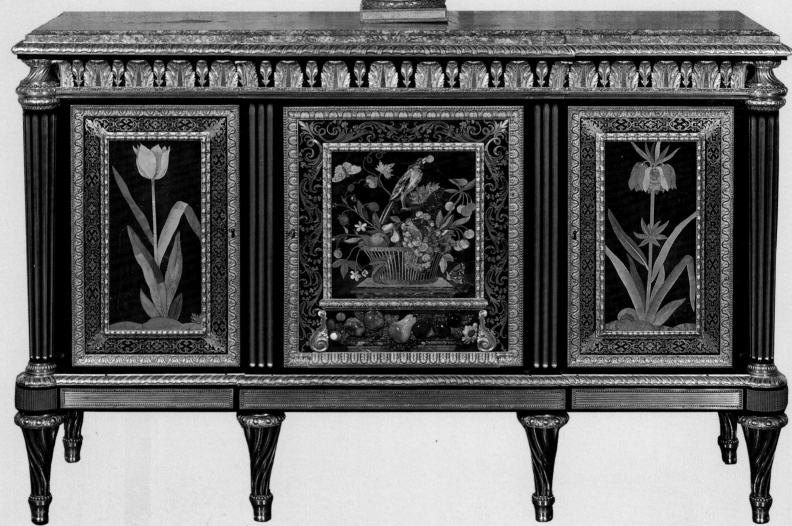

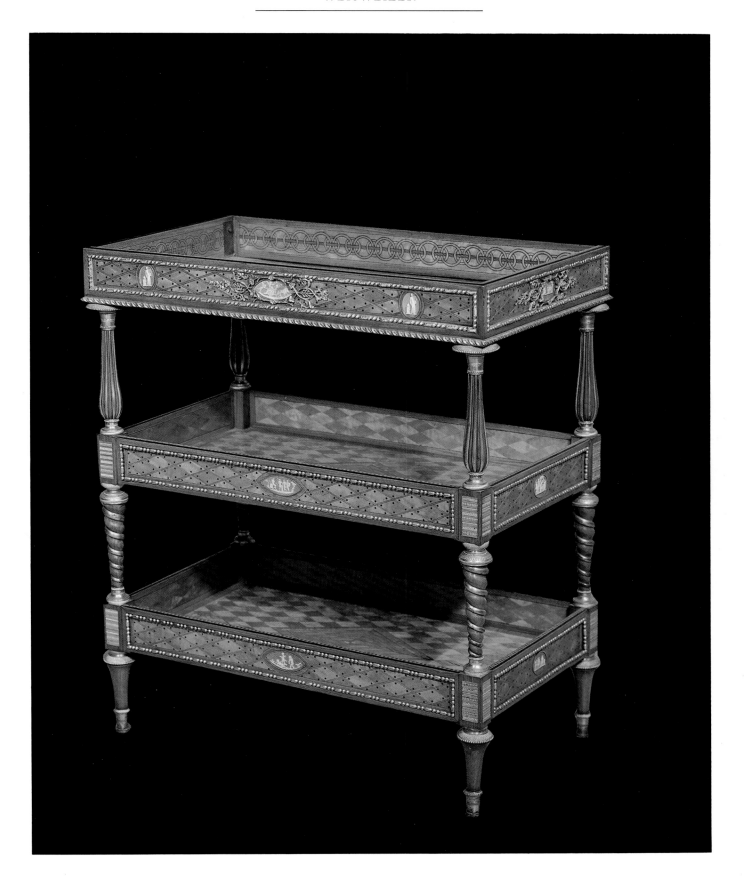

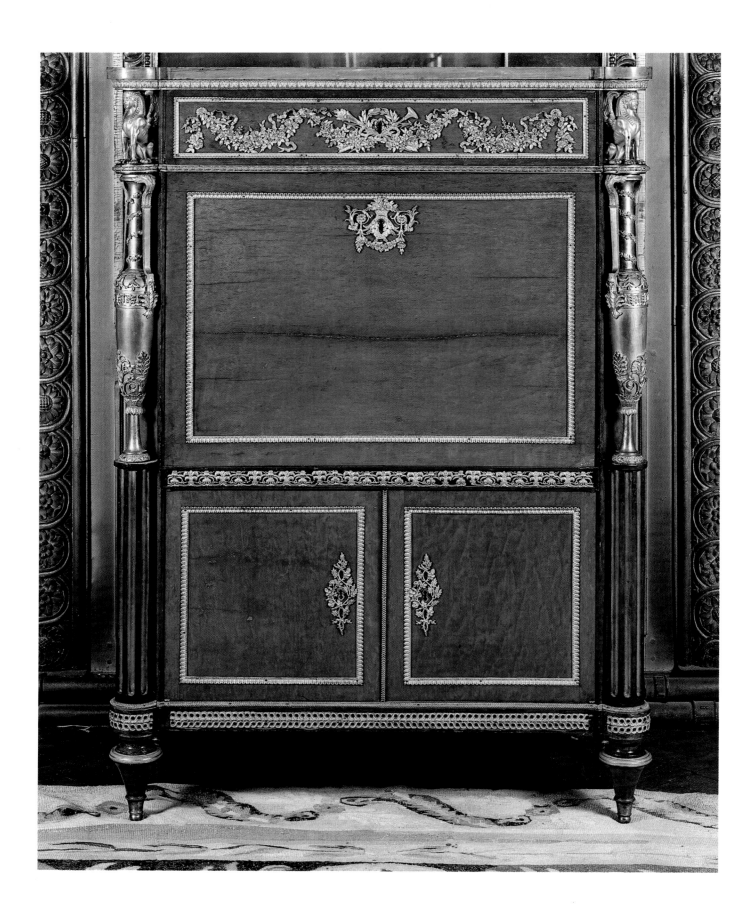

BENNEMAN

d. 1811; MASTER 1785; ÉBÉNISTE IN THE SERVICE OF THE CROWN 1786–92

T he date of birth of Guillaume Benneman in Germany is unknown. He was trained as an ébéniste there and moved to Paris, where he worked independently in the rue du Faubourg Saint-Antoine before receiving his first royal commissions in 1784; at the end of the 1780s he moved to 6 rue Forest in the neighbourhood of the Temple. The Crown's choice of an unknown craftsman such as Benneman can be explained within the context of the reforms which took place in the Garde-Meuble Royal during the years 1784–85. Mainly for reasons of economy an alternative was sought to Riesener who was deemed too expensive and also perhaps out of fashion. A wood-carver, Jean Hauré, was placed in charge of all

furniture, chairs and beds as well as ébénisterie. He decided to order his luxury furniture from the dealer Daguerre, and have the rest made by a team of craftsmen, either independent or in the service of the Garde-Meuble, dividing the work among casters, chasers, gilders, locksmiths, marble-carvers and ébénistes. Under this scheme, with its strict demarcation of work, foreshadowing the world of the nineteenth-century worker, the ébéniste, instead of supplying the finished piece of furniture, as he had in the past, was now reduced to a humble artisan in a team. Having tried various ébénistes, including Levasseur, Papst, Bircklé, Dubuisson and Lacroix, the choice of the Garde-Meuble fell on Benneman. He became a mas-

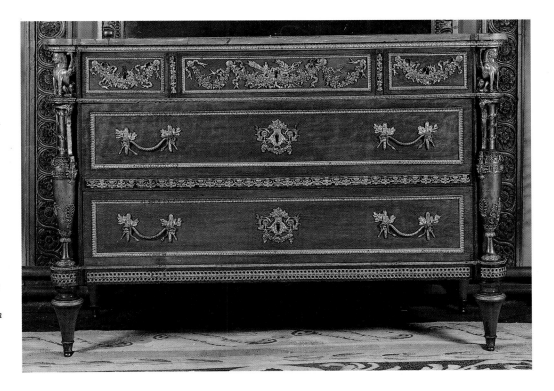

[500] (opposite) *Secrétaire by Benneman matching the commode shown at [501], and also from the Hermitage which was furnished with other pieces by Benneman. (Sotheby's London, 17 April 1964, lot 118)*

[501] *Commode in plum-pudding mahogany stamped Benneman, c. 1790, originally in the Hermitage, St Petersburg, where according to the inscription it was in the bedroom of the treasurer to the Empress. (Sotheby's London, 17 April 1964, lot 117)*

ter-ébéniste in September 1785 with a dispensation from the police as to 'the necessary rights and conditions of residence'. In February 1786 the Garde-Meuble provided him with his tools and employed nine and then sixteen craftsmen on his instructions.

Benneman was at first employed to repair existing furniture and to make functional furniture such as firescreens, boxes, bidets and commode chairs. Then under Hauré's direction he undertook a whole programme of copying and altering existing furniture in the drive for economy. Thus for the King at Compiègne he supplied in 1786 and 1787 several pastiches and copies based on a commode by Joubert, which had originally been supplied in 1771 for the Salon des Nobles of Marie-Antoinette at Versailles. Initially he delivered a second commode, a smaller copy of the original (private collection, Paris), followed by a bureau plat (Louvre) [503], a writing-table (Petit Trianon), and a secrétaire à abattant (Metropolitan Museum of Art). The same marquetry of 'intertwined hearts and lozenges' is found on almost all these pieces as well as the same mounts which were used by Joubert; Vitruvian scrolls, egg-shaped feet and caryatids. Only the secrétaire was fitted with new mounts in the form of superb Egyptian caryatids modelled by Boi-

zot. Joubert was the inspiration for a number of other copies by Benneman; a second commode for the cabinet of the Comte d'Artois at Compiègne (sale Christie's, 17 June 1987, lot 69) was a copy of the one delivered in 1774 by Joubert (private collection, Paris). This was followed by a bureau plat (formerly in the Schloss Museum, Berlin; illustrated in F. J. B. Watson, *Louis XVI Furniture*, fig. 107) placed in Louis XVI's library at Fontainebleau. Also in 1786 Benneman copied the lower part of the 'bureau du Roi' made by Oeben and Riesener twenty years earlier, providing a bureau plat matching it for Louis XVI's Cabinet at Versailles (now at Waddesdon Manor).

From 1786 to 1787 Benneman worked to complete or transform a series of commodes by Stockel, which the Garde-Meuble had purchased from the dealer Sauvage. They had originally been made for the Comte de Provence. Orders and counter-orders from the Garde-Meuble followed in quick succession. At vast expense (nearly 35,000 livres) the four commodes, as a result of Benneman's 'tinkering', became eight commodes of a staggering richness. In the meantime the originals had been either reduced or enlarged, or even both, one after the other, and sometimes raised in height. Everything had been reveneered, all the mounts were regilded and some pieces had their porcelain plaques removed. On one of the pieces the mounts were removed to be placed on its copy, while the carcase served as the basis for a totally different piece. Pierre Verlet has retraced the

[502] *This commode, stamped Benneman, was supplied in 1788 with its pair for the bed-chamber of Louis XVI at Saint-Cloud and priced at 5,954L the pair.*

Originally in Chinese lacquer, it was later applied with pietradura. (J. Paul Getty Museum, Malibu, California)

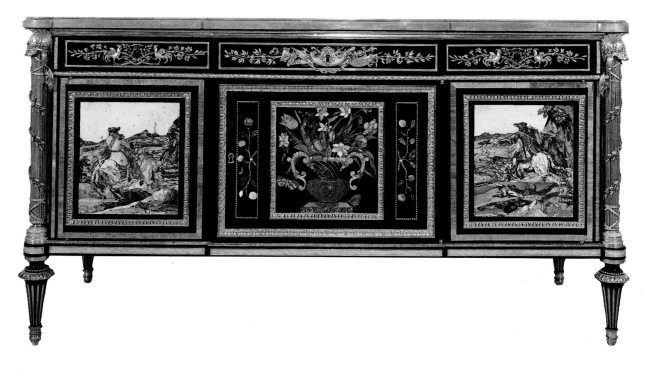

history of these pieces. Here is a resumé:

— 'Commode with doves': originally in tulipwood, it was reveneered in mahogany and reduced in width, then the door was replaced with three drawers and the mounts regilded. It was then placed in the bedchamber of Louis XVI at Compiègne [505].

— 'Commode with lictors' fasces': originally in tulipwood, it was also partly reveneered in mahogany. It was first raised in height in 1787, and a year later widened at the sides. It was for use in the Council Chamber at Compiègne.

— 'Commodes à encoignures with the cypher of Marie-Antoinette': originally decorated with a floral porcelain plaque. The veneer was completely stripped and reveneered in mahogany and ebony and then reduced in size. Benneman made a copy of it in 1786, decorated as on the original with a porcelain plaque. It was enlarged and then again modified in 1787. The porcelain plaque was replaced by the Queen's cipher in gilt-bronze. A second copy was made in 1787, based on the preceding one, and both pieces were placed in the Queen's Salon des Jeux at Compiègne. However, the original commode, drastically altered in 1788, was placed in the Queen's Bedchamber at Saint-Cloud.

— 'Commode with foliate scrolls'. It was enlarged, reveneered and the mounts regilded. The porcelain plaques were removed and replaced with a large Sèvres biscuit medallion. First it was copied and then, since the destination of these pieces had changed (they were going to be used in the Queen's Salon des Jeux at Fontainebleau) and as the measurements of the first commode were no longer appropriate, Benneman had to make a second copy on which were fitted the mounts from the original commode, while the carcase served as the basis for yet another piece in mahogany for use in the bedchamber of the Comte de Provence at Versailles [506].

At the same time Benneman altered numerous pieces and refurbished them to suit the current fashion. This was the case with Louis XV's bureau at Choisy attributed to B. V. R. B., originally in Chinese lacquer, which he fitted with two drawers and completely reveneered in bois jaune or 'walnut from Guadeloupe' (now in the Archives Nationales). In 1788, continuing its programme of copies, the Garde-Meuble commissioned Benneman to make a copy of a mahogany commode made by Riesener in 1784 for

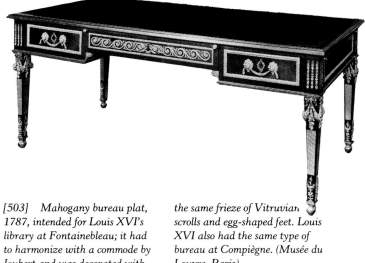

[503] Mahogany bureau plat, 1787, intended for Louis XVI's library at Fontainebleau; it had to harmonize with a commode by Joubert and was decorated with the same frieze of Vitruvian scrolls and egg-shaped feet. Louis XVI also had the same type of bureau at Compiègne. (Musée du Louvre, Paris)

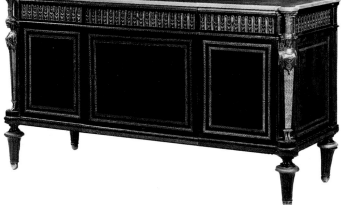

[504] Commode with hinged panels in mahogany stamped Benneman, made in 1787 with its pendant (which is now in the Louvre) for the wife of the Commissioner of the Garde-Meuble Royal. (Christie's London, 3 July 1986, lot 138)

[505] 'Commode with doves' stamped Benneman, who in 1786 reveneered a commode by Stockel in mahogany, then made it smaller and replaced the original door with drawers. (Musée du Louvre, Paris)

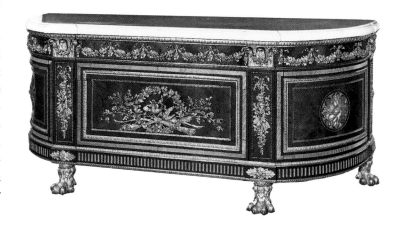

the Queen's Bedchamber on the ground floor at Versailles. The two pieces were placed in the Salon des Nobles of the Queen at Saint-Cloud.

From 1787 Benneman, still under the direction of Hauré, started supplying original pieces of his own work: a pair of commodes with panels in mahogany were made in that year for the wife of the Commissioner-General of the Garde-Meuble, Mme de Ville-d'Avray [504] and were placed in 1792 in the Council Chamber at the Tuileries. The caryatids at the corners, in severe Neo-classical taste, were cast by Forestier, chased by Thomire and Bardin and gilded by Chaudron. The ébéniste's role was of little significance and represented barely a third of the total cost (3,292 livres). One of these commodes is today in the Louvre, the other was recently sold (Christie's London, 3 July 1986, lot 138). In the year following this consignment, Benneman made a pair of commodes with panels in lacquer using leaves from a screen which was supplied by the Garde-Meuble. The sumptuous gilt-bronze mounts in the form of lictors, fasces and trophies of arms, which echo the decorative elements in the King's Bedchamber at Saint-Cloud for which they had been designed, account for the originality and richness of these pieces. The mounts, cast by Forestier after a model by Martin, chased by Thomire and Bardin and gilded by Galle, accounted for the main expense. The role of the ébéniste was even less significant than in the construction of the mahogany commodes as it amounted only to 1,031 livres out of a total of 5,954 livres. These commodes had a chequered career. In 1790 Benneman altered them, replacing the doors with two large drawers. Between 1793 and 1848 they were again fitted with doors and lost their lacquer panels. One of them, fitted with panels of pietra-dura, is now in the J. Paul Getty Museum [502], while the second, now with pictorial marquetry, has been identified in the Royal Palace in Madrid. In the case of these pieces, Benneman's creative role was reduced and the initiative came from Hauré. It seems, however, that in 1788 Hauré fell from favour with the Garde-Meuble, which then went direct to Benneman. From then on his name appears

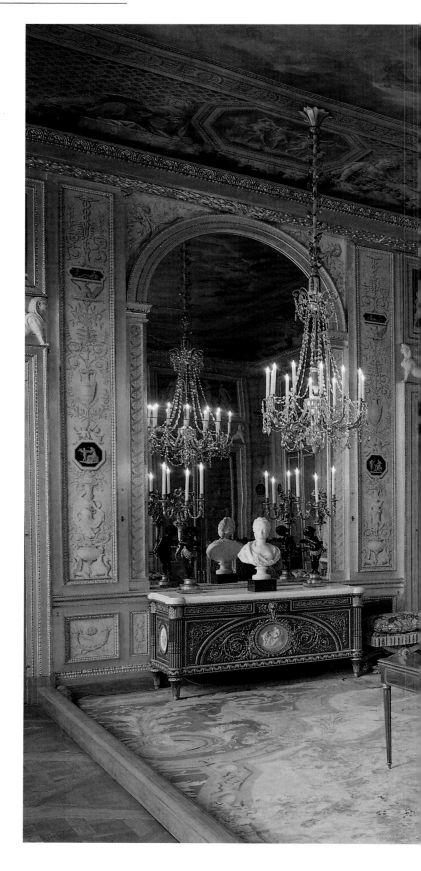

[506] Marie-Antoinette's Salon des Jeux at Fontainebleau including the pair of 'commodes with scrolls' made by Benneman in 1786. The Sèvres biscuit medallions are in imitation of Wedgwood and matched the wall panels. (Château de Fontainebleau)

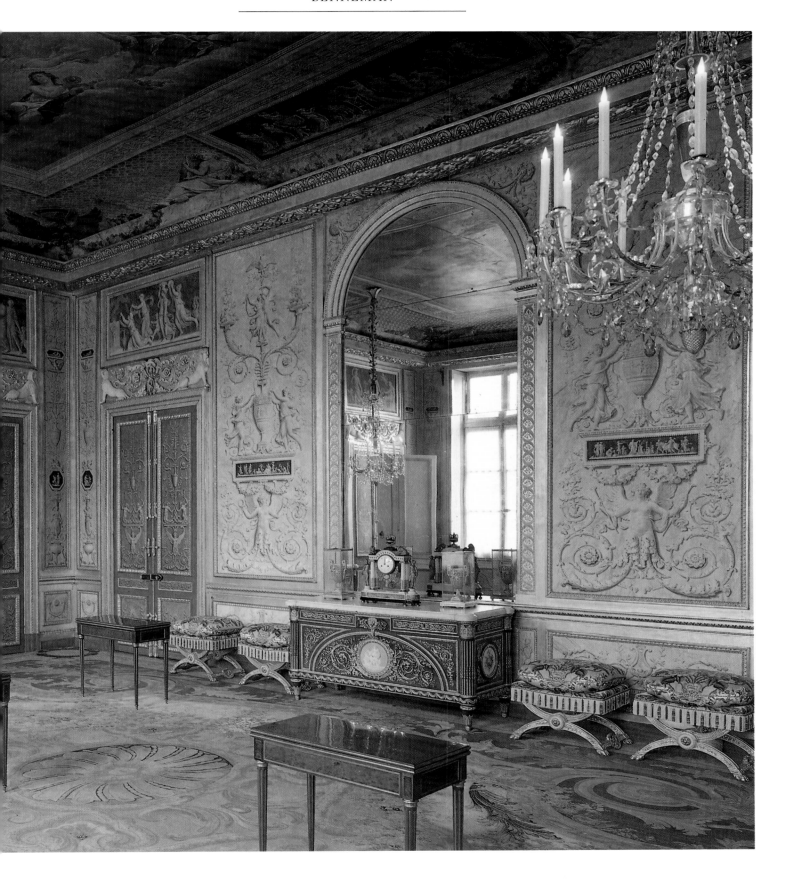

at the head of the invoices and not in a subdivision of Hauré's accounts.

In 1788 the Garde-Meuble provided Benneman with mahogany and additional tools 'sufficient for twenty workers'. Shortly before 1791 Louis XVI acquired a strange piece of furniture by Benneman (now at Versailles) with funds from his privy purse. It was a cabinet decorated with panels of feathers, butterfly-wings and plants applied to wax, possibly made by the mother of the painter Troyon. Christian Baulez has suggested that it might correspond to a piece for which 6,000 livres was paid by Louis XVI to Jacques Hettlinger, co-director of the Sèvres manufactory. It was certainly a special commission, the initiative for which was provided either by Hettlinger or possibly by Louis XVI himself.

Benneman's workshop employed numerous assistants, as many as twenty in 1788, and his output between 1786 and 1792 was copious. Apart from the furniture identified above, he supplied many pieces, whose whereabouts are now unknown, to Versailles, and from 1788 onwards to the Château de Saint-Cloud which the Queen completely refurnished. There is no doubt that these pieces had to complement those made by Weisweiler supplied at the same time by Daguerre, not only for the same residences but sometimes even for the same rooms. The style of Benneman's furniture was very close indeed to that of Weisweiler. In both their work the same mahogany commodes with three panels 'à brisure' are found, the same toupie feet, fluted panels, chased frames and decoration in the arabesque style. The similarities are so numerous that one cannot help wondering sometimes if the Garde-Meuble Royal was not using Benneman to make deliberate copies or pastiches of the sumptuous and original furniture supplied by Daguerre. In the eyes of Hauré the two were completely interchangeable. Thus he writes: '[on the subject of] two other mahogany commodes which were begun by Sieur Benneman for M. Thierry [de Ville-d'Avray], finding similar ones soon afterwards for sale at Daguerre's, I acquired them, to save time' [Arch. Nat. O¹3648).

The collaboration between Weisweiler and Benneman is confirmed by the presence of both their stamps side by side on several pieces of furniture made in typical Daguerre style: on two mahogany long-case clocks (British private collection) which belonged to Marie-Antoinette as well as a series of four mahogany consoles [493]. Moreover, certain consignments by Benneman, such as the one in October 1786 for the Salon des Jeux at Saint-Cloud, exactly echo the work of Weisweiler; this one consisted of two semi-circular consoles in mahogany, 'richly decorated with friezes of arabesques and caryatids'. The mounts which are aftercasts are described in detail: 'female heads, with cushion' and 'small sphinx in the friezes'. Even if this was a new type of furniture made after designs by Lalonde, as the description states, it is clear that the mounts were borrowed from models belonging to Daguerre which are usually found on Weisweiler's furniture.

From August 1786 Daguerre supplied a series of completely new furniture in 'bois jaune' (satinwood) called 'noyer de la Guadeloupe'. First, he supplied a commode for the King at Fontainebleau as well as a writing-table. In October he supplied a bonheur-du-jour for the Queen at Choisy and then in March 1787 various pieces for the Dauphin's use at Versailles: writing-table, bonheur-du-jour, commode en console, encoignures à étagères and secrétaire à abattant. At the same time, Benneman received stocks of bois jaune and in his turn supplied various pieces in May 1787 for the Dauphin, comprising two writing-tables and a console. The consignments by Benneman increased in volume as compared to those of Daguerre: in 1788 he supplied 17,433 livres worth compared to Daguerre's consignment of 10,580 livres. In 1789 Benneman's rose to 55,927 livres as against 30,305 livres for Daguerre. From 1790 the amounts of the invoices dropped noticeably. Benneman still supplied a number of mahogany pieces to the royal family, now in the Tuileries, as well as pieces for Compiègne and Saint-Cloud. In 1792 he supplied several modestly priced desks to replace those used in the National Assembly. On 10 August 1792 the civil list ceased to function and Benneman was left almost without work. Between 1793 and 1795 the Garde-Meuble commissioned a few further small works such as the furniture for the Girondin Deputies imprisoned in the Conciergerie. After Thermidor, his workshop gained a certain amount of new business. In 1798 he supplied a complete series of mahogany furniture to the dealer Collignon, comprising a secrétaire and a matching commode as well as a chiffonnier, three bookcases and a dressing-table. The most beautiful

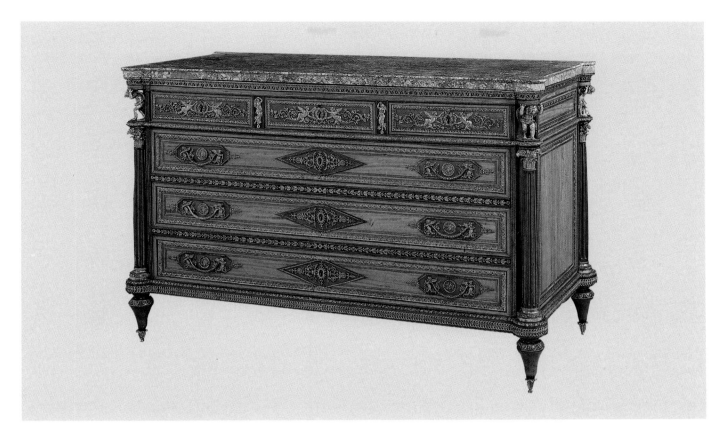

[507] Commode in satinwood
and amaranth attributed to
Benneman, c. 1790; the gilt-
bronze mounts are found on
various pieces stamped by

Benneman, such as the commode
in the Hermitage, another in the
Royal Palace in Madrid and a
pair in an American private
collection. (Galerie Lupu, Paris)

hogany commodes, today in a private American col-
lection (illustrated in the exhibition catalogue by
Rosenberg and Stiebel, *Elements of Style*, New York,
1984), are ornamented at the corners with caryatids in
the form of cherubs with heads bowed which are also
found on other unstamped pieces [507] and which
must definitely be considered as further character-
istics of Benneman.

pieces from this period are a commode and a secré-
taire made to designs by Percier, now at the Château
de Fontainebleau.

It is difficult to discuss Benneman's style with the
knowledge that he was usually content to copy the
works of Joubert, Riesener and Weisweiler. The
degree of his personal responsibility in the conception
of various pieces originating from his workshop was
very limited, as the Garde-Meuble provided him both
with the design (by Lalonde or Dugourc) and all the
gilt-bronze mounts. It would be more apt to talk of a
'Hauré style' or, from 1788, of a 'Thierry de Ville-
d'Avray style' after the name of the head of the Garde-
Meuble. This style usually includes the following
characteristics: handles in the form of ropes, attached
to Hercules' clubs, are to be found on numerous
pieces, as well as frames and brass-reeded panels on
the square tapering legs of bureaux. A pair of ma-

BIBLIOGRAPHY

F. de Salverte: *Les Ébenistes,* pp. 16–18
Pierre Verlet: *Le Mobilier royal français,* vol. 1, 1945,
pp. 8–9, pp. 36–45, vol. 2, 1955, pp. 100–14; *French
Royal Furniture,* 1963, pp. 20–21 and pp. 152–57
Geoffrey de Bellaigue: *The James A. de Rothschild
Collection at Waddesdon Manor,* vol. 2, pp. 458–65 and
p. 864
F. J. B. Watson: *The Wrightsman Collection,* vol. 1,
pp. 195–201, vol. 2, p. 534
Christian Baulez: 'Un médaillier de Louis XVI à
Versailles', *La Revue du Louvre,* no. 3, 1987, pp. 172–75
Gillian Wilson: 'A pair of cabinets for Louis XVI's
bedroom at Saint-Cloud', *Furniture History Society
Bulletin,* 1985

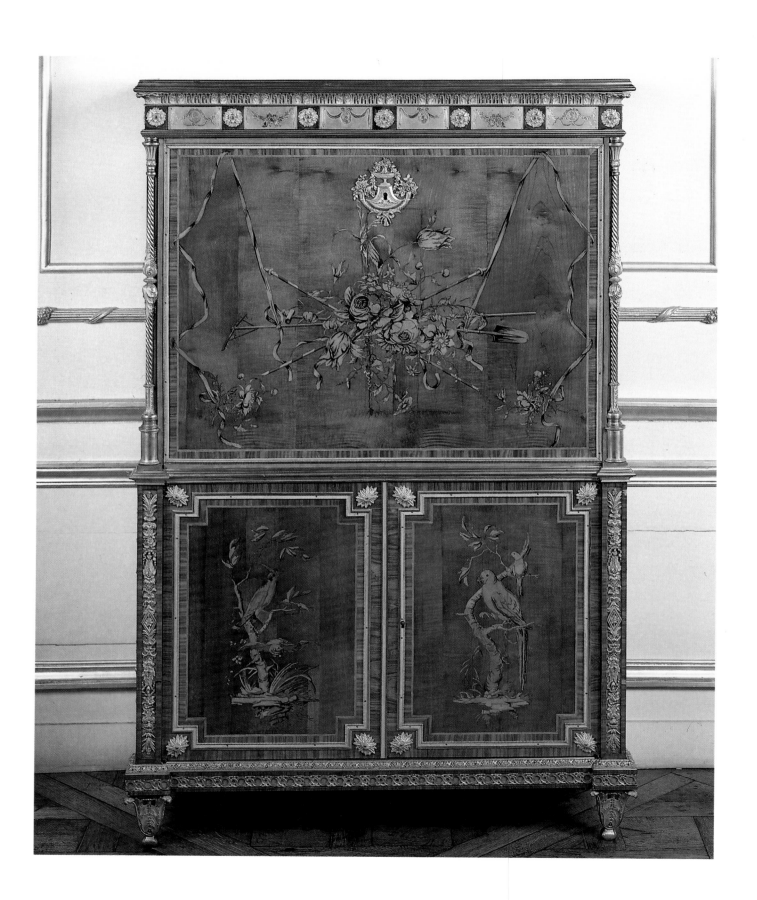

David
ROENTGEN

1743–1807; ACTIVE AT NEUWIED 1772–95; MASTER IN PARIS 1780; ÉBÉNISTE-MÉCANICIEN DU ROI ET DE LA REINE 1785

Although he lived and worked in Germany, Roentgen has a place in this book as he was admitted master in Paris. Born in the Rhineland town of Neuwied, he was the son of Abraham Roentgen (1711–93), a cabinet-maker and member of a zealous Protestant sect, the Herrnhuter. In 1772 David took over the running of the workshop founded by his father in 1750, and where he had already been working for a number of years. The reputation of the workshop extended only as far as neighbouring German principalities, and its products were sold mainly at the Frankfurt fair. From the beginning David Roentgen showed a spirit of enterprise, having the idea in 1769 of organizing a sale by lottery of his furniture in Hamburg. The project, greeted with considerable hostility by the Herrnhuter community, was nevertheless a financial success, as well as excellent publicity for the Roentgens. Their reputation rapidly extended into Saxony, Prussia, Bavaria and even as far as Courland. From 1770, hoping to extend commercial links in the direction of the Baltic and the Russian and Polish courts, David Roentgen planned to settle in Berlin. Frederick the Great did not, however, lend his support to this project and the Neuwied furniture-maker had to remain in his home town. He then sought a commercial opening in France and in 1774 undertook his first trip to Paris. There, thanks to the engraver Wille, he established fruitful contacts. He thus came into contact with the Neo-classical taste fashionable in Paris at the time, as well as the work of the decorators Boucher fils, Lalonde and Delafosse. On his return to Neuwied he received his first important commission: between 1775 and 1779 he provided Prince Charles of Lorraine, an uncle of Marie Antoinette and Governor of the Low Countries at Brussels, with about 15 pieces of furniture totalling 25,000 florins in value. Amongst them was the bureau-cabinet and the large marquetry wall panelling delivered in 1776 and 1781 respectively, preserved today in Vienna.

In March 1779 he made his second trip to Paris. This time he arrived with a selection of furniture which he exhibited at the Salon des Artistes et Savants. Pahin de la Blancherie noted 'a number of pieces remarkable for their marquetry and a mahogany table with a polish so perfect that to eye and hand it gives the illusion of marble' (*Nouvelles de la république des lettres et arts*, 23 March 1779). An advertisement in the same journal reads: 'Small marquetry

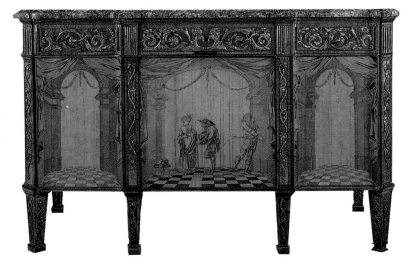

[508] *Secrétaire à abattant attributed to Roentgen, c. 1785, with floral marquetry on a sycamore ground. The gilt-bronze mounts, of exceptional quality, must have been made in Paris. (Private collection)*

[509] *Commode à vantaux attributed to Roentgen, c. 1778, bearing the château mark of Versailles; this is probably the piece bought by Louis XVI in 1779. (Metropolitan Museum of Art, New York; Linsky Bequest)*

413

table for use as a chiffonnière by M. David Roentgen at M. Brebant, rue Saint-Martin. The marquetry top of this table represents a group of shepherds. . .' His success was enormous and the royal family acquired a number of pieces. A large 'secrétaire à tombeau', identical to the one made for Charles of Lorraine, was acquired by the King for the astronomical sum of 96,000 livres and placed in the Salle de la Vaisselle d'Or at Versailles [512]. The King also bought a commode, probably the one in the Linsky Collection, now in the Metropolitan Museum of Art, for 24,000 livres [509]. This commode was placed in the Salle des Buffets at Versailles. The King's brother, the Comte d'Artois, as well as his wife, also wanted the same commode. The Comtesse d'Artois placed hers in her Petits Appartements at Versailles: this one is probably the example now in the Victoria and Albert Museum. The Queen also acquired a commode by Roentgen which is recorded in 1797 in the sale of Citizen Collignon (16th Thermidor, VI): 'A commode in figured mahogany of 4½ pieds, decorated with swags of fronds, leaves and fruit, escutcheons, handles and mouldings, all in bronze with matt gilding, perfectly made by David of Neuwied, repaired and restored at 4,310L. Sold to

Citizen Le Payen for 3,600L'.

In Paris Roentgen moved in with Brébant, a marchand-miroitier in the rue Saint-Martin opposite the rue du Vertbois, and to whom he entrusted the sale of his furniture. He was soon in trouble with the Parisian guild of ébénistes, who forced him to obtain his mastership in May 1780 at a cost of 600 livres. He should therefore have stamped the pieces of furniture destined for the Paris market; so it is astonishing to find henceforth only one piece with the stamp 'D. Roentgen'. From 1781 Roentgen had his own shop in Paris in the rue de Grenelle (now rue Jean-Jacques Rousseau) close to the rue Saint-Honoré. An advertisement appeared in *Les Annonces, affiches et avis divers* for 8 January 1781 indicating that 'In the shop of M. Roentgen, ébéniste, formerly of the rue Saint-Martin, opposite the rue de Vertbois, and at present in the rue de Grenelle, at the first arch to the right coming from the rue Saint-Honoré, there are bureaux of various types, cabinet chairs, toilet-tables, mechanical strong-boxes, pianofortes, games-tables for quadrille, trictrac and others in mahogany, well finished and polished like marble. The aforesaid undertakes all kinds of ébénisterie'. Despite his success, his French clientèle did not

[510] *Bureau à gradin in bois jaune attributed to Roentgen, c. 1786, a piece probably made for the Russian market, where it* *would have matched Russian furnishings in Carelian birch. (Sotheby's Monaco, 11 February 1974, lot 393)*

[511] *Mechanical table in mahogany, c. 1780; Roentgen made numerous examples of this model with sophisticated* *mechanisms and characteristic notched gilt-bronze (cadres brettés) on the legs. (Private collection)*

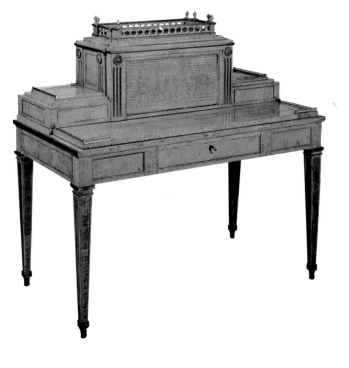

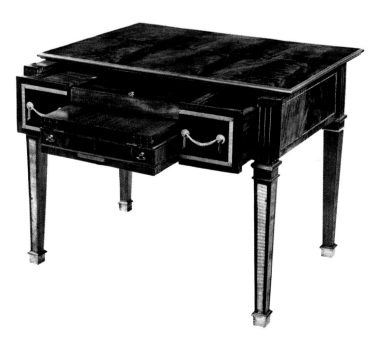

[512] *Bureau-cabinet which originally belonged to King Frederick-William II of Prussia. Louis XVI bought a piece identical in all respects for the Pièce de la Vaisselle d'Or at Versailles; the complexity of the mechanisms and the extraordinary quality of the marquetry justified the price of 96,000L paid by the King for what was the most expensive piece of furniture of the eighteenth century. (Schloss Köpenick, Berlin)*

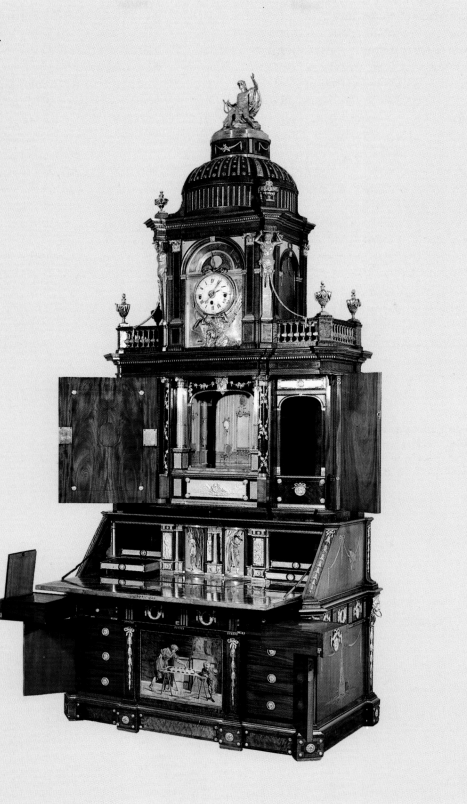

know him by his own name, no doubt difficult for them to pronounce. Amongst Louis XVI's personal accounts is this reference to him: 'I paid the Germans 2,400L for a large commode'. Charles of Lorraine referred to Roentgen as 'the man from Neuwied' and he was elsewhere referred to as 'David'.

Roentgen probably also sold marquetry panels in Paris to his colleagues to incorporate in their own pieces. This is suggested by a pair of encoignures by Riesener in the Victoria and Albert Museum with marquetry panels typical of Roentgen. The latter placed one of his compatriots, the Berliner Johann Gottlieb Frost (1746–1814) in charge of his Paris shop, and in 1785 Frost bought the shop from Roentgen. In the same year the Comte de Provence bought from Roentgen a secrétaire à cylindre (either the one now at Versailles or the one in Buckingham Palace), and the Queen received an automaton in the form of a female tympanist (today in the Conservatoire des Arts et Métiers, Paris). The final royal acquisition, a long-case clock by Roentgen [515] in the form of a double column, belonging to the Queen or the Comtesse d'Artois, was part of the furniture and objects listed in a confiscation at Versailles in 1793. Roentgen's final trips to Paris took place in 1784, 1785 and 1787.

In the meantime Roentgen was also doing business in Russia. In 1783, with the help of a flattering letter of introduction from Baron Grimm (who described him as 'the best ébéniste mécanicien of the century') to Catherine the Great, Roentgen made the trip to St Petersburg. The Empress immediately bought the sumptuous secrétaire à cylindre which Roentgen offered to her for 20,000 rubles (to which she added a tip of 5,000 rubles) and ordered numerous pieces for the Hermitage and Pella. Nevertheless, in an amusing letter to Grimm she described her dislike of Roentgen: 'Your M. Roentgen (who doesn't rhyme badly with Gretschen!) has burst in upon us with such a load of furniture. And he wanted to "herrnhutize" the entire Hermitage. There is too much about sheep and lambs in his religion and he failed to arouse our interest in his faith. So he got his payment, gave us the keys, and

took away his preaching. With him gone, boredom has gone as well.' (5 April 1784.)

This dislike notwithstanding, the Empress sent her grandsons Alexander (the future Tsar) and Constantine to Roentgen for a course of instruction in cabinet-making. In 1784 the orders for furniture comprised five rectangular tables or stands for writing standing or seated, five toilet-tables in mahogany or palm, two oval tables, three large mahogany armoires decorated with mounts with garlands and medallions, one clock crowned by Apollo, the dial supported by the figure of Time, one harpsichord stand, and four bureaux.

The order in 1786, much more important, was for fifty pieces of furniture, for the most part in ma-

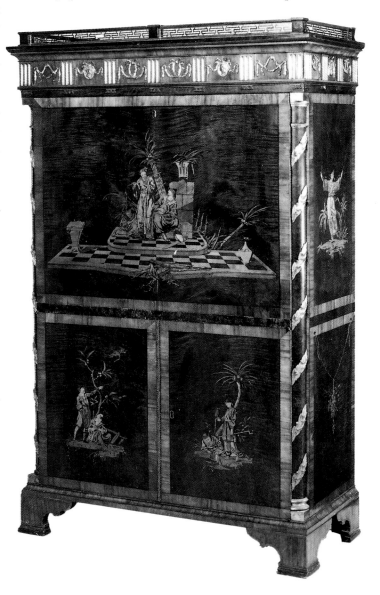

[513] Secrétaire à abattant attributed to Roentgen, c. 1780, with marquetry of chinoiserie *motifs on a sycamore ground. (Christie's London, 29 June 1972, lot 91)*

hogany, with certain pieces in bois jaune, to a total value of 72,704 rubles. Between 1783 and 1789 Roentgen visited St Petersburg five times. Besides the Empress, he was also able to sell furniture to the Grand Duchess Maria Fyodorovna, as well as Prince Galitzine and Count Shuvalov. En route Roentgen had the opportunity to stop in Berlin to expand his clientèle there. Among them were King Frederick-William II, Prince Louis-Ferdinand of Prussia and Count Redern. In a number of European centres Roentgen established workers, trained by him, as his agents: in Berlin, David Hacker who acquired his own workshop in 1791: in St Petersburg, Christian Meyer, who, according to his contemporaries, was able to copy Roentgen's work so well that it was impossible to tell the original from the copy. In Paris his agent was Frost; in Brunswick, Christian Härder, who was established in 1800. The French Revolution put a brake on Roentgen's activities; in 1790 his Parisian agent Frost was forced to close the shop – and he went into liquidation in 1791. Roentgen's stock in Paris, classed as émigré property, was confiscated and sold. In 1795 the advance of the French armies forced Roentgen to leave Neuwied and move his stock and equipment eastwards. He did not return to Neuwied until 1802. Napoleon's armies had thrown the German aristocracy into confusion and Roentgen found his activities considerably curtailed. He was forced to sell his stock in 1805 and died in 1807.

THE NEUWIED WORKSHOP

The workshop that initially employed fifteen assistants in the 1770s employed more than twenty-four in 1779, and up to forty before the Revolution (certain eye-witnesses even speak of three hundred). Its production was vast. It is more accurately to be called a manufactory than a workshop, as it was organized on an industrial rather than artisanal basis, with very specialized groups of craftsman in different workshops. The house at Neuwied consisted of one floor reserved for two large workshops, a laboratory and an office. On the second floor there was furniture in its final stages of construction and also a showroom. The third floor was reserved for the Roentgen family and rooms for the workers. On the street side the house was flanked by two pavilions which were used as shops, and there was also a warehouse for storing wood. This

manufactory was equally well-equipped to build the carcase of a piece of furniture as the execution of its marquetry, complicated mechanisms, the screws and gilt-bronze mounts, the locks and clock movements. To leave the business for the long periods that he spent in Russia or France, Roentgen obviously had to rely on competent assistants. Among them David Hacker and Christian Härder were the most important, and Roentgen helped to establish them in Berlin and Brunswick when the manufactory at Neuwied had to close. Christian Krause was the principal technician and for a long time his right-hand man. A number of his assistants, including Frost, Holst, Klinkerfuss, Knesing, Kronrath, Johan Georg Roentgen, Röttig, Rummer and Streuli, having worked for Roentgen, went on to open their own workshops. The principal clock-maker employed by Roentgen was Peter Kinzing who seems to have worked independently, receiving the title of 'clock-maker to the Queen' in 1785. Finally, the painter Januarius Zick, working near Coblenz, provided Roentgen with designs for his elaborate marquetry.

[514] *Secrétaire à cylindre in mahogany attributed to* *Roentgen, c. 1785. (J. Paul Getty Museum, Malibu, California)*

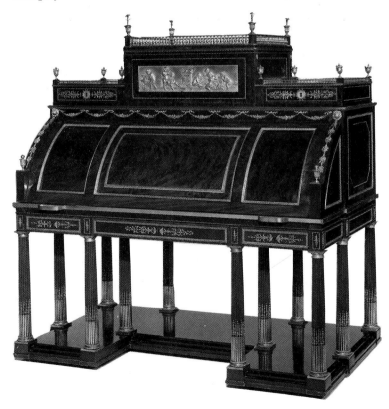

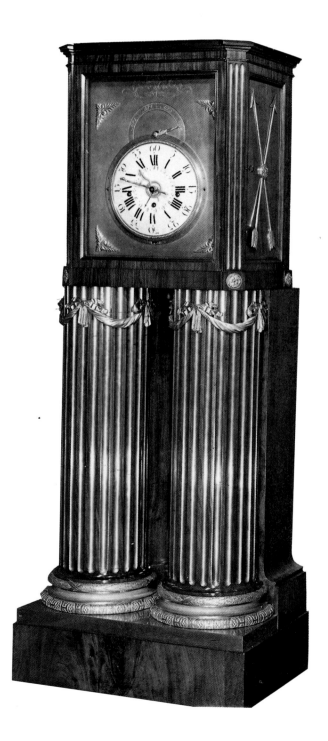

[515] *Long-case clock in mahogany signed by Roentgen and Kinzing (on the movement). An identical clock, described in the list of objects inventoried at Versailles in the former* apartments of Marie-Antoinette on 13th Prairial, II (1794), is now in the Conservatoire des Arts et Métiers, Paris. (Sotheby's Monaco, 26 May 1975, lot 269)

In spite of the semi-industrialized production that Roentgen aimed to achieve in his workshop, the quality of the furniture remained exceptional. The workshop excelled in the production of mechanical furniture, so popular among the princes of Europe, with its secret compartments which spring out when buttons are pressed to reveal further small secret drawers. These pieces were constructed and assembled to a standard far superior to any in France, with the carcase neatly constructed in oak (and sometimes certain parts in pine) and the drawers in cedar and mahogany, made with the precision of English cabinetmaking. But Roentgen's supreme achievement lay ultimately in his marquetry. The panels representing scenes from the Commedia dell'arte, chinoiserie, concert or theatre scenes, or simple bouquets of flowers suspended on long ribbons, were created with the use of tiny pieces of wood mosaic to render shades, without resorting to French pokerwork methods or to engraving. In Roentgen's work even the shadows are indicated by means of different pieces of wood. These pictures were created on a striped sycamore ground to create warm ground tones. The quality of the pieces in mahogany or pale wood rests on the beauty of their form. They are indeed architectural miniatures, always with fluted pilasters, entablatures underlined by gilt-bronze triglyphs, steps and Doric columns. The technical excellence of Roentgen's Neo-classical furniture is such that it seems to have discouraged the latter-day faker.

Roentgen's influence continued into the early nineteenth century in the form of numerous imitators in Germany and Russia, in the first place those who had trained under him – David Hacker, Christian Härder and Johan Frost, as well as Anton Reusch at Neuwied, Klinkerfuss at Stuttgart, and Knesing in Leipzig. But the most beautiful pastiches in Roentgen style were the pieces of furniture made by Christian Meyer and Heinrich Gambs in St Petersburg between 1799 and 1815.

BIBLIOGRAPHY

Hans Huth: *Roentgen Furniture*, London, 1974

Catalogue of the Linksy Collection, Metropolitan Museum of Art, New York, 1984, pp. 223–25

Gaspard
SCHNEIDER

MASTER 1786

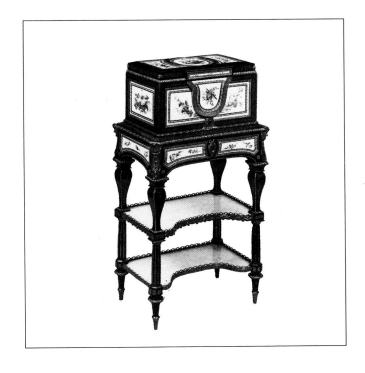

Born in Augsburg, Schneider settled in Paris at an unknown date; in the 1780s he was working as an independent artisan in the rue du Faubourg-Saint-Antoine. Under the name of Gaspard he supplied the Garde-Meuble Royal in October 1785 with a 'veneered secrétaire 4½ pieds in length, the same proportions as one made by M. Riesener, well made, with matt gilt mounts by Thomire, the whole manufactured in good order 820L'. Shortly after Carlin's death he married his widow, Marie-Catherine Oeben. The marriage-contract indicates that Schneider enjoyed a certain affluence at that time. He took over Carlin's workshop, became a master on 15 March 1786, and produced or modified porcelain, mahogany and ebony pieces in the style of Carlin for Daguerre. The Revolution ruined him; he was obliged to close his business, and moved to rue Beautreillis, where his wife died on 16 December 1799. Schneider was described in 1806 as insolvent.

BIBLIOGRAPHY

F. de Salverte: *Les Ébénistes.* pp. 301, 302.
David Cohen: 'Four tables guéridons by Sèvres', *Antologia di Belle Arti,* nos 13–14, 1980, pp. 1–11

[516 above] Jewel-cabinet stamped by Schneider, the porcelain plaques dated 1778. Similarities existing between its upper section – very much in the style of Carlin – and a drawing in the Saxe-Teschen album (see pp. 5 and 39) would suggest that the piece was intended for the Duchesse de Saxe-Teschen. (Christie's New York, 19 November 1977, lot 123)

[517] Oval guéridon in mahogany stamped Schneider, decorated with Sèvres biscuit medallions and gouaches under glass attributed to Lagrenée the Younger; mounts by Thomire. This table was made for the Sèvres manufactory to designs by Boizot and Lagrenée the Younger in 1786. (Petit Trianon, Versailles)

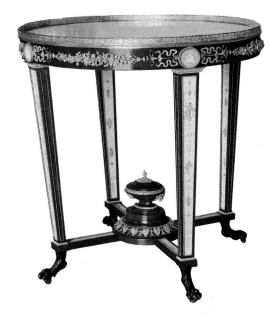

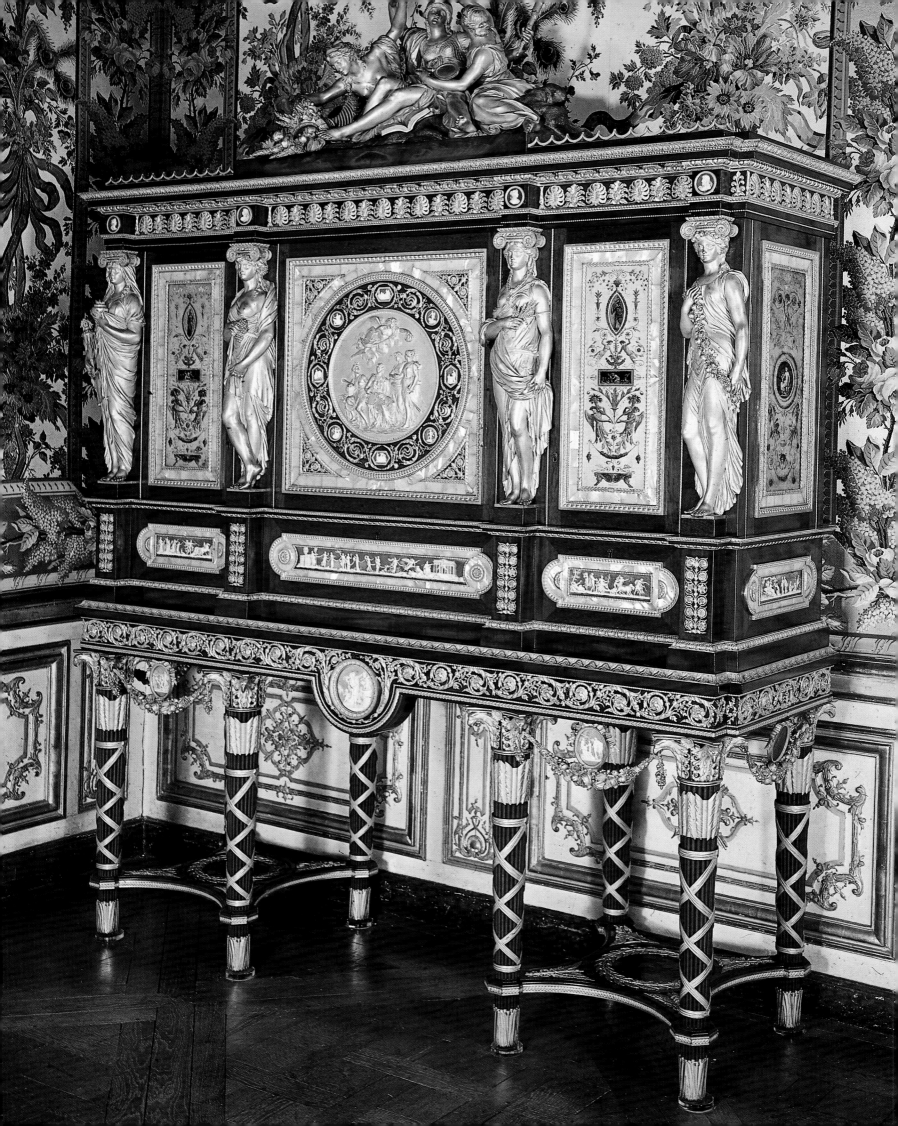

Jean-Ferdinand
SCHWERDFEGER

ACTIVE *c.* 1760–90

Very little is known of Jean-Ferdinand Schwerdfeger, an ébéniste of German origin, other than that he settled in Paris before 1760 (when he was recorded as witness at the marriage of Stumpff, one of his fellow ébénistes). He did not become a master until 1786, and stamped very little of his work. The few known pieces by him must have formed a part of an exceptional ensemble executed or intended for Marie-Antoinette. It comprised the important jewel-cabinet ordered in 1787 by Bonnefoy-Duplan after drawings by Dugourc [518], as well as the work-table and console in the Petit Trianon. These pieces, decorated with gilt-bronze basketwork motifs, ornamented the 'trellis bedroom' of Marie-Antoinette at

the Petit Trianon, where they matched the clock (still in situ), the wall brackets (Gulbenkian Museum, Lisbon) and the polychrome furnishings by Jacob. The furnishings were probably intended to be completed with a very similar commode and secrétaire now in Boston. The choice of Schwerdfeger to execute furniture of this importance makes one wonder if he had not become personal ébéniste to the Queen.

According to Salverte, Schwerdfeger worked from the rue Saint-Sébastien until at least 1798.

BIBLIOGRAPHY
F. de Salverte: *Les Ébénistes,* p. 303

[518] *Jewel-cabinet made by Schwerdfeger in 1787 for Marie-Antoinette at Versailles; in mahogany encrusted with mother-of-pearl, Sèvres biscuit plaques imitating Wedgwood and gouaches under glass by Degault. (Musée de Versailles)*

[519] *Mahogany commode by Schwerdfeger, c. 1787; the*

basketwork motifs in gilt-bronze seem to harmonize with the furnishings in the Trellis Bedroom of Marie-Antoinette at the Petit Trianon. (Museum of Fine Arts, Boston)

[520] *Secrétaire à abattant in mahogany matching the commode shown at [519]. (Museum of Fine Arts, Boston)*

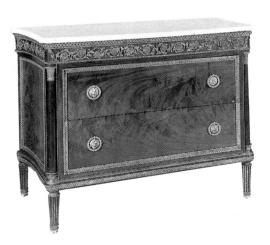

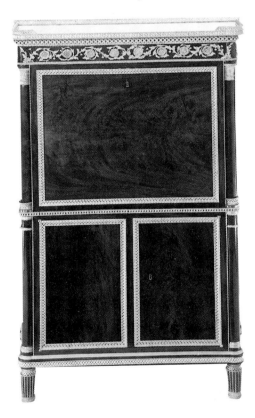

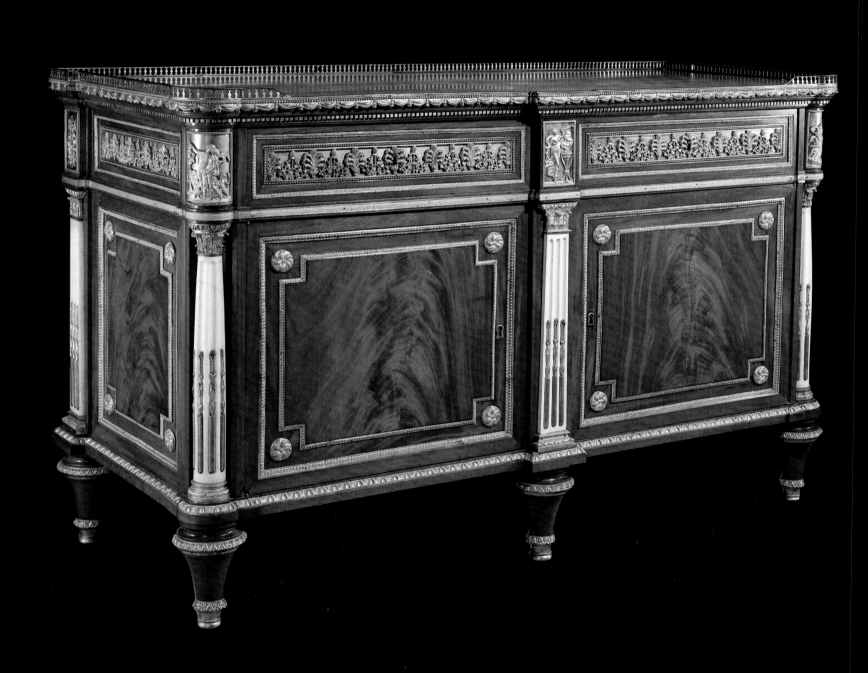

Jean-Jacques
PAFRAT

d. 1794; MASTER 1785

On becoming a master in 1785, Jean-François Pafrat bought or completed certain pieces of furniture by Carlin who had died that year. A table à déjeuner in the Victoria and Albert Museum, supposedly given by Marie-Antoinette to Lady Auckland, bears the stamp of both ébénistes. According to Salverte, Pafrat had a shop in the rue de Charonne and Nicolas Petit was a witness at his marriage in 1788. Recorded furniture by Pafrat is always in mahogany and of very sober form, relying on a refined contrast of colours: the secrétaire and commode at Versailles [522, 523], confiscated from the Duc d'Orléans at Raincy in 1793, have mahogany panels with ebony borders, thus emphasizing the effect of the gilt-bronze frames. The commode with doors at Alexander and Berendt Ltd [521] has fluted columns in white marble at the corners, a detail unique in French furniture, but which is found on pieces in Russian palaces. Perhaps this piece was intended for export to Russia?

In 1789 Pafrat took part in the storming of the Bastille and volunteered for the Revolutionary armies.

BIBLIOGRAPHY
F. de Salverte: *Les Ébénistes*, p. 253

[523] *Secrétaire à abattant en suite with the Raincy commode. (Musée de Versailles)*

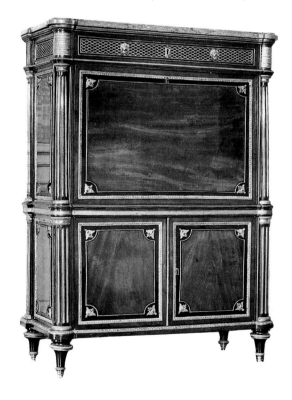

[521] *Commode with doors in mahogany, c. 1790, stamped Pafrat. (Alexander and Berendt Ltd, London)*

[522] *Mahogany and ebony commode stamped Pafrat, c. 1785, confiscated during the Revolution from the Duc d'Orléans at the Château du Raincy. (Musée de Versailles)*

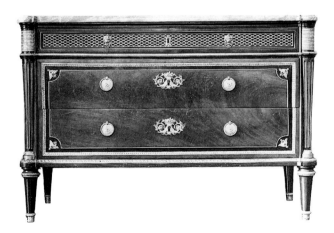

Jean-Georges
ROBIERSCKY

1760–1822; ACTIVE 1788–92

Jean-Georges Robierscky was born in Copenhagen, the son of a Danish cabinet-maker. He came to Paris before 1789. Settled in the Place de la Porte-Saint-Antoine, he worked as an independent craftsman. He specialized in mahogany furniture, mainly desks, serres-papiers and work-tables. His furniture was very well made, and he attracted orders from the Garde-Meuble Royal in the early stages of the Revolution for various desks. The high prices charged would indicate that these pieces were of the highest quality. Among them was a small document cupboard (armoire serre-papiers) in mahogany [524] made for Louis XVI's study at the Tuileries. Ruined as a result of the Terror, he was forced to close his workshop. His affairs were as much in eclipse during the Empire, and in 1815 he applied for the post of furniture-restorer at the Tuileries, which he did not obtain. He lived at 233 rue Saint-Martin until his death in 1822.

BIBLIOGRAPHY

Arch. Nat. 0¹3653, 3654, 3655

F. de Salverte: *Les Ébénistes*, p. 104

D. Ledoux-Lebard: *Les Ébénistes du XIXe siècle*, p. 389

P. Verlet: 'The great Louis XVI's secrétaire at Versailles', *Connoisseur*, 1961, pp. 130–5

APPENDIX

EXCERPT FROM THE ACCOUNTS OF THE GARDE-MEUBLE ROYAL RELATING TO ROBIERSCKY'S INVOICES FOR ITEMS SUPPLIED

Year 1790 [0¹3653-1-]
Supplied 1 serre-papiers with pigeon-holes veneered in bois jaune from Guadeloupe and bois satiné, decorated with frames, plain mouldings, rosettes, scrolls and a frieze chased along the top, with mouldings; the whole in gilt-bronze, or moulu and matt gilding; the white-veined marble top 3 pieds wide and 4 pieds 4 pouces high. *800L*

Year 1791 – January [0¹3654.1]
Paris: for the use of the Administration:
1 mahogany serre-papiers for 12 files, decorated with gilt-bronze mounts. Price agreed at 400L.

Plus a dozen box files in green morocco at 100L, the whole *500L*

April 1791 [0¹3654.3]

For the Cabinet du Roi at the Tuileries:
— 1 serre-papiers in mahogany of choice wood with 2 shutters, one above the other: above, 8 shelves decorated with frames and friezes in matt gilt-bronze, sabots and capitals in matt gilt-bronze, 2 locks and 2 keys à l'anglaise. The marble top white with bronze gallery. *1300L*
— 1 table en abattant with break-front in solid mahogany, gilt-bronze sabots and capitals. *160L*
— 3 oak benches stained to resemble mahogany. *40L*
— 1 corner cupboard in mahogany with mouldings and rosettes in gilt-bronze, white marble top. *200L*

Year 1791 [0¹3655.1]

For the King's use at the Tuileries:
— Supplied, a piece with shelves above and further shelves between the legs, drawers in the frieze, fluted columns at the front and pilasters at the back, plain panels at the sides, 2 pieds high by 18 pouces wide. The upper shelves decorated with free-standing columns and pilasters. The white marble top embellished with a bronze gallery in matt gilding – mahogany polished – brass flutes (burnished), frames, capitals and bases of columns and other decoration all in matt gilt-bronze, key à l'anglaise and au trèfle. The said piece in total 4 pieds 9 pouces high. Veined white marble top and gilt-bronze gallery. *1,200L*
— 2 tables in solid mahogany

with bronze capitals and sabots, sets of green leather fitted drawers closing with chased escutcheons, all in gilt-bronze. *700L the two*
— 2 encoignures in mahogany. *400L*

[524] *Mahogany armoire serre-papiers, unstamped, with the mark of Saint-Cloud; supplied in 1791 by Robierscky for Louis XVI at the Tuileries (information supplied by Mr Patrick Leperlier); later it was sent to Saint-Cloud. (Private collection)*

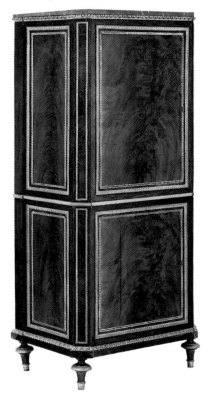

Joseph
STOCKEL

1743–1802; MASTER 1775

Stockel was of German origin and settled in Paris before 1769. On gaining his mastership he established himself in the rue de Charenton where he practised his craft until the Revolution, when he moved to 59 rue des Fossés-du-Temple. His stamp is found on furniture almost always in mahogany and in severe Neo-classical style: for example, the massive commode with doors and fasces at the corners and the secrétaire en cabinet in the Musée des Arts Décoratifs, or the bureau plat mounted with lictors' fasces in the Assemblée Nationale. This last piece confirms the attribution to Stockel of a small unstamped ebony bureau plat which was formerly in the Grognot and Joinel Collections and which has the same shape and the same fasces [525]. These fasces, which would seem a hallmark of Stockel's work, are again found on a large commode which was modified in 1786 and then again in 1787 for Louis XVI's Council Chamber at Compiègne.

Pierre Verlet has made a study of the complete series of furniture by Stockel which was supplied for the apartments of the King and Queen after 1787. He has discovered that the four commodes stamped by Stockel and Benneman are not the outcome of a collaboration between the two ébénistes, but were pieces originally by Stockel, bought in 1786 for 6,000 livres from the mercier Sauvage, Denizot's son-in-law, and then altered by Benneman. These pieces were subjected to such radical alterations (enlarged, reduced, reveneered, mounts removed) that it is no longer possible to visualize Stockel's original pieces. Nevertheless, one can point out their massive form, the presence of heavy flutings at the corners and the fact that two of them were originally mounted with porcelain plaques. Stockel was therefore one of the few ébénistes of this period who used porcelain plaques, and the

only one, together with Dester, who was not one of Daguerre's regular suppliers (Carlin, Weisweiler, R. V. L. C., Leleu and Saunier). Pierre Verlet also reveals that these commodes formerly belonged to the Comte de Provence, as one of them originally carried his cipher. Here is an indication that Stockel carried out commissions for the Comte de Provence through the marchand-mercier Philippe-Ambroise Sauvage. The role of the dealer would explain, moreover, the richness of the gilt-bronze mounts and the presence of porcelain plaques.

BIBLIOGRAPHY

Pierre Verlet: *Le Mobilier royal français,* vol. I, pp. 36–43, and vol. II, pp. 100–11

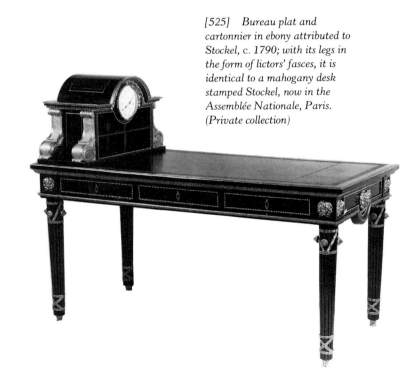

[525] Bureau plat and cartonnier in ebony attributed to Stockel, c. 1790; with its legs in the form of lictors' fasces, it is identical to a mahogany desk stamped Stockel, now in the Assemblée Nationale, Paris. (Private collection)

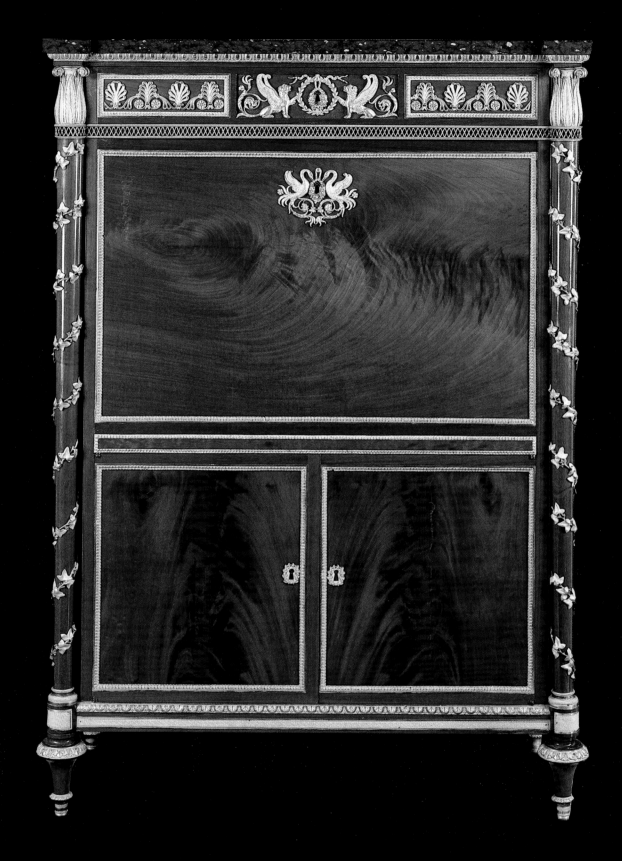

Bernard
MOLITOR

1755–1833; MASTER 1787

Bernard Molitor was born in Betzdorf in Luxembourg and settled while still very young in Paris, certainly before 1778. In that year he is mentioned in the *Petites Affiches* advertising a product to kill bugs. At the time he was established at the Arsenal where he subleased a workshop. In 1782 he advertised 'hand-warmers . . . made in the form of books, for use in church, in a carriage, at the theatre or when travelling'. These ingenious little boxes were in mahogany or walnut and contained metal canisters designed to hold preheated brickettes or stones. He did not become a master until 1787. He must have practised the craft of ébéniste for some time before this, as, on the occasion of his marriage in 1788, his

assets were estimated at the considerable sum of 15,000 livres. In the spring of 1787 he was commissioned to construct a mahogany floor for Marie-Antoinette's boudoir at Fontainebleau, with the Queen's cipher incorporated in the design. He made the acquaintance of Julie-Élisabeth Fessard, daughter of the 'charpentier du roi', at Fontainebleau, whom he married on 7 June 1788. Shortly after his marriage he

[526] (opposite) *Secrétaire à abattant in mahogany stamped Molitor, c. 1787–90, reputedly made for Mesdames at Bellevue. (Formerly in the Marquis de Villefranche's collection)*

[527] *Commode attributed to Molitor, en suite with the secrétaire shown at [526]. (Formerly in the Marquis de Villefranche's collection)*

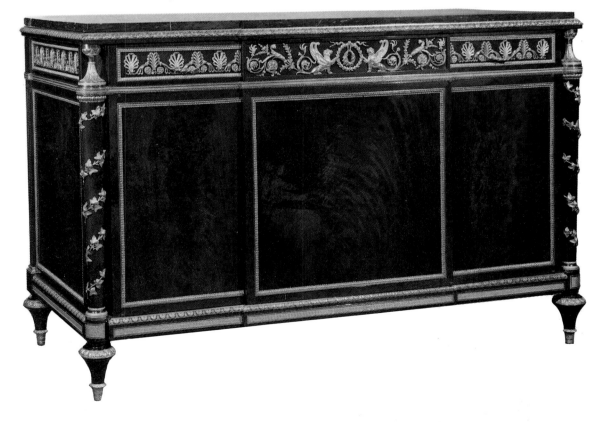

moved from the Arsenal to the rue de Bourbon (now rue de Lille) to a house owned by Trompette who was the chief menuisier to the Garde-Meuble Royal.

Molitor's business was extremely successful and amongst his elegant clientèle were not only members of the Queen's circle, the Polignac family, the Fitz-Jameses, the Duchesse de Vaudemont and the Comtesse de Lamarck (to whom he supplied furniture until 1792) but also La Fayette, Boisgelin, Levy-Mirepoix, Medavy, the Comte de Tessé, La Vieuville, Bonnecar-rère, the Comtesse de La Charte, Jaucourt, M. de Verdun and the Swedish ambassador, husband of Mme de Staël. Molitor employed his father's cousin, Michel Molitor, whom he paid 1,500 livres for works between 1791 and 1796.

With the advent of the Revolution and the disappearance of his smart clientèle, Molitor's workshop was forced to close for a while (he had to appear before the Revolutionary Tribunal). Nevertheless he started up again with even greater success at the end of the Terror. In 1796, on the death of his wife, his workshop was again in full production, having eight work-benches (as many as Weisweiler, one of the most important ébénistes of the period). The inventory after her death lists a large stock of furniture: 48 pieces of which a dozen were still incomplete and 4 commodes 'without their bronze mounts'. Certain pieces had

ungilded mounts. The main woods used were mahogany and satinwood ('one secrétaire 3 pieds in length with oak leaf decoration in bois jaune' and '2 armoires in bois jaune with coloured marble tops 3 pieds 8 pouces in height, one with a drawer and the other with sliding shelves, priced together at 500 livres . . . one deep-rimmed table in bois jaune'). Nevertheless, also to be found are 'one commode in tulipwood' and 2 writing-tables 'à la Pompadour' with marquetry valued at 400 livres. The high estimate and the term 'à la Pompadour' indicate a piece out of fashion in 1796. This has enabled Ulrich Leben to identify the two tables, one today in the Huntington Library, the other in the Wallace Collection [530]. All the commodes have a marble top 'white with veining' or 'red Languedoc' or 'coloured'. Of the 48 pieces described, 24 are tables for various uses (writing, trictrac, tables with deep rims, 'tables à patins', dining-tables, and tables with shelves), 7 are commodes and there are 3 desks, 3 secrétaires, 5 guéridons, 3 armoires, 2 coffers and one box. The inventory notes amounts owed to 'Demay,

[528] *Commode with doors in Japanese lacquer stamped Molitor, c. 1790; the frieze composed of palm leaves is characteristic of Molitor. (Sotheby's Monaco, 7 February 1982, lot 346)*

[529] *Secrétaire en cabinet, one of a pair in Japanese lacquer stamped Molitor, c. 1800; bought by the Garde-Meuble Royal in 1822. (Musée du Louvre, Paris)*

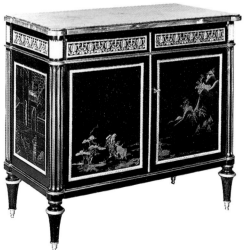

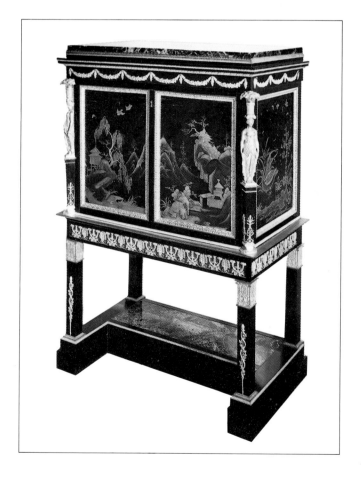

menuisier, rue de Cléry, for works effected during Fructidor IV [1796]' totalling 447 livres. This probably implies that Demay made the various mahogany chairs for Molitor who sold them after having stamped them.

Under the Directoire his affairs prospered and in 1800 he bought a house, 17 rue du Faubourg Saint-Honoré to which address he moved in 1801. He moved to the corner of rue Neuve-du-Luxembourg and the boulevard de la Madeleine between 1803 and 1811, and then returned to his old address in the Faubourg Saint-Honoré. Between 1806 and 1812 he supplied furniture to King Jérôme at Cassel and in 1811 he received a commission from the Emperor (all part of the Imperial policy of revitalizing the furniture trade, dismantled by the Revolution). Nevertheless, with the Restoration and the return of his former clientèle, his affairs prospered even more and in 1833, when he died at the age of seventy-eight, he was in possession of a considerable fortune.

Molitor's production seems to have been an extension of that of Weisweiler. Serving the same aristocratic clientèle, he produced above all sumptuous furniture in mahogany or Japanese lacquer, more rarely in marquetry. Like Weisweiler he seems to have had a predilection for a type of lady's 'secrétaire en cabinet' of which the lower half forms a table, while the upper part is designed with caryatids at the corners. Several examples in Japanese lacquer are recorded, in particular a pair reputedly ordered by Marie-Antoinette in 1790 (according to a tradition founded by Molitor himself) and bought in 1822 by the Garde-Meuble. The commodes usually have three doors, flanked at the corners by free-standing columns or pilasters. A small mahogany secrétaire à abattant by him (formerly in the Rothschild Collection) is decorated with small detached bamboo columns entirely in Weisweiler's style. Moreover, two guéridons in mahogany (one in the Petit Trianon, the other in the Ader sale, Monaco, 11 November 1984) are obviously derived from tea-tables by Weisweiler. Even before the Revolution, Molitor used certain gilt-bronze mounts which became his hallmark: palmette friezes and the motif of opposed griffons which we think of as Empire style are already found on a mahogany commode and secrétaire (formerly Marquis de Villefranche Collection – [526, 527]) that can be dated before 1792. Another characteristic of Molitor found

on these pieces is detached columns around which curl ivy trails, a detail which is found again on another commode with doors as well as a secrétaire formerly in the Wildenstein Collection (now in the Cleveland Museum of Art). At a later date he used a gilt-bronze frieze made up of palmettes and the cornucopiae which run like a leitmotiv through his work. These are to be found on a suite in Japanese lacquer consisting of a commode, console-desserte, pair of secrétaires en cabinet and pair of low cabinets which were made around 1796 for the Duc de Choiseul-Praslin (private collection).

There is little noticeable artistic development in Molitor's production between the 1790s and the 1820s. The types of furniture produced are similar. The only concessions to fashion were the use of mounts such as Egyptian heads in about 1796–1800 and the shape of the stands of cabinets (legs of square section with capitals).

BIBLIOGRAPHY

Ulrich Leben: official thesis on Molitor, Bonn University, 1988; '1796, l'atelier de Bernard Molitor sous la Révolution', *L'Estampille*, January 1985; 'Die Werkstatt Bernard Molitor', *Kunst und Antiquitäten*, IV/87; 'Une commande impériale à Molitor, *L'Estampille*, no. 12, 1986 Denise Ledoux-Lebard: *Les Ébénistes du XIXe siècle*, Paris, 1984, pp. 486–92

[530] Table stamped Molitor; probably the table referred to in the inventory of Molitor's workshop drawn up in 1796 as *'table à la Pompadour'; the pair to it is now in the Huntington Gallery, San Marino, California. (Wallace Collection, London)*

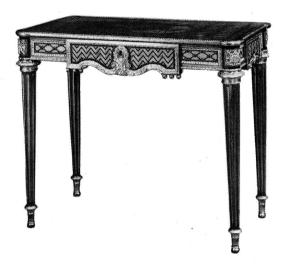

GLOSSARY OF WOODS
EXOTIC WOODS OR 'BOIS DES ÎLES'

Amaranth (purplewood) comes from Brazil or Dutch Guiana; it was used for veneering from the time of Louis XIV and even sometimes in solid wood. Very fashionable at the beginning of the eighteenth century, it was frequently used as a plain veneer on commodes and bureaux plats. Later it was used to form a dark framework surround to bois satiné or tulipwood. Its colour, reddish violet with pale veins, becomes dark-brown with age.

Bois de Cayenne is a bois satiné, pale and very golden, used for instance in the 1730s by Cressent.

Bois de citron or **d'hispanille**, from San Domingo, is pale yellow in colour spotted with darker yellow and very different from citronnier.

Bois jaune is an imprecise eighteenth-century term probably denoting satinwood.

Bois satiné, from Guiana and San Domingo, is a hard wood close to mahogany in colour but of a shiny red colour. There are two varieties: the 'satiné rouge' (of a reddish brown) and the 'satiné rubané' (striped and more golden). Used in Paris from the time of Louis XIV, it reached the height of fashion between 1730 and 1750 with the furniture of Cressent, B.V.R.B. and Jacques Dubois.

Burr amboyna (loupe d'amboine) is a rare wood from the Moluccas. The figure is very irregular with small dark spots resembling mahogany. This wood was used around 1785 by Weisweiler.

Burr thuya (loupe de thuya), of homogeneous tint close to mahogany, resembles burr amboyna but is redder and more pitted. It was used around 1785 by Weisweiler and Saunier.

Calambour, also called **calambac** or **bois d'aigle**, of a decorative dark brown, is recorded between 1680 and 1720.

Cedar (cèdre), from the Lebanon or North America, with a light brown tone, was used during the reign of Louis XIV for the sides of drawers and even for complete pieces of furniture. Later, it was also used by J.-F. Oeben.

Citronnier (or **bois jaune**, **satinwood**), from the Antilles, is an extremely hard wood of pale yellow, varying in appearance according to cut. It is rarely found in Parisian ébénisterie before the 1780s. At that time it was used for veneering overall or contrasted with dark woods such as mahogany, ebony or amaranth in furniture by R.V.L.C., Levasseur and Saunier.

Coral wood (bois de corail), a heavy wood of a strong red hue, comes from Africa or Western Asia; one of its varieties, Padoukwood, was used during the reign of Louis XIV for making the drawers of certain sumptuous pieces of furniture such as the 'commodes Mazarines' [17] by Boulle.

Ebony (ébène), from Africa, Madagascar and India, is a very dense wood, black with lighter grain. Used predominantly in the seventeenth century for plain veneering or combined with pewter and brass, or again used as a ground for floral marquetry, ebony went out of fashion during the reign of Louis XV and only came back into fashion in the years around 1760–80 with the revival of the Louis XIV style.

Kingwood (bois de violette), called 'bois violet' in the eighteenth century, comes from Brazil. The name refers to its colour: light brown-violet, the grain is prominent in dark zebra stripes. With age it takes on an amber tint darker and more banded than tulipwood. A very hard wood, it is used only for veneering. It was employed from the seventeenth century; its popularity culminated during the Régence and it continued to be used throughout the eighteenth century (in the inventory of Noël Gérard in 1736 it was the cheapest exotic wood). According to Pierre Verlet the term 'bois violet' was used in a loose sense during the reign of Louis XIV and could also refer to amaranth.

Mahogany (acajou), from Cuba, became widespread in Parisian ébénisterie from the 1760s with the commodes 'à la grecque' by J.-F. Oeben and the demand for furniture in this wood increased during the reign of Louis XVI. The first mahogany chairs were made by ébénistes such as Garnier and Moreau in 1778. Occasionally furniture was made in solid mahogany but it was mostly applied as a veneer. The following types of mahogany may be noted:
Figured mahogany (acajou ronceux) of wavy pattern, coming from the forks of branches at the top of the trunk, the most expensive part.
'Plum-pudding' mahogany (acajou moucheté), marked with numerous knots forming dark spots.
Acajou chenillé with shaded paler lines.
Flame mahogany (acajou flambé), where the grain appears in red bursts, giving the appearance of flames.

Palisander or **rosewood (palissandre)**, called 'palissante' in the eighteenth century, comes from India, Madagascar and Brazil. Its colour varies from light brown to violet/brown with a black grain. Very popular under Louis XIV and the Régence, it was thereafter superseded by kingwood.

Tulipwood (bois de rose), called 'bois rose' in the eighteenth century, comes from Brazil. On being cut it gives off an odour reminiscent of roses. It is pinky-yellowish in colour with darker-pink grain; with age it takes on an amber tone. It began to be used by Parisian ébénistes only in the years around 1745. From about 1750 tulipwood replaced bois satiné as the ground for floral marquetry and its popularity culminated in the Transitional style in the years 1760–75.

INDIGENOUS TIMBERS

Beech (hêtre), sometimes used in ébénisterie of lesser quality for panels or legs, was frequently used in eastern France for whole carcases of furniture.

Cherry (cerisier) was frequently used during the eighteenth century for games tables and utilitarian furniture; it was sometimes also used as a veneer on the inside of doors of certain pieces with amaranth fillets (by Gaudreaus, for example).

Oak (chêne), originally from the forests of the Vosges and Limousin, was the standard wood used in the eighteenth century in the construction of the carcases of furniture in Paris, sometimes combined with panels of walnut or deal. After 1740 the drawers of furniture made in Paris are in oak. Riesener and Weisweiler used a lighter and finer variety of oak from Hungary.

Olivewood (olivier), of buff colour with strong brown grain, was used as a veneer on Parisian furniture between 1680 and 1720 (Gole used it around 1680, and Hecquet around 1720).

Pine or deal (bois de pin) was frequently used for the carcases of furniture in the seventeenth century and in the eighteenth until about 1740; later it was less frequently used for furniture of quality. White in colour, it oxidizes on the outer surfaces of the carcase, taking on a reddish tinge.

Poplar (peuplier), a commonplace white wood used in panels for the carcases of mediocre furniture during the eighteenth century (according to Roubo), but mostly from the beginning of the nineteenth century.

Walnut (noyer) was frequently used for furniture in solid wood, or applied in veneer on fine furniture in the seventeenth century (cabinets, tables, guéridons); during the eighteenth century it was used rather for utilitarian furniture (night-tables, toilet-tables, commodes and secrétaires made for rooms of lesser importance). Until about 1740 the drawers of furniture of quality were in walnut; after this date they are generally in oak. The best types of walnut came from the area around Grenoble.

1 *Acajou moucheté ('plum-pudding' mahogany)*
2 *Acajou ronceux (figured mahogany)*
3 *Amaranth (purplewood)*
4 *Bois de rose (tulipwood)*
5 *Bois de violette (kingwood)*
6 *Citronnier (satinwood)*
7 *Corne teintée bleu (blue-stained horn)*
8 *Corne teintée vert (green-stained horn)*
9 *Ébène (ebony)*
10 *Écaille brune (brown tortoiseshell)*
11 *Écaille rouge (red tortoiseshell)*
12 *If (yew)*
13 *Ivoire (ivory)*
14 *Loupe d'amboine (burr amboyna)*
15 *Loupe de thuya (burr thuya)*
16 *Os (bone)*
17 *Palissandre (palisander)*
18 *Prunier (plum)*
19 *Satiné doré*
20 *Satiné rouge*
21 *Sycomore maillé (sycamore in chain-mail pattern)*

GLOSSARY OF FRENCH TERMS

Armoire: Tall cupboard, with hinged doors, containing shelves or drawers.

Bas d'armoire: Low cupboard, not as deep as a **commode à portes**.

Bibliothèque: Bookcase of any size with either glazed or wire mesh doors, the mesh sometimes backed with silk.

Bois de bout: Wood cut across the grain, the grain being used in marquetry to depict strikingly naturalistic leafage or flowers.

Bonheur-du-jour: Small lady's desk with a superstructure, with either open shelves, small cupboards, drawers, or a tambour front; in fashion *c.* 1770–1800.

Bronze doré: Gilt-bronze. A technique of covering metal (especially bronze) furnishings and mounts with a layer of gold leaf, widespread in the eighteenth century. The term covers a wide range of quality from inferior alloys to 'ormolu' (or-moulu) work, with gilding by the expensive mercury process.

Bronze verni (also referred to as **bronze en couleur**): Brass or bronze, lacquered with a gold tinted lacquer to resemble gilding; used on the majority of mounts till the end of the Louis XV period, as a cheaper alternative to mercury gilding.

Bronzier: Makers of bronze furnishings. Two guilds were involved: the **fondeurs**, the casters and finishers; and the **doreurs** or **ciseleurs-doreurs**, the chasers and gilders.

Bureau brisé: Variety of **bureau Mazarin** evolved by Gole, with the top divided into two along its length, the front half lifting while the top front row of drawers (in fact made of false drawers) acts as a fall-front, revealing a writing surface inside.

Bureau Mazarin: Form of knee-hole writing bureau in fashion between 1680 and the beginning of the eighteenth century, from which both the bureau plat and the commode evolved. A flat-topped writing-desk with drawers on either side of a central recess with a door; generally on eight legs with stretchers; made to stand against the wall, so undecorated on the back.

Bureau plat (also referred to as simply **bureau**): Flat-topped writing desk on legs; generally with three – but sometimes more – drawers in the frieze.

Cabinet: Rectangular piece of furniture, usually on a stand, with numerous small drawers to contain papers or objects, and sometimes a fall-front or a door or doors enclosing the drawers. Out of fashion in France after 1700, it came back into fashion *c.* 1780 as a low cabinet without stand.

Caisson: Stand of a **cartonnier**, often detached from the upper part, which is called a **serre-papiers**.

Cartonnier (also called **serre-papiers**): Filing cabinet with open shelves designed to contain leather or cardboard boxes; either standing on a bureau plat (called 'bout de bureau' in the eighteenth century) or free standing, supported by a low cupboard, when it was generally placed at one end of a bureau plat.

Chiffonnier: Tall piece of furniture, with many drawers fitting on top of each other, generally not very deep. When it has seven drawers, it is called a **semainier**.

Ciseleur-doreur: *See* **Bronzier**.

Coffre: Chest, a piece of furniture that went generally out of fashion after 1700, and was replaced by the **commode**.

Coffre à bijoux: Jewel-cabinet of varying size. Under Louis XVI the most elaborate ones took the form of cabinets on stands.

Coffret (or cassette): Casket.

Coiffeuse: *See* **Table de toilette**.

Commode: Chest of drawers. A piece of furniture that evolved from the bureau *c.* 1695. First used only in bedrooms to contain clothes, it was subsequently placed in private rooms and at the end of the eighteenth century began to be used in reception rooms without any functional purpose.

Commode à encoignures: Chest of drawers with curved doors at the sides.

Commode à la grecque: Rectangular chest of drawers with drawers in the middle and in the frieze, and doors on either side of the central drawers; invented by J.-F. Oeben *c.* 1760.

Commode à l'anglaise: Chest of drawers with open shelves at the sides.

Commode à brisure: Commode with three panels, the central one being hinged on one of the side ones.

Commode à portes: (also called **meuble à hauteur d'appui**): Low cupboard of the same height and depth as a commode, generally with drawers inside.

Commode en console: Chest of drawers with a single row of drawers, on tall legs.

Commode à la Régence: Chest of drawers with two rows of drawers, on tall legs.

Commode en tombeau: Chest of drawers with three rows of drawers, on short legs.

Console: Side table of any shape to stand against the wall, undecorated on the back and generally with a marble top. Sometimes called a 'console-desserte' when it has a marble shelf below matching the marble top. It began to replace the traditional giltwood consoles in reception rooms in the 1780s.

Crowned C poinçon: Small mark of varying size which corresponds to a tax levied from 1745 to 1749 on any alloy with copper. In theory it should be struck on every individual gilt-bronze mount.

Ébéniste, Ébénisterie: *See* Introduction, pp. 12–15.

Écritoire: Standish fitted with writing equipment (inkwells, sand-shakers, pens, knife and paper) and a writing surface. It was intended for writing in a confined space, such as in a carriage or in bed.

Encoignure: Corner cupboard, generally low, with one or two doors, sometimes with open corner shelves on top.

Fondeur: *See* **Bronzier**.

Gaine: Pedestal supporting a piece of sculpture or a clock, generally of square tapering shape, but also taking other forms.

Garde-Meuble Royal: Administration dealing with the furnishing of the French royal palaces; it operated from the Middle Ages onwards.

Gradin: Set of shelves, sometimes closed with a tambour or a cupboard, intended to stand on top of a **bureau plat** or a table. The term could also refer to the shelves that often surmounted an encoignure.

Guéridon: Originally a tall candlestand with a tripod base, made in pairs to go on either side of a table, and with decoration matching the table's. In the eighteenth century it became a low circular or oval table with three legs or a tripod base.

Livre: The French eighteenth-century currency. There were 24 livres in one Louis d'or and 20 sols or sous in one livre.

Marchand-mercier: Dealer, with entitlement to retail specific goods

Detail of the mechanical table by
Riesener and Cosson shown at
[463]

(including imported ones) but who could not produce them himself.

Marqueterie: Decorative veneer of exotic woods, sometimes stained, or other materials in contrasting colours and shapes applied to the carcase of furniture. The design was first stuck to the wood, and the different parts were cut out by hand with a fine marquetry saw; the pattern was then reassembled and glued to the carcase. Until the middle of the eighteenth century the term 'marqueterie' meant **marqueterie Boulle**, as distinct from 'marqueterie de fleurs', which meant floral marquetry in wood veneer.

Marqueterie Boulle: Marquetry using metal (brass, copper or pewter) in combination with tortoiseshell or ebony. When in 'première partie', the ground is tortoiseshell or ebony with metal inlays; when in 'contre partie', the ground is metal with tortoiseshell or ebony inlays.

Menuisier: Furniture-maker specializing in carved furniture.

Pied: Measure equivalent to 32.48 cm.

Pietra-dura: Mosaic work, either flat or in relief, composed of semiprecious stones (jasper, agate, lapis lazuli, etc.), first produced in Florence and Prague by Italian craftsmen, then in Paris at the Manufacture des Gobelins.

Pouce: Measure equivalent to 2.7 cm. There are 12 pouces in 1 pied.

Quart-de-rond (or carderon): Brass or bronze moulding usually found around the top of a bureau plat.

Rafraîchissoir: Table incorporating a wine cooler on the top shelf.

Régence, Style: Style of design intermediate between the Baroque and Rococo in France, broadly speaking at the time of the Regency of the Duc d'Orléans during the minority of Louis XV (1715–23).

Régulateur (also called **pendule à secondes**): Long-case clock.

Secrétaire (also called **secrétaire en pente** or **bureau dos d'âne**): Low desk, with a sloping front hinged as a writing surface.

Secrétaire à abattant (also called **secrétaire en armoire**): Flat-fronted upright desk, the upper section with a hinged fall-front as a writing surface, the lower section with two doors or with drawers.

Secrétaire à cylindre: Locking desk with a flat writing surface which pulls forward as the cylindrical cover slides back. The model was invented by Oeben c. 1760.

Secrétaire en cabinet: Small upright desk with a fall-front in the upper section, resting on a stand like a cabinet. The fashion for this piece of furniture was begun by the **marchands-merciers** c. 1760.

Serre-papiers: See **Cartonnier**. Strictly speaking, in the eighteenth century the term referred to the upper part of a cartonnier with open shelves, sometimes placed on a low cupboard called a **caisson**.

Table d'accouchée: Table with a removable top fitted with four short legs, which can be lifted to be placed on a bed for writing, eating, etc.

Table ambulante: Imprecise term for a small portable table with no specific use.

Table à la Bourgogne (also called **secrétaire en capucin** or **à la Bourgogne**): Table with a divided top, the rear part rising mechanically to reveal a set of drawers, the front half folding forward as a writing surface.

Table creuse (or **vide-poches** or **en auge** or **en crachoir**): Small table with a deep rim around the top.

Table de chevet (or **table de nuit**): Bedside-table with handles on the sides, designed to be carried in the evening from closet to alcove; with a compartment and marble slab to take a chamber pot.

Table en chiffonnière: Small table, oval or rectangular, with several drawers on top of each other.

Table à écrire (or **table-écritoire**): Writing-table suitable for a woman, usually fitted with a drawer containing inkwells, etc. or with a writing slide on the front or at the side.

Table de jeu: Gaming-table. There were many sorts. The 'table de trictrac' or backgammon table was rectangular with small drawers opening on either side; the 'table à quadrille' and 'table de piquet' were square, but the former had rounded corners to take candlesticks or cards; the 'table de brelan' was circular with a hollow recess in the centre to take cards or a candlestick; and the 'table de tri' was triangular. These pieces, especially the table de quadrille and the table de tri, were often folding tables.

Table mécanique: Writing-table with a large drawer in the front which pulls forward while the marquetry top slides back, usually revealing a central writing surface flanked by compartments.

Table de nuit: *See* **Table de chevet**.

Table de toilette (or **coiffeuse**): Dressing table. Originally a plain table with a cloth ('toilette' meaning thin cloth) supporting toilet equipment – pomades, brushes, perfumes, etc. It attained the status of a formal piece of furniture under Louis XV with a central mirror (which could be raised or folded flat) surrounded by compartments and small drawers.

Table à la tronchin: Architect's table with a flat-topped writing surface which rises on adjustable trestle supports, and rises again on a ratchet. Intended for reading and drawing when standing upright.

Toilette en coeur (or **toilette en papillon**): Small heart-shaped dressing table designed for men; a rare piece created probably by J.-F. Oeben c. 1758.

Transition, Style: Style of design in French furniture intermediate between the Rococo and the Neo-classical, during the late 1750s and early 1760s.

Vernis Martin: French imitation of oriental lacquer, deriving its name from the brothers Martin who obtained letters patent in 1730 for its manufacture. The term denotes pictorial lacquer, sometimes in relief, as well as plain-coloured lacquer applied in numerous successive coats.

THE STAMP

Although a stamp is often confused with a signature, it actually has nothing to do with it. Far from being an indication of authorship of an artist proud of his work, such as the signature of a painter or sculptor, the stamp was merely an obligatory mark for every Parisian master ébéniste. The statutes of 1751 stipulated precisely: 'Each master must have his own individual mark and likewise the guild, impressions of which stamps shall be lodged at the office on a sheet of lead, and the said masters may not supply any work – except to the Bâtiments to which this does not apply – which has not first been marked with their stamp, on pain of confiscation and a fine of 20 livres for each piece not marked.' These statutes had been drawn up as early as 1743 but their definitive registration was carried out by the Parlement only in 1751. It may be said that the obligation to stamp work began to take force from 1744 onwards and became general practice after 1751.

This regulation in fact was not a constraint to ébénistes. Besides being a label of quality for the body of master ébénistes, it enabled them to maintain a quasi-monopoly of production, at the same time giving them a form of rudimentary publicity. Actually, as D. Augarde has discovered (L'Estampille, June 1985), the concept of a stamp predates 1744 and had its origins in the seventeenth century when the guild of menuisiers had already attempted to force the tapissiers (upholsterers), then the principal retailers of furniture, to sell only the work of master menuisiers. A decree of 1637 stipulated that menuisiers were to mark their work. At the same time the tapissiers were forbidden to retail unmarked furniture. The use of the stamp did not become widespread, however, and it was not until the years 1720–30 that the first examples are found. Thus the stamp of François Lieutaud, Mathieu Criard, Carel and Noël Gérard is to be found on pieces which may be dated to the 1730s at the latest. It is also known that the ébénistes Doirat (died 1732) and Nicolas Sageot (died 1731) generally stamped their work. Bernard II Vanrisamburgh also used a stamp before 1744: the bureau at Temple Newsam [173], stamped by both F.L. and B. V. R. B., dates from c. 1735, while the commode of Maria Leszczyńska, which bears his stamp, was supplied in 1737. The majority of abbreviated stamps date from this period: those of F. L. (François Lieutaud), N. G. (Noël Gérard), L. S. P. (Louis Simon-Painsun), F. G. (François Garnier), F. M. D. (François Mondon), I. D. F. (Jean-David Fortanier), B. V. R. B. (Bernard Vanrisamburgh), D. F. (Delorme-Faizelot?) and M. C. (first stamp of Mathieu Criard?). In this context the obligation to use a stamp, instituted in 1743, was merely the formalization of an already established practice justified by the desire to compete with the independent craftsmen, principally, as D. Augarde has written, 'because in an ordered society such as that of France in the eighteenth century, practice preceded rules, or itself became accepted custom.'

In theory most Parisian furniture produced after 1751 had to be stamped. Under these circumstances it is astonishing to find so many pieces unstamped. This may be explained in several ways. In most cases they must have been made by independent craftsmen working in the privileged areas and sold directly to private clients; in this case the guild could not interfere. They could also have been pieces made by independent craftsmen for the marchands-merciers. As a result of a judgment of 1749, the latter had obtained the right to sell unstamped pieces of furniture. The situation becomes more complicated in the case of pieces which are unstamped, yet are obviously the work of ébénistes who were already masters, such as B. V. R. B., Joseph, Carlin or Weisweiler. The usual explanation, attributing the lack of stamp to the negligence of the maker, does not hold water. It may be that these ébénistes used the stamp or not, according to the wishes of the marchands-merciers who had commissioned the work. But in the case of Carlin, it is difficult to understand the logic in his use of the stamp: all his porcelain-mounted furniture was made for the same dealer, Poirier; however, twenty-two pieces, more than twenty-five per cent of those known, are unstamped. Why stamp some and not the others? The only possible explanation is

that the dealers, wishing to avoid the publicity that the stamp represented for the maker, and hoping to avoid the possibility of their clients going directly to him, asked their usual suppliers not to stamp their wares where possible. However, the visits of the guild juries were frequent, necessitating that all the furniture present in the workshop should be stamped. Only a small proportion of pieces – those made between inspections by the juries – could avoid being stamped.

Various indications reinforce this hypothesis that the marchands-merciers sought to remove or disguise the stamp. Numerous examples are recorded of stamps defaced with a punch; this almost always occurs on pieces of luxury furniture intended for the marchands-merciers – on several pieces by Carlin, for example. On the table-console which belonged to the financier Beaujon (Gulbenkian Museum, Lisbon), the stamp, although defaced, is still legible as that of Carlin. Another clue is the fact that the stamps of the ébénistes who worked for the dealers are often very small and difficult to find. It is surely no coincidence that the smallest stamps are those of Joseph, Carlin, Schneider, Boichod and Levasseur, ébénistes who worked mainly for dealers.

Another problem is the presence of two different stamps, as evidenced on numerous pieces of furniture. Sometimes three different stamps or more are to be found: on a Louis XV secrétaire which recently passed through the art-market in Belgium, four different stamps were present, all perfectly genuine, those of Landrin, Carel, Chevallier and R. V. L. C. Certain experts endeavoured to explain this mystery as evidence of successive restorations to the piece, each restorer adding his stamp at the time the work was carried out. Certainly, it can in many cases be proved that ébénistes stamped furniture that they restored or altered. There is the example of genuine pieces by Boulle made between 1690 and 1720 which bear the stamp of J.-L.-F. Delorme, or J. Dubois or Levasseur or even Riesener, corresponding to restorations carried out in the years 1770–80. However, in many cases the two adjoining stamps are those of contemporary ébénistes, which disproves the hypothesis that one maker restored a piece made only recently by another maker.

In fact, the problem of double stamps is more closely related to the general practice of subcontracting by Parisian makers. As Roubo has indicated, certain ébénistes were happy to make the carcases of furniture for other ébénistes who finished them and sold them. These were probably stamped at each stage of the production. At the time numerous ébénistes were working for the ébénistes-marchands to whom they delivered finished pieces. The inventories taken after deaths or the business records of ébénistes such as Migeon or Boudin give numerous examples of such subcontracting. For instance, Migeon employed Landrin who supplied him with 85,000 livres' worth of furniture between 1742 and 1751, as well as numerous other ébénistes (Topino, R. V. L. C., Mondon, Canabas, Macret, Criard, etc.). Boudin employed various makers, among them Topino, who, for example, supplied him with forty-nine small tables 'with chinoiserie subjects' between 1772 and 1775. If the examples of double stamping are examined, it will be found for the most part that the dominant stamp is of a celebrated ébéniste, almost always a dealer, alongside the less obvious stamp of the maker, usually a less well-known ébéniste. On one small table [142] Migeon's stamp is found next to Lhermite's which has been somewhat effaced' On a bureau in the Louvre [158] Migeon's stamp is again obvious while that of Dubois has been obscured. In some cases one of the stamps has even been punched out or concealed beneath another more legible stamp. As in the case of the marchands-merciers, one senses the ébéniste-marchand's desire to erase the mark of the maker and replace it with his own, and one therefore returns to the hypothesis that the stamp was resented as a mark of publicity. It must not be forgotten that stamps now often difficult to find were more obvious in the eighteenth century, when the wood had not yet been subjected to use and oxidization due to the passage of time, or the tools of the restorer.

ANCELLET, Denis-Louis, m.* 1766
ANGOT, Jacques, m. 1743
ARMAND, Henri (b. 1737)
ARMAND, Jacques (1714–c. 1784)
ARTZT, Jean-André, m. 1785
AUBIN, Jean-Julien (1734–93), m. 1777
AUBRY, Louis, m. 1744
AVRIL, Étienne (1748–91), m. 1744
BARRAULT, Joseph (c. 1730–98), m. 1768
BARTHÉLEMY, Charles, m. 1777
BARY, Michel (c. 1690–1761)
BAYER, François, m. 1764
BEAUCE, Louis-Laurent, m.1787
BEAUCLAIR, Benoît BUTTE, called (c. 1720–1803), m. 1767
BEAUDRET, Nicolas (1st third of 18th cent.)
BENNEMAN, Guillaume, m. 1785
BERLUY, François (mid-18th cent.)
BERLUY, Pierre (1st half of 18th cent.)
BERNARD, Jacques, m. 1760
BERNARD, Nicolas (b. c. 1713), m. 1742
BERNARD, Pierre (c. 1715–c. 1770)
BERTHELMI, Nicolas (2nd quarter of 18th cent.)
BERTRAND, Jean-Pierre (b. 1737), m. 1775
BESSON, Charles (1734–1808), m. 1758
BILLIARD, Claude (1688–c. 1760)
BIRCKEL, Jean-Frédéric (1726–1809), m. 1786
BIRCKLÈ, Jacques (1734–1803), m. 1764
BIRCLET, Laurent-Charles, called BIRCKLÉ le Jeune (c. 1736–76), m. 1766
BOICHOD, Pierre, m. 1769
BOLTEN, Henri, m. 1774
BONNEMAIN, Pierre (1723–1800), m. 1751
BOUDIN, Léonard (1735–c. 1804), m. 1761
BOULLE, André-Charles (1642–1732), m. bef. 1666
BOULLE, André-Charles II, called BOULLE de Sève (1685–1745)
BOULLE, Charles-Joseph, called BOULLE le Jeune (1688–1754)
BOULLE, Jean-Philippe (c. 1680–1744)
BOULLE, Pierre-Benoît (c. 1682–1741)
BRANDT, Georges (c. 1746–1806), m. 1789
BROCHET, Jean-Baptiste, m. 1741
BRULLÉ, Jacques, m. 1776
BRUNS, Jean-Antoine, m. 1782
BUCHETTE, François-Henri, m. 1770
BUNEL, Pierre-Paul, m. 1778

BURGEVIN, Jean-Claude (c. 1667–1743)
BURY, Ferdinand, called FERDINAND (1740–95), m. 1774
BUTTE, see BEAUCLAIR
B. V. R. B., called BERNARD, see VANRISAMBURGH
CAMP, Michel (bef. 1620–c. 1684)
CANABAS, François-Antoine, m. 1779
CANABAS, Joseph GENGENBACH, called CANABAS (1712–97), m. 1766
CAREL, Jacques-Philippe, m. 1723
CARLIN, Étienne, m. 1753
CARLIN, Martin (d. 1785), m. 1766
CAUMONT, Jean (1736–af. 1800), m. 1774
CHAPUIS, of Paris (?) and Brussels (end 18th and beg. 19th cent.)
CHARRIÈRE, P. (2nd half of 18th cent.)
CHARTIER, Étienne-Louis, m. 1781
CHARTIER, Jacques-Charles, m. 1760
CHAUMONT, Bertrand-Alexis (1741–af. 1790), m. 1767
CHAVIGNEAU, Victor-Jean-Gabriel (1746–1806), m. 1787
CHEVALLIER, Charles, called LE JEUNE (c. 1700–71), m. bef. 1737
CHEVALLIER, Jean-Mathieu, L'AÎNÉ (1696–1768), m. 1743
CHEVALLIER, see CRIARD
CHOQUET, Claude-Julien (1696–1764), m. bef. 1737
CLÉRET, Pierre, m. bef. 1737
COCHOIS, Charles-Michel (d. 1764), m. bef. 1737
COCHOIS, Jean-Baptiste (d. 1789), m. 1770
COIGNARD, Pascal (1748–af. 1791), m. 1777
COLBAULT, Pierre-Barthélemy, m. 1770
COLLET, Edmond (1681–c. 1755)
CORDIÉ, Guillaume (c. 1725–1786), m. 1766
COSSON, Jacques-Laurent, m. 1765
COSTE, Charles-Louis, m. 1784
COUET, Louis-Jacques, m. 1774
COULERU, Abraham-Nicolas (1716–1812), m. Montbéliard 1750
COULERU, Pierre-Nicolas (1755–1824), of Montbéliard
COULON, Balthazar (mid-18th cent.)
COULON, Gaspard (d. af. 1774)
COULON, Jean-François, m. 1732
COURTE, Jean-Baptiste (1749–1843), m. of Dijon 1777
COUTURIER, Antoine, m. 1767
CRAMER, Mathieu-Guillaume

(d. 1804), m. 1771
CRÉPI, François CRESPI, called LE ROMAIN (b. 1744), m. 1778
CRESSENT, Charles (1685–1768)
CRESSON, Jacques-Louis (1743–95), m. 1759
CRIARD or CRIAERD, Antoine-Mathieu, called CHEVALLIER (c. 1724–87), m. 1749
CRIARD or CRIAERD, Mathieu (1689–1776), m. 1738
CRIAERD or CRIARD, Sébastien-Mathieu (1732–96)
CUCCI, Domenico (bef. 1640–1705)
DAUTRICHE, Jacques Van OOSTENRYK, called (d. 1778), m. 1765
DAUTRICHE, Thomas-Jacques (b. 1744)
DEFRICHE, Pierre, m. 1766
DELACOUR, Jean-François, m. 1768
DELAITRE, Louis, m. 1738
DELOOSE, Daniel (d. 1788), m. 1767
DELORME, Adrien FAIZELOT-, m. 1748
DELORME, Alexis FAIZELOT-, m. 1772
DELORME, François FAIZELOT- (1691–1768). m. bef. 1735
DELORME, Guillaume (1757–95), m. 1786
DELORME, Jean-Louis FAIZELOT-, m. 1763
DEMOULIN, Bertrand (1755–1853), of Dijon
DEMOULIN, Jean (1715–98), first of Paris, m. Dijon 1780
DEMOULIN, Jean-Baptiiste (1750–1837), m. Dijon 1783
DENIZOT, Jacques (c. 1684–1760)
DENIZOT, Pierre (c. 1715–82), m. 1760
DESGODETS, Claude-Joseph, m. 1749
DESJARDINS, Pierre, m. 1774
DESTER, Godefroy, m. 1774
DETROULLEAU, Jean-Baptiste (1737–1780), m. 1767
D. F. (François DELORME?), active c. 1740–50
DOIRAT, Étienne (c. 1675–1732)
DOMAILLE, Henri-Gilles, m. 1778
DUBOIS, Jacques (1694–1763), m. 1742
DUBOIS, Louis (b. 1732), m. 1755
DUBOIS, René, m. 1757
DUBUISSON, Nicholas-René (b. 1728), of Paris and Versailles
DUBUT, Jean-François (d. 1778)
DUCOURNEAUX, Jean, m. 1782
DUEZ, Nicholas-Joseph, m. 1788
DUFOUR, Charles-Joseph (1740–c.1782), m. 1759
DUHAMEL, François (1723–1801),

m. 1750
DUPRÉ, Pierre (1732–99), m. 1766
DURAND, Bon, m. 1761
DUSAULT, Nicolas-Philippe, m. 1774
DUSAUTOY, Jean-Pierre (1719–1800), m. 1779
ELLAUME, Jean-Charles, called ALLEAUME, m. 1754
ERSTET, Jean-Ulric, m. 1763
EVALDE, Maurice-Bernard EWALD, called, m. 1765
EVRARD, Gaspard (2nd quarter of 18th cent.)
FEILT, Gaspard (d. 1763)
FÉLIX, Laurent, m. 1755
FELIZET, Edme-Jean (2nd quarter of 18th cent.)
FERDINAND, see BURY
FERMET, Jean-Bénigne, m. 1759
FEUERSTEIN, Jean-Philippe (b. 1749), m. 1785
FEUERSTEIN, Joseph (1733–1809), m. 1767
F. G., see GARNIER, François
FILON, Gabriel-Cécile (1726–98), m. 1750
FLÉCHY, Pierre (1715–af. 1769), m. 1756
F. L., see LIEUTAUD, François
FLEURY, Adrien (1721–75)
FLEURY, François (mid-18th cent.)
FLEURY, René-Charles, m. 1755
F. M. D., see MONDON, François
FONTAINE, Jean-Michel, m. 1767
FORSCHMANN, Augustin (b. 1727), m. 1773
FORSTER, Richard (d. 1794), m. 1788
FORTANIER, Jean-David, or I. D. F
FOULLET, Antoine (c. 1710–75), m. 1749
FOULLET, Pierre-Antoine (b. c. 1732), m. 1765
FOUREAU, Louis, m. 1755
FROMAGEAU, Charles (d. 1688)
FROMAGEAU, Jacques-André (1735–1810), m. 1765
FROMAGEAU, Jean-Baptiste, m. 1755
FROST, Jean-Gotlieb (c. 1746–1814), m. 1785
GALET, Jean-Baptiste (d. 1784), m. 1754
GALLIGNÉ, Pierre-Antoine, m. 1767
GAMICHON, Jean-Baptiste (d. 1832)
GARNIER, François (d. 1774) or F. G.
GARNIER, Pierre (c. 1720–1800), m. 1742
GARRÉ, Louis-Guillaume, m. 1741
GAUDREAUS, Antoine-Robert (c. 1680–1751)
GAUDRON, Aubertin, active c. 1670–1700

GAUDRON, Renaud, active c. 1690–1710
GAUTIÉ, Jean-Baptiste, m. 1761
GENTY, Denis, m. 1754
GÉRARD, Nöel (bef. 1790–1736), marchand-ébéniste and mercier
GIGUN, François LÉBE-, m. 1786
GILBERT, André-Louis (1746–1809), m. 1744
GILLET, Jean, m. bef. 1737
GILLET, Louis, m. 1766
GOLE, Pierre (c. 1620–84), m. bef. 1656
GOSSELIN, Adrien-Antoine, m. 1772
GOSSELIN, Antoine (1731–94), m. 1752
GOSSELIN, Josse, called LE JEUNE, m. 1768
GOYER, François, m. 1740
GOYER, Jean, m. 1760
GRANDJEAN, Jean-Louis (b. 1739), m. 1766
GREVENICH, Nicolas, m. 1768
GRIFFET, Jean-François, m. 1779
GUÉRARD, Pierre, m. 1740
GUÉRIN, Jean-Louis, m. 1778
GUIGNARD, Pierre-François, called QUENIARD, (1740–94), m. 1767
GUILLARD, Pierre, m. 1777
GUILLAUME, Simon (3rd quarter of 18th cent.)
GUILLEMAIN, Pierre (b. 1697)
GUILLEMART, François (d. 1724), m. bef. 1672
GUYOT, Nicolas (1735–1812), m. 1775
HACHE, Christophe-André (1748–1831), of Grenoble
HACHE, Jean-François, called L'AÎNÉ or LE FILS (1730–96), of Grenoble
HACHE, Pierre, (1705–76), of Grenoble
HACHE, Thomas (1664–1747), of Grenoble
HAIMARD, Louis-Jacques, m. 1756
HANNOT, Antoine-Simon, m. 1758
HANSEN, Hubert, m. 1747
HARMANT, Jean (d. 1670)
HECQUET, Charles (d. 1731), active from 1709, marchand-joaillier 1729
HÉDOUIN, Jean-Baptiste (d. 1783), m. 1738
HENRY, Jean (1747–1809), m. 1779
HENRY, Jean-Baptiste, m. 1777
HENRY, Nicolas, m. 1773
HÉRICOURT, Antoine (c. 1730–92), m. 1773
HÉRICOURT, Nicolas (1729–90)
HERTEL, Georges, m. 1777
HERVIEUX, Antoine-Marie (d. 1793), m. 1786
HOFFMANN, Jean-Diebold, m. 1785

*m. – master

HOLTHAUSEN, Jean, m. 1764
I. D. F., see FORTANIER, Jean-David
IGOU, Balthazar-André (d. bef. 1737)
IGOU, Guillaume (2nd quarter of 18th cent.)
JACOB frères, collaboration 1796–1803
JACOT, Antoine-Pierre, m. 1766
JANSEN, Georges (b. 1726), m. 1767
JAVOY, Claude, m. 1779
JOLLAIN, Adrien-Jérôme, m. 1763
JOSEPH, Joseph BAUMHAUER, called (d. 1772), 'ébéniste privilégié' c. 1749
JOSEPH, fils or Gaspard-Joseph BAUMHAUER (b. 1747)
JOUBERT, Gilles (1689–1775), m. c. 1714
KANS, Jean, m. 1783
KASSEL, Georges, m. 1779
KEMP, Guillaume, m. 1764
KINTZ, Georges, m. 1776
KIRSCHENBACH, Jean-Adam, called LE JEUNE, m. 1774
KIRSCHENBACH, Jean-Jacques, m. 1778
KOCKE, Bernard, m. Strasbourg 1741
KOECHLY, Joseph (d. 1798), m. 1783
KOFFLER, Jean-Mathieu (1736–96)
KOPP, Maurice, m. 1780
KRIER, Charles (b. 1742), m. 1774
LACROIX, Pierre-Roger VANDERCRUSE, called LACROIX, (c. 1750–1789), m. 1771
LACROIX, Roger VANDERCRUSE, called R. LACROIX or R. V. L. C. (1728–99), m. 1755
LAFOLIE, Pierre, m. 1755
LAINÉ, Louis, m. 1740
LANCELIN, Nicolas, m. 1766
LANDRIN, Germain, m. 1738
LANNUIER, Nicolas, m. 1783
LAPIE, Jean, called LE JEUNE, m. 1762
LAPIE, Jean-François (1720–97), m. 1755
LAPIE, Nicolas-Alexandre, called L'AINÉ (d. 1775), m. 1764
LARDIN, André-Antoine (1724–90), m. 1750
LARDIN, André-Antoine, fils m. 1774
LARDIN, Louis-François, m. 1774
LARZILLIÈRE, Jean-Gérard (first half of 18th cent.)
LATZ, Jean-Pierre (c. 1691–1754), 'ébéniste privilégié' bef. 1741
LEBESGUE, Claude, m. bef. 1737
LEBESGUE, Claude-Pierre (d. 1789), m. 1750
LEBESGUE, François (d. 1765)
LEBESGUE, Robert-Claude (b. 1749), m. 1771
LEBLOND, Jean-François, m. 1751
LECLERC, Charles-Michel

(1743–1805), m. 1786
LECLERC, Jacques-Antoine (1744–92), m. 1779
LEFAIVRE, Charles (d. 1759), m. 1738
LEGRY, Jean-Louis-François (1745–af. 1792), m. 1779
LEHAENE, Pierre-Joseph, m. 1789
LELEU, Jean-François (1729–1807), m. 1764
LELIBON, Laurent (d. bef. 1673), m. af. 1665
LEMARCHAND, Charles-Joseph, m. 1789
LEPAGE, Guillaume-Joseph, m. 1777
LEPENDU, Jean-Baptiste, m. 1782
LESUEUR, François, m. 1757
LETELLIER, Jacques-Pierre, m. 1767
LEVASSEUR, Étienne (1721–98), m. 1767
LEVASSEUR, Pierre-Étienne (c. 1770–c. 1820)
LEVESQUE, Albert, m. 1749
LHERMITE, Martin-Étienne, m. 1753
LIDONS, Louis, m. 1777
LIEUTAUD, Balthazar (d. 1780), m. 1774
LIEUTAUD, François or F. L. (d. c. 1749)
LIMONNE, Jean-Baptiste (d. 1761), m. 1737
LOUASSE, Nicolas, m. 1781
LOVIAT, Jean-François, m. 1779
L. S. P., see Louis-Simon PAINSUN
LUCIEN, Jacques (1748–c. 1811), m. 1774
LUTZ, Gérard-Henri (1736–1812), m. 1766
MACÉ, Jean (1602–1672)
MACLARD, Charles (d. 1775), m. 1742
MACRET, Pierre (1727–af. 1796), 'ébéniste privilégié' 1756, marchand-mercier 1771
MAGNIEN, Claude-Mathieu, m. 1771
MAIGNAN, Jean, m. 1786
MALBET, Pierre, m. 1765
MALLE, Louis-Noël (1734–82), m. 1765
MALLEROT, Michel (1675–af. 1753)
MANSER, Jacques (1727–c. 1780)
MANSION, Antoine-Simon, m. 1786
MANSION, Simon (1741–c. 1805), m. 1780
MANTEL, Pierre (d. 1802), m. 1766
MARCHAND, Nicolas-Jean (b. c. 1697), m. bef. 1737
MARTIGNY, Nicolas, m. 1738
MATHIEU, Jean-Paul (d. 1745)
MAUR, Jean-Georges, m. 1781
MAUTER, Conrad (1742–1810), m. 1777
MEUNIER, Pierre (b. 1735), m. 1767
MEWESEN, Pierre-Harry, m. 1766
MICHAELIS, Jean-Frédéric,

m. 1787
MICHAUT, Jean-Louis, m. 1775
MIGEON, Pierre I (b. c. 1670)
MIGEON, Pierre II (1701–58)
MIGEON, Pierre III (1733–75), m. 1761
MILET, Pierre-François, m. 1767
MILLET, Jean-Jacques, m. 1757
MOLITOR, Bernard (1755–1833), m. 1787
MONDON, François, or F. M. D. (1694–1770), m. bef. 1737
MONDON, François-Antoine, m. 1757
MONGENOT, François (1732–1809), m. 1761
MONTIGNY, Philippe-Claude (1734–1800), m. 1766
MOREAU, Adrien, m. 1750
MOREAU, Louis (d. 1791), m. 1764
MULLER, Joseph-Adam, m. 1785
N.G., see Noël GÉRARD
NICOLAS, Antoine, m. 1765
NICQUET, Jean-Baptiste (d. 1781), m. 1775
NOCART, Jacques-Joseph (3rd quarter of 18th cent.)
OEBEN, Jean-François (1721–63), m. 1759, 'ébéniste du roi' 1754
OEBEN, Simon (d. 1786), m. 1769
OHNEBERG, Martin, m. 1773
OPPENORDT, Alexandre-Jean (c. 1639–1715)
ORTALLE, Charles, m. 1756
PAFRAT, Jean-Jacques (d. 1793), m. 1785
PAINSUN, Louis-Simon or L. S. P. (d. bef. 1748)
PAGET, Dieudonné, m. 1786
PAPST, François-Ignace, m. 1785
PASQUIER, Philippe (d. 1783), m. 1760
PÊCHE, Guillaume (1752–1800), m. 1784
PELLETIER, Denis-Louis, m. 1760
PÉRIDIEZ, Brice, m. bef. 1737
PÉRIDIEZ, Gérard, m. 1761
PÉRIDIEZ, Louis (b. 1731), m. 1764
PETIT, Jean, m. 1767
PETIT, Jean-Marie (b. 1737), m. 1777
PETIT, Nicolas (1732–91), m. 1761
PETIT, Nicolas (1730–98), m. 1765
PIERRE, Louis-Claude, m. 1767
PIGNIT, Jean-Baptiste (1745–91), m. 1777
PIONIEZ, Pierre (d. 1790), m. 1765
PLÉE, Pierre (1742–1810), m. 1767
POITOU, Joseph (c. 1682–1718), m. 1717
POITOU, Philippe (c. 1650–1709), m. bef. 1676
POPSEL, Jean (1720–af. 1785), m. 1755
PORQUET, Jacques (1704–af. 1788), m. 1767
POTARANGE, Jean, HOFFENRICHLER, called, m. 1767
POUSSAIN, Marc-Antoine, m. 1772
PROVOST, Charles-Bernard (1706–86), m. 1737

PRZIREMBEL, Godefroy, m. 1766
QUERVELLE, Jean-Claude (1731–78), m. 1767
QUILLART, Pierre (d. 1746), m. 1716
RAISIN, Jean-Georges, m. 1755
RATIÉ, Jean-Frédéric, m. 1783
REBOUL, Jean-Pierre, m. 1766
REBOUR, Isaac-Simon (1735–af. 1793), m. 1767
REIZELL, François (d. 1788), m. 1764
REVAULT, Claude (d. 1757), m. 1755
RICHTER, Charles-Erdmann, m. 1784
RIESENER, Jean-Henri (1734–1806), m. 1768
ROBIERSCKY, Jean-Georges (d. 1822), active c. 1790
ROCHETTE, Laurent (b. 1723)
ROENTGEN, David (1743–1807), m. 1780
ROGER, Antoine-Symphorien, m. 1779
ROHT, Michel-François, m. 1773
ROUSSEL, A. (d. bef. 1726)
ROUSSEL, Jacques (d. 1726)
ROUSSEL, Pierre (d. 1726)
ROUSSEL, Pierre I (1723–82), m. 1745
ROUSSEL, Pierre II, m. 1771
ROUSSEL, Pierre-Michel, m. 1766
ROUX, Hubert, called LEROUX, m. 1777
RÜBESTUCK, François, called Franz or France (c. 1722–85), m. 1766
R. V. L. C., see LACROIX
RYSSENBERG, see VANRISAMBURGH
SADON, Mathieu (1730–98)
SAGEOT, Nicolas (d. 1731)
SAINT-GERMAIN, Joseph de, m. 1750
SAR, Jean-Girard (b. 1724), m. 1766
SAUNIER, Charles, m. bef. 1737
SAUNIER, Claude-Charles (1735–1807), m. 1765
SAUNIER, Jean-Baptiste, m. 1757
SAUNIER, Jean-Charles, m. 1743
SAUVAGE, André, m. 1752
SAUVAGE, André, m. 1769
SAVARD, Dieudonné, m. 1763
SCHEFFER, François, called Berger, m. 1782
SCHEFFER, Jean-Conrad, m. 1786
SCHEY, Fidelis, called Fidely (d. 1788), m. 1777
SCHILER, Jean-Martin called SCHÜLER, (1753–1812), m. 1781
SCHLICHTIG, Jean-Georges (d. 1782), m. 1765
SCHMIDT, Antoine-Marie, m. 1784
SCHMITZ, Joseph, m. 1761
SCHNEIDER, Caspar, called Gaspard, m. 1786
SCHNEIDER, Jean (d. 1769), m. 1757
SCHÜLLER, Jean-Philippe b. 1734), m. 1767

SCHUMANN, André, m. 1779
SCHWERDFEGER, Jean-Ferdinand, m. 1786
SCHWINGKENS, Guillaume (mid-18th cent.)
SÉVERIN, Nicolas-Pierre (1728–98), m. 1757
SÉVERIN, Pierre-Charlemagne, m. 1787
SIMONOT, Alexandre-Pierre, m. 1783
SINTZ, Joseph, m. 1785
SOMER, Jacques (d. 1669)
STADLER, Charles-Antoine, m. 1776
STOCKEL, Joseph (1743–1802), m. 1775
STRACH, Zacharie (beg. of 18th cent.)
STUMPFF, Jean-Chrysostome (1731–1806), m. 1766
TEUNÉ, François-Gaspard (b. 1726), m. 1766
THIBAULT, C. (2nd quarter of 18th cent.)
TOPINO, Charles (b. c. 1735), m. 1773
TOUPILLIER, Denis, m. 1764
TRAMEY, Jacques, m. 1781
TRICOTEL, Alexandre-Roch, m. 1767
TUART, Jean-Baptiste, m. 1741
TUART fils (b. c. 1720), m. tabletier and marchand-mercier
TURCOT, Jean-Baptiste-Charles, m. 1772
TURCOT, Pierre-Claude, m. 1783
TURCOT, Pierre-François, m. 1772
VANDERNASSE, Silvain-Lambert, m. 1771
VANRISAMBURGH (Bernard) of B. V. R. B. – Bernard I (d. 1738) – Bernard II (d. c. 1765), m. bef. 1737 – Bernard III (d. c. 1732–1800)
VASSOU, Jean-Baptiste (b. 1739), m. 1767
VAUDORME, Jean-Pierre, m. 1786
VEAUX, Pierre-Antoine (1738–84), m. 1766
VERMUNT, Gérard (d. 1764), m. bef. 1787
VIÉ, Sébastien, m. 1767
VIEZ, Joseph, m. 1786
VIRRIG, Nicolas, called NICOLAS, m. 1781
VOVIS, Jean-Adelbert called WOWITZ (b. 1735), m. 1767
WACKNER, Valentin, called VALENTIN, m. 1781
WALTER, Pierre (mid-18th cent.)
WATTEAUX, Louis-Antoine, m. 1779
WATTELIN, Pierre (b. 1719), m. 1757
WEBER, Jean-Vendelin, m. 1786
WEISWEILER, Adam (1744–1820), m. 1778
WIRTZ, Henri, m. 1767
WOLFF, Christophe (1720–95), m. 1755
YESMELIN, François (d. 1686)

BIBLIOGRAPHY

Daniel Alcouffe: 'Dal Rinascimento al Luigi XIV', in *Il Mobile Francese*, Milan, 1981; 'Le mobilier parisien', in exh. cat. *Louis XV*, Paris, 1974, pp. 307–33

Jean-Dominique Augarde: 'Historique et signification de l'estampille des meubles', *L'Estampille*, June 1985

E.-F. J. Barbier: *Journal d'un bourgeois de Paris sous le règne de Louis XV*, ed. Ph. Bernard, Paris, 1963

Christian Baulez: 'Il Luigi XVI', in *Il Mobile Francese*, Milan, 1981

Geoffrey de Bellaigue: 'Edward Holmes Baldock', *The Connoisseur*, 1975, pp. 209–99; September 1975, pp. 18–25; *The James A. de Rothschild Collection at Waddesdon Manor*, 2 vols, London, 1974; 'George IV and French Furniture', *The Connoisseur*, June 1977; '18th-century French furniture and its debts to the engraver', *Apollo*, January 1963, pp. 16–23; 'Engravings and the French eighteenth-century marqueteur', *Burlington Magazine*, May 1965, pp. 240–50; July 1965, pp. 357–62

P. Biver: *Histoire du château de Bellevue*, Paris, 1933

André Boutemy: *Meubles français anonymes du XVIIIe siècle*, Brussels, 1973

C. Briganti: *Curioso itinerario delle collezioni ducali parmensi*, Parme, Cassa di Risparmio, 1969

H. Brunner: *Die Kunstschätze der Münchner Residenz*, Munich, 1977

A. de Champeaux: *Le Meuble*, Paris, 1855; n.e., 2 vols, Viaux, no. 14

J. Cordey: *Inventaire des biens de Madame de Pompadour, rédigé après son décès*, Paris, 1939

Duc de Croÿ: *Journal inédit*, ed. Vicomte de Grouchy and P. Cottin, Paris, 1906

C. C. Dauterman, J. Parker, and E. A. Standen: *Decorative Arts from the Samuel H. Kress Collection at the Metropolitan Museum of Art*, London, 1964

Baron de Davillier: *Le Cabinet du duc d'Aumont et Une vente d'actrice sous Louis XVI: Melle Laguerre*, Paris, 1870; repr. New York, 1986

C. Dreyfus: *Le Mobilier français du Louvre, époque de Louis XVI*, 1921

L. Duvaux: *Livre-Journal, 1748–1758*, ed. Louis Courajod, Paris, 1873; Paris, 1965

Svend Eriksen: *Early Neoclassicism in France*, London, 1974

A. Feulner: *Kunstgeschichte des Möbels*, 3rd ed., Berlin, c. 1930

C. Fregnac and J. Meuvret: *Les Ebénistes du XVIIIe siècle français*, Paris, 1963

Michel Gallet: *Demeures parisiennes, époque Louis XVI*, Paris, 1964

Henry Havard: *Dictionnaire de l'ameublement et de la décoration depuis le XVIIIe siècle*, Paris, 4 vols, 1889–90

H. Hébert: *Dictionnaire pittoresque et historique de Paris*, Paris, 1766

Hans Huth: *Lacquer of the West*, Chicago, 1971

G. Janneau and P. Devinoy: *Le Meuble léger en France*, Paris, 1952

Sir G. F. Laking: *The Furniture of Windsor Castle*, London, 1905

Lalive de Jully: *Catalogue historique du cabinet de peinture*, 1764; repr. New York, 1988

R. Lespinasse: *Les Métiers et Corporations de la ville de Paris*, vol. II, Paris, 1892

C. Luynes and Duc d'Albert: *Mémoires*, Paris, 1860–65

F. Mathey: *Musée Nissim de Camondo*, Lausanne, ed. 1973

L. S. Mercier: *Le Tableau de Paris*, 1783; repr. Paris, 1979

E. Molinier: *Histoire générale des arts appliqués à l'industrie*, vol. III, 1896

J. Nicolay: *L'Art et la Manière des ébénistes français au XVIIIe siècle*, Paris, 1955

Baronne d'Oberkirch: *Mémoires*, Paris, 1970

James Parker and C. Le Corbeiller: *The Wrightsman Galleries*, New York, 1979

A. du Pradel: *Livre commode des adresses de Paris*, 1692; repr. Paris, 1878

S. de Ricci: *Le Style Louis XVI, mobilier et décoration*, Paris, 1913

W. Rieder: *France 1700–1800: Guide to European Decorative Arts*, Philadelphia Museum of Arts

Denis Roche: *Le Mobilier français en Russie*, Paris, c. 1900

Roubo: *L'Art du menuisier*, Paris, 1769–74, 5 vols, Viaux, no. 4465–4468 [Vol. III pt 2 is devoted to menuiserie, vol. III pt 3 to ébénisterie]; repr. Paris, Laget, 1976

F. de Salverte: *Les Ebénistes du XVIIIe siècle*, Paris-Brussels, 1923, 5th ed., 1962; *Le Meuble français d'après les ornemanistes de 1660 à 1789*, Paris, 1930

A. Setterwall: 'Some Louis XVI Furniture decorated with pietra dura reliefs', *Burlington Magazine*, December 1959

M. Stürmer: *Herbst des Alten Handwerks*, Munich, 1979

A. Theunissen: *Meubles et Sièges du XVIIIe siècle*, Paris 1934

Peter Thornton: *Seventeenth-Century Interior Decoration in England, France and Holland*, New Haven and London, 1978

Pierre Verlet: *Objets d'art français de la collection Calouste Gulbenkian*, Lisbon, 1969; 'Le commerce des objets d'art et les marchands-merciers à Paris au XVIIIe siècle', *Annales*, January–March 1958, pp. 10–29; *Le Mobilier royal français*, 3 vols: vols I and II, Paris, 1945–55; vol. III, London, 1963; *Les Meubles français du XVIIIe siècle*, vol. I, *Menuiserie*; vol. II, *Ebénisterie*, Paris, 1956, repr. 1982; *L'Art du meuble à Paris au XVIIIe siècle*, Paris, 1958; *La Maison du XVIIIe siècle en France*, Fribourg, 1966; *Styles, meubles et décors*: vol. II, *Du Louis XVI à nos jours*, Paris, 1972

H. Vial, A. Marcel, and A. Girodie: *Les Artistes décorateurs du bois*, 2 vols, Paris, 1912, 1922

J. Viaux: *Bibliographie du meuble (mobilier) civil français*, Paris, 1966

R. Wark: *French Decorative Art in the Huntington Collection*, The Huntington Library, San Marino, Calif., 1961, repr. 1979

F. J. B. Watson: *Wallace Collection Catalogue: Furniture*, London, 1956; *Louis XVI Furniture*, London, 1960; trans. 1963; *The Choiseul Box*, Oxford, 1963; *The Wrightsman Collection, Furniture, Gilt Bronzes, Carpets*, 2 vols, New York, 1966; 'Beckford and the taste for Japanese lacquer in 18th-century France', *Gazette des Beaux Arts*, 1963, pp. 101–27

Gillian Wilson: *Decorative Arts in the J. Paul Getty Museum*, Malibu, Calif., 1977; 'Acquisitions made by the Department of Decorative Arts', *The J. Paul Getty Museum Journal*, vols 6–7, 1978–79; vol. 8, 1980; vol. 11, 1983; vol. 12, 1984; vol. 13, 1985; vol. 14, 1986; vol. 16, 1988

F. de Windisch-Graetz: 'Französische Möbel aus des 18. Jahrhunderts in Wiener Privatbesitz', *Alte und moderne Kunst*, January–February 1965, pp. 26–31

AUTHOR'S ACKNOWLEDGEMENTS

I should like to thank those members of museum staffs, art historians, private collectors and specialists who kindly helped me with advice and information and allowed me access to their collections or photographic archives:

AUSTRIA
M. Christian Witt-Doring.

FRANCE
M. Daniel Alcouffe, M. Didier Aaron, Mme Geneviève Attal, M. Gérard Auguier, M. Robert de Balkany, Mme Barzin, M. Christian Baulez, la Princesse de Beauvau-Craon, le Comte de la Béraudière, M. Stéphane Boiron, MM. Jean-Paul and Michel Fabre, M. Jean Feray, M. François Fossier, M. Jean-Jacques Gautier, M. Jean Gismondi, M. Hubert de Givenchy, M. Jérôme de la Gorce, M. Pierre de Gunzbourg, Mme Barbara Hottinguer, M. Patrick Hourcade, M. Michel Jamet, M. Philip Jodidio, M. Karl Lagerfeld, M. Ulrich Leben, M. Patrick Leperlier, M. Francis Lesur, Mme Levet, M. Claude Lévy, M. Jean Lupu, M. Gérard Mabille, M. Michel Meyer, Mme Mazery, M. Stavros Niarchos, M. Jacques Perrin, le Baron de Rédé, M. Jean-Marie Rossi, la Baronne Guy de Rothschild, M. Maurice Segoura, M. Claude Sère, M. Bernard Steinitz, M. Tigréa, le Comte Patrice de Voguë, le Commandant Paul-Louis Weiller.

GREAT BRITAIN
Sir Geoffrey de Bellaigue, Mr Frank Berendt, Mr Jonathan Bourne, Miss Frances Buckland, Mr Charles Cator, Mr Martin Chapman, Mrs Elizabeth Conran, Mr Gervase Jackson-Stops, Miss Katherine Maclean, Mr Frank Partridge, Mr Adrian Sassoon, Mr John Whitehead.

PORTUGAL
Mme Isabelle Pereira-Coutinho.

SWEDEN
Mme Lis Granlund.

SWITZERLAND
Mme Annelise Nicod.

UNITED STATES
Mrs Gillian Arthur, Mr Roger Berkowitz, Mr David Cohen, Mr Theodore Dell, Mr Henry Hawley, Mr Peter Krueger, Mr Thierry Millerand, Mr Jeffrey Munger, Mrs Helen Neithammer.

I should like to thank Miss Gillian Wilson especially for her care in correcting and commenting on the English translation of this book.

INDEX OF PRINCIPAL NAMES OF PERSONS

Page numbers in Roman type refer to the main text, those
in italics to captions, and those in bold to appendices

INDEX OF PRINCIPAL PLACE-NAMES

ILLUSTRATION
ACKNOWLEDGEMENTS

Grateful acknowledgement is due to the following for their kind permission to reproduce copyright photographs (numbers are those of illustrations except where page numbers are given):

MUSEUMS AND PUBLIC COLLECTIONS

Alte Pinakothek, Munich, 183

Bibliothèque Nationale, Paris, 16, 102

Bowes Museum, Barnard Castle, Co. Durham, 51

Cleveland Museum of Art, Cleveland, Ohio, 127 (John L. Severance Fund, 49.200), 335 (John L. Severance Fund, 51.115 and 51.116), 337 (Elizabeth Prentiss Collection, 44.113)

Fine Arts Museums of San Francisco, 408 (Gift of Archer M. Huntington), 418 (Gift of Mr and Mrs Bruce Kelham for the Grace Spreckels Hamilton Collection)

Frick Collection, New York, 115, 212, 321, 454

J. Paul Getty Museum, Malibu, California, jacket (front and back), 2, 27, 49, 56, 65, 136, 175, 188, 264, 278, 514

Gulbenkian Museum, Fundação Calouste Gulbenkian, Lisbon, 90, 91, 160, 171, 269

Huntington Art Gallery, Pasadena, California, 409, 410, 482

Livrustkammaren, Stockholm, 11

Metropolitan Museum of Art, New York, p. 5, p. 38, p. 39; 186, 192, 203 (Gift of Mr and Mrs Charles Wrightsman, 1973 (1973.315.1); photograph by Taylor & Dull, New York), 237, 375, 407, 471 and 472 (Bequest of William K. Vanderbilt, 1920), 477 (Gift of Mr and Mrs Charles Wrightsman, 1977), 481 (Gift of the Samuel H. Kress Foundation, 1958)

Musée d'Art et d'Histoire, Geneva, p. 37 (below); 226, 461

Musée des Arts Décoratifs, Paris, p. 12, p. 35; 30, 36

Musée du Mans, 190

Museum of Fine Arts, Boston, 217 (Gift of Mrs Alfred J. Beveridge in memory of Delia Spencer Field), 519 (Helen and Alice Colburn Fund), 520 (Bequest of Marianne S. Rogers)

National Gallery of Ireland, 266

The National Trust, Waddesdon Manor, Buckinghamshire, 74, 98, 129, 152, 317, 328, 449, 450, 451, 453

Her Majesty Queen Elizabeth II, 96, 167, 243, 348, 415, 492, 498

Residenzmuseum, Munich, p. 21 (below); 67, 81, 89, 106, 274

Réunion des Musées Nationaux, p. 9; 6, 17, 22, 31, 37, 42, 45, 52, 53, 92, 97, 99, 116, 118, 119, 149, 158, 172, 204, 216, 222, 233, 259, 356, 358, 372, 396, 398, 399, 403, 419, 420, 448, 470, 475, 476, 486, 494, 495, 503, 505, 506, 517, 518, 522, 523, 529

Rijksmuseum, Amsterdam, 155, 424, 462

Schloss Köpenick, Berlin, 512

Swedish Royal Collections, by kind permission of His Majesty the King, 112, 257, 490, 491

Toledo Museum of Art, Toledo, Ohio, 68

The Trustees of the Victoria and Albert Museum, London, 1, 15, 209, 285, 427

Wallace Collection, London, 10, 13, 43, 59, 117, 123, 124, 202, 211, 298, 330, 331, 340, 352, 388, 452, 499, 530

PRIVATE SOURCES

Alexander and Berendt Ltd, London, 50, 234, 239, 244, 252, 521

Arnault Carpentier, Paris, 7, 88, 93, 138, 255, 262, 370, 401, 455

Christie's, London, 4, 12, 23, 103, 133, 134, 181 (photo A. C. Cooper), 207, 208, 235, 248, 256, 258, 277, 294, 299, 301, 303, 306, 319, 322, 361, 369, 376, 378, 380 (photo A. C. Cooper), 381 (photo A. C. Cooper), 384 (photo A. C. Cooper), 389, 397 (photo A. C. Cooper), 400 (photo A. C. Cooper), 404, 414, 416, 429, 437, 493, 497, 504, 516

Documentation T. Dell (photo David Drey), 66

Jean-Yves Dubois, Paris, 25, 32, 46, 125, 146, 189, 232, 260, 351, 353, 354, 355, 391, 394, 422, 423, 500, 501, 508, 526

Edimedia, Paris, 3 (photo Pascal Hinous), 131, 341, 342

Etude Ader-Picard-Tajan, Paris, 135

Etude Couturier-Nicolaÿ, Versailles, 144, 261, 268, 479

Etude Godeau-Audap-Solanet, Paris, 219

Etude Ojer-Dumont, Paris, 137

Archives Galerie Aveline, Paris, p. 6 (below); 5, 20, 26, 33, 61, 71, 72, 78, 87, 104, 110, 168, 191, 238, 240, 251, 253, 254, 302, 332, 338, 343, 345, 357, 371, 430, 433, 434, 441, 442, 464, 467, 480, 502

Archives Galerie Didier Aaron, Paris, 438, 459

Archives Galerie Fabre, Paris, 34, 35, 85, 236, 241, 242, 325, 363, 406, 417

Archives Galerie Gismondi, Paris, p. 8; 28, 40, 107, 195, 205, 213, 228, 296, 310

Archives Galerie Léage, Paris, 109, 250

Archives Galerie Levy, Paris, 63, 164, 185, 245, 431, 456, 468, 469

Archives Galerie Lupu, Paris, 84, 295, 439, 507

Archives Galerie Meyer, Paris, 157, 220, 344

Archives Galerie Mikaeloff, Paris, 402

Archives Galerie Perrin, Paris, 111, 113, 179, 198, 199, 379, 383

Archives Galerie Maurice Segoura, Paris, 41, 60, 73, 79, 82, 121 (photo G. Cigolini), 140, 147, 161, 218, 227, 275, 336, 465, 485, 525

Archives Galerie Steinitz, Paris, 95, 178

Giraudon, Paris, 122, 271, 280, 282, 287, 309, 323

Hector Innes, 304

Partridge (Fine Arts) plc, London, 265, 307

M. Alexandre Pradère, p. 1, p. 16, p. 31 (above), p. 32, p. 36; 9, 18, 24, 39, 69, 100, 108, 151, 173, 174, 272, 279, 283, 284, 293, 312, 326, 349, 359, 367, 374, 377, 395, 411, 432, 440, 463, 527; pp. 430, 432, 440

Sotheby's, p. 6 (above, below left), p. 7, p. 17, p. 18, p. 30, p. 31 (below), p. 37 (above), p. 40, p. 41 (above right), p. 43; 8, 14, 21, 29, 44, 47, 48, 54, 55, 58, 64, 70, 75, 76, 77, 83, 86, 94, 101, 105, 114, 120, 126, 128, 130, 132, 139, 141, 142, 143, 145, 148, 150, 153, 154, 156, 159, 162, 163, 165, 166, 169, 170, 176, 177, 180, 182, 184, 187, 193, 194, 197, 200, 201, 214, 221, 223, 224, 225, 229, 230, 231, 246, 249, 263, 267, 273, 281, 286, 288, 289, 290, 291, 292, 297, 300, 305, 311, 313, 315, 316, 320, 324, 327, 346, 347, 350, 362, 364, 365, 366, 368, 373, 382, 385, 386, 390, 392, 393, 412, 413, 421, 425, 426, 428, 435, 436, 443, 444, 445, 446, 447, 457, 458, 460, 473, 474, 484, 487, 489, 509, 510, 511, 515, 524, 528; p. 439

Philip Wilson Publishers Ltd, London, 38, 206, 215, 329, 334, 339, 387, 488, 513

Other private collections, p. 19, p. 21 (above), p. 41 (left above and below), p. 42; 19, 57, 80, 196, 247, 270, 276, 308, 314, 318, 333, 360, 405, 466, 478, 496

Clock with figure of Atlas: there is an identical clock, on a triangular pedestal, in the Musée des Arts et Métiers, Paris. It is signed by the clock-maker Thuret and dated 1712, with provenance from the widow of Le Bas de Montargis, financier and client of Boulle. (Sotheby's Monaco, 15 June 1981, lot 142)

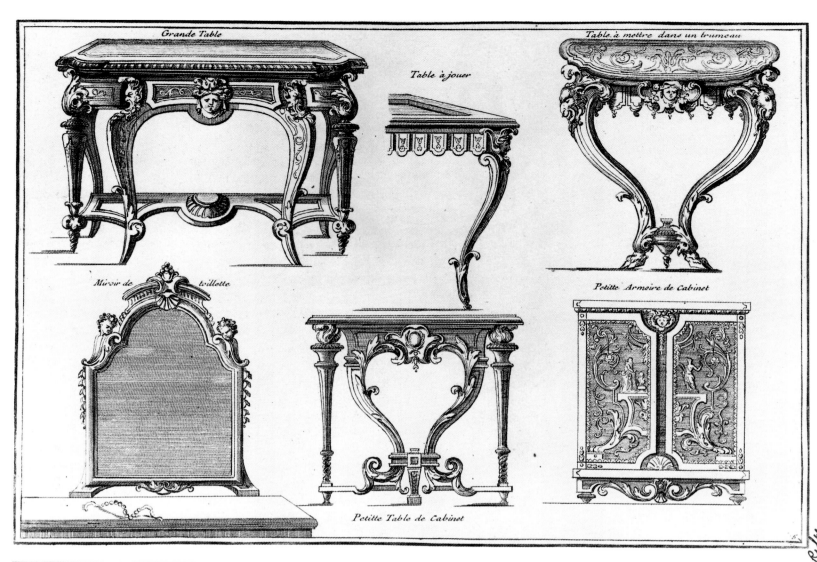

Grande Table

Table à jouer

Table à mettre dans un trumeau

Miroir de toillette

Petitte Armoire de Cabinet

Petitte Table de Cabinet

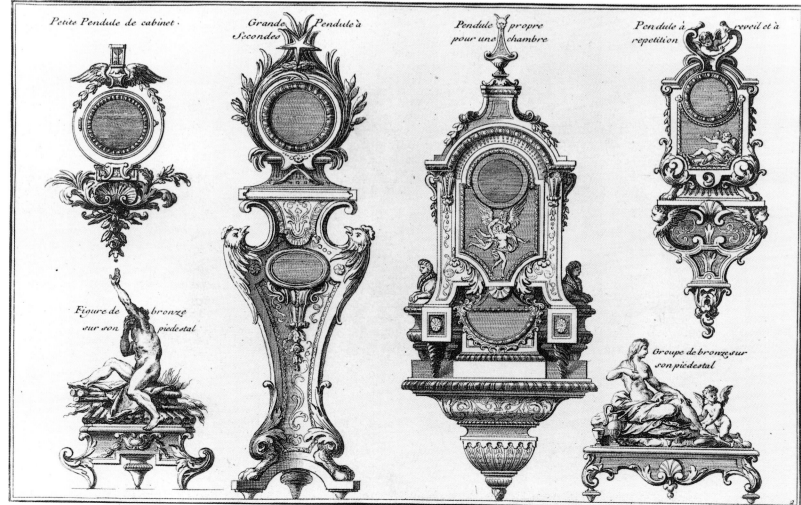

Petite Pendule de cabinet.

Grande Pendule à Secondes

Pendule propre pour une chambre

Pendule à reveil et à repetition

Figure de bronze sur son piedestal

Groupe de bronze sur son piedestal